D1586625

IMAGING SO

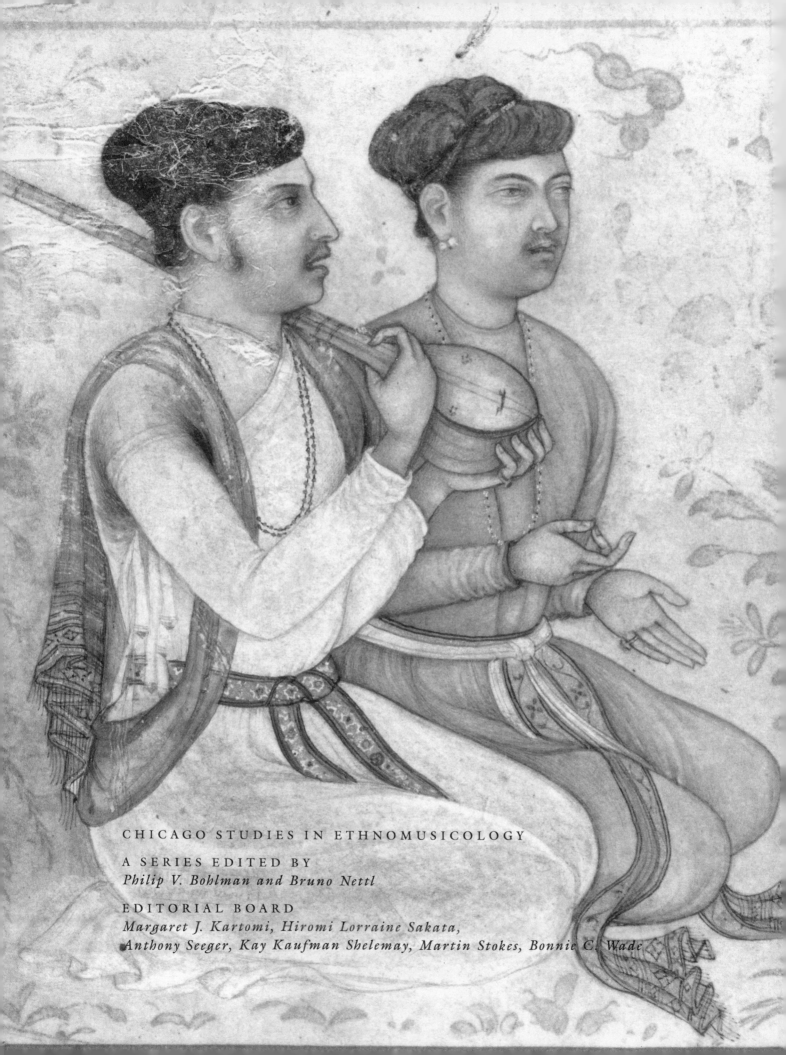

CHICAGO STUDIES IN ETHNOMUSICOLOGY

A SERIES EDITED BY
Philip V. Bohlman and Bruno Nettl

EDITORIAL BOARD
*Margaret J. Kartomi, Hiromi Lorraine Sakata,
Anthony Seeger, Kay Kaufman Shelemay, Martin Stokes, Bonnie C. Wade*

AN ETHNOMUSICOLOGICAL

IMAGING

STUDY OF MUSIC, ART, AND

SOUND

CULTURE IN MUGHAL INDIA

Bonnie C. Wade

THE UNIVERSITY OF CHICAGO PRESS

Chicago & London

BONNIE C. WADE is professor of music, Dean of Undergraduate Services, and Chair of the Deans of the College of Letters and Science at the University of California, Berkeley.

The University of Chicago Press, Chicago 60637
The University of Chicago Press, Ltd., London
© 1998 by The University of Chicago
All rights reserved. Published 1998
Printed in the United States of America

06 05 04 03 02 01 00 99 98 1 2 3 4 5

ISBN: 0-226-86840-0 (cloth)
ISBN: 0-226-86841-9 (paper)

Frontispiece: Detail of a royal hunting party. Folio from an *Album Assembled for Jahangir*, India, Mughal, c. 1591, opaque watercolors, gold and ink on paper, 41.0 cm × 23.8 cm. Courtesy of the Los Angeles County Museum of Art, Nasli and Alice Heeramaneck Collection, Museum Associates Purchase, M.78.9.11.

Library of Congress Cataloging-in-Publication Data

Wade, Bonnie C.
 Imaging sound : an ethnomusicological study of music, art, and culture in Mughal India / Bonnie C. Wade.
 p. cm.—(Chicago studies in ethnomusicology)
 Includes bibliographical references and index.
 ISBN 0-226-86840-0.—ISBN 0-226-86841-9 (pbk.)
 1. Music—Mogul Empire—History and criticism. 2. Music in art. I. Title.
II. Series.
ML338.W318 1998
700'.954'0903—dc21 97-14033
 CIP

This book is printed on acid-free paper.

In memory of the Mughal rulers,

patrons of the arts, and the Mughal women

and families, partners in the

great enterprise

CONTENTS

vii

ACKNOWLEDGMENTS

I was well into the completion of this book before I read John Richards's *The Mughal Empire* (1993) and happily noted in his preface that one of his purposes was to encourage more scholarly work on the Mughal period in South Asia. This is my aim as well in the current study. The Mughal empire was one of the largest premodern centralized states and one of the most complex and interesting—even more so for its largesse and patronage of the arts, culture, and intellectual activities, a kind of cradle of the "life of the mind" and the "life of the soul." I hope the reader will gain a strong sense of that in *Imaging Sound*.

I was drawn to the Mughal period initially by the sheer beauty of its so-called miniatures. How that interest was transformed into this book will soon be apparent. Throughout this endeavor I have had wonderful support in innumerable ways from students, colleagues, and family. Here at Berkeley, I have had the good fortune to team-teach two graduate seminars on visual sources for the documentation of music history with my colleague Daniel Heartz. As I was wrestling in the early days with ways to organize overwhelming amounts of new information from hundreds of paintings, he showed me how to tease out incredible jewels of insight and information from just one work of pictorial art. I have benefited from the collections of, conversations with, and advice from Joanna Williams, my colleague in South Asian art history. I also appreciate my confrere in South Asian languages, Aditya Behl, who was helpful with regard to the history of religions and Persian materials. Other colleagues who have been willing

discussants and who offered suggestions and encouragement include Richard Crocker (with whom I team-taught a seminar on oral traditions), Joseph Kerman, Richard Taruskin, and especially Benjamin Brinner, whose ideas in the entire realm of music I greatly value and enormously respect. I also want to mention the late John Blacking, whose vital presence in the field of ethnomusicology remains strong and whose friendship and intellect I sorely miss.

Through the years, several graduate students have assisted me tremendously as enthusiastic research assistants on this project. They include Farhad Ataei, George Ruckert, Ruth Charloff, Marisol Berrios-Miranda, Seow Chin Ong, Partow Hoosmanrad, Rajna Klaser, Zahra Taheri, and especially Chan Le, who has performed yeoman service in the dogged pursuit of plates and permissions. The graduate students, both ethnomusicologists and musicologists, in the annual course Music 200C Seminar, Introduction to Music Scholarship: Ethnomusicology, have been good partners in discussing issues relating to gender and feminist viewpoints on music, culture and reception studies, postmodernism, and other au courant themes in the field which have contributed both explicitly and implicitly to this book. I especially thank all the graduate students in ethnomusicology through the years this work has been in progress: the interchange of ideas and other aspects of each of their areas of study and work have also helped inform mine.

I am also grateful to the College of Letters and Science and to the Committee on Research of the University of California, Berkeley, Academic Senate for generous stipends to support my research and to provide a subvention for permissions and publication of illustrations for this and various articles of mine on the Mughal era. I also give special thanks to the Vice Chancellor and Provost, Carol T. Christ, who has been enormously supportive of my research throughout the period of my deanships.

I want to acknowledge my boon companion in Indic music studies, Regula Burckhardt Qureshi. How many conversations and scholarly exchanges over the years we have had about each of our various projects, culminating with her very helpful suggestions on this one! Reis Flora has been a generous friend, with insights on organology and iconography in South Asia. As well, Hormoz Farhat was helpful with Persian translations and musical ideas. Pirkko Moisala and I enjoyed good, useful conversations about various aspects of this work.

In both the history and art history of South Asia, I am most grateful to several scholars. Shahab Sarmadee, the historian of Muslim India, guided me through passages in the *Akbar Nāma* and the *A'īn-i Akbarī* and led me to sources on Amir Khusrau. I have benefited from his depth of knowledge and kindness since we first met at Aligarh two decades ago. John Richards, preeminent historian of the Mughal period, gave my manuscript a thorough reading and made incisive comments and suggestions which helped the precision and focus of the historical context and materials. Milo Beach, Curator of the Arthur M. Sackler Gallery and Freer Gallery of Art of the Smithsonian Institution, himself the author and producer of several outstanding books on Mughal painting and an aficionado of Indian music, generously found time in his busy schedule to read my manuscript and to offer encouragement and useful suggestions. I am immensely thankful to the art historian Catherine Asher, who went over a draft with a microscopic lens, bringing to bear her expertise in Mughal art, architecture, and history. I want also to mention the art historians of India John Seyller

and Ellen Smart for giving me something new to think about in every scholarly exchange we have. Another South Asia art history specialist, Daniel Ehnbom, has been very helpful with information on locations and other details pertinent to the paintings included herein.

The final shape of the book was conceived in late 1993 after a lecture about MTV by the music critic Andrew Goodwin at the University of California, Berkeley. Almost immediately after, I had the very good fortune to spend a few days in Ottawa with an ethnomusicology colleague, Jocelyne Guilbault. The impetus for the book's structure came from the lecture by Goodwin; its implementation resulted from my discussions with Guilbault.

I offer special thanks to the curators and aides in the various libraries, museums, and other institutions which house the originals of these fabulous paintings and for granting permissions to reprint them. Most particularly I mention Henry Ginsburg, whose help at the British Library gave me a good start in the world of research in collections of visual materials. As well, Stan Czuma, Curator of South Asian Art at the Cleveland Museum of Art; Michael Meister at the University of Pennsylvania; Otto Thieme at the Cincinnati Art Museum; Diana Withee and Hiram Woodward at the Walters Art Gallery in Baltimore; Carole Bolon at the Freer Gallery of Art in Washington, D.C.; Joanna Wallace at the Victoria and Albert Museum, London; Nicole Tetzner at Royal Collection Enterprises (Windsor Castle); Ghorban Azizzadeh of Reza Abbasi Museum, Tehran; Ali Reza Anissi, Director of the Golestan Palace Museum, Tehran; Dr. M. D. Atiqur Rahman of Khuda Bakhsh Library; Anand Krishna at Banares Hindu University; Dr. W. H. Siddiqi of the Rampur Raza Library; and private collectors, some of whom wish to remain anonymous, but were generous with permissions, have all gone out of their way to help. I am thankful, too, for the gracious assistance given me by Stuart Cary Welch, Curator Emeritus of the Arthur M. Sackler Museum at Harvard University, and Shokoofeh H. Kafi, Curatorial Assistant in the Department of Islamic and Later Indian Art (formerly in the Fogg Museum) of the Sackler Museum, Harvard University. I also appreciate the numerous clerks and other officials at the National Museum in New Delhi, the India Office Library in London, the Chester Beatty Collection in Dublin, and several museums in the former Soviet Union, now Russia and Uzbekistan—Moscow, Tashkent, Samarkand, Bukhara— and along the Silk Road in China and Mongolia, as well as the richness of bookstalls along that way.

I am pleased to be publishing this work in the Chicago Studies in Ethnomusicology and want to take this opportunity to thank and laud Bruno Nettl and Philip Bohlman for establishing the series, stepping in to fill the void left by the death of John Blacking and the demise of the authoritative Cambridge Studies in Ethnomusicology. I am further indebted to Bruno for his unflagging support of me in this and other endeavors. I appreciate the work on this book of Leslie Keros, Peter T. Daniels, and Matt Howard at the Press and most particularly I want to thank Chicago's superb senior editor, David Brent, for his persistence in seeing this work through its review for the series and thereafter in his professional oversight of the volume. Members of our Department of Music staff have been helpful through the years, but most particularly I want to thank Paul Young for his assistance in the process of obtaining permissions and photographs.

On a personal note, there is the unflagging and seemingly endless energy and encouragement of Ann M. Pescatello, who seems effortlessly to write a successful book every few years. Had I not

especially had the example she set as "a *real* historian," with a belief that one must not live without a search in historical time for elucidation of the present, I probably would not have had the courage to leave even temporarily the contemporary time, people, and performance-based ethnomusicological research of my other projects, such as *Tegotomono* (1976) or *Khyal* (1984). On another personal note, I treasure the warmth and caring of David Josephson through these many years. I want to thank Jocelyne Guilbault (again), Ankiça Petrovic, and Susan McClary for the wonderful spring semester of 1993, when all three held visiting teaching appointments in the Department of Music at Berkeley. Our long walks up Euclid Avenue, our Monday evening dinners, and the stimulating conversations throughout the term were scholarly and personal treasures I shall never forget. Finally, I thank all those interested parties who have sat through innumerable lectures and presentations of this material and from which, each time, I have garnered something new. I hope that this book succeeds in putting it all together for everyone.

NOTE ON TRANSLITERATION AND RUBRIC

A never-ending problem with scholarly works in the South, Central, and West Asian spheres is the rendering of words in the "correct" form of transliteration. There is, of course, no one "correct" way. I have tried to be orthographically consistent with explanation of alternatives, and beg the reader's indulgence of any slips that may have occurred in the attempt. The reader will note a maddening variety of spellings of Persian, Arabic, Mongol, Urdu, Hindi, and Sanskrit words and terminology among the numerous primary and secondary sources. The more modern adapters rely on the *International Journal of Middle East Studies,* F. Steingass's *Comprehensive Persian–English Dictionary,* and John Platts's *Dictionary of Urdu, Classical Hindi, and English,* which covers both Perso-Arabic and Hindi-Sanskrit derivations. I have consulted all of them and they have been useful, with Platts's being the most useful for my purposes.

The words are entered there as they appear in the text in the chosen form of transliteration; in some instances of frequent or well-known words, alternate spellings/transliterations are given in parentheses. I have chosen not to provide accents for proper names, but I have not changed the variety of spellings in the quotations, article and book titles, or illustrated manuscripts and albums.

Changes in spellings, transliterations, and terms depend on the translators and the cultures from which they came and their own culture's language(s). Since Islam, like Buddhism and Christianity, has implanted itself

across the globe in diverse civilizations, it is to be expected that there would be an enormous variety of ways of expressing these terms. Thus a brief note on Islamic rubrics is also in order. According to Gibb, the word *Islam,* "finally adopted by Mohammed as the distinctive name of the faith which he preached, means 'submitting [oneself or one's person to God].' The adherent of Islam is usually designated by the corresponding adjective *Muslim* (of which *Moslem* is a Western adaptation). The Persians adopted a different adjective *Musalman,* from which are derived the Anglo-Indian *Mussulman* and French *Musalman.* Modern Muslims dislike the terms *Mohammedan* and *Mohammedanism,* which seem to them to carry the implication of worship of Mohammed, as Christian and Christianity imply the worship of Christ" (1962: 1–2). The reader will note that all of these and many more variations of these terms appear in the book, mostly in the quotations in both primary and secondary sources.

NOTE ON DATES AND CALENDARS

In this book I have used the C.E. (common era, equivalent to the familiar A.D., *anno Domini,* in the year of the Lord, Christian) calendar. However, various Islamic materials and dates refer to events as A.H. (*anno Hegirae*) (or *Hijra* or *Haj,* among the various versions). This derives from the year of the "Emigration" (*Hejira*) when Muhammed moved from his native city of Mecca to Medina, in the year 622 C.E. That date marked a turning point in Islamic history because, although the beginnings of Islam are in Muhammad's teachings in his hometown of Mecca, the latent characteristics of the faith were developed only after his move to Medina. From 622 until Muhammad's death ten years later, the basic structure of Islam was developed, not simply as a body of private religious beliefs, but as the establishment of an independent community with its own system of government, laws, and institutions. So quickly had this development occurred that that date was already recognized by the first generation of Muslims, who adopted the year 622 C.E. as the first year of the new Islamic era. The reader will note, however, a variety of inconsistent numerical equivalents in C.E. dating of A.H. events in various sources cited throughout, in part because of C.E. and A.H. differences in computing months and years.

Also confusing is that some dates within a month and even some months do not conform in every document because they are based on either a solar or lunar calendrical interpretation of time. I have not attempted to address this issue, only to alert the reader to the problems in dating which are caused by one's calendrical preferences.

ABBREVIATIONS

Below are abbreviations of Mughal-period sources used in the text. See bibliography for further information.

AiA	*A'īn-i Akbarī*
AiN	*Akhlāt-i Nasirī* (The Nasirean Ethics)
AN	*Akbar Nāma*
BN	*Bābur Nāma* (Memoirs of Babur)
HN	*Humāyūn Nāma* (The History of Humayun)
MiA	*Ma'āsir-i-Alāmgīrī*
MtT	*Muntakhabu-t-Tāwārīkh* (The Reign of Akbar, from 963 to 1004 A.H.)
MutL	*Muntakhab al-Lubab*
PSN	*Pādshāh Nāma*
RiA	*Rukaat-i Alāmgīrī* (Letters of Aurangzeb)
SJN	*Shāh Jahān Nāma*
TaN	*Ṭabakāt-i Nasīrī. A General History of the Muhammadan Dynasties of Asia, including Hindustan, from A.H. 194 (810 C.E.) to A.H. 658 (1260 C.E.)*
TiA	*Ṭabakāt-i Akbarī* (or *Tabaqāt-i Akbarī*)
TiF	*Tarīkh-i Firishta*
TiJ	*Tūzuk-i Jahāngīrī* (The Memoirs of Jahangir)
TiSS	*Tarīkh-i Sher Shahī* of Abbas Khan Sharwani
TN	*Tīmūr Nāma (Tarīkh-i Khandan-i Tīmūriya)* (The History of the House of Timur)
TuN	*Tūtī Nāma* (Tales of a Parrot)

CHART I
Timur's (alleged) Line

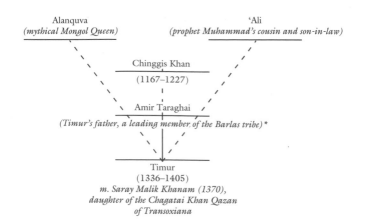

Alanquva
(mythical Mongol Queen)

'Ali
(prophet Muhammad's cousin and son-in-law)

Chinggis Khan
(1167–1227)

Amir Taraghai
*(Timur's father, a leading member of the Barlas tribe)**

Timur
(1336–1405)
*m. Saray Malik Khanam (1370),
daughter of the Chagatai Khan Qazan
of Transoxiana*

*The Barlas tribe was one of many that made up the Chagatai *ulus*.
The Barlas are Turkic, but their exact lineage is uncertain.
They (including Timur) claimed that they shared a common ancestor
with Chinggis Khan. It seems (from fifteenth-century Timurid texts) that
the Barlas tribe had been assigned to Chagatai Khan's retinue before
Chinggis Khan's death, and they had long been associated with
military leadership under the Mongols.

Dotted lines mean that Timur traces his ancestry to those figures,
although it cannot be proved.

Sources for all charts: Beach and Koch 1997; Gascoigne 1971; Hambly 1977;
Howorth 1970; Lambton 1988; Lentz and Lowry 1989.

CHART II
Chinggis: General Line

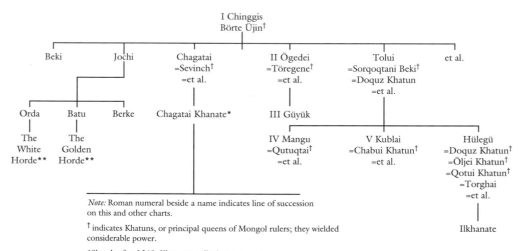

I Chinggis
Börte Üjin†

| Beki | Jochi | Chagatai =Sevinch† =et al. | II Ögedei =Töregene† =et al. | Tolui =Sorqoqtani Beki† =Doquz Khatun =et al. | et al. |

Orda — Batu — Berke

Chagatai Khanate* — III Güyük

The White Horde** — The Golden Horde**

IV Mangu =Qutuqtai† =et al.

V Kublai =Chabui Khatun† =et al.

Hülegü =Doquz Khatun† =Öljei Khatun† =Qotui Khatun† =Torghai =et al.

Ilkhanate

Note: Roman numeral beside a name indicates line of succession
on this and other charts.

† indicates Khatuns, or principal queens of Mongol rulers; they wielded
considerable power.

*Shortly after 1340, Khannate splits into two parts:
Mughalistan and Transoxiana.

** See map 4.

Mughalistan was ruled by Mongols who retained
their traditional steppe and shamanistic customs and strong tribal affiliations.

Transoxiana was controlled by Mongols who had intermarried with Turkic
tribes, such as the Barlas; they adopted Turkic affiliations and practices,
and many converted to Islam.

CHART III
Legendary Turkic Line
(with earlier descendants of Mogol Khan, legendary head of the tribes)

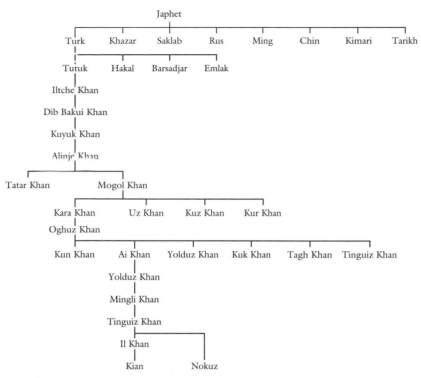

Note: The families of Tatar Khan and Mogol Khan were constantly feuding.
Some Mongols allegedly were under the yoke of the Tatars for four hundred years.

CHART IV
The Il-Khans (Persia) Line

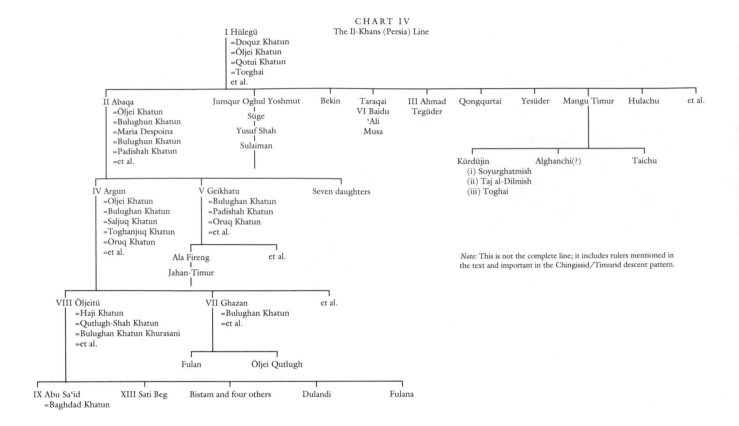

I Hülegü
=Doquz Khatun
=Öljei Khatun
=Qotui Khatun
=Torghai
et al.

II Abaqa
=Öljei Khatun
=Bulughun Khatun
=Maria Despoina
=Bulughun Khatun
=Padishah Khatun
=et al.

Jumqur Oghul Yoshmut
Süge
Yusuf Shah
Sulaiman

Bekin

Taraqai
VI Baidu
'Ali
Musa

III Ahmad
Tegüder

Qongqurtai

Yesüder

Mangu Timur

Hulachu

et al.

Kürdüjin
(i) Soyurghatmish
(ii) Taj al-Dilmish
(iii) Toghai

Alghanchi(?)

Taichu

IV Argun
=Oljei Khatun
=Bulughan Khatun
=Saljuq Khatun
=Toghanjuq Khatun
=Oruq Khatun
=et al.

V Geikhatu
=Bulughan Khatun
=Padishah Khatun
=Oruq Khatun
=et al.

Seven daughters

Ala Fireng
Jahan-Timur

et al.

Note: This is not the complete line; it includes rulers mentioned in the text and important in the Chingissid/Timurid descent pattern.

VIII Öljeitü
=Haji Khatun
=Qutlugh-Shah Khatun
=Bulughan Khatun Khurasani
=et al.

VII Ghazan
=Bulughan Khatun
=et al.

et al.

Fulan

Öljei Qutlugh

IX Abu Sa'id
=Baghdad Khatun

XIII Sati Beg

Bistam and four others

Dulandi

Fulana

CHART V
Chinggis to Babur Line

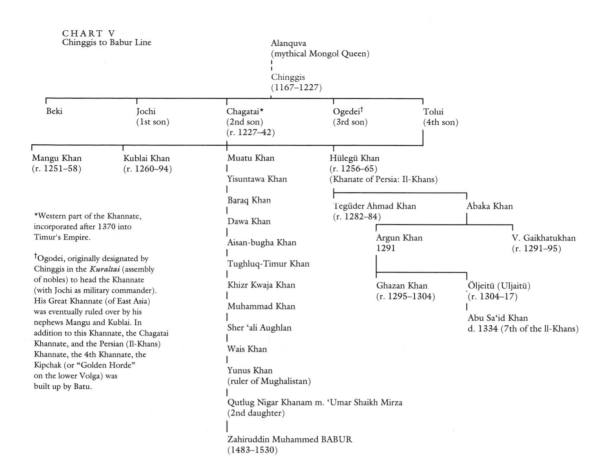

Alanquva
(mythical Mongol Queen)

Chinggis
(1167–1227)

| Beki | Jochi (1st son) | Chagatai* (2nd son) (r. 1227–42) | Ogedei† (3rd son) | Tolui (4th son) |

Mangu Khan
(r. 1251–58)

Kublai Khan
(r. 1260–94)

Muatu Khan
|
Yisuntawa Khan
|
Baraq Khan
|
Dawa Khan
|
Aisan-bugha Khan
|
Tughluq-Timur Khan
|
Khizr Kwaja Khan
|
Muhammad Khan
|
Sher 'ali Aughlan
|
Wais Khan
|
Yunus Khan
(ruler of Mughalistan)
|
Qutlug Nigar Khanam m. 'Umar Shaikh Mirza
(2nd daughter)
|
Zahiruddin Muhammed BABUR
(1483–1530)

Hülegü Khan
(r. 1256–65)
(Khanate of Persia: Il-Khans)

Tegüder Ahmad Khan
(r. 1282–84)

Abaka Khan

Argun Khan
1291

V. Gaikhatukhan
(r. 1291–95)

Ghazan Khan
(r. 1295–1304)

Öljeitü (Uljaitü)
(r. 1304–17)

Abu Sa'id Khan
d. 1334 (7th of the Il-Khans)

*Western part of the Khannate, incorporated after 1370 into Timur's Empire.

†Ogodei, originally designated by Chinggis in the *Kuraltai* (assembly of nobles) to head the Khannate (with Jochi as military commander). His Great Khannate (of East Asia) was eventually ruled over by his nephews Mangu and Kublai. In addition to this Khannate, the Chagatai Khannate, and the Persian (Il-Khans) Khannate, the 4th Khannate, the Kipchak (or "Golden Horde" on the lower Volga) was built up by Batu.

CHART VI
Timur to Babur Line

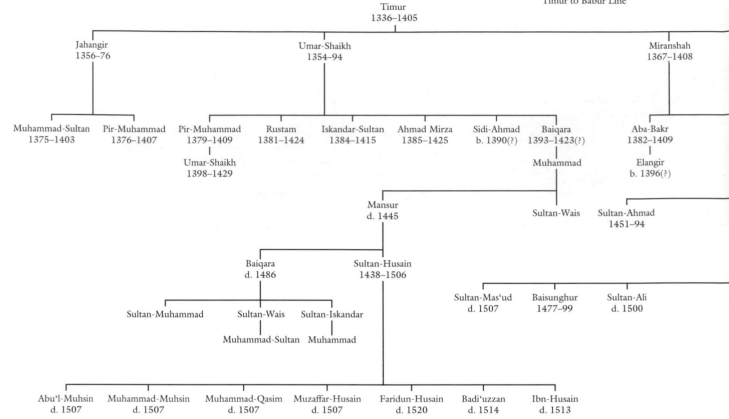

Timur
1336–1405

Jahangir
1356–76

Umar-Shaikh
1354–94

Miranshah
1367–1408

Muhammad-Sultan
1375–1403

Pir-Muhammad
1376–1407

Pir-Muhammad
1379–1409

Rustam
1381–1424

Iskandar-Sultan
1384–1415

Ahmad Mirza
1385–1425

Sidi-Ahmad
b. 1390(?)

Baiqara
1393–1423(?)

Aba-Bakr
1382–1409

Umar-Shaikh
1398–1429

Muhammad

Elangir
b. 1396(?)

Mansur
d. 1445

Sultan-Wais

Sultan-Ahmad
1451–94

Baiqara
d. 1486

Sultan-Husain
1438–1506

Sultan-Mas'ud
d. 1507

Baisunghur
1477–99

Sultan-Ali
d. 1500

Sultan-Muhammad

Sultan-Wais

Sultan-Iskandar

Muhammad-Sultan

Muhammad

Abu'l-Muhsin
d. 1507

Muhammad-Muhsin
d. 1507

Muhammad-Qasim
d. 1507

Muzaffar-Husain
d. 1507

Faridun-Husain
d. 1520

Badi'uzzan
d. 1514

Ibn-Husain
d. 1513

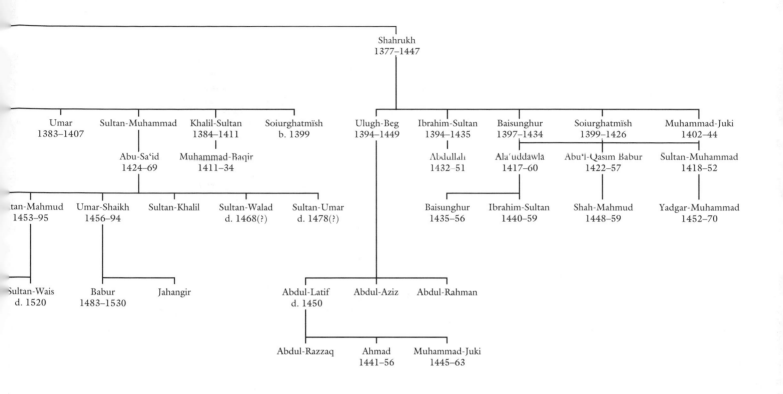

Shahrukh
1377–1447

Umar
1383–1407

Sultan-Muhammad

Khalil-Sultan
1384–1411

Soiurghatmïsh
b. 1399

Ulugh-Beg
1394–1449

Ibrahim-Sultan
1394–1435

Baisunghur
1397–1434

Soiurghatmïsh
1399–1426

Muhammad-Juki
1402–44

Abu-Sa'id
1424–69

Muhammad-Baqir
1411–34

Abdullah
1432–51

Ala'uddawla
1417–60

Abu'l-Qasim Babur
1422–57

Sultan-Muhammad
1418–52

Sultan-Mahmud
1453–95

Umar-Shaikh
1456–94

Sultan-Khalil

Sultan-Walad
d. 1468(?)

Sultan-Umar
d. 1478(?)

Baisunghur
1435–56

Ibrahim-Sultan
1440–59

Shah-Mahmud
1448–59

Yadgar-Muhammad
1452–70

Sultan-Wais
d. 1520

Babur
1483–1530

Jahangir

Abdul-Latif
d. 1450

Abdul-Aziz

Abdul-Rahman

Abdul-Razzaq

Ahmad
1441–56

Muhammad-Juki
1445–63

CHART VII
Babur to Bahadur Shah II

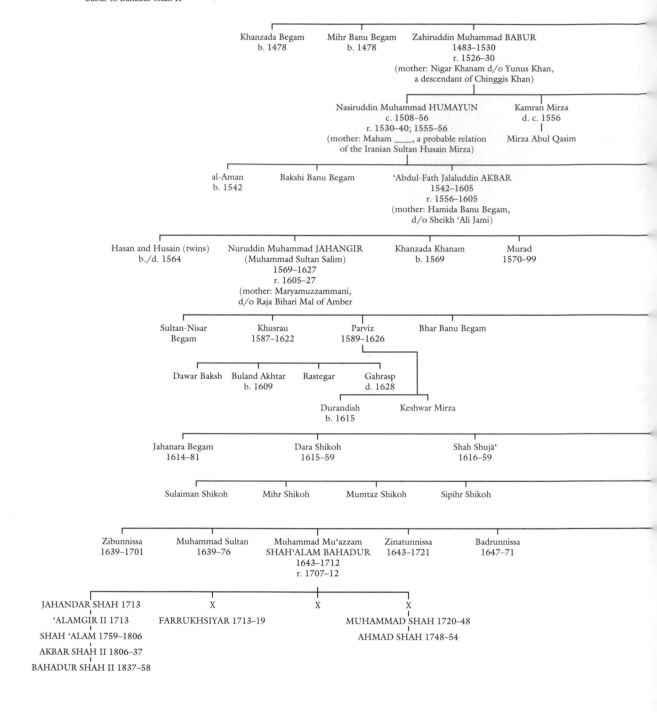

Khanzada Begam
b. 1478

Mihr Banu Begam
b. 1478

Zahiruddin Muhammad BABUR
1483–1530
r. 1526–30
(mother: Nigar Khanam d/o Yunus Khan,
a descendant of Chinggis Khan)

Nasiruddin Muhammad HUMAYUN
c. 1508–56
r. 1530–40; 1555–56
(mother: Maham ____, a probable relation
of the Iranian Sultan Husain Mirza)

Kamran Mirza
d. c. 1556

Mirza Abul Qasim

al-Aman
b. 1542

Bakshi Banu Begam

'Abdul-Fath Jalaluddin AKBAR
1542–1605
r. 1556–1605
(mother: Hamida Banu Begam,
d/o Sheikh 'Ali Jami)

Hasan and Husain (twins)
b./d. 1564

Nuruddin Muhammad JAHANGIR
(Muhammad Sultan Salim)
1569–1627
r. 1605–27
(mother: Maryamuzzammani,
d/o Raja Bihari Mal of Amber

Khanzada Khanam
b. 1569

Murad
1570–99

Sultan-Nisar
Begam

Khusrau
1587–1622

Parviz
1589–1626

Bhar Banu Begam

Dawar Baksh

Buland Akhtar
b. 1609

Rastegar

Gahrasp
d. 1628

Durandish
b. 1615

Keshwar Mirza

Jahanara Begam
1614–81

Dara Shikoh
1615–59

Shah Shujā'
1616–59

Sulaiman Shikoh

Mihr Shikoh

Mumtaz Shikoh

Sipihr Shikoh

Zibunnissa
1639–1701

Muhammad Sultan
1639–76

Muhammad Mu'azzam
SHAH'ALAM BAHADUR
1643–1712
r. 1707–12

Zinatunnissa
1643–1721

Badrunnissa
1647–71

JAHANDAR SHAH 1713
'ALAMGIR II 1713
SHAH 'ALAM 1759–1806
AKBAR SHAH II 1806–37
BAHADUR SHAH II 1837–58

X

FARRUKHSIYAR 1713–19

X

X

MUHAMMAD SHAH 1720–48
AHMAD SHAH 1748–54

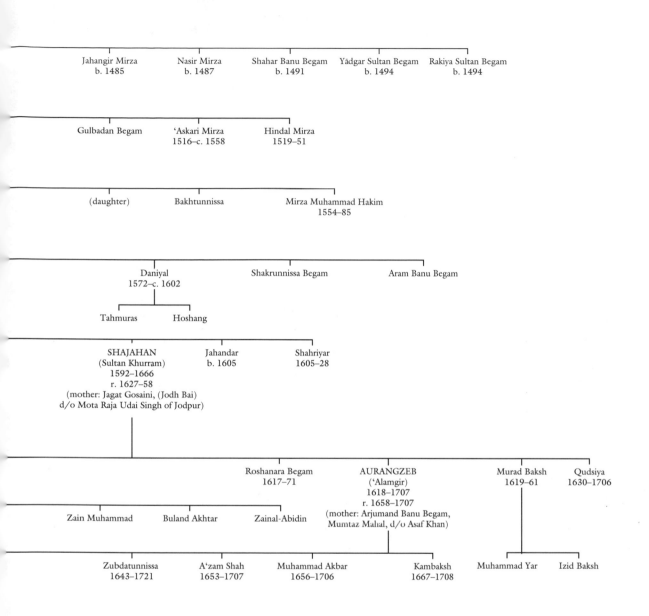

Jahangir Mirza b. 1485 — Nasir Mirza b. 1487 — Shahar Banu Begam b. 1491 — Yādgar Sultan Begam b. 1494 — Rakiya Sultan Begam b. 1494

Gulbadan Begam — 'Askari Mirza 1516–c. 1558 — Hindal Mirza 1519–51

(daughter) — Bakhtunnissa — Mirza Muhammad Hakim 1554–85

Daniyal 1572–c. 1602 — Shakrunnissa Begam — Aram Banu Begam

Tahmuras — Hoshang

SHAJAHAN (Sultan Khurram) 1592–1666 r. 1627–58 (mother: Jagat Gosaini, (Jodh Bai) d/o Mota Raja Udai Singh of Jodpur) — Jahandar b. 1605 — Shahriyar 1605–28

Roshanara Begam 1617–71 — AURANGZEB ('Alamgir) 1618–1707 r. 1658–1707 (mother: Arjumand Banu Begam, Mumtaz Mahal, d/o Asaf Khan) — Murad Baksh 1619–61 — Qudsiya 1630–1706

Zain Muhammad — Buland Akhtar — Zainal-Abidin

Zubdatunnissa 1643–1721 — A'zam Shah 1653–1707 — Muhammad Akbar 1656–1706 — Kambaksh 1667–1708 — Muhammad Yar — Izid Baksh

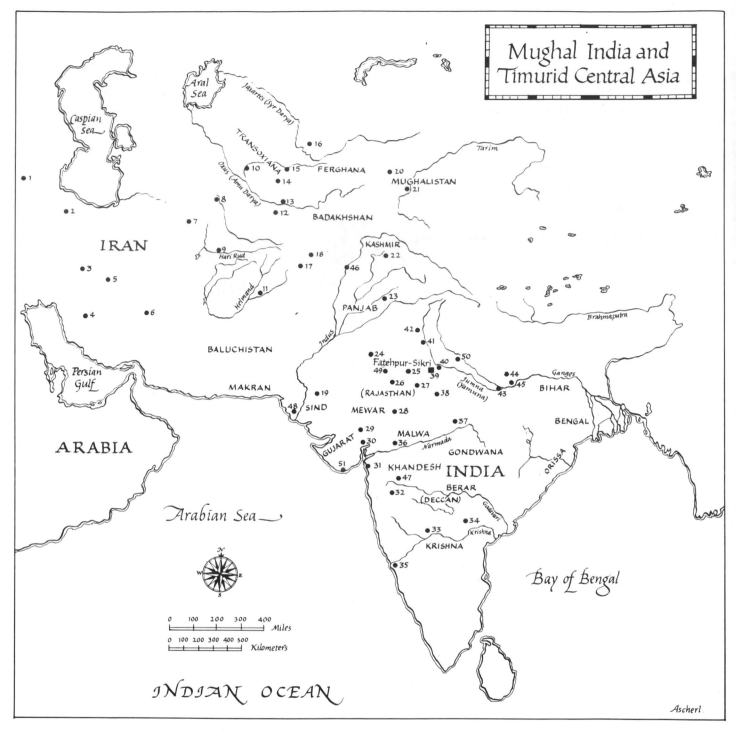

Mughal India and Timurid Central Asia

1 Tabriz	12 Balkh	22 Srinagar	32 Ahmadnagar	42 Panipat
2 Qazvin	13 Tirmiz	23 Lahore	33 Bijapur	43 Allahabad
3 Isfahan	14 Kesh/Shahr-i Sabz	24 Bikaner	34 Hyderabad	44 Jaunpur
5 Yazd	15 Samarqand	25 Amber (Jaipur)	35 Goa	45 Varanasi (Banaras)
6 Kirman	16 Tashkent	26 Ajmer	36 Mandu	46 Atak Banaras
7 Mashhad	17 Ghazni	27 Ranthambhor	37 Panna	47 Daulatabad
8 Marv	18 Kabul	28 Chittorgarh	38 Gwalior	48 Thatta
9 Herat	19 Umarkot	29 Ahmadabad	39 Fatehpur-Sikri	49 Nagaur
10 Bukhara	20 Kasghar	30 Cambay	40 Agra	50 Kanauj
11 Qandahar	21 Yarkhand	31 Surat	41 Delhi	51 Diu

Map 1. Mughal India and Timurid Central Asia, 1571–85. From Michael Brand and Glenn Lowry, *Akbar's India: Art from the Mughal City of Victory* (New York: Asia Society, 1985), 10. Reprinted with permission from the Asia Society, New York.

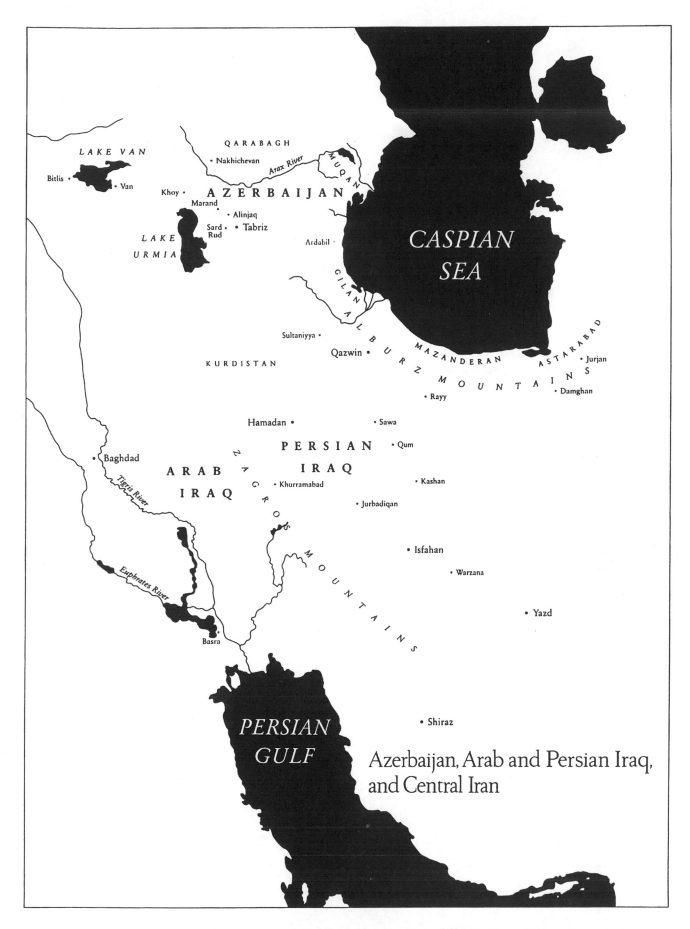

Azerbaijan, Arab and Persian Iraq, and Central Iran

Map 2. The Timurid world: Azerbaijan, Arab and Persian Iraq, and central Iran. From Thomas Lentz and Glenn Lowry, *Timur and the Princely Vision: Persian Art and Culture in the Fifteenth Century* (Los Angeles: Los Angeles County Museum of Art, 1989), 22. © Museum Associates, Los Angeles County Museum of Art. Reprinted with permission.

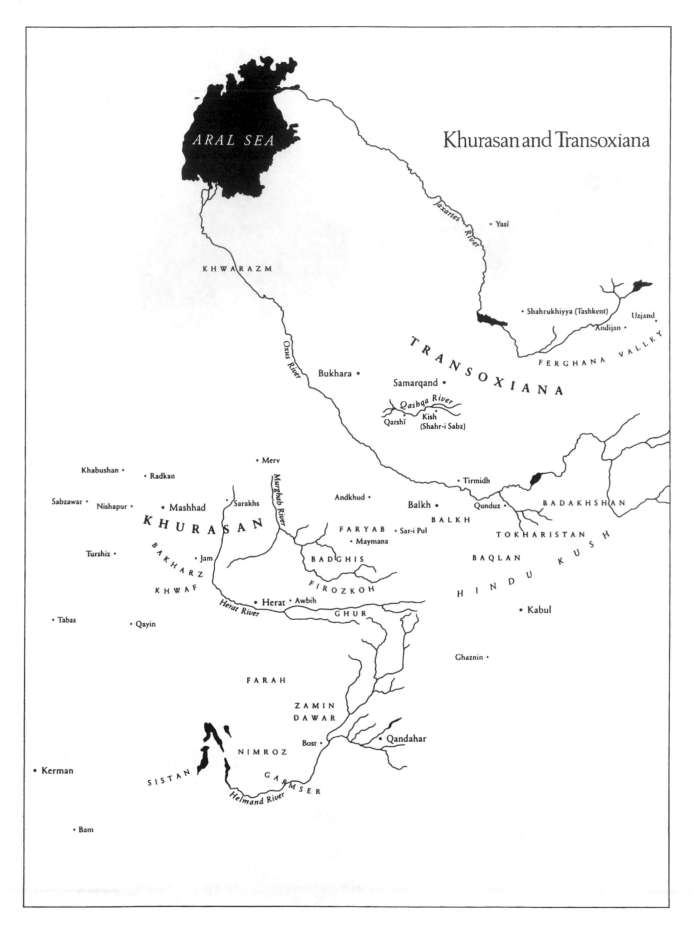

Map 3. The Timurid world: Khurasan and Transoxiana. From Thomas Lentz and Glenn Lowry, *Timur and the Princely Vision: Persian Art and Culture in the Fifteenth Century* (Los Angeles: Los Angeles County Museum of Art, 1989), 23. © Museum Associates, Los Angeles County Museum of Art. Reprinted with permission.

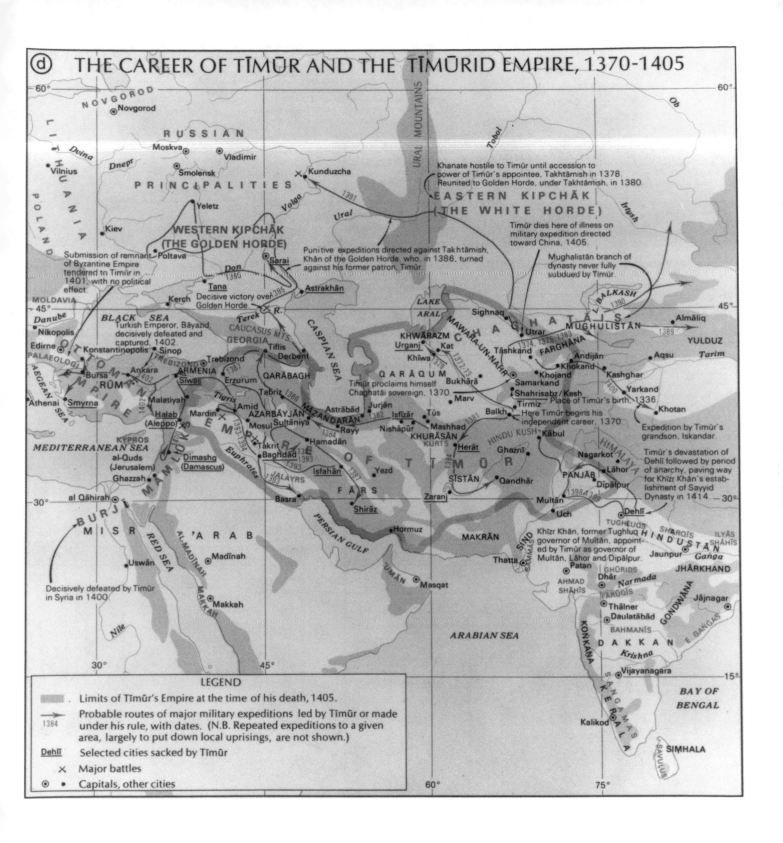

Map 4. The career of Timur and the Timurid Empire, 1370–1405. From Joseph Schwartzberg, ed., *A Historical Atlas of South Asia* (New York: Oxford University Press, 1992), 44. Reprinted by permission.

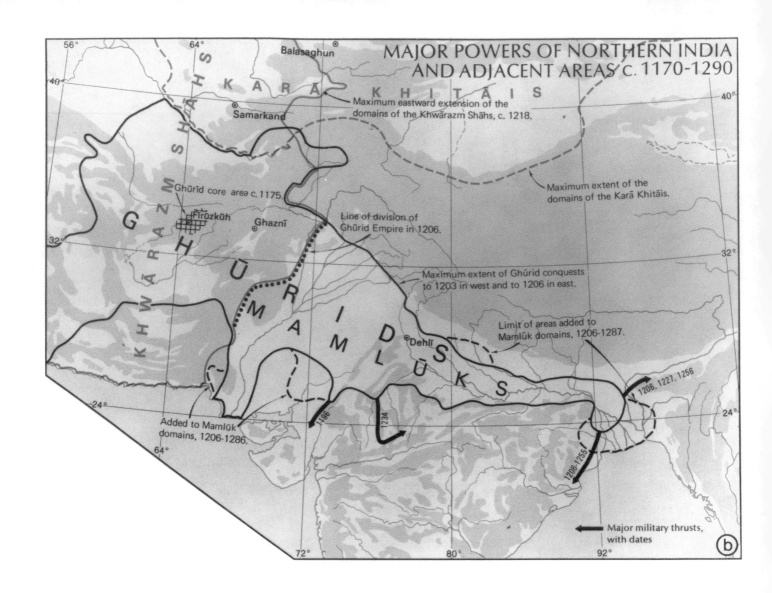

MAJOR POWERS OF NORTHERN INDIA
AND ADJACENT AREAS c. 1170-1290

Maximum eastward extension of the
domains of the Khwārazm Shāhs, c. 1218.

Maximum extent of the
domains of the Karā Khitāis.

Ghūrīd core area c. 1175.

Line of division of
Ghūrid Empire in 1206.

Maximum extent of Ghūrid conquests
to 1203 in west and to 1206 in east.

Limit of areas added to
Mamlūk domains, 1206-1287.

1206, 1227, 1256

Added to Mamlūk
domains, 1206-1286.

1206-1256

Major military thrusts,
with dates

KARĀ KHITĀIS

KHWĀRAZM SHĀHS

GHŪRIDS

MAMLŪKS

Balasaghun
Samarkand
Fīrūzkūh
Ghaznī
Dehlī

Map 5. Major powers of northern India and adjacent areas, c. 1170–1290. From Joseph Schwartzberg, ed., *A Historical Atlas of South Asia* (New York: Oxford University Press, 1992), 37. Reprinted by permission.

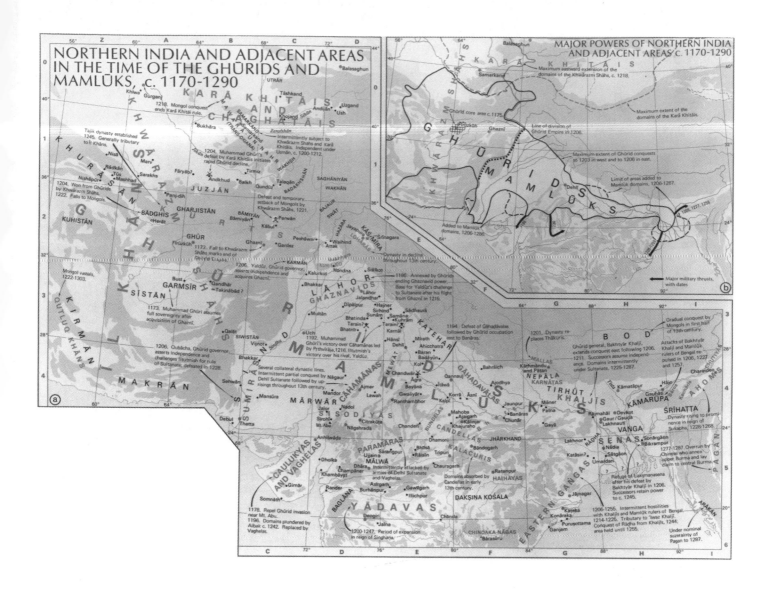

Map 6. Northern India and adjacent areas in the time of the Ghurids and Mamluks, c. 1170–1290. From Joseph Schwartzberg, ed., *A Historical Atlas of South Asia* (New York: Oxford University Press, 1992), 37. Reprinted by permission.

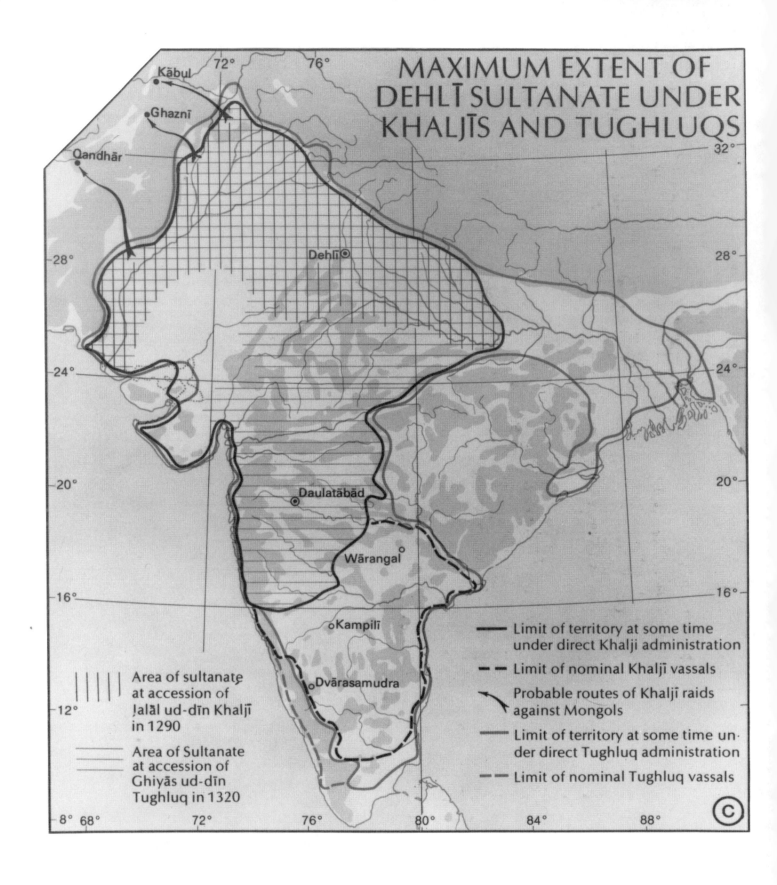

MAXIMUM EXTENT OF DEHLĪ SULTANATE UNDER KHALJĪS AND TUGHLUQS

Area of sultanate at accession of Jalāl ud-dīn Khaljī in 1290

Area of Sultanate at accession of Ghiyās ud-dīn Tughluq in 1320

—— Limit of territory at some time under direct Khalji administration

- - - Limit of nominal Khaljī vassals

↖ Probable routes of Khaljī raids against Mongols

—— Limit of territory at some time under direct Tughluq administration

- - - Limit of nominal Tughluq vassals

Map 7. Maximum extent of Delhi Sultanate under Khaljis and Tughluqs. From Joseph Schwartzberg, ed., *A Historical Atlas of South Asia* (New York: Oxford University Press, 1992), 38. Reprinted by permission.

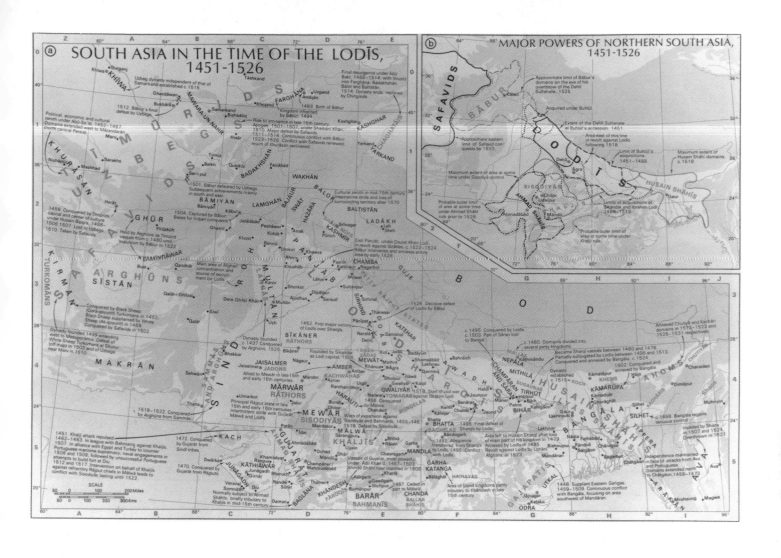

Map 8. South Asia in the time of the Lodis, 1451–1526. From Joseph Schwartzberg, ed., *A Historical Atlas of South Asia* (New York: Oxford University Press, 1992), 40. Reprinted by permission.

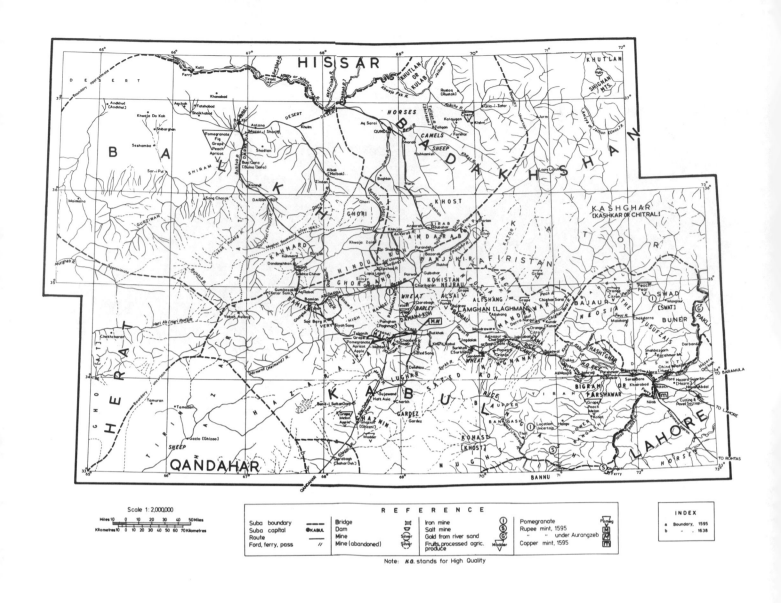

Map 9. Northern Afghanistan at the beginning of the Mughal Empire. From Irfan Habib, *An Atlas of the Mughal Empire* (Delhi: Oxford University Press, 1982), maps 1a–b. Reprinted by permission.

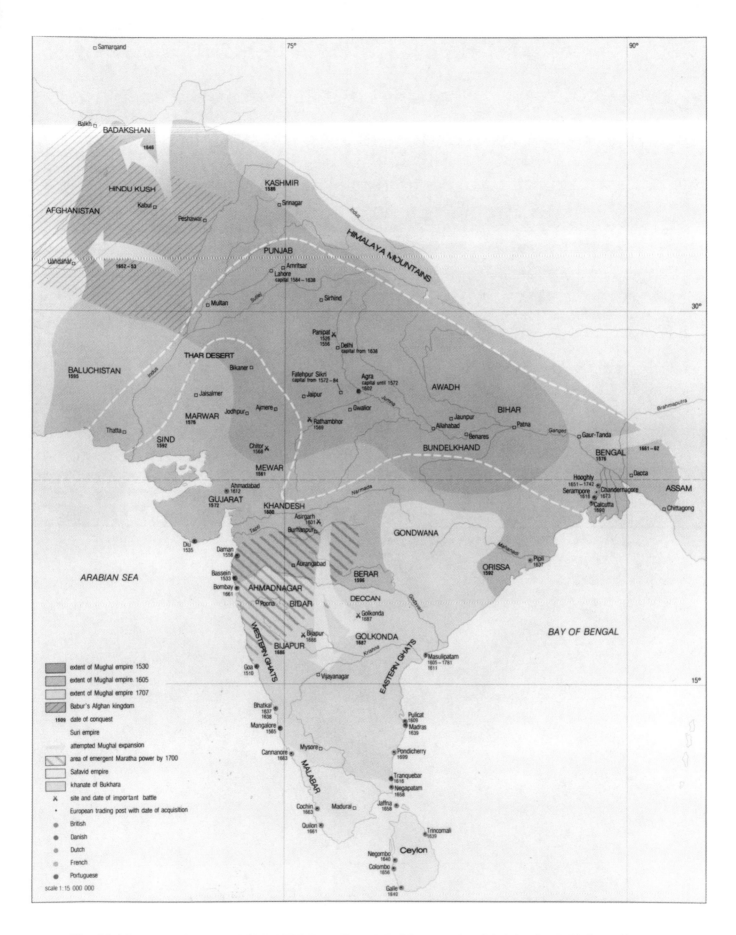

Map 10. The Mughal Empire, 1526–1707. From Francis Robinson, *Atlas of the Islamic World since 1500* (Abingdon: Andromeda Oxford Ltd., 1982), 59. Reproduced by permission of Andromeda Oxford Ltd., Abingdon, U.K. ©.

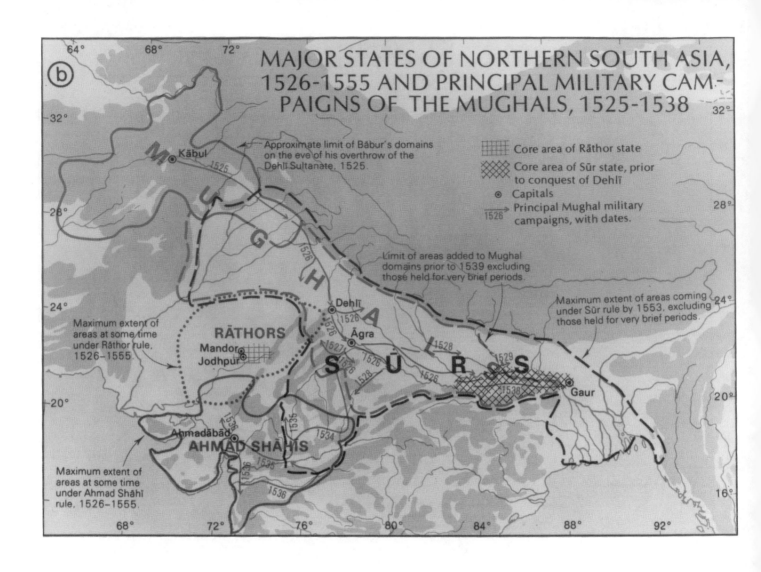

MAJOR STATES OF NORTHERN SOUTH ASIA, 1526-1555 AND PRINCIPAL MILITARY CAMPAIGNS OF THE MUGHALS, 1525-1538

Approximate limit of Bābur's domains on the eve of his overthrow of the Dehlī Sultanate, 1525.

Core area of Rāthor state

Core area of Sūr state, prior to conquest of Dehlī

Capitals

Principal Mughal military campaigns, with dates.

Limit of areas added to Mughal domains prior to 1539 excluding those held for very brief periods.

Maximum extent of areas coming under Sūr rule by 1553, excluding those held for very brief periods.

Maximum extent of areas at some time under Rāthor rule, 1526-1555.

Maximum extent of areas at some time under Ahmad Shāhī rule, 1526-1555.

Map 11. Major states of northern South Asia, 1526–55, and principal military campaigns of the Mughals, 1525–38. From Joseph Schwartzberg, ed., *A Historical Atlas of South Asia* (New York: Oxford University Press, 1992), 44. Reprinted by permission.

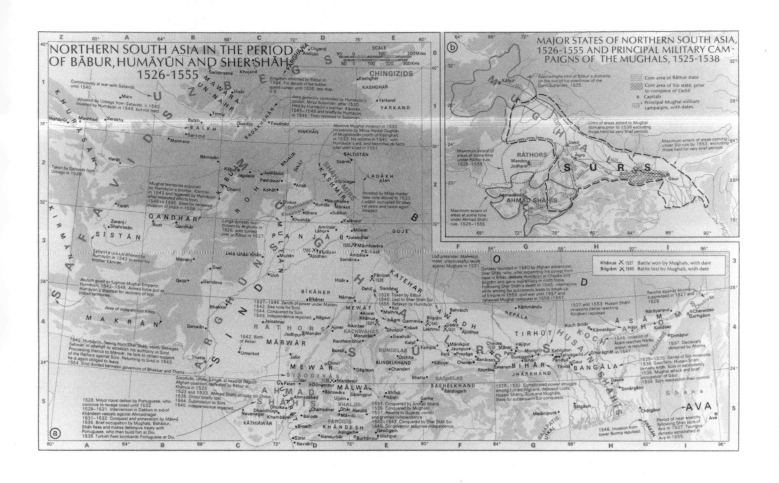

Map 12. Northern South Asia in the period of Babur, Humayun, and Sher Shah, 1526–55. From Joseph Schwartzberg, ed., *A Historical Atlas of South Asia* (New York: Oxford University Press, 1992), 44. Reprinted by permission.

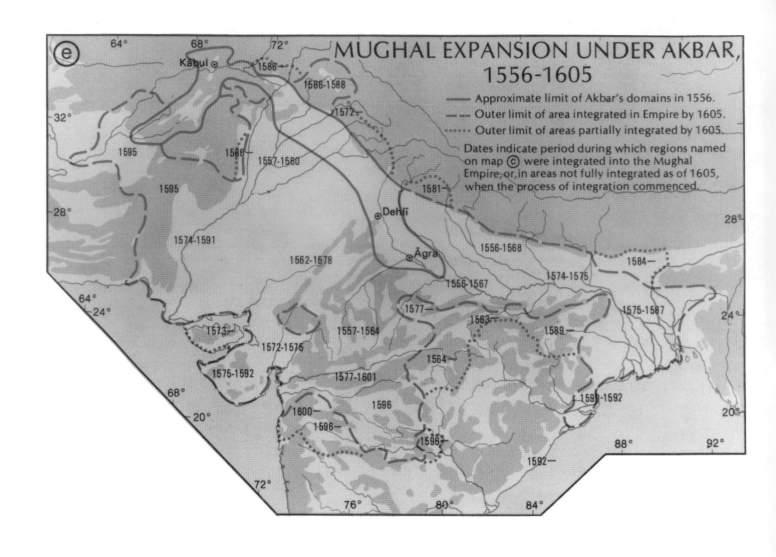

MUGHAL EXPANSION UNDER AKBAR, 1556-1605

Approximate limit of Akbar's domains in 1556.
Outer limit of area integrated in Empire by 1605.
Outer limit of areas partially integrated by 1605.

Dates indicate period during which regions named on map (c) were integrated into the Mughal Empire, or, in areas not fully integrated as of 1605, when the process of integration commenced.

Map 13. Mughal expansion under Akbar, 1556–1605. From Joseph Schwartzberg, ed., *A Historical Atlas of South Asia* (New York: Oxford University Press, 1992), 44. Reprinted by permission.

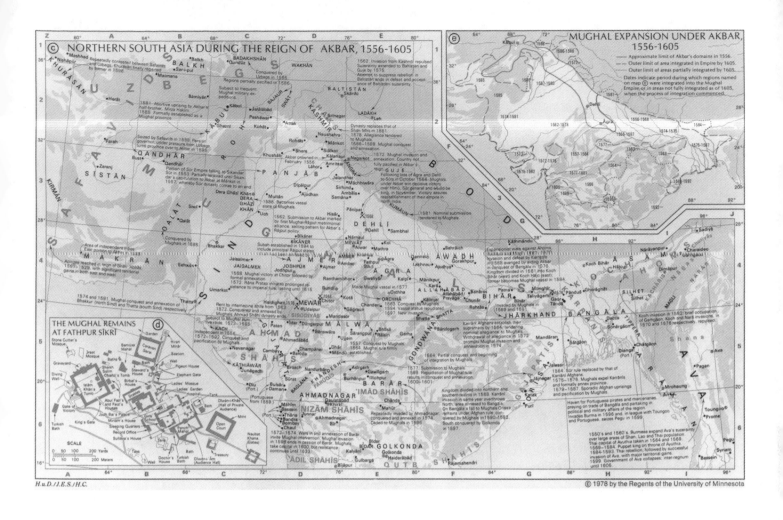

Map 14. Northern South Asia during the reign of Akbar, 1556–1605. From Joseph Schwartzberg, ed., *A Historical Atlas of South Asia* (New York: Oxford University Press, 1992), 44. Reprinted by permission.

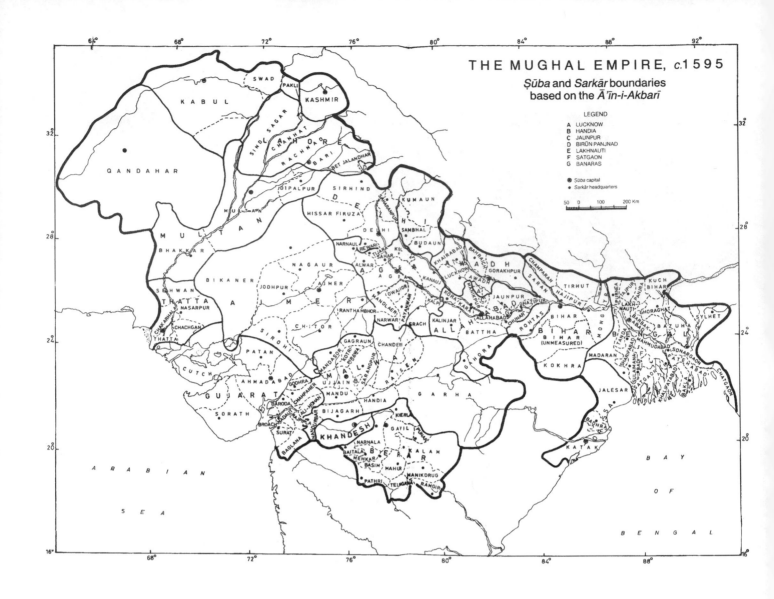

Map 15. Sūba and Sarkār boundaries of the Mughal Empire, c. 1595. From Shireen Moosvi, *The Economy of the Mughal Empire c. 1595: A Statistical Study* (Delhi: Oxford University Press, 1987). Reprinted by permission.

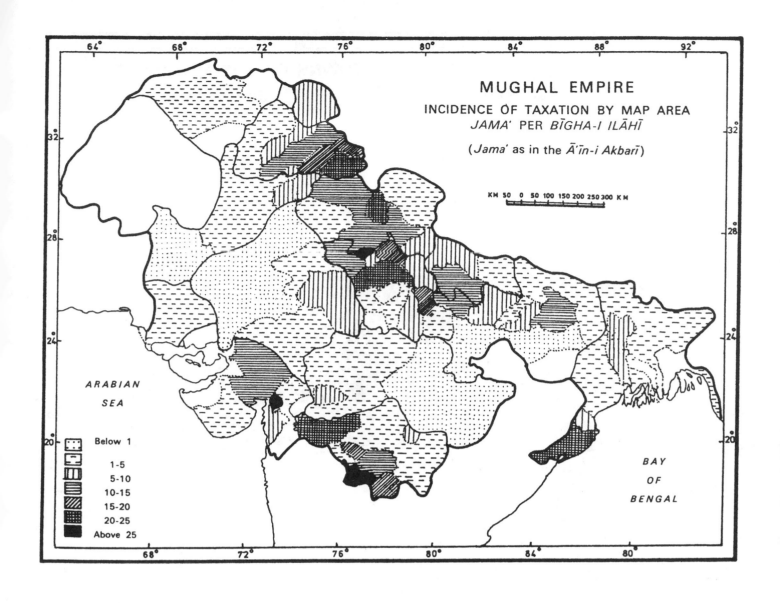

MUGHAL EMPIRE

INCIDENCE OF TAXATION BY MAP AREA
JAMA' PER BĪGHA-I ILĀHĪ

(Jama' as in the Ā'īn-i Akbarī)

KM 50 0 50 100 150 200 250 300 K M

ARABIAN SEA

Below 1
1-5
5-10
10-15
15-20
20-25
Above 25

BAY OF BENGAL

Map 16. Incidence of taxation in the Mughal Empire by map area, *jama'* per *bīgha-i ilāhī*, c. 1595. From Shireen Moosvi, *The Economy of the Mughal Empire c. 1595: A Statistical Study* (Delhi: Oxford University Press, 1987). Reprinted by permission.

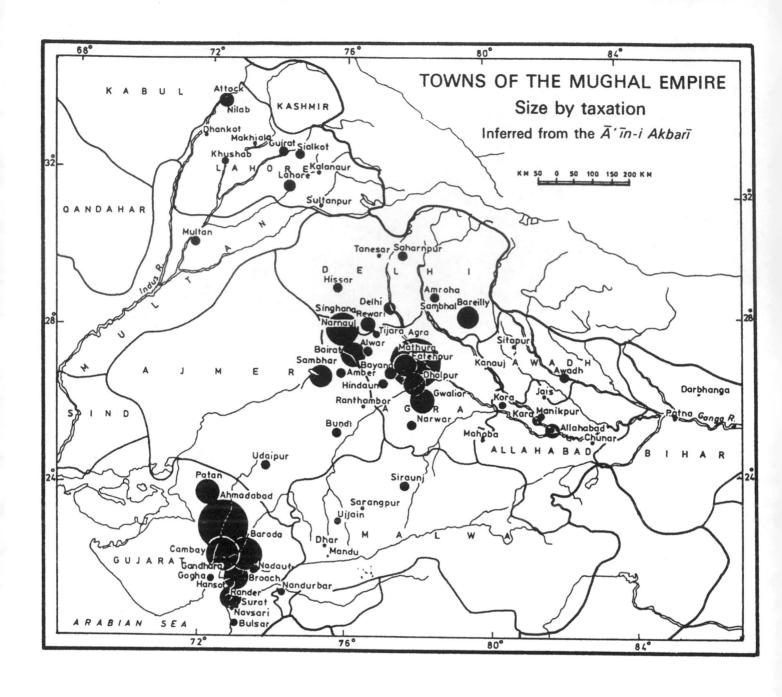

TOWNS OF THE MUGHAL EMPIRE

Size by taxation

Inferred from the $\bar{A}'\bar{i}n$-i $Akbar\bar{i}$

Map 17. Towns of the Mughal Empire, size by taxation, c. 1595. From Shireen Moosvi, *The Economy of the Mughal Empire c. 1595: A Statistical Study* (Delhi: Oxford University Press, 1987). Reprinted by permission.

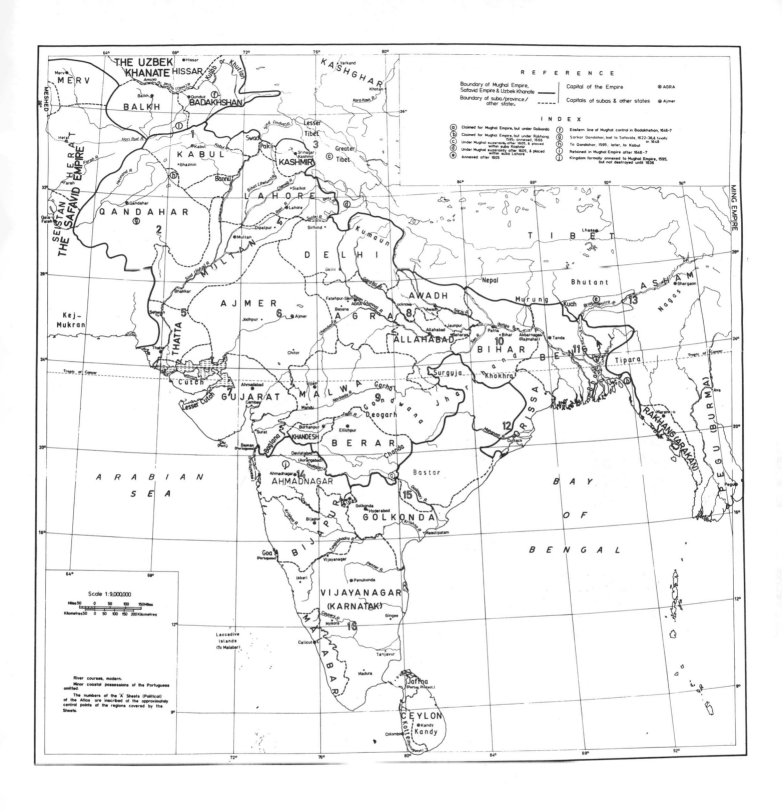

Map 18. The Mughal Empire, 1601. From Irfan Habib, *An Atlas of the Mughal Empire* (Delhi: Oxford University Press, 1982), map OA. Reprinted by permission.

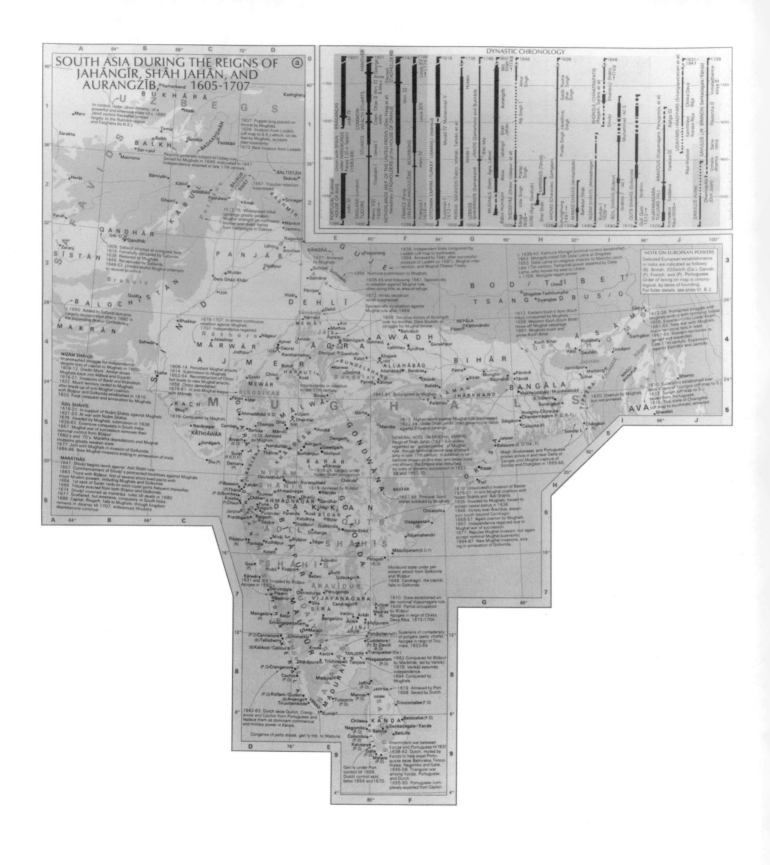

Map 19. South Asia during the reigns of Jahangir, Shah Jahan, and Aurangzeb, 1605–1707. From Joseph Schwartzberg, ed., *A Historical Atlas of South Asia* (New York: Oxford University Press, 1992), 46. Reprinted by permission.

Map 20. The western Deccan, 1707. From Irfan Habib, *An Atlas of the Mughal Empire* (Delhi: Oxford University Press, 1982), map 14A. Reprinted by permission.

Map 21. Territories of the Great Mughals. From Bamber Gascoigne, *The Great Moghuls* (London: Rainbird Publishing Group Ltd., 1971), 251.

INTRODUCTION

This book is a study of cultural synthesis in the Indian subcontinent undertaken by combining multidisciplinary methodologies and theories, primarily ethnomusicological and art historical, with historical, ethnographic, elitelore, and folklore; it is also informed by political and sociological approaches and materials. I began working on it about seventeen years ago, giving my first oral presentation on some of its subject matter as the John Levy Distinguished Lecture at the Durham (England) Music Festival in July 1982, and I conceived its final shape thanks to an ethnomusicology colloquium on the subject of MTV by the critic Andrew Goodwin in late 1993 at the University of California, Berkeley. My research began as a study of musical change and a search for evidence in visual sources of how Indian musicians of Hindustan encountered and absorbed music from the Persian cultural sphere in the sixteenth and seventeenth centuries. But the nature of the sources—miniature paintings commissioned by successive generations of Mughal rulers—changed this study of cultural synthesis; as the evidence unfolded, it inevitably led to a broadening of focus beyond my initial view, to the Mughals as patrons, their roles in the process of musical change, the gradual Indianization of Persianate musical culture, and the concomitant evolution of musical instruments and practice. The amount of illustrated materials available varies from ruler to ruler, but the richest lode of paintings was commissioned by Akbar the Great (r. 1556–1605); thus he assumes a pivotal place in the study.

This is my most interpretive work to date; throughout most of it I

have asked "why," with only the final chapter devoted primarily to "what." The book is in two parts, one focused on the political agenda, the other on the cultural agenda of the Mughal rulers. It was my intention that this study encompass the entire Mughal period from 1526 to 1858 because most studies of the Mughal empire tend to be confined to the first century or two. But like the book's structure, its timeline was determined by the primary resource on which it is based—the visual sources available in illustrated manuscripts and paintings; thus the time frame is 1526–1707. Dealing solely with paintings that depict music-making, the first three chapters, which comprise part 1, introduce the "patrimonial" Mughal family, explore the question of why Akbar created so many illustrated manuscripts, and analyze these sources vis-à-vis each of the great Mughal rulers. In part 2, chapter 4 suggests the reasons for the remarkable amount of musical activity in the pictorial content, most particularly, of Akbari manuscripts. Chapter 5 elucidates the means by which Akbar created a context conducive to cultural transformation, and chapter 6 presents the evidence of transformation of Mughal musical culture in the reigns of Jahangir, Shah Jahan, and 'Alamgir (Aurangzeb), the last of the so-called Great Mughals.

The evidence in the paintings is not notated music, because then, as now, music was transmitted orally. Rather, drawings of instruments, composition of ensembles, contextual associations, portraits of musicians, and the like constitute the material meaningful for this cultural interpretation. Checked against and complemented by written sources of the period, the miniature paintings prove to be an invaluable source for a special perspective on Mughal culture. The written sources, both etic and emic, which confirm and complement the visuals also help define the historical parameters and cultural contexts for understanding the Mughal Empire and its rulers (see the genealogy chart).

The Mughal Empire in the Indian subcontinent spanned nearly three and a half centuries (1526–1858), from Babur to Bahadur Shah II, but it is the first six rulers, known as "The Great Mughals," from Babur to Aurangzeb ('Alamgir) (1526–1707), who embody the greatness of empire and who are central to this book. An invaluable historiographic perspective on this cohort of great rulers is found in major primary sources, by "insiders" and "outsiders": both the remarkable set of Mughal imperial histories and their illustrations, and the memoirs and histories of the rulers themselves; as well as contemporary European travel accounts. Recent historical analyses offer the perspective of the present, thus lending a temporal coherence to explication of the Mughal era. For example, in *Timur and the Princely Vision* (1989), Thomas Lentz and Glenn Lowry suggest that the feared conqueror and his Timurid line refined a coherent aesthetic which they developed consciously to undergird and support political domination. The first Mughal ruler, Babur, clearly understood and acted on that princely vision; and Stephen Dale's "Steppe Humanism: The Autobiographical Writings of Zahir al-Din Muhammad Babur, 1483–1530" (1990) elucidates and complements Babur's very personal *Bābur Nāma*. In those memoirs, Akbar's grandfather and the founder of the Mughal dynasty is seen to be a sensitive musical critic and an involved patron.[1]

While Babur could simply have treated his various successful raids in Timur's sacking fashion, and scourging and then retreating to Kabul, he stayed on and strengthened his presence in the subcontinent. He left the development of empire to his son Humayun, Akbar's father, whom we

know only from secondhand accounts such as works by his servant Jauhar Aftabchi and a court officer, Bayazid Bayat; a history (the *Humāyūn Nāma*) by his sister Gulbadan Begam; and the retrospective *Akbar Nāma*.[2] The latter, an official chronicle commissioned by Akbar, traces Mughal history from Timur to the author Abu'l Fazl's assassination in 1602 and treats the reigns of both Babur and Humayun in great detail. Despite the difficulties Humayun endured in furthering the interests of empire and the nomadic nature of his adult life, to him goes the credit for patronage of Persian artists on whose skill and aesthetic taste the Mughal style of art was largely based.

With the Mughal restoration complete under Humayun, the definition of the dynasty and the empire was left to his son. In Akbar, renowned for his musical acumen, his catholicity of artistic taste, and his political agenda, we now see a quintessential example of power operating in the production of texts—in the *Akbar Nāma*, in the approximately forty-five illustrated manuscripts Akbar caused to be created, and in the *A'īn-i Akbarī*. Prepared by Abu'l Fazl and submitted to Akbar in 1593 as an appendix to the *Akbar Nāma*, the *A'īn-i Akbarī* provides detailed statistical information on Akbar's administration, including musicians and poets; on sixteenth-century Mughal government; and on contemporary Hinduism and Islam. It is particularly valuable because the author actively participated in developing many of the institutions he describes.[3] A corroborating contemporary perspective is *The Commentary of Father Monserrate,* written in 1582 by the first Jesuit missionary to Akbar's court. The historian Douglas Streusand provides a recent perspective with his provocative interpretation of the evolution of Mughal political institutions in *The Formation of the Mughal Empire* (1989).[4]

Jahangir, the frustrated son of a long-lived father, had to wait thirty-eight years before ascending the throne. He then expressed independence from the artistic legacy of his powerful father in interesting musical ways, revealed in his favored albums of assorted paintings and in the illustrations of his memoirs, the *Tūzuk-i Jahāngīrī*. These memoirs offer an account of important events, particularly of the early years of his reign, and a candid view of Jahangir's personal life, replete with his vices as well as his virtues. They are further supported by an excellent example of the Indo-Muslim "Mirrors of Princes" literature, *Advice on the Art of Governance,* a treatise written in Jahangir's reign (edited and translated by Sajida Alvi, 1989); by the candid biography of a Mughal nobleman, Mirza Nathan's *Bahāristān-i Ghaybī* (1936); and by an English diplomat's version of Mughal court life and the political situation at Jahangir's court from 1615 to 1618, *The Embassy of Sir Thomas Roe* (1926).

Shah Jahan, more interested in jewels and architecture, nonetheless left one set of illustrations in his chronicle, the *Pādshāh Nāma,* that offer stunningly beautiful confirmation of the Indianization of Mughal culture. Milo Beach's *The Grand Mogul: Imperial Painting in India 1600–1660* (1978) explicates and provides superb art historical analysis of painting under Shah Jahan as well as Jahangir. And further confirmation is offered in Stephen Blake's *Shahjahanabad: The Sovereign City in Mughal India, 1639–1739* (1991), both an excellent, albeit controversial, analysis of Shah Jahan's new city and a useful methodological-theoretical perspective on the patrimonial-bureaucratic empire.[5]

The degree of Indianization becomes ever clearer both through a few conservative Persianate

paintings of the period of Aurangzeb, and through other primary works on this last of the "Great Mughals." Insight into Indianization of the Persianate/Timurid/Mughal culture as substantiated in the small number of paintings during this time, and some introspection on Aurangzeb's worldview, are offered in the *ʿAlamgir Nāma* (by Muhammad Kasim), Saqi Mustad Khan's *Maʾāṣir-i Alāmgīrī*, and the *History of ʿAlamgir*.[6] All underscore both the Indianization and the conservatism of the culture and of the ruler. They are lent further contemporary credibility in the *Storia do Mogor* by the Venetian Nicolao Manucci (1907), who came to India as a youth and survived more than fifty years of adventures and court intrigue; and most particularly in *Travels in the Moghul Empire* by the French physician François Bernier (1934), who arrived in India in 1658 and spent twelve years there, first as Prince Dara's physician and then as a respected resident. His firsthand information about North India and life at the Mughal court and his descriptions and analysis of Mughal rule make him a major primary source.

General histories, of course, paint the entire picture. Most particularly, John Richards's *The Mughal Empire* (1993) provides an excellent historical frame for the period 1526–1720 by analyzing the dynamism, innovation, ideological changes, politico-religious relationships, and institutions of the empire.[7] As regards the imperial timeline of this study, another historian noted that at the close of the seventeenth century and after nearly two centuries of Mughal rule, the subcontinent was

> abounding in life and energy, and at the same time abounding in contrasts. . . . There were no half shades or subdued tones. There were extremes of tragedy and comedy, of variety and monotony, of sentiment and cruelty. . . . India was more peaceful, more prosperous, and perhaps happier than she had been for several centuries. . . . (Spear 1972:159)

The remaining Mughals did patronize the arts to some extent, and there were a few occasional flashes of brilliance in rule and patronage in the remaining century and a half, such as under Muhammad Shah (1719–1748). But, as so incisively discussed by Muzaffar Alam (1986), there had arisen *The Crisis of Empire in Mughal North India*. The empire had begun its decline from ossification and intolerance, from the rise of powerful states within and foreign interests, political interference, and military interventions without, from plundering Persian raids and de facto British rule.

Written materials have long offered a rich lode for study, but it is the visual sources that provide us a new and largely untapped major resource allowing the development of new hypotheses, ideas, and interpretations in the history of the Mughal Empire.[8] And, when viewed in isolation from the hundreds of other paintings of this period, those which contain depictions of music-making comprise a group with special perspectives that raise some significant questions: In a painting system that emerged from both Indian and Persian systems and styles, which created numerous conventional scene-types, why were particular events chosen for illustration? Who was the intended audience for those particular scenes? In a court culture that was largely Persianate, and specifically in artistic depictions that are overwhelmingly Persianate musically, why were musicians playing Indian instruments included in the pictorial content? What were the forces for cultural synthesis which Akbar exploited through painting and music? What can be learned about particular musicians and their media for performance?

Naturally, much mining of these paintings had to be done first that was positivistic in nature,

uninterpretive observation of pictorial content. In particular, had Akbar not used visual communication to the astounding extent that he did, this book could not have been written; there simply would not have been a sufficiently large sample of musical material from which to either raise questions or suggest conclusions of any sort. The size of the sample for any specific item or idea is a constant methodological issue, of course, and I have constantly kept that in mind. Close study of each type of instrument in the paintings revealed remarkable detail, some of which will eventually be presented in even more detail elsewhere but is simply not that pertinent here. Consideration of the musical content, artist by artist, proved less meaningful than I expected, as few artists are consistent in their representation of particular instruments, for example. That perspective, too, is largely left to later publications.

Conversely, reading and rereading the contemporary chronicles and other archival records proved more fruitful than I had expected from early forays into them. I have emerged from this research enormously grateful for the intense scholarly effort, in the first half of this century, by a handful of British translators of the major primary sources for the period from Babur to Shah Jahan, including their scrupulous cross-referencing of each other's work and their exhaustive indexes of people and places. Their work simplifies checking pertinent passages in the Persian texts. Especially worthy of mention is the only woman among the translators, Annette S. Beveridge, whose rendering of the *Bābur Nāma* from its original Turki text (1922), and whose interest in translating from Persian the only major contemporary work by a female author, Gulbadan Begam's account of her brother, *The History of Humayun* (1902), had a powerful effect on my perspective. Through editorial commentary by Beveridge, and in their own writing, I could feel the empathy of Babur and his daughter Gulbadan Begam for the women in the Mughal sphere. Their words, along with scattered remarks in recent works by others such as Elizabeth Moynihan and the historian of religion and language, Annemarie Schimmel, sensitized me to the Mughal female milieu. They thus contributed another dimension to this study by educing the gender perspective, in particular of chapter 3, "The Interface of *Ḥarem* and Court," and elsewhere, where pertinent, throughout the book.

The literature on gender and feminist studies has been growing rapidly, and frameworks developed therein have helped to situate my interpretive agenda. Although they had their roots in anthropology and literary studies, they have become an important element in music scholarship (albeit mostly in Western classical and popular music), and also in reception theory studies.[9] As the interest in and audience for such interpretations has grown, so have ideologies, models, and theories. Earlier studies began with the premise that "Human activities and feelings are organized, not by biology directly, but by the interaction of biological propensities and those various and culture-specific expectations, plans, and symbols that coordinate our actions and so permit our species to survive" (Rosaldo and Lamphere 1974:5). Later writings provide more and varied overviews and positions. One such is the idea of gender and sexuality as cultural (symbolic) constructs and implies study of the sources, processes, and consequences of their construction and organization. Within this context are two perspectives—the culturalist (which informs my work) and the sociological; the former analyzes things from the top down, stressing that "no particular gender symbol can be

well understood without an appreciation of its place in a larger system of symbols and meanings," while the latter works from the bottom up and considers how "certain types of social orders tend to generate, through the logic of their workings, certain types of cultural perceptions of gender and sexuality" (Ortner and Whitehead 1981:2, 4, passim). More recent works focus specifically on gender and music (McClary 1991; Solie 1993) and feminist music criticism and theory (Kramer 1992). Some musicologists have been excited by this phenomenon, noting a "new critical spirit in musicological studies, which draws on semiotics, film theory, psychoanalysis, and literary criticism to ask new questions about the cultural meanings of music" (Dunn and Jones 1994: 5). Attention to gender in ethnomusicology tends to be more ethnographically oriented and informed. Important sources for us in this regard are di Leonardo 1991; Koskoff 1987; Rebollo-Sporghi 1993; Sarkissian 1992; and Herndon and Ziegler 1990.

In addition to gender and related perspectives, cultural studies have become an important element in recent scholarship.[10] The rapprochement of anthropology and literary studies, which began in the early 1980s with James Clifford, Clifford Geertz, and Edward Said, among others, led to the creation of "cultural studies" as a field in itself as well as to a broadening and deepening of both anthropology and literary criticism. The result has been that literary critics have applied anthropology to their studies; they ask questions about the construction of meanings under historical situations and reflect on cultural "situatedness." Anthropologists, in turn, have discovered narratives other than those of the social sciences that can and should be used in ethnographies. Perhaps the most precise definition of cultural studies is the observation of power operating in the production of texts, with broad latitude in the definition of "texts." In this study, "texts" means explicitly the use of the visual medium of illustrated manuscripts for political ends. Thus cultural studies and concomitant cultural interpretation have prompted me to leave for future contemplation more explicitly musical matters, such as consideration of ensemble performance practice informed by comparison of paintings with musical theoretical writing from the period.[11] Focused studies, such as an article on ensembles for dance accompaniment or an essay about women musicians, are also left for other publication venues.

To prepare for the writing of this book, I have devoted considerable time to the study of Indian art history—which, in a way, is like learning another language. One has to become conversant with the methodologies, issues, theories, controversies, and other aspects of the art history field in general and Indian art history in particular. It is this substantive use of a second discipline that I think most distinguishes this work from that of other ethnomusicologists who have used the paintings as a source in their research. I needed, for instance, to be able to distinguish artistic convention from artistic license; to consider the role of an individual artist in the decision about pictorial content; to trust to a greater or lesser degree a particular artist's drawing of an instrument; to ascertain whether musical content was repeated from Persian models or indicative of reality in India. Most significantly, I needed to know the nature of the questions asked of the paintings by art historians in order to use them carefully myself.

Consequently, in this study I do take some positions on art historical issues. A major conclusion from my research is that I stand with those historians of Mughal painting who consider the

role of the patrons (particularly Akbar and perhaps Shah Jahan) to have been active and decisive when it came to choice of some scenes to be illustrated and even, perhaps, details of pictorial content. By "active," I do not mean that when Akbar viewed the work of the imperial artists, as Abu l Fazl reports, he would comment, "This painting doesn't have enough action in it; add dancers and musicians." But he might have said, "I want credit for my patronage of Indian musicians, so be sure to put them in appropriate scenes." Or, "I want to be sure that the Indian women in the *ḥarem* who see this painting take particular notice of it, so put something in there to get their attention." Or, "I want a clear connection made here to my Timurid ancestry." Or, "I want to record the opulence, wealth, and splendor that I have at my disposal; display them in the chronicle of my reign." It would have been an atelier supervisor or artist, perhaps, who understood the patron's taste and attitude who would decide on the pictorial means of carrying out the directive. Further, the illustrated books produced in the imperial ateliers were artifacts for private rather than public life, seen by relatively few; I take the stance that the audience for them—even for particular illustrations—is sometimes meaningful for pictorial content.

I must also address a specific art historical issue concerning the Mughal artists' illustrations of former time: How to properly handle the fact that paintings (such as those for the *Tīmūr Nāma* or the *Bābur Nāma*) illustrate the past but do so from a position in the present. Most South Asia art historians argue that Mughal artists' depiction of historical time cannot be taken as real information on historical time—that no serious effort was made to depict historical time differently from present time. I have found that, with some notable exceptions commented on in this work, Akbari-period artists tried to suggest the past in their depiction of historical music-making and dance. That is to say, the artists were fairly consistent in showing something different from music-making in the present; the nature of that difference may or may not have been real in historical time. One example: Ensembles of musicians consisting of both females and males are rare except in paintings of historical time.

Since I have written with South Asian art historians as one of my intended audiences, I hope I contribute here a different insight into the paintings that they will find viable. I began this work in utter dependence on them; and while I can now, with reasonable certainty, date some paintings by musical content, I remain humble about my foray into "their" field, with no pretensions to being anything other than grateful for their generosity in providing me methodological and theoretical resources useful to my work. While I rue the territoriality of academic disciplines, I myself have been guilty of same on occasion and reckon it as a reality of life in the modern academy.

When one writes a book such as this, one must take into consideration the fact that the audience will be diverse and one must be clear about the contribution to scholarship one intends to make. In addition to the obvious audience of music scholars and art historians, I hope this work will prove of interest to historians of South Asia as well as those who study culture, elite-lore, and folklore. In terms of scholarly fields, I believe that this book will contribute to the discipline of ethnomusicology, in terms of methodology, theoretical construct, and sources; to the area of cultural studies, by its obvious focus; to South Asian studies, by virtue of its use of two art sources—music and art—to support the explication of historical, sociopolitical, and cultural interpretation;

to gender studies, by both explicit and implicit focus on the role of women in Mughal culture and music; and to the study of Indian history and Indian music history.

As regards the latter, I am happy to report that historical ethnomusicology is flourishing. Among the recent works that interest me most are those that deal with the contact of multiple groups of people with multiple musical traditions and the transformation of culture that results. Anthony Seeger (1991), for example, analyzes the Brazilian Suya Indians' adoption of other tribes' musical styles as a means of controlling the otherness, incorporating "the power and material resources of the outsider into the reproduction of their own society" (Seeger 1991:33). Thomas Turino (1991), writing on Peruvian panpipe style and the politics of interpretation, looks at the historical process of appropriation by one group of the meaning that is attached to music by another group, and reconstructing that meaning for contemporary political use. While the work of Seeger and Turino—like most studies in ethnomusicology in the last decade or so—is on people quite different from the elite sociopolitical rulers of an Asian empire who are the focus of my study, this book nonetheless resonates with that sort of historical interpretation.

As I analyze it, most historical work in ethnomusicology has by necessity, in view of the sources available, proceeded from the present to the past, as scholars have sought explanations for the way music is by turning to the way it was. This study actually developed as part of that same procedure. Using traditional ethnomusicological field research methodology, I produced a detailed analysis of the North Indian vocal genre *khyāl* as it has been performed by musicians in this century (Wade 1984) and next wanted to delve into the history of the genre. Then Mughal painting captured me, at first aesthetically, soon disciplinarily, and I was led inexorably to this study which lies entirely in the past and turns the historical equation around: looking at how music was in order to see how it came to be what it is. In a significant way, this study is timely, for the rapprochement between historical musicology and ethnomusicology is as fast upon us as the rapprochement of anthropology and ethnomusicology was in the 1970s and 1980s.

In the end, this has been both an enormous challenge and enormously enjoyable. The Mughal world has become so vivid to me that I have been utterly captivated by imagining that I was there with Babur, Akbar, and the Mughal wives especially, consulting with the wonderful artists in the imperial atelier as they played out their roles as "photographers" and "servants" as well as creative artists. To a large extent we can only know the musicians and dancers as the patrons and painters both let them "be."

PART ONE

The Political Agenda

The Early Mughal Era

CHAPTER ONE

Mughal Exercise of Power in the Creation of Texts

Communication and Political Synthesis

History has moments when many great rulers appear in the same era in different sections of the world. The sixteenth century was one of those times; South Asia was one of those places.[1] Although several of the Mughals could warrant the accolade "great," the greatest of them all was Akbar. The description given of him by his son Jahangir painted a perhaps not handsome but certainly sympathetic portrait:

> In his august personal appearance he was of middle height, but inclining to be tall; he was of the hue of wheat; his eyes and eyebrows were black, and his complexion rather dark than fair; he was lion-bodied,[2] with a broad chest, and his hands and arms long. On the left side of his nose he had a fleshy mole, very agreeable in appearance, of the size of half a pea. Those skilled in the science of physiognomy considered this mole a sign of great prosperity and exceeding good fortune. His august voice was very loud, and in speaking and explaining had a peculiar richness. In his actions and movements he was not like the people of the world, and the glory of God manifested itself in him. (*TiJ* 1:33–34)

This intimate, familial description puts a human face on one of the most famous, complex, and successful figures in Indian history: a superb soldier, an accomplished administrator, an adroit statesman, a genius, an inspiring and commanding leader, an intellectual, and a great patron of the arts. "Akbar created the Mughal empire from two sets of components, what he found in Hindustan and what he, or rather his father, had brought

1

with him from Central Asia. He synthesized these two legacies to produce a distinctly Mughal polity and culture. The fusion involved individuals, institutions, patterns of behaviour, and literary and artistic styles" (Streusand 1989:23). Akbar's flexibility and "the concept of political compromise illuminates the formation of the Mughal empire. . . . The Mughal polity was thus the product of the Akbari political compromise" (ibid. 16). Politically, Akbar created an empire based on organized local government and a relatively fair, well-organized land revenue settlement system; he developed a policy of partnership with the Hindu rulers, integrated secular and sacred communities, and shifted the state from a feudal lordship to an imperial bureaucracy. Culturally, he provided the empire with the stamp of Timurid artistic achievement and the imprimatur of Persian character, aesthetics, and indelible influence—and in his day gave new meaning to the term "communicator."

With the most flowery language imaginable, the Mughal historian Abu'l Fazl informs us that Akbar ascended to the throne of Hindustan upon the untimely death of his father Humayun. While the fact of the death was concealed from the public for several days, Akbar's place was secured, and on 14 February 1556, the teenage prince was enthroned on a makeshift brick platform in the garden at Kalanaur (in the northeast, Punjab, near Lahore). What Abu'l Fazl imparts in the most important of all Mughal-period documents, the *Akbar Nāma,* is the spirit of the occasion:

A great feast and great assemblage, such as might move the envy of celestial writers, were organized.

Maṣnavī
A heart-delighting feast was prepared
'Twas decked both without and within
In front of that verdant kiosk
They spread a carpet wide as a parade-ground,
Screens tipped with ornaments
Were drawn round the banquet hall.
The covering of the ground from end to end
Was silk of Tartary and Chinese brocade.
From the number of gold-threaded awnings
The air was like a screen inlaid with gold.
They inclosed the sky with pure gold
For a blue [color of mourning] veil becometh not a feast.
The fumes of the banquet's far-reaching scents
Made heaven like a ball of musk.
The palace-grandees rose up.
They dressed a throne in bridal fashion
For now would the virgin of empire
be wed to the Shah, the Prince Fortunatus;
Two worlds were conjoined
And made fast by an eternal bond,
Time thus sang strain upon strain,
"O Fortune' [*sic*] dally with dominion's throne.

> A king seats himself thereon
> From whom the throne shall gain fixity
> he sitteth in the royal seat
> With whom Fortune will take shelter.

At that place, in a felicitous hour, to wit, near noon of Friday . . . , that glory of his lofty lineage put on his person a golden robe, and on his head a dark tiara, and sate with good auspices and prestige on the dais of sovereignty and the throne of the Caliphate. Congratulatory shouts arose from the six sides of the world, and the heaven-resembling pulpit was exalted by the proclamation (_Khuṭba_) of fortune, and the stairs [pulpit steps] of exaltation were made venerable by praises and sublimities. [The preacher declares him sovereign by reading the _Khuṭba_ in his name in the mosque.]

On the same day the rescript of sovereignty was exalted by the titles of H.M. the Shāhinshāh [and appropriate coinage was struck]. . . . From time to time they poured from trays silver and gold into the lap of the world's hope, and cast varied presents into the bosom of the universe. _The blare of the trumpets of joy and gladness burst forth, the drums of rejoicing beat high._ . . . The quadrangular throne of the assembly received elevation. . . . The o'er-shadowing umbrella of dominion was opened out over the horizons. The refulgent standard received a lofty sight. . . .

All the Signors and Sirdars, all the generals and generalissimos, and the other pillars of empire and eyes of sovereignty, gave their allegiance to that lofty-lineaged one from the bottom of their hearts and with a sincere conscience, and ratified the compact and loyalty by an oath to God. (_AN_ 2:4–9, emphasis added)

Thus began one of the most creative and historically decisive periods in the history of South Asia. When Akbar assumed the throne he had before him a formidable task, for his family had not established themselves firmly in India by the time of his succession. His grandfather, Babur, who in 1526 entered the territory of Hindustan with the intention of staying permanently, lived only four years beyond that date. The succession of Babur's son Humayun was hotly contested by half-brothers, and Humayun was also challenged by Indian and Afghani-Indian leaders who had just recently been overcome by Babur. Humayun did not handle the challenges well, was chased into exile in Safavid Persia for almost fifteen years, and spent most of his time once back in Hindustan regaining his domain. He was reacclaimed as the "king" in Delhi in 1555—less than a year before he died. Humayun's successor Akbar had been born during his father's flight to Persia and spent his early childhood under the jealous care of a rebellious half-uncle in the Afghani city of Kabul. Only after Akbar began his rule in 1556 did the distaff side of the Mughal family move from Kabul to India.

In the first half of his reign, and based partly on the centralizing measures in revenue assessment, military organization, and administrative system that Sher Shah had been developing, Akbar fashioned "a new set of administrative institutions and practices, a new conception of kingship and the constitution of government and society, a new military system, and new norms of political behaviour." (Streusand 1989:14). He organized the government by grouping his officials into _mansab_s, their authority weighed by the numbers over whom they exerted control, such as 1,000,

2,000, or more troops. "The Mughal empire, at its height, possessed a highly unified and systematized bureaucratic apparatus, the central point in which was the *manṣab* (numerical rank) . . . [which] defined the status and income of the holder. . . . Much of the inner political history of the empire . . . centered on the grants of *manṣab*s and appointments to offices" (Athar Ali 1985:ix).[3] The *mansabdar* was expected to maintain the troops on behalf of the empire, in return for which he received a *jāgīr*, a piece of land. Ownership of that land remained with the people who lived on and worked it, but the *mansabdar* received from it revenues sufficient to support his troops. Since Akbar needed no extra revenues and made no distinction among religions, in 1564 he abolished the *jizya*, the capitation tax on non-Muslims.[4] Further, he created the imperial infrastructure and frame for communications by developing the road system. By the time he died in 1605, after forty-nine years of arduous, substantive work, Akbar ruled an empire from Kabul to the mouth of the Ganges; Mughals were firmly in control of vast reaches of North India, and his successors had relatively far fewer challenges to meet than did he.

Visible and Audible Presence of Power: The Naubat

The Mughal Empire that emerged in the subcontinent was one of the most remarkable and dazzling of imperial entities. At the pinnacle of the empire sat a single individual vested with the power and authority to manage the affairs of what one historian has analyzed as a patrimonial-bureaucratic imperial state. For Stephen Blake, the controlling metaphor in the patrimonial state is the patriarchal family and the central element is the imperial household.[5]

The location from which the ruler reigned was, in effect, an imperial mansion; the sovereign city or encampment was an enormously extended patriarchal household, the imperial palace-fortress writ large.[6] By the time of Akbar's grandson, Shah Jahan, the imperial household was that, in every sense.

> The imperial palace-fortresses were enormous structures, covering between 125 and 2,700 acres, and containing from 60,000 to 100,000 persons. In addition to the household troops of the emperor, they held merchants, artisans, servants, poets, painters, musicians, clerks and administrators. They also contained workshops, stables, stores, treasuries, state records, mints and weapons. They were the most important neighborhoods or quarters in these cities and set the pattern for the mansions of princes and nobles. The residential complexes of the great men ordered the urban system, the palace-fortress directing the life of the city as a whole and the noble mansions the affairs of their sectors. (Blake 1991:xiii)

Within such a context, it was crucial for the patriarch to maintain a constant sense of "presence," to communicate his power and authority.[7] Akbar could employ the usual means of maintaining and communicating that presence that are available to any leader at any time, but here I shall concentrate on two senses which Akbar cultivated to maximum effectiveness—the audible and visible means at his imperial disposal. In so doing, Akbar revealed political genius, but he also left a tangible cultural heritage which brought to India a glory which has persisted to the present.

THE HERALDING ENSEMBLE

Visible—but more importantly, audible in a very conspicuous fashion—was a musical ensemble, the *naubat,* by which the presence and sovereignty of the emperor was announced, enunciated, reiterated, and symbolized (fig. 1). This "orchestra of world dominion" was housed in the *naqqāra khāna,* the "drum house" atop a high gate at a prominent point of approach and entrance to the imperial fort-palaces which was an integral part of the quarters of the imperial residence.[8] Assigned to that location, which permitted the sound of its playing to carry the greatest distance, the *naubat* ensemble—or, as it was likely to be referred to, the *naqqāra khānu*—was an audible means by which the imperial household was linked to the city over which it reigned.

Putting the welcoming, heralding musicians atop a gateway in a room that was designed to be both an enclosing space and open to the outside is not an element of design found consistently in the relatively few Persian paintings that illustrate the practice of heralding. A fifteenth- or sixteenth-century painting shows a player of a pair of kettledrums and a trumpeter holding a long instrument with a crooked tube heralding from a rooftop the arrival of several men on horseback, one of whom is shielded by the umbrella of royalty (fig. 2).[9]

The Mughal ensemble comprised instruments whose sound would carry even in the imagination of those who saw them in paintings: trumpets and horns, double-reed shawms, cymbals and drums (fig. 3, see detail). The chronicler of Akbar's reign, Abu'l Fazl, enumerated the instruments among the ensigns of royalty.

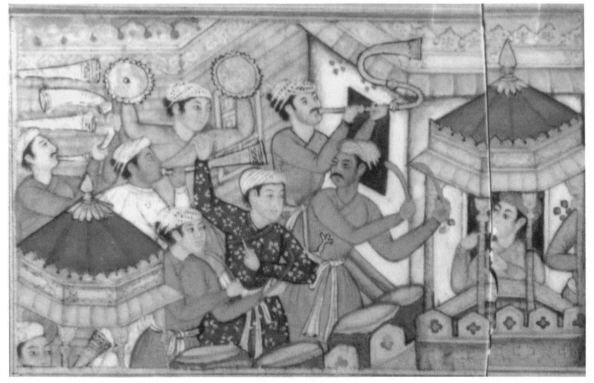

Detail of figure 3

Of musical instruments used in the *Naqārahkāna,* I may mention, 1. the *Kuwarga,* commonly called *damāma;* there are eighteen pair of them more or less; and they give a deep sound. 2. The *naqāra,* twenty pair, more or less. 3. The *duhul,* of which four are used. 4. The *Karnā* is made of gold, silver, brass, and other metals, and they never blow fewer than four. 5. The *surnā* of the Persian and Indian kinds; they blow nine together. 6. The *nafir,* of the Persian, European, and Indian kinds; they blow some of each kind. 7. The *sing* is of brass and made in the form of a cow's horn; they blow two together. 8. The *sanj,* or cymbal, of which three pair are used. (*AiA* 1:52–53)

From high in the *naqqāra khāna* the musicians heralded the activities of the sovereign himself, supposedly attentively "on duty" and prepared for any appearance. Were he to be "out of station," they stood at the ready to announce his return, informing all in hearing distance within and without the residence of his royal presence. In a wonderful illustration in a manuscript of the *Bābur Nāma* (the memoirs of Akbar's grandfather), the musicians in the gateway room were caught unawares, and they are portrayed in odd positions: One trumpeter must be just warming up as he holds his instrument up inside the room rather than extending it out so as to be heard (fig. 1).[10] The account in the text explains the lack of readiness evidenced not only by the musicians, but also by the servant who is in the process of putting the cloths and pillows on the *dīvān*-like platform just inside and the servant who sprinkles the ground with water to still the dust. There was not even time for the proper ceremonial greeting of the Mughal by his sons.

An order had been given that no-one soever should take news of us ahead. We reached Kābul at the Mid-day Prayer, no person in it knowing about us till we got to Qūtlūq-qadam's bridge. As Humāyūn and Kāmrān heard about us only after that, there was not time to put them on horseback; they made their pages carry them, came, and did obeisance between the gates of the town and citadel. (*BN* 395)

The shape of the trumpet that is being played by one of the mounted musicians who accompanies Babur as he unexpectedly enters Kabul (fig. 1) is a peculiar one, with sharp angles rather than a curved tube; strikingly, such an instrument is also drawn in a Persian painting of the fifteenth or sixteenth century where drummers and a trumpeter are placed on the gateway (fig. 2). Perhaps such an instrument really did exist rather than being a figment of artistic imagination.

The most important function of the "orchestra of world dominion"—the audible and visible interface of the Mughal establishment with the realm which he ruled—is illustrated in scenes of the "personal" life of the sovereign. Heralding the birth of the future ruler Jahangir in the *Akbar Nāma,* for instance, artist Kesu Kalan places the ensemble where it would have been played, between the interior of the palace and the exterior where the poor have gathered to receive the alms that were always distributed at such a time (fig. 4).

THE TIME-KEEPING ENSEMBLE

The audible reminder of Mughal power did not have to wait for such a sporadic excuse as the arrival of the Mughal or an imperial celebration in the palace-fortress. Playing by the ensemble in the *naqqāra khāna* was the means by which the watches—the periods—of each passing day were marked. Indeed, it was in this function—playing periodically—that the term *naubat* came to be

given to the imperial ensemble. As traced in Arabic-language sources by Farmer in his important *History of Arabian Music,* in the tenth century there was a company of musicians called *nauba* who performed at certain specified periods of the day or who took turns in performance (1929:153). The term *nauba* eventually was transferred from the performers to the performance, to mean music that was performed at particular times of the day. The times of the day which were so marked coincided with the five times of prayer in the daily life of Muslims. The ensemble for such performance was a military band, the *ṭabl-khāna,* which consisted of trumpets/horns and drums (for which the generic term was *ṭabl*).

> The display of suzerainty and military power by using every instrument of loudest report and musical appeal is found so much fussed about by the Turks and the Turko-Iranians, who took their turns in thronging over Baghdad after the "decline," dating back to 847. It was then that the influx of "Persian notions" and "Turkish ideas" set in. Eventually, the Buwaihids (945–1055), the Saljuqid(s) (1055–1184), and the Khwarizmian(s) (1184–1231), the so-called "protectors" of the Caliphate at Baghdad, provide a span of centuries for the upkeep of the cultural conditions conducive to the sustained growth of the art of *nauba.* (S. Sarmadee, pers. comm., March 1982)

The conflation of the *nauba*—periodic musical performance—with the phenomenon of the military band, and the association of those with political and cultural authority, then, are ideas that were widespread in the South and West Asian spheres from at least the ninth century. If they were already a functioning part of Indian culture, they were reinforced by the practice of the invading Muslim cultures. That Akbar considered his ensemble a military rather than purely ceremonial band is clear from the *A'īn-i Akbarī.* Writing of the personnel of the *naqqāra khāna,* Abu'l Fazl informs us: "*Manṣabdārs, Aḥadīs,* and other troops are employed in this department. The monthly pay of a foot-soldier does not exceed 340 and is not less than 74 *dāms*" (*AiA* 2:53. One *rupee* equaled 40 *dām* at the time). Indeed the same instruments are used in battle as are played atop the gateways for heralding. In figure 5, for example, Akbari painters show Babur's men urged on by players of drums and trumpet in their pursuit of the Hazara tribe of Afghanis through their mountainous territory.

With Babur, the founder of the Mughal dynasty in India, the "five-fold *nauba*" became further conflated with the system he found in place in Hindustan for marking off eight periods, or watches, of the day. He described the Hindustani system in detail:

> As in our countries . . . a day-and-night is divided into 24 parts, each called an hour (Ar. *sā'at*), and the hour is divided into 60 parts, each called a minute (Ar. *daqīqa*), so that a day-and-night consists of 1440 minutes,—so the people of Hind divide the night-and-day into 60 parts, each called a (S.) *g'harī.* They also divide the night into four and the day into four, calling each part a (s.) *pahr* (watch) which in Persian is a *pās.* A watch and watchman had been heard about (by us) . . ., but without these particulars. Agreeing with the division into watches, a body of *g'harīālīs* is chosen and appointed in all considerable towns of Hindustan. They cast a broad brass (plate-) thing, perhaps as large as a tray (*ṭabaq*) and about two hand's-thickness; this they call a *g'harīāl* and hang up in a high place. . . . They announce the end of a watch by several rapid blows of their mallets. (*BN* 516–17)

Babur adopted the system, amending it only slightly. There is no mention in his memoirs of his use of the gong for the purpose. Rather, references to the time of day and announcement of it before he went to Hindustan refer to the Muslim hours of prayer and to drums:

> Near the Afternoon Prayer of that same day, a horseman [who had been sent with a written message] appeared at the foot of the valley. . . . Such news! Off we hurried, that very hour—it was sun-set,—without reflecting, without a moment's delay, just as if for a sudden raid, straight for Marghīnān. Through that night [we] rushed without delaying anywhere, and on next day til at the Mid-day Prayer, halt was made. . . . We rode out again at beat of (twilight-) drum and on through that night till shoot of dawn. . . . At the Sunnat Prayer [the voluntary prayer, offered when the sun has well risen] we reached Fort Marghīnān. (*BN* 99–100)

As "Babur receives ʿAli Dost Taghai at Marghinan," a trumpet blares, cymbals crash, and drums resound in an illustration of a copy of the *Bābur Nāma*. Perhaps the reference to the beat of drum in the passage inspired the presence of the instruments (fig. 6, see detail).

In the next generation, Babur's daughter, Gulbadan Begam, writes of the Hindustani watch (*pahr*) as the functioning system:

> Next day he [Humayun] came to the tent of this lowly person, and the entertainment lasted till the third watch [*pahr*] of the night. Many begams were there, and his sisters, and ladies of rank and of position, and other ladies, and musicians and reciters. After the third watch [*pahr*] his Majesty was pleased to command repose. His sisters and the begams made resting-places in his presence. (*HN* 130)

Yet another conflation occured, then, in the Mughal culture of Hindustan. The custom of marking off the Hindustani watches of the day became conflated with the use of drums and, in more stationary circumstances, of an imperial ensemble—the *naubat* ensemble, otherwise known as the *naqqāra khāna*.

THE CONCERT ENSEMBLE

Under Akbar, the ensemble played a more explicitly musical function as well, albeit one that extended quite considerably the audible reminder at the beginning of each day of just who was in charge. Abu'l Fazl wrote:

> Formerly the band played four *gharīs* before the commencement of the night, and likewise four *gharīs* before daybreak; now they play first at midnight, when the sun commences his ascent, and the second time at dawn. One *gharī* before sunrise, the musicians commence to blow the *surnā*, and wake up those that are asleep; and one *gharī* after sun-rise, they play a short prelude, when they beat the *kuwarga* a little, whereupon they blow the *karnā*, the *nafīr*, and the other instruments, without, however, making use of the *naqāra*; after a little pause the *surnās* are blown again, the time of the music being indicated by the *nafīrs*. One hour later the *naqāras* commence, when all musicians raise "the auspicious strain" [probably blessings on his majesty, the translator Blochmann speculated]. (*AiA* 1:53)

Descriptions of the sound of such a "band" come from European observers. In the reign of Akbar's great-grandson, Aurangzeb, Bernier reported that the ensemble in the *naqqāra khāna* played

> in concert at certain hours of the day and night. . . . In the night, particularly, when in bed and afar, on my terrace this music sounds in my ears as solemn, grand, and melodious. This is not to be altogether wondered at, since it is played by persons instructed from infancy in the rules of melody, and possessing the skill of modulating and turning the harsh sounds of the hautboy and cymbal so as to produce a symphony far from disagreeable when heard at a certain distance. (Bernier 1934:260)

In the nineteenth century, Captain Charles Day found that "when [the ensemble is] heard from a little distance upon a still Indian night, and the sound is subdued, there is a good deal of wild beauty about it that possesses a charm peculiarly its own" (1891:96). It is not insignificant that this constant reminder of the presence, the power, and the authority of the Mughal ruler had "produce[d] a symphony far from disagreeable" and "possesse[d] a charm peculiarly its own," and was still a central element even in the decline of empire.[11]

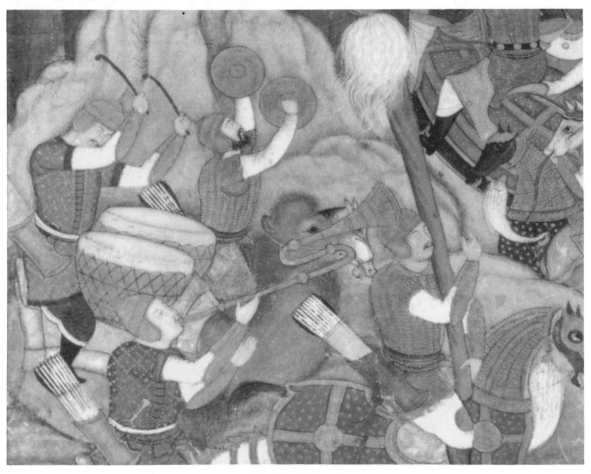

Detail of figure 6

THE ENSEMBLE IN PROCESSION

Not only did the *naubat* ensemble herald the emperor in his palace-fortress, but instrumentalists traveled with him almost everywhere he went, in order to inform all who were along the route of the presence of the sovereign. We read in the commentary by Akbar's aunt, Gulbadan Begam, about "music" that most probably was made by instruments of the *naqqāra khāna* to announce the presence of Humayun. On this occasion the announcement was a forceful, aggressive assertion of the right to sovereignty. Upon his return from exile in Persia, the greatest battle that Humayun had to fight was the recapture of his half-brother Kamran's stronghold at Kabul. Humayun camped out on the 'Uqābain (the "Hill of the Two Eagles") and blockaded Kabul for seven months. When he first arrived to take up that position,

> in triumph and glory and to the sound of music, the Emperor entered the 'Uqābain, with Mīrzā Hindāl in attendance and a splendid cavalcade. He set up for himself tents and pavilions and an audience hall. (*HN* 183)

Procession scenes are found among the earliest of Akbari period illustrations. Painted on cloth, c. 1570, "A prince riding an elephant in procession" is lively, with varied facial expressions and vivid colors, the bustle and hubbub—the unpredictability—of a moving throng that were characteristic of painting before artists developed formulaic compositions to serve as models (Topsfield and Beach 1991:22–23) (fig. 7). Beside the grand elephant being ridden by the prince trots a tiny baby elephant, while bringing up the rear, also on elephants, is a cortege including a player of the double-reed *sūrna* with tellingly puffed cheeks and a player of a large pair of drums—both instruments of the *naqqāra khāna*.

By the end of the Akbari period, paintings suggest that such princely processions had taken on the character of carefully controlled ritual.[12] "Akbar hunts at Sanganer on his way to Gujarat" presents such stylization, with the ensigns of royalty tucked into a corner of the painting behind the rocks (fig. 8). Not only are there standards of several designs, but the trumpets and large drums are complemented with cymbals. It had come to be standard to show drummers mounted on the backs of elephants, while the players of other instruments sat astride camels or horses.

As the power of the Mughals grew, the assertion of that power in visible and audible form became more resplendent. In the *Akbar Nāma*, little doubt is left about the nature of imperial processions in non-military circumstances. On 1 December 1581, when Akbar returned to his new city of Fatehpur, for example, Abu'l Fazl described the event:

> On this day of joy the great officers, the loyal servants, and others were drawn up in two sides of the way for a distance of four *kos* from the city. The mountain-like elephants stood there in their majesty. The Khedive of the world proceeded on his way on a heaven-like elephant, attended by the "Avaunt" of the Divine Halo. The obedient princes moved on in their order. Many grandees proceeded in front of the mace-bearers (yesāwalān). The panoply was there in its splendour and was followed by various officers. The noise of the drums and the melodies of the magician-like musicians gave forth news of joy. Crowds of men were gathered in astonishment on the roofs and at the doors. (*AN* 3:549)[13]

"In procession" was not limited to cavalry-like marching; it included movement on rivers by boat. From one episode related in the *Akbar Nāma*, we know that instruments of the *naqqāra khāna* accompanied Akbar on such a trip.

> On the day of S̲h̲ab H.M. halted at Īlahābās (Allahabad). On the day . . . when he left that pleasant station, the river was very boisterous. There blew a hurricane, and eleven boats were sunk. The orchestra [*naqqāra khāna*] too was damaged, but was saved by the Divine help. (*AN* 3:124)

Indeed, in fig. 9, "Akbar returns to Agra by boat, 1562" there are the insignia of royalty: the throne on which he sits, the banners carried by servants in two boats, and also a drum of the type in the *naqqāra khāna*. Astonishingly, other elements of court scenes which are symbols of royalty or power are also there in the boats—a falconer with his bird, and servants controlling riderless horses. To onlookers from the banks of the river, there would be no mistaking the personage in that procession.

Explicitly Visual Ensigns of Royalty

A more explicitly visual reminder of the presence of the Mughal ruler that complemented the audible set of instruments was other ensigns of royalty, "standards and paraphernalia of majesty":

> Then, by the exhibition of standards and paraphernalia of majesty, and the glory of the cavalcade, and the pompous beating of kettle-drums, [Khān Zamān] became certain that the Emperor in person was with the army. Accordingly, he ordered his troops to fall in and began to draw up his lines. (*MtT* 2:998)[14]

As he so helpfully enumerated in the *A'īn-i Akbarī* the instruments in the *naqqāra khāna*, Abu'l Fazl also listed the "standards and other paraphernalia," that is to say, the visual ensigns of royalty (fig. 1).

> I shall mention some of the insignia used at present.
> 1. The *Awrang,* or throne, is made of several forms. . . .
> 2. The *Chatr,* or umbrella, is adorned with the most precious jewels, of which there are never less than seven. . . .
> 5. The *'Alam,* or standard. When the king rides out, not less than five of these are carried. . . .
> 6. The *Chartrtoq,* a kind of 'Alam, but smaller than it, is adorned with the tails of Thibetan[*sic*] yaks.
> 7. The *Tumantoq* is like the *Chatrtoq,* but longer. Both insignia are flags of the highest dignity, and the latter is bestowed upon great nobles only. (*AiA* 1:52)

In the Mughal system of government, it was necessary—and therefore customary—for there to be another visible reinforcement of the ruler's power: constant audiences with the sovereign himself.[15] There were two periods of audience in a day. The British ambassador to Jahangir's court, Thomas Roe, described the daily program as "regular as a clock that stricks at sett howers" (1926: 240), and those basic elements remained the same from Akbar to Shah Jahan, albeit becoming more formalized and complex through time. One part of the routine began before sunrise: musicians

played to wake up the court, and at the moment of sunrise the emperor presented himself in his *jharokā-i darshan,* or "balcony of appearance" of the fort or palace.[16] In addition to the musicians playing, one of Akbar's many innovations was to have his appearance timed with the rising sun (although in a gossipy aside, the journalist Gascoigne intimates that both Akbar and Jahangir returned to bed for two more hours, 1971:144). The balcony on which the emperor appeared was high or he stood on a platform so that the people gathered below could reassure themselves that he was alive and that the empire was calm; even when the sovereign was ill, it was necessary to have him seen publicly at least once a day in order to maintain his control and guard against immediate anarchy. As well, although it was more likely symbolic than functional, this was a time when people might make personal requests directly to the ruler, each of whom devised a variety of means by which these petitioners could gain their attention. Humayun, for example, put a drum beneath the wall so that the petitioners could beat it to get his attention.

In illustrations of these audiences, artists display the visible ensigns of royalty as if they would have been seen from the beginning of empire. In figure 10, Babur sits on the most typically depicted throne, as does Akbar in figure 11, and in each folio servants also hold the 'alam, furled in a cloth bag. More magnificent standards (including the *tūmān togh* topped by a yak tail), are displayed in figure 1, held by horsemen who accompany Babur. In plate 1, where Akbar is seated in his *jharokā* for audience, the ensigns are near at hand but on the level below. The *chatr* is held on a long pole; it can be seen in figure 12 as well, carried behind Akbar as he rides triumphantly to the conquered city of Surat in Gujarat. In a different sense, the court musicians depicted in these scenes are also "ensigns of royalty"—not only the players in the *naubat* ensemble, but the players of the stringed instruments as well.

Books and the Exercise of Power

In addition to the external manifestations of enforcement of rule, I think that it was to a large extent due to Akbar's need to assert his sovereignty "internally" as well that he encouraged the production of another visible sign of authority: the visual medium of books. Important for the texts they conveyed, now they also serve us as vehicles for information about music in the Mughal sphere.

Faced with the reality of his tenuous situation as a newly anointed, teenaged ruler of an unsettled "kingdom," Akbar showed maturity beyond his years and, I think, realized the power of communication through books and paintings from the early days of his reign. The *Ḥamza Nāma,* the first illustrations that are known to be a result of his direct patronage (alongside, probably, the completion of the *Tūtī Nāma*), were commissioned in the 1560s—within a decade of his assuming the throne in 1556.[17] Akbar needed to communicate with—indeed, gain and keep the loyalty of—a diverse group of people whose identities could be defined in various ways: in terms of "us vs. others," for example those of his own immigrant Timurid heritage vs. the Indians whose territory he was overrunning; in terms of gender—the men whose cooperation he had to have and the

women in his imperial household whom he had to keep content; or in terms of religious tradition—primarily Muslim and Hindu, newly arrived and local.

Even in light of the traditional Timurid love of books, Akbar had a remarkably large number of manuscripts produced, certainly significantly more than any of his successors did. In the language of cultural studies, we have in Akbar's administration a quintessential example of power operating in the production of texts. Akbar had both a political and a cultural agenda: He had to secure his place at the pinnacle of what he hoped would become a large empire, and he was determined to create a new culture in India, essentially in his own image, by consciously drawing on his inherited culture; by incorporating (in some cases, appropriating) what he found useful (and, I think, interesting) from Indic culture; and by asserting his individual reinterpretation of it all. For a heterogenous group of courtly viewers, he used the manuscripts to assert his reinterpretation of history, to present an affirmation of the cultural synthesis he was generating and to suggest that it was a positive course to follow, and in general to control a crucial means of communication.

As books were a vital mode of communication, reinforcing and reinforced by a strong literary tradition in Akbar's own Timurid heritage and in that of the Indian subcontinent, so too were libraries a basic cultural institution in South and West Asian life. In the time of the Khalji and Tughluq sultans of North India, the saint Nizamuddin Auliya possessed a library in Delhi that was open to every man of letters. Not unlike in modern times, conquests resulted in whole libraries changing hands. Sultan Feroz Shah Tughluq, a patron of learning who gathered around him scholars, poets, and men of letters of the time, including Hindi poets and scholars of Islam, "obtained" about thirteen hundred books from the temple of Juwala Mukhi (Nagarkot) (Nadvi 1945:329–30). When Akbar's grandfather, Babur, defeated Ibrahim Lodi at Panipat, he sent his son Humayun to Agra, the Lodi capital, to seize the royal palaces and treasure; but Babur also took into his possession the private library of Ghazi Khan, the most distinguished courtier of the Lodi sultan. He recorded in his memoirs:

> After spending two nights on the rise, I inspected the fort. I went into Ghāzī Khān's bookroom; some of the precious things found in it, I gave to Humāyūn, some sent to Kāmrān (in Qandahār). There were many books of learned contents, but not so many valuable ones as had at first appeared. (*BN* 460)

Besides the imperial library, Babur had his personal library where he kept selected books of his choice. It was in this library that he rested for some time on an occasion when he was poisoned (Nadvi 1945:331).

Like his father, Humayun treasured books and, perhaps unwisely, seems always to have carried a number of valuable books with him even when he was engaged on the battlefield. A poignant entry in the *Akbar Nāma* recalls how Humayun, defeated by his half brothers as well as by the determined Sher Shah in 1536, and reduced to wandering in the desert of Sind as a fugitive, was encamped at Cambay when a body of forest tribes attacked his camp at night:

> The Gawāns came and proceeded to plunder, and many rare books, which were real companions and were always kept in his Majesty's personal possession, were lost. Among these

was the Timūr-nāma, transcribed by Mullā Sulṭān ʿAlī and illustrated by Ustād Bihzād, and which is now in the [great Shah] Shāhinshāh's [Akbar's] library. (*AN* 1:309–10)

Ironically, Humayun's library played a significant role in Mughal history in another way: On 24 January 1556, he had been visiting it in the fortress at Delhi he had recently won from the Surs when the sunset call to prayer sounded. Startled, he hurried down the slippery stairs to heed the call, tripped, and fell down the staircase, fracturing his skull. He never regained consciousness and died three days later. Because it was important for the Mughal to be *seen* in order to maintain his position of control, a double appeared in his place at audience times for the next fourteen days in order to secure the throne for his thirteen-year-old son, Akbar.

Akbar too had a large library. He increased what he had inherited from his ancestors by the addition of a sizable number of books obtained in his conquests from libraries in Gujarat, Jaunpur, Bihar, Kashmir, Bengal, and the Deccan. His library was unique in its collection of rare books, among which was the Persian *Dīvān* of Humayun Shah, whose few couplets have been quoted by Abu'l Fazl in the *Aʾīn-i Akbarī* (see Brand and Lowry 1985:57, 58, 61, 67–68, 87–106; Aziz 1967).

As books and libraries were of prime importance to the Timurids, so too were libraries and Timurid manuscripts important to the Mughals. The library (*kitāb khāna*) was a complicated institution made up of several units, including the center of manuscript production and painting and the translation bureau. Some of the library's components were located in private areas, such as the interior of the palace and the treasury (used as a rare books room, perhaps), while others were in (relatively) more public places. In the Agra fort, much of the Royal Library was housed in the big hall on the side of the octagonal tower (later rebuilt by Shah Jahan, according to Nadvi 1945: 332). Furthermore, its functions were maintained in several cities so that the Mughal ruler could have branch libraries.

If the library was organized in the time of Akbar as it was in the period of his grandson, Shah Jahan, it was a complex organization employing a large staff (Nadvi 1946:18, from *SJN* 2:505). The library was headed by the *nāẓim*, a noble of the court who was responsible for the income as well as expenses of the library and the appointment and dismissal of servants. The *dārogha*, in charge of the internal management of the library, had to be able and well-versed in all the arts and sciences. With the help of an assistant, he selected, purchased, and classified the books according to subject. He supervised many clerks for cataloguing as well as employees who arranged the books in trunks and *almiras* (bookcases, cupboards) in serial numbers. Books were greatly treasured and cared for; yet another echelon of employee was to take out every book, remove the dust and clean the book after turning every page, and separate the pages if they had stuck together. There were bookbinders and painters, as well as calligraphers, expert in different styles, who wrote entire books or completed unfinished ones. Scribes copied rare books, with copyists working along with them to copy some particular portion at greater speed. Books written by calligraphers and scribes were sent for proofing by the comparing scribe, whose duty it was to compare a copy with the original and correct any mistake. A specialist called the corrector (*muṣaḥḥiḥ*) had to be a man of great ability and learning. If any books were eaten by worms so that only half a word remained, he had to restore the words in a correct way. He had also to remove defects or mistakes in the original.

Courtiers, too, were collectors of books. Mun'im Khan, the Khan Khanan, who was the governor of Jaunpur during Akbar's reign, owned a personal library. A lover of books, he tried to acquire them from wherever possible; his friends knew his taste and sent him books which they considered rare (Nadvi 1945:334). Faizi, the "poet laureate" at the court of Akbar, brother of Abu'l Fazl, was a renowned scholar as well as the son of a scholar and he, too, collected rare and fine books for his library. Most were either penned by the authors themselves or were written in their time; Faizi's own works numbered 101. The 4,600 books in his library, all of which passed to the Imperial Library after Faizi's death, were on literature, medicine, astronomy, music, philosophy, science, mathematics, commentary, and jurisprudence, among other subjects (Nadvi 1945:337).

The sovereign dominated not only the social and economic but also the cultural life of the empire. By commissioning new books, translations of others, and copies of treasured older works, Akbar set the cultural standards for his growing empire, disseminated the emerging Mughal style of art, and most importantly, disseminated information and perceptions that he wanted and needed to communicate to those in his imperial hierarchy. The great men of court also were expected to be expert in the arts of both peace and war, and their households too comprised poets, musicians, dancers, painters, calligraphers, historians, and architects.

THE MUGHAL LOVE OF BOOKS

The audience for books/manuscripts was an exclusive but crucial one, so production and distribution were carefully worked out. Multiple copies of important books would be made and distributed to appropriate persons. Among such important items were "histories."[18] To older members of the community who had had firsthand experience of great events, "There was an order issued—write down whatever you know of the doings of Babur and Humayun." With those words Gulbadan Begam, Humayun's sister, began one of the three surviving memoirs of this type; of the other two, one was by Humayun's ewer-bearer, Jauhar Aftabchi, the other by a royal retainer, Bayazid Bayat. Bayazid's *Tadkira-i Humāyūn wa Akbar* serves as an excellent example of Akbar's interest in both the creation of books and the distribution of information.[19] Of the nine copies made of Bayazid's memoirs, three were presented to Akbar's sons Salim, Murad, and Daniyal; one to Akbar's aunt, Gulbadan Begam; two to the historian Abu'l Fazl; one was perhaps kept by the author (*HN* 76); the two remaining copies were deposited in the sovereign's library. Likewise, more than four copies were made of the *Bābur Nāma,* the illustrated memoirs of Akbar's grandfather. At least two copies were made of the *Akbar Nāma,* the chronicle of Akbar's own reign. One copy of any new work most likely remained in the imperial library, and among the first acts of a newly enthroned Mughal ruler was to visit the imperial library to affirm on the item itself with signature and/or seal the new ownership of the volume.

The fact that Gulbadan Begam wrote the *Humāyūn Nāma,* one of the most important documentary sources for the Mughal period, makes it obvious that the audience for the manuscripts was not only "the great men"; women in the imperial household also wanted and needed access to them. "His Majesty's library is divided into several parts; some of the books are kept within and some without the Harem" (*AiA* 1:109). Akbar's reason for housing part of the imperial library in

the *ḥarem* was probably not just that he spent a great deal of time there, but because the women therefore had access to the books as well. Another case in point is Salima Sultana, Humayun's niece (daughter of a sister) and one of Akbar's wives, whose request for a book put the historian Bada'uni in disgrace:

> And on account of the book *Khirad-afzā*, which had disappeared from the Library, and concerning Salīmah Sultān Bēgum's study of which the Emperor reminded me . . . , an order was issued that my *madad-ma'āsh* [allowance] should be stopped, and that they should demand the book of me.[20] (*MtT* 2:389)

That the women in the top echelons of Mughal society were educated should not come as a surprise. In his 1916 book on the promotion of learning in India, Law took the unusual step of culling documentation on educated women in order to be able to assert: "We are justified in the conclusion that the Muhammadan ladies during the Muhammadan rule could not have been so ignorant as is generally supposed" (p. 205).[21] Sultan Ghiyasuddin, who reigned (1469–1500) in Malwa shortly before the Mughal period, established within his *ḥarem* all the separate offices of the court: "Among [the women in the *ḥarem*] were school-mistresses, musicians, women to read prayers, and persons of all professions and trades" (Firishta 4:236, cited in Law 1916:201). Likewise, in Akbar's time regular instruction was given to the ladies of the royal household; in Fatehpur Sikri, Akbar set apart certain chambers as a school for their education (Law 1916:200–5, picture 1, following).

The literary accomplishments of female members of the ruling Mughal family are now widely recognized. With Gulbadan Begam stand several other outstanding examples. "The princesses were highly educated and cultured. Some of them wrote excellent poetry," such as the eldest of 'Alamgir I's five daughters, Zibunnissa (Salima Sultana), who herself knew Persian and Arabic, was thoroughly proficient in the knowledge of the Koran, skilled in calligraphy, wrote many Persian poems under the nom de plume of Makhfi ("concealed"), "and whose poems are read by lovers of Indo-Persian poetry even today with delight; Nur Jahan and Mumtaz Mahal are also credited with writing poetry" (Naqvi 1990:63). Jahanara, eldest daughter of the fifth Mughal ruler, Shah Jahan, composed a tract about the revered Ajmeri Sufi saint, Muinuddin Chishti; a copy of the tract is in the British Museum (H. Beveridge, foreword to Law 1916:xxvii).[22]

Females of the Mughal reigning family and in the imperial household were patrons of learning as well. In Akbar's household, Maham Anaga, who was like a foster mother to him and who was extremely influential at the beginning of his reign, in 1561 founded a college (*madrasa*) in Delhi which had a mosque (*masjid*) attached. The Madrasa stands almost in front of the western gate of Purana Qila, near the supposed site of the western gate of the Delhi Sultanate rulers (Law 1916:165–67). On the recommendation of her tutoress and chief librarian, Satiunnissa, Mumtaz Mahal, beloved wife of Shah Jahan, provided pensions and donations to the daughters of poor scholars, theologians, and pious men. Her eldest daughter, Jahanara, encouraged the educated men of the time with rewards and allowances. In the next generation, the aforementioned Zibunnissa Begam employed many learned men, poets, and writers. She had numerous compilations and original works dedicated to her (Law 1916:204). Indisputably, the heritage of the Mughal family, from

Timurid times through at least the sixth generation from Akbar, included love of learning, acquisition and production of books, and patronage of scholars and artists.

AKBAR'S PRODUCTION OF ILLUSTRATED MANUSCRIPTS

Not only did Akbar order the production of an extraordinarily large number of manuscripts, but the number of those which were illustrated with paintings was noteworthy. He clearly understood the potency of the visual medium for communication: Akbar did not read; his own methods for learning were visual and aural.

It is frequently written that Akbar "was illiterate," for which various reasons have been posited. Most frequently his inability to read is reported disparagingly, with overtones smacking of disapproval of a boy who refused to study. The first in a series of diligent tutors was appointed in November 1545 to teach Akbar, but none was able to direct their pupil away from such outdoor activities as pigeon-flying or swordsmanship and other martial arts. However, it was obvious that he had an insatiable curiosity and an amazingly retentive mind, and there seems little question that his inability to read sharpened his memory. He knew the names of his innumerable horses, elephants, and pigeons as well as those of his vast entourage of soldiers, administrators, artists, craftsmen, and—although it is not mentioned in any contemporary source—likely his musicians. Certainly the epithet "illiterate" in Akbar's case could not be taken to mean "uneducated," for even as a boy he memorized verses by such mystical poets as Hafiz (see plate 2) and Jalaluddin Rumi.

It has also been suggested that Akbar never learned to read or write because he did not need to; there was always someone available to read aloud to him (Schimmel 1983:118). Indeed, as a youngster he enjoyed being read to from a rapidly expanding library and, as Abu'l Fazl noted, Akbar's habit of regular study continued.

> Experienced people bring them [books] daily and read them before His Majesty, who hears every book from the beginning to the end. . . . Among the books of renown there are few that are not read in His Majesty's assembly hall; and there are no historical facts of the past ages, or curiosities of science, or interesting points of philosophy, with which His Majesty, a leader of impartial sages, is unacquainted. He does not get tired of hearing a book over again, but listens to the reading of it with more interest. (*AiA* 1:109–10)

Another aural means by which Akbar learned was by discussion. On Fridays and Sundays as well as on holy nights, the "Sufis, doctors, preachers, lawyers, Sunnis, Shi'as, Brahmanas, Jains, Buddhists, Charbaks, Christians, Jews, Zoroastrians and learned men of every belief" were invited to the royal assembly, and each fearlessly brought forward his assertions and arguments. Schimmel presumes that Akbar gained much of his understanding of Hinduism in his *harem* (Schimmel 1983: 30–31).

Art historians agree that Akbar's inability to read probably intensified his patronage of the visual arts. The art historian Ellen Smart asserts:

> Akbar demanded illustrations in all types of manuscripts because he could not read the words. He knew the texts and wanted a visual representation of the events in them. Manuscript illustration was an Islamic tradition. Humayun had provided his son with foundations

of a studio that could produce illustrated texts. Akbar involved himself with this aspect of courtly life, leaving the stamp of his dynamic inquiring mind on the style and content of the pictures. (1981:103)

More importantly, Smart suggests another cause for Akbar's inability to read despite the fact that he lived his life in avid search of knowledge: The likely possibility is that he suffered from some learning disability, such as dyslexia syndrome, which prevented him from learning to read from any of his five childhood tutors. In the fascinating article just cited, "Akbar, Illiterate Genius," Smart presents evidence of Akbar's extensive interests and accomplishments, notes that his physical prowess and energy were legendary, and recounts the various categories of activity in which he involved himself personally—the arsenal, improving the line of the royal elephants, the imperial kitchen, the fruitery, perfumes, the wardrobe (he even invented a waterproof raincoat), painting, and of course military campaigns by which he amassed and consolidated a substantial empire. Smart also presents evidence of neurological disturbance, suggesting that the trances Akbar occasionally experienced would be diagnosed today as a mild form of epilepsy. (In his day, they were looked upon as communications with higher beings.)

Akbar employed hundreds of painters to work in his royal workshop, and the number of manuscripts that were created by them is large—perhaps as many as forty-six. To produce the number of illustrated manuscripts that he desired, Akbar chose artists not just from those whose hereditary profession was painting, but by talent. Daswanth, the son of a humble *pālkī* [palanquin]-bearer, was a favorite of Akbar's who, according to Abu'l Fazl,

> devoted his whole life to the art, and used, from love of his profession, to draw and paint figures even on walls. One day the eye of his Majesty fell on him; his talent was discovered, and he himself handed over to the Khwāja. In a short time he surprised all painters, and became the first master of the age. (*AiA* 1:114)

Not content to have his painters reproduce the Persian styles of painting that predominated in West Asia, he created a climate in his painting workshop where a new style could emerge, and he undoubtedly chose designers and painters whose minds were open to change.

Many (but not all) art historians think that Akbar was personally involved in the production of the illustrated manuscripts; in this arena, as in so many others, he caused culture to be created in his own image. He determined what the subjects of the books would be, chose the authors of new books and the translators of preexisting books, and regularly saw the progression of work on manuscripts. Every week the supervisors brought to Akbar the "performance" (paintings) of every artist, and the Emperor rewarded each one with bonuses and salary increases in proportion to his merit (*AiA* 1:113).

Yes, Akbar seems to have wanted a visual representation of what he could not read. But I suggest a further possible reason for the large number of illustrations: He knew that they were a powerful means by which to communicate his "messages" to an audience much wider than that for the texts of the books themselves. Could they not be useful for "speaking" to those who knew little or no Persian, the language of the text of the books? And, of course, might not paintings deliver messages with meaning beyond that of the prose or poetry that they illustrated? As a person who

depended on reading paintings for meaning, Akbar would know very well that they could. In addition to personal joy and a tendency for micromanagement, then, could he not have been checking the paintings each week in order to direct the content of them as "an aspect of his statesmanly ambitions" as Annemarie Schimmel put it so elegantly (1983:36)?

THE AUDIENCE FOR THE BOOKS: WOMEN AND OTHERS

Since some of the library was kept in the *harem*, one might logically assume that Akbar had his women in mind when some of the manuscripts were produced. Not only did Akbar have a large audience of Mughal women in the *harem* who would be able to read the Persian texts, but also others who might not, for he defied his family's custom and Islamic law with a decision made for political reasons: He married the daughters of the Indian Rajput leaders with whom he needed political/military alliance.[23] His first Rajput wife was the eldest daughter of Raja Bihari Mal of Amber, whom he married in 1562 and who was the mother of Prince Salim, Akbar's successor—Jahangir. Regardless of its political motivation, this marriage was happy and established the persistent importance of the Kachwaha Rajputs in the Empire. It also led to further marital alliances between Akbar and women from other distinguished and powerful Rajput clans (Schimmel 1983: 30). In 1570, for instance, the Raja of Jaisalmer asked to be allowed to present a daughter to the imperial *harem;* she was graciously accepted, and Bhagwan Das was sent to collect her. In that same year, the Raja of Bikaner offered a niece; she too was accepted, and so "that occupant of the howdah of chastity was brought within the screens of purity" (*AN* 2:518–19).

Into the Mughal extended patriarchal household then moved discrete households of Indian princesses. Little documentation exists to inform us about the pleasures and vicissitudes of life for all the women in Akbar's *harem*. Despite the fact that Islam had been present in South Asia for several hundred years, and Persian culture as well, the differences in religious faiths and traditional cultures must have created some interesting situations. In addition, there was the language factor to be considered. With what must have been varying degrees of proficiency in the Persian language of the manuscripts among all members of the court, illustrations could more probably be counted on to be "read" by absolutely everyone. Through illustrations in manuscripts, there could be communication—of whatever Akbar wanted to communicate. In light of this, the choice by Akbar of *Deval Rani Khizr Khān* to be among the first illustrated manuscripts he commissioned is quite striking. He married his first Indian wife in 1562 and the book was completed in the 1560s.

Deval Rani Khizr Khān, a literary classic in Persian written in the Sultanate period by the great Indian poet Amir Khusrau Dihlavi (1251–1326), recounts the love (albeit tragic) of a son of the (Muslim) Sultanate-period ruler Allauddin Khalji for the daughter of an Indian *rāja*.[24] While the style of the illustrations is basically Persian, the story would have had a receptive audience among the Mughal women as well as Akbar's Indian "constituency." As always with an epic, the story is long and involved, so I shall simply sketch it here.

It begins with battles: In 1296, Sultan Allauddin Muhammad Khalji won the throne of the Sultanate and dispatched his forces to seize other provinces in India. From Gujarat his victorious troops sent Kanulodi, the beautiful wife of Raja Karn, to Allauddin. Kanulodi had left her two little

daughters with their father, but soon the elder child died, leaving only the six-month-old Devaldevi (Devalrani). Kanulodi, who became a concubine at the Khan's court, missed her daughter greatly and obtained Sultan Allauddin's permission to bring her to his court. In the course of time Deval Rani and the Sultan's son, Khizr Khan, fell in love; figure 13 illustrates that happy occurrence.[25] When Khizr Khan's relatives learned of it, in an act of religious intolerance they forbade the couple to meet. Khizr Khan was married off and Deval Rani was removed to another court, so that the couple could only exchange letters. At that time the Sultan was taken seriously ill; Khizr Khan, who grieved at the news, set off to worship at holy places in Hatnapur. In his absence, trouble brewed and the prince was unfairly charged with treason, resulting in imprisonment by his father, who had not been given all the facts. Deval Rani did as much as she could to make things easier for Khizr Khan, to whom she was still devoted. After Allauddin's death in 1315, Malik Naib Kafur selected a child puppet for the throne and, to be certain that Khizr Khan would not be a threat, put out the young man's eyes. As if that were not enough, another son of Allauddin managed to regain the throne, but he wanted Deval Rani to be his concubine. Khizr Khan protested and was executed. In one version of the story, Deval Rani, true to her beloved, burned herself to death on a bonfire.[26]

In order to base the story on real events and feelings, Amir Khusrau was privy to records and letters of Khizr Khan, who asked Amir Khusrau to write the poem. Illustrations of the story were quite fantastic, however; more characteristic of Persian than later Mughal art, the couple is shown together, she wearing the wings of an angel, as do the female dancers, while female and male musicians are playing harp, *daf*, and *nā'ī* (fig. 13). As the art historian Yusopov comments, the Persian artists of his father whom the young Akbar had adopted as the masters in his atelier had ready pupils, but the painting is beginning to take on Mughal characteristics. The fairy world that was depicted by artists in the Safavid courts of the cities of Tabriz and Qazvin

> has been brought down to earth as the landscape, the building and the figures are more realistic. The symbolism of the wings . . . uplifts the pleasure scene in a different manner than in the Persian style. The multi-dimensions of Herat are incorporated, but the pavilion shows those Rajasthani kiosks which Akbar introduced into his architecture. The colours are denser. The faces and figures of the characters are individualised with emphasis on the moods they express. (Yusopov 1983, note to fig. 17, pp. 42–43)

Interpreted in the context of Akbar's household, the story of *Deval Rani Khizr Khān* could very well have been seen to contain a message from Akbar: "It should have been all right for a man and woman from two different groups to marry, as I have done. If it is accepted in good spirit in the first place, tragic consequences can be avoided. And therefore it is acceptable for me to marry Indian princesses." Tolerance in the *harem* would have been very important, because unlike his Indo-Muslim predecessors who had made Indian women of Hindu faith in their households convert to Islam, Akbar permitted all his wives to maintain their own cultures and religion (Rizvi 1975b: 179).

The situation seems to have been a congenial, interdependent one. As mentioned in note 23 above, the Rajputs, who were Hindus of the Kshatriya class and hereditary leaders in the government and warfare, had considerable access and likely some leverage with Akbar, while Akbar gained

military support in Rajasthan, the strategic western area of the subcontinent. One can speculate that there would have been a flow of communication between the Rajput women in Akbar's household and their families, a river navigable in both directions for sending information, impressions, and interpretations.

In being mindful of the women of his extended household, Akbar had abundant example set by Babur, the grandfather he admired so greatly. Akbar could still "know" his grandfather from the older women in his household, and his aunt, Gulbadan Begam, wrote of Babur's concern for his womenfolk in her *Humāyūn Nāma*. Remembering the occasion of the family's move from Kabul to Hindustan, for instance, she wrote of the care that Babur took for their welfare.

> In short, all the begams and khānams went, ninety-six persons in all, and all received houses and lands and gifts to their heart's desire.
>
> All through the four years that (my father) was in Āgra he used to go on Fridays to see his paternal aunts. One day it was extremely hot, and her Highness my lady said, "The wind is very hot, indeed; how would it be if you did not go this one Friday? The begams would not be vexed." His Majesty said, "Māham! it is astonishing that you should say such things! The daughters of Abū-saʿīd Sulṭān Mīrzā, who have been deprived of father and brothers! If I do not cheer them, how will it be done?"
>
> To the architect, Khwāja Qāsim, his Majesty gave the following order: "We command a piece of good service from you. It is this: whatever work, even if it be on a great scale, our paternal aunts may order done in their palace, give it precedence, and carry it out with might and main." (*HN* 97–98)

From the memoirs of Babur alone, Akbar would have known of his respect for women in his family, for Babur wrote in a manner that was expressive of personal as well as political matters. Indeed, Babur's "willingness to depict women—not simply as individuals, but as persons with negative as well as positive traits—offers an important clue to the sources of his atypical social candor (Dale 1990:51).[27] In speaking of the elder women of his family (mother, grandmother, and others) "Babur uses the honorific plural, a form of rare occurrence except for such women, for saintly persons and exceptionally for The supreme Khan [does the translator imply the Muslim God?]. For his father he has never used it" (*BN* 149n).

From Babur's memoirs as well, Akbar would have taken the political involvement of the women of his family for granted. The men consulted together in the presence of women, including his maternal grandmother, Aisan-daulat Begam:

> Khwāja-i-Qāzī and (Sayyid) Qāsim *Qūchīn* and ʿAlī-dost Ṭaghāī met other well-wishers of mine in the presence of my grandmother, Āīsān-daulat Begīm and decided to give quietus to Ḥasan-i-yaqʿūb's disloyalty by his deposition. (*BN* 43)

It is abundantly clear from contemporary sources that women could and often did play strong roles in the political machinations of the Mughal court establishment from its earliest days.[28] That is not surprising since marriage was usually a political arrangement and the women knew very well that they were political actors in the dramatic acquisition of power. About Aisan-daulat Begam, Babur remarked: "Few amongst women will have been my grandmother's equals for judgment and

counsel; she was very wise and farsighted and most affairs of mine were carried through her advice" (ibid.). His paternal Timurid grandmother was also involved politically. Babur wrote of her on an occasion when some of his men had been captured: "On the next following day, my father's mother, my grandmother, Shāh Sultān Begīm arrived from Andijān, thinking to beg off Jahāngīr Mīrzā if he had been taken" (*BN* 113).

"Muhammad Husain Mirza in the bedding" (fig. 14) is a colorful depiction of a crucial political moment when Babur's respect for his aunts came into play. In 1504 Babur had taken Kabul, which would become his base and his family's favorite dwelling place for the next two decades and more. He writes of the moment in his journal:

> [From a garden on the outskirts of Kabul] we sent letters of victory to all the courtiers, clans, and retainers. This done, I rode to the citadel. Muḥammad Ḥusain Mīrzā [of Kabul] in his terror having run away into Khānīm's [his wife's] bedding-room and got himself fastened up in a bundle of bedding, we appointed Mīrīm *Dīwān* with other begs of the fort, to take control in those dwellings, capture, and bring him in. Mīrīm *Dīwān* said some plain rough words at Khānīm's gate, by some means or other found the Mīrzā, and brought him before me in the citadel. I rose at once to receive the Mīrzā with my usual deference [he was related by marriage], not even shewing too harsh a face. (*BN* 319)

In the illustration, we gain the impression that the captured *mīrzā* [prince] was "brought into the presence" in a throne room–like chamber in the fort. Gulbadan Begam confirms the account of the incident and explains why the *mīrzā* was not treated harshly:

> Mīrzā Muḥammad Ḥusain was in his wife's house. She was his Majesty's younger maternal aunt. He flung himself down on a carpet, and in fear of his life cried to a servant, "Fasten it up!" His Majesty's people heard of this. They took him out of the carpet and brought him to the presence. In the end, his Majesty forgave the mīrzās their offences, for the sake of his aunts. He used to go, in his old fashion, in and out of his aunts' houses, and showed them more and more affection, so that no mist of trouble might dim their hearts. He assigned them places and holdings in the plain-country. (*HN* 89)

From Babur's memoirs Akbar would also have heard vivid examples of potential trouble from the political involvement of women. Babur lost his hard-won control of his family's ancestral capital of Samarkand one time due to the machinations of a woman—the mother of a prince (*mīrzā*). Sultan Ali Mirza (*pādshāh* of Samarkand) had given Samarkand to Shaibani Khan (the Shaibanid ruler of the Uzbeks (see chapter 2, note 10).

> The particulars are these;—The Mīrzā's mother, Zuhra Begī Aghā (*Aūzbeg*), in her ignorance and folly, had secretly written to Shaibānī Khān that if he would take her (to wife) her son [Sultan Ali Mirza] should give him Samarkand and that when Shaibānī had taken (her son's) father's country, he should give her son a country. Sayyid Yūsuf *Arghūn* must have known of this plan, indeed will have been the traitor inventing it. . . . As for that calamitous woman who, in her folly, gave her son's house and possessions to the wind in order to get herself a husband, Shaibānī Khān cared not one atom for her, indeed did not regard her as the equal of a mistress or concubine. (*BN* 125–28)

Recounted most dramatically by Babur, and then retold by Gulbadan Begam, was the incident of the attempted assassination of Babur by the mother of the defeated Ibrahim Lodi, whose kingdom was the basis for the future Mughal empire. Ibrahim died fighting Babur at Panipat, but Babur, ever mindful of the fate of women, saw to it that Ibrahim's mother was cared for; ungratefully, she plotted to kill him. In a letter Babur wrote from Kabul to the women of his family in Hindustan, he recounted the event in what became the entry of 21 December 1526 in his memoirs. The intent of the letter was to assure them that he was all right, but it is also indicative of the level of detail which he knew the women would want to hear.

> The ill-omened old woman Ibrāhīm's mother heard that I ate things from the hands of Hindūstānīs—the thing being that three or four months earlier, as I had not seen Hindū-stānī dishes, I had ordered Ibrāhīm's cooks to be brought and out of 50 or 60 had kept four. Of this she heard, sent to Atāwa (Etāwa) for Aḥmad the *chāshnīgīr*—in Hindūstān they call a taster (*bakāwal*) a *chāshnīgīr*—and, having got him, gave a *tūla* of poison, wrapped in a square of paper . . . into the hand of a slave-woman who was to give it to him. That poison Aḥmad gave to the Hindūstānī cooks in our kitchen, promising them four *parganas* if they would get it somehow into the food. Following the first slave-woman that ill-omened old woman sent a second to see if the first did or did not give the poison she had received to Aḥmad. Well was it that Aḥmad put the poison not into the cooking-pot but on a dish! He did not put it into the pot because I had strictly ordered the tasters to compel any Hindū-stānīs who were present while food was cooking in the pots, to taste that food. Our graceless tasters were neglectful when the food (*āsh*) was being dished up. Thin slices of bread were put on a porcelain dish; on these less than half of the paper packet of poison was sprinkled, and over this buttered fritters were laid. (*BN* 541–42)

The account is lengthy; it is Babur at his most detailed—what he ate, what it did to him, how he punished the culprits.[29]

His daughter Gulbadan Begam's is a secondhand retelling of the incident. She recalled it in the manner of a flashback at the time Babur became ill just before he died, because his condition was reminiscent of that illness.

> When they felt his Majesty's pulse, they came to the opinion that there were symptoms of the same poison as that given him by Sulṭān Ibrāhīm's mother. It was in this way: that ill-fated demon (the mother) gave a *tōla* of poison to one of her maids, and said: "Take this and give it to Aḥmad the taster and tell him to put it in some way or other into the special dishes prepared for the Emperor." And she promised him large rewards. The ill-fated demon did this although his Majesty used to call her "mother," and had assigned her place and lands with every favour, and had been kindly pleased to say: "Consider me as in the place of Sulṭān Ibrāhīm." But as ignorance prevails amongst those people, she did not regard his kindness. The (fitting) hemistich is well known:
>
> > "Everything reverts to its original type,
> > (Whether pure gold, or silver, or tin)." (*HN* 108)

The conclusion, in short, was that the cook (Heaven having made him blind and deaf) spread the

poison which had been brought and given to him on the Emperor's bread only, and so very little was eaten.

If that were not enough to apprise Akbar of the power of the women, he himself would have been aware of it from his own personal experience in early childhood. At the time of Akbar's birth, his father Humayun was trying to maintain control of the kingdom that Babur had left him. Humayun's archrival, his half brother Kamran, was determined to wrest the throne by military might. To save his life and his crown, Humayun fled with a small retinue to Persia, in order to enlist the help of Shah Tahmasp of the Safavid dynasty. The child Akbar was captured several times during this unsettled period, but taken care of by his half-uncle Askari's wife, who treated him kindly, and consigned by Kamran to a trusted aunt, Khanzada Begam, "itself considered an act of kindness and surety" (*HN* 47) and also an indication, perhaps, of the conflicted and fluid relationships among Babur's sons and some deeper Timurid ideal. It is likely that the woman in figure 15 is one of those two protectresses; the scene depicts a wrestling match arranged by Kamran between his own son and the child Akbar to decide the ownership of the *naqqāra* (the drums pictured there), the symbol of power.

For these several reasons, it seems to me that some of the manuscripts Akbar chose to have produced, and also many of the particular illustrations, are very likely to have been determined by that potentially powerful audience in the *ḥarem*. Akbar knew that he needed to communicate with that important and diverse part of his imperial household, and he also knew that he needed to control them. Among the means available were visual messages, presented not in a threatening but in an aesthetically appealing manner. Coming from Akbar, the messages would nevertheless be authoritative.

According to the art historian John Seyller (1992:308), the *Tūtī Nāma* [Tales of a Parrot] would not have had any appeal to the *dynastic sensibilities* of the Mughals, so I suggest a different reason for the choice of that project for the imperial atelier. The *Tūtī Nāma* was a compendium of fifty-two stories—"oft-told tales"—collected and retold in the fourteenth century by a Persian-language writer in the court of the Delhi Sultanate; the tales were known to Hindu and Muslim alike. Significantly, the central character of the *Tūtī Nāma* is a woman, and in the illustrations she is Indian; also significantly, she is a woman who is being cajoled into good behavior. Originally a manuscript incompletely illustrated mostly in the Indian Candayana style of painting, the choice to complete it would seem to have been made with the *ḥarem* in mind as much as (indeed, even more than) Akbar himself with his "youthful zest for entertaining fables," as is normally assumed (Schimmel 1983:45, for instance). The framing story concerns Khojasta, whose merchant husband had gone away for fifty-two days to make his fortune. From her cloistered home, she looks beyond her walls, falls in love with a young man, and determines to go out at night to meet him. Her pet parrot (Tuti), however, finds a way to keep her in: he tells her such a good story on each of the fifty-two nights that she forgets until too late that she was going to go out. It was a pleasant sort of control, but control nevertheless, with the point about correct behavior of a woman being made fifty-two times. In addition, several of the stories are about bad behavior on the part of a female, with disastrous results—the story of the eighth night, for instance, recounted below at note 33. Completed

c. 1570, the illustrations in the *Tūtī Nāma* reveal a process that was routine in the Mughal atelier—the updating and completion of a preexisting manuscript, including therefore examples of two Indian styles of painting and the already mature Mughal style (Seyller 1992).

While the conditions of political marriage were a fact of life for the women in Akbar's household, good relations in their domain of the imperial residence could be fostered through items of mutual enjoyment. The material in the stories of the *Tūtī Nāma* is rich and diverse, and any of the women in the *ḥarem*—Indian or other—would have found material with which they could associate and empathize. "The Story of the Origin and Development of the Science of Music and Composition, the Rules of Musical Melodies, the Ten Traits of Men, and the Seven Attributes of Women," told by the parrot to Khojasta on the fourteenth night of her husband's absence, serves as a good example.

> When the august phoenix—the sun—moved into its nest in the west and the auspicious bird—the moon—rose from its aerie in the east, Khojasta trailing her skirt like a peacock went to ask Tuti's permission to leave and said, "Oh faithful friend of the people and the king of birds, wise men say that there are two ways to stimulate love, one by wine and the other by song. Last night you talked so much about songs that without tasting wine I became continually intoxicated and without hearing a song I became completely absorbed.
>
> "Now elucidate and explain to me in understandable terms and dulcet phrases who originally discovered the science of music and composition."
>
> Tuti answered, "Oh Khojasta, the science of music [*mūsīqī*] is like a turbulent ocean, the depth of which cannot be reached, and the (musical *mazāmīr*) terminology is like an undulating sea, the shores of which cannot be seen. Nevertheless I will relate to you what I have heard from the mentors of the birds and the teachers of the flying creatures. . . . The art of *mūsīqī* is a science of utmost sensitivity. Every temperament cannot grasp it, and every mind cannot understand it, for the acquisition of the science of *mūsīqī* is not possible except for gentle natures and true geniuses. No one understands the charm of musical melodies [*naghāmat al-mūsiqāt*] and their subtle phrases which reveal the mysteries of the invisible world except those noble souls who have been purified of nature's imperfections and base desires. . . .
>
> Some say that those who acquired the knowledge of *mūsīqī* and established the rules of its melodies [*naghamāt*] were the wise men of India." (*TuN* 102–6)

This tale related by Tuti on the fourteenth night reverberates with an idea about music which would have been shared by the Indian Hindu and Muslim "readers"—what is essentially the Indian theory of the *rasika* (knowledgeable listener)—but it imparts the suggestion from orthodox Muslim culture that some instruments are "the work of the devil" (see discussion in chapter 5). Seizing perhaps on the shared valuing of stringed instruments in both South Asian and West Asian cultures, the painter has interpreted the tale in his painting (fig. 16) by substituting the quintessential Indian instrument, the *rudra vīṇā,* for the foreign *chang* (harp) that is mentioned in the story.[30]

> It happened that once a wise man was travelling on the road. In the middle of the day while resting under a tree, he saw a monkey leaping from one branch to another. Suddenly its belly was torn open by the sharp point of a branch, and his intestine was hung between the two branches. After some time, the intestine dried. When the wind blew upon it, it pro-

duced a pleasing sound. The wise man brought it down and attached a bent stick to it. It began to produce a more appealing sound. Later he added a string to it and fastened a gourd at the head of the stick, and it became a musical instrument [$\bar{a}l\bar{a}t$-i $m\bar{u}s\bar{\imath}q\bar{\imath}$]. After that every one according to his intelligence developed [songs] and composed [melodies] until the work culminated in the harp [*chang*] and the *rab\={a}b*. But most of the musical instruments are the invention of the Devil. He is still engaged in this work. It is said that when Satan invented a drum [*ṭabl*] even he himself laughed. When he was asked why he was laughing, he replied, "I am laughing at the people who will be happy with this sound." (*TuN* 103–4)

The parrot continues speaking of the origin of the science of music. The illustration of this passage contains unambiguous reference to India, by means of a man holding a *rudra vīṇā*, seated beside a "fabulous bird."

Others say in the provinces of India there was a fabulous bird called Qaqnos. He had a wide beak like that of a duck with seven holes in it. After a year, at the season of flowers and the time for wine making, he became jubilant. From each of these apertures, seventy different sounds came forth. Most of the wise men developed the science [of music] from these tones. (*TuN* 104)

The third explanation of the origin of the science of music relates how Pythagoras developed the science of *mūsīqī* from the sweet tones and cheerful sounds to the revolutions of heavenly bodies and the movements of the stars.

Then Tuti said:

Now arise and go to your lover. Test him with the science of music so that the degree of his nobility may become evident." . . . Khojasta said, "If there are no musical instruments [*mazāmīr*] available at our tryst, how will my purpose be achieved?" . . . Tuti answered, "If at that meeting no *mazāmīr* is performed, tell him that there are ten characteristics the possession of which establishes a man as a paragon of virtue. . . . Tenth, he must be well versed in the art of *mūsīqī* so that he can entertain his sweetheart." (*TuN* 102–5)

That last line appears on the illustration of the "fabulous bird" along with the ninth virtue: "He must not be an excessive drinker so that in the eyes of his beloved he will not be lacking in self control" and a poem:

> O Nakhshabi, acquiring knowledge demands diligence,
> Ignorance is utter folly in men of position;
> Today a person is only considered proficient
> If he master all branches of learning and tradition.
>
> (*TuN* 105)

Our painter has assured us that "the sweetheart" is a virtuous man, not only because he makes music (at least holds a *rudra vīṇā*), but because his carafe of wine sits neglected as he sings, or perhaps reads, having mastered "all branches of learning and tradition." He seems to be a noble person, as well, for he sits on a gorgeous carpet, with his delicate shoes neatly arranged, and his shield, quiver and arrows hung on a tree. Khojasta misses her chance to meet him that night, however, because "suddenly the noises of the day began, the dawn unveiled its brilliant face, and her

departure was delayed" (*TuN* 106). No matter how noble he may have been, the wife must not leave her home to go to him.

To Indians in Akbar's extended imperial household, both women and men alike, the fact that Akbar commissioned translations of major Indian works—the epic *Mahābhārata,* known in Persian as the *Razm Nāma,* and the epic *Ramāyana*—would have constituted a rhetorical statement of magnitude. While they had no need to read the Persian texts, they could enjoy the paintings and recall the episodes from their own cultural memories. Their focus on the illustrations would have been the same as Akbar's manner of viewing the manuscripts (fig. 17).

To his own family and to the West and Central Asian courtiers who might have had access to the imperial library, the astute Mughal sovereign could speak through new manuscripts of Persian literature such as the precious little illustrated copy of the *Dīvān* of the poet Anvar (fig. 18), which Schimmel has suggested might have been commissioned with some lady in mind (1983:31). The histories of his family—the *Timūr Nāma* and the illustrated copies of the *Bābur Nāma,* too, would have appealed directly to his close circle of associates. Following the style established by the revered Babur, the Mughal taste tended to prose rather than to rhymed verse (the Persian preference), complemented by the painting style of the Persian master painter Mir Sayyid-'Ali with his exquisitely fine brushwork, two-dimensional designing, and naturalistic rendering (Schimmel 1983:17).

A MESSAGE THROUGH THE BOOKS:
THE DESIDERATUM OF CULTURAL SYNTHESIS

Of the many messages which Akbar seems to have wanted to communicate, one in particular can be viewed from the point of view of music: the desirability, or rather the necessity, of synthesis as a basic modus operandi in his bold efforts to create a distinctive culture. The recommendation for such an approach to government recurs in the dense pages of a book that was among those which Akbar liked to have read to him (and in which one of the very few illustrations of the painting workshop can be found!), the *Akhlāt-i Nasiri* or Nasirean Ethics by Nasiruddin Tusi, which appeared initially c. 1235 and became the best-known ethical digest to be composed in medieval Persia, if not in all of the medieval Islamic world.

> Ṭūsī was already a celebrated scholar, scientist, politico-religious propagandist, and general man-of-affairs [in 1235], and his work has a special significance as being composed at a crucial time in the history he was himself helping to shape: some twenty years later Ṭūsī, at the side of the Mongol prince Hulagu, was to cross the greatest psychological watershed in Islamic civilization, playing a leading part in the capture of Baghdad and the extinction of the generally acknowledged Caliphate there. (*AiN* 9)

In the "third discourse" on politics, Tusi makes recommendations to a King:

> From this it is evident that Politics (which is the science embraced in this Discourse) is the study of universal laws producing the best interest of the generality inasmuch as they are directed, through co-operation, to true perfection. The object of this science is the form of a community, resulting by virtue of combination and becoming the source of the members' actions in the most perfect manner. . . .

> We have said that the object of this science is the form of combination among human individuals; but the combination of human individuals both generally and in particular. . . . The first combination occurring among individuals is that of the household; the second combination is that of the people of a locality; this is followed by the combination of the inhabitants of a city; next comes the combination of great communities, and finally the combination of the inhabitants of the world. . . .
>
> Since the synthesis of the world's inhabitants has been determined in this wise, (it follows that) those persons who forsake the synthesis, including to isolation and loneliness, will remain without part in this virtue; for it is sheer Tyranny and Injustice to choose loneliness and solitude, and to turn away from co-operation with the rest of mankind, when one has need of the things they have acquired. . . .
>
> Men need each other, then, and the perfection and completion of each one lies with other individuals of his species. . . . There is an inescapable need for a synthesis, which will render all individuals, co-operating together, comparable to the organs of one individual. (*AiN* 192–95)

The title of the second section of Tusi's discourse on politics is "On the virtue of love, by which the connection of societies is effected, and the divisions thereof." If informing persons of different communities about each other in order to help bridge the barriers between them by the mode of mutual respect could be called "love," then it seems that Akbar was heeding the advice of the medieval political scientist. The illustrations he ordered in the manuscripts on the history of his family made knowledge of "the other" to some extent accessible to Akbar's Indian wives and associates (see chapter 2). He ordered Abu'l Fazl to collect information on Indian culture and present it in the first volume of the *A'īn-i Akbarī* including, most notably here, a long section on "*Saṅgīta*" ("Music") so that he and others could learn about Hindustan. The translations he ordered of the great Hindu epics made knowledge of "the other" accessible to Akbar's West Asian cohorts. Perhaps most significantly,

> We see in Akbar, perhaps for the first time probably in Muhammadan history, a Muslim monarch sincerely eager to further the education of the Hindus and Muhammadans alike. . . . Hindus and the Muhammadans studying in the same schools and colleges. [all learned Persian, then sciences]: morality, arithmetic, accounts, agriculture, geometry, longimetry, astronomy, geomancy, economics, the art of government, physic, logic, natural philosophy, abstract mathematics, divinity and history. The Hindus read the following books on their subjects of learning, for ex: *Vyākaraṇa Vedānta, Patañjali,* every one being educated according to his particular views of life and his own circumstances. (Law 1916:160–62)

To effect the needed synthesis, Akbar surrounded himself with individuals of like mind who assumed leading positions in his court. Largely because their eclecticism complemented so well that of the ruler, for example, three members of one family were appointed to positions at court and rapidly became the most influential group for Akbar's political and cultural agenda. Shaikh Mubarak was a freethinker, as were his two sons Abu'l Fazl and the elder Faizi (see Rizvi 1975b, esp. chap. 2). The *shaikh* took the leading place among the palace religious scholars, and Faizi became the poet laureate. Abu'l Fazl willingly launched into the many tasks which would bring him into

the emperor's close trust and was ultimately commissioned to write the official *Akbar Nāma,* the chronicle of Akbar's reign.

Contrasting with the success of Abu'l Fazl, and indicative of the sort of spirit rejected by Akbar in those he promoted to the highest ranks, is Bada'uni, whose history of the reign of Akbar was not discovered until 1615 when both of the writers and Akbar were dead. In 1574, both would-be historians arrived at Fatehpur Sikri to enter Akbar's service. Since early childhood Abu'l Fazl had known Bada'uni, eleven years his senior, because Bada'uni had studied at Agra under Abu'l Fazl's father, Shaikh Mubarak. Each now immediately caught Akbar's eye; each seemed destined for a most promising career. But their paths rapidly diverged. Bada'uni was a strict Sunni and rigidly orthodox, in sympathy with very powerful members of the *ulama* or religious hierarchy, for whom developments during the second half of Akbar's reign were not as they had hoped (see Rizvi 1975b).[31] Bada'uni sank to the official level of a mere translator, for whether it was "with characteristic lack of concern for Bada'uni's bigotry" or a type of punishment, Akbar gave him the four-year task of translating into Persian the Hindu classic the *Mahābhārata,* in which he predictably found nothing but "puerile absurdities of which the eighteen thousand creations may well be amazed" (*MtT* 2:330).

As described by a modern writer, the difference between the two histories is that between a brilliant diary (Bada'uni's) and the most magnificent of ornamental scrolls (Abu'l Fazl's). According to Gascoigne (1971:109), Bada'uni's commentary on the reign of Akbar—crotchety, bigoted, ruthlessly honest with himself as well as with others—is much the more readable and in modern terms is far better written, while Abu'l Fazl's chronicle effuses on (as in the passage cited near the beginning of this chapter) to a total of 2,506 pages in the printed English translation. But with those two commentaries and the *A'īn-i Akbarī*'s additional 1,482 pages, we have an extremely detailed (albeit in the case of Abu'l Fazl an *occasionally* whitewashed) account of the affairs of one court.

Coupled with the leading courtiers whose sympathies lay with Akbar's modus operandi of synthesis, the servants at court as well comprised "forces" which could forge the requisite cultural change—the painters whose backgrounds were so varied, for example, and the leading musicians who, by evidence of Abu'l Fazl's list in the *A'īn-i Akbarī,* sustained in his court the possibilities for a process of musical synthesis that had begun in previous centuries. According to the compendium, Akbar patronized a bevy of musicians, both male and female; a few came from Transoxiana but many singers and musicians were from Persia and Kashmir (map 2). Indeed, the schools in Kashmir had been founded by "Irani and Turani musicians patronized by . . . the king of Kashmir." In addition to numerous singers, there were instrumentalists such as Usta Dost, a *nā'ī* player, and Mir Sayyid Ali, a *ghichak* player, both from Mashad; Usta Yusuf, a *tāmbūr* player from Herat; and the singer/chanter Pirzada, from Khurasan (*AiA* 1:680–82) (map 3). Joining those musicians from various cultural centers in Persia and elsewhere were many singers from the Indian city of Gwalior, among whom was Tansen, the most famous singer of the age. Undoubtedly also important for the development of music at court was Baz Bahadur, the ruler of Malwa, whose political downfall

brought a talented singer, instrumentalist, and lover of Indian music to the court in the person of the ruler himself.

SYNTHESIS AND SYMBOLISM: A MUSICAL VIEW

Not that the process of the synthesis of West Asian and South Asian cultures was new with Akbar; he was well aware of the persistence of that process and built on it. The *naubat* ensemble, after all, was a product of cultural synthesis; and the symbolism of kingship that was imparted by even a small selection of those instruments was a sign of synthesis already well in place before the Mughals arrived. That the immediate Muslim predecessors of the Mughals in India practiced the periodic daily sounding of an imperial musical ensemble is well documented. Entries in the *Tabakāt-i Nā-sirī*, a thirteenth-century chronicle of the dynasties which flourished in the Central Asian regions of Ghor and Ghazni as well as in Hindustan, affirm it:

> On the arrival of the honorary dress from the Court of Un-Nāṣir-ud-Dīn Ullah, the imperial *naubat* five times a day was assumed by the Sulṭān. His dominions became wide and extended, and from the [eastern extremity] of Hindustan, from the frontier of Chin and Ma-Chin, as far as 'Irak, and from the river Jihun and Khurasan to the sea-shore of Hurmuz, the Khutbah was adorned by his auspicious name. He reigned for a period of forty-three years. (*Ta N* 383)

> In the year 629 H. [1231 A.D.] Sulṭān Shams-ud-Din Iltutmish came to the determination of undertaking the reduction of the fort of Gwāliyūr. . . . The Sulṭān continued before that fortress for a period of eleven months. . . . The fortress was kept under investment, until Tuesday, the 26th of the month Ṣafar, 630 H., when the stronghold of Gwāliyūr was acquired. . . . On the 2nd of the month, Rabī'-ul Akhir, of this same year, the Sulṭān withdrew from before the fortress of Gwāliyūr, and placed the camp at about the distance of a league from the foot of the walls in the direction of Dihlī, the capital; and, at that halting ground, the imperial *naubat* five times daily was assumed.[32] (*Ta N* 619–21)

The symbolism of the *naubat* ensemble is incorporated even in the previously cited early Mughal manuscript the *Tūtī Nāma* (c. 1570) in which there is an early coupling of the visual symbol with its significance (pl. 3). "The story of the prince, the seven viziers, and the great misfortune which befell the prince because of his father's handmaiden," told by the parrot to Khojasta on the eighth night of her husband's absence, is a long and complicated story about a prince whose horoscope at birth had foretold a calamity that would befall him in his thirteenth year but which he would be able to overcome (figure 19 shows the scene of the astrologers making the prediction).[33]

The prince's father wanted him to learn many sciences and become a master of the arts. However, he was extremely slow-witted and thick-headed, and the story relates how various teachers tried to educate him, seemingly to no avail. The explanation given for that to the king by one scholar was astrological: "Until now a star in the celestial sphere was watching over this realm causing his dullness and retardation. From this day on, thanks to his good fortune, this star will pass beyond the point of influencing him." Thereby the king was convinced to give the now teen-aged prince over to that scholar for a period of six months, during which time the bad star would gradually pass on. Surely enough, that worked. At the end of the six months, when the prince was

to appear before his father to show his wonderful new accomplishments, the scholar consulted the prince's horoscope to determine the right moment for the interview. He discovered that if the prince were to speak on the already designated day and for several days thereafter, his life would be endangered. So when the king interviewed the prince, the young man could not be induced to speak. In frustration, the prince was remanded to the *harem,* assigned to the care of a handmaiden whose assignment was to discover the nature of the problem. However, the handmaiden had long coveted the attention of the young man and immediately set about to seduce him. The prince fled from that situation, and the handmaiden, to protect herself, ran to the king to accuse the prince of having evil intentions toward his own mother. The prince still would not speak, even in defense of himself. So the king condemned him to death for his heinous crime.

On six consecutive days, the prince was led to execution at the insistence of the handmaiden; but wise men in the court, in the hope that gradually the king would understand what was really happening, managed to delay the execution by telling the king moralistic stories about devious and untrustworthy women. Finally the king understood, at a time that coincided with the passing of the unlucky star that had kept the prince from speaking. Needless to say, all was explained:

> When the King realized that his son was eager to be well informed on the various scientific subjects and to become familiar with all the branches of knowledge, he placed the crown of the kingdom upon his head and invested him with the robe of royalty. He shaved his own head, put on the robe of the Sufis, and ordered that the wicked handmaiden be executed. (*TuN* 68)

Although no mention of music is made in the text, the artist who illustrates the climax of the story (in pre-Mughal Indo-Persian style) establishes the sovereignty of the young man with the ensigns of royalty—the throne, the umbrella, and especially the ensemble of trumpet and drums (pl. 3).

The association with kingship of the *naqqāra* (kettledrum) in the mini-*naubat* of the illustration was also exploited by Akbar. The most frequently cited piece of evidence for the *naqqāra* being a symbol of power and authority that was linked with Akbar is the tale of a wrestling match between the child Akbar and Kamran's son Ibrahim, a story within a story of the struggle between the brothers Kamran and Humayun. Akbar and Ibrahim wrestled over the possession of the symbol of power—the *naqqāra*—about which incident Abu'l Fazl waxed eloquently (fig. 15).

> On a day when the Mīrzā [Kamran] held a feast and had for his own glorification sent for his Majesty the Shāhinshāh [the child Akbar] it chanced that on the occasion of the Shab-i-Barāt they had, according to the custom, brought a decorated kettle-drum for his son Ibrāhīm Mīrzā. His Majesty the Shāhinshāh took a fancy to it, in accordance with the principle that the orchestra of world-conquest must strike up in his name, and the drum of world-rule and universal adornment must give forth a loud sound on the roof of his residence. The uncomprehending Mīrzā did not wish to let him have it, and reflecting that M. Ibrāhīm was the elder of the two and apparently the stronger, he made the taking of the drum a pretext for a trial of strength and a wrestling-match. Whoever conquered was to have the drum. His Majesty who was aided by heaven, and sustained from all eternity and who regarded not the pomp of M. Kāmrān nor the superior age of Ibrāhīm Mīrzā, rejoiced on hearing the condition, imposed by the Mīrzā for his own enjoyment, and became a means of augmenting the

Mīrzā's sorrow. Despite his tender years [two or three years of age], which made such actions very surprising, he, by Divine inspiration, and celestial teaching, without hesitation girt up his loins, and rolled up his sleeves, and with strong arm, which was strengthened by eternal power, stepped bravely forward. He grappled with Ibrāhīm Mīrzā according to the canons of the skillful and of the masters of wrestling and putting his hand before his waist so lifted him up and flung him on the ground that a cry burst forth from the assemblage, and that shouts of Bravo arose from far and near. This was the beginning of the beating of that drum of victory and conquest [*naqqāra-i fath va nusrat*] of his Majesty the Shahinshah, the Shadow of God, which came to be beaten above the loftiest pinnacles of earth, and beneath the green vault of heaven. . . .

His Majesty beat the drum which he had gained by the strength of his arm, and the joyous sound gladdened the hearts of the royal servants. (*AN* 1:455)

In addition to the already shared symbolism of the *naqqāra* and the *naubat,* the text and the illustrations of the *Tūtī Nāma* manuscript make the point repeatedly that the process of synthesis of Persian and Hindustani music was already underway at a deep level. Enunciated in the story of the thirteenth night, for example, is an ideal for a person of noble birth:

A person should know . . . how many Indian melodies are contained in one Persian melody. He must know which of these melodies is masculine and which is feminine and how many feminine themes there are in a masculine melody. (*TuN* 98)

Strikingly, a similar statement was made about Akbar himself, who, according to Abu'l Fazl, lived out this ideal of cultural synthesis:

The knowledge which H.M. has of the niceties of music, as of other sciences is, whether of the melodies of Persia or the various songs of India, both as regards theory and execution unique for all time. (*AN* 2:279)

POWER IN THE ILLUSTRATION OF TEXTS

What we cannot doubt is that Akbar established his control by as many means as possible: he was the ruler of Hindustan! Lest there be any doubt, one illustration in the *Akbar Nāma* stated the message plainly. Laden with meaning, the scene is one of battling between rival sects of Hindu *yogi*s, *sannyāsī*s at Thanesar, one of the most sacred places of pilgrimage for the Hindus (fig. 20). As explained by Abu'l Fazl:

The *Saraswati* flows near it for which the Hindus have great veneration. Near it is a lake called *Kurukshetra,* which pilgrims from distant parts come to visit and where they bathe, and bestow charitable offerings. This was the scene of the war of the *Mahābhārat* which took place in the latter end of the *Dwāpar Yug.* (*AiA* 2:286)

The right ankle of the goddess Durga is said to have fallen there on her being cut to pieces and her limbs scattered over the earth by Vishnu. During eclipses of the moon, the waters of all other tanks are believed to visit Kurukshetra, so that the bather is blessed by the concentrated virtues of all other ablutions (ibid. n. 2). During eclipses, therefore, pilgrims gather to bathe in the sacred tank, recite their prayers under the banyan tree, and give alms to the *yogi*s.

While [Akbar] was encamped at Thānesar, a dispute arose among the Sanyāsīs which ended in bloodshed. The details of this are as follows. Near that town there is a tank which might be called a miniature sea. Formerly there was a wide plain there known as the Kūrkhet which the ascetics of India have reverenced from ancient times. Hindus from various parts of India visit it at stated times and distribute alms, and there is a great concourse. In this year before his Majesty's arrival the crowd gathered. There are two parties among the Sanyāsīs: one is called Kur and the other Pūrī. A quarrel arose among these two. . . . The cause of the quarrel was that the Pūrī sect had a fixed place on the bank where they sat and spread the net of begging. The pilgrims who came there to bathe in the tank used to give them alms. On that day the Kur faction had come there in a tyrannical way and had taken the place of the Pūrīs and the latter were unable to maintain their position against them.

Their leader Kīsū Pūrī came to Umballa, and did homage and made a claim for justice, saying that the Kurs had fraudulently taken their place. . . . As both parties were disordered in their minds and desires and had entered on the path of misery, they obtained permission to have a contest. It chanced that on that day a great number of each party had assembled. The two sides drew up in line and first one man on each side advanced in a braggart fashion and engaged with swords. Afterwards bows and arrows were used. After that the Pūrīs attacked the Kurs with stones. . . . They (the king's troops) joined the Pūrīs in their attack on the Kurs and so exerted themselves that the Kurs could not withstand them and fled. The Pūrīs pursued them and sent a number of the wretches to annihilation. They came up with their Pīr and head, who was called Anand Kur, and slew the miserable creature. The rest scattered. The holy heart, which is the colourist of destiny's worship, was highly delighted with this sport. Next day he marched from Thānessar. (*AN* 2:422–23)

As related in the *Akbar Nāma* by Abu'l Fazl, this incident of 1567 at Thanesar had nothing to do with charitability and prayers but everything to do with greed on the part of the *sannyāsīs*. Far more significantly, it seems to have been visually illustrated to assert several statements by Akbar: he should not be perceived to be the enemy; this was a case not of Muslim against Hindu but of Hindu against Hindu; he, Akbar, possessed authority over the Indian territories which he, his father, and his grandfather had occupied; and the power of his word transcended the power of the most militant of Hindu symbols, the *saṅkh* (conch shell "trumpet"). It is not to be missed that the *sannyāsīs* had to ask Akbar for permission to live their lives in the manner that they wished.[34]

Into an illustration of this scene (fig. 20, see detail) the artist Basawan has packed incredible detail. At the top left the many-colored, many-shaped tents of the royal encampment affirm the proximity of the Mughal ruler's presence. Framing the bottom of the painting as well are magnificent elephants which haul firewood; at the bottom right a goat—perhaps for supplying the troops with milk—stands among the camels from whose backs we so frequently see the imperial drums suspended. At this point the Mughal soldiers have not entered the fray. Men of Akbar's company look on, between their tents at the top left and the edge of the tank; a cow—sacred to the Hindus—nurses her young in that part of the painting as well. The blue waters of the tank dominate the center of the folio; in it swim fish, and men whose clothes lie stretched out on the bank. Battling has begun in the area beside the tank on the right. Bows and arrows are out; knives are in evidence, and the trident staff by which devotees of Vishnu are recognizable is being used as a spear.

Detail of figure 20

A banyan tree frames the top right of the picture, and beside the platform built around its base stand *sannyāsīs* blowing conch shells and a short horn, adding the suggestion of aural ferocity and confusion to the visual, but also invoking the sacred symbol of power. In the *Mahābhārata*, Krishna uses a conch called *panchajanya* on the battlefield (Krishnaswamy 1965:23). In the *Rāmayāna*, the *sankha-nāda* (the sound of the conch) was used to rouse the martial fervor of the soldiers on the battlefield. Every general had a conch of his own and informed the enemy of his readiness to fight by blowing his conch (Sambamoorthy 1967:5).

This Mughal painting draws on a tradition of visual representation of the conch as a sacred instrument in battle. In a rock-cut relief in the South Indian temple complex at Mamallapuram of about the middle of the seventh century, a scene illustrates how Vishnu took possession of the universe in three strides (Kramrisch 1954, pl. 85). His right foot rests in the nether world of the defeated demons; his raised left foot traverses the air world, where the soaring figures of the Sun and Moon and that of Trisanku, a denizen of midair, mark the second stride. The toe of the god's left foot high up in the clouds is worshiped by Brahma in the heaven world. Shiva on his lotus is on

the right of Vishnu. The weapons of Vishnu are: bow, shield, and conch on the left; sword, club, and discus on the right.

As one of the symbols with which Lord Vishnu is associated, the conch—the most ancient wind instrument known—holds a special place among wind instruments in Indian culture.

> Wind instruments . . . are looked upon as of secondary importance. Possibly this may have some reason in the fact that Brahmins are not allowed by their religious laws to use them, excepting only the flute blown by the nostrils, and one or two others of the horn and trumpet kind. And so men of low castes are employed as players of wind instruments. But all unite in ascribing to wind instruments a very high antiquity. The conch shell, still used in the daily temple ritual in almost every place in India, is said to have been first used by the god Krishna, and it is mentioned in the great epic of the Ramayana, where it is called Devadata. We also find it under the name of Goshringa, both in the Ramayana and the Mahabharata. (Day 1891:103–4)

The conch has performed a function in sacred ceremonies not only of the Hindus, but in Buddhism (it is depicted in sculpture of the third century at Sanchi),[35] and in the Sikh religion as well, where the martial element is maintained.

> [Good] attention is paid to the music at Nander, where the singers and instrumentalists are as noted as those at the Golden Temple, Amritsar. They perform at the evening ceremonies, which last from two to three hours, and are stationed in the centre of the Nander temple, near the inner sanctuary containing the tomb of the great Guru Govind, the Sikh leader, who was murdered at Nander a little over two hundred years ago. Singing and chanting are important features of the ritual, and a large number of bells, gongs, cymbals and horns are used. Various huge shells are employed for fanfares and rhythmic accompaniments, and although producing a harsh sound, they are in keeping with the military atmosphere of the temple, which is guarded by armed sepoys, and decorated with votive offerings, consisting of two-edged swords and other warlike implements. (Rosenthal 1928:39)

This particular incident could be perceived by some as a very real Hindu–Muslim cultural conflict, but many scholars see the Hindu–Muslim construct and tension as very much a product of twentieth-century communalism and are more likely to view this as less religious and more political; i.e., Mughal authority vs. non-Mughal authority. Whether Basawan's painting (fig. 20) or the incident itself indicates a conflict between religious or (more likely) political cultures here, in the chronicle of the reign of Akbar, the bearers of the great and sacred symbol of martial power of the Indians are subject to a greater earthly power—the sovereign of the Mughal empire.

CHAPTER TWO

Music-Making in Mughal Family History and Life

For Akbar to have considered music a viable element worthy of fostering in his agenda for cultural synthesis is by no means surprising. From sources written and visual it is evident that music-making was a part of the fabric of Mughal life, from generation to generation. With a particular lens on both visual and written evidence, in this chapter I trace the family history and suggest perspectives lent on it through passages and paintings about music-making and dance. Gathered coherently, the paintings form a group in which there is a kind of subtext, with the music-making suggesting another meaning to the occasions depicted. Also, these illustrations teach ancillary lessons about the unstable nature of the right to rule in the Central Asian system which was Akbar's heritage and, concomitantly, the reason for the need to maintain a constant sense of presence of the Mughal sovereign himself.

Historical manuscripts are prominent among the books commissioned by Akbar. The *Tīmūr Nāma* (*Tarīkh-i Khandan-i Tīmūriya, The History of the House of Timur*), dating from c. 1584, was a major document about the paternal side of the Mughal family. The *Jāmī al-Tavārīkh* and specifically the portion of it called the *Chinggis Nāma*, considered to have been completed late in Akbar's reign, c. 1596, chronicles the Mongol lineage of his mother's family. The *Bābur Nāma,* the first copy of which dates from 1588 (British Library) or from 1589 (Smart 1977:46), details the life of Akbar's grandfather, the conqueror of northern Hindustan (see appendix). To chronicle his own reign, Akbar commissioned a text from histo-

36

rian Abu'l Fazl, which was completed in the 1590s. Illustrations that may have been made in 1586–87 for an earlier (now lost) text were used to illustrate Abu'l Fazl's text, thereby constituting one copy (now in the Victoria and Albert Museum) of the *Akbar Nāma*. An entirely new set of paintings to illustrate the new text was also rendered in 1596–97 (the Chester Beatty/British Library copy; Seyller 1990).

Akbar needed such books for several reasons.[1] One historian notes that Akbar's objective was "to present the longevity and grandeur of his lineage made up of such illustrious conquerors as Timur and Chingiz Khan" (John Richards, pers. comm., July 1994). Stressed by art historians is his need to glorify his family's history in order to justify his right to rule in Hindustan. They have also surmised that tracing one's family history is an act of nostalgia on the part of people, like the Mongols (Mughals), who had left their native environs; and the books must certainly have had a powerful effect of assuring continuity to the sizable contingent of persons who had accompanied wanderers such as Humayun, Akbar's father, to a new, unfamiliar land.

To this analysis I would add that the production of such books may have provided a crucial tool in Akbar's basic premise of rule: The creation of an atmosphere of greater trust and therefore cooperation among communities. By familiarizing his Indian subjects—women and men alike—with the illustrious members of his family, he might be able to create the perception of himself as less foreign, less alien, less threatening. Along with "illustrious history," "family" was a key designator in this system of rule from a patrimonial household. To the women who had married Akbar and the fathers who had committed their families to alliance with him by giving him their daughters, the sense of extended family would have been very important. I will suggest here that the more personal sense of patrimonial household is revealed in several of the incidents which were selected for illustration in the various historical manuscripts. I have organized the discussion here in chronological order of the family's history because it lends greater coherence to the points I wish to make, although it is somewhat out of the sequence in which Akbar had the manuscripts produced.

The Mongol and Timurid Ancestors of the Mughal Family

The roots of Akbar's family extended three centuries back in time to the Mongol hordes which found their unity and leader in the great Temujin, confirmed as Chinggis (Genghis) Khan (frequently referred to as "universal ruler") at a convening of the Mongol tribes on the banks of the Kerulen River in 1206 A.D. (see genealogy chart 2). A great organizer, he based his political structure on the principle of family: families form clans, clans tribes, and so forth. To this he secured sacred and secular sanction of his role: he asserted that Eternal Heaven had delegated to him a divine mission (designating him the only legitimate ruler of the world and transmitting that sovereignty to his descendants) and he drew up an imperial code of laws, or Great Yasa, superior to the Khan, also first promulgated in 1206. As well, Chinggis had the ability to learn from others; thus, for example, he was able to build a civil administration dominated by the commercially successful Uighur Turks, many of whom were Nestorian Christians, centered in Turfan (now in Xingiang

Province, China), along the Silk Route.[2] This ability to borrow and synthesize was to become a hallmark of his descendant Akbar's rule as well.

Chinggis undertook many campaigns of subjugation, but the one pertinent to this story is his conquest of the Turkish empire of Khorezm (between the Caspian Sea and Amu Darya River) in 1219–21. During this campaign, the hordes of Chinggis Khan swept down through the mountains from Central Asia but stopped at the Indus River. Through this venture he acquired not only prize cities such as Bukhara and Samarkand, which were rich, irrigated centers of production, trade, and Islamic culture, but also the services of merchants and financiers who were Muslim. As well, he incorporated the Turkish tribes into his Mongol "family."

According to family-tribal organization, Chinggis divided his empire among the four sons of his principal wife; his grandsons helped expand the empire, by which time it was divided into four main khanates (see genealogy chart 5). Three of the khanates were agricultural areas—South Russia, Persia, and China—and peripheral to the communication center in Mongolia and Turkestan. As a result, the fourth khanate—Transoxiana and eastern Turkestan—that of Chinggis's second son, Chagatai, became the strategic center. The Khanate of Chagatai (1227–42), the western part of which after 1370 was incorporated into the empire of Timur (Tamerlane, 1336–1405) (map 4), is relevant to our discussion, for it is from Chagatai that Akbar's mother was descended. Also, it is from the word "Mongol" that we have the form "Mughal," the term by which the later Indian dynasty came to be known.[3]

With hundreds of choices of Mongol leaders to depict in the *Jāmi al-Tavārīkh,* one in particular seems to have been the type of historical figure who would have interested Akbar.[4] In figure 21, "Muhammad Khudaband Öljeitü on the throne," a pre-Timurid Mongol ruler of the Il-Khanid group of Mongols (r. 1304–17), is hosting a grand celebration (see genealogy chart 4).[5] That it is a festive occasion beyond a mere court scene is signaled in the illustration in a manner conventional to Akbari-period paintings: by the presence of liquid refreshment which is placed in the center—in this case on the carpeted throne area rather than on a table. Why would Muhammad Khudaband Öljeitü be portrayed in this manuscript? Perhaps it was because the Mongol leader appears to have been a kindred spirit to Akbar who exhibited a profound intellectual curiosity in many religions. Öljeitü grew up within the shamanist traditions; was baptized a Christian in his childhood; became a Buddhist; subsequently converted to *Sunni* Islam; then, alienated by the strife between the *Shafi'i* and *Hanafi* factions in *Sunnism,* became a *Shi'a* (Lambton 1988:255). The Il-Khanids, like the majority of Mongols in the thirteenth century, originally adhered to ancestral shamanism; Buddhism was attractive to them, as was Nestorian Christianity. But, as with each of the Mongol khanates, the Il-Khanids became subjected to the cultural influences of their domains. A religiously expedient group, by the 1280s they had begun converting to Islam of the *Shi'a* sect, the dominant faith of the lands they ruled. The musicians portrayed in the painting, however, are either a gross mistake by the painter or they are there to suggest something more about the central character. The player of the plucked lute and the *dā'ira* offer no mystery, but an Indian duo of *rudra vīnā* player and singer is placed in this Central Asian scene! This would hardly be remarkable, since most of Akbar's painters were Indian, were it not for the fact that such historical slips are

extremely rare in Akbari-period paintings. His painters tended to be careful about the portrayal of instruments in historical time, inserting explicitly Indian musical ensembles only in meaningfully suggestive scenes. Perhaps the scene was repainted later in the Mughal period when artists had become less careful, or perhaps they are there to represent or to emphasize the eclecticism of Muhammad Khudaband Öljeitü.

The period 1240–1340 is referred to as the "Mongol Century," years between earlier and later times when Arab or Turkish forces controlled Central and West Asia. The tactics and strategies of the generals and the armies of the Mongols gained them a reputation for savagery and brutality, one that gradually swept across the landscape and mindscape of Europe and Asia, becoming more pronounced with time. Fearsome characters of this era appear in the *Chinggis Nāma,* among whom was Oghuz Khan, a legendary Turkic ruler of Central Asia (see genealogy chart 3), from whom groups that were important in the Timurid succession claimed descent (Lentz and Lowry 1989: 242). That he was a conqueror becomes obvious in "King Oghuz on his throne in a gold tent celebrates his conquest of the territory from the River Talas to Bukhara and its conversion to Islam" (fig. 22) and "King Oghuz holds a feast in a gold tent to celebrate victory over Iran, Turan, and Rum" (pl. 4). One wonders if part of his legendary persona was as a lover of festivities, for in these folios of the *Chinggis Nāma* great celebrations are illustrated by the master artists Lal and Basawan, respectively. Certainly the lands conquered were so significant and large as to warrant enormous festivities. On the other hand, seeing the conqueror enjoying the celebrations diverts attention from the probable reality of the particularly savage form of Mongol warfare. In figure 22 (see details), a large *naubat* ensemble in performance declares his rank—four pairs of drums, two sets of cymbals (the crashing sound of one of which might be justifiably bothering a drummer who looks back at the player), two trumpeters, and a player of *surnā.* However, the most indicative element of a major celebration in the pictorial content is dance. In a close threesome are two women dancers, wearing the Central Asian cap, and a male dancer. A mixed male–female ensemble accompanies them: at least one woman singing and one playing *dā'ira,* while two men play plucked lute and *nā'ī.* That the dance ensemble is shown to include male and females together constitutes representation of difference in historical times; that does not occur in depictions of Mughal court culture. Likewise, a mixed-gender musical ensemble is extremely rare in Mughal paintings depicting contemporary time. What appear to be puffy loaves of bread imply the feasting that would take place at such an event. Considerably greater attention is paid to the feasting in plate 4, including preparation of food at the top of the painting and the dispensation of generous liquid refeshment.

Other reputedly fearsome characters are subjects for pictorial–historical reinterpretation, such as in the *Jāmī al-Tavārīkh,* "Entertainment and feast in honor of Hülegü Khan (by Mangu Khan) on the eve of the march to Iran" (fig. 23), a painting by the artist Miskin rendered with some humor so as, perhaps, to project the subject as more likable (see genealogy chart 2). Hülegü Khan, Chinggis's grandson and builder of the Khanate of Persia (Il-Khans), was a man to be royally entertained (see genealogy chart 4). I would suggest that the atmosphere which is depicted might be attributed to the character of Mangu Khan rather than that of Hülegü Khan, however; as the patron of Nasiruddin Tusi, author of the *Akhlāt i-Nasirī,* one would expect Hülegü to be depicted in a more

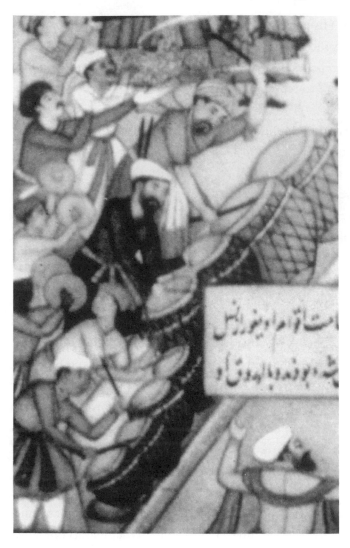

Detail of figure 22

sober manner (Rizvi 1975b:46). The atmosphere in figure 23 feels looser than the august celebrations of Oghuz's victories, with two thin (lithe?) female dancers looking distinctly as if they are having to dance faster than they normally would. A third, thin woman runs toward them, shot through by a panel of text; the impression given is akin to her saying "Wait! I'm coming! And you can't start without the *dā'ira!*" The player of the plucked lute (*rabāb*) who sits close to Hülegü Khan is not holding his instrument in a serious playing position; he sits apart from the other musicians, hinting that he is, perhaps, a soloist. The guests sitting in the foreground suggest the mood more of a personal party than a political one; in depictions of contemporary Mughal time, female dancers are usually discretely not painted into scenes of personal male parties, so this may be another artistic implication of historical difference. It is the suggestion of the *naubat* with the *naqqāra* and *surnā* as well as the honored guest on a throne-like seat which puts this into the sphere of an official entertainment.

The last great warlike successor to Chinggis Khan was the conqueror Timur (Tamerlane, Timur the Lame) (1336–1405), a Turki from Chagatai's Central Asian Khanate, who came to power

in 1369 (see genealogy chart 1). Operating from his capital at Samarkand, he cut a bloody swath through Persia (Iran) and Mesopotamia (Iraq) and briefly invaded northern Hindustan near the end of the Tughluq period of the Delhi Sultanate.[6] Sweeping away all in his path, Timur crossed the Indus River in 1398, leaving a trail of carnage along the route. Many a flourishing town was depopulated, corpses littered the streets, people fled in alarm from their homes at the approach of the enemy, and places through which Timur passed became desert. The landscape and mindscape of Hindustan sustained injuries which did not quickly heal. Delhi, the queen of Indian cities, was sacked, burning for five continuous days so that, as a consequence, where the Sultanate once had been a union of major Muslim states, Timur's actions had destroyed the locus of power and centripetal strength. One politically unfortunate consequence was that the Sultanate rulers thereafter spent their lives and coin in war and bloodshed.

Nonetheless, Timur was the forebear the Mughals most admired, for despite his being a scourge he also appreciated knowledge and arts and adorned his capital city of Samarkand with beautiful buildings. Perhaps Akbar sought to provide a balance between Timur's dreaded reputation and his support for culture, for Akbar's historical chronicling of Timur defuses some of the savagery. The great warrior is shown as a child in "Timur plays king" (fig. 24); he is heralded by a miniature trumpet and set of kettledrums. In figure 25, from the *Tarīkh-i Khandan-i Tīmūriya,*

Details of figure 22

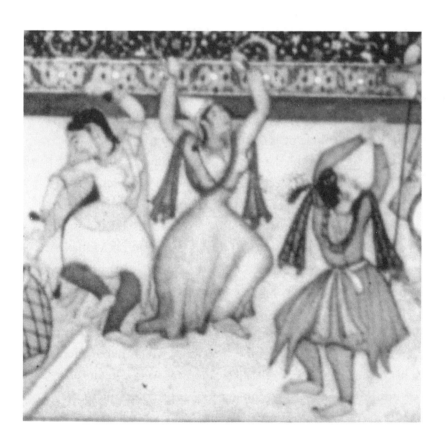

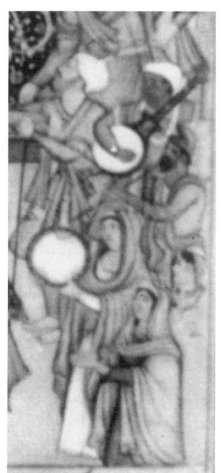

furthermore, "Timur and Amir Husain celebrating peace jointly at Qunduz," central placement and a carpet at ground level is provided for each of the two *amirs* to represent equality, although Timur is distinguishable by the standard-bearer standing behind him. Musical entertainment is provided on wind, string, and percussion, by male musicians in this entirely male sphere. This is a gentle version of a victory celebration, because Amir Husain is the Mongol ruler and Timur's closest rival, whose defeat signaled for Timur the beginning of success that would distinguish him from the myriad other petty tribal rulers in the region (Lentz and Lowry 1989:25).

An equally peaceful depiction is figure 26 from the same manuscript, "Timur holds a music party"; in this illustration, Timur appears to be a gracious patron. Notably, among the musicians are Indians—a player of *rudra vīṇā* with a singer, and the dancer is posed in an Indian dance position (see pp. 86–87). Why would they be there in this depiction of historical time? It must have been widely known that after his terrible raid on India Timur absconded with a number of Indian artisans whose work still survives in Samarkand. Thus, it is not wildly unlikely that Indian musicians as well would have been taken back to Central Asia.

To legitimize his succession in the House of Chinggis Khan and thus leadership of a reinvigorated Chingissid kingship (see genealogy chart 1), Timur used the mechanism of political marriages which his descendant Akbar later employed. Timur himself married a daughter of the Chagatai Khan Qazan, and to further strengthen his relationship among the Mongols he wed three of his sons to noble women in the line of Chinggis Khan (Lentz and Lowry 1989:27). Another son, Shahrukh, married the daughter of Sultan Mahmood, an ally in Timur's terrible raid on India. That is possibly why there is Indian musical content in one of the rare marriage scenes in Akbari-period manuscripts—"Daughters of Sultan Muhammad are married to Amirzada Muhammad Sultan, Mir Muhammad, and Shah Rukh" (fig. 27) in a manuscript of the *Tarīkh-i Khandan-i Tīmūriya*. Entertaining in the women's quarter behind walls at the top right is an Indian woman playing *rudra vīṇā*. Among the musicians accompanying the dancers below is an unmistakably Indian female singer with a woman playing a cylindrical drum that is usually played by Indians in Mughal paintings. Peculiarly, the Turki women dancers wear the ankle bells of an Indian dancer.

Timur died suddenly in 1405, just as he had assembled a vast army to conquer and Islamize China. His death marked the end of the Mongol ability to keep Central Asia unified, which in turn sparked the dissolution of trade routes and relationships between East and West. During his lifetime, Timur distributed his realm among his male descendants: to Shahrukh he gave Khurasan, with its capital at Herat, but the throne in Samarkand he designated for his grandson Pir Muhammad, heir of Timur's late son, Jahangir. "Mirza Khalil Sultan ascends the throne in Samarkand after Timur's death," painted c. 1580–85 about an event c. 1405, recognizes the celebratory grandeur that would have been available in Samarkand (fig. 28) even though it chronicles a usurpation of rule. The shape of the throne is similar to the one on which Babur sits in figure 29. Behind Timur's grandson stand not one but two umbrellas—the significant symbol of royalty which Babur mentions time and again in his memoirs; his throne has an umbrella-like canopy as well. The number of courtiers is multiplied, and not one but three appear to be coming forward to offer their fealty to Mirza Khalil Sultan; one has his hands in the same position as Babur's courtier, while the two

behind make a sign of greeting. Carafes of drinking material are present, but there is more in this painting to suggest festivity—namely, the large *naubat* ensemble which heralds the event.

Mirza Khalil Sultan's presence on the throne of Timur at Samarkand was shortlived. Challenged by his uncle, Shahrukh, and despite some success in battle, Khalil Sultan was eventually defeated by desertions and the opposition of Timur's old *amirs*.

> The "victory-bearing banners" of Shahrukh crossed the Oxus, and the prince entered his father's capital on May 13, 1409, where he installed his son Ulugh-Beg as governor and immediately took steps to consolidate his realm. [Shahrukh's capital was in Herat.] The state he formed had little resemblance to the steppe empire created by Timur; a different set of political relationships emerged. While the princes essentially had been vassals to Timur, under the nominal leadership of Shahrukh they established themselves as sovereigns. . . . The Timurids under Shahrukh no longer mounted ambitious campaigns striking at long distances across Asia. Instead they struggled to preserve dynastic coherence and the territorial integrity of their kingdom. Shahrukh's long reign (r. 1405–47) can be characterized as one of tenuous stability, with Shahrukh at times recognized as little more than a beleaguered figurehead unable to compete with the rapidly mythologized legacy of his father. (Lentz and Lowry 1989:69)

Shahrukh ruled the empire not from Samarkand but from Herat, which Timur had initially given to him and which had become the primary cultural center of the Timurid line; and cultural connections between Herat and Muslim states in Hindustan in this period and later can be assumed. Shahrukh also ruled as an Islamic sultan rather than as a Turco-Mongol warlord-conqueror. In dynastic chronicles he is exalted as a man of great piety, diplomacy, and modesty—a model Islamic ruler who repaired much of the physical and psychological damage caused by his father (ibid. 69, 80).

Babur, Founder of the Mughal Dynasty

BEFORE COMING TO INDIA

Born in 1483 in a small principality east of Samarkand in the Ferghana Valley north of the Hindu Kush (now in Uzbekistan), Zahiruddin Muhammad Babur, founder of the Mughal dynasty in India, claimed heritage from both Mongol and Turki lines: from Chinggis the Mongol through his son Chagatai and fifth in descent from Timur through Timur's son Miranshah (see genealogy charts 6, 7). Though the dynasty he founded came to be identified with Mughal splendor, it was the glorious Timurid civilization which gave Babur his pride of place, his paternal grandfather (Sultan Abu-Sa'id Mirza) having asserted Timurid supremacy over Chagatai Khaqans (*BN* 722).

Writing originally in his native Turki language, Babur begins his memoirs: "In the month of Ramzan of the year 899 (June 1494) and in the twelfth year of my age, I became ruler in the country of Farghāna" (*BN* 1; see fig. 29).[7] He is highly observant and attentive to detail; in the first major section (the Ferghana section) we learn from Babur about the Central Asian area in which he lived, are introduced to a large number of relatives, both older and contemporary, and follow the skir-

mishes, victories, retreats, truces, personal news, and the like through his twenty-first year. By this time he had twice occupied (1497, 1500) and lost Samarkand; lost, regained, then lost forever his Ferghana patrimony; and finally was forced to flee Transoxiana for Afghanistan. The second large portion of his memoirs (the Kabul section) covers the period from 1504, when he seized Kabul and fought Afghanis in numerous locales, through 1525 (map 9). His account enables us to empathize with his numerous struggles, including a seemingly final success at gaining Samarkand, the capital of his illustrious ancestor, Timur. From it we discover that the young Babur is beset by challenges on every hand, and we learn of life's uncertainties at the time for rich and poor, men and women. We sympathize as he is forced to leave the prized Samarkand in order to regain Andijan, the seat of his family's Ferghana Valley home, which his half brother, Jahangir Mirza, tried to claim. Despite two large gaps in the text (May 1508–January 1519, December 1519–October 1525) this section covers the five expeditions he made into Hindustan. A third, incomplete part, from 1525 to 1529, forms the Hindustan section.[8]

Akbar ordered Babur's memoirs translated into Persian and rendered in illustrated manuscripts; six copies are known to have been made.[9] The number of folios in the four most complete copies ranges from 375 to approximately 590; the number of folios containing illustrations in each copy ranges from about 183 to 191. With some omissions in the shorter copies and a few additions and/or deviations, the scenes that are illustrated are consistent from copy to copy.

From his father, 'Umar Shaikh Mirza (fourth in descent in direct line from Timur), Babur inherited the struggle to retain leadership of the family's small principality of Ferghana (*BN* 1–12). His father's was a troubled rule, and when he died in 1494, he left a precarious throne to his eleven-year-old son. The death of a Timurid leader—in this instance Babur's father—occasioned attempts by others to capture the heir's territory. At the time of the accident which killed his father (he was in his pigeon house at the edge of a ravine and apparently the foundation collapsed), Babur was away from the Andijan fort, but his return was protected by men loyal to him against the danger of immediate invasion by neighbors eager for territory and spoils. His first major act was to enter the citadel of the town and to have its important men come to pledge themselves to him (*BN* 30). When he reached the citadel, the process of reaffirmation took place:

> Khwāja Maulānā-i-qāẓī and the begs came to my presence there and after bringing their counsels to a head, busied themselves in making good the towers and ramparts of the fort. A few days later, Ḥasan, son of Yaq'ub, and Qāsim *Qūchīn,* arrived, together with other begs. . . . They also, after waiting on me, set themselves with one heart and mind and with zeal and energy, to hold the fort. (*BN* 30)

No grand feast or other ceremony for his assumption of the throne is recounted by Babur in his memoirs. The procedure, which became increasingly clearer through the chronicles of succeeding Mughal generations, was for the occasion to be marked by meetings with one's followers, to lay contingency plans and ascertain personal loyalties. Appropriately for the small scale of place and numbers of supporters, fol. 2v of the British Library copy of the *Bābur Nāma* shows a relatively quiet but formal court scene with two courtiers seated before him and one standing with hands

raised toward Babur on his throne, probably intended to suggest the moment of swearing of loyalty to the new leader (fig. 29). With backs turned to us, two male musicians entertain, one playing a plucked lute, and the other a *dā'ira*. Nothing particularly marks this scene as a special moment; the contents of the painting do not distinguish it from other formal but festive court scenes. Only the presence of the carafes and perhaps, more importantly, dishes of food on a table with a servant busily emphasizing their presence suggest that the scene is festive in any way.

Ferghana had seven separate townships, of which Andijan held central position as capital of the principality. It was known for its grain production and abundant fruits, such as excellent grapes and melons. After Samarkand and Kish, the fort of Andijan was the largest in Transoxiana, and Babur hastened to affirm that his capital was a cultured place:

> Andijānīs are all Turks, not a man in town or bāzār but knows Turkī. The speech of the people is correct for the pen; hence the writings of Mīr 'Alī-shīr *Nawā'ī*, though he was bred and grew up in Hīrī [Herat], are one with their dialect. Good looks are common amongst them. The famous musician, Khwāja Yūsaf, was an Andijānī. (*BN* 4)

What Babur also inherited was close and active entanglement with ambitious kinfolk, as did 'Umar Shaikh Mirza, who seems to have provided the model which the young man followed, for he described his father and one family group as follows:

> As 'Umar Shaikh Mīrzā was a ruler of high ambition and great pretension, he was always bent on conquest. On several occasions he led an army against Samarkand; sometimes he was beaten, sometimes retired against his will. More than once he asked his father-in-law into the country, that is to say, my grandfather, Yūnas Khān, the then Khān of the Mughūls in the camping ground of his ancestor, Chaghatāī Khān, the second son of Chīngīz Khān. Each time the Mīrzā brought The Khān into the Farghāna country he gave him lands, but, partly owing to his [the Mīrzā's] misconduct, partly to the thwarting of the Mughūls, things did not go as he wished and Yūnas Khān, not being able to remain, went out again into Mughūlistān. When the Mīrzā last brought The Khān in, he was in possession of Tashkīnt. . . . He gave it to The Khān, and from that date (1485) down to (1503) it and the Shāhrukhiya country [that of Timur's successors] were held by the Chaghatāī Khāns. (*BN* 12–13)

It took Babur many years and much travail to succeed in such a system of interplay, contest, and conquest, much of which comprised challenges from within his family. Some of the paintings of the *Bābur Nāma* offer a realistic view of that life, leaving aside the aim of depicting an illustrious family history. One poignant story of family travail occured when the newly ascended youthful Babur had to act quickly to quell the ambitions of his paternal uncle, Sultan Ahmad Mirza. Having immediately gained the allegiance of local leaders, Babur's forces proceeded to move against his uncle. Babur's men had to cross a "stagnant, morass-like water" by a bridge which was so narrow that, in the ensuing crowding on the bridge, numerous horses and camels were pushed off and perished in the water. Shortly thereafter, an epidemic broke out, killing still more animals (*BN* 30–31). While the text does not mention drums, "The bridge at Qaba" in the Walters/Moscow copy shows a pair of *naqqāra,* the likes of which are so ubiquitous in military scenes that one might easily assume them to be part of the military equipment.

That a climatic event is being heralded in the paintings of the "Battle at Mirza's Bridge, 1497" (fig. 30) is reinforced pictorially by the presence of military musical instruments in no less than four copies of the manuscript, though again there is no mention of them in the text. The first battle scene to be "weighted" in this fashion in the manuscript, it depicts Babur's first successful capture of his family's ancestral capital at Samarkand. (He first won it in 1497, when he was fourteen; lost it the next year; regained it in 1500, but was unable to retain possession; from 1500 to 1504, he lost both Samarkand and Ferghana; see below.) Readers of the manuscript find the right to his Timurid heritage reconfirmed with the illustration, as Babur himself must have felt as he regained the city. Of the several illustrations, fol. 24r of the manuscript at the Walters Art Gallery has the most elaborate instrumentation: one large and one medium-sized pair of kettledrums mounted on camelback, two types of trumpet/horn, and another instrument that is either a short horn or a double-reed *shahnā'ī* (see fig. 30).

No painting illustrates the young Babur regretfully giving up Samarkand shortly thereafter (1498) in response to pleas from his womenfolk in Andijan that they were being besieged by Babur's half brother Jahangir; as a result of his preoccupation with Samarkand, Babur temporarily lost Andijan. The key lesson the young prince had yet to learn was: *Presence was required in order to maintain control.* Temporarily homeless and on the run, the Prince's first happy moment in that sojourn occurs in the arrival at the fort at Marghinan, where Babur's entourage finally finds temporary refuge (fig. 6); this is the next illustration in which heralding instruments occur. Babur still does not seem a threatening conqueror; in the events chosen for illustration he is young, and essentially untested.

In one of the two copies that illustrate "Babur's victory over [arch-rival] Tambal at the battle of Khuban" (National Museum in New Delhi, fol. 65v), the artist Khemkaran may have responded to this unusually jubilant tone on Babur's part in the memoirs when he drew drums and horn: "This was my first ranged battle; the Most High God, of His own favour and mercy, made it a day of victory and triumph. We accepted the omen" (*BN* 113). It was difficult to stay victorious over the troublesome Tambal, however; no fewer than five illustrations in three copies (a Moscow folio and British Library fol. 94v including military instruments) of the *Bābur Nāma* record a battle against Tambal at Bishkharan shortly thereafter. The political significance of the moment probably led to the decision to depict it in a painting: a truce was made with Tambal and with Babur's pesky half brother Jahangir, with agreement that Babur could resume his inherited position in Andijan, and that later he and Jahangir together would move again on Samarkand (*BN* 118–19).

Continuing that pursuit of Samarkand, Babur regained it again temporarily in 1500. A painting is dedicated to his entering the town but realistically does not have noisy instruments heralding the event, because he and his men sneaked in undetected at midnight. He settled once again into Samarkand, moving his family from Andijan.

Babur's uneven relationship with his half brother Jahangir Mirza remained unproblematic for a while, as he wrote in the spring of 1505: "For a few days Jehāngīr Mīrzā was our host, setting food before us and offering his tribute" (*BN* 240). That undramatic single sentence was the springboard for the beautiful painting of a private "Party at Jahangir Mirza's in Ghazni, spring 1505" (fig. 31, by

Bhim Gujarati). In Gulbadan's *Humāyūn Nāma* and in the *Bābur Nāma,* sociopolitical gatherings are mentioned under the rubric of "feast" or "assembly"; it is clear that music, food, and drink did grace numerous such occasions. In this illustration the covered plates of food are as numerous and centrally placed as in any Mughal painting of a private party. Babur is given a throne-like seat above, but slightly separate from, other honored guests. Musicians—players of *dāʾira, nāʾī,* and a very long-necked plucked lute—seem to entertain discreetly and quietly, if their proportion and pictorial placement is any indication. This is a dignified, princely occasion, probably illustrated in the manuscript despite its one-sentence entry because it shows Babur's sometimes challenging younger brother paying respect to his elder brother.

Babur once again encountered difficulty when yet another attempt to permanently take Samarkand was thwarted by his archfoe, Shaibani Khan, powerful leader of the ethnic Uzbeks.[10] This time Babur turned for help to his maternal kin, to The Khān of the Chaghatai Turks, whose capital was in Tashkent. When they gathered together, an old Mongol ritual was performed—the proclaiming of the standards. So important was the ritual that it is depicted in each of the four most complete copies of the *Bābur Nāma* in considerable detail (pl. 5, figs. 32–33). By this means the Mongol/Mughal side of Babur's heritage was "introduced"; it may also have been of particular interest to the Indian viewers of the manuscript that a cow—sacred to the Hindus—was important in the ritual.

> The Khān . . . got his army to horse and rode out from Tashkīnt. Between Bīsh-kīnt and Sām-sīrak he formed up into array of right and left and saw the count of his men. This done, the standards were acclaimed in Mughūl fashion. The Khān dismounted and nine standards were set up in front of him. A Mughāl tied a long strip of white cloth to the thighbone of a cow and took the other end in his hand. Three other long strips of white cloth were tied to the staves of three of the (nine) standards, just below the yak-tails, and their other ends were brought for The Khān to stand on one and for me to stand and Sl. Muḥ. Khānika to stand each on one of the two others. The Mughūl who had hold of the strip of cloth fastened to the cow's leg, then said something in Mughūl while he looked at the standards and made signs toward them. The Khān and those present sprinkled [fermented mare's milk] in the direction of the standards; hautbois and drums were sounded towards them; the army flung the war-cry out three times towards them, mounted, cried it again and rode at the gallop round them. Precisely as Chīngīz Khān laid down his rules, so the Mughūls still observe them. Each man has his place, just where his ancestors had it. (*BN* 154–55)

Only in figure 32 is there a double-reed instrument; trumpets prevail in plate 5 and figure 33.

Babur's preoccupation with Samarkand having caused him to lose Ferghana yet again, his forces wandered south in 1504 into present-day Afghanistan. The ruler of Kabul was unprepared to withstand a seige, so in 1504 Babur easily took Kabul and from 1505 settled in the kingdom. From there he kept surveillance on Kandahar and Badakshan and made excursions in all directions, in the persona of prince (*mīrzā*), conqueror, and tourist. In plate 6, in one of the grandest displays of the imperial *naubat* ensemble found in any Mughal painting, Babur is escorted through the countryside in 1505. (We do not see him in this half of a double-page illustration.) With his entourage— dressed as citizens, not as soldiers—he is on his first excursion toward Hindustan and to find the

Hindu holy place Gur-khattri, near the Khyber Pass and Indus River. As was Babur's wont, they sought not to destroy it, but to learn about it. Royal standards adorned with yak tails—two covered in cloth bags, but one unfurled—are borne by men who ride with the players of instruments of the imperial ensemble: *naqqāra, karnā,* and *surnā.* If indeed Babur did take such a grand entourage with him on the adventure, the power implied by the nature of the procession must have been clear to residents of the area. In reading of the excursion, as related by Babur in his memoirs, one gets no sense that he or his power was unwelcome in the place. In actuality it probably was, since the guide led them astray. In this painting, the patron of the painter let the non-Mughal audience of the illustration have a good laugh: the guide never managed to find the temple.

> Tales had been told us about Gūr-khattrī; it was said to be a holy place of the Jogīs and Hindūs who come from long distances to shave their heads and beard there. I rode out at once from Jām to visit Bīgrām, saw its great tree, and all the country round, but, much as we enquired about Gūr-khattrī, our guide, one Malik Bū-saʿīd *Kamari,* would say nothing about it. When we were almost back in camp, however, he told Khwāja Muḥammad-amīn that it was in Bīgrām and that he had said nothing about it because of its confined cells and narrow passages. The Khwāja, having there and then abused him, repeated to us what he had said, but we could not go back because the road was long and the day far spent. (*BN* 230)

Only several years later, on a return visit, did Babur find the place (and this was also illustrated, but without instruments).

In 1506 Babur, ever mindful of his Timurid connections, made a lengthy visit to the flourishing cultural center of Herat (Heri), on the occasion of the death of Sultan Husain Bayqara. He had been planning to march from Kabul to Herat to support his kinsman's struggles against the Uzbeks and, despite hearing the news of Husain's death prior to departing, decided to continue on. Although Babur himself complained that his Timurid cousins had been "laggard in shewing me respect" (*BN* 299), eventually Babur was welcomed and entertained in a manner befitting a Timurid prince, as described for another occasion for his son Humayun.

> It is proper that Ḥāfiẓ Sābir Qāq, Maulānā Qāsim Qānūnī, Ḥāfiẓ Dost Muḥammad Khāfī, Ustād Yūsuf *Maudūd,* and other famous singers and musicians who may be in the city, be always present, and whenever his Majesty desire it, please him by singing and playing. (*AN* 1:427)

> On the third day when your mind shall be at rest with regard to the *cahār-tā,* the city Avenue, and the brightening up of the Cahār Bāgh let heralds be appointed in the city, its wards, and the environs, and the neighboring villages, to proclaim that all the men and women of the city shall assemble on the morning of the fourth day in the Avenue (*Khiyā-bān*), and that in every shop and *bāzār,* where carpets and cloths shall be spread in order, the women and maidens will be seated, and, as is the rule in that city, the women will engage in pleasant sayings and doings with the comers and goers. And from every ward and lane let the masters of melody come forth, so that the like of it will not be seen in any other city of the world. And bid all the people come forth to offer welcome. (Ibid. 428–29)[11]

Babur's impressions of his Timurid elder relative's Herat court, among the most cultured in the early sixteenth century Persian sphere, are vividly recalled not only in the portrayal of pleasant occasions like the parties he attended, but in the detailed accounting he made of the Sultan's personnel, such as the chief courtiers and justices, as well as poets and musicians.[12] Even in a list-like context that is paraphrased here, Babur's depth of attention to music is revealed:

> Of musicians, no-one played the dulcimer so well as Khwāja ʿAbduʾl-lāh Marwārīd.
>
> Qul-i-muḥammad the *oud* player also played the *ghichak* beautifully and added three strings to it. For many and good preludes (*peshrau*) he had not his equal amongst composers or performers, but this is only true of his preludes. Shaikhī the flautist (*nāyī*) was another; it is said he played also the *oud* and *ghichak,* and that he had played the flute from his 12th or 13th year. He once produced a wonderful air on the flute, at one of Badīʿuʾz-zamān Mīrzāʾs assemblies; Qul-i-muḥammad could not reproduce it on the *ghichak,* so declared this a worthless instrument; Shaikhī Nāyī at once took the *ghichak* from Qul-i-muḥammadʾs hands and played the air on it, well and in perfect tune. (*BN* 291)

The *ghichak,* or *kamānche,* to which Babur referred was a very popular instrument in the Persian cultural sphere, where Persian paintings suggest that it was likely to have been played at relatively casual male gatherings. It is a spiked-lute type of instrument, meaning that the neck (spike) continues through the body and extends beyond the resonating chamber to form a "foot" on which the player can rest the instrument while bowing. The *kamānche/ghichak* type of spiked lute has the following general characteristics: The spike is long out of the bottom of the instrument; the resonating bowl is round and the diameter of the face of the soundtable is the same as or smaller than that of the bowl; the neck is round, wider toward the top end so that it can incorporate the peg attachment in the continuing line of the neck; and a finial decorates the top. The instrument's general shape is seen in figure 34, "The emperor at a repast," painted c. 1620 by the Persian painter Aqa Riza, who had joined Jahangir's atelier. Other visible details are the cavity at the wider upper end of the neck into which the pegs fit and from which the strings extend down the neck, a high bridge, and the ornate nature of the bottom spike. Equally ornate spikes are seen in illustrations both earlier than the c. 1620 date of that Jahangiri painting—in figures 35 and 36 of the Akbari period—and later in plate 7 (see detail) from Aurangzeb's time. Also visible in those plates and in

Detail of plate 7

figure 37 is the characteristic body that is likely to be made of strips of wood rather than a solid bowl; unlike the strips of wood on the *ṭāmbūr,* these taper vertically toward the soundtable.

Several observations emerge from these accounts and illustrations of Babur's visit to Herat. His report clearly suggests that the *ghichak, oud,* and flute (*nā'ī*) were used for compositions created expressly for instrumental performance.

> Shāh Qulī the guitar-player [*sic*] was another; he was of 'Irāq, came into Khurāsān, practised playing, and succeeded. He composed many airs, preludes and works (*nakhsh, peshrau u aīshlār*). . . .
>
> Ghulām-i-shādī (Slave of Festivity), the son of Shādī the reciter, was another of the musicians. Though he performed, he did it less well than those of the circle just described. There are excellent themes (*ṣūt*) and beautiful airs (*nakhsh*) of his; no-one in his day composed such airs and themes. (*BN* 291–92)

It is also obvious that musicians "toured" from location to location within the Persian cultural sphere. It is further evident from Babur's, his grandson Akbar's, and other Mughals' patronization of cosmopolitan collections of musicians that this was recognized as a natural activity among the elite of his cultural heritage.

From another entry in his memoirs on the occasion of his lengthy visit to Herat, Babur's own musical acumen is revealed in critical commentary on events at a party.

> Amongst the musicians present at this party were Ḥāfiẓ Ḥājī, Jalālu'd-dīn Maḥmūd the flautist, and Ghulām *shādī*'s young brother, Ghulām *bacha* the Jews'-harpist. Ḥāfiẓ Ḥājī sang well, as Herī people sing, quietly, delicately, and in tune. With Jahāngīr Mīrzā was a Samarkandī singer Mīr Jān whose singing was always loud, harsh and out-of-tune. The Mīrzā, having had enough, ordered him to sing; he did so, loudly, harshly and without taste. Khurāsānīs have quite refined manners; if, under this singing, one did stop his ears, the face of another put question, not one could stop the singer, out of consideration for the Mīrzā.
>
> After the Evening Prayer we left the Ṭarab-Khāna for a new house in Muẓaffar Mīrzā's winter-quarters. There Yūsuf-i-'alī danced in the drunken time, and being, as he was, a master in music, danced well. The party waxed very warm there. (*BN* 303)

Peculiarly, painter Jamshid Chela did not include music-making in his illustration of "Muzaffar Mirza's party in Herat, October 1506,"[13] despite the lengthy text describing it in Babur's memoirs. A painting in the Akbari-period manuscript of the poetic *Divān* of Hafiz, however, suggests the mood of that occasion in Herat (pl. 2). The man who dances while holding a lute seems like the Yusuf-'ali who "danced in the drunken time" and who was "a master in music." That Yusuf-'ali was not a professional musician is clear in other passages in the *Bābur Nāma* (pp. 675, 687); rather, he was a commander of military forces, in the service eventually of Babur's son Humayun also.

During the years after Babur had settled into Kabul as home to his clan and intensive military activity was not constantly required, there was more time for informal social gatherings. Having supposedly sworn to abstain from wine when he reached his fortieth birthday, Babur decided to enjoy libations as long and as intensively as possible until then, bingeing and holding one wine party after another.[14] To these parties a variety of people were invited—even a dervish among them: "Qūtlū Khwāja *Kūkūldāsh* had long before abandoned soldiering to become a darwīsh;

moreover he was very old, his very beard was quite white; nevertheless he took his share of wine at these parties" (*BN* 406). The entertainment could also be diverse, such as the party held in a smallish tent: "Ghiyās the house-buffoon (*kīdī*) arrived; several times for fun he was ordered kept out, but at last he made a great disturbance and his buffooneries found him a way in" (*BN* 400). Diversity in the guest list continued; Babur's librarian was invited to that intimate gathering.

To the pleasure of drinking parties, Babur added the general enjoyment of river rafting and boating. On three such occasions, when boating and drinking together were the order of the day, groups went along whom Babur identified as musicians.

> (March 5th) Next morning when the Court rose, we rode out for an excursion, entered a boat and there drank *'araq*. The people of the party were Khwāja Dost-khāwand, Khusrau [and others including the musicians] Rauḥ-dam, Qāsim-i-'alī the opium eater (*tariyākī*), Yūsuf-i-'alī and Tīngrī-qulī. Towards the head of the boat there was a [platform supported on four posts] on the flat top of which I sat with a few people, a few others sitting below. There was a sitting-place also at the tail of the boat. . . . *'Araq* was drunk till the Other Prayer when, disgusted by its bad flavour, by consent of those at the head of the boat, *ma'jūn* was preferred. Those at the other end, knowing nothing about our *ma'jūn* drank *'araq* right through. At the Bed-time Prayer we rode from the boat and got into camp late. [The party continued.] Bābā Jān the *qabūz*-player had not been of our party (in the boat); we invited him when we reached the tents. He asked to drink *'araq*. . . . Bābā Jān even, when drunk, said many wild things. . . . Try as we did to keep things straight, nothing went well; there was much disgusting uproar; the party became intolerable and was broken up. (*BN* 385–86)

Three of the same musicians went along on another party on a boat.

> Having ridden out at the Mid-day Prayer for an excursion, we got on a boat and *'araq* was drunk. The people of the party were Dost Beg [and others]. The musicians were Rauḥ-dam, Bābā Jān, Qāsim-i-'alī, Yūsuf-i-'alī, Tīngrī-qulī, Abū'l-qāsim, Ramẓān *Lūlī*. We drank in the boat till the Bedtime Prayer. (*BN* 387)

Since Yusuf-i-'ali, noted as a dancer as well as a musician, was an officer in Humayun's service, and since Tingri-quli is mentioned by Babur with the title of Beg in a passage about yet another wine party (*BN* 415), it is possible that the other musicians along on the excursion were more courtiers or soldiers rather than professional musicians.

Of those seven musicians noted above, only Abu'l-qasim did not go along on another boating party, the third held within one week in March 1519.

> Today we rode out before mid-day and got into a boat where *'araq* was drunk. The people of the party were Khwāja Dost-khāwand [and others]. The musicians were Rauḥ-dam, Bābā Jān, Qāsim [and three others]. We got into a branch-water (*shakh-i-āb*) for some time when down-stream, landed a good deal below Bhīra and on its opposite bank, and went late into camp. (*BN* 388)

Since Babur was so explicit about who they were, and listed them in the same order in each of three passages, one wonders if they had not gathered themselves into a good ensemble which Babur enjoyed so much that he made them the reason around which the three successive parties were organized.

Two of those musicians—Rauh-dam and Tingri-quli—appear in the memoirs yet a fourth time. In August of the same year a multiple excursion in the area of Kabul was made by Babur in company of what seems to be more a collection of friends than a group of soldiers.

> (August 18th, 1519) Riding on next day, we made the circuit of Khwāja Khāwand Saʿīd's tomb, went to China-fort and there got on a raft. Just where the Panjhīr-water comes in, the raft struck the naze of a hill and began to sink. Rauḥ-dam, Tīngrī-qulī and Mīr Muḥammad the raftsman were thrown into the water by the shock; Rauḥ-dam and Tīngrī-qulī were got on the raft again. A China cup and a spoon and a ṭambour went into the water.[15]

The artist Kamal Kashmiri, who illustrated this incident in one copy of the *Bābur Nāma,* took the prose text literally and drew a musician holding a badly drawn plucked lute in the water, leaving little to the imagination.[16] A second rendition of this episode included a better-drawn plucked lute—clearly a *rabāb*—in the water (fig. 38). Thus, we know that the ensemble consisted of at least a plucked lute (*ṭāmbūr* or *rabāb*) and bowed lute (*qūbüz*). Unless the ensemble included some wind instrument such as a double-reed or a trumpet (which is unlikely), the ensemble sound would have been a relatively quiet one, as neither lute would have produced much volume. Nevertheless, the mood of the music could have been anything that might suit the mood of the revelers.

Just what type of bowed lute the *qūbüz* was is unclear.[17] According to Andrea Nixon (1984c), the Central Asian *qobüz* of today is related to the Mongol *khiil*. That shred of modern-day information becomes meaningful when juxtaposed with a statement in the *Bābur Nāma* by Babur about his army's initial foray into the Indian subcontinent. The person he mentions was a leader of the "Mughals"—or, as Babur always put it, "of the Mughal horde" (read "Mongol"):

> Sayyid Yūsuf [was an *amir* of Sultan Ahmad Mirza, ruler of Samarkand]. His grandfather will have come from the Mughūl horde; his father was favoured by Aūlūgh Beg Mīrzā (Shāhrukhī). His judgement and counsel were excellent; he had courage too. He played well on the *qūbuz*. He was with me when I first went to Kābul; I shewed him great favour and in truth he was worthy of favour. I left him in Kābul the first year the army rode out for Hindūstān; at that time, he went to God's mercy. (*BN* 39)

Yet another musician—a Chagatai who served with Babur and is mentioned with the gentleperson's title of Beg—provided entertainment on another boating party: "At dawn on Saturday we went on board a boat, and took our morning [draught of hot spiced wine to comfort the stomach]. Nūr Beg . . . played the lute at this gathering" (*BN* 395).

Babur himself may have contributed to the music-making. That he composed is suggested by this entry in his memoirs for 7 January 1520:

> ʿMullā Yārak played an air he had composed in five-time and in the five-line measure (*makhammas*), while I chose to eat a confection (*maʾjūn*). He had composed an excellent air. I had not occupied myself with such things for some time; a wish to compose came over me now, so I composed an air in four-time. (*BN* 422)

Dancing, too, was enjoyed by men in their private social gatherings. Babur pointedly commented on the dancing on two occasions:

I went to one wine-party of Muẓaffar Mīrzā's. Ḥusain of 'Alī Jalāïr and Mīr Badr were both there, they being in his service. When Mīr Badr had had enough, he danced, and danced well what seemed to be his own invention. (*BN* 299)

Also, using a word (*qūshūq*) that is allowed, both by its root and by usage, to describe improvisations of combined dance and song, he commented on an earlier occasion:

Khwāja Ḥusain Beg was a good-natured and simple person. It is said that, after the fashion of those days, he used to improvise very well at drinking parties. (*BN* 26)

Although there is no illustration of such dancing in the *Bābur Nāma* manuscripts, we can imagine it from plate 2 from the *Dīvān* of Hafiz. While his companion holds a pose familiar from male dancers in other paintings, the lutenist has sunk to the floor on one knee and is moving with his arm raised. Contrasting the two dancers in this one painting, one wonders if we see both a formulated dance and improvisation.

The men who danced at private parties could be high-ranking officers or courtiers who would have been the guests at the party. Annette Beveridge, translator of the *Bābur Nāma*, recounts a story told in an Afghani source about Babur himself dancing at such a party. It seems that when he assumed control in Kabul, Babur had to deal with the Yusuf-zai, a powerful Afghani tribe. First he professed friendship but then became prejudiced against them by their enemies, the Dilazak, who underwrote their charges against the Yusuf-zai by timely financial support that Babur badly needed. Babur therefore determined, said the Yusuf-zai chronicler, to kill their leader Malik Ahmad and invited him to Kabul. Ahmad accepted the invitation and set out with four brothers who were famous musicians. Meanwhile, the Dilazak had persuaded Babur to execute Ahmad immediately upon his arrival, saying that Ahmad was so clever and eloquent that if allowed to speak, he would induce the Padshah to pardon him—and that is what happened.

It is said that when Ahmad arrived in Kabul, he learned that Babur's real object was his death. His companions wanted to tie their turbans together and let him down over the wall of the fort, but he rejected their proposal as too dangerous for him and them and resolved to await his fate. Except for one of the musicians, he dispatched his companions to hide in the town. The next morning there was a great assembly. Babur sat on the throne and when Ahmad appeared before him, Babur raised his bow and prepared to shoot. But Ahmad managed to speak quickly and eloquently, and won Babur over by clever conversation.

The Pādshāh now became quite friendly with Aḥmad, came down from his throne, took him by the hand and led him to another room where they drank together. Three times did Babur have his cup filled, and after drinking a portion, give the rest to Aḥmad. At length the wine mounted to Bābur's head; he grew merry and began to dance. Meantime Aḥmad's musician played and Aḥmad who knew Persian well, poured out an eloquent harangue. When Bābur had danced for some time, he held out his hands to Aḥmad for a reward, saying "I am your performer." Three times did he open his hands, and thrice did Aḥmad, with a profound reverence, drop a gold coin into them. Bābur took the coins, each time placing his hand on his head. He then took off his robe and gave it to Aḥmad; Aḥmad took off

his own coat, and gave it to Adu the musician, and put on what the Pādshāh had given. (*BN*, App. K, xxxvii–xxxviii)

From such stories, from manuscript illustrations, and from his own writings, Babur emerges as a lively, fun-loving person. Like his Mongol and Timurid forefathers depicted in other manuscripts, he enjoyed music and dance. Beyond the fun, however, there is a bonding process described here that was crucial for Babur who desperately needed to connect his nobles to himself. To be easily considered legitimate in Timurid eyes, he needed to have been descended from a Timurid mother rather than father (C. Asher, pers. comm., August 1995).

Among the major events of Babur's Kabul period were the births of his children, and such events would certainly have been of interest to the women readers/viewers of the illustrated manuscript (fig. 39). Beyond marriage, the most important moments in a wife's life were the births of children with the persistent hope by each woman that she would produce *the* heir. But from the memoirs and chronicles it is clear that the event of the birth of the heir was an important moment for the father as well. With considerable feeling and detail, Babur relates the births of both princes and princesses. His writing style makes it possible for us to understand the difficulties and uncertainties for women in the unsettled times and circumstances in which he and his family lived—in terms both of the constant movement women had to endure even when expecting a baby, and of the real possibility (even likelihood) that infant and/or mother might not survive. Babur's first child was born after his second short success in Samarkand, and he wrote:

> After our departure (last year) from Andijān, my mothers and my wife and relations came, with a hundred difficulties and hardships, to Aūrātīpā. We now sent for them to Samarkand. Within a few days after their arrival, a daughter was born to me by ʿĀyisha-sulṭān Begīm, my first wife, the daughter of Sl. Aḥmad Mīrzā. They named the child Fakhru'n-nisā (Ornament of women); she was my first-born, I was 19. In a month or 40 days, she went to God's mercy. (*BN* 135–36)

From the phrase "they named the child" it seems that the women at that time named the daughters; later accounts suggest that the practice changed.

In his memoirs Babur also relates that the birth of a prince—or at least the probable heir—warranted celebration by the father more than did the birth of a princess. Indeed, no birth of a princess is accorded an illustration, as was the birth of a prince (fig. 39, pl. 8).

> At the end of this year, on Tuesday the 4th day of the month of Zū'l-qaʿda (March 6th 1506 AD. [the correct date is 1508]), the Sun being in Pisces, Humāyūn was born in the citadel of Kābul. . . . A few days later he received the name Humāyūn; when he was five or six days old, I went out to the Chār-bāgh where was had the feast of his nativity. All the begs, small and great, brought gifts; such a mass of white *tankas* [standards] was heaped up as had never been seen before. It was a first-rate feast! (*BN* 344)

Although Babur was more likely than other Mughal writers to identify female persons, he does not explain the mother, Maham Begam's, lineage; Abu'l Fazl in the *Akbar Nāma*, however, reports having "heard from some reliable persons," that she was from a noble Khurasan family, related to Sultan Husain Mirza and "connected to" his Holiness Shaikh (Ahmad) Jam, and that Babur mar-

ried her when he was residing in Herat perhaps as a sign of condolence to the bereft sons of Sultan Husain Mirza (AN 1:285). Regardless of the origin of her relationship to Babur, Maham remained an important member of the family until well into the reign of her son.

The Charbagh to which Babur repaired for the feast of Humayun's nativity was a fairly extensive park-like area outside the walls of Kabul, to which many references are made in the various Mughal-period memoirs and chronicles. It was apparently walled off, containing such structures as a picture gallery over a gate in the wall and an audience hall. In the illustrations of the festivity in two copies of the *Babur Nama,* an outer garden wall is indeed evident, framing the area as in many Mughal paintings, but canopies have been erected in the open (shown by trees in the background) over what seems to be a slightly raised platform on which carpeting has been laid (fig. 39, pl. 8).

The nature of the festivity is consistent in the two illustrations (and with other such scenes in Mughal manuscripts), though they differ in details. In one of the illustrations feasting is more prominent, while in the other, drinking is emphasized. In both, gifts are being carried in, and entertainment in the form of music and dance takes a good portion of the space in the scene. Multiple groupings of entertainers are suggested in these paintings. In figure 39, the two women dancers are accompanied by two women *da'ira* players, while quite separately, closer to Babur, sit players of plucked lute and *da'ira.* In plate 8, there may even be three different music/dance activities simultaneously: The player of the plucked lute may be separate from the male musicians who accompany the sword dancer; finally, a woman dancer has her female accompanists—a flutist and two *da'ira* players who appear to be singing. Additionally, another lutenist outside the grounds is approaching the gate with the bearers of gifts. Artist Sur Das (Gujarati) has suggested a plethora of entertainment riches, appropriate for "a first-rate feast!"

Gulbadan Begam, Babur's daughter, stressed the fact that her father celebrated the birth of an heir (her brother Humayun) in yet another way.

> The blessed birth of the Emperor Humāyūn, the first-born son of his Majesty, *Firdaus-makānī,* occurred in the night of Tuesday (March 6th, 1508), in the citadel in Kābul, and when the sun was in the sign Pisces.
>
> That same year his Majesty was pleased to order the amīrs and the rest of the world to style him emperor (*bādshāh*). For before the birth of the Emperor Humāyūn he had been named and stylized Mīrzā Bābar. All kings' sons were called mīrzās [princes]. (*HN* 90)

Babur must have felt that the birth of an heir presumed the possibility of a dynasty over which a *bādshāh* (*pādshāh*) would reign.

Babur, *pādshāh* of an embryonic empire, is shown to be a very human figure with a sense of humor in "The crocodile frightens the fish, which jump into one of Babur's boats" (pl. 9), for although he was in command of a fleet of boats, the joke was on them.

> (April 14, 1529) I left . . . by boat on Thursday. I had already ordered the boats to wait, and on getting up with them, I had them fastened together abreast in line [forming a beaters' line]. Though all were not collected there, those there . . . greatly exceeded the breadth of the river. They could not move on, however, so-arranged, because the water was here shal-

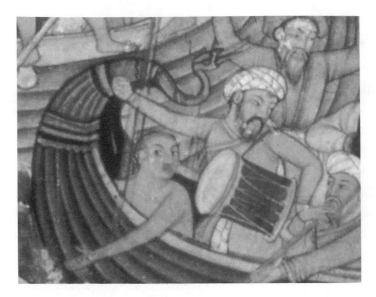

Detail of plate 9

low, there deep, here swift, there still. A crocodile (*ghariāl*) shewing itself, a terrified fish leaped so high as to fall into a boat; it was caught and brought to me. (*BN* 662–63)

Two rather humble-looking musicians in one of the front boats seem to be trying to frighten the crocodile away; one toots on a conical horn. The cymbal held by one man in this scene suggests that the cumulative group of musicians in three boats are playing instruments of a military/heralding ensemble, though they are not grouped in that manner and there is nothing imperial about their appearance. Musicians from the group with Babur, riding as retinue in smaller boats, also have drums with them—a pair of bowl-shaped drums (*naqqāra*) in one boat and a cylindrical drum in a second which is probably a *ḍhol*.

Indeed, in addition to the bowl-shaped *naqqāra*, a drum called *duhul* was included in the *naubat* ensemble in Akbar's time, according to Abu'l Fazl (*AiA* 1:53). "The *Duhul* (drum) is well-known," he says, in his list of Indian instruments in the *A'īn-i Akbarī* (*AiA* 3:270), to which a note is appended by one of the translators, H. Blochmann, to clarify that *duhul* "is the Persian equivalent of the ordinary *dhol* of Hindustan"; *duhul/ḍhol* are double-headed drums, cylindrical or barrel-shaped.[18] Indeed, a *ḍhol* is sounding forth in the ensemble that heralds Lord Krishna as he is greeted by Raja Bhismaka in a folio from an illustrated manuscript of the Indian Harivamsa (fig. 40). The *ḍhol* in plate 9 (see detail) is drawn so well that the V-lashing from skin to skin is clear, as are the places where the skin is pulled by the lashing going through it. The player has his right arm high ready to strike, with fist closed as if he is holding a stick, but the palm and fingers of his left hand are close to the drum head at that end.

BABUR AND HINDUSTAN

From his base in Kabul, Babur secured Persian support for his last successful march on Samarkand, but his tenure was to be short-lived because in *Sunni* Turkestan the estimation of *Shī'ism*—the dominant Islamic sect of Persia—was unfavorable. Thus Babur's perceived role as a Persian surro-

gate made a permanent stay difficult. Successful on the political and military levels but thwarted by religion and culture, in 1513 he abandoned his ambitions in Central Asia.

Although Babur enjoyed a relatively stable base in Kabul, his inability to retain Samarkand permanently was the impetus for him to retrain his sights on the south and east and, with his innate leadership abilities, to pave the way for a reunification of territories in northern Hindustan. In 1521 Babur secured Kandahar, the major city of southern Afghanistan, but India had long tempted him. He had undertaken a reconnaissance foray in 1519, the first of five visits to the subcontinent; soon he raided India again. Before those two incursions, Sikander Lodi, sultan of the kingdom bearing his name, died (1517) and his son Ibrahim came to power. Where his father, Sikander, had reigned as primus inter pares of a confederation of Afghani nobles, Ibrahim sought to increase his royal authority by curbing the nobles. With discontent increasing, Daulat Khan Lodi, governor of the Punjab, invited Babur to India and in 1524 Babur accepted, only to have the excursion delayed due to an Uzbek threat in the north. Finally, in the winter of 1525, Babur completed his move on the Punjab, quickly turning Daulat Khan's conspiracy to resistance. In April 1526, Babur met and vanquished Ibrahim, who died on the historic battlefield of Panipat, fifty miles north of Delhi.

Persistent political instability in the wake of Timur's destruction had permitted the adventurous and ambitious Babur to defeat the Sultan of Delhi and his weak confederates, but at a terrible cost. Victory was won for Babur by the swift and slender Central Asian horses he prized (which are shown in many paintings). Even when mortally wounded, these horses had been known to carry their masters to safety before they fell. Babur's artillery was directed by Turkish officers from Constantinople and his cavalry was trained in Turkish wheeling and flanking charge tactics, so that despite being severely outnumbered (sources vary, giving the ratios from $4:1$ to as high as $10:1$), the disciplined forces loyal to Babur inflicted a major defeat on the Afghani tribesmen.[19] The slaughter was excessive—more than 20,000 men—and for centuries the battlefield was said to be haunted at dawn. Babur occupied Delhi and pushed on to Agra without resistance but found it a ghost city; undoubtedly, with memories of Timur historically fresh in their minds to exacerbate the present disaster, the people had fled in fear. Perhaps to ameliorate such memories of carnage by Timur's forces at Delhi and Babur's at Panipat, battle scenes comprise far fewer paintings in the *Bābur Nāma* than one would expect from the text itself—only about eighteen or so in each copy.

Not surprisingly, illustrations in all four of the most complete copies of the *Bābur Nāma* celebrate Babur's having seated himself on the throne in the quarters of the vanquished Ibrahim Lodi in Agra (fig. 41). By pictorial arrangement, including the choice and placement of instruments, the illustration in the National Museum (New Delhi) copy is a conventional scene type—a formal court session. Humayun had actually arrived in Agra first, and at this gathering in Ibrahim's private apartments, Babur bestowed on him (from the treasury of Sultan Ibrahim) a cloth of gold, a sword-belt, a *tīpūchāq* horse with saddle mounted in gold; "and to the begs and braves, to each according to his rank, were given sword-belts, dagger-belts, and dresses of honour" (*BN* 527).[20]

Even with the Afghani to his east in disarray, Babur still had problems with which to deal. His own Turkish forces disliked the hot and dusty Gangetic plain, preferring cooler climes to the inferno

that was Agra in summer, so Babur immediately laid out a garden, which still exists as the Ram Bagh.[21] An exceptional leader, capable, clever, engaged, one who encouraged loyalty despite hardships, Babur managed to keep his cohorts contented in other ways. This was important, for he soon confronted another force. The Rajputs, in confederacy under Rana Sanga of Mewar, were pleased with the demise of the Lodis but not with Babur's intent to remain in Hindustan. Rana Sanga had hoped that Babur would follow Timur's lead and return to the north, thereby making the Rajput Rana de facto chief of the fallen empire. But this was more than a century after Timur; Babur had no empire to speak of, and certainly not Timur's riches to which he could return; nor did he intend to. Hindustan possessed enormous potential resources which could be realized only if unity and order were brought to those broad reaches. Indeed, "From the vantage point of Agra and his Indian conquests, he interpreted his life as a continuous struggle to establish a new Timurid state . . . [and] his victories in northern India [were] conquests that he justified by citing the precedent of Timur's brief occupation of Delhi in 1398" (Dale 1990:40). As well, Babur was probably tired of running, as it were, if not acquiescing to permanency. He decided to stay; Rana Sanga prepared to fight.

Babur's victory at Kanua over the far more formidable Rajput Hindu forces of Rana Sanga in 1527 was a major one. His weaponry and Central Asian cavalry tactics were as effective against the much larger force of 80,000 Rajput cavalrymen and 500 armored war elephants as they had been against the Afghans. Two paintings illustrate the rout. In one folio (fig. 42), Babur is depicted leading the chase and being cheered on by a drummer, a trumpeter, and an enthusiastic player of a pair of large cymbals; while in the other folio, the defeated forces are shown fleeing.[22] To celebrate his military triumphs and to underscore a political victory as well, invitations were sent, as Gulbadan Begam put it, "in all directions," to urge hereditary servants, guests from Ferghana, and Timurid and Chinggiss-Khanid kinsfolk to come and see prosperity with him now. On Saturday, 18 December 1528, there was a feast attended by a collection of ambassadors—envoys from his archrivals the Samarkand Uzbeks, from the Persian court, and also Rajputs from Hindustan. Paraphrased here is a description of the affair (*BN* 630–34): An octagonal pavilion had been newly erected for the occasion, covered with *khas,* scented grass of which the roots were fitted into window spaces and moistened to mitigate dry, hot winds. The seating of the guests to left and right of Babur was carefully arranged, and those closer to or further away from him; the diagonal lines of courtiers in paintings come to mind when reading the description of the arrangement. Before food was shared, all the sultans, khans, grandees, and amirs brought gifts of gold, silver, and copper coins, of cloth and various other goods, pouring them out onto a carpet which Babur had ordered spread. While the gifts were being brought, fierce camels and elephants were set to fight on an island opposite (possibly a peninsula left by the receding Jamna River after the rains), and rams as well; thereafter wrestlers grappled (fig. 43). After food had been set out, Babur distributed gifts—clothing, headwear, gold and silver, daggers, etc. Finally, Hindustani acrobats were ordered to come and show their tricks. Although "many dancing-girls came also and danced," what got illustrated of this party was the manly sports. In one rendition of the scene, the imaginable sound of

the instruments of the *naubat*—drums, *surnā,* and cymbals—suggests considerable enhancement of the level of excitement at the event and asserts that it was an imperial celebration.[23]

For the following year in the memoirs another male social gathering is illustrated, with the meaning likely to have been to emphasize that Babur was asserting himself over the established local leaders and that they were accepting his leadership (fig. 44). Point made: Wherever possible, Babur tried to proceed diplomatically rather than militarily. Musical entertainment and wrestlers were added to this event which is narrated so unspectacularly in Babur's memoirs:

> [On March 4, 1529, when Babur and his men were on military march near Benares] I dismounted at Sl. Jalāu'd-dīn's house inside Karrah-fort where, host-like, he served me a portion of cooked meat and other viands. After the meal, he and his sons were dressed in unlined coats and short tunics [gifts from Babur]. At his request his elder son was given the style Sl. [Sulṭān] Mahmūd [thereby giving the Sharqi family the right to rule in the area]. (*BN* 652)

Presumably, it is the father who presents his two sons (the ones with arm raised in the gesture of grateful greeting) to Babur, for whom a throne-like place has been prepared. Food is placed before seated courtiers. The artist may have added the wrestlers because so many references are made to them in the memoirs around this time. As for the bowed-lute player, it is difficult (though not impossible) to imagine that he was meant to be paired with the wrestling. It is more likely that he was simply another possible element in this atmosphere of political entertainment.

Babur spent what remained of his life in Hindustan trying to consolidate and unify the northern provinces.[24] In 1529, at Patna, he defeated a bevy of Afghan chiefs rallied to his east in present-day Bengal and Bihar. That was his last military engagement. Fairly firmly in control now in Hindustan, Babur established a model later to be followed by his grandson, Akbar, by turning to more peaceful pursuits and setting out to learn about Hindustan. His particular interest was in the flora and fauna he found in the new country, and a handsome percentage of the paintings in the *Bābur Nāma* are devoted to lifelike illustrations that correlate with his observations. This would have not only pleased Indian viewers of the manuscripts but taught his non-Indian entourage about Hindustan. Another sizable body of the paintings in each copy are devoted to the gardens which Babur had laid out in the subcontinent.

Babur was a complex, engaging, attractive figure. Despite enormous hardships and considerable setbacks, he retained composure and evinced conviviality. Despite his military prowess, he composed competent Persian poetry, was highly regarded in the ranks of Turki-language poets, and was a prose stylist whose autobiography is considered a masterpiece in any language.[25] Despite the fierce reputation of his Timurid and Mongol ancestry, he displayed good Persian manners and taste, loved nature, and appreciated music and art. He founded the Mughal Empire almost by sheer force of personality, although it was left to his successors, most notably his grandson Akbar, to create, design, and devise the infrastructure and insignia of empire (map 10).[26]

Humayun: Heir to an Elusive Throne

A dramatic sequence of events takes us into the second generation of the Mughal dynasty; the climax of those events was when Babur vowed to sacrifice his own life in order to save that of his son. Humayun had fallen critically ill, and there was great concern as to whether he would revive. In order to secure the survival of his son, and following the Timurid-Mughal custom of tendering the dearest thing in the world—one's own life—in exchange for another, Babur walked three times around Humayun's bed and offered his life to spare his son's. Soon Humayun grew stronger, Babur weaker, and he died in December 1530. But on his deathbed, Babur designated as his successor his eldest and favorite son, the same Jahanbani Nasiruddin Muhammad Humayun (Fortunate). Whether the story is apocryphal or not, it is in keeping with Babur's character as well as with his family's ancestral customs. A double-page illustration by the master artist, Lal, in a copy of the *Akbar Nāma* records that "Babur appoints Humayun to succeed him in 1530" (fig. 45). Heralding the event, adding imperial weight to match the moment as described in the *Akbar Nāma,* is the royal *naubat* ensemble consisting of three types of wind instruments (including a strange, somewhat curved horn) and three pairs of drums.

> Then out of his active mind and truth-seeking soul, [Bābur] summoned his officers and nobles and making them place the hands of homage to the empire in the hands of Humāyūn, appointed him his heir and successor, placing him on the throne of sovereignty, while he himself remained bed-ridden at the foot of the throne. Khwāja Khalīfa, Qambar 'Alī Bēg, Tardī Bēg, and all the others were in attendance. Lofty counsels and weighty mandates, such as might form a stock of lasting fortune and eternal auspiciousness, were imparted. (*AN* 1:276)

Contradictory to the chronicle, in this depiction Babur sits erect on his throne, looking fit and healthy. As sometimes did happen in the manuscripts, the illustration may have been intended for a different episode and was inserted there as a general scene (M. C. Beach, pers. comm., July 1994).

Some have questioned whether Babur had really intended to designate Humayun as his heir in part because the accession is given less than "royal treatment" by Abu'l Fazl. Although he summarizes Humayun's virtues, the rendering of the succession is sparsely noted in his account.

> The accession of his Majesty took place in Agra on (29th December, 1530). . . . A few days later, he made an excursion upon the river and placing the barks of pleasure in the stream of joy, gave away on that day, a boat full of gold, and by the largesse laid a golden foundation of dominion. (*AN* 1:286)

Another indication that approval of Humayun's succession was by no means universal and that he had to argue for support is also suggested:

> The nobles and great officers and the whole of the victorious army were brought into obedience by proper measures. Everyone who breathed disaffection . . . bound the cincture of service on the waist of obedience. (*AN* 1:287–88)

Because the *naubat* ensemble is rarely included in enthronement scenes, its presence in figure 45

may be all the more meaningful. Perhaps that illustration was chosen for use here because the *naubat* functions to assert the authority of the sovereign, as if the supervisor of the manuscript added this sentence to the prose account of Babur's designation of Humayun: "I put the full weight of my authority into this; no challenges are appropriate."

Despite hypotheses to the contrary, it is almost certain that Babur himself intended Humayun as his successor. Babur was prepared to exchange his own life for his son's; and Humayun was not only his favorite, but also his eldest son and geographically placed much closer to Babur than Humayun's several younger brothers. Assuming the throne in his twenty-third year, Humayun brought several positive traits to his position: bravery, military adeptness, the ability to inspire and endure. He had the Persian gentlemanly virtues: besides being versed in the arts, he was polished and dignified, sported a sense of humor and openness of personality, and was affectionate. Conversely, he also possessed some attributes that nearly brought him to ruin and were, perhaps, the basis for perceiving some reluctance on the part of the court and Babur's followers—though presumably not Babur himself—to feel comfortable with Humayun's accession. Humayun was a hedonist, addicted particularly to opium. Further, because of his affectionate and trusting nature he was frequently unable to distinguish between friends and sycophants, loyalists and secret enemies, particularly those who would stoke the ambitions of his younger siblings, thus creating difficulties for him in his attempt to assert his authority.

Nonetheless he assumed the title, and a double-page illustration of "Humayun's accession darbar at Agra, 1530" shows numerous courtiers flocking in to greet him (fig. 46). Seated on the familiar throne as others crowd in, Humayun is being greeted by a young man, perhaps his half brother, Kamran, whom he appointed to the governorship of Kandahar and Kabul. A servant pours liquid from a carafe at the ubiquitous low table in the foreground that suggests a festivity of extraordinary significance. Another servant brings food or a gift in a covered tray. Two musicians—a *rabāb* and a *dā'ira* player—are among those who seem to be rushing forward, crowding in, straining to see the activities or to gain a place closer to Humayun, all lending the impression that this is not a very formally arranged moment, but an unexpected one.[27] Like other accession scenes in Mughal manuscripts, the *naubat* is not included here.

The joy at Humayun's accession was short-lived. Although his father had "founded" a dynasty, he had not firmly established one, and many challengers sought to erase the outlines of empire (map 11).[28] Humayun had little willing support among Hindustan's leaders. To the east, the Afghans were restive, seeking to restore Lodi rule; on the west, the sulking Rajputs bided their time, though they themselves were targets of the ambitions of the brilliant Bahadur Shah of Gujarat, in the south, who had his sights on Mewar. But the most dangerous and persistent challenge proved to be Humayun's brother Kamran, who was in Kabul at Babur's death and who, shortly thereafter, by acquiring Punjab through the support of his own full brother 'Askari, reduced Humayun's legacy by half. Kamran set out immediately to challenge Humayun elsewhere. Repeatedly Humayun's three brothers moved against him, and as often the tolerant Humayun forgave them.[29] Despite his many troubles related in the *Akbar Nāma,* Humayun's sister, Gulbadan, assures her readers (perhaps with more loyalty than objectivity) in her *History of Humayun* that during the ten

or so years after the death of Babur that Humayun was in Hindustan, "the people dwelt in repose and safety, and obedience and loyalty" (*HN* III). It is true that during that period he was successful in subduing Gujarat, a strong and rebellious area that preoccupied the Mughals in successive generations. And, in 1535, in a dazzling and valorous campaign he defeated Bahadur Shah but failed to depose him or to formally annex the kingdom. His attention to trouble was erratic and his success in quelling resistance sporadic.

Humayun eventually found himself deprived of access to the resources of the Punjab and traditional Mughal Central Asian bases. The havoc wreaked by Kamran and others ultimately forced Humayun from his position of power, and he gradually lost control of the area that his father had bequeathed him, effectively chased by Sher Khan. When, in May 1540, the Afghan army met and butchered the Mughal army at Kanauj, Humayun fled first to Agra, then to Lahore. One day at Lahore, when Humayun had received an ambassador from Sher Khan, a curious thing happened.

> The Emperor's blessed heart was cast down. He fell asleep in a sad mood, and saw in a dream a venerable man, dressed in green from head to foot and carrying a staff, who said: "Be of good cheer; do not grieve"; and gave his staff into the royal hand. "The most high God will give you a son who shall be named Jalālu-d-din-Muḥammad Akbar." The Emperor asked: "What is your honourable name?" He answered: "The Terrible Elephant, Aḥmad of Jām"; and added: "Your son will be of my lineage." (*HN* 145)

Sher Khan now claimed the empire of Hindustan as Sher Shah (map 12).[30] Humayun and his brothers met at Lahore but produced no plan to move against the Afghani leader. Soon, Kamran seized the opportunity to close off both the Punjab and Kabul to his brother. As Humayun headed out of Hindustan, to Sind, then Rajasthan, then back to Sind, he stopped temporarily with his half brother, Mirza Muhammad Hindal, and Hindal's mother, Dil-dar.

> The mīrzā's *ḥaram* and all his people paid their respects to his Majesty [Humāyūn] at this meeting. Concerning Ḥamīda-bānū Begam, his Majesty asked: "Who is this?" They said: "The daughter of Mīr Bābā Dost." . . . Of Ḥamīda-bānū he said: 'She . . . is related to me."
>
> In those days Hamīda-bānū Begam was often in the mīrzā's residence (*maḥall*). Another day when his Majesty came to see her Highness my mother [Dil-dār, who was Gulbadan's and Hindāl's mother], he remarked: "Mīr Bābā Dost is related to us. It is fitting that you should give me his daughter in marriage." (*HN* 149–50)

Hindal objected, sending off an exasperated Humayun, but the girl's mother reacted favorably to Humayun's request to marry Hamida-banu Begam, so Hindal's mother exerted some diplomacy, "fetched his Majesty, and on that day she gave a party." Humayun pushed the matter further, but it became obvious that Hindal had been opposed because Hamida-banu herself had objected. As related by Humayun's half-sister, Gulbadan, Hamida-banu Begam was a spirited and, in this instance, reluctant young woman.

> On another day [Humāyūn] came to my mother, and said: "Send someone to call Ḥamīda-bānū Begam here." When she sent, the begam did not come, but said: If it is to pay my respects, I was exalted by paying my respects the other day. Why should I come again? An-

other time his Majesty sent Subḥān Qulī and said: "Go to Mīrzā Hindāl, and tell him to send the begam." The begam said: "Whatever I may say, she will not go. Go yourself and tell her." When Subḥān Qulī went and spoke, the begam replied: "To see kings once is lawful; a second time it is forbidden. I shall not come." . . .

For forty days the begam resisted and discussed and disagreed. At last her highness my mother, Dil-dār Begam, advised her, saying: "After all you will marry someone. Better than a king, who is there?" The begam said: "Oh yes, I shall marry someone but he shall be a man whose collar my head can touch and not one whose skirt it does not reach." Then my mother again gave her much advice.

At last, after forty days (discussion), at mid-day on [a Monday, in September 1541], his Majesty took the astrolabe into his own blessed hand and, having chosen a propitious hour, summoned Mīr Abū'l-baqā and ordered him to make fast the marriage bond. He gave the mīr two laks of ready money for the dower, and having stayed three days after the wedding in Pātr, he set out and went by boat to Bhakkar. (*HN* 150–51)

The fourteen-year-old bride and a huge, helpless contingent of women, children, and noncombatants accompanied Humayun. They were, of course, refused refuge in Kabul by Kamran and had no choice but to continue, embattled and in desperate search of water, on a long and terrible journey across the desert to Sind (now in Pakistan). Gulbadan Begam remembered hearing how, after one battle, Humayun had no horse left that was appropriate for Hamida-banu, who was by that time quite pregnant. He was about to take the camel of his ewer-bearer and give her his own horse, when one of his men, Nadim Beg, placed his own mother on a camel and gave her horse to Humayun (*HN* 155).

THE BIRTH OF AKBAR

Finally they reached the Sind region and the small desert town of Umarkot ('Umrkot) (now in Pakistan), where they were hospitably received by the Rana. After seven weeks of rest in Umarkot, Humayun set out on a military foray in aid of their host (a fitting reciprocity), leaving behind many people, including his bride. Three days after Humayun's departure, to Hamida-banu Begam, in the early morning of Sunday, 15 October 1542,

there was born his Imperial Majesty, the world's refuge and conqueror, Jalālu-d-din Muḥammad Akbar *Ghazi*. The moon was in Leo. It was of very good omen that the birth was in a fixed Sign, and the astrologers said a child so born would be fortunate and long-lived. The Emperor was some thirty miles away when Tardī Muḥammad Khān took the news to him. He was highly delighted, and by way of reward and largesse for the tidings he forgave all soever of Tardī Muḥammad Khān's past offences. He gave the child the name he had heard in his dream at Lahor, the Emperor Jalālu-d-din Muḥammad Akbar. (*HN* 158)[31]

According to the *Akbar Nāma*, Humayun was approximately sixteen miles away, and the news was brought by Mehtar Sumbul, an old slave who was subsequently raised considerably in rank as a reward. When Humayun heard the news of Akbar's birth, he bowed his head in adoration and rubbed his forehead in the dust. A number of courtiers were assembled and in attendance, says Abu'l Fazl, who proceeded to interpret the event.

After due rendering of thanks, he proceeded to the camp and entered the spacious hall of audience. A feast was given to the world and the rites of prosperity were revived. The drums of joy and rejoicing raised a sound like the exultation of Kaiqubād. . . . The cupbearer seized the goblet of pure wine. . . . Melodious musicians and enchanting vocalists played on divers instruments and produced a variety of notes. Harpers [*chang*] smote the strings of purpose—lutanists buffetted the world's sorrows,—dulcimer-players bound the chords with the ringlet of success,—strong-breathed flautists drew out harmonious strains,—mandolin [*ghicak*]-players suspended hearts on the curl of desire,—tambourinists [*dā'ira-dastān*] held up the mirror of fortune before their faces . . . and crowds of great and small, of sages and servants, paid their respects. (*AN* 1:62–63)

An illustration which depicts Humayun receiving the news of the birth of his son provides classic evidence of the reinterpretation of history with a painting (fig. 47). One obvious example is that he is shown to be in the same location as Hamida-banu Begam, separated only by walls of the residence. Another is that he likely could not have given alms to the poor as shown at the bottom of the painting because Humayun was probably too poor to do so at that point in time. Indeed, the only "feast" that the happy father could muster was the sharing around of one melon.

Three of the elements in figure 47 might reflect the reality of the situation at the time. Festive music is so ubiquitous in the convention of birth scenes that it probably did take place. The male sword dancer (who reminds us of the dancer in the scenes of Babur in his garden celebrating the birth of Humayun) (fig. 39, pl. 8) and his drum and *surnā* accompanists could very well have been among the small coterie who were on the arduous journey with Humayun as part of the army.

Secondly, although Humayun would not have received his newborn son's horoscope immediately as suggested in figure 47, the casting of the horoscope of the newborn would indeed have been carried out at the time of birth of any prince. Inclusion of the astrologers constitutes a very significant difference between this depiction and that of Humayun's birth (fig. 39, pl. 8).

The third realistic aspect, which is possibly appropriate for the place of birth, are two South Asian elements depicted here. Because the host of Hamida-banu Begam was a Rana, the Hindu/Indian elements in the painting are appropriate. Among the women in the *harem* quarters are three Indian women, recognizable by uncovered heads and wrist ornaments. And above Humayun's head, suspended from the poles of his porch-like structure, are leaves of the mango tree that are used extensively in the performance of rituals when naming a newborn baby (and during Hindu marriage ceremonies). The leaves are woven into a garland and tied usually to the entrance of the house to ward off evil and bring good luck to the family.

In relating the birth of Akbar, Abu'l Fazl is at his most effusively descriptive, his account perhaps enhanced by the obvious prominence of music in the celebrations. Here he gives the mother's perspective (*AN* 1:57–58).

They spread the carpet of joy under the canopy of chastity and curtain of honor, and made ready a feast of joy and exultation. The veiled ones of the pavilion, and the chaste inmates of the royal harem anointed the eye of hope with the collyrium of rejoicing and coloured the eyebrows of desire with the indigo of merriness. They decked the ear of good tidings with the earring of success, painted the face of longing with the vermilion of pleasure, encircled

the fore-arm of wish with the bracelet of purpose, and donning the anklet of splendour on the dancing foot, stepped into the theatre of delight and joy and raised the strain of praise and gratulations. Fan-wavers sprinkled otto of roses, and winnowed the air with sandal-scented arms. Dark-haired maidens freshened the floor by rubbing it with perfumes. . . . Rose-scented, jasmine-cheeked ones soothed the rapid dancers with camphorated sandal-wood. Gold in thuribles on the borders of the carpet, gave off fumes of incense. They un-covered the stoves which were filled with lign-aloes and ambergris. Musicians created en-chanting ecstacy, and melodious minstrels breathed forth magic strains.

> *Verse*
> And soft-voiced Indian maids,
> Glorious as Indian peafowl,
> And light-fingered Chinese musicians
> Produced intoxication with wineless cups;
> And dulcimer-players from Khurasan
> Brought ease to laden breasts,
> And singers from the land of 'Iraq,
> Everlasting capturers of joy.

Artistic depiction equivalent to Abu'l Fazl's enthusiastic written reception to the birth of Akbar and his recounting of the festivities celebrating the occasion had to wait until the next generation and the birth of Salim (Jahangir).

Abu'l Fazl's account of Akbar's birth in volume 1 of his *Akbar Nāma* also reinforces the crucial presence of the astrologer. Along with music, astrology heralded the arrival of a preeminent figure in the history of Hindustan.[32]

Among the strange circumstances which occurred near the time of the appearance of the light of fortune [the birth of Akbar], there was this. . . . Maulānā Cānd, the astrologer, who by the king's order, had been stationed by the chaste threshold in order that he might cast the horoscope, was perturbed, as the moment was inauspicious. "In a short time, a glorious moment will arrive, such as does not happen once in a thousand years. What an advantage if the birth could be delayed." Those who were present made light of it and said, "What is the good of your agitation? Such things are not under control."

At this very instant the impulse to bring forth passed off and the astrologer's mind was set to rest somewhat by the transit of the unlucky moment. The ostensible cause of this supreme blessing was that a country midwife had been just brought in to perform her office, and her appearance was repulsive, the holy soul of [Māham] felt disgusted and her even temper was rebuffed and so the urgency for parturition left her. But when the chosen time came, the Maulānā became disturbed, lest it should accidentally pass by. The confidants of the harem said to him, "Her Majesty, has after much suffering, got an interval of relief and is now slumbering. It would not be right to waken her. Whatever Almighty God, in His good pleasure has determined, must happen." Just as they were speaking, the pains of travail came upon her Majesty, and awoke her and in that auspicious moment, the unique pearl of the viceregency of God came forth in his glory. (*AN* 1:56–57)

Numerous pages that follow in the *Akbar Nāma* support that auspicious horoscope, including

commentary on the meaning of details in the Indian astrological system; the following statement seems to have been significantly borne out by Akbar's life as a patron:

> The lord of the Fifth House (Sagittarius) is Jupiter and he is in the Second. He . . . will have ample treasures and great countries will come under his sway. And as Venus is also in the Second House, he will be acute and discriminating in musical notes, in subtle harmonies and in the secrets of melody. (*AN* 1:94)

As if to put the forecast in context, Abu'l Fazl gives the horoscopes of Akbar's Timurid ancestors as well. The comparison of Akbar's horoscope with that of Timur himself is a major point of the commentary on Timur in the *Akbar Nāma* (1:79, 124). Appropriately, astrologers are part of the pictorial content of the illustration of the birth of Timur in the *Akbar Nāma* as well (pl. 10).

Since scenes of a royal birth do not emerge in Mughal painting from the Persian artistic tradition, they are particularly significant in several respects. The inclusion of the mother in the illustration was no daring flight of artistic fancy, because there are fourteenth-century Mongol and Timurid precedents for the scene type (Vaughan 1994:122–23) and depiction of a significant birth is also a common motif in several Indian painting styles—Jain paintings of Western India, for instance. In these Mughal scenes, however, the pictorial content localizes the meaning. The depiction of the mother asserts Akbar's Timurid ancestry, drawing on established mythology about the birth of Timur to the semi-mythical Mongol queen Alanquva and asserting the legitimacy of descent through the mother as Timurid tradition demanded. Inscribed on the jade sarcophagus of the tomb of Timur in Samarkand is this passage that reaffirmed the mythology even for Timur himself:

> And no father was known to this glorious (man), but his mother (was) Alanquva. It is said that her character was righteous and chaste, and that she was not an adultress. She conceived him through a light which came into her eyes from an upper part of a door and assumed for her the likeness of a perfect man (Koran 19:17). (cited in Brand and Lowry 1985:17)

As related by Abu'l Fazl in the *Akbar Nāma,* the widowed Alanquva

> was reposing on her bed, when suddenly a glorious light cast a ray into the tent and entered the mouth and throat of that fount of spiritual knowledge and glory. The cupola of chastity became pregnant by that light in the same way as did her Majesty Miriam (Mary) the daughter of Imran. . . . That day [of Ālanquwā's conception] was the beginning of the manifestation of his Majesty, the king of kings [Akbar], who after passing through divers stages was revealed to the world from the holy womb of her Majesty Miriam-makānī for the accomplishment of things visible and invisible. (*AN* 1:179–80)

Thus, Alanquva shared with the Virgin Mary the "experience" of virgin birth.[33] In verse, Abu'l Fazl exhorts his readers:

> If you listen to the tale of Mary,
> Believe the same of Ālanquwā. (*AN* 1:182)

And Akbar, by association with Timur, assumed that divine imagery through his mother, Hamida-banu Begum.

The pictorial image of the mother in this and other scenes of the birth of princes in Mughal manuscripts is not a depiction of a noble woman in intimate circumstances in the Mughal household. Rather, it is a reproduction in Mughal painting style of the iconography of the Virgin Mary, i.e., the personification of a giver of virgin birth. Akbar's understanding of the Christian images of Mary there is likely due to the presence of Catholic clergy, although Monserrate exaggerates the idea of Akbar actually worshipping the Virgin Mary.

> When the King heard of the arrival of the Fathers he came alone to their house, and proceeded straight to the chapel, where (having laid aside his turban and shaken out his long hair) he prostrated himself on the ground in adoration of the Christ and his Mother . . . he told his sons to do reverence to the pictures of Christ and his Virgin Mother. One of the nobles exclaimed with emotion that she who was sitting on her throne in such beautiful garments and ornaments was in truth the Queen of Heaven. The King himself accepted with the greatest delight a very beautiful picture of the Virgin, which had been brought from Rome. (Monserrate, 1582:48–49)

> It was so widely reported amongst the Musalmans that the King had become a worshipper of the Virgin Mary, the Mother of God, that a certain noble, a relation of the king, secretly asked the officer in charge of the royal furniture for the beautiful picture of the Virgin which belonged to the King, and placed it (unknown to the King himself) on a bracket in the wall of the royal balcony at the side of the audience-chamber, where the King was wont to sit and show himself to the people . . . and draped the picture with the most beautiful hangings of cloth of gold and embroidered linen. . . . The King warmly praised the idea. (Ibid., 176)

Not surprisingly, for the portrayal of Timur's birth in the chronicle an entire folio is devoted to the mother's side of a birth scene (pl. 10). In accordance with the mythological message of the folio, the crucial elements of this scene are the mother and child in the top register as well as the group of astrologers, placed also at the top, who cast the horoscope of Timur. Crowded into a small band of the painting, men bring a cradle and gifts—elements new to the composition of the scene of the birth of a prince compared to those for Humayun and Akbar. A scribe records the gifts. The cradle is of the same design that can be seen in markets of Central Asia today. Two male dancers signify a festivity. The *naubat* ensemble proclaims the imperial status of the child and also stands in for the person of the father, symbolizing the paternal presence in a painting such as that for the birth of Akbar (fig. 47).[34]

THE RECONQUEST OF HINDUSTAN

Nearly two years after Akbar's birth, the suffering party of Humayun crossed the border to Herat in 1544 and found refuge with Shah Tahmasp of Persia, for he was, after all, a Timurid prince, dutifully—and more or less cordially—received by the Safavid ruler.[35] In September 1545, Humayun finally took charge of his own future, its path determined by the demise of Sher Shah. For five years Sher Shah had ruled over Hindustan, although most of that time was spent in military campaigns in which he unintentionally cleared the way for the restoration of the Mughals. He took the Punjab from Humayun's brother Kamran and Malwa from Raja Maldev (Rana Sanga's successor) and pushed him back to Rajasthan, where he then dictated the terms of peace in 1543. After another

offensive against other Rajputs at Kalanjar in Bundelkhand (near Malwa), Sher Shah died from injuries suffered when he was struck by a cannonball. It is interesting to speculate on whether there ever would have been a Mughal empire had Sher Shah lived and succeeded in extending and pacifying his territories in Hindustan. Although an Afghan chieftain, he was an appreciator of things Persian, including artistic and aesthetic tastes, as can be seen in the Purana Qila built in Delhi. He was an able administrator, too, leader, diplomat, organizer, and systematizer; in fact, Mughal success and eventual solidification of an empire was founded on the system he was developing. Indeed, it should be noted that the outline and infrastructure of empire was being organized by Sher Shah to a level unseen since prior to Timur's invasion; Akbar would owe a measure to him.

Upon Sher Shah's death, the throne passed to his son, Islam Shah Sur. A leader more in the Afghan chieftain mode than in his father's obvious Persianizing, sophisticated style, he had been in successive conflict with his own nobles. He was able neither to consolidate his father's administration nor to centralize his own rule. This was due partly to economic woes brought on by a drought, then famine, partly to growing discontent in the population, and partly to general Afghan demoralization. It was a good confluence of events for Humayun, who began to reverse his fortunes. Supported by Shah Tahmasp, and with fresh funds and troops, Humayun led a combined Mughal–Persian army which took the crucial trade city of Kandahar held by his half brother 'Askari; Humayun beseiged it for forty days.

> As the daily increasing success of his Majesty Jahānbānī [Humāyūn] was patent, and it became clear to the garrison that owing to the good fortune of his Majesty Jahānbānī and the zeal of his devoted servants it would be impossible to maintain the defence, M. 'Askarī awoke from the sleep of carelessness and became disturbed in his mind, and could neither advance nor stay where he was. At first he asked to be allowed to surrender Qandahār and to proceed to Ḳabul, but his Majesty Jahānbānī did not agree to this, and the Mīrzā's crude idea came to nought. Out of necessity he had to send her Highness Khānzāda Begam to his Majesty to beg forgiveness of his offences. At the request of that cream of chastity's family the writing of forgiveness was drawn over the register of his offences, and on Thursday (3rd September, 1545) he came out of the fort, contrite and repentant, and in the train of the cupola of chastity. His Majesty Jahānbānī had formed an assemblage in the dīwānkhāna [audience hall] and the Caghatāī and Persian officers were drawn up in line according to their rank. In accordance with the royal orders Bairām Khān hung the sword round M. 'Askarī's neck and introduced him. His Majesty Jahānbānī, in spite of all the mortal injuries which he had received from him, put aside the canons of sovereignty and with native kindness and excessive clemency accepted the intercession of the cupola of chastity and drawing the pen of forgiveness over the schedule of his deeds, [Humāyūn] encompassed him with the curtains of favour and with exceeding affection. After returning thanks to God for the beginning of success, he gave orders for the removal of the sword from the Mīrzā's neck, and after he had paid his respects bade him be seated. (*AN* 1:467)

In the illustration of the submission of 'Askari to Humayun (fig. 48, see detail), the cast of important players is easy to recognize, as the artist has been careful to distinguish them. The court musicians have their backs turned and are watching the action as one would expect at such a dra-

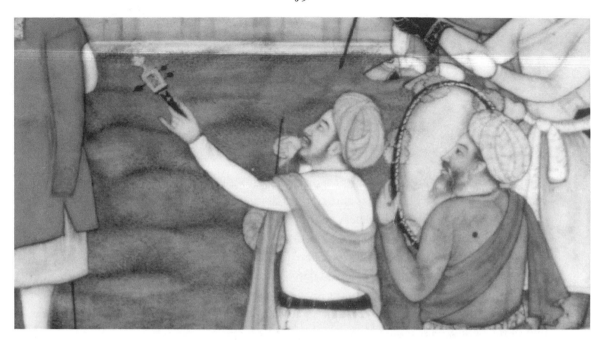

Detail of figure 48

matic moment; the *dā'ira* is ubiquitous, but the lute is the bowed type (*ghichak*) popular in Persian musical culture rather than the plucked lute that is pictured more frequently in Mughal court scenes. By means of that substitution, the artists remind viewers that the event took place outside India.

With Humayun's defeat of his half brother, 'Askari, and reassertion with resounding certainty of his reemergence as his father's heir, a festive celebration was held.

> From the close of day up to early dawn, which is the time of the arrival of the glory of heaven, there was a delightful assembly. Instructive elements were described, and Mīr Qalandar and other reciters and players discoursed excellent music, thereby removing the rust from his Majesty's world-adorning soul. (*AN* 1:468)

Humayun then grasped the opportunity to attack the Safavid garrison and take it for himself. Forgetting his promise to return Kandahar, Humayun continued his success, moving on Kabul and wresting it from his brother Kamran.

> In an auspicious moment the drummers of dominion beat high the great drum (*kūrāka*) of prestige and the standard-bearers of victory advanced the stelliform standards of glory to the starry sphere. On the night of the (18th November, 1545), the conquest of Kābul, the beginning of countless victories, was accomplished by heavenly aid, and the gates of joy and success opened to the hearts of mankind. (*AN* 1:480)

When Humayun had succeeded in reasserting his authority he enjoyed a reunion with members of the family. Despite the florid style with which Abu'l Fazl recounts it, the personal moments which followed are quite touching.

On 12 November 1545 Humayun was reunited with his sisters, Gulchihra Begam and Gulba-dan, and their mother, Dil-dar, after five years of uncertainty. Gulbadan Begam recalled the time:

Again and again we joyfully made the prostration of thanks. There were many festive gatherings, and people sat from evening to dawn, and players and singers made continuous music. Many amusing games, full of fun, were played. (*HN* 178)

Nothing about the retaking of Kabul was as important to Humayun as his reunion with his young son Akbar, who had been more or less hostage during the flight to Persia. While Hamida-banu Begam accompanied her husband to Persia, their child had been left in the care of a trusted aunt, Khanzada Begum.

When the gates of joy and gladness opened at the glorious indicates of the personality of his Majesty the Shāhinshāh, and the foundations of dominion were thereby renewed, his Majesty Jahānbānī regarded not the defeat of M. Kāmrān, nor the conquest of Kābul, but abode in expectation of the blissful footsteps of his Majesty the Shāhinshāh until they brought to him, in an auspicious moment, the world-intelligence who was at that time . . . aged three years two months and eight days. His Majesty obtained spiritual and temporal felicity by beholding that blissful nursling of light divine, and prostrated himself in thanksgiving for the safety of the young shoot of fortune's garden, and for the glorious acquisition of the lamp of the family. (*AN* 1:481)

Akbar's mother, Hamida-banu Begum, who had remained in Kandahar when that city was retaken, was now brought to Kabul for a joyous reunion with her son. At Humayun's suggestion, a princely festival was organized for that moment in the "pavilions of chastity" and also at Humayun's suggestion Hamida-banu sat among the numerous ladies present in order to see if Akbar would pick her out.[36]

By light divine His Majesty [Akbar], without difficulty, hesitation, or mistake, and in virtue of his abiding intelligence and innate discernment took refuge with his saintly mother, and put himself into her arms. (*AN* 1:484)

Indeed, festivity upon festivity was arranged in celebration of the taking of Kabul.

It was also the moment for the young prince to be circumcised and Humayun turned that necessity into general festivity, as well:

Humāyūn under the guise of rite of circumcision offered thanksgiving to the Bestower of spiritual and temporal blessings. Each day there was a novel, royal feast, and thanks were returned to the world-adorning Creator. . . . At a moment when the constellations were shedding light from favourable aspects upon mortals the meeting for the decorating of the young plant of the Divine rose garden, to wit, for the circumcision of his Majesty the Shāhinshāh, was held with thousands of rejoicings. . . . Small and great shared in the princely gifts, and high and low experienced the royal favour. The world's pains ended in pleasure and the world's differences changed into unison. The captains presented their gifts, and were exalted by grand favours. (*AN* 1:485–86)

Humayun's sister, Gulbadan, placed the event logistically (though the reader will note the difference in age given by Abu'l Fazl and Gulbadan):

The Emperor Muḥammad Akbar was five years old when they made the circumcision feast in Kābul. They gave it in [the] large Audience Hall Garden. They decorated all the bāzārs.

Mīrzā Hindāl and Mīrzā Yādgār-nāṣir, and the sulṭāns and amīrs, decorated their quarters beautifully, and in Bega Begam's garden the begams and ladies made theirs quite wonderful in a new fashion. All the sulṭāns and amīrs brought gifts to the Audience Hall Garden. There were many elegant festivities and grand entertainments. (*HN* 179)

Continuing perhaps to appeal to the women through illustrations, the artist places this joyous occasion in the women's quarters, with Humayun sitting comfortably on a porch with (presumably) Hamida-banu, who holds the child in her lap (pl. 11). Three Turki dancers accompanied by women musicians in the *harem* behind the walls fill the center of the painting with festive activity, dancing on a gorgeous carpet. This was a man's festival, however, having been ordered by Humayun, and a rite of passage for a royal male child, so the imperial *naubat* holds forth outside the women's walls, where other men are gathered but keep careful distance between them and a male sword dancer. The elaborate but delicately detailed painting of this folio, Abu'l Fazl's ornate prose, and Gulbadan Begam's delightful memories seem to merge to render the joy that all participants (except perhaps the child!) must have felt at this event.

From 1545 to 1553, Humayun alternately fought and reunited with his brothers across the Afghan countryside. Finally, under pressure from his nobles, Humayun had his brother Kamran blinded, a Central Asian mode of rendering ineffective a royal heir. From his temporary capital at Kabul, Humayun now laid plans for the recapture of India. The propitious moment arrived, for when Sher Shah's successor, his son Islam Shah, died in 1553 after eight years of troubled rule, he was succeeded by Muhammad 'Adli (Adali) Shah, a less dangerous opponent due, in part, to the family division of Sur holdings upon Islam Shah's death. Thus, the breakdown of Afghan authority coincided with Humayun's growing success. In mid-November 1554, Humayun took a raft down the Kabul River to Peshawar and later crossed the Indus. A ceremony was then held to seek a divine blessing on the undertaking. Twelve-year-old Akbar was solemnly read verses from the Koran, with each reading followed by ritual breathing upon the son by his father.

The combination of military and spiritual forces proved effective. By February 1555, Humayun had taken Lahore. The victory was ascribed to Akbar, who was at once declared heir apparent. The Mughals encountered little resistance in their new, reinvigorated drive into Hindustan until they met the ruler of the Punjab, Sikander Shah Sur, with a large army; the Mughals prevailed at the town of Sirhind. In July 1555, Humayun captured Delhi and Agra from the disarrayed Afghans and was finally restored to the throne.[37] With his father's conquering army, young Akbar ("Great") had come to the heart of Hindustan for the first time. Himself an ethnic mixture—with Turki, Mongol, and Indian blood flowing in his veins—he was to fashion one of the most fabulous empires—an Indian empire—the world has ever known and to instigate and oversee a process of gradual synthesis of culture and Indianization of the conquering family.

CHAPTER THREE

The Interface of *Ḥarem* and Court

In the patrimonial-bureaucratic system of rule which Akbar established, the controlling metaphor was the patriarchal family, and the central element was the imperial household (Blake 1991). Incorporated into the imperial household were wives of numerous heritages. To the fathers who had committed their families to alliance with Akbar by giving him their daughters, and to those daughters who married Akbar, the sense of extended family would have been very important. From the female perspective, for example, the word "family" in "family histories" would probably have borne a more immediate sense than "ancestral lineage." I will suggest in this chapter that three aspects of life in the patrimonial household are revealed in the illustrations of manuscripts, particularly Akbari, with music-making again contributing a kind of subtext, adding sometimes a symbol, sometimes a clue to a complex of meanings. Because few paintings dwell explicitly on female-only scenes, the picture we gain is one of the interface of the female with the male spheres of life—in everyday life, at the crucial moment of the birth of an heir, and in opportune moments of political machinations.

Festivities Patronized from the Ḥarem

From Nur Jahan and Mumtaz Mahal to Indira Gandhi and Benazir Bhutto, some women have played highly visible roles in the subcontinent's history, a reality that defies the general perception by outsiders of women in South

Asian civilization. As the historian John Richards notes, "Certainly the women were much more active and influential than we have been prepared to admit in the past" (pers. comm., July 1994).[1] Although a wife's position in Mughal India was extremely constrained (in relative terms) and she did not ordinarily attend official court functions, it has been shown that in her role as grandmother, mother, or aunt as well as that of wife, it was possible for her to wield considerable power. Similar to our own (at least, "traditional") system, the women organized sociopolitical affairs under the rubric of "feast" or, in grander terms, "festival." As the description below of such a feast shows, preparations for these occasions would have consumed considerable time and expense. This a woman could manage with her own livelihood, for it was possible for wives to gather considerable wealth, and we know from contemporary sources that women of the imperial household were given allowances and other generous stipends.[2] For example, when Hamida-banu Begam, the mother of Akbar, died forty years after her husband's death, she left behind a large treasure store which she had accumulated in her house, with the request that it be divided among her male descendants (Schimmel 1983:30).

Gulbadan Begam, Humayun's half sister, for whom festivities seem to have been a highlight of life, provides a lengthy description of a celebration organized by her sister-in-law. Ostensibly in honor of Humayun's return after he had successfully squelched an uprising by a faction of the Lodi family (the dynasty toppled by Babur; see Chapter 2), it seems also to have been a celebration to mark the completion of Humayun's first year on the throne, perhaps even of his survival. Unfortunately, Gulbadan does not elaborate on two lines in the lengthy descriptive passage: "Young men and pretty girls and elegant women and musicians and sweet-voiced reciters were ordered to sit" and "young people sat in the room and players made music." John Richards affirms that "Mughal women were the architects and entrepreneurs of Mughal social life and in that capacity they arranged for music, and music was such a vital part of social life" (pers. comm., July 1994). Hence we can know that, by virtue of their role as organizers of social occasions of which musical entertainment was a natural part, the women were patrons of music.

> My lady who was Māham Begam, gave a great feast. They lit up the *bāzārs*. . . . Then she gave orders to the better class and to the soldiers also to decorate their places and make their quarters beautiful. . . . [There was] a jewelled throne, ascended by four steps, and above it gold-embroidered hangings, and laid on it a cushion and pillows embroidered in gold. The covering of the pavilions and of the large audience tent was, inside, European brocade, and outside, Portuguese cloth. The tent-poles were gilded; that was very ornamental. [Māham] had prepared a tent-lining and [an umbrella] and [tent walls] of Gujrātī cloth-of-gold, and a ewer for rose-water, for candlesticks, and drinking-vessels, and rose-water sprinklers—all of jewelled gold. With all her stores of plenishing, she made an excellent and splendid feast. . . . [Included among the holdings were] twelve strings of camels, and twelve of mules, and seventy *tīpūchāq* horses, and one hundred baggage horses. She gave special robes of honour to 7,000 persons. The festivities lasted several days. (*HN* 113)

A "House of Feasting," called "the Mystic House," was set up on the bank of the river (presumably the Jamna), and constructed as follows:

First there was a large octagonal room with an octagonal tank in the centre, and again, in the middle of the reservoir, an octagonal platform on which were spread Persian carpets. Young men and pretty girls and elegant women and musicians and sweet-voiced reciters were ordered to sit in the tank.

The jewelled throne which my lady had given for the feast was placed in the fore-court of the house, and a gold-embroidered divan was laid in front of it, (on which) his Majesty and dearest lady [Māham] sat together. On her right sat her paternal aunts [36 are named, some with explanation of relationships]. There were other begams, very many, adding up altogether to ninety-six stipendiaries. There were also some others.

Facing west (was) the audience hall; facing east, the garden; on the third side and facing south, the large octagon; and on the side facing north, the small one. In these houses were three upper rooms. One they named the House of Dominion, and in it were nine military appurtenances, such as a jewelled scimitar and gilded armor. . . . In the second room, called the House of Good Fortune, an oratory had been arranged, and books placed. . . . In the third room, which they called the House of Pleasure, were set out a gilded bedstead and a coffer of sandal-wood, and all imaginable pillows. Then in front were spread specially choice coverlets, and before these table-cloths, all of gold brocade. Various fruits and beverages had been got ready, and everything for merriment and comfort and pleasure.

On the feast-day of the Mystic House, his Majesty ordered all the mīrzās and begams to bring gifts, and everyone did so. [They gathered them all into three heaps and distributed them variously.] No one received less than 100 or 150 [coins], and those in the tank especially received very much. His Majesty was pleased to say: "Dearest lady! If you approved, they might put water in the tank." She replied: "Very good," and went herself and sat at the top of the steps. People were taking no notice, when all at once the tap was turned and water came. The young people got very much excited. [They all came out.]

Then the viands of the feast were set forth, and robes of honour were put on, and gifts bestowed. . . .

On the margin of the tank was a room [wooden, raised above ground level] fitted with talc windows, and young people sat in the room and players made music. Also a woman's bāzār had been arranged, and boats had been decorated. (*HN* 118–26)

What Gulbadan Begam referred to as a "woman's bāzār" is probably the same type of event that Abu'l Fazl dubbed "Akbar's bazar"; both it and the grand feasts demonstrate the enormous purchasing power of the women.

On the third feast-day of every month, His Majesty holds a large assembly for the purpose of inquiring into the many wonderful things found in this world. The merchants of the age are eager to attend, and lay out articles from all countries. The people of His Majesty's Harem come, and the women of other men are also invited, and buying and selling is quite general. His Majesty uses such days to select any articles which he wishes to buy, or to fix the prices of things, and thus add to his knowledge. The secrets of the empire, the character of the people, the good and bad qualities of each office and workshop, will then appear. His Majesty gives to such days the name of *Khushrūz,* or the joyful day, as they are a source of much enjoyment. (*AiA* 1:286–87)

Celebrations on the Birth of an Heir

Of equal significance for "the court" and the *ḥarem* was the birth of an heir. For the official (and male) perspective on that event, written accounts are available. In his memoirs, Jahangir succinctly recounts the circumstances of his own birth (likely based on the frequent retelling of the lore surrounding it). For the many potential mothers of an heir, the tension on their part can only be imagined.

> Till he was 28 years old, no child of my father had lived, and he was continually praying for the survival of a son to dervishes and recluses, by whom spiritual approach to the throne of Allah is obtained. As the great master, Khwāja Mu'īnu-d-dīn Chishtī, was the fountainhead of most of the saints of India, he considered that in order to obtain this object he should have recourse to his blessed threshold, and resolved within himself that if Almighty God should bestow a son on him he would, by way of complete humility, go on foot from Agra to his blessed mausoleum [which he did, as illustrated in the *Akbar Nāma*]. . . . At the time when my venerated father was on the outlook for a son, a dervish by the name of Shaikh Salīm, a man of ecstatic condition, who had traversed many of the stages of life, had his abode on a hill near Sīkrī, one of the villages of Agra. . . . As my father was very submissive to dervishes, he also visited him. One day, when waiting on him and in a state of distraction, he asked how many sons he should have. The Shaikh replied, "The Giver who gives without being asked will bestow three sons on you." My father said, "I have made a vow that, casting my first son on the skirt of your favour, I will make your friendship and kindness his protector and preserver." The Shaikh accepted this idea, and said, "I congratulate you, and I will give him my own name." When my mother came near the time of her delivery, he (Akbar) sent her to the Shaikh's house that I might be born there. After my birth they gave me the name of Sultan Salīm. . . . My revered father, considering the village of Sīkrī, which was the place of my birth, lucky for him, made it his capital. (*TiJ* 1:1–2)

Unlike Abu'l Fazl's ebullient "report" on the birth of Akbar (see chapter 2), the birth of the future Jahangir passes in one reference in the *Akbar Nāma* in one remarkably brief sentence (possibly because this reference was to the mother): "At length, in an auspicious moment, the unique pearl of the Caliphate emerged from the shell of the womb, and arrived at the shore of existence in the city of Fatḥpūr" (*AN* 2:503). The date was 30 August 1569.

The mother (whom Abu'l Fazl neglects to name but whom her son Jahangir revered), Maryamuzzamani, was an Indian Rajput, the daughter of the Raja of Amber, Bihari Mal. This was symbolic in ways both cultural and political, epitomizing the birth of both family and empire. After a series of victories over—in Gwalior in central India, Jaunpur in eastern India, and Gondwana in south central India—and agreements with various Rajput clans, only the leading Rajput power, Mewar, under the proud Rana Udai Singh, resisted incorporation. As head of the Sisodia clan he possessed the highest ritual status of all the Rajput *raja*s and chiefs in northern and central India. Through happenstance, his son had been in residence at Akbar's court; he fled home, ostensibly when asked by Akbar whether he would support him or his own father, Udai Singh, in a confrontation. Akbar moved against Mewar in September 1567, using the Rana's son's flight and Rajput

clan dissensions as pretexts for action, and siding with Amber (confused by some with Jaipur, which was not founded until 1737) and others successfully against Mewar. By granting personal privileges which implied equal status even more than political concessions, Akbar gained Rajput allegiance and partnership in empire. This was the first major political turning point for him because it not only demonstrated the inability of others to defy him successfully, but also signified that he was no longer a foreigner imposing alien rule and religion but rather the "Indian" head of a joint enterprise in empire-building, establishing the "foundation of an *Indian* empire ruled *by* Mughals, rather than a Mughal empire *in* India" (Spear 1972:130; emphasis added). The birth of Jahangir cemented this political point in personal and cultural terms.

With his sympathy clearly on the side of his patron, and also suggesting the reality of the importance of a male heir to the Mughal sovereign, Abu'l Fazl writes a great deal more prose (and verse) to suggest Akbar's reaction to the happy event than he earlier had written about the mother or the birth itself.

Messengers conveyed the happy tidings to Agra, and there was general rejoicing. Delight suffused the brain of the age.

> *Verse*
> Time arranged an assembly of enjoyments
> The cup-bearer sate and the glass rose up
> There was a banquet more joyous than life's foundation
> A cup-bearer unequalled as a drawer of cups
> They made an illumination for the world
> There was a vernal assemblage . . .
> The king came and the desire of friends was fulfilled
> He sate at the feast by the cup and the relish
> His diadem he raised to the sky
> His forehead he fastened to the ground
> He issued a proclamation for the enjoyment
> He invited the world as his guest
> The cup-bearer opened the lid of the goblet
> The treasurer opened the door of the treasury
> The skirt and wallet of the sky were filled
> In order that it might shower pearls on the world.
>
> (*AN* 2:504)

For the occupants of the *ḥarem* such events as the birth of the heir must have held very personal as well as political importance. This is a quintessential example of the interface between the *ḥarem* and the court. Scenes depicting the celebration of the birth in illustrated manuscripts produced in the imperial ateliers must have attracted considerable attention of wives in the imperial household. What would they have seen? How would they have read the pictorial content of such scenes? Two folios illustrate the importance of the occasion in the copy of the *Akbar Nāma* with the earliest paintings: One depicting Akbar's celebration of the news of the birth, the other at the scene of the birth.[3] In the celebratory painting (pl. 12), Akbar indeed "sate at the feast." While the

wine is in clear evidence in the form of a number of readied goblets and the cupbearer filling the glasses of guests on the left, there is just a hint of the feast in the one large covered dish in front of the goblets. The artist placed the "treasurer opening the door of the treasury" in the painting of the mother's side. Dressed in the gossamer-thin cotton worn by the elite in the Mughal period, the fortunate bearer of the news stands on the step of Akbar's dais. Other courtiers—the "friends" in the verse—crowd in behind him and also line the right-hand side of the folio.

While music and dance are not specified in the text, they consume nearly half the space in the illustration, contributing considerably to the air of festivity and bustle of the joyous occasion. There are three different clusters of entertainers; two comprise dancers and musicians so associated with male Mughal scenes that they impart no particular suggestion of the location in Hindustan of the event, nor that the heir was born of a Rajput mother. In one of these two clusters, two female dancers wearing the Turki cap perform closest to Akbar. Standing with them on the left side of the folio are three female musicians actively playing to accompany them; two hold good-sized *dā'ira* and may be singing, while the third plays a vertical flute but holds it up in a strange position. Sounding just as such tambourine-type instruments do today, the *dā'ira* would probably have complemented the rhythm of the dance. There also seems to be a male musician accompanying the Turki dancers; playing a bowed lute, he stands next to a courtier who leans over to greet Akbar. His quiet instrument could hardly have been heard in this busy context.

In the second of these two groups, the performers are all males. A dancer brandishing two heavy, threatening-looking swords moves with a step that looks as if he were running. His clothing corresponds in some respects to that of other sword dancers in Akbari paintings, with pants that stop at the calf and a sash flying with movement. His accompanists are consistent with accompanists of all male dancers in the paintings, the ubiquitous *naqqāra* (here, two sizes) and what is probably intended to be a double-reed *surnā*. Raucous reeds and unmuffled kettledrums would have dominated the soundscape around them. The abundance of music and dance portrayed suggests that the amount of sound in the scene is more than plentiful.

Only in the third cluster of entertainers does the viewer get some sense that we are in Hindustan. Here, I suggest, is the "presence" of the mother of the heir—the Indian Rajput princess of Amber. At the bottom of the painting, two musicians hover at the fringe close to the enclosing balustrade. Clothed in a short *cholī* blouse and with hair uncovered—in total contrast to the covered Turki women—there is no possibility of mistaking that the woman is Indian. Rather than orienting to, and therefore taking part in, the festivities, she and her male companion look toward the stick-wielding marshal beside whom they stand to make their music. Either they are uncertain about him or they are staying close to him for protection in the crowded area; the reason for his raised stick is unclear. In either case, those musicians are definitely not a comfortable pair in the context.

The male musician holds a waisted drum of substantial size, painted by the artist with a red like that used for drums in other paintings, probably suggesting a type of wood. This appears to be a drum that is among the Indian instruments described by Abu'l Fazl. "The *Awaj* is made of a hollow piece of wood, and might be described as two kettle-drums joined at the reverse ends and

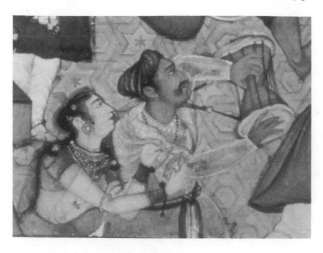

Detail of plate 12

their heads covered with skin and braced with thongs" (*AiA* 3:270). In a translation of the Persian text that differs somewhat from Jarrett's, Francis Gladwin offers this description: "The Awej resembles two falconers drums fastened together. It is braced with strings of silk" (cited in Tagore 1965:206). Gladwin's is more apt, for the falconer's drum was conical-shaped, narrow toward the bottom (fig. 49).

Abu'l Fazl specified further that the *awaj* was also known as the *huruk* (*AiA* 3:271). Several centuries later, Grieg provides a description of today's *huruk* as "an hourglass-shaped drum with two heads laced together. By constricting the laces between them, either with the crux of the elbow or by a string over the shoulder, the pitch of the drum can be altered while it is struck with the fingers" (1987:494). The correlation of Grieg's description with plate 12 (see detail) is remarkable. The lacing is clearly visible, and the player seems to be constricting them in two ways. A strap fastened at the right end of the drum does not go around the man's neck so must be passing over the left shoulder and under the left arm, which he could be pressing down to constrict the strings. He also grasps the lacing with his left hand, with which he must also be supporting the weight of the instrument. He is striking the right head of the drum with his hand flat, as he tightens the lashing with his left hand—which technique would alter the pitch. That awkward position drawn by Kesu Kalan or painted by Chitra looks precisely like the drum and playing technique of the present day.

The woman plays a small pair of *tāla*, the hand cymbals used for marking the metric *tāla*. Such cymbals have abounded throughout Indian music-making from the earliest historical documentation. "The first verse of the 31st chapter of the *Nātyaśāstra* squarely connects ghana instruments—instruments of the cymbal type—with tāla. . . . Cymbal playing was the dominant and distinctive feature of gāndhārva tāla" (Lath 1978:451). Cymbals are varied in shapes and sizes, but are musically definable as a pair of large or small, roughly concave bell-metal or brass plates. The two sections, similar in all respects, are clashed against each other. The general term for such idiophones in India is *tāla* or *tālam*—obviously related to the word *tāla*, or "rhythm," "meter."[4]

In Deva's comments on the various shapes of Indian cymbals, the simplest is just concave without any noticeable flat rim (as in fig. 50) (1978:55), and that seems to be the type described by

Abu'l Fazl: "The *Tāla* is a pair of brass cymbals like cups with broad mouths" (*AiA* 3:270). With some exceptions, in Mughal paintings the cup without a noticeable flat rim is the cymbal drawn by the artists (fig. 17). Occasionally, however, a *tāla* will be drawn to have a rim with a central concavity, the boss, and this painting (pl. 12) of the celebration of Salim's birth is one of those occasions.

The player seems to grasp a ring of cord; such a cord would pass through a hole in the center of the cymbals and be knotted on the inside.[5] This pair of cymbals, with its boss and rim, and with holding cords, is carefully drawn and unlike most others in Mughal paintings. While this is noteworthy, without more drawings of cymbals by the same artists it is not possible to be certain that a different type is really intended. In other paintings as well the two parts are connected by means of a clearly visible cord that hangs down (fig. 51). The cord might be decorated (or made visible in the illustration) by beading along the cord (fig. 19).

The paintings permit some comment about playing technique. The collision of the two parts of a cymbal may be face to face or rim to rim, either vertically or horizontally; in plate 12 the player holds both parts vertically and seems to be moving both of them. Figure 17 (see detail) clearly demonstrates the two parts being struck face to face, but in most of the paintings the convention

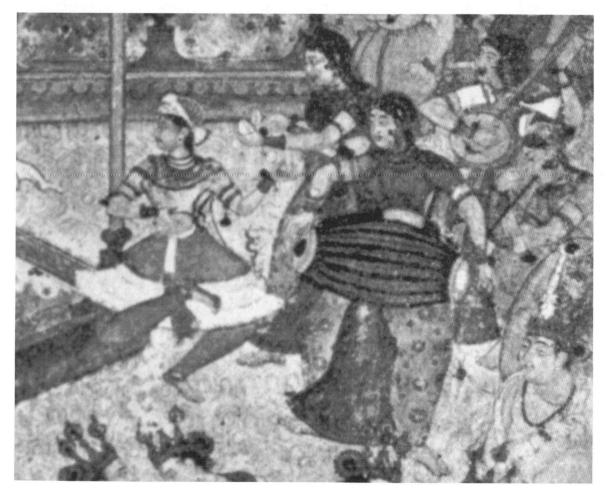

Detail of figure 17

is to show the two parts separately, with movement toward the clash only implied. In some illustrations one of the pair is held relatively stationary—usually by the left hand, while the right hand moves toward it (fig. 52).[6] In these two paintings and others, the left hand seems almost to cup the cymbal, with a thumb up ready to damp the sound perhaps. In a remarkable number of illustrations for such a detail, however, the moving part is held carefully between thumb and index finger in such a way that it would not be damped by contact (fig. 19).

The Indian pair in the scene of Akbar's celebration of the birth of Salim (pl. 12) are identifiable, and we can even imagine what they might be performing. Portrayed with her mouth open, the woman is definitely shown singing. I find no reason to doubt that these are the very musicians of whom Abu'l Fazl wrote:

> The *Hurkiyah* men play upon the *Huruk*, which is also called *Awaj*, and the women the *Tāla*, and they also sing. Formerly they chanted the *Karkha*, but nowadays only the *Dhurpad*, and the like. Many of the women add great beauty to their musical accomplishments. (*AiA* 3:271)

Huṛukīyāh is the term by which a group of musicians who played the *huṛuk* was known. Abu'l Fazl also identifies the *karkha*: "The war songs and heroic chants called *Karkha*, they termed *Sādara*, and these consist also of four, six, and eight lines and are sung in various dialects" (ibid. 267).[7]

Approximately twenty years had passed between the birth celebrated in this scene and the writing of the *A'īn-i Akbarī*. We can imagine—and perhaps the artist intended for his audience to remember—that these *huṛukīyā* could very well have been singing heroic songs (for which they are renowned even today) in honor of the Rajput mother of the newly born prince. But as Akbar's power increased and as his adversarial relationships with the Rajputs decreased, the patrons of such musicians might have discouraged them from singing Rajput heroic songs that would be inappropriate in the Mughal household.

We might further posit that if these musicians are really *huṛukīyā*, then we are provided a fresh perspective on the *dhrupad* (Abu'l Fazl's *dhurpad*) genre in the time of Akbar. In the early sixteenth century, *dhrupad* may have been widespread through the center of the plains area of northern India. Appealing to the masses as well as to the elite, *dhrupad* was espoused by singers of the *bhakti* devotional movement, resulting in thousands of songs about Lord Krishna, the beloved mischievous incarnation of Lord Vishnu, and about the love of the milkmaid Radha for the elusive, flirtatious Krishna. Religious mendicants roamed the countryside singing devotional *dhrupads*, accompanying themselves on the stick-zither instrument, *rudra vīṇā*, and a temple repertoire developed as well.

In historical accounts of Hindustani music, however, *dhrupad* has been associated mostly with Gwalior, a kingdom ruled from 1486 to 1516 by an important patron of music in North Indian history, Man Singh Tomar. With remarkable singers in his employ, *dhrupad* emerged as a court genre whose roots separated it in several ways from the historical *prabandha* form that it came to replace in importance. Composed in the oldest and best-known *rāgas* of the existing classical *prabhanda* but also in more locally known *rāgas*, *dhrupad* was an immediately accessible genre. And

unlike earlier Indian classical vocal music, the texts of which were in Sanskrit, the texts of *dhrupad*s were in the vernacular Hindi language. Finally, eschewing the classical poetic meters of earlier song, *dhrupad* texts were unconstricted by prosodical length of words or syllables. *Dhrupad* marked the beginning of a new era in Hindustani classical music. While we know that *dhrupad* was developed further into the prominent vocal genre at the Mughal court by the great singer Tansen (discussed below), we see here as well that performance of the genre by other than the best classically trained musicians continued in the court context at least through Akbar's reign.

Compared to the levity lent to the scene of Akbar's celebration by the active dancers and implied cacophony of music and human sounds (pl. 12), the companion folio devoted to the mother's side imparts an entirely different effect (fig. 4). Here, one might anticipate a clearer sense of the mother, a more feminine perspective on the birth of the heir. However, this is a very impersonal painting. At the top of the picture is the mother, a familiar symbolic figure whose appearance recalls Akbar's Timurid ancestry rather than the actual mother. Likewise, two thirds of the pictorial space is devoted to the "presence" of Akbar. In the middle register of the painting, his presence is symbolized by the heralding *naubat* ensemble. Spilling from the middle to the lower register, the generosity of the emperor is centrally displayed; as described in the verse cited above, the "treasurer opened the door of the treasury" and servants standing on the parapet pour coins from bags into the bowls, scarves, and hands of the poor who cluster below. As in the painting of Akbar's celebration, the explicitly Indian element within the household is minimal. It consists only of female servants assisting in the mother's chamber in the top register.

To the women in the *harem* who would probably have taken note of every detail in these two paintings, messages appear to be both enunciated and suggested. While there is token acknowledgment of "India" through the two musicians on the male side and through the female servants on the mother's side, there is no real recognition given to the baby's Rajput mother. Akbar was clearly emphasizing the importance of the birth to *his family line:* He seems to be saying that no matter who the mother is, what is important is that "I am the father."

The impression of the political intent of the pictorial content in figure 4 and plate 12 is strengthened when one considers the illustration of Salim's birth in the other surviving copy of the *Akbar Nāma:* the "imperial presence" of Akbar is asserted far less. Supplementing the sparse birth announcement in the chronicle, the artist of the works in the Chester Beatty folios seems to draw on the voluptuous description of Akbar's birth to paint this scene (figs. 53, 54). The mother and child are given two complete folios to themselves. The mother rests as in all other such scenes, while mostly Indian attendants—as would have been appropriate in the essentially Indian household of the princess—are busy with their work (fig. 53). No musicians attend. The companion folio, however, shows not just entertainment, but entertainment appropriate to the birth of an Indian child (fig. 54). Filling the middle register of the painting, sandwiched between the ubiquitous astrologers above and the giving of alms below, are again multiple groupings of entertainers. A complete *naubat* ensemble signifies the rank of the child and represents the father, but they are off to one side rather than taking up almost the full middle register. A duo of male musicians plays the unmistakably Indian *rudra vīṇā* and a flute, and two Indian women dance, accompanied by Indian

women musicians—one playing an Indian cylindrical drum and two singing. The scene is light-hearted, festive, and overwhelmingly *Indian* in pictorial content.

While it may be that the artist, Lal, was being culturally sensitive in this contrasting illustration of the birth of Salim, it is probably more likely that it was the purpose of the illustrations that dictated the difference in pictorial content. If indeed the paintings discussed above (fig. 4 and pl. 12) were produced earlier (c. 1586–87) for a now lost historical text, the Chester Beatty folios painted later (c. 1604) for Abu'l Fazl's text may very well reflect a diminishing need for Akbar to assert his right to rule through such means as pictorial content (see note 3). Looking at it from the point of view of the prince in the painting, there are two interpretive possibilities. On the one hand, Salim's position as heir could by that time be taken for granted. On the other hand, tension was mounting also around this time between the long-lived Akbar and the ambitious Salim. The imperiality of the occasion may have been downplayed as a result of that. In any case, the pictorial content of the two illustrations of the same event are notably different.

Then, in the older original set of paintings for the *Akbar Nāma,* there are also folios illustrating the birth of Akbar's second son, Shah Murad (fig. 55).

> In this fortunate year . . . a noble son, in whose forehead the lights of high fortune were visible, appeared in the fortunate quarters of Shaikh Selīm in Fathpūr. A new rose of the Caliphate bloomed. In a fortunate hour the name of that fortunate prince was inscribed in fortune's page as Shāh Murād. In rejoicing for the rising of this star of fortune, great feasts were held, and largesse bestowed. (*AN* 2:514)

The historian Bada'uni informs us that the festivities for Murad's birth were equal to those for Salim.

> On Thursday the 3rd of the month of Muḥarram in the year 978 there took place in the house of Shaikh Salīm the rising of the star of prosperity and happiness, the Prince Murād. And a royal feast just like the former one was prepared. (*MtT* 2:135–36)

A double-page depiction of Akbar receiving the news is far more conventional than figure 4, resembling the illustrations of Humayun's accession *darbār* (fig. 46) (Leach 1995, 1:244–45).

Dispersed from the 1604 *Akbar Nāma* is a double-page illustration of the birth in 1572 of Akbar's third son, Daniyal, as well (Leach 1995, 1:242 n. 16). That birth scenes were dedicated to three sons recalls the auspicious promise made to the sovereign by Shaikh Salim of Fatehpur Sikri (see p. 75).

The illustration of the birth of Shah Murad may have been directed to the *ḥarem.* Unmistakably weighted with extravagant references to Indian culture, the content of the scene of Shah Murad's nativity might have been intended to soothe the ruffled feelings of the Indian women in the imperial household who found no credit accorded them in the illustrations of the birth of Salim despite the fact that one of them had produced a healthy heir. Bhurah, a painter in the Akbari atelier, reconfirms what must have been realistic touches of Indian culture in the quarters of Indian mothers in Akbar's *ḥarem.* The busyness of this painting is wonderful. Almost every wall is decorated with garlands of mango leaves, and more are being hung by one Indian woman and pulled from a basket held by another Indian woman. Most significantly here, a woman sits playing the

Indian cylindrical drum while another woman sings beside her. Another Indian cylindrical drum hangs from the wall at the very top of the picture. At the bottom is the ubiquitous *naubat* playing away, here accompanying two male dancers who wield sashes instead of swords in this gentler scene of the female side.[8] They are crowded, however, by the bearer of a large cradle who is placed in the center of the bottom register. The astrologers (who are specifically mentioned in the chronicle) are given less space in the painting than the busy Indian attendants in the middle register.

Another possible explanation of the contents of the illustration of Shah Murad's birth is the most esoteric, and also the most politically suggestive. Akbar's consultations with his gathering of learned men encompassed the subject of the legality of his wives according to Islamic law, and it may be significant that the discussion proceeded then to the subject of the children. At issue were two types of marriage: *nika,* the orthodox type between two Muslims which constituted the majority of marriages in the Mughal family through generations; and *muta,* a marriage with a freeborn woman of another religion, involving a pact between the man and the woman. Bada'uni, who considered Akbar's number of wives to be excessive, informs us about the discussion:

> The first of the questions which the Emperor asked in these days was this: "How many freeborn women may a man legally marry by *nikah*?" The lawyers answered that four was the limit fixed by the Prophet. The Emperor thereupon remarked that in early youth he had not regarded the question and had married what number of women he pleased, both freeborn and slaves, he now wanted to know what remedy the law provided for his case. The discussion continued for some time. . . .
>
> The question of the regard for children born of the two types of marriage was considered: The Shī'ahs, as was well-known, loved children born in *mut'ah* wedlock more than those born of *nikah* wives, contrary to the Sunnīs or Ahl-i Jamā'at. On the latter point also the discussion became rather lively. (*MtT* 2:211)

With this illustration, then, Akbar might have been asserting his position on the matter: Murad was born of a concubine, unnamed in a source which unconcernedly relates the fact—the memoirs of Jahangir (*TiJ* 34). There certainly is a warmth and a statement of valuation in this illustration, through the happily busy and celebratory tone it imparts. In one way this is the most personal and loving of all the birth scenes: only here is it the mother who cradles the child in her arms.

In a later painting, "The birth of Salim (Jahangir)," produced in the atelier of Akbar's son for a *Tūzuk-i Jahāngīrī* manuscript, we can see that the convention for depicting the birth of a prince had changed to a certain extent (fig. 56). Not surprisingly for the atelier of Jahangir, portraiture is a prominent purpose of the painting, and his mother is shown almost close up. The woman sitting next to her is possibly Hamida-banu Begam (Akbar's mother), who lived to see many grandsons born and survive. A woman from the older Mughal generation takes the time of birth to the astrologers who wait outside. An Indian drummer and singer are there, not in the background but prominently situated in front of a group of other women. Other than the depiction of astrologers, this is strictly a woman's scene, so much so that even the symbolic presence of the father through the pictorial content of the *naubat* ensemble is missing. With the female figures lined up diagonally to either side, this approaches the format for a court scene with the dais replaced by the mother's

bed. It is almost as if there is a message being sent not *to* the ḥarem, but *from* the ḥarem, and in the reign of Jahangir that is not an impossibility.

In any case, conventional as they might have appeared, the scenes of the birth of a prince were heavily laden with meaning embedded among the illustrations in Mughal manuscripts. As personal as births might seem, they were an essential ingredient in the intersection of the public lives of the men and the relatively more private lives of the women in the Mughal household.

Women Dancers: Crossing the Gender Boundaries

Another facet of communication, and an important bridge between both the public and private and the male and female spheres, although at an entirely different social level, was embodied by the female dancers (fig. 57).[9] That they were integral to life in the male sphere is copiously suggested by the great scenes of festivities already discussed in chapter 2. Women dancers were a constant element not only in forts and palaces, but also on the great hunting or fighting expeditions. Along with drumming and other military music, recitations of heroic poetry, banquets, and lively conversation, Turki female dancers assuaged the heat and dust of life in the field (Schimmel 1983: 24–25). That they entertained in the female quarters as well is suggested by an illustration of the circumcision of young Akbar (pl. 11). Unfortunately, female dance figures in Mughal paintings are so stylized that it is not possible to identify the same persons dancing in both the female and male spheres.

In Babur's memoirs, we find acknowledgment that early on, women dancers had also been a desirable item in the lives of Mughal women. Writing on 12 May 1526 about the distribution of the treasure which he acquired upon his defeat of the Sultan Ibrahim Lodi, Babur remarked: "Indeed to the whole various train of relations and younger children [his daughters] went masses of red and white (gold and silver), of plenishing, jewels and slaves," among whom were the dancing girls of Sultan Ibrahim (*BN* 522). Gulbadan, a recipient of such a gift, wrote of the instructions that her father gave to Khwaja Kilan Beg, who was responsible for delivering them:

> To each begam is to be delivered as follows: one special dancing girl of the dancing-girls of Sulṭān Ibrāhīm, with one gold plate full of jewels—ruby and pearl, cornelian and diamond, emerald and turquoise, topaz and cat's eye—and two small mother-o'-pearl trays full of *ashrafīs,* and on two other trays *shāhrukhīs,* and all sorts of stuffs by nines—that is, four trays and one plate. Take a dancing-girl and another plate of jewels, and one each of *ashrafīs* and *shāhrukhīs,* and present, in accordance with my instructions, to my elder relations the very plate of jewels and the self-same dancing-girl which I have given for them. (*HN* 95)

From other unexpected sources we gain the impression not only that female dancers were commonplace in Mughal court life, but also that they were a regular part of most activities in the cloistered women's quarters. The following episode confirms this and also illustrates the contrasting viewpoints of the chroniclers, Bada'uni and Abu'l Fazl. As usual, Abu'l Fazl takes the official line, probably because Akbar reacted negatively to the episode cited here, while Bada'uni offers a contrary interpretation. First, Bada'uni.

[Shahim Beg was one of the Qurchis of the palace.] When Shāhim Bēg came from the imperial camp to Jounpūr, agreeably with the age of youth, . . . [he] was much occupied in prayer with the congregation, and in thanksgiving and reading the Qorān, and private prayer, and continual sanctity, and never turned his eye to unlawful things. . . . But, since the asceticism of youths is of unstable equilibrium, this piety was in a short time changed to the opposite. . . .

Shāhim Bēg became attached to a dancing-girl named Arām Jān, who was very fascinating, and graceful in her movements; apropos of which:

> No one can force the affections of the heart,
> Nor count on winning or by grace or art:
> Many of beauteous form, and glances sweet,
> Pour forth their heart-blood at the loved one's feet:
> Many a one of fairest cheek, and mild,
> Has been despised by him on whom she smiled.

Shāhim Bēg could not rest till he had gained her, and although the Khān Zamān possessed this girl in lawful marriage, he gave her up to him. He was perfectly happy with her for some days, and then he gave her up, and made her over to ʿAbd-ur-Raḥmān bin Muʾayyid Bēg, who had a desperate fondness for her. When news of the Khān Zamān['s misconduct] came to the court, the Emperor's wrath knew no bounds. (*MtT* 2:14–15)

The story continues, none of it good.

Abu'l Fazl's account assumes quite another tone about the woman in question, undoubtedly because "the Emperor's wrath knew no bounds":

(The story of Aram Jan is this.) She was a prostitute, and ʿAli Quli K̲h̲ān, from love to her, which had its sources in lust, surrendered his futile heart to that street-walker, who was the embraced of thousands and married her. He put her in the rank of his wives, and had the shamelessness to bring that slut to the drinking-bouts which he had with S̲h̲āham Beg in order that she might recite and sing, and become the groundwork of strife. At last S̲h̲āham Beg by degrees fell in love with her, or rather came to lust after her. (*AN* 2:128)

As a wife, Aram Jan would reside in the *ḥarem*, but her life was obviously not a cloistered one. Of note in Abu'l Fazl's passage is reference to her singing, while Bada'uni introduces her as a dancer. From that we might deduce that that group of women was skilled in multiple arts.

Another confirmation that such women were an integral part of life in Muslim Indian culture —and an attempt on my part to restore the reputation of those graceful women we see in the paintings—can be found in Bada'uni's poignant story about another female singer, a type of story which has circulated widely in West Asian culture for many centuries. In endless pages of text resembling the style of present-day soap opera, he relates the tragic love of a Muslim man for the wife of a Hindu goldsmith, thereby recontextualizing an old, familiar West Asian Muslim story. Recognizing his melodramatic style—"For the language of love carried the reins of my pen irresistibly out of the grasp of my control, and prolixity has been the result. Forgive me!"—the staid Bada'uni apologizes, then continues the melodrama (*MtT* 2:122–23):

A somewhat similar event had taken place prior to this. It was as follows: One of the sons of a Shaikh of Gwālyār, who was related to Shaikh Muḥammad Ghous, and was renowned for his remarkable equity and purity, became enamoured of a singing girl in Āgrah:

> In the darkling west of her tresses she mustered
> A hundred caravans of moons, and of planets.
> In the skirt of union and separation she bound
> The ill-fated and the happy-starred alike.
> In the circle of her tresses she hid
> The turban of the circling sphere.

This came to the ears of the Emperor, and he gave that singing girl to Muqbil Khān, who was one of his courtiers. Then the son of the Shaikh having lost the desire of his heart, went one night to the guarded castle, whither his rival had carried his beloved and imprisoned her, and throwing the lasso of determination, climbed up and carried her off.

The Emperor commanded Shaikh Ziyā'uddīn, son of Shaikh Muḥammad Ghous, who now has succeeded to his father on the pathway of spiritual direction and guidance, to bring back that relative of his and that house-devastating woman by means of persuasive advice and friendly counsel. When they came into his presence, the Emperor requested that they would unite them in marriage, but Shaikh Ziyā'uddīn and the others forbade. So the disconsolate lover, being unable to endure his grief, killed himself with a stroke of the dagger, and obliterated his name from the register of existence. And a great dispute arose among the learned men with respect to his interment and burial. Shaikh Ziyā'uddīn said that in accordance with the tradition: "He who loves and is chaste, and conceals his love and dies, dies a martyr," he was a martyr to love, and he ought to be committed to the dust just as he was. . . . But Shaikh 'Abdunnabī, the chief Çadr, and other Ulamās and Qāzīs, who were controllers of the *çadr* court, said that having died unclean and stained with adultery, he was not resting in love; but God knows best! But any rate that singing girl went into mourning, and tearing the skirt of patience, clothing herself with a winding-sheet upon his grave, elected to sweep his tomb, till after some days having gone to the secret chamber of non-existence, they two were perfectly united:

> When the Fair-ones lift up the veil,
> The Lovers expire at the sight of such majesty.

In the paintings, the Turki female dancers constitute a presence which is entirely different from that of the Indian dancers. As much as any pictorial element, they are a reminder of the non-Indian origin of Mughal culture and suggest the maintenance of the style of dance the Mughals would have known before coming to India. The Turki dancers are always fully robed in flowing gowns from neck to floor, conical headgear covers their hair, and at least one sash, sometimes quite wide, swings out from over their shoulders to enhance the sense of motion (plates 8 and 13, for example). Their dance position calls for an erect standing stance without much bending of knees or torso (Vatsyayan 1982:108). It is logical to assume that the Mughal court artists must have observed such a dance style on a regular basis to have depicted it so consistently in so many paintings.

By contrast, a pose struck by Indian dancers, most of whom are male, in these paintings is one of bent knees, with one leg lifted toward the other at about the level of the knee; this is identified

as *ardhamandali* (demi-plié) by the dance historian Kapila Vatsyayan (1982:112). Another Indian dance position is that of legs spread apart with knees slightly bent, feet facing opposite directions (fig. 26 and pl. 4).

While the Indian dancers are likely to wear ankle bells, the Turki dancers almost always use castanets for rhythmic punctuation. As described by Abu'l Fazl, "The *Kath Tāla,* or castanets, are small and fish-shaped. The set consists of four pieces, of wood or stone" (*AiA* 3:270). I have observed that similar castanets of black river stone are used by dancers in Bukhara at the present.

In every case, multiple musicians accompany the Central Asian women dancers: a frame drum is always there, and usually a melodic instrument, mostly voice but sometimes flute. In plate 11 Turki women musicians play vertical flute (*nāʾī*) and *dāʾira* (also called *ḍaf*). The *dāʾira/ḍaf* is the percussion instrument most frequently played by musicians in the Mughal paintings, whether male or female. (When a different drum is present, such as the *huṛuk* discussed above, it is noteworthy.) The morphology that overwhelmingly prevails in the paintings is a single-headed drum; its skin seems to have been glued on, because no tacking or lashing is clearly visible in any of the many paintings of *dāʾira* that I have located. While some frame drums have small bells or clusters of metal rings attached to the frame, in Mughal artistic depiction the jingling idiophone is clearly a set of cymbals. In a few paintings the artist shows both discs (fig. 27; fig. 37, see detail). Also remarkably consistent in artistic rendering are five sets of small metal cymbals, spaced more or less equidistantly around the frame. The space between any two sets of cymbals is sufficient to allow the player to hold the frame. In some illustrations the frame of the instrument is highly ornamented, either inlaid with mother-of-pearl, or with decorative figures painted on (pl. 14, see detail).

With some exceptions, the women players who accompany dancers hold the instrument somewhat out from their bodies and at a height that puts the top of the instrument about even with the nose (figs. 22 and 27). To hold their *dāʾira* as far out from their bodies as the women musicians do, the instruments must be fairly light. In addition, most hold the drum vertically, at

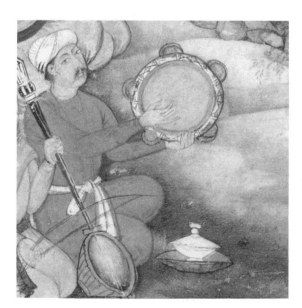

Detail of plate 14

Detail of figure 37

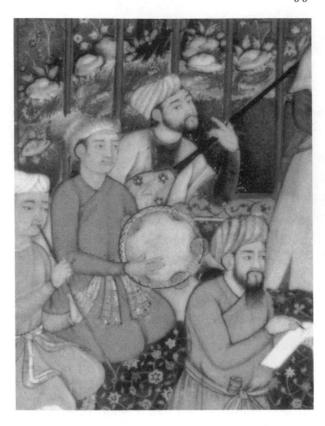

Detail of figure 31

a right angle to their bodies, supporting it at the bottom or slightly up the side. Most performers in Mughal paintings hold their instruments in their left hand and play just with the right hand. The artists show us sometimes the skin side (fig. 58), sometimes the underside of the instrument (fig. 31, see detail; fig. 59).

Like servants in general, whose presence is so ubiquitous as not to be noticed, the depiction of Turki dancing women in Mughal paintings is so conventional that their presence is likely to be taken as stereotypical rather than meaningful pictorial content. Crossing boundaries as they undoubtedly did, however, Turki women were perfectly placed to contribute actively to the cultural synthesis that Akbar was striving to effect, and their rather insistent appearance in the illustrations should be taken seriously.

Accompaniment for Dance: Crossing the Culture Boundaries

Shared as it was by West, Central, and South Asian audiences, the enjoyment of dance accompaniment provided a pleasurable context in which cultural synthesis might take place. Aiding this was a performance practice shared as well—dance accompaniment customarily provided by both a percussion and a melody instrument. One painting in particular suggests that dance, especially dance accompaniment, provided a context for the synthesis of styles under the auspices of Akbar's patronage. What seems to be real musical collaboration among women musicians is drawn in the little masterpiece in the *Dīvān* of Anvari (fig. 18). Though this is an illustration of a book of poetry and

not officially about Akbar, it is Akbar who sits surrounded by women who provide him with wine, a cooling breeze, some delicacies to eat, and dance. The dancer is identifiable as Central Asian though her drapery is more flowing than usual and—most significantly—her knees more flexed in movement. A Central Asian woman plays the ubiquitous *dā'ira*. The other two musicians are Indian, one performing on the quintessentially Indian *rudra vīṇā*, her companion playing a vertical flute.

Whereas historical sculptural evidence shows Indian women accompanying dance playing the horizontal, side-blown flute (Kramrisch 1965, figs. 117 and 118, for example), in Mughal paintings they play the West Asian end-blown (vertical/oblique) flute, the *na'i* (or *nārh*). The *nā'ī* is a relatively long, thin flute with a cylindrical bore that produces a low and sweet tone. Depicted more properly in some paintings than in others, it should be held in a downward and slightly angled position. The flute in figure 18 is unique in one respect—a fipple-like mouthpiece; that it seems so purposefully drawn presents a dilemma for future research.

There is some visual evidence that women played *nā'ī* in Persian culture, as accompaniment for dance and in other contexts. For example, an illustration from a *Shāh Nāma* manuscript of 1439 produced in the Timurid sphere, shows a familiar Persianate type of scene, "Meeting of lovers" who cuddle in an alcove in a palace, accompanied by women musicians playing *nā'ī*, frame drum, and harp ('Ukashah 1983:131, pl. 80; see also chapter 5, note 1 below). While "a couple being entertained" is not a common scene type in Akbari-period painting, there is similar illustration of Deval Rani and Khizr Khan being entertained by a small ensemble of female musicians, among them a player of *nā'ī* (fig. 13).

Because both the Indian horizontal flute and the Persian *nā'ī* were historically part of ensembles that accompanied dance, the flute had potential for cultural synthesis at an early date in Indian musical history. In the thirteenth century, about which relatively much is known musically due to the writing of courtier Amir Khusrau, a *nā'ī* player was one of the "ordainers and organisers of the state musical assemblies" in the court of Allauddin Khalji (Sarmadee 1976:245). Visual evidence, too, places the *nā'ī* in dance ensembles in India in the Sultanate period when cultural synthesis was already well underway. In a 1534 painting of the Sultanate ruler Muhammad Tughluk (fig. 60), for instance, two female dancers holding an *Indian* dance position respond to the accompaniment of female musicians: one playing the Indian *rudra vīṇā,* the other blowing a West Asian vertical flute; another dancer (holding the same position but with opposite leg up) is accompanied by a second group of women: a player of the Indian *pakhāvaj* (barrel drum), singers—one of whom holds the Indian dance *tāla*—and also players of the West Asian frame drum and West Asian long-necked plucked lute.[10]

I offer two hypotheses here, both brash and largely unexplored, to explain the playing of the vertical flute by Indian women in the Sultanate- and Mughal-period dance ensembles. One possibility is that some type of vertical flute was always played in India to accompany dance although it was not documented in sculpture, and therefore the vertical flute in the Sultanate painting is not West Asian.

My second hypothesis concerns the *bhakti* period of religious devotion which permeated In-

dian culture during the Sultanate period. In the *bhakti* period, the Indian horizontal flute became a gendered male instrument, strongly associated with religious devotion through music. It is the instrument of Lord Krishna, the capricious cowherder deity who dances and plays his way into the hearts of every female. For Indian women to have played it in the period of the flourishing *bhakti* religious movement may not have seemed appropriate, with the result that the traditional dance accompaniment on flute used the West Asian *nā'ī*.

That the Turki women dancers shared performance time with Indian dancers and that the two populations of dancers would have been able to observe each others' styles in Akbar's extended household is suggested by a striking scene of a group of Indian women dancers and musicians in the *Akbar Nāma* (pl. 15), which also provides valuable information for Indian dance history. Those dressed in multi-layered skirts are court dancers, formerly in the employ of Baz Bahadur of Malwa and now performing before Akbar, who is sitting high on his throne. As noted by Vatsyayan, the dance movement or pose that has been captured by the designer Kesu Kalan (or the painter Dharm-das) is a crossing of the feet that is a culminating point of movement after having turned a pirouette. The multi-layered skirt swirls out and shows tight pajamas that come down to the ankle which, notably, is not adorned with ankle bells. The dancer wears a short blouse with midriff bare, and covers her hair with a plumed cap. One dancer makes the saluting gesture of touching her forehead with one hand, reminiscent of the greeting gesture of modern-day Kathak dancers. The accompanist for these dancers is most definitely an Indian drummer playing the barrel-shaped drum, *pakhāvaj*. Asserts Vatsyayan:

> The dancers seem to have a unmistakable link with a kind of performance which was widely prevalent outside the court circles. . . . Such short multiple skirts are worn by Krishna in several *rāgamālā* and in other paintings of the late 16th century and early 17th century. . . . These dancers from Baz Bahadur's court represent the transformation of an indigenous popular tradition in a Moghul court milieu. Although Mandu [the capital of Malwa] was cosmopolitan, these dancers represent an indigenous tradition which was perhaps popular and widespread, covering the area from Jaunpur to Malwa. . . . Since Abu'l Fazl does not leave us with as vivid an account of dances as he does of music, we cannot speculate much about the thematic content and stylistic features of this dance. Yet, we can say that the *mṛdaṅga* [*pakhāvaj*] accompaniment with recited mnemonics (*bols*) was an indispensible feature of this dance. (1982:108–10)

Barrel-shaped drums such as the one featured above are scarce in Mughal paintings. It is generally agreed that this type is traceable to the ancient- and medieval-period indigenous Indian drum *paṭaha,* best described as an elongated barrel-shaped drum: the ratio of length to maximum diameter usually exceeds two to one, and the width at the center is usually larger than at the heads.[11] The ancient *paṭaha* had a right head larger than the left and was played with the hands, with sticks, or with both hand and stick. In Mughal paintings such as this one, the width at the center of the barrel-shaped drums is definitely larger than at the heads, and they are always played with the hands.

Among the Indian instruments enumerated by Abu'l Fazl, the drum of this shape was called *pakhāvaj:*

Detail of plate 15

The *Pakhāwaj* is made of a thick shell of wood shaped like a myrobolan and hollow. It is over a yard in length and if clasped round the middle, the fingers of the two hands will meet. The ends are a little larger in circumference than the mouth of a pitcher and are covered with skin. It is furnished with leather braces which are strained, as in the *nakāra* or kettle-drum, and four pieces of wood, under a span in length, are inserted (between the shell and the braces) on the left side and serve to tune the instrument. (*AiA* 3:269–70)

Indeed, tuning wedges are clearly delineated on this very heavy *pakhāvaj,* the right end of which is clearly visible. Three wedges lie under the lashing very close to the right end of the body (pl. 15, see detail).

With both Indian and non-Indian styles of dance and dance music coexisting in Akbar's court, then, it is not surprising to see evidence of synthesis in both music and dance in a painting of that period, as in figure 18. It is only surprising that evidence of such synthesis does not occur in more paintings.

Political Machinations from the Ḥarem *and the Ruler's Response*

While it cannot be doubted that all the women dancers and their accompanists at the court of Akbar were players in the process of cultural synthesis, in the paintings the Turki dancers seem to be used pictorially more as a conventional means of representing the Mughal ruler's Central Asian culture, while Indian dancers are featured in illustrations which are linked to specific incidents. The incident portrayed in the scene of the Indian dancers from Mandu in Malwa performing before Akbar (pl. 15) provides an example of the involvement of women in the patrimonial household in political machinations. While women did not sit publicly on the throne in the Mughal world, privately they were immensely powerful, and *ḥarems* were loci of political and cultural influence.[12]

The political machinations to which plate 15 refers, however, were not on the part of a wife, mother, or aunt: rather, they bring to the fore a figure from Akbar's childhood, Maham Anaga, his former nurse, who

> on account of her abundant sense and loyalty, held a high place in the esteem of the Shāh-inshāh, and who had been in his service from the time of the cradle till his adornment of the throne, and who trod the path of good service with the acme of affection. (*AN* 2:86)

This plate is, in fact, one in a set of four paintings which, though scattered throughout the *Akbar Nāma,* are linked through the subject of Maham Anaga. Those four are linked by the nexus of Maham Anaga to three more concerning Bairam Khan, Akbar's guardian and commander-in-chief. All seven paintings contain music-making, and I posit that by them Akbar sent a message directly to the *ḥarem,* this one firm and stern, to all the women in his household: I demand from you as well as from the men the personal loyalty on which our entire system is built, and there is a high price to pay for involvement in political machinations that challenge me in any way. This point was driven home in the sagas first of Bairam Khan and later of Adham Khan (Maham Anaga's son), both occurring within a relatively short time and both discussed here in detail.

Maham Anaga's political scheming most immediately pertinent to these paintings revolves around Bairam Khan. Akbar was in his fourteenth year when his father died. Appointed Akbar's guardian/regent by Humayun, the able, loyal, and noble Bairam Khan virtually ruled in his ward's name. Several months after Akbar's enthronement, Hemu, a minister of one of the Sur heirs, the weak Muhammad Adil Shah of Chunar, moved against Delhi. The Hindu Hemu claimed royal status through the ancient Sanskrit title of Raja Vikramaditya, trying to resurrect the Sanskritic/Brahmanic monarchic tradition in Hindustan, now long subservient to centuries of Muslim rule. On the now familiar battlefield of Panipat, and with young Akbar at his side, Bairam Khan's triumph there assured the inexorable march of the Mughals as permanent rulers of, rather than peripatetic adventurers in, Hindustan (map 13). Bairam Khan continued his regency until 1560; consolidated Akbar's position; enlarged the borders of empire from the Indus to Bihar in the north and to the east; and held Ajmer, thereby securing Rajput areas to the west, and Gwalior, thus controlling the road south, in essence controlling Hindustan and the entire Indo-Gangetic plain (map 14).

The strong guiding role of Bairam Khan is told in a painting in the *Akbar Nāma* that records the first service provided by the Khan Khanan (commander-in-chief) upon the accession of Akbar in 1556: the "arrest of Shah Abu'l Ma'ali" (fig. 61). The name of Shah Abu'l Ma'ali is profaned by the chronicler, Abu'l Fazl, with such phrases as "ruined by the worship of his own beauty," and "crapulous debauchee," but his major fault actually seems to have been seditious intrigues evincing a lack of loyalty to the child Akbar.

> On the third day after the accession a great assembly was organised in the same delightful spot. H.M. the Shāhinshāh sate on the throne of sovereignty, and the leaders and commanders respectfully stood around. Before this meeting had taken place, a message had been sent to that recalcitrant, announcing that a great festival had been agreed upon, and that affairs of state and finance would be brought forward, and that his presence was necessary. That self-conceited fool made excuses, which were worse than his offence, and among them

were that he had not yet left off mourning (for Humāyūn), and that, supposing that he came, how would H.M. the Sh̲āhinsh̲āh behave to him, and where would he sit in the assembly, and how would the officers come forward to receive him? . . . After making his attendance conditional on certain things which were of no value, he attended. . . . He sate down on H.M. the Sh̲āhinsh̲āh's right hand. It was the time when the festive board was about to be spread, and when he put out his hands to wash them, Tolaq Kh̲ān, who was strong and nimble, behaved dexterously, and coming [from] behind seized both of Shah Abū-l Maʿalī's arms, and made him a prisoner. (*AN* 2:28–29)

The unexpectedness of the arrest is accentuated by the action of a *rudra vīṇā* player who was waiting just outside the enclosure and is being forcefully chased away: as any instrumentalist with concern for a fragile instrument would do, the musician holds it high, hopefully out of harm's way.

Although the event occurred in 1556, this illustration was produced c. 1586–90. Whether or not the artist is suggesting that a *vīṇā* player would have been present for a court session at such an early point in Akbar's reign is unfortunately not possible to tell by this painting; it may or may not be significant that this musician is outside the royal enclosure where petitioners usually are, rather than inside among the courtiers. Basawan, who designed the illustration, was prone to putting music into his illustrations, and there is no *vīṇā* in a second version of this scene, executed by Lal, in a later copy of the manuscript c. 1604 (Beach 1987, pl. 83).

In the early days of his reign, when Akbar was a young, inexperienced teenager who preferred play to business, there were naturally other forces in the court sphere who saw an opportunity to gain more influence for themselves. The most powerful opposition to Bairam Khan came from the fringes of Akbar's family and the *ḥarem* and was headed by Maham Anaga, a shrewd and ambitious woman whose power derived from her former position as Akbar's chief nurse. Her ambition centered on the advancement of her younger son Adham Khan, who, as Akbar's Turani foster brother, was regarded almost as one of the family (Gascoigne 1971:79). So important was Maham Anaga to the history of Akbar's reign that, in an illustration (fig. 62), she is depicted sitting on the carpet below the young Akbar.

By the time he was seventeen, the young king began his own rebellion against Bairam Khan, and several clashes between the two assured alliance between Akbar and the dissident faction of court nobles.[13] As Akbar matured into his responsibilities and wished to demonstrate more independence, Bairam Khan's antagonists seized every opportunity of encouraging Akbar to assert himself over his guardian. Curiously, several of Akbar's relatives, including his mother, Hamida-banu Begam, encouraged a coup. In March 1560, Maham Anaga and Adham Khan tricked Akbar into coming to Delhi without Bairam Khan, who remained at Agra. Since Akbar had begun to assume more personal control of affairs, they were easily able to persuade him to dismiss Bairam Khan from his post as chief minister. In a letter to the Khan Khanan, Akbar suggested that he could choose personal service at court (not as regent) or temporary exile in a pilgrimage to Mecca—the Mughal version of ostracism—and offered to provide him money for the journey. Bairam Khan, though obviously pained at Akbar's refusal even to meet him, was too loyal to accept the suggestion of some of his followers that he should march on Delhi and forcibly rescue the young emperor from his new advisers. Instead, he set off for Mecca after receiving a trusted messenger from Akbar.

As soon as Bairām Khān saw Mun'im Khān he became reassured, and knew that the message which they had brought from H.M. the Shāhinshāh was genuine. He came forward hopefully and embraced him, and showed excessive shame. Mun'im Khān encouraged him by promises and covenants and took him towards the sublime threshold. . . . H.M. the Shāhinshāh accepted his excuses, and with his sacred hand raised Bairām Khān's head from the ground of humiliation and embraced him. . . . Thereafter he rose up and bestowed on Bairām Khān a glorious robe which he was wearing over his own breast, and gave him permission to go to the Hijāz. (*AN* 2:180–82)

The scene of the submission of Bairam Khan to Akbar was illustrated in a folio of the second copy of the *Akbar Nāma,* attributed to the painter Dharmdas (see fig. 36; Beach 1981:105). The choice of the *ghichak* player with the *dā'ira* player as musicians in this scene rather than the more usual *rabāb* or *rudra vīṇā* in Mughal court scenes can be read as meaningful in several ways. The *ghichak* may be emphasizing the location of the incident beyond the central seat of court power in the Siwalik Mountains. In addition, the *ghichak* is more likely to have been depicted in illustrations of incidents such as this in early Mughal history.

The older, overbearing Bairam Khan had run afoul of the maturing and masterful young Akbar, and the ill-fated former Khan Khanan's troubles soon ended. On 31 January 1561, while en route to Mecca, sightseeing in Patan, the ancient capital of Gujarat not far from the pilgrimage port of Cambay, he was murdered in a personal vendetta by an Afghan whose father had died in a battle against forces which Bairam Khan had led five years earlier (Gascoigne 1971:79–80; Richards 1993:14).

When Bairam Khan's days of power were declared over, Akbar bestowed his symbols of authority—his flag, kettledrum, and *tūmān-togh*—on Khan A'azim Atga Khan and made him governor of the Punjab (*AN* 2:182). When the greedy Atga Khan informed Akbar by letter of Bairam Khan's murder, he suggested that the reason for Bairam Khan's death was treason (lack of loyalty) and that he, Atga, should also be given Bairam Khan's office of Khan Khanan. Not surprisingly, his request was denied. To the contrary, in a gesture of loyalty to his former guardian, Akbar extended his personal protection to Bairam Khan's young son, 'Abdurrahim.

News of Bairām Khān's death. . . . reached H.M., the Shāhinshāh, and a gracious order was issued for the attendance of 'Abdu-r-raḥīm. . . . Several true men such as Bābāī Zambūr, Yādgār Ḥusain, brought that new fruit of loyalty to Agra in the middle of the sixth divine year, corresponding to the beginning of September 1561, and submitted him to the testing eye of H.M. and exalted him by prostration on the threshold. H.M. the Shāhinshāh, in spite of evil-speakers and evil-thinkers, received that child of lustrous forehead . . . with inborn kindness, and reared him in the shadow of his own supervision. In a short time he was distinguished by the title of Mīrzā Khān. . . . He was raised to the very highest rank, that of the Khān Khānān. (*AN* 2:203–4)

The illustration of the welcoming of Bairam Khan's young son, 'Abdurrahim, contains all the pictorial elements of a formal Mughal court scene, including the throne raised to the height of three steps, the insignia of royalty, a falconer and a trainer of hunting cheetah, a riderless horse at

the ready for presentation, a cluster of courtiers, and, of course, musicians (fig. 11). The instrumentalist (a *bīnkār*) is a person of generous proportions; he stands flanked by two singers. (Formal court etiquette dictated that all would stand in the presence of the Mughal ruler.)

Much of the power formerly enjoyed by Bairam Khan now passed to Maham Anaga. For two years she, her son Adham Khan, and a cousin, Shihabuddin, who served as governor of Delhi, had almost complete control of the purse and political power. Her involvement in political affairs of the court is pointedly highlighted by means of the only wedding scene illustrated in the *Akbar Nāma*.

> In the end of this year [1561], beginning in fortune and ending in joy. The cupola of chastity Māham Anaga, who was linked to H.M. the Shāhinshāh by real and ostensible ties, and to whose knowledge and perspicacity the bridle for opening and closing all affairs, political and financial, was, through the blessings of the sublime regard to business, entrusted at this time, formed the design of marrying her elder son Bāqī Muhammad Khān. As one daughter of Bāqī Khān Baqlānī had been married to Adham Khān, she wished that the other daughter should be united to her elder son and that she might prepare a delightful banquet in view of the holy advent (of Akbar). With this design she obtained leave from the sublime Court, and engaged herself in arranging this joy-giving festival. The marriage-feast was adjusted according to the rules of magnificent spirits, and alert and skillful attendants on the sublime threshold applied their arts to the fitting up of the premises and to the disposition of the entertainment. At the petition of this fortunate and approved servant H.M. the Shāhinshāh in his abundant grace and favour bestowed the light of his presence on that picture-gallery of delight. (*AN* 2:204–5)

While depictions of marriage celebrations are rare in Akbari-period manuscripts, two full folios in the earlier set of illustrations of the *Akbar Nāma* are devoted to the occasion of the marriage of Maham Anaga's undistinguished elder son (pl. 13, fig. 62). That in itself is noteworthy and invites explanation. With little reason to think that male viewers of the painting would be interested in a wedding scene, this illustration seems to be aimed at a female audience. Furthermore, this scene is remarkable in a second way. Although the marriage was not within the immediate Mughal family, if one were to see only the right side of the double-page illustration (pl. 13), one would assume this to be a royal wedding. The scene is lavish, drawing on all the pictorial conventions used in Mughal art to suggest an imperial festivity. Seated male guests line the top perimeter of the painting. The *naubat* ensemble, representing the favor of Akbar and also his presence at the occasion, is about as large as it ever is in Akbari paintings, including three sizes of the booming *naqqāra,* straight and swan's neck–shaped trumpets, large cymbals, and *surnā*s. As usual, the Turki women dancers are accompanied by female Turki musicians.

Notably, there are Indian women musicians in the scene. Their drum is a cylindrical instrument with the length of the body roughly equal to its widest diameter and therefore a *ḍhol*.[14] Women players seem to have liked to decorate their drums by covering them with brightly colored fabric. While on some it is a brighter color across most of the body (fig. 19), sometimes bordered by a band of dark color at either end (fig. 63), in this scene the fabric covering is spectacularly multicolored (pl. 13). The women in this painting may be those identified by Abu'l Fazl as musicians of the Indian *dhādhi* community who

chiefly play on the *Daf* and the *Duhul,* and sing the *Dhurpad* and the *Sohlā* on occasions of nuptial and birthday festivities in a very accomplished manner. Formerly they appeared only before assemblies of women but now before audiences of men. (*AiA* 3:271–72)

Because there is only one explicitly Indian pictorial element in this entire elaborate pair of pages, the presence of the Indian musicians invites explanation. Putting myself in the place of female "readers" of this painting, I would imagine they would have attracted the attention particularly of the Indian women viewers in the patrimonial household, and I suggest the possibility that they are there to extend Akbar's message to the Indian occupants of his *ḥarem* who were just as capable of political machinations as non-Indians.

The conflation of so much sound and motion into one scene is likely to draw the reaction of modern viewers that the real occasion could not have been as it appears. A reasonable explanation for the implied cacophony is that the artist chose for pictorial reasons to conflate into one scene several different musical ensembles that would have been placed at some distance from each other. Anyone who has experienced an Indian *mela* (festival), however, can imagine just such juxtaposition. An account in 1928 suggests replication of this Mughal scene:

> The girls commenced their performance during the course of a Gargantuan banquet, at which no less than seventy kinds of comestibles were served to the men guests. The only females present were the entertainers and the author, as the Indian ladies of the establishment and their friends were in *parda,* and remained hidden in the *zenana.* The artists possessed most enviable powers of concentration, and remained engrossed in their work, despite the perpetual movement of servants, attendants and other satellites who ministered to the wants of the Maharaja and his suite. Before each song the vocalists ran through the melody with the principal *sárangí* players, who stood close beside them, and during the performance the soloists gave their orders to the instrumentalists. Most of the lyrics were of an amorous nature, as befitted the character of the festivities, and the music continued for about six hours. (Rosenthal 1928:31)

In the illustration of the wedding of Baqi Muhammad, the left side of the double page (fig. 62) shows the imperial favor: the young Akbar sits on a raised seat (his fly-swatter and standard-bearer adjacent), with Maham Anaga comfortably and commandingly seated "beside" him. The men greeting Akbar are probably her sons—the younger being Adham Khan and the older, Baqi Muhammad; but in any case it is clear that Akbar, and not the groom, is the center of attention. The courtiers are protected from the sun on the terrace by a decorative fabric canopy that complements the gorgeous carpets. To the right side of the painting stand two male musicians who would have been there at the behest of their female patron, one playing the West Asian plucked lute called *rabāb* and the other with his hands lifted to suggest that he is a singer. Such a duo would have been equally appropriate in a Persian rendering of a male gathering. At the bottom of the scene a scribe keeps a list of the gifts that are being brought. The overall impression from the illustration is one of opulence and good will.

In February–March 1561, an army under Adham Khan and Pir Muhammad Khan invaded the important kingdom of Malwa, ruled by Baz Bahadur, a household name for both the quality of his *ḥarem* and for his talents as a musician; indeed his love songs in Hindi to the most famous and

beautiful of his women, his principal queen Rupamati, were so popular that they could be heard throughout the bazaars of Hindustan (Gascoigne 1971:79). But his love of the arts and lavish patronage of them drew no kind words from Abu'l Fazl:

> From innate insouciance Bāz Bahādur did not concern himself with public affairs. Wine, which experts have prescribed, in small quantities and at fixed times . . . was made by this man, who was immersed in bestial pleasures, a cause of increased folly, and he was continually indulging in it, without distinguishing night from day or day from night, and was continually using it. Music and melody which the wise and farsighted have employed at times of lassitude and depression, such as arise from the press of business and the burden of humanity, as a means of lightening the mind and of cheerfulness, were regarded by this scoundrel as a serious business, and he spent upon them all his precious hours. (*AN* 2:211)

This exaggerated lambasting of Baz Bahadur (who later joined Akbar's court as a singer) was possibly to set him up for a fall or to justify the conquest of Malwa by Adham Khan's forces.

> Bāz Bahādur, wine-stained and disgraced, hastened off towards Khandesh and Barhānpūr. All his goods and chattels, his seraglio, and his singing and dancing women, who were the material of his pleasures and the decoration of his life, fell into the hands of the victors. (*AN* 2:213)[15]

There are two versions of what happened to the Malwa ruler's possessions. One says that Baz Bahadur himself had left orders with men he trusted that in the event of his defeat, in accordance with Indian custom and the Hindu rite of *jauhar,* they should put all his people to the sword to keep them from falling into strangers' hands. The other suggests that Adham Khan followed the Central Asian practice of wholesale slaughter of the garrison—men, women, and children, Muslim theologians, and Sayyids (descendents of the Prophet). Regardless of who was the instigator, supposedly what happened to his possessions was as follows:

> The chief of them was Rūpmatī, renowned throughout the world for her beauty and charm. Bāz Bahādur was deeply attached to her and used to pour out his heart in Hindi poems descriptive of his love. A monster who had been left in charge of her uplifted the sword of wrong and inflicted several wounds on her. Just then the army of fortune [Akbar's] arrived and brought out that half-slaughtered lovely one. When Bāz Bahādur had fled Adham Khān came in all haste and excitement to Sārangpūr to seize the buried and other treasures, and the seraglio with its singers and dancers whose beauty and melody were celebrated throughout the world, and whose heart-ravishing charms were sung of in the streets and markets. He took possession of all Bāz Bahādur's property, including his concubines and dancing girls, and sent people to search for Rūpmatī. (*AN* 2:213)

According to Abu'l Fazl, rather than be captured, Rupamati took poison.

Adham Khan was seized with his own arrogance. Though brave in battle, he was impetuous, cruel, and totally unfitted for any responsible command. He hosted a great feast of victory and distributed presents, as was the custom, but reserved for himself all the exquisite articles, stores of treasure, and many of the famous dancing beauties, singers, and musicians. He sent some elephants to Akbar, along with the news of the victory, but neglected to offer all that he conquered, as was

the rule (see below). Akbar recognized Adham Khan's insolence and, considering his greed (and other actions) to be seditious, set out for Sarangpur to take charge of the situation (followed swiftly by Maham Anaga, who was justifiably angry but also concerned about her son's behavior). Adham Khan had no choice but to pay obeisance to the emperor, and

> produced before His Majesty whatever had come into his hands from Bāz Bahādur's estate, whether moveable or immovable, as well as all the wives, dancing girls and courtezans. His Majesty in accordance with his general benevolence accepted them. (*AN* 2:221)

The scene of Akbar watching the performance of the dancing girls, then, was not a glimpse into his patronage of the Indian arts; it is a political painting, showing him in possession of what he deemed was rightfully his (pl. 15).

This system of turning over all booty to the Commander was one in which Mughal and Indian custom were in accord. As noted by Manu, the great ancient lawmaker of India: Chariots, horses, parasols, money, grain, cattle, women, all kinds of goods, and base metals all belong to the one who wins them (Davis 1993:27). In ancient Indian custom it was a matter of "victory," not of theft. The moral question for the Indians of Manu's time, as for the Mughals of Akbar's, was not whether one may expropriate objects (and living property as well) from defeated opponents, but how one should properly distribute the booty. And that was the crux of Adham Khan's trouble, for the ambitious son of Maham Anaga had initially sequestered for himself the booty (dancing girls and musicians) from the defeat of Baz Bahadur in Malwa rather than yielding it to Akbar. No doubt adhering to his respect for Maham Anaga, Akbar forgave Adham and, having properly received the dancers,

> presented him with some of them. [Akbar] stayed four days in Sārangpūr, . . . then set out on his return to Agra. [Almost immediately] Adham Khān gave way to evil thoughts and disgraced himself for ever and ever. . . . As folly and blindness of heart were the confirmed qualities of Adham Khān he intrigued with his mother's servants who waited in the royal harem, and spirited away from the Shāhinshāh's enclosures two special beauties from among Bāz Bahādūr's women and who had been recently exhibited to His Majesty. (*AN* 2:221)

In order to prevent Akbar from discovering the truth about their disappearance and to protect her son, Maham Anaga had the two women killed.

But Adham Khan outdid himself in his deceit and treachery (fig. 64) when, angered by Akbar's appointment of another noble as the chief minister, Adham Khan led an attack that killed the new *vakīl*.

> The account of this affair is that Adham Khān, the younger son of the cupola of chastity Māham Anaga, had neither understanding nor good conditions. He was intoxicated by youth and prosperity and was continually envious of Shamsu-d-dīn Muḥammad the Ataga Khān. Mun'im Khān, the Khān-Khānān, also suffered much from this malady and used to throw out dark hints such as the generality could not comprehend and instigate Adham Khān to strife and intrigue. At length on the day of . . . 16th May, 1562 . . . an extraordinary occurence, which was far from equability, took place. On a court-day Mun'im Khān, Ataga Khān, Shibābind-din Aḥmad Khān and other magnates were sitting in the royal hall and

transacting public business, when Adham Khān suddenly entered in a riotous manner and attended by others more riotous than himself. The members of the assembly rose up to do him honour and the Ataga Khān rose half-up. Immediately upon entering Adham Khān put his hand to his dagger and went towards the Ataga Khān. Then he angrily signed to his servant Khūsham Uzbeg and the other desperadoes who had come with their loins girt up for strife saying: "Why do you stand still?" The wicked Khūsham drew his dagger and in-flicted a dangerous wound on the breast of that chief-sitter on the pillow of auspiciousness. The Ataga Khān was thoroughly amazed and ran towards the door of the hall. Immediately thereon Khudā Bardī came and struck him twice with a sword. That great man was martyred in the court-yard of the hall of audience. A loud cry arose in the palace on account of this outrage, and general horror was exhibited in that glorious abode. That doomed one in spite of his past audacity presumptuously advanced towards the sacred harem—to which there be no access for the wicked—with evil intentions. His Majesty the Shāhinshāh had gone to sleep in the auspicious palace, but his fortune was awake. . . .

In short, His Majesty was awakened by the dreadful clamour and called for an expla-nation. As none of the women knew of the affair he put his head outside of the palace-wall and asked what was the matter. . . . When His Majesty the Shāhinshāh saw the body he became nobly indignant. From a Divine inspiration he did not come out by the door where that demented wretch was standing and meditating evil, but by another way. As he was coming out, a servant of the seraglio put into his hands without asking for it, the special scimetar [sic] . . . When he had passed over one side of the terrace and had turned into another he saw that villain. . . . That presumptuous wretch hastened to seize His Majesty's hands and to say "Inquire and deign not deliberate!"

His Majesty withdrew his hand therefrom and struck him such a blow on the face with his fist that that wicked monster turned a summersault and fell down insensible. Farhat Khān and Sangrām Ḥūsnāk had the good fortune to be present. His Majesty angrily said to them, "Why do you stand gaping there? Bind this madman." . . . The righteous order was given that the fellow who had outstepped his place should be flung headlong from the top of the terrace. Those shortsighted men . . . did not throw him down properly, and he remained half-alive. The order was given to bring him up again and this time they dragged him up by the hair and in accordance with orders flung him headlong so that his neck was broken and his brains destroyed. In this way that blood-thirsty profligate underwent retribution for his actions. (AN 2:269–72)

The depth of Akbar's feeling is understandable in light of his relationship with the slain man. Shamsuddin Muhammad Ataga Khan, the son of a simple farmer of Ghazni, had entered the service of Humayun's troublesome brother, Kamran, as a common soldier. After Humayun's defeat at Kanauj, Humayun crossed the river "on an elephant" and dismounted on the other side, where a soldier who had escaped death in the current stretched out his hand to assist him to jump up on the high bank. This soldier was Shamsuddin; Humayun kept him in his service and subsequently honored him by appointing his wife to be a wet nurse to his infant son Akbar at Umarkot. Shamsuddin remained with the child Akbar while Humayun was in exile in Persia, and after the Mughal ruler's restoration received the title of Ataga (foster father) Khan.

Akbar himself informed Maham Anaga of the execution of her son, saying simply "Adham

<u>Kh</u>ān killed our Ataga, we have inflicted retaliation upon him." To which she replied, "You did well" (*AN* 2:274).

Like the scenes of the wedding of Maham Anaga's older son, and the illustration of the Indian dancers performing before Akbar, the recording of the downfall and death of Adham Khan is not a conventional depiction, as are so many of the Mughal paintings, but the capturing of an extraordinary single occurrence (fig. 64). Akbar appears on the upper terrace from the *ḥarem* quarters and faces the men to whom he gives the fateful orders. Adham Khan falls headfirst, about to hit the ground. The slain man lies in the bottom left corner and courtiers flee from him. A *bīnkār* who would have been providing entertainment for the functioning court holds his instrument with one hand and runs off to the left. An Indian *huṛukīyā*—grasping his drum with one hand—and his female fellow musicians run frantically from the falling body of Adham Khan (see detail).

The presence of musicians suggests three possibilities. One is that Akbar was so angry that he moved unexpectedly swiftly to punish Adham Khan, thus surprising all who were tending to their regular business and into whose midst he was suddenly hurled to his death. Pictorially, the motions of the musicians emphasize the suddenness. It is also possible that Miskin, the painting's designer, included them in order to rouse the memory of the earlier Malwa affair, when Adham Khan had sequestered the musicians and dancers, thereby further justifying Akbar's judgment. But there is another and, I think, stronger likelihood that such musicians really were present on that occasion. The close correspondence between Abu'l Fazl's account and details incorporated in a second illustration of this same scene imply that the drummer and Indian women had been summoned or were expected to be there on that occasion. An unfinished illustration in the Chester Beatty manuscript (fig. 65) affirms Akbar's emergence from the *ḥarem* quarters by showing a woman handing Akbar his sword while two other females stand just behind her in the doorway on the upper terrace. The bloodied, slain Ataga Khan lies more prominently on the ground where Adham Khan is about to land. The *bīnkār* who is included in figure 64 is not included in the second illustration, but the

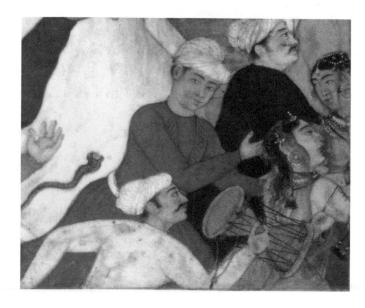

Detail of figure 64

huṛikīyā musicians are. In both paintings they are featured down among the courtiers who are conducting a typical day of business in the imperial household. A further implication of the musicians' presence at the event is that their type of music—regional Indian music—was included in the regular music-making of palace life.

In a final act of loyalty to his former nurse, Akbar built the overly devoted mother and her viciously ambitious son a superb tomb near the Qutb Minar (Asher 1992:39, 41–43). In the four non-conventional paintings for his official chronicle, the *Akbar Nāma,* however, those involving Maham Anaga seem to convey an admonition directly to the *ḥarem:* See how good Akbar was to Maham Anaga (the fabulous wedding with his attendance and blessing), look what the son for whom she schemed did to Akbar (the episode of the booty and the murder of Ataga Khan), and ponder hard on the results (his death). Akbar demands from you as well as from the men the personal loyalty on which our entire system is built, and there is a high price to pay for involvement in political machinations that challenge him in any way.[16]

PART TWO

THE CULTURAL AGENDA

The "Great Mughals," from Akbar to Aurangzeb

CHAPTER FOUR

Music in Akbar's Court and Paintings

The rendering of music in paintings or manuscripts in the Mughal era reached its apogee in the Akbari period. Not only did Akbar commission an extraordinarily large number of new manuscripts relative to his predecessors and successors, but the amount of music-making in the paintings in those manuscripts is enormous. In this chapter, I explore this phenomenon and provide documentation to support the interconnected reasons I note for its preponderance. Among those reasons, for example, was the precedent for the inclusion of music-making in all the stylistic traditions with which the Mughal painting style intersected: In Persian art, in illustrations of the Muslim courts in the pre-Mughal Sultanate period in India and in the contemporary Deccan, and certainly in Indic artistic traditions from time immemorial. A second reason—that the patronage of music by Mughal rulers was a given—has been introduced in the preceding two chapters. It seems logical that music-making would have been featured in paintings that illustrated various events in the lives of the Mughals and would have been included in the visual historical record. If music-making in the illustrations were to be explained only by Akbar's inherited Persian and familial Timurid sense of artistic appreciation, then one could expect that his son Jahangir, with his efforts to renew his Persianate roots, would have followed the tradition in the paintings produced for him. However, the percentage of illustrations that include musicians in the pictorial content is much higher in Akbari-period paintings relative to those produced for Jahangir, a great patron of

105

the miniaturists. A third reason has to do with traits and interests of Akbar. Other reasons derive from the art form itself, in terms of painterly considerations, placement in manuscripts, and artists' preferences.

The relationship of a painting to the prose or poetry of a manuscript certainly influences musical content. From the very nature of the prose which the illustrations graced, we would expect to find music-making in paintings for the copies of the *Bābur Nāma,* for instance, and from those illustrated memoirs of Akbar's grandfather we gain a lively sense of Babur's pleasure in music and dance.

The Addition of Sound to Visual Image

To the visual content of illustrations, a musician playing or even holding an instrument added sound. For someone with Akbar's aural acumen particularly, "seeing" would also be "hearing" in the mind's ear in a manner similar to that in which musically literate singers and instrumentalists see notated music and "hear" it. Numerous examples of this have already been cited: The *naubat* ensemble, Turki women musicians, and Indian women musicians in the celebration of the marriage of Maham Anaga's son create the sensation of aural cacophony (pl. 13) just as the postures of the dancers create the sensation of motion. In the painting of the fighting entertainment provided by Babur for visiting ambassadors, the drums, cymbals, and double-reed add musical sounds to those of scuffling or urging of the watchers (fig. 43). The sound (and motion) in the center of the painting of the celebration on the birth of Salim (fig. 54) is given primacy in the pictorial content; without the musical sound the sober astrologers quietly consulting and the pushing poor frantically begging would create a scene entirely without the feeling of festivity. Without the imagined sound from the *bīnkār* and singer in figure 66, the pleasure of the central figure would be considerably reduced. The complementary sonorities so characteristic of West Asian culture—recitation from a book and musical sound—are emphasized in the orientation of the central person in figure 67, a scene depicting ideal elements of a good life. In the crowded scene of rival *sannyāsī*s fighting, the easily imagined harsh blasts of the conches seem to drive the motion of the figures forward (fig. 20). And the effort to scare away the crocodile that frightens the fish which jumps into one of Babur's boats becomes an aural one with the blasting of horns and beating of drums (pl. 9).

Such obvious aurality is present also in military scenes. Without the pounding of the huge kettledrum, the sight of the bullocks dragging cannons uphill during a seige by Akbar's forces would come across as sheer drudgery; instead, one can "hear" a working cadence urging men and animals upward (fig. 68). A pair of very large drums is mounted on the cannon that had to be pushed and dragged up the side of a steep ravine for the seige in February–March 1569 of a Rajput stronghold, the great fortress of Ranthambhor. Pounded at full force by the drummer who sits astride the weapon, the sound of the great drums must have thundered back and forth in echoes through the ravine. Designed by Miskin and painted by Paras, the scene is crowded with struggling laborers, mighty bullocks, craggy rocks with trees with exposed roots clinging to them, tops of the tents in the camp below, and cannons already in place being fired above. Providing a natural coun-

terfoil, and true to Miskin's love of painting animals, a mountain goat peers out between a tree and the cannons as if undisturbed by it all, while at the top of the mountain calmly stand Raja Todar Mal and Qasim Khan, the leaders in charge.

Akbar's Aural and Musical Interests

Evidence of Akbar's aural acumen is provided by different types of information. Recall, for instance, that Akbar's means of study was to hear books read to him; the *Babur Nāma* was a favorite, and he referred to it as "The Memoirs of Babur, the Conqueror of the World, which may be called a Code to Practical Wisdom." Significantly, he chose book readers for their pleasant voices (Moynihan 1979:115); for the daily prayers (before dawn, midday, afternoon, after sunset, and bedtime), he also chose readers for the sound of their voices, among whom was the irascible historian, Bada'uni:

> And in this year the Emperor, on account of the beauty of my voice, which was comparable with the sweet voice, and ravishing tones of a parrot, made me the Reader of the Prayers on Wednesday evenings, and entered me among the seven Imāms [private chaplains, Akbar had one for each day of the week]. And the duty of summoning the congregation on that day and night he commited to Khwājah Doulat Nāzir Ghaif Shadīd (a eunuch, neither man, nor woman), and appointed him to look after me that I should be present at the five hours of prayer. (*MtT* 2:231–32)

That Akbar possessed a critical ear is also revealed by a passage in the *Akbar Nāma:*

> One of the occurrences was the amazement of the superficial at the knowledge of mysteries possessed by H.M. One day he heard in his privy chamber the beating of a drum. Though those who had access there searched for the drummer, they could find no trace of him. It fell from the mouth full of pearls, "Something tells me that it is the admirable work of Yār Muḥammad." When they searched they found it to be so. (*AN* 3:343)

If one were to believe the prediction in his horoscope, it is not surprising that Akbar is said to have possessed some musical acumen himself as a player of the drum, the *naqqāra*. Whether this was actual musical practice, or an "active" interpretation by Abu'l Fazl of the symbolic association of the Mughal sovereign with the *naqqāra*, is impossible to know from the following passage, which is appended to the list of instruments in the imperial ensemble.

> In his knowledge of music, His Imperial Majesty holds a position which even the master of this art do not have. Likewise he excels others in observing all grades of excellences involved in the performance of this easy-looking but difficult art. In particular [he has no equal] in the art of *Naqqāra(h)-Nawāzī*.[1]

Like his grandfather, Akbar appointed musicians to be courtiers (and courtiers, musicians). Bada'uni, whose attitude toward Hindus is exposed in the telling, informs us about an Indian musician whom Akbar elevated to a position of authority.

> The Emperor from his youth up had shown a special predilection and inclination for the society of various religious sects, such as Brahmans, and musicians, and other kinds of Hindūs. Accordingly at the beginning of his reign a certain Brahman musician, Gadāī Brahma-

dās by name, from the district of Kālpī, whose whole business was perpetually to praise the Hindūs, and who was possessed of a considerable amount of capacity and genius, came to the Court. By means of conversing with the Emperor and taking advantage of the idiosyncracies of his disposition, he crept day by day more into favour, until he attained to high rank, and was honoured with the distinction of becoming the Emperor's confidant, and it became a case of "Thy flesh is my flesh, and thy blood my blood." He first received the title of Kab Rāī, meaning Prince of Poets, and afterwards that of Rājah Bīrbar meaning "Renowned Warrior." When the Emperor's mind became alienated from Rājah Jai Chand, commandant of Nagarkōt, who was in attendance at the Court, he appointed that fortess as jāgīr to Bīrbar, and having imprisoned Jai Chand, he wrote a farmān to Ḥusain Qulī K͟hān, ruler of Lāhōr, to seize Nagarkōt and hand it over to Bīrbar. (*MtT* 2:164–65)

To summarize this event, the capture of Nagarkot involved the taking of a Hindu temple outside the city and a massacre of considerable proportions, which, to the bigoted Bada'uni, seems to have been a source of relish:

On this occasion many mountaineers became food for the flashing sword. . . . And black cows, to the number of 200, to which they pay boundless respect, and actually worship, and present to the temple, which they look upon as an asylum, and let loose there, were killed by the Musulmāns. . . . So many Brahmans, sojourners in the temple, were killed, that both friends and strangers heap a thousand thousands of curses on the head of Bīrbar, who reckoned himself a saint among the Hindūs (curse on them!). So the outer city was taken. (*MtT* 2:165).[2]

Bada'uni also reported on a courtier who was a musician and sent on a political mission by Akbar. In this instance, the courtier seems more to have been a generally cultured person rather than primarily a musician; he had been in the service of an Indian ruler whom Akbar had defeated.

In these days, the Emperor sent . . . Mahā-pātra *Bād farōsh* (who had been of the favoured courtiers of Shīr Shāh and Islīm Shāh, and was without a rival in the science of music and Hindū poetry) on an embassy to the Rāja of Orissa who was distinguished above the other Rājas for his army and military pomp. (*MtT* 2:77)

A poem (see p. 65) heralding the birth of Akbar in the *Akbar Nāma* is also suggestive of the musical array of Akbar's future court. He was a patron of musicians on a grand scale. In the most frequently cited portion of the *A'īn-i Akbarī* that concerns music, Abu'l Fazl lists thirty-six imperial musicians whose homelands are as diverse as the poem suggested was the ideal (*AiA* 1:681–82). They came not only from throughout the subcontinent, but from diverse places in present-day Russia, Turkey, Afghanistan, China, Iraq, and Iran.

Akbar's Greatest Musician, Tansen

In the prose text of the *Akbar Nāma,* musicians Akbar patronized are rarely mentioned by name, but one certainly is: Tansen, who graced the court of Akbar from 1562 until his death in 1586 and who, by oral tradition, is considered the most illustrious musician of medieval India. Abu'l Fazl's entry leaves no doubt that Akbar's patronage of Tansen was initiated as a political act in his effort to bring Ram Chand, the Baghela Rajput ruler, under his control. "Among the three great Rājas of

Hindūstān whom Bābar mentions in his memoirs, the Rājas of Bhath are the third" (*AiA* 1:445); and Ram Chand in Akbar's time was still proving the merit of that designation.[3]

> Among the occurrences was the coming of Tān Sen to the holy court. The brief account of this is as follows. Inasmuch as the holy personality of H.M. the Sḥāhinsḥāh is a congeries of degrees, spiritual and temporal, and a collection of divine and terrestrial excellencies, so that when matters are discussed the master of each science imagines that the holy personality has devoted his whole attention to his particular subject, and that all his intellect has been expended on it, the knowledge which H.M. has of the niceties of music, as of other sciences, is, whether of the melodies of Persia or the various songs of India, both as regards theory and execution unique for all time. As the fame of Tān Sen, who was the foremost of the age among the kalāwants of Gwāliār came to the royal hearing and it was reported that he meditated going into retirement and that he was spending his days in attendance on Rām Cand the Rajah of Pannah, H.M. ordered that he should be enrolled among the court-musicians. Jalāl Ḳhān Qūrcī, who was a favourite servant, was sent with a gracious order to the Rajah for the purpose of bringing Tān Sen. The Rajah received the royal message and recognized the sending of the envoy as an honour, and sent back with him suitable presents of elephants of fame and valuable jewels, and he also gave Tān Sen suitable instruments and made him the cheek-mole of his gifts. In this year Tān Sen did homage and received exaltation. H.M. the Sḥāhinsḥāh was pleased and poured gifts of money into the lap of his hopes. His cap of honour was exalted above all others. As he had an upright nature and an acceptable disposition he was cherished by a long service and association with H.M., and great developments were made by him in music and in composition. (*AN* 2:279–80)

Bada'uni's sympathy in this incident seems to have lain with Ram Chand:

> This Rām Chand in his natural disposition was of such high spirit, that he has none equal in our days. And among his presents was this: he gave in one day a *kror* of gold pieces to Miyān Tānsingh, the musician. . . . Miyān Tānsingh did not wish to leave him. Finally Jalāl Ḳhān Qurchi came, and brought him back to his sense of duty. (*MtT* 2:345)

Khandalavala and Chandra suggest that Tansen had not been with Ram Chand for more than seven years, since "Raja Rāmchand in all probability persuaded Tānsen to come to his court when the Sur paramountcy ended with Humayun's victory in 1555" (Khandalavala and Chandra 1955–56:14). From such stuff as the mutual attachment of Ram Chand and Tansen comes legend; Ram Chand treasured him and did not want to give him up and, quite possibly, Tansen did not want to go.

> When the time came for Tansen to depart permanently from the Raja's court, a diamond bracelet was also gifted to him. Tansen promised, "My right hand which has worn this ornament will not receive any other gift from any other patron"; and, they say that he never accepted a gift from anyone with his right hand. (Deva 1974:52)

By a rule of etiquette, the implication here is that Tansen never accepted any further gifts.

In Abu'l Fazl's entry about Tansen's coming to the court of Akbar in 1562, the singer does not yet bear the honorific "Miyan" before his name, so it can be conjectured that that title, which shows respect to an elder, was "awarded" him in Fatehpur Sikri. Bada'uni refers to him consistently with

the honorific as part of his name. Responding to the generosity of Akbar, Tansen composed texts, such as the following, praising his patron in a manner greatly pleasing to the Mughal.

> The *cakravarti* king *Akbar* adorned the throne at a time when there were many auspicious planets all around. Even the wicked people started serving the king by holding his umbrella. His kingdom is like a heaven in which all the noblemen and kings live. The king removes all the suffering of the people. *Tānasena*—the composer—blesses the king for having such fortune. (Srivastava 1977:46)

Where, then, is the illustrious Tansen among the musicians in the illustrations of Akbari-period manuscripts? Probably only in one or two surviving formal portaits, although there are several other paintings in which a musician is identified as Tansen. That there would be a portrait of Tansen is due to Akbar's individualistic creativity: Without precedent in Islamic or Indian painting, realistic portraits of individuals were his innovation. Abu'l Fazl noted that at the sovereign's command portraits were painted of all his grandees and an immense album formed: "Those that have passed away have received a new life, and those who are still alive have immortality promised them"(*AiA* 1:115). These pictures are almost always of a single person standing with hands folded in an attitude of respect, against a green background; they are true portraits (Smart 1981:104). Two such paintings have been identified as Tansen (figs. 69, 70).

Identification of portraits of Tansen is an issue in two publications, Khandalavala and Chandra 1955–56 and a response by Hiren Mukherjee (1969). Khandalavala and Chandra nominate a portrait (fig. 69) in the National Museum in New Delhi as authentic; Mukherjee presents unconvincing arguments to refute that opinion. Given to the National Museum by the Maharana of Udaipur, the portrait in question was painted probably between 1585 and 1590 when Tansen was about fifty-five years old. Tansen is shown to be a tall man of dark complexion with a sharp aquiline nose, pointed chin, drooping moustache, and side whiskers. He wears a thoughtful and somewhat dreamy expression. His hands are small, with long, sensitive fingers. Whereas in most Akbari portraits the persons stand with hands folded, this man faces right, clapping his hands, apparently in the attitude of singing, thereby suggesting his profession. The figure wears a white *jāma* reaching to the ankles, a *dupaṭṭa* crossed over the chest, and a *kamarband* to which dagger and knife are attached. The long *jāma* was not the court dress of Akbar's time, though it is seen on rare occasions in paintings, but was in vogue in the Deccan at the court of Ibrahim Adil Shah of Bijapur and at the Ahmadnagar court.[4] Perhaps those from Gwalior and other Kalawants affected this long *jāma,* or it may be that Tansen had adopted this costume at the Sur court of Muhammad 'Adli or at the Rewa court and continued to wear it (see biographical discussion below). The small, tightly bound turban and long narrow *paṭkā* (waist sash) ends are characteristic of the Akbari-period style, however (Khandalavala and Chandra 1955–56:15–17). A very similar person stands in a painting in the Chrysler Museum in Norfolk, Virginia (fig. 70). Because an inscription (reading *"shabīh-i tānsen"*) across the bottom of the figure's long white *jāma* identifies him as Tansen, Brand and Lowry (1985:150) present the portrait without argument as one of the great singer. Though shown against the standard flat green background, he has been anchored in space on a flower-strewn field. In both portraits the figure has bells or tassels hanging from his waist as well as the knife tucked into the sash. In the Chrysler

Museum painting (fig. 70), the figure holds a managerial staff that would have been appropriate for Tansen's position but does not identify him as a musician.

Musicians depicted in other Mughal paintings have also been identified as Tansen by various art historians, and some of those identifications provide musicians in North India today with a significant historical link to Tansen: to him is traced the musical authority of the Seniya *gharānā* of players of plucked instruments. Tansen's connection to instrumental music is traceable through the marriage of his daughter (discussed below), but the assumption is also made that Tansen himself played instruments.[5]

In non-portraiture Mughal scenes which feature several personages, scholars have identified musicians as Tansen, but Khandalavala and Chandra argue against those proponents on art-historical and pictorial-content grounds such as details of costume. Among those is "The arrival of Tansen, the musician, at the court of Akbar, A.D. 1562," which the art historian Percy Brown, in an early work (1924), fairly certainly asserted to be a miniature dated with "a fair degree of accuracy" as an early Akbari-period painting (Brown 1981:56). There is now general agreement by art historians that Brown's dating of the execution of the painting was far too early, that the painting was done in the Shah Jahani period or later. The composition of the painting, however, is held "to be Akbari and this may be a rather faithful copy" (M. C. Beach, pers. comm., July 1994). On musical grounds I suggest that when the painting was copied, the instrumentation was updated. According to Brown, it is Tansen who stands with a small group of musicians below and to the left of Akbar in figure 71, accompanied by players of *ṭāmbūr* and *dāʾira*. I discuss below that the use of a *ṭāmbūr* in that manner occurs from Jahangiri paintings forward, not in Akbari paintings. In any case, if this really is a correctly titled scene, it seems peculiar that Tansen would be identified as one in a cluster of musicians in the usual court position beside the outer balustrade rather than as the person who is being received by Akbar. If Tansen is the figure who greets Akbar rather than one of the musicians to the side, then the inclusion of a *dāʾira* player makes more sense: It seems highly unlikely that a Hindu *dhrupad* singer from Gwalior would have been accompanied on *dāʾira*. In any case, the musical content of this painting is either unique documentation of an Akbari-period ensemble or else not to be trusted; I suggest the latter.

In that same 1924 study, Brown identified an elderly instrumentalist in a Jahangiri-period painting (pl. 16) as Tansen. Khandalavala and Chandra likewise argue against that identification, reasoning that there is no physical resemblance between that elderly musician and the singer in figure 69 whom they consider to be Miyan Tansen (1955–56:21). Indeed, if the artist of the scene of that procession in Jahangir's time intended a portrait of Tansen, he was either committing an unusual act of historical inaccuracy or memorializing the great singer who had been dead for at least a decade and a half. But I would suggest that, given the values of the Mughals, placing a legendary musician of such high rank in a procession among a multitude of other musicians (and dancers) would hardly have been an appropriate manner of memorializing him.

Strikingly, the Jahangiri musician identified by Brown as Tansen shows him as an instrumentalist rather than as a singer. While this painting does not offer real "evidence," it does raise the question of whether Tansen performed publicly as both instrumentalist and singer. It is widely

assumed that he did play (an) instrument(s), but references to Tansen in the contemporary sources offer little hard evidence. In one passage by Bada'uni, "music and song" might indicate instrumental music as well as singing, but in another only "singing" is mentioned. In the passage about "music and song," Bada'uni offers "Miya Tan Sin" a backhanded compliment in a statement that concerns another musician and other patrons:

> And in the same way, the Khān Khānān, although he had nothing in his treasury, gave at one sitting a *lac* of *tankah*s worth in money and goods to Rām Dās of Lak'hnou, who was one of the musicians [*kalāvant*] of Aslīm Shāh, and one that in music and song you might term a second Miyān Tān Sīn. This man used to be the Khān Khānān's companion and intimate associate, and by the beauty of his voice continually brought tears to his eyes. (*MtT* 2:37)

In another passage about "singing," Bada'uni connects Tansen with an additional patron, 'Adli, the last of the Sur kings, who was defeated by Humayun in 1555. " 'Adli was so highly skilled in singing and dancing that Miyan Tansin, the well-known *kalan-wat* who is a past master in this art used to own to being his pupil. . . . "[6]

Among the few existing documentary remarks, two others likewise lack any hint that Tansen was an instrumentalist as well as singer. Abu'l Fazl wrote of Tansen that few had equaled him in India in the last thousand years (*AN* 3:816). The memoirs of Jahangir, who was undoubtedly familiar with Tansen's music, include a metaphoric passage that must have reinforced and prolonged Tansen's superlative reputation as singer and poet. Describing flora he observed on a journey in the area of Gujarat, Jahangir recalled poems by the great musician.

> The flower of the lotus, which in the Hindi language they call *kumudinī,* is of three colours—white, blue, and red. I had already seen the blue and white, but had never seen the red. In this tank red flowers were seen blooming. Without doubt it is an exquisite and delightful flower, as they have said—
>
> "From redness and moistness it will melt away." The flower of the *kanwal* [a water lily] is larger than the kumudinī. Its flower is red. I have seen in Kashmir many kanwal with a hundred leaves (petals). It is certain that it opens during the day and becomes a bud at night. The kumudinī, on the contrary, is a bud during the day and opens at night. The black bee, which the people of India call *bhaunrā,* always sits on these flowers, and goes inside them to drink the juice that is in both of them. It often happens that the kanwal flower closes and the bee remains in it the whole night. In the same manner it remains in the kumudinī flower. When the flower opens it comes out and flies away. As the black bee is a constant attendant on these flowers, the poets of India look on it as a lover of the flower, like the nightingale, and have put into verse sublime descriptions of it. Of these poets the chief was Tān Sen Kalāwant, who was without rival in my father's service (in fact, there has been no singer like him in any time or age). In one of his compositions he has likened the face of a young man to the sun and the opening of his eyes to the expanding of the kanwal and the exit of the bee. In another place he has compared the side-glance of the beloved one to the motion of the kanwal when the bee alights on it. (*TiJ* 1:412–13)

It could be that Tansen was an instrumentalist as well as a singer and that such musical versa-

tility was so taken for granted by contemporary writers that it did not bear mentioning. They would have reported what was most important: His appointment as a singer whose eminence was based on his talent as a composer as well as performer. While there is scant documentary evidence that he played any musical instrument, oral tradition certainly asserts it. One reason could be that his songs were the basis for much of the repertoire of North Indian (Hindustani) instrumental music, in much the same way as song still functions in South Indian (Karnatak) instrumental music.

In addition to Akbar's political power play in bringing Tansen to his court, to Akbar's avid interest in music, and also to his patronizing the best contemporary artists, I believe there was probably another element which made Tansen attractive to him. There seem to have been multiple cultural strands in Tansen's background; and for Akbar, whose cultural agenda was to foster synthesis to the maximum extent, such a musician would have been invaluable (Bhanu 1955:25). Those multiple cultural strands were both Hindu and Muslim, for Tansen lived during a period when vibrant personal religious devotion sprang to life: in the Hindu tradition in the *bhakti* movement, and in the Islamic sphere through *Sufism*.[7] The Hindu milieu produced poets/singers who were and are regarded as saints in Indian cultural history, among whom were Sur Das, said to have been a friend of Tansen (Schimmel 1983:36; Gangoly 1948:53), Mira Bai, Tulsi Das, Baiju Bawra, Ramdas, and Swami Haridas, who is widely thought to have been Tansen's teacher. In the Islamic sphere, *Sufi* devotional cults also flourished with music at the center of their religious expression; Tansen is thought to have been connected to the latter through Muhammad Ghaus. What one knows of Tansen does not deeply affiliate him with either movement, but the Hindu and Muslim influences in Tansen's background are nonetheless important and are reiterated in oral tradition in stories of his birth and his early training. The Indian musicologist Chaitanya Deva summarized these:

> Makarand Pande (Mukundram Pande, Makarand Misra) was a Hindu priest, living in Behat village close to Gwalior and seems to have been proficient in music as well. While he begot many children, not one of them lived long. His neighbours advised him, therefore, to seek the blessing of the Muslim saint of Gwalior, Hazrat Mohammad Ghouse. Accordingly, Pande travelled to the city and beseeched the *fakir* to bless him with a child. Ghouse was moved by the poor man's prayer and gave him a talisman to be tied round the neck of Pande's wife; and in due course the lady delivered a boy who was named Ramtanu. The lad was also called Tanna Misra. . . . The year of his birth is not certain, though it is generally taken as 1506 A.D. (1520 or 1532). However, more recent studies have put his birth between 1492 and 1493 A.D. or, more generally, the last decade or two of the fifteenth Century. (1973:88)

As expected in oral tradition, there are variants on the details in those stories.[8] And, as Chaitanya Deva cautioned, we do not have incontrovertible facts about his musical tutelage (1974:53).[9] Deva objects to the most prevalent opinion—that Tansen was a pupil of Swami Haridas—pointing out that that Haridas was a *sannyāsī*, a devotee of Lord Krishna/Vishnu. "Neither Tansen's life nor his style of language show the religious depth of his master, if he did learn with Haridas at all."[10]

Throughout oral accounts concerning Tansen, a prominent character is Muhammad Ghaus (Muhammad Ghauth Gwaliori), a powerful religious personality of the Akbari period, at one time respected by Bada'uni.

And in the jungle at the foot of the Chunār hill I came to the dwelling and abode of Shaikh Muhammad Ghous, one of the great shaikhs of India, and a man of prayer. One of his followers met me, and showed me a cave where the Shaikh had lived for twelve years as a hermit, subsisting on the leaves, and fruit of the desert trees. So celebrated had he become for the fulfilment of his blessings, that even powerful and absolute monarchs used to bow the head of sincerity and courtesy in his honour. (*MtT* 2:28)

Bada'uni turned against the Shaikh, however:

While [Bada'uni had been in Agra as a student and the Shaikh was 80 years old] the Shaikh came in the dress of a Faqīr, with great display and unutterable dignity, and his fame filled the universe. I wished to pay my respects to him, but when I found that he rose up to do honour to Hindus, I felt obliged to forego the pleasure. (*MtT* 2:62)

Bada'uni's comments provide insight into the connection between Ghaus and Tansen and his family. The Shaikh was apparently liberal with respect to Hindus and, according to Schimmel, his work was an interesting combination of *Sufi* thought, astrology, and magic (1983:29). There was also an early connection of Muhammad Ghaus with the Mughal family: his brother, Shaikh Phul, had been Humayun's adviser but was killed by Humayun's brother, Hindal, who feared Shaikh Phul's power (ibid. 29). Then, Shaikh Muhammad Ghaus himself, "while at Gujrat had by means of inducements and incitements brought the Emperor, at the beginning of his reign, entirely under his influence as a teacher" (*MtT* 2:62). If that were so, then Akbar would have had all the more reason to think that, as an associate of Muhammad Ghaus, Tansen possessed an open mind regarding religion and other matters.

Tansen's connection to Muhammad Ghaus has been so strongly maintained through time in the oral tradition that it should not be easily dismissed. It is possible that Ghaus was the spiritual adviser, if not music teacher, of Tansen. In either case, the implication is that Tansen was fully conversant with *Sufism*.

The most common mental image of Tansen is that of the great musician performing before courtly audiences. But one piece of documentary evidence puts Tansen into an explicitly Muslim, indeed *Sufi*, context, where he is called into the quarters of a dying Muslim *Sufi pīr* (spiritual guide, master). The death of Shaikh Salim Chisti (15 February 1572), who had foretold to Akbar the birth of his three sons, is recounted in detail as a flashback by Jahangir in his memoirs, on the occasion of his visit to the saint's mausoleum in January 1619.

One day my father incidentally asked [the Shaikh] how old he was, and when would he depart to the abiding regions. He replied: "The glorious God knows what is secret and hidden." After much urgency he indicated this suppliant (Prince Salīm), and said: When the Prince, by the instruction of a teacher or in any other way, shall commit something to memory and shall recite it, this will be a sign of my union with God." In consequence of this, His Majesty gave strict orders to all who were in attendance on me that no one should teach me anything in prose or verse. At length when two years and seven months had passed away, it happened one day that one of the [pensioned] women was in the palace. She used to burn rue constantly in order to avert the evil eye, and on this pretext had access to me.

She used to partake of the alms and charities. She found me alone and regardless of (or ignorant of) what had been said (by Akbar), she taught me this couplet:

O God, open the rosebud of hope
Display a flower from the everlasting garden.

I went to the Shaikh and repeated this couplet. He involuntarily rose up and hastened to wait on the King, and informed him of what had occurred. In accordance with Fate, the same night the traces of fever appeared, and the next day he sent someone to the King (with the request) to call Tān Sen Kalāwant, who was unequalled as a singer. Tān Sen, having gone to wait upon him, began to sing. After this he sent some one to call the King. When H.M. came, he said: "The promised time of union has come, and I must take leave of you." Taking his turban from his head, he placed it on mine, and said: "We have made Sulṭān Salīm our successor, and have made him over to God, the protector and preserver." Gradually his weakness increased, and the signs of passing away became more evident, til he attained union with the "True Beloved." (*TiJ* 2:70–71)[11]

Another issue that has persisted in the oral tradition is whether Tansen actually converted to Islam. One legend asserts that, in order to impart the gift of music to his promising pupil, Muhammad Ghaus touched his tongue with his own, and thus Tansen lost caste and became a Muslim.[12] Another account by an Indian historian states with apparent certainty: "A few years after entering the Emperor's service, Tan Sen embraced Islam and the title of Mirza was conferred upon him by Akbar and a high place at the court given to him" (Bhanu 1955:23).

Contradicting that viewpoint, Chaitanya Deva provides reasons to refute the belief that Tansen converted to Islam. He asserts that Tansen's compositions evince no trace of Islamic influence and that his devotion to Hindu gods is well known. As evidence to support that, in a *dhrupad* by Tansen the iconography associated with Shiva is luxuriantly expressed:

Śiva has rings in his ears and is wearing a *muṇḍamāla* (a garland of human skulls) around his neck. His body is smeared with ashes. He is holding the trident in his hand and wearing the moon on his forehead. He is accompanied by his consort *Pārvatī*. He is riding a bull and bears on his head the *Gaṅgā* which flows from the braids of his hair. *Tānasena* says that Śiva has three eyes. He carries the trident, the beggar's bowl made out of human skull and the *ḍamaru* in his hands. He sings in a joyful mood. (Srivastava 1977:44)

Strangely, while Deva notes that the rituals at his funeral were typically Hindu (1973:89), the description of his funeral in the *Akbar Nāma* is of Muslim custom.

On 26 April 1589, Mīyān Tānsen died, and by H.M.'s orders, all the musicians and singers accompanied his body to the grave, making melodies as at a marriage. The joy of the Age was overcast, and H.M. said that his death was the annihilation of melody. It seems that, in a thousand years, few have equalled him for sweetness and art! (*AN* 3:816)

Tansen was buried in Gwalior, and his tomb, under a *nīm* tree in the southwest corner of the mausoleum of Muhammad Ghaus, has become a place of pilgrimage.[13]

Two factors cause me to question the theory that Tansen converted to Islam, despite the fact that he was buried in Muslim manner. First, if Tansen had converted, it is highly unlikely that he

would not have been the object of virulent attack by the anti-Hindu chronicler Bada'uni. In a spirit reminiscent of more recent intolerant communalism, Bada'uni would not let Tansen's reputation rest without challenge. For example, he states that Akbar really preferred a Muslim singer to Tansen and other "singers of Hind," and that Tansen and other musicians were financially over-compensated.

> One day [the Emperor] had an interview with one Shaikh Banj'hū by name, a singer with a sweet voice, and of Çūfī tendencies, one of the disciples of Shaikh Adhan of Jounpūr . . . and had a very agreeable time of it. Then he sent for Miyān Tānsīn, and other unequalled singers of Hind; but he preferred him to any of them, and ordered that Shaikh Banj'hū should carry off the whole of that sum of money [a pond-full of copper coins]. But his strength was unequal to carrying it, so he asked for a little gold instead. The Emperor, accordingly, presented him with nearly 1,000 rupees in exchange. And the rest of that money the Emperor in the course of three years, more or less, got rid of by means of various expenses.
>
> About this time he received from Shaikh Mubārak a lecture on his extravagant expenditure. Before that, at the time of the [musical] exhibitions, Shaikh Faizī had said: "Our Shaikh is not much of a courtier." "No," replied the Emperor, "he has left all those fopperies to you." He sent Shaikh Banj'hū, and Miyān Tānsīn, and all the musicians to the Shaikh that he might tell him what they were worth as musicians. He said to Miyān Tānsīn: "I have heard that you can sing a bit." At last he compared his singing to the noise of beasts, and allowed it no superiority over it. (*MtT* 2:273)

Secondly, two of Tansen's five children had Hindu names—his daughter Sarasvati and his son Surat Sen. He also had sons who, in histories, are mentioned with Muslim names, but that can have various explanations. An obvious one would be that those sons converted to Islam. Also, without any historical evidence to support this assumption, "it is generally believed" that Tansen had two wives, one Hindu and the other Muslim (Srivastava 1977:143). In either case, that he would father both Muslim and Hindu children is "testimony" to Tansen's spirit of synthesis, which would have made him attractive to Akbar. Furthermore, it can be questioned whether imposition of the paradigm of the master cleavage of Hindu and Muslim (requiring "conversion") in this medieval context is appropriate with regard to Tansen and other court musicians.

The legends of Tansen's musicality are legion. Ousley wrote in the nineteenth century:

> *Mia Tonsine,* a wonderful musician in the time of King Akber, sung one of the *Night Raug*s, at mid-day: the powers of his music were such that it instantly became night, and the darkness extended in a circle round the palace as far as the sound of his voice could be heard. (Tagore 1965:13–14)

Kuppuswami and Hariharan relate another oft-repeated story.

> The anecdote relating to the singing of Rāga Dīpak at the behest of Akbar in spite of apprising the Emperor [of] the danger of his getting burnt, is very well known. Akbar in a fit of proud disdain discredited any such possibility. But Tānsen knowing his fate requested the Emperor grant him a fortnight's time to prepare the rāga well. During this period Tānsen taught his talented daughter Sarasvati, the Rāga Mēgh Mallār with all the subtle intricacies and he was confident that its correct rendering would surely cause rain. He had instructed

his daughter on the day of his singing the Rāga before the Emperor, to sit at a place close to the Emperor and begin singing the rāga Mallār after a particular lapse of time.

So Tansen began his recital of Rāga dīpak on the appointed day, before a fully attended open durbar. Within a short time, Akbar could notice from Tānsen's face and gestures of his body, the effect of the rāga. Tānsen continued singing the rāga for some time and informed Akbar that if he did not stop then, he may be disabled for life. Akbar relented after verifying the actual effect of rāga dīpak on Tānsen. At the same time it is said Sarasvati's delicate rendering of Mēgh Mallār brought forth rain and cooled Tānsen's burning body. (1984:77–78)[14]

Tansen's musical legacy has also been attested to in countless other sources, just one of which suffices to show the respect he is accorded: "As a composer of Dhrupad, Tansen was peerless, and his composition has poetical quality which is very often epic in its sweep and sometimes tender and exquistely lyrical" (Gosvami 1961:124). Tansen is also credited with the creation of new *rāga*s such as *Darbārī Kāṇḍā, Miyāṇ kī Malhār,* and *Miyāṇ kī Toḍi* and is reported to have written three books, *Śrī Gaṇeś-stotra, Saṅgīta Sāra,* and *Rāgamālā.* According to Srinivasa, two of the books are available, but the third one is not (1977:143). In a footnote, Gangoly reports that Pandit Bhatkhande believed the *Rāgamālā* volume to have been a spurious work compiled by some later authors and "fathered on Tansen to lend a halo of authority to the work" (1948:53).

Very little is actually known about his singing style. A remark made in the preface of a collection of *dhrupad*s by the contemporary musician Bakshu can be interpreted in several ways: "During his singing he used to always take other singers as aides and he did so even when he was asked to sing solo" (Sharma 1972:12). Interpreted negatively, this could be taken as a need for support, a sign of Tansen's advanced age (remembering that he came to Fatehpur when he was close to retirement). Interpreted positively, this could refer to Tansen's important role as a teacher and evidence of a performance practice for initiating younger singers such as exists today. In any case, it could not have been unusual, because multiple singers appear in Akbari scenes (fig. 11, for instance, where a singer stands to either side of the *bīnkār.*) That Tansen sang to the accompaniment of the Indian drum, the *pakhāvaj,* was asserted by Fakirulla, *subedār* of Kashmir in the seventeenth century and translator of the book *Rāga Darpaṇa,* and repeated by Hakim Mohammad Karam Imam, a courtier of Wajid Ali Shah, a nineteenth-century ruler of Lucknow: "Bhagwan Aima Pakhawaji was a well known Pakhawaj player in the court of Akbar. He accompanied Tansen" (Imam 1959:17). Remarkably, I have found no Mughal painting which shows a male singer who performs with *pakhāvaj* who could possibly be Tansen.

OTHER AKBARI MUSICIANS

Although Tansen clearly was the star, other Indian singers listed by Abu'l Fazl in the *A'īn-i Akbarī* were among the leading imperial musicians: One was Miyan Lal (*AiA* 1:681). If that Miyan Lal was also known as Lal Kalawant, as is possible, he is mentioned in the memoirs of Jahangir as well.

On the 2nd of the said month [in 1608] La'l Kalāwant, who from his childhood had grown up in my father's service, who had taught him every breathing and sound that appertains to

the Hindi language, died in the 65th or 70th year of his age. One of his girls (concubines) ate opium on this event and killed herself. Few women among the Musulmans have ever shown such fidelity. (*TiJ* 1:150)[15]

Two of Tansen's sons did not make Abu'l Fazl's musician list, but a third, Tantarang Khan, achieved "everlasting" fame by being noted among Akbar's leading imperial musicians (*AiA* 1: 681–82). Tansen's other Muslim son, Bilas Khan, is remembered because a *rāga* is attributed to him by legendary account.

Bilas Khan (the son) sang spontaneously a rag most pathetically with feeling and emotion near the corps of his father (when he left this world) in bitter grief, that the body, (corps) touched and moved by the excellence of the raga lifted its hand and blessed the singer, i.e., the song. Since then this rag has come to be known as Bilaskhani Todi. (Ram 1982:163)

The reputations of Tantarang Khan and Bilas Khan (as well as that of their illustrious father) were sealed when in the mid-seventeenth century Faqirulla categorized them as *atāī*, a singer who knows only practical music, not the theory and principles of music (Imam 1959:14), but whose social rank was higher than that of most professional musicians.

NAUBAT KHAN

Tansen may have been the most acclaimed musician in Akbar's service, but his son-in-law Naubat Khan is the musician whose presence is most celebrated in contemporary paintings. Although he is not mentioned among the leading imperial musicians, Naubat Khan was honored with a superb portrait, c. 1604, ascribed to the great artist Mansur (fig. 72). He is unmistakably an instrumentalist because he holds a *rudra vīṇā*.

Not surprisingly, in terms of both personality and physical persona the Mughal artists found Naubat Khan more interesting than Tansen to portray among the courtiers in the depiction of court scenes. That the Naubat Khan of the portrait is the musician in plate 1 as well cannot be denied upon comparison of the dark face with small eyes and mouth that suggest a physical frame on which too much flesh has been accumulated, and the gloriously corpulent proportions of his entire person. The illustrated event, "Husain Quli Khan pays his respects to Akbar in 1573" (Sen 1979:3), otherwise known as "Husain Quli presents prisoners of war from Gujarat," occasioned a double-page composition in the Victoria and Albert copy of the *Akbar Nāma*. The left folio of the captured Timurid princes in Gujarat who rebelled against Akbar in 1572–73 illustrates the penalty paid for disloyalty to Akbar: they are brought to court in humiliation, clothed or sewn into raw animal skin that would gradually shrink fatally around them as the skins dried. In the right folio (pl. 1) with his generals Husain Quli Khan and Khan Jahan, Akbar is shown seated in the high, porch-like *jharokā* where he would have a good view of the spectacle. The rest of the court gathered below, among whom stands the unmistakable *bīnkār* Naubat Khan, gorgeously portrayed in sheer clothing rendered sensitively by the painter Husain Naqqash, and his visage touched up by the master portraitist, Kesu Kalan. In addition, the *bīnkār* in figure 11 might be Naubat Khan if his physical proportion is a proper clue; the face is not unmistakable, but then no specialist in portraiture is designated for this painting.

Gallery Section

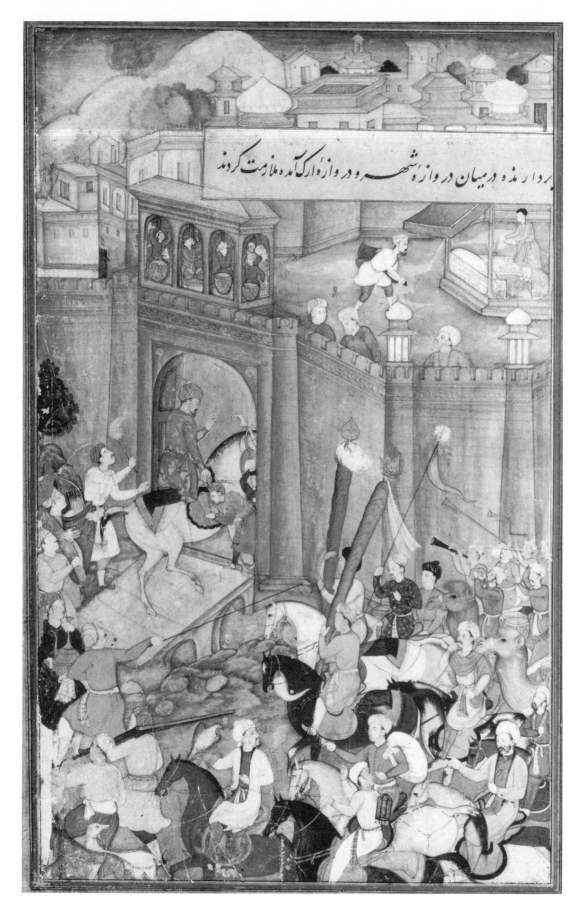

Figure 1. Babur welcomes Humayun and Kamran at Kabul. *BN*, fol. 16, c. 1595–1605.
Courtesy of The Walters Art Gallery, Baltimore, W. 596.

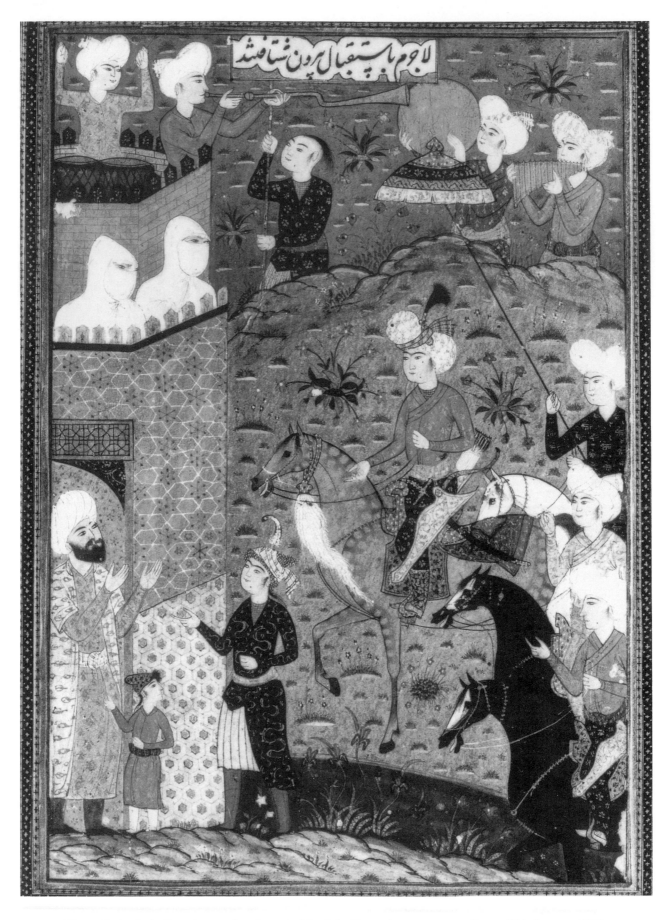

Figure 2. Arrival of a prince at the city gate (*Arrivée d'un prince aux portes d'une ville*), Iran, c. 1500, gouache on paper. Courtesy of Musée des Arts Décoratifs, L. Sully Jaulmes, Paris. All rights reserved.

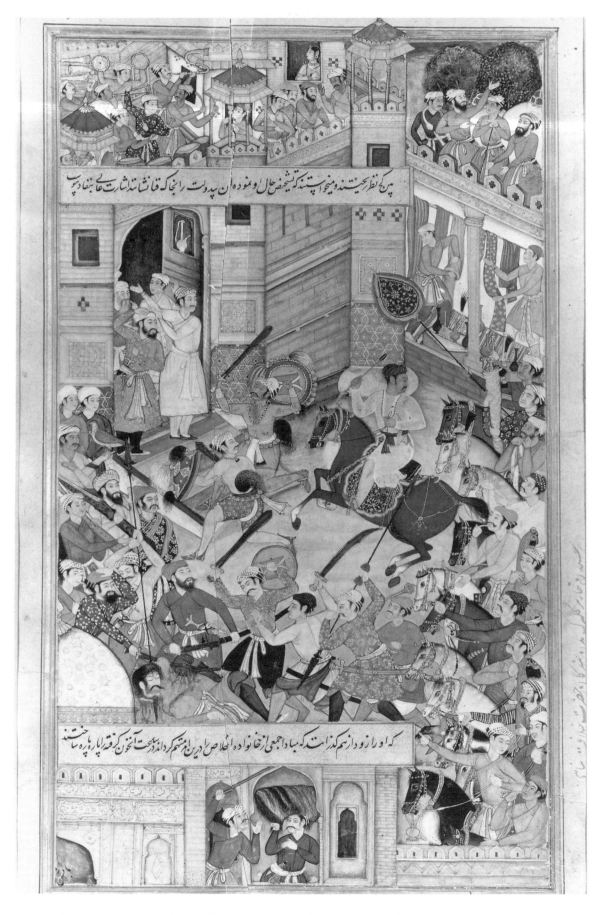

Figure 3. Attempt to assassinate Akbar at Delhi (detail appears on p. 5). *AN*, 1590 or earlier, painted by Bhagwari Kalan, faces by Madhu, composed by Jagan. Courtesy of the Board of Trustees of the Victoria and Albert Museum, IS.2-1896 33/117.

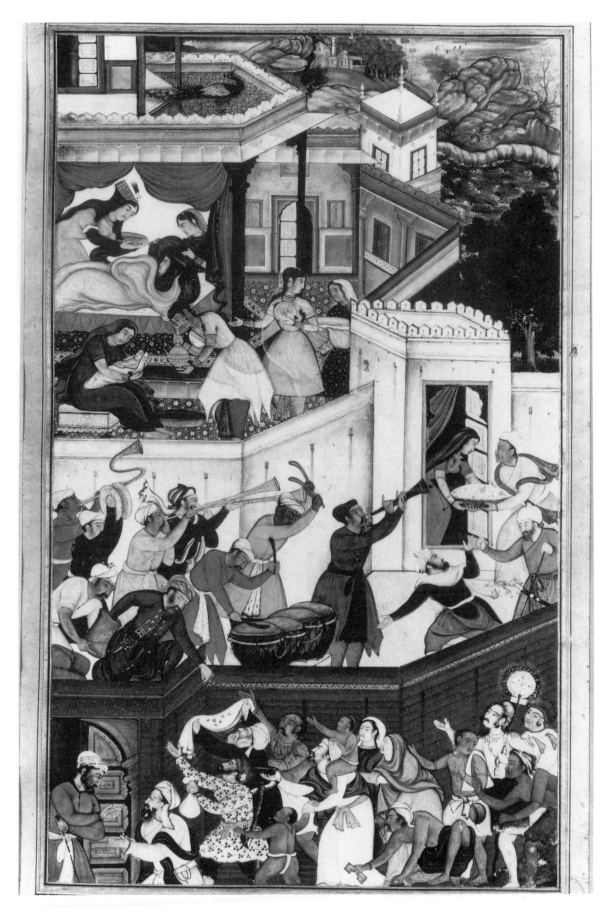

Figure 4. Rejoicings at Fatehpur Sikri on the birth of Akbar's first son. *AN*, 1590 or earlier, composed by Kesu Kalan, painted by Ramdas. Courtesy of the Board of Trustees of the Victoria and Albert Museum, IS.2-1896 80/117.

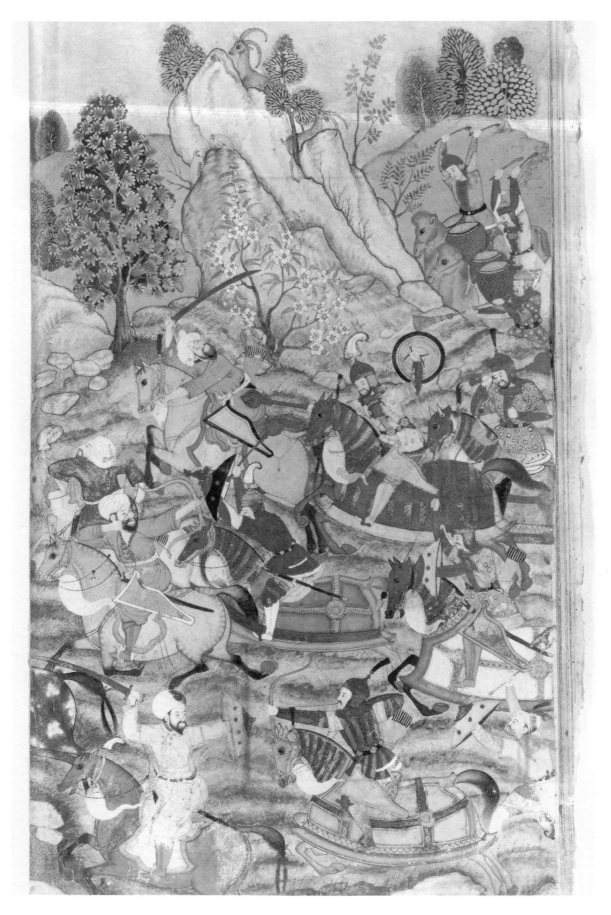

Figure 5. Hazaras being chased by Babur's men through a ravine. *BN*, c. 1588. Courtesy of the Board of Trustees of the Victoria and Albert Museum, IM272-1913.

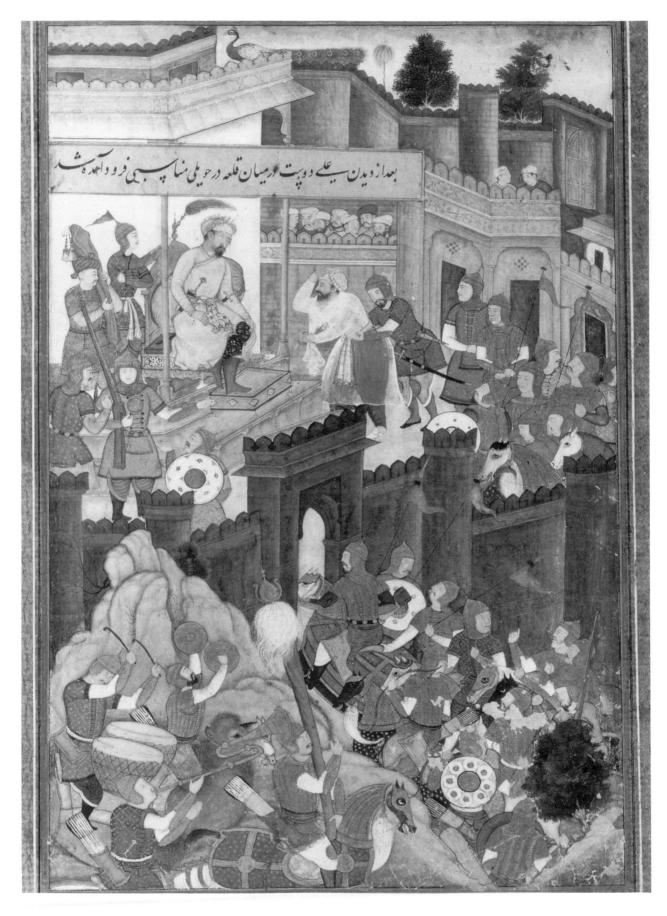

Figure 6. Babur receives ʿAli Dost Taghai at Marghinan (detail appears on p. 9). *BN*, fol. 9v, c. 1595–1605. Courtesy of The Walters Art Gallery, Baltimore, W. 596.

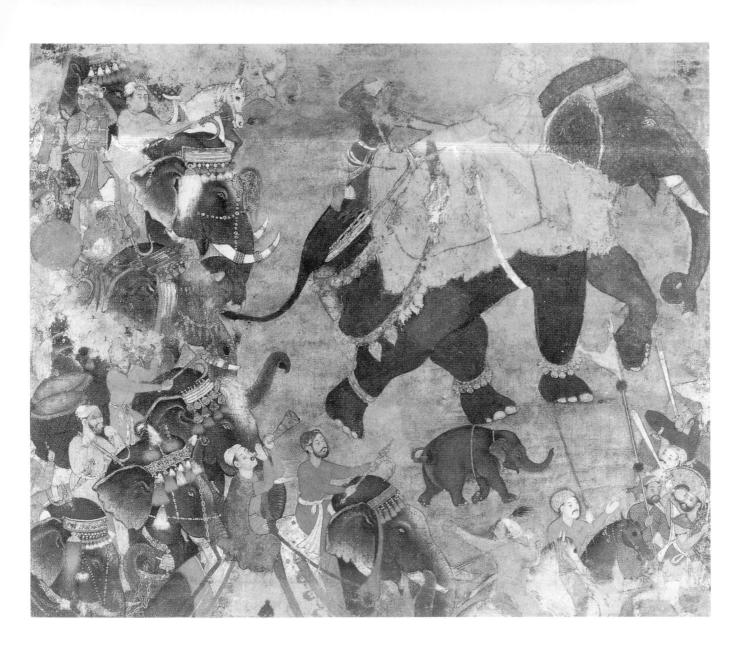

Figure 7. A prince riding an elephant in procession, c. 1575–80. Collection Howard Hodgkin, London.

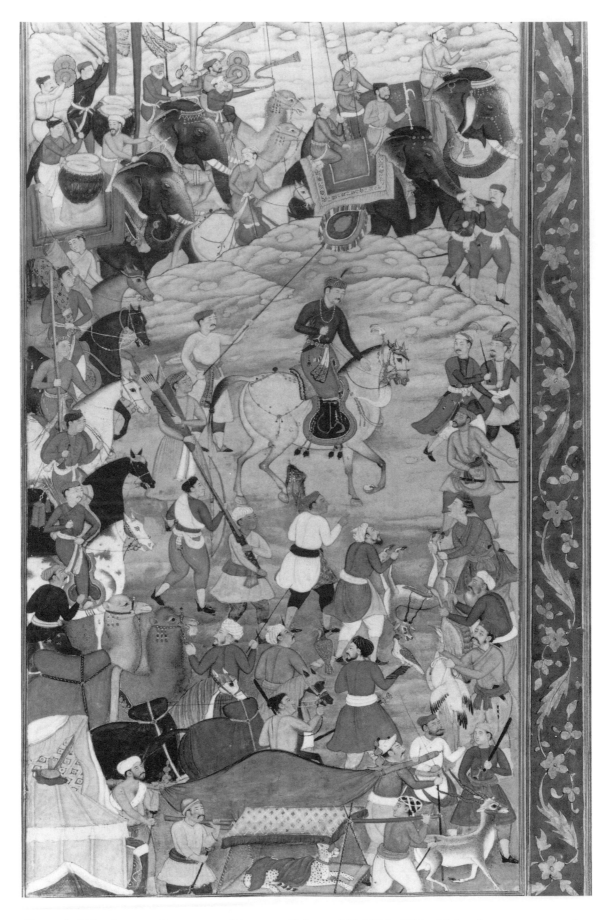

Figure 8. Akbar hunts at Sanganer on his way to Gujarat. *AN*, 1596–97, by Makand, opaque watercolor and gold on paper. San Diego Museum of Art, Edwin Binney 3rd Collection, 1990:0315.

Figure 9. Akbar returns to Agra by boat, 1562. *AN*, 1590 or earlier, designed by Tulsi, painted by Narain. Courtesy of the Board of Trustees of the Victoria and Albert Museum, IS.2-1896 23/117.

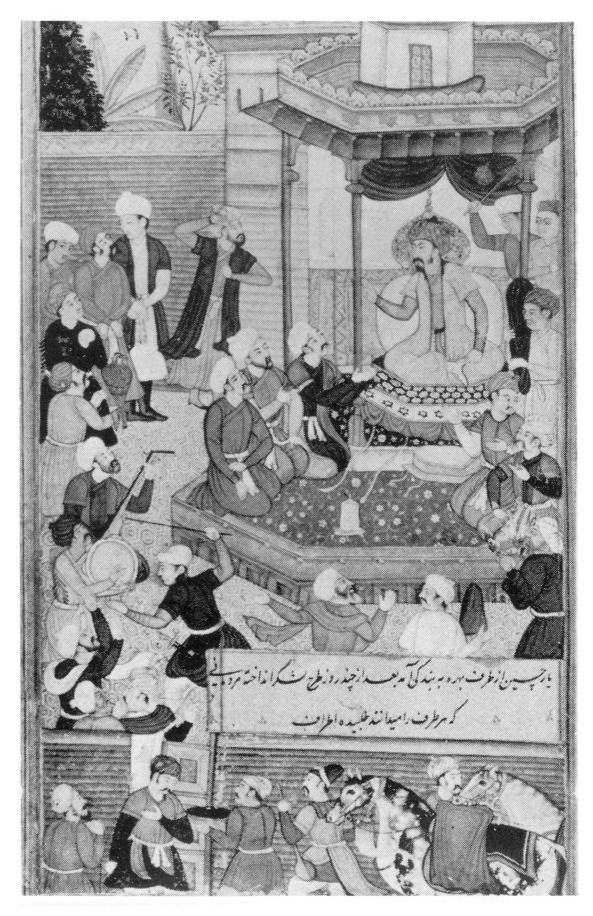

Figure 10. Yar-i-Husain, son of Darya Khan from Bhera, seeking an audience with Babur at Kabul. *BN*, fol. 135r, c. 1597–98, painted by Nama. Courtesy of the National Museum, New Delhi.

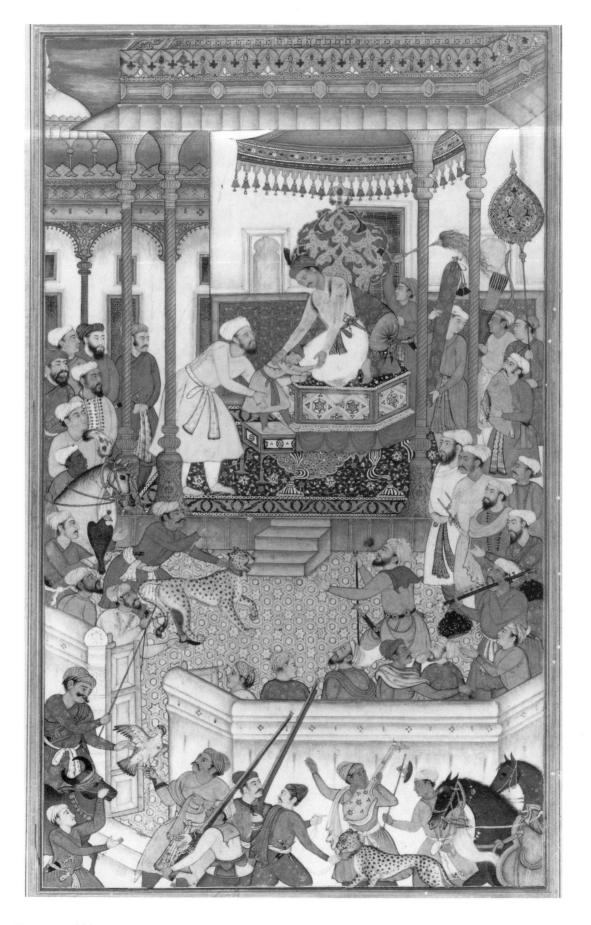

Figure 11. Akbar at court receives the child ʿAbdur-r-rahim at Agra, 1562. *AN*, 1590 or earlier, painted by Anant. Courtesy of the Board of Trustees of the Victoria and Albert Museum, IS.2-1896 7/117.

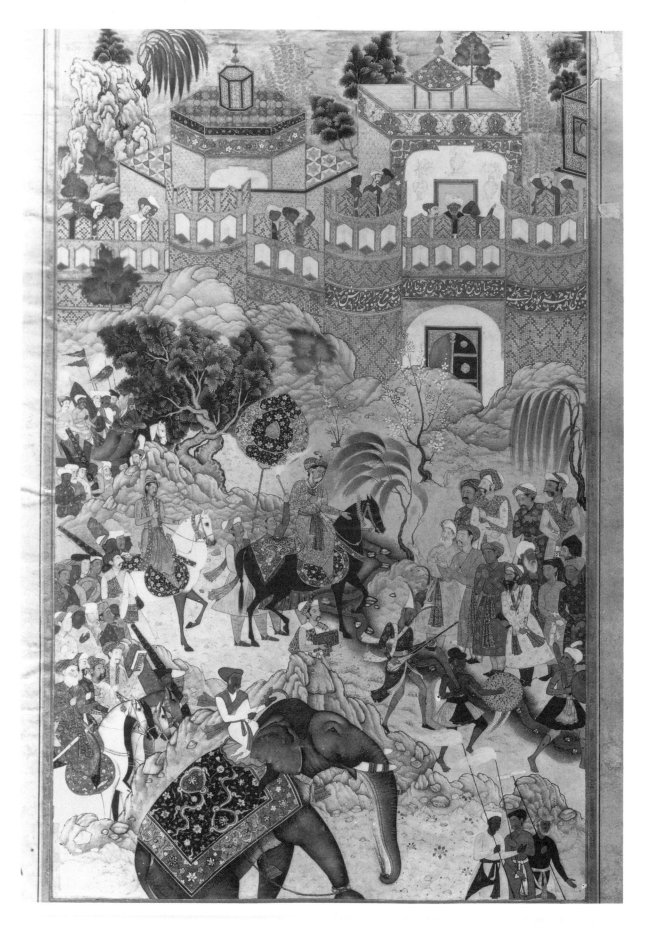

Figure 12. Akbar's triumphant entry into Surat. *AN*, 1590 or earlier, by the Persian artist Farrukh Beg. Courtesy of the Board of Trustees of the Victoria and Albert Museum, IS.2-1896 117/117.

Figure 13. Deval Rani and Khizr Khan together (marriage scene). *Deval Rani Khizr Khān*, c. 1568, by Amir Khusrau Dihlavi. Courtesy of the National Museum, New Delhi.

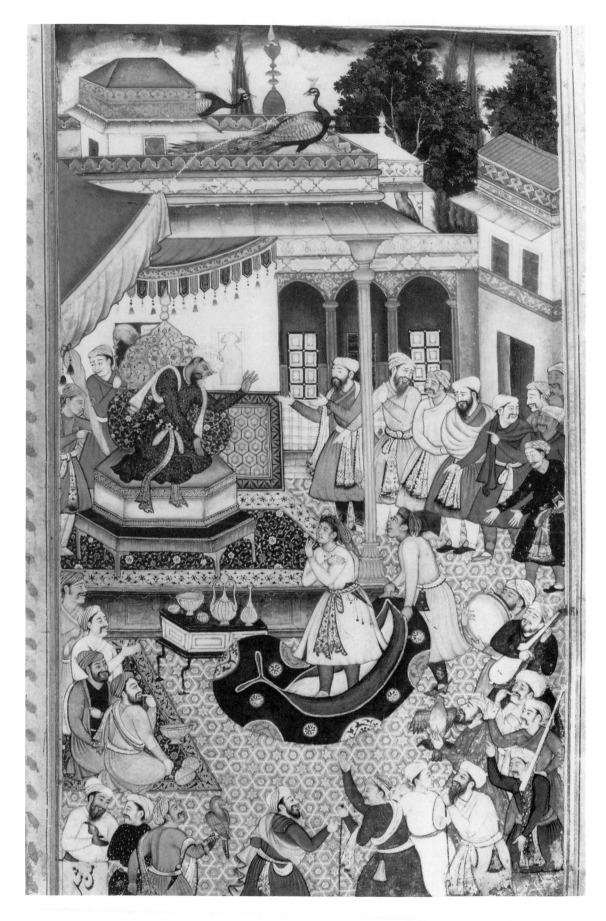

Figure 14. Muhammad Husain Mirza in the bedding, April 1507. *BN*, fol. 279v, c. 1591, painted by Shankar Gujarati. Reproduced by permission of the British Library, OR3714.

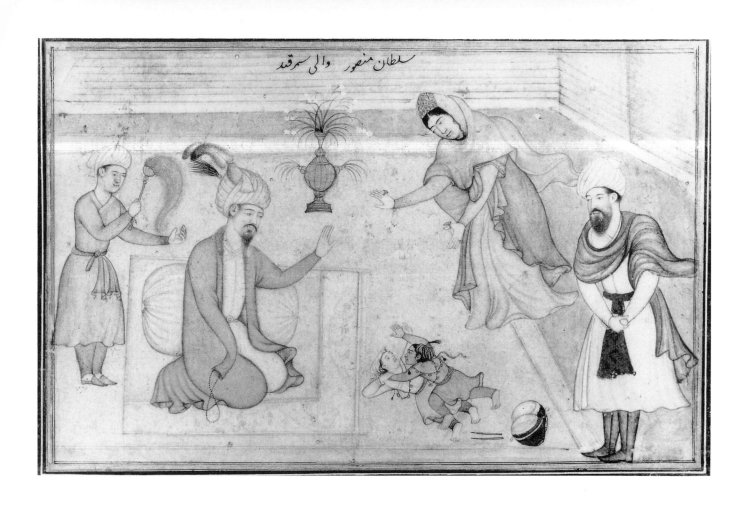

Figure 15. Two-year-old Akbar wrestling. Courtesy of The Bodleian Library, Oxford, MS Ouseley Add.171, fol. 13v, seventeenth century.

Figure 16. Invention of musical instruments from monkey intestines. *TuN*, fol. 108v, India, Mughal school, reign of Akbar, c. 1560, color and gold on paper, 20.3 cm × 14.0 cm. © The Cleveland Museum of Art, 1997, Gift of Mrs. A. Dean Perry, 1962.279.

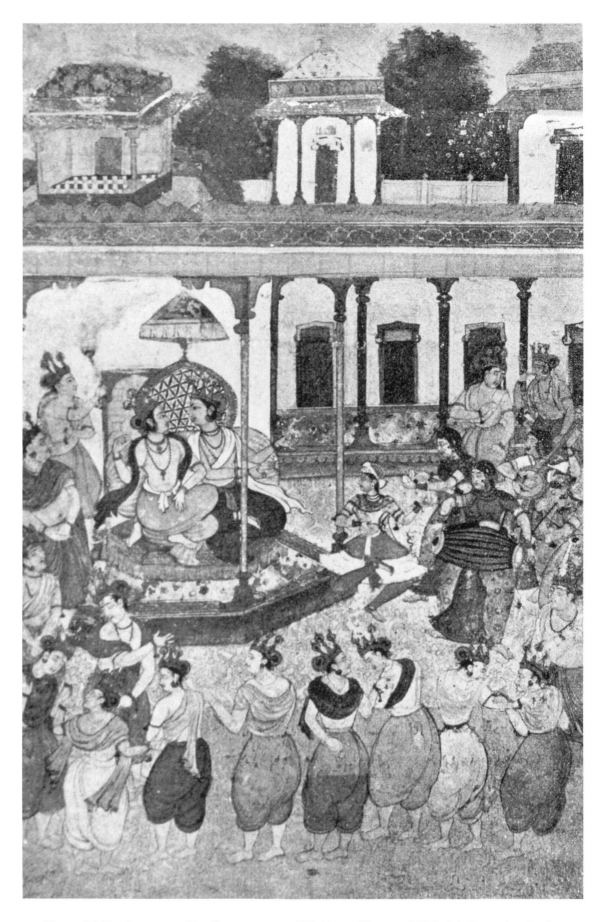

Figure 17. Pandava court (detail appears on p. 79). *Razm Nāma*, c. 1582–86. Housed at Sardar Government Museum, Jodhpur.

Figure 18. A prince, attended by maidservants and musicians, watches a girl dancer. *Dīvān* of Anvāri, fol. 245, 1588, opaque watercolor and gold on paper, 14 cm × 8 cm. Courtesy of the Arthur M. Sackler Museum, Harvard University Art Museums, Gift of John Goelet, 1960.117.8.

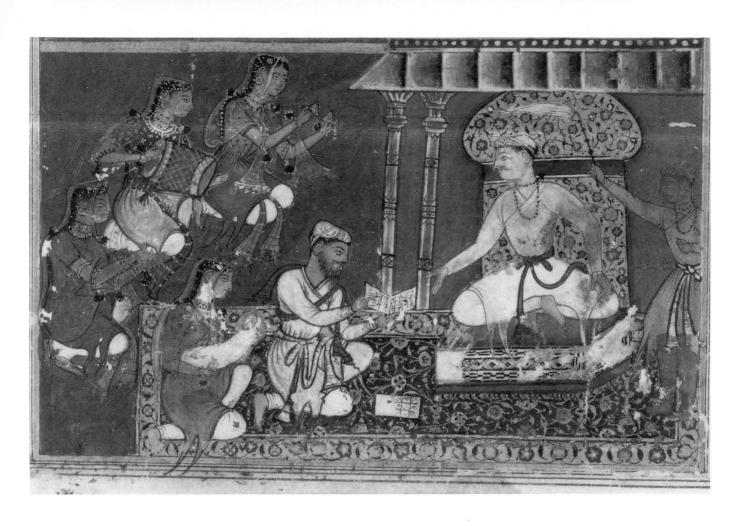

Figure 19. Astrologer predicts calamity for newborn prince. *TuN*, fol. 52v, India, Mughal school, reign of Akbar, c. 1560, color and gold on paper, 20.3 cm × 14.0 cm. © The Cleveland Museum of Art, 1997, Gift of Mrs. A. Dean Perry, 1962.279.

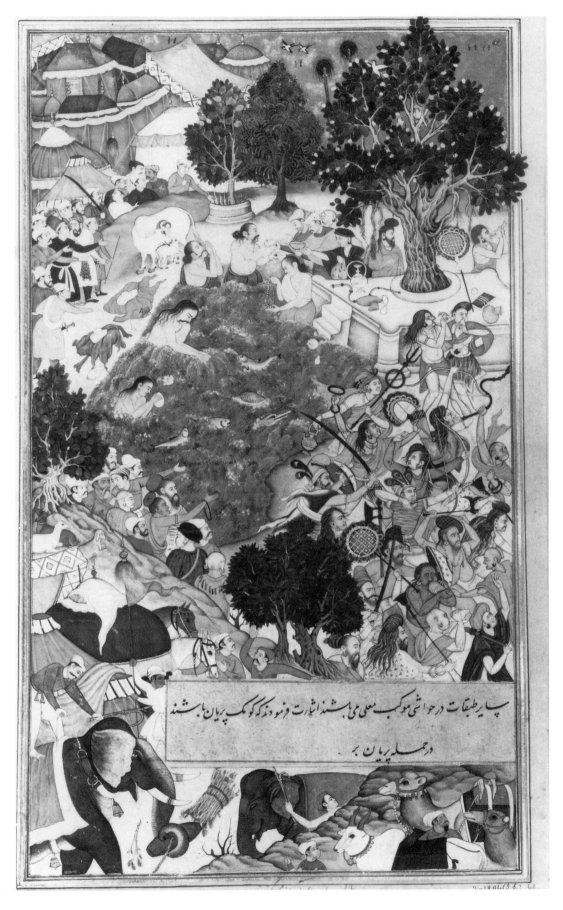

Figure 20. Battle between two rival groups of *sannyāsī*s (detail appears on p. 34). *AN*, 1590 or earlier, composed by Basawan, painted by Tara the Elder, retouched by Basawan. Courtesy of the Board of Trustees of the Victoria and Albert Museum, IS.2-1896 139/117.

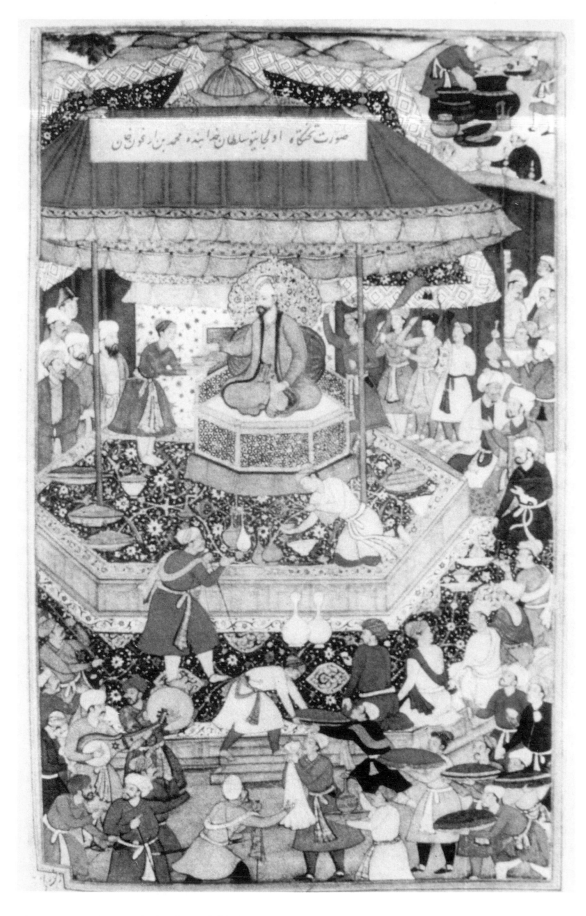

Figure 21. Muhammad Khudaband Öljeitü on the throne. *Chinggis Nāma*, 1596. By Basawan, Sur Das Gujarati, Madhu. Courtesy of the Golestan Palace Museum, Tehran.

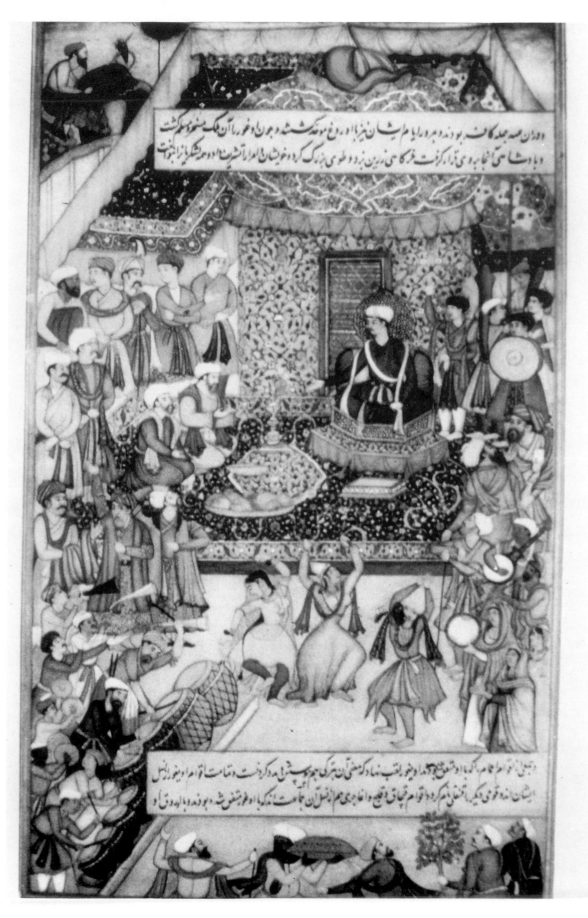

Figure 22. King Oghuz on his throne in a gold tent celebrates his conquest of the territory from the River Talas to Bukhara and its conversion to Islam (details appear on pp. 40, 41). *Jāmī al-Tavārīkh*, fol. 415r, introduction to sec. 1, bk. 1, pt. 1, 1596; drawn by Lal, portrait by Dharmdas, color by Keshu Khord. Courtesy of the Golestan Palace Museum, Tehran.

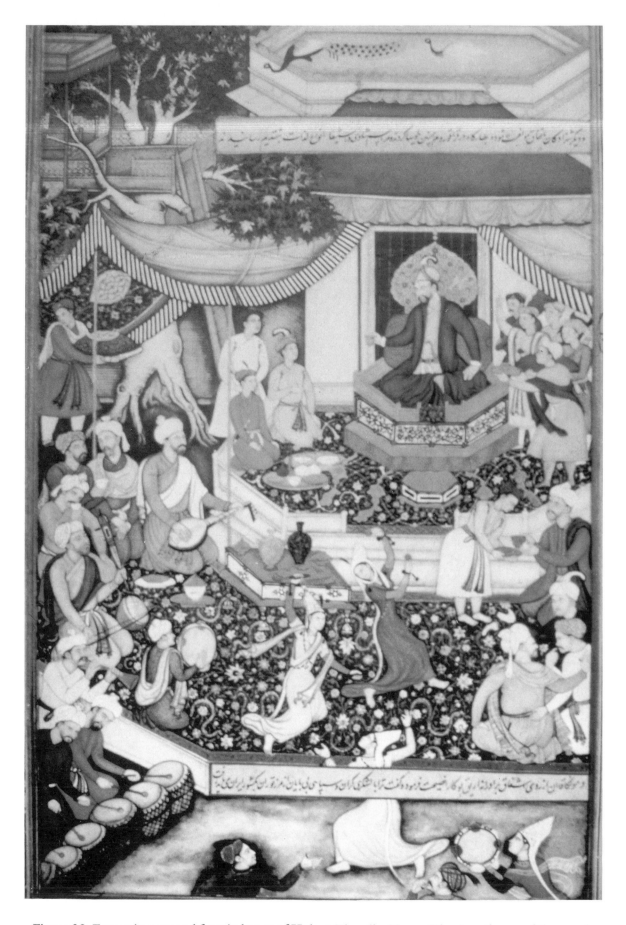

Figure 23. Entertainment and feast in honor of Hülegü Khan (by Mangu Khan) on the eve of the march to Iran. *Jāmi al-Tavārīkh*, 1596, drawn and color by Miskin. Courtesy of the Golestan Palace Museum, Tehran.

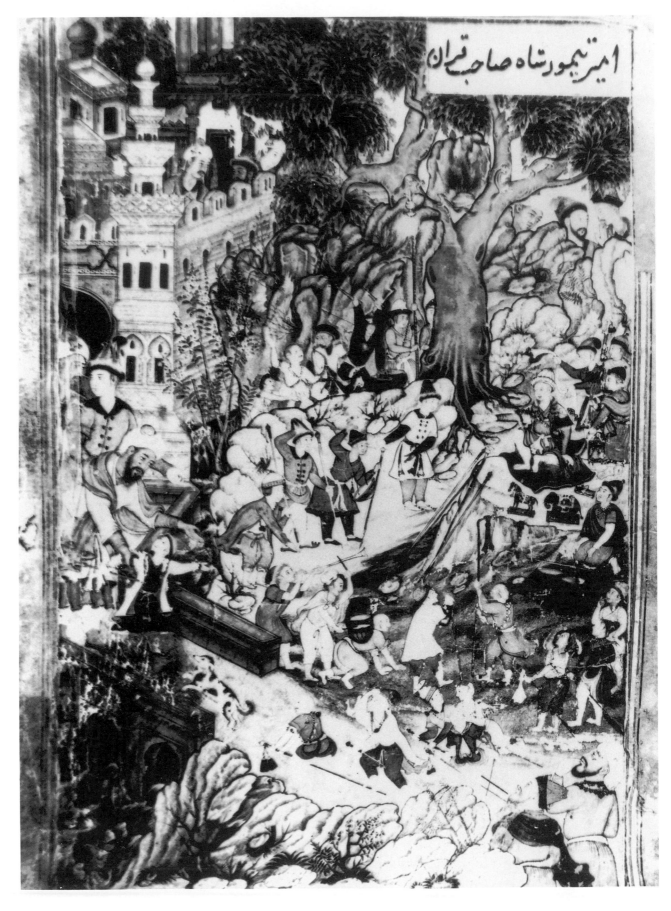

امیر تیمور شاه صاحب قران

Figure 24. Timur plays king. *Tīmūr Nāma*, fol. 2b, c. 1580–85, designed by Daswanth, painted by Jagjivan Kalan. Courtesy of the Khuda Bakhsh Oriental Public Library, Patna, MS 551.

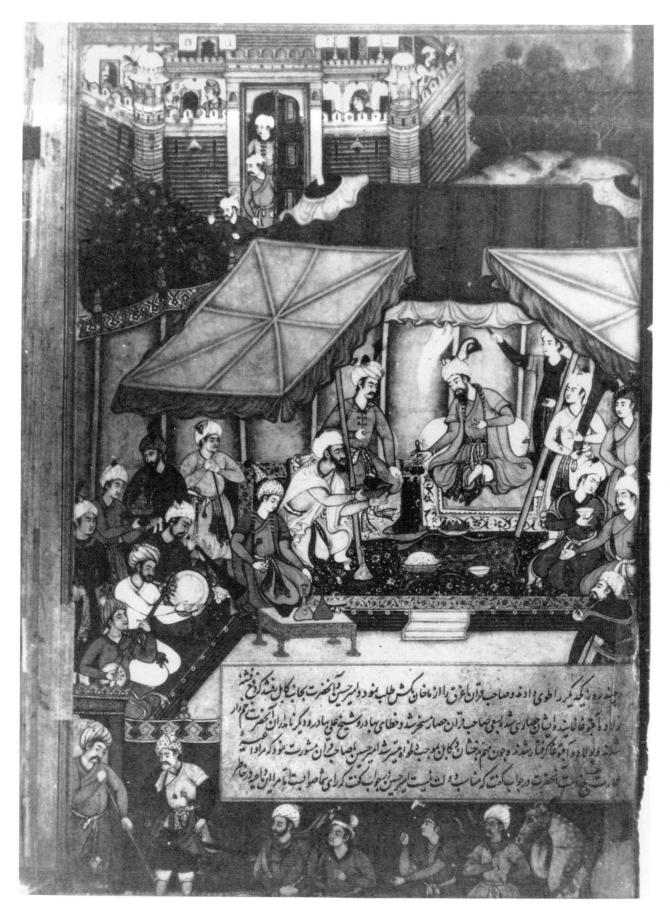

Figure 25. Timur and Amir Husain celebrating peace jointly at Qunduz. *Tīmūr Nāma*, fol. 20a, c. 1580–85, by Qumelu, Tulsi Kalan. Courtesy of the Khuda Bakhsh Oriental Public Library, Patna, MS 551.

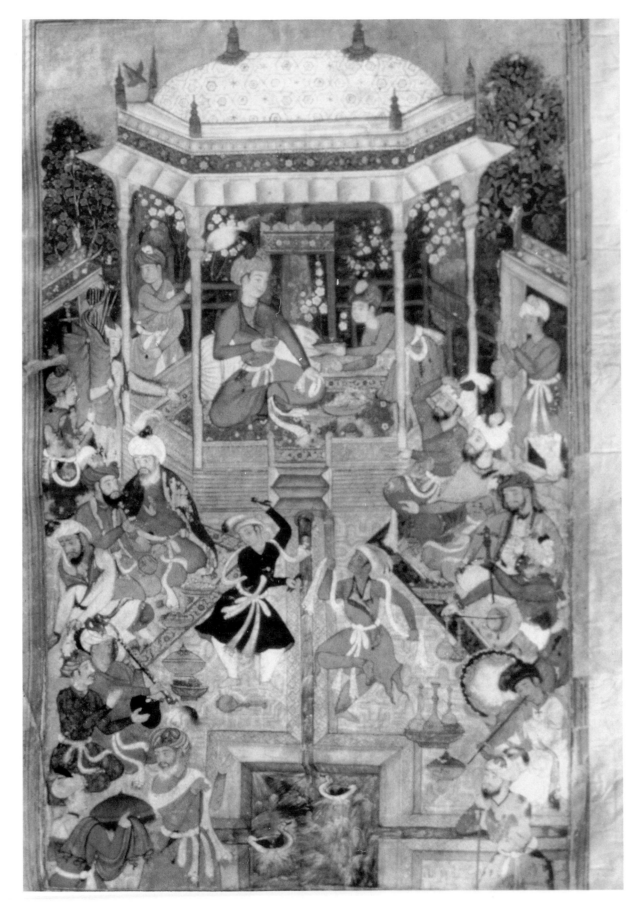

Figure 26. Timur holds a music party. *Tīmūr Nāma*, fol. 4, c. 1580–85, by Basawan. Courtesy of the Khuda Bakhsh Oriental Public Library, Patna, MS 551.

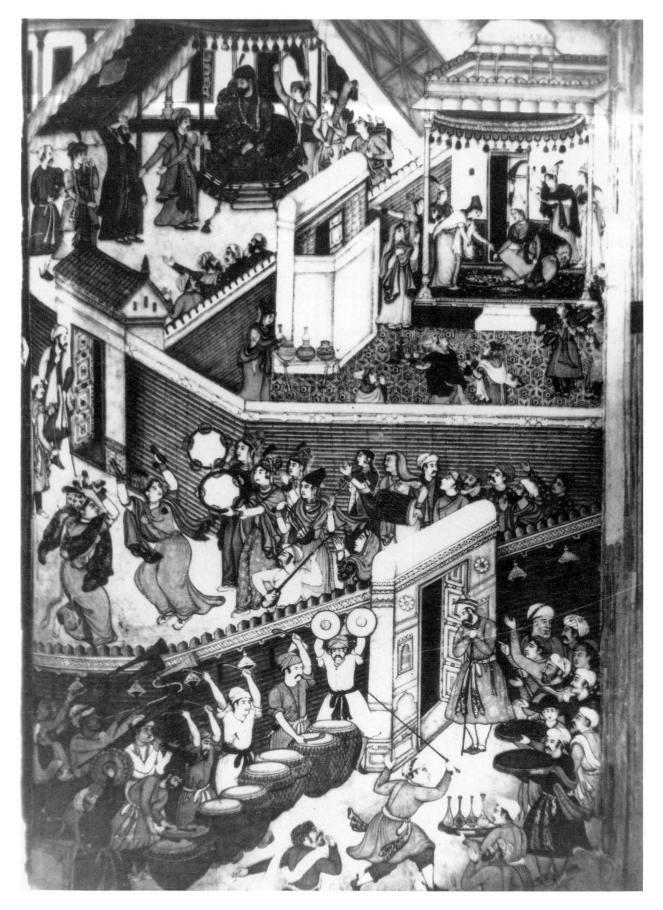

Figure 27. Daughters of Sultan Muhammad are married to Amirzada Muhammad Sultan, Mir Muhammad, and Shah Rukh. *Tīmūr Nāma*, fol. 40b, c. 1580–85. Courtesy of the Khuda Bakhsh Oriental Public Library, Patna, MS 551.

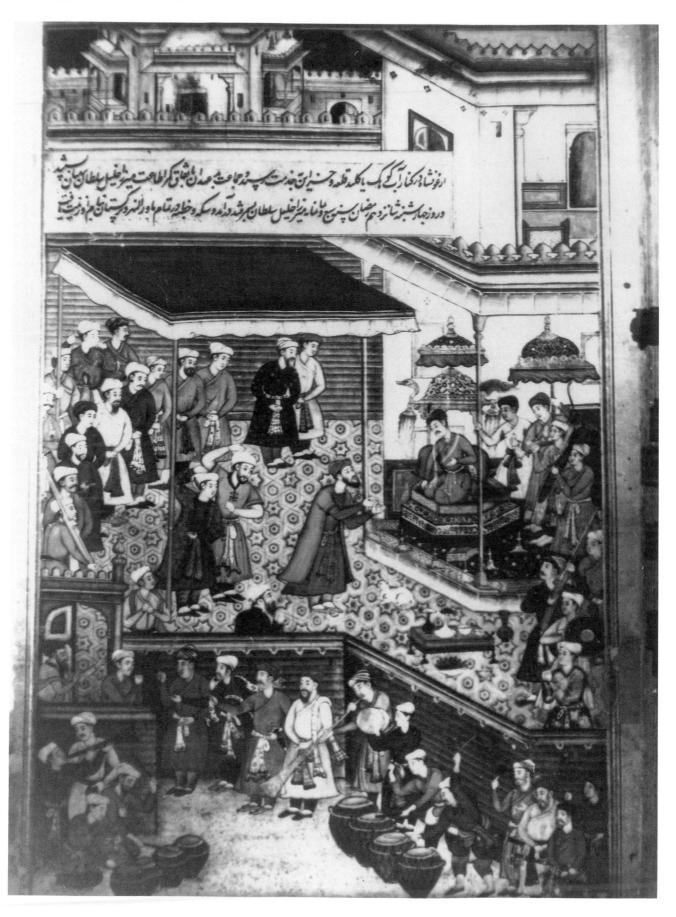

Figure 28. Mirza Khalil Sultan ascends the throne in Samarkand after Timur's death. *Tīmūr Nāma*, fol. 136b, c. 1580–85, sketches by Tulsi Khan, painted by Sarwa. Courtesy of the Khuda Bakhsh Oriental Public Library, Patna, MS 551.

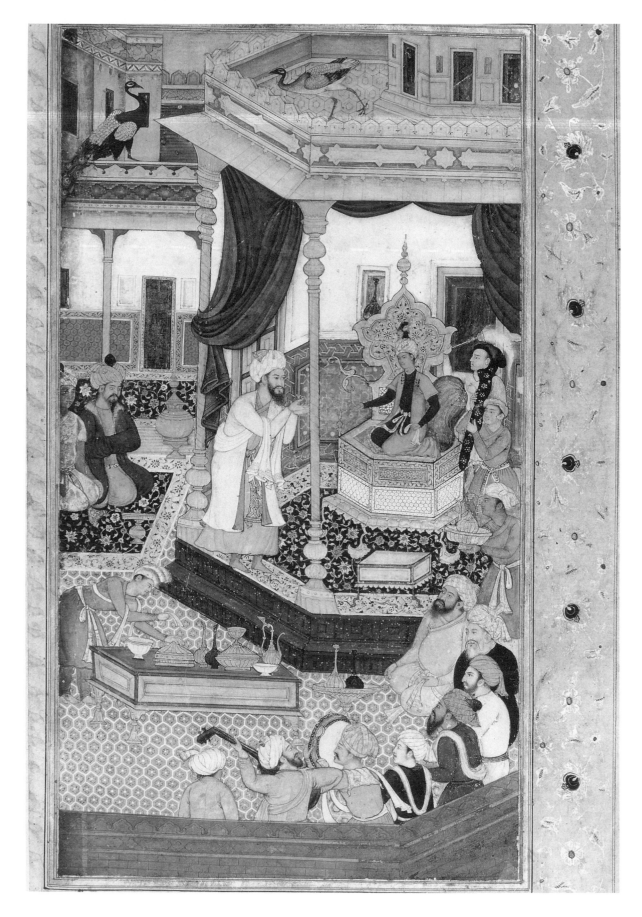

Figure 29. Babur becomes the ruler of Ferghana. *BN*, fol. 2v, c. 1591. Reproduced by permission of the British Library, OR3714.

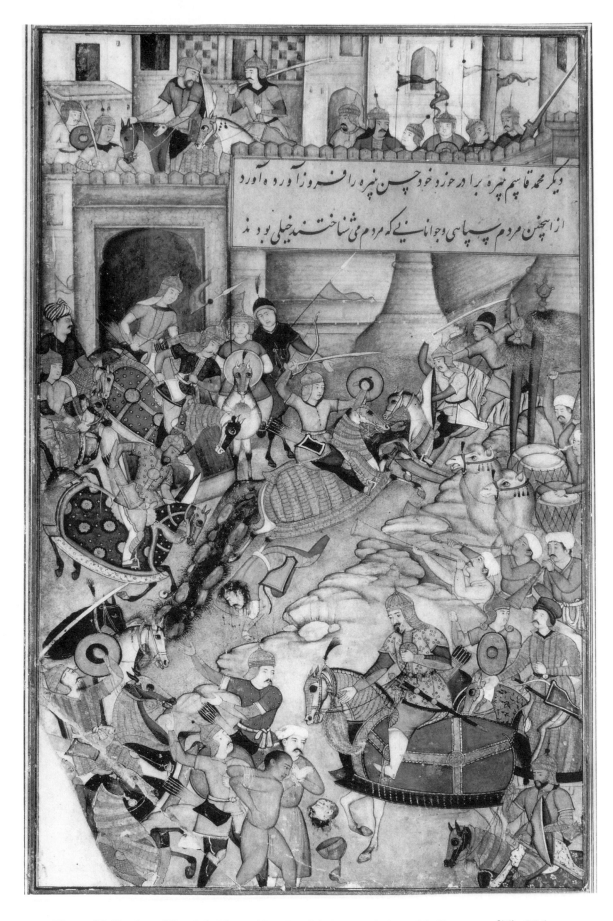

Figure 30. Battle at Mirza's bridge, 1497. *BN*, fol. 24, c. 1595–1605. Courtesy of The Walters
Art Gallery, Baltimore, W. 596.

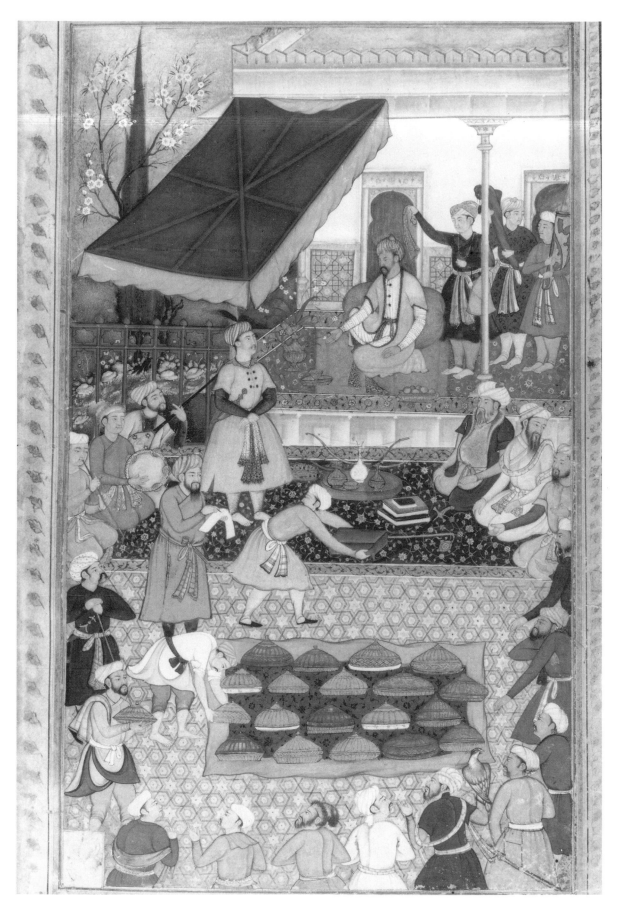

Figure 31. Party at Jahangir Mirza's in Ghazni, spring 1505
(detail appears on p. 88). *BN*, fol. 208b, c. 1591, by Bhim Gujarati. Reproduced by permission of the
British Library, OR3714.

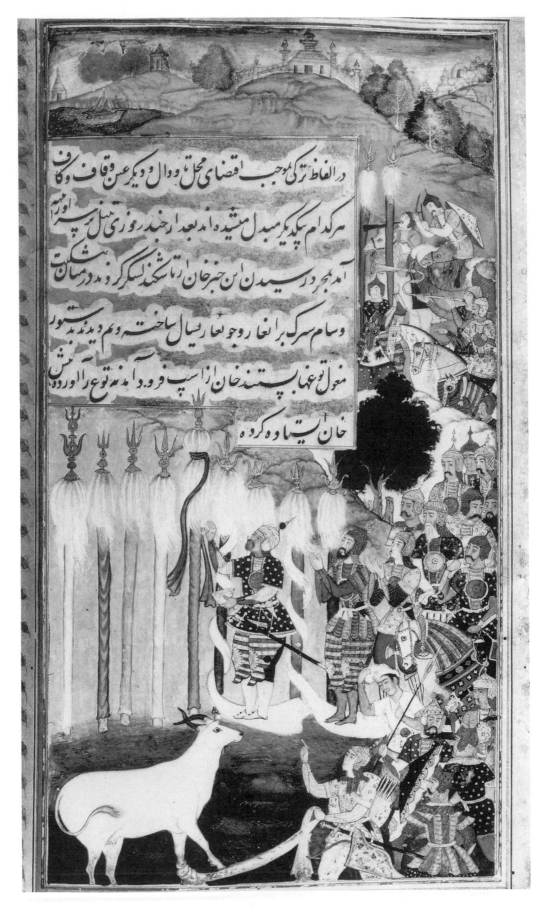

Figure 32. Acclaiming of the standards. *BN*, fol. 128v, c. 1591. Reproduced by permission of the British Library, OR3714.

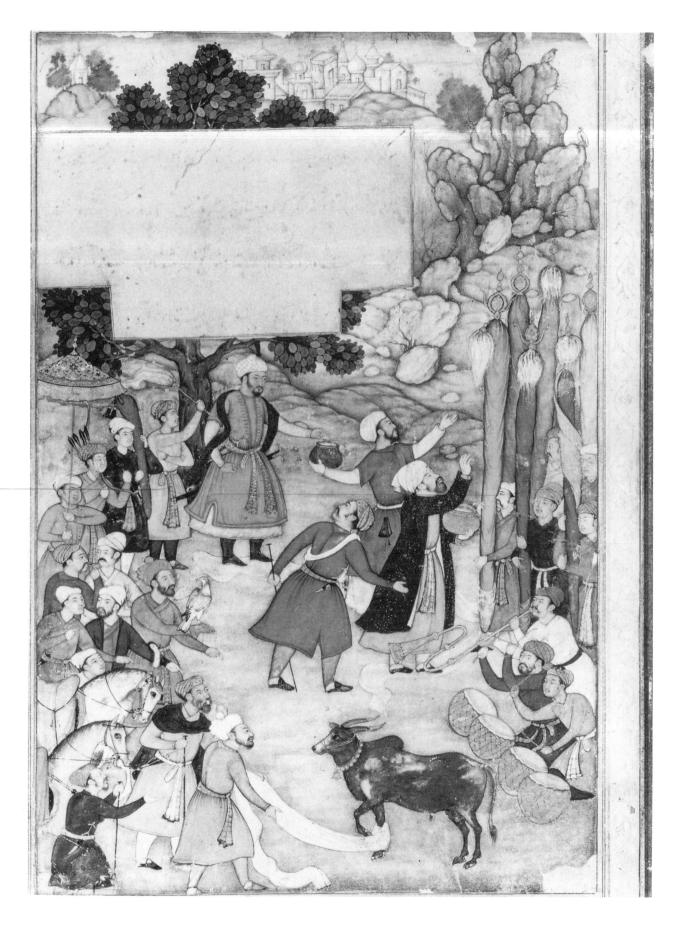

Figure 33. Acclaiming of the standards. *BN*, fol. 33v, c. 1593, attributed to Basawan. Courtesy of The Walters Art Gallery, Baltimore, W. 668.

Figure 34. The emperor at a repast. India, Mughal school, c. 1610, color on paper, 22.8 cm × 14.0 cm. © The Cleveland Museum of Art, 1997, Gift of J. H. Wade, 1920.1966.

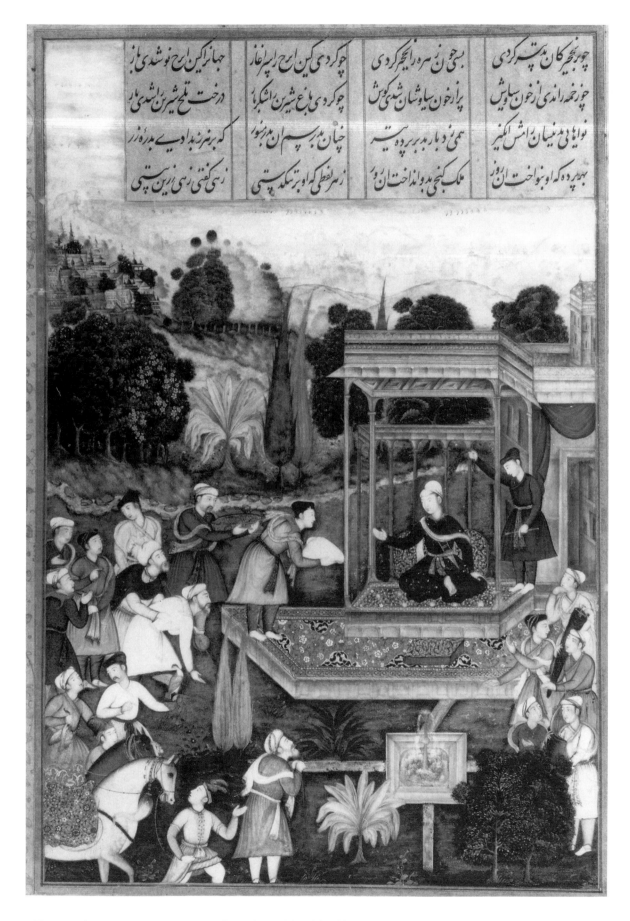

Figure 35. Young man receiving gifts and musician (detail appears on p. 190). *Khamsa* of Nizami, fol. 54, c. 1597–98. Reproduced by permission of the British Library, OR12208.

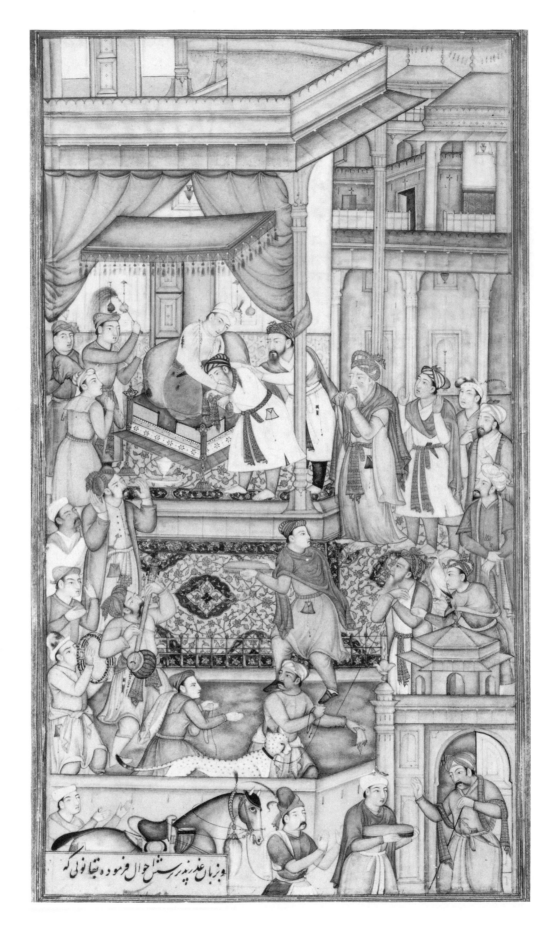

Figure 36. The submission of Bairam Khan. *AN*, c. 1604, attributed to Dharmdas, color and gold on paper, 24.2 cm × 12.9 cm. Courtesy of the Freer Gallery of Art, Smithsonian Institution, Washington, D.C., 52.33.

Figure 37. Woman entertaining a wood spirit (detail appears on p. 87). Folio from *Kathasaritsagara: The Tale of Somaprabha*, India, Mughal, c. 1590, opaque watercolor, gold and ink on paper, 13.0 cm × 12.7 cm. Courtesy of the Los Angeles County Museum of Art, Nasli and Alice Heeramaneck Collection, Museum Associates Purchase, M.78.9.13.

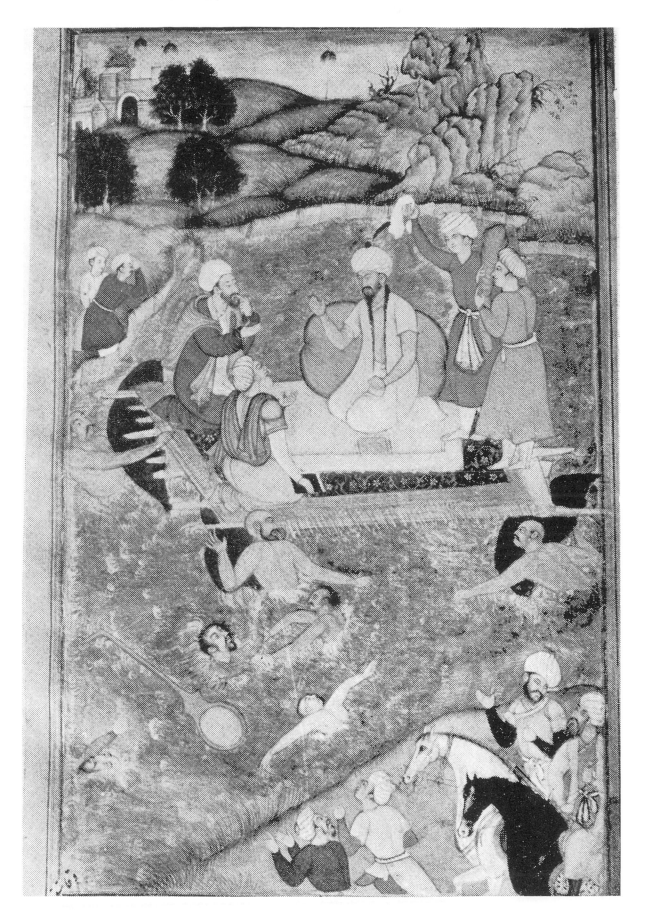

Figure 38. Babur on a raft crossing a river near Kabul. *BN*, fol. 234, c. 1597–98.
Courtesy of the National Museum, New Delhi.

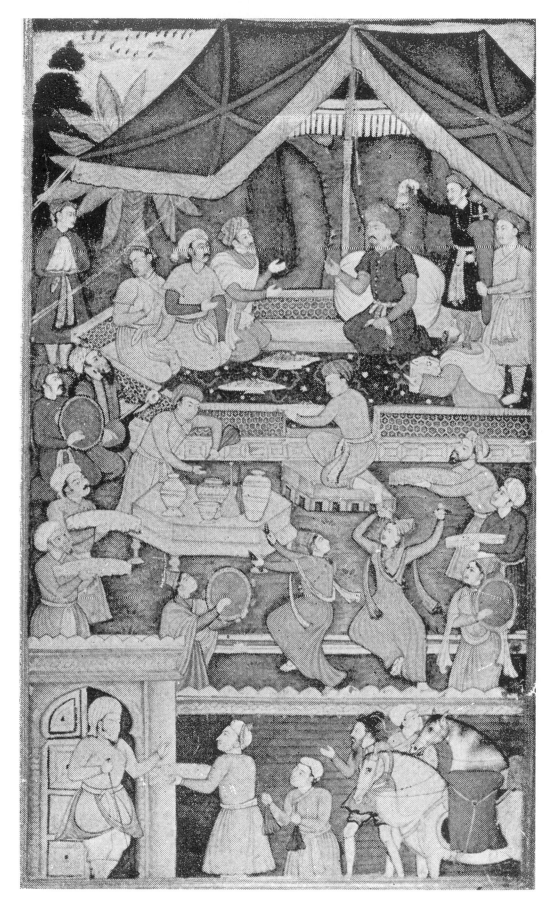

Figure 39. Babur celebrating the birth of Humayun in Char-bagh, Kabul. *BN*, fol. 209, 1597–98. Courtesy of the National Museum, New Delhi.

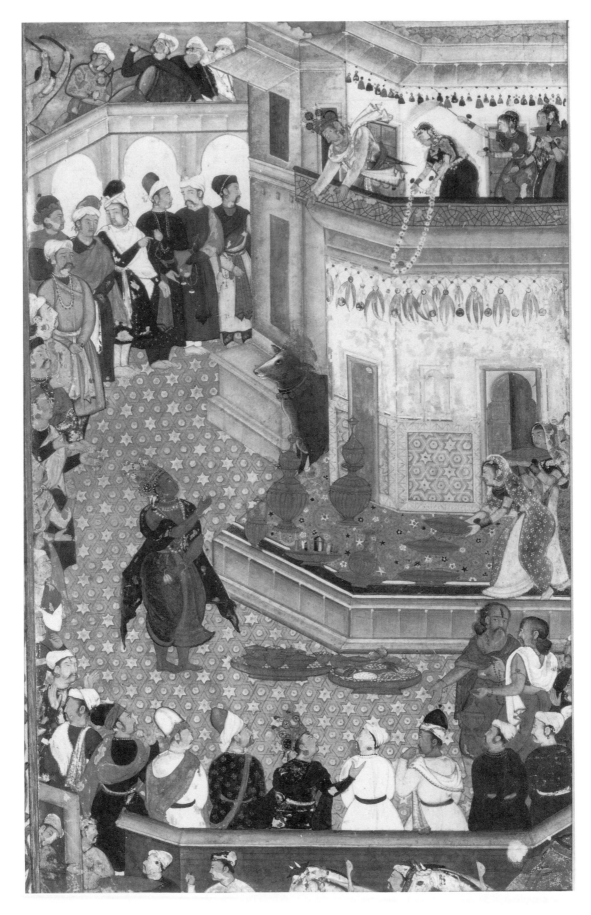

Figure 40. Lord Krishna received by Raja Bhismaka at Kundinapura. *Harivaṃśa*, c. 1590, 19.8 cm × 32.0 cm. Courtesy of the Board of Trustees of the Victoria and Albert Museum, IS.4-1970.

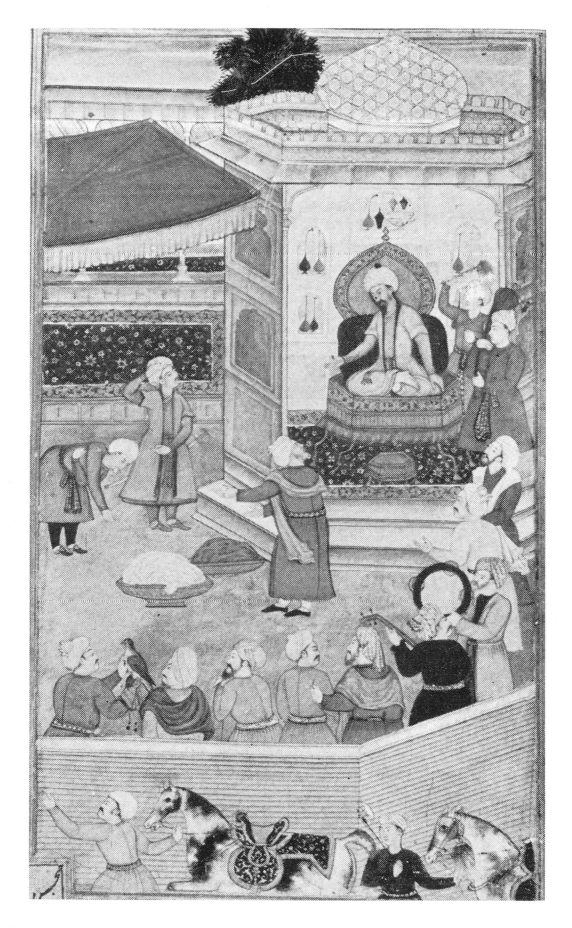

Figure 41. Babur holding a meeting in the pillared porch of Sultan Ibrahim's private apartments and bestowing gifts. *BN*, fol. 298, c. 1597–98, painted by Anant. Courtesy of the National Museum, New Delhi.

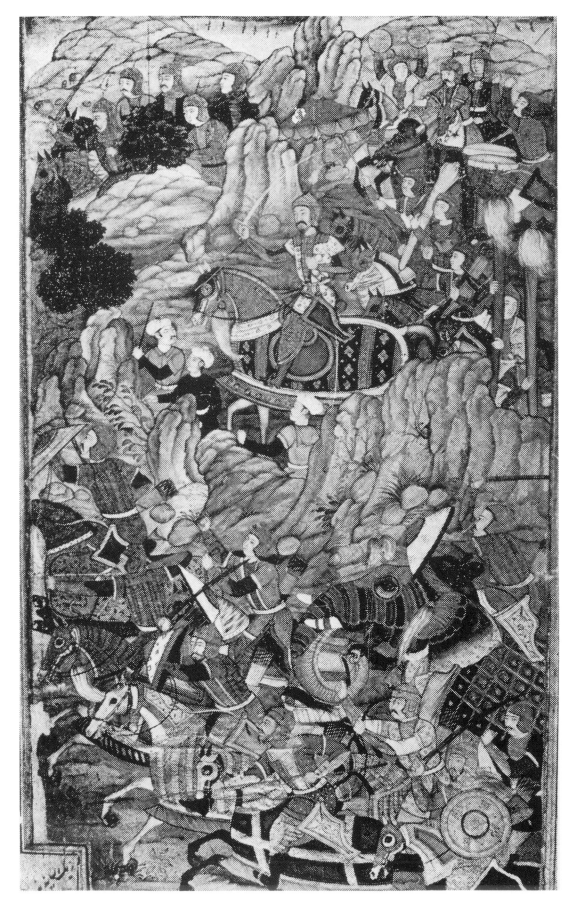

Figure 42. A scene from the battle of Kanua. *BN*, c. 1597–98. Courtesy of the National Museum, New Delhi.

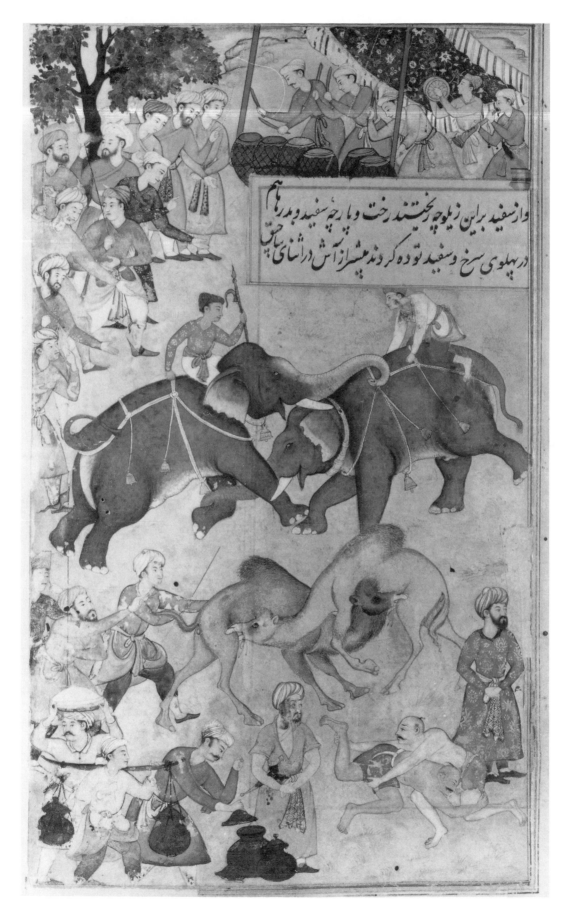

Figure 43. The entertainments at Babur's party, 1528, at Agra. *BN*, fol. 516r, c. 1588. Courtesy of the Board of Trustees of the Victoria and Albert Museum.

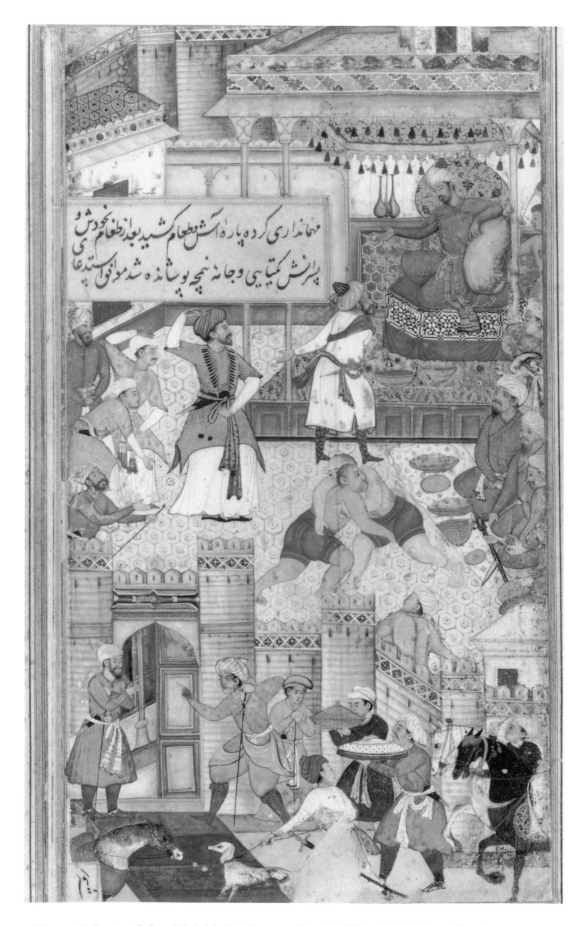

Figure 44. Feast at Sultan Jalalu'd-din's house at Karrah. *BN*, c. 1590, ink, gold, colors on paper, 35.5 cm × 23.3 cm. Courtesy of the Art Museum, Princeton University. Museum purchase, Carl Otto von Kiesenbusch, Jr., Memorial Collection, y1971-30.

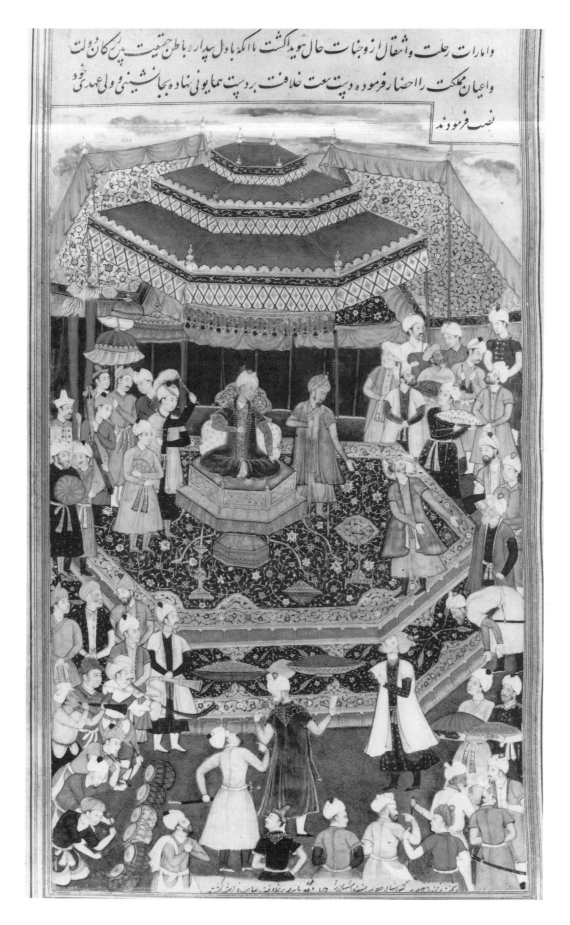

Figure 45. Babur appoints Humayun to succeed him in 1530. *AN*, fol. 53r, 1596–97 or 1604. Reproduced by permission of the British Library, OR12988.

Figure 46 (above and opposite). Humayun's accession *darbār* at Agra, 1530. *AN.* Courtesy of the Board of Trustees of the Victoria and Albert Museum, IM127-1921.

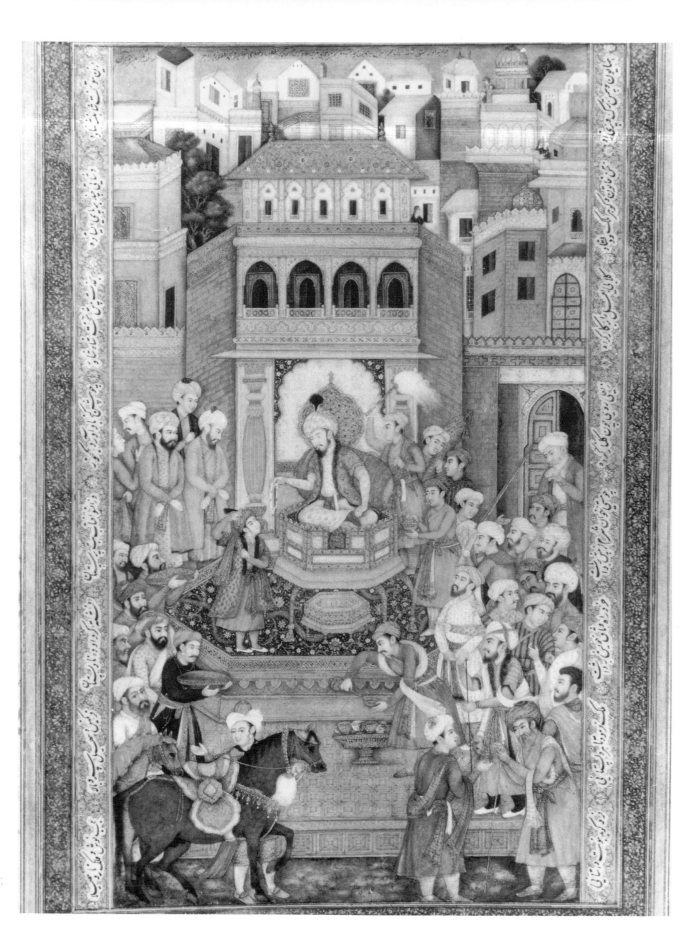

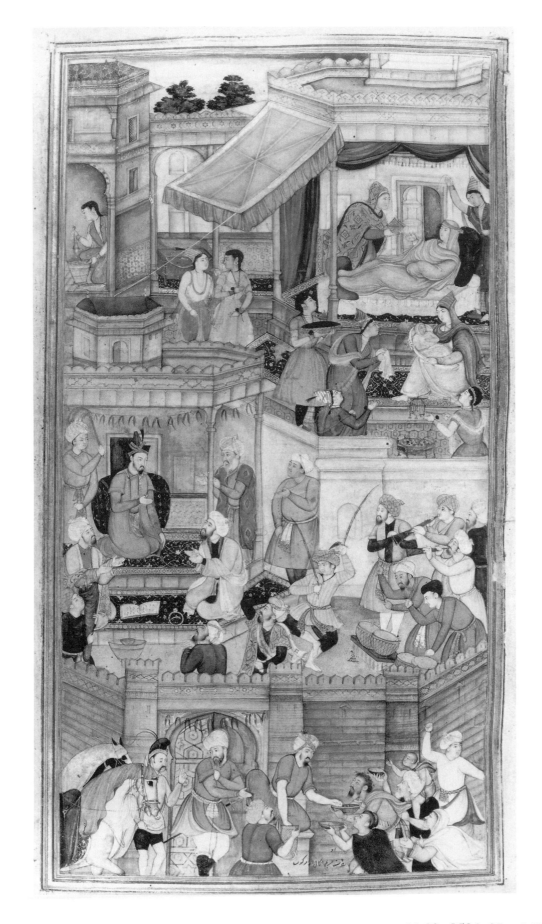

Figure 47. Rejoicing on the birth of Akbar (detail appears on p. 141). *AN*, fol. 22r, 1596–97 or 1604. Reproduced by permission of the British Library, OR12988.

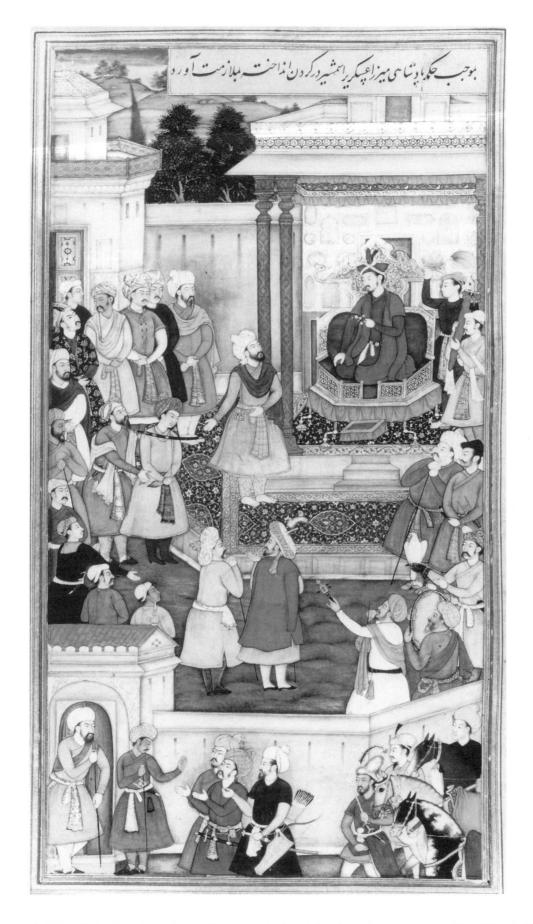

Figure 48. Mirza ʿAskari's submission to Humayun in Qandahar (detail appears on p. 69). *AN*, fol. 106r, 1596–97 or 1604. Reproduced by permission of the British Library, OR12988.

Figure 49. Conical horn and falconer's drum. *Tilasm*, c. 1565–70. Housed at the Rampur Raza Library.

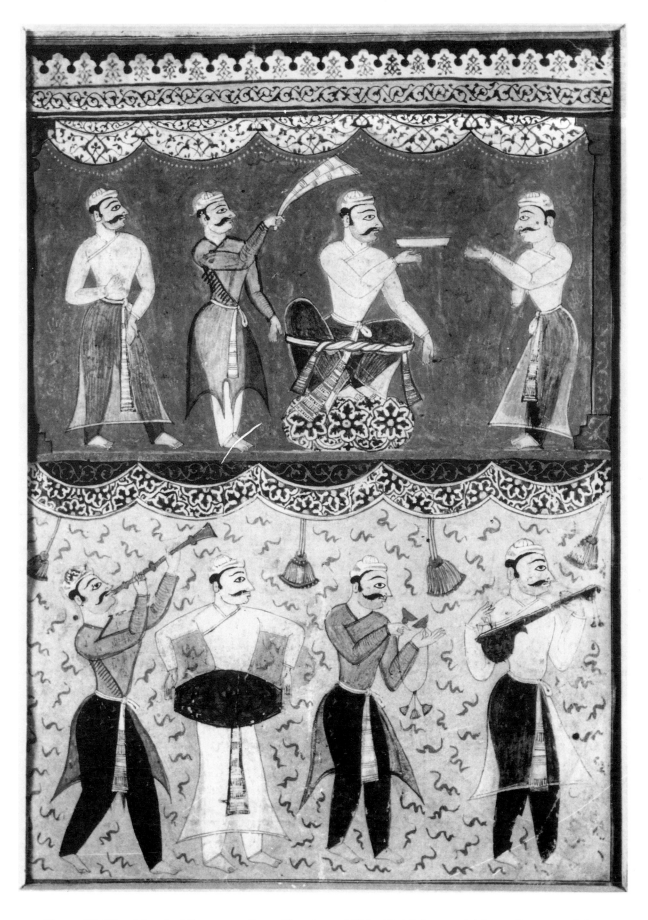

Figure 50. Khanjahan holding court. *Laur-Chandra*, c. 1525–70, 20.0 cm × 14.1 cm. Courtesy of the Trustees of the Prince of Wales Museum of Western India, Bombay.

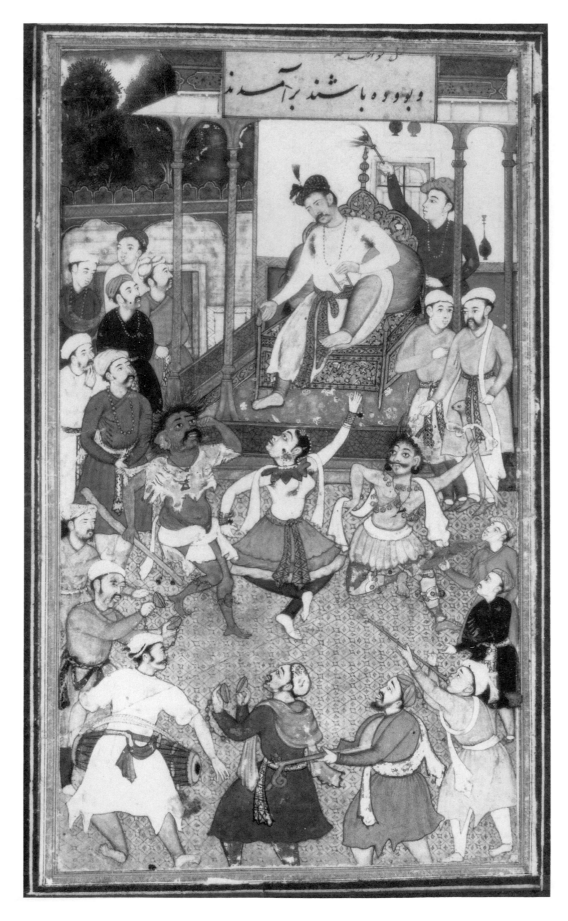

Figure 51. Grotesque dancers performing. India, Subimperial Mughal, c. 1600, color on paper, 16 cm × 9 cm. © The Cleveland Museum of Art, 1997, Andrew R. and Martha Holden Jennings Fund, 1971.88.

Figure 52. Madhavanala. *Kamakandala*, fol. 8, c. 1600–1603. Courtesy of Staatliche Museen zu Berlin-Preußischer Kulturbesitz Museum für Indische Kunst, MIK I 5685.

Figure 53. The birth of Prince Salim (with mother). *AN*, fol. 142b, 1596–97 or 1604. Reproduced by kind permission of the Trustees of the Chester Beatty Library, Dublin, MS 3.

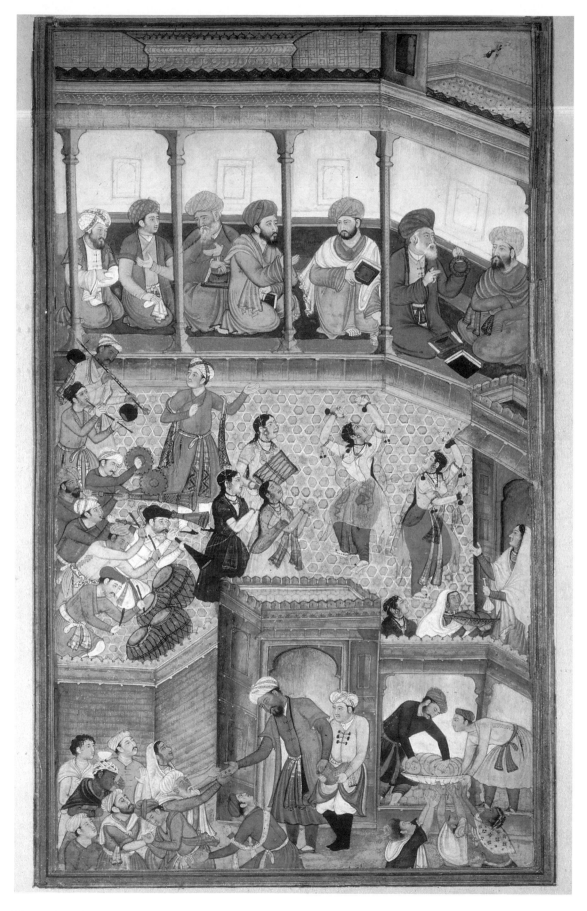

Figure 54. The birth of Prince Salim. *AN*, fol. 143b, 1596–97 or 1604. Reproduced by kind permission of the Trustees of the Chester Beatty Library, Dublin, MS 3.

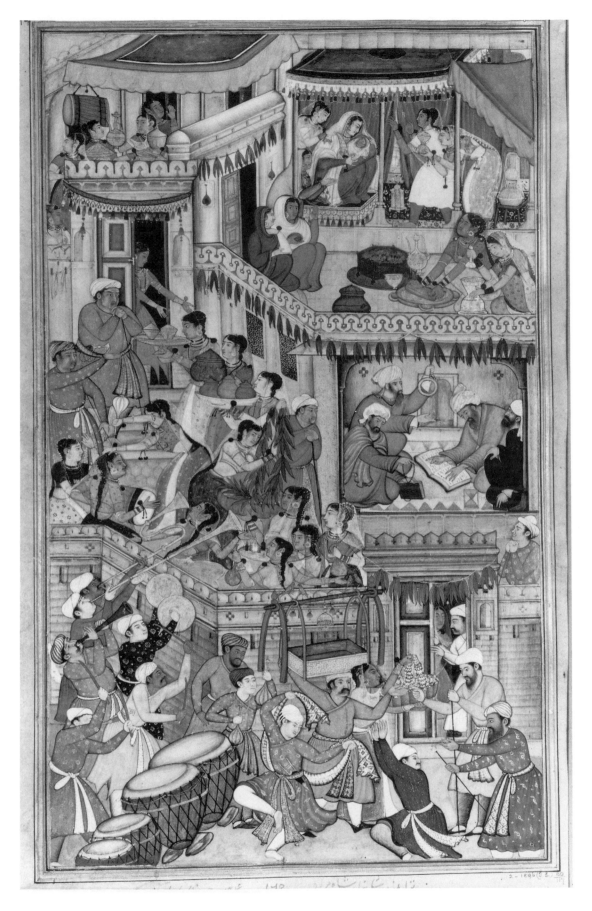

Figure 55. Rejoicing at Fatehpur Sikri on the birth of Akbar's second son. *AN*, 1590 or earlier, painted by Bhurah. Courtesy of the Board of Trustees of the Victoria and Albert Museum, IS.2-1896 80/117.

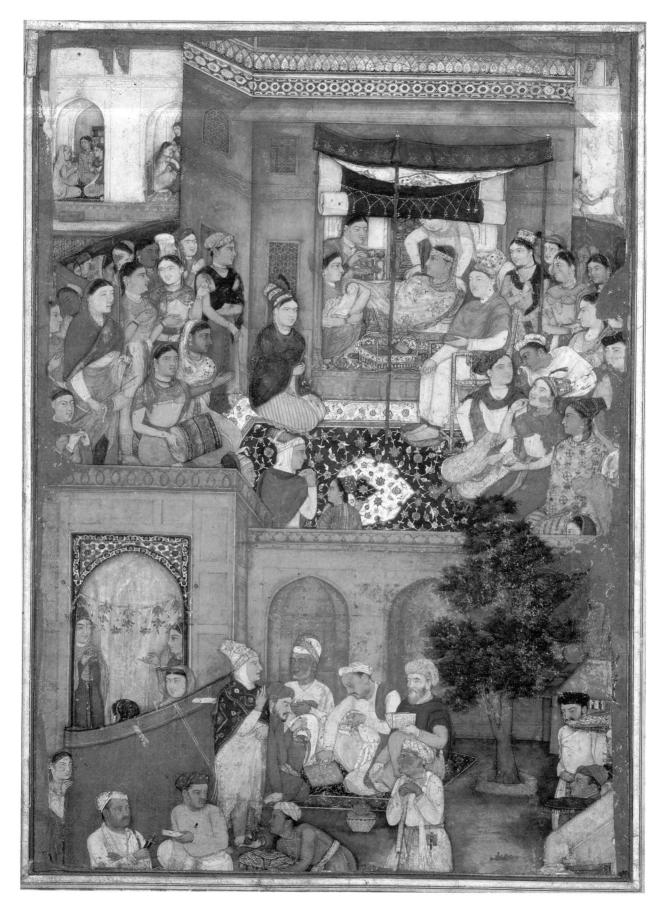

Figure 56. Birth of a prince. *Jahāngīr Nāma*, c. 1620, attributed to Bishandas, opaque watercolor on paper, 26.4 cm × 16.4 cm. Francis Bartlett Donation of 1912 and Picture Fund. Courtesy of the Museum of Fine Arts, Boston, 14.657.

Figure 57. A banquet at the court of Caliph-al-Mutawakkil. *Tarīkh-i Alfī*, late sixteenth century, painted by Tarya with portraits by Nar Singh, color and ink on paper, 42.1 cm × 24.6 cm. Courtesy of the Freer Gallery of Art, Smithsonian Institution, Washington, D.C., 31.27.

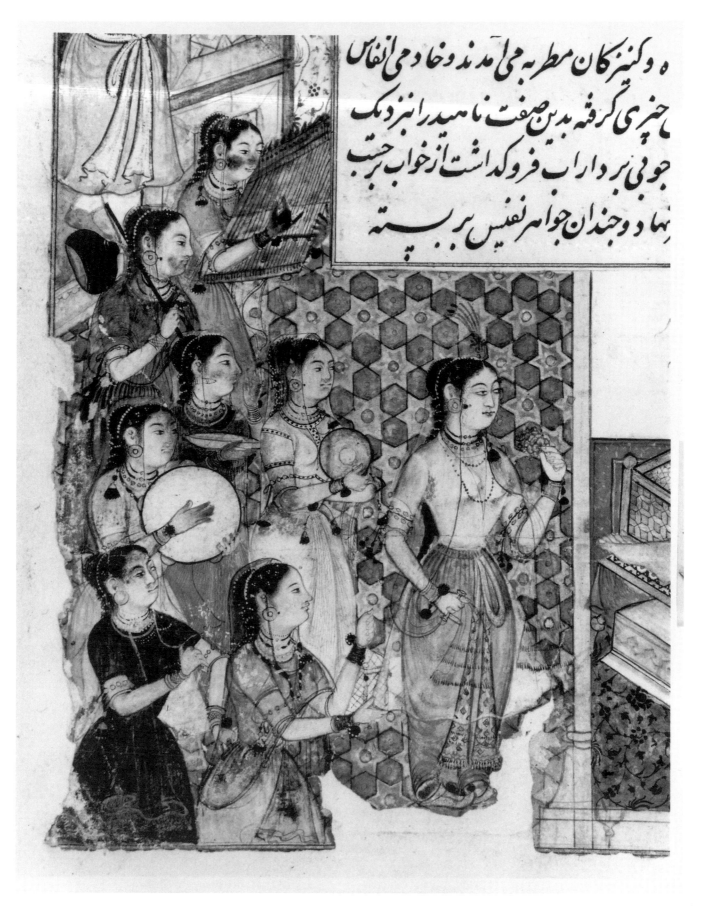

Figure 58. Woman playing board zither. *Dārab Nāma,* fol. 129a, c. 1580–85. Reproduced by permission of the British Library, OR4615.

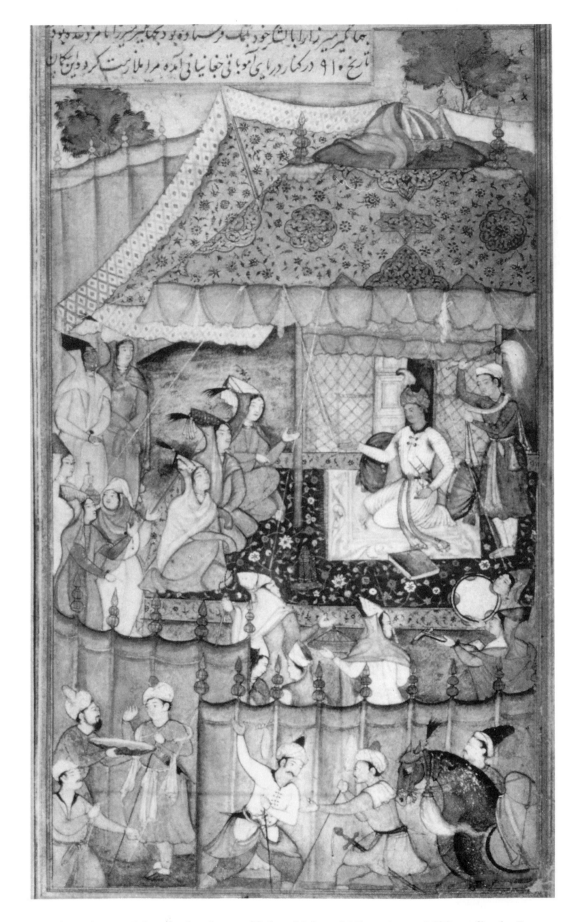

Figure 59. Babur receiving the daughters of Sultan Mahmud Mirza. *BN*, c. 1590, outline by Basawan, painting by Dharmdas (after Stuart Cary Welch, "Early Mughal Miniature Paintings from Two Private Collections Shown at the Fogg Art Museum" in *Ars Orientalis* 3:133–46, fig. 2).

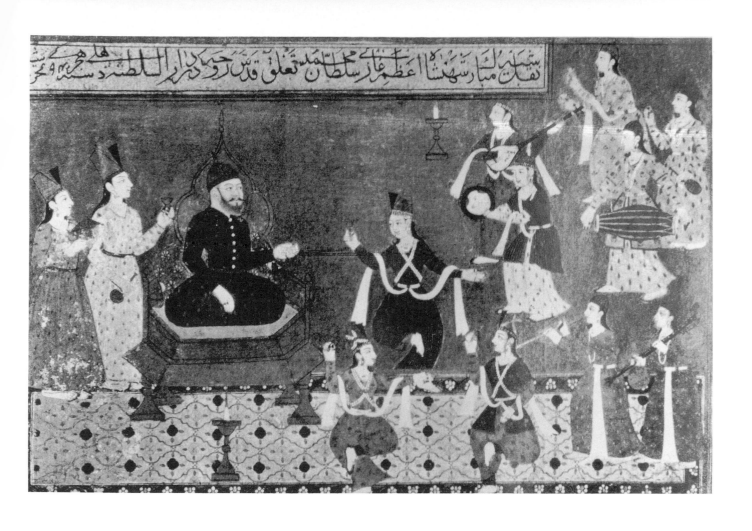

Figure 60. A nautch party at the court of Muhammad Tughluk. From a Sultanate manuscript, 1534, by Shapur of Khurasan.

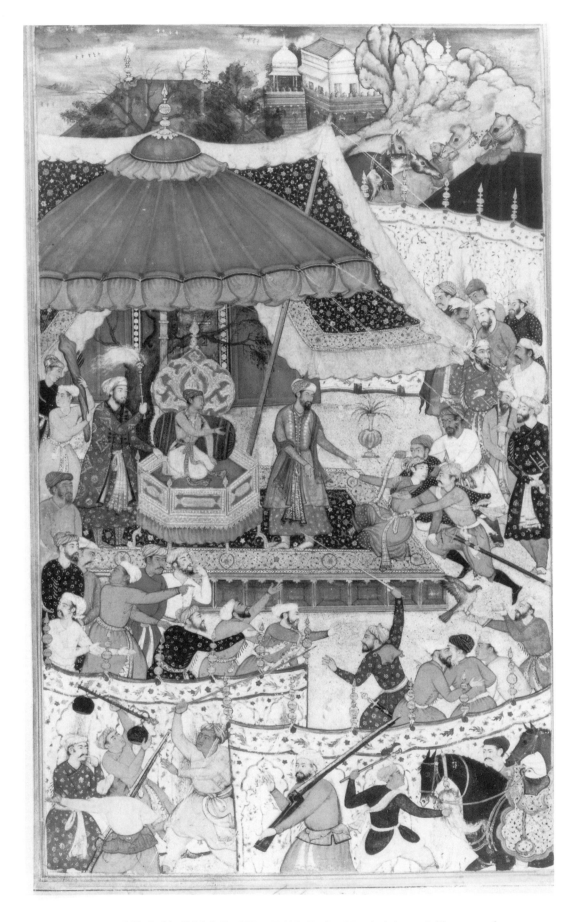

Figure 61. Arrest of Shah Abu'l Ma'ali. *AN*, c. 1590, India, Mughal, imperial image, color on paper, 34.3 cm × 20.0 cm. Lucy Maud Buckingham Collection, 1919.898. Photograph © 1996, The Art Institute of Chicago. All rights reserved.

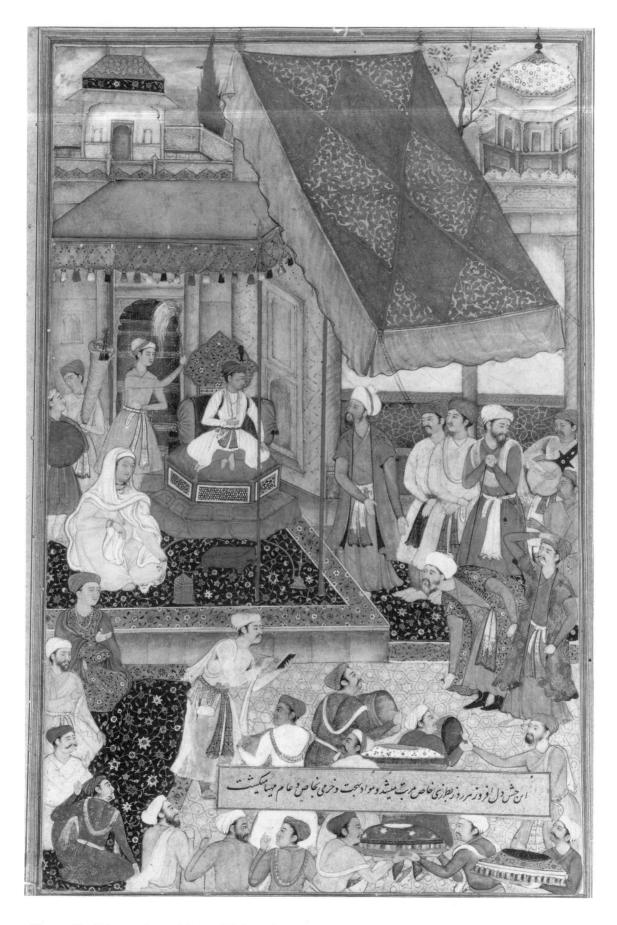

Figure 62. Akbar at the wedding of Maham Anaga's son. *AN*, 1590 or earlier, copied by Lal, painted by Sanwala. Courtesy of the Board of Trustees of the Victoria and Albert Museum, IS.2-1896 9/117.

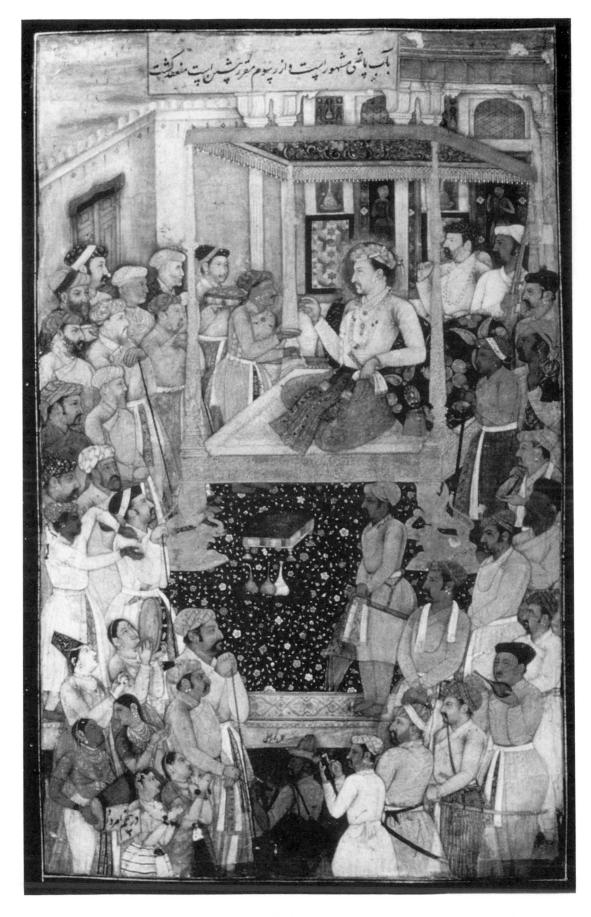

Figure 63. A scene of the Ab-Pashi festival. *TiJ*, 1614, painted by Govardhan. Housed at the Rampur Raza Library.

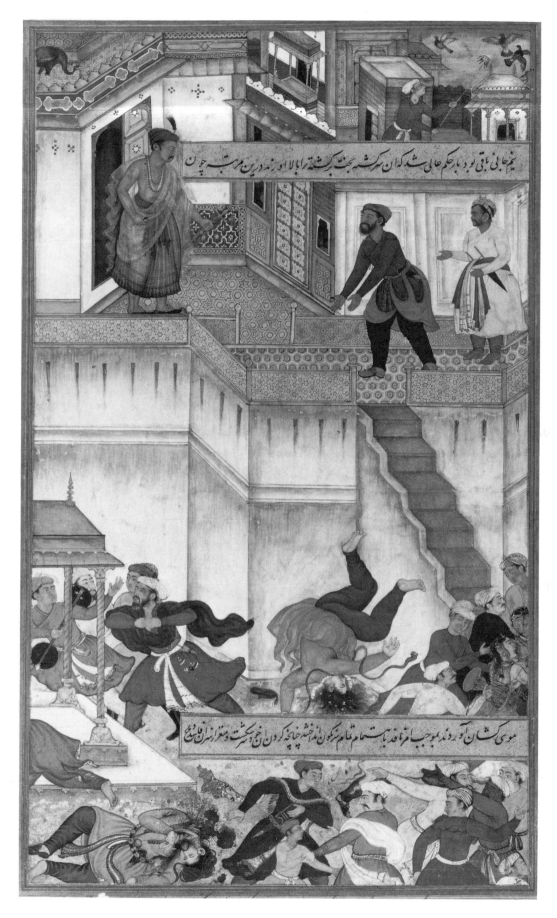

Figure 64. Adham Khan thrown to his death (detail appears on p. 100). *AN*, 1590 or earlier, composed by Miskin, painted by Shankar, faces by Miskin. Courtesy of the Board of Trustees of the Victoria and Albert Museum, IS.2-1896 29/117.

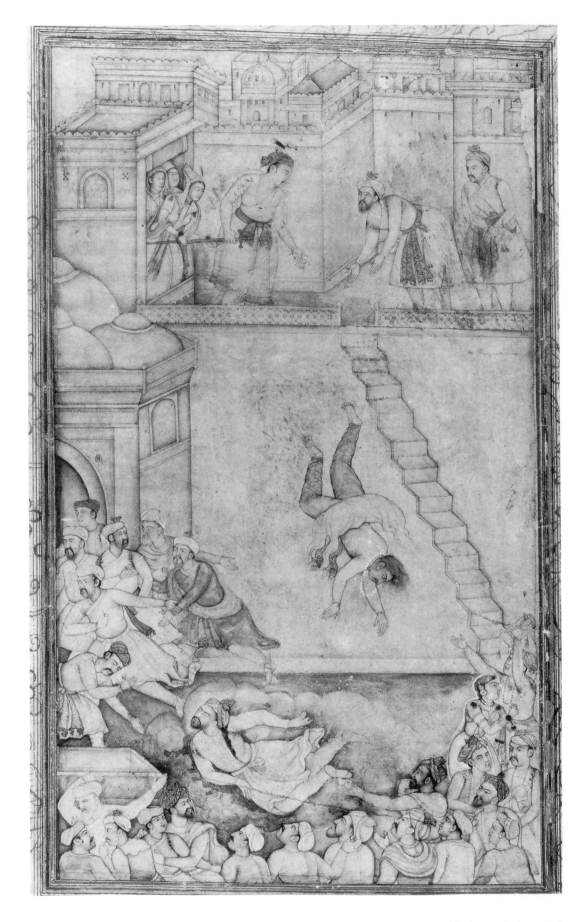

Figure 65. Akbar orders the punishment of Adham Khan, n.d. Reproduced by kind permission of the Trustees of the Chester Beatty Library, Dublin, MS 7.

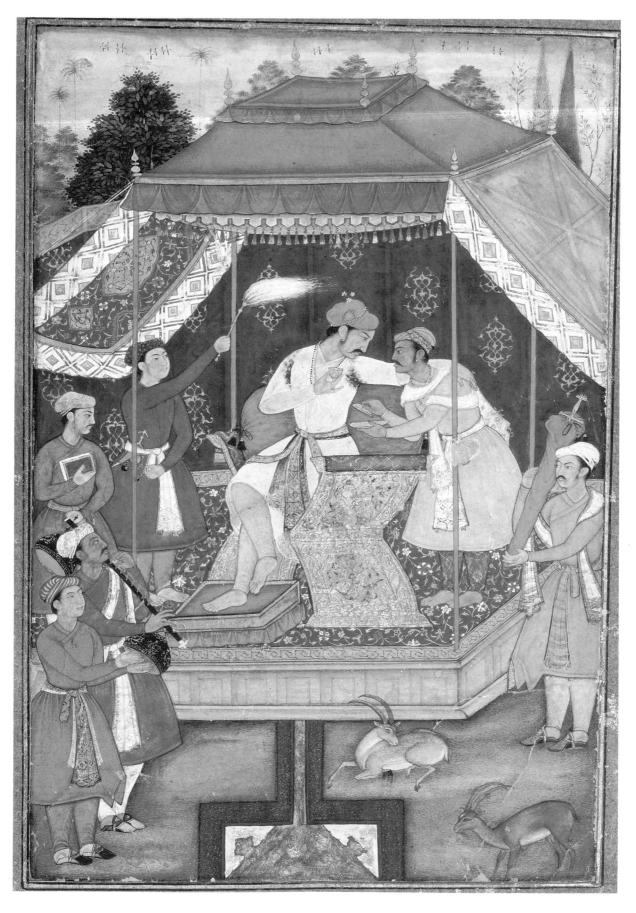

Figure 66. Prince Salim with a courtier and attendants in a tent. Attributed to Sur Das Gujarati, c. 1600, color and gold on paper, 17.0 cm × 11.4 cm. Courtesy of the Freer Gallery of Art, Smithsonian Institution, Washington, D.C., 60.27.

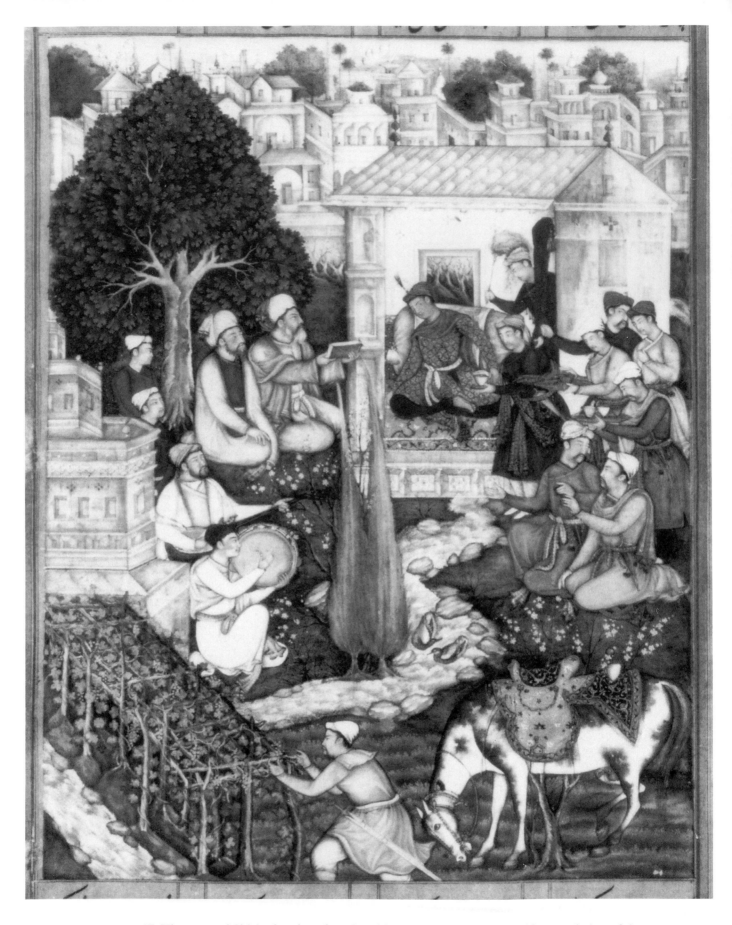

Figure 67. Khusrau and Shirin drunk, n.d., painted by Dharmdas. Reproduced by permission of the British Library, OR12208, fol. 40v.

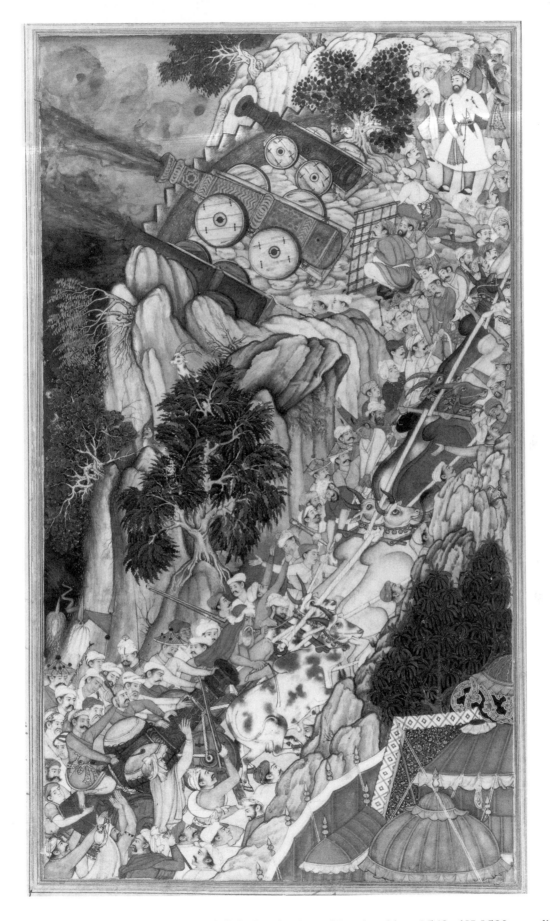

Figure 68. Bullocks drag the cannons uphill during the siege of Ranthambhor, 1569. *AN*, 1590 or earlier, composed by Miskin, painted by Paras. Courtesy of the Board of Trustees of the Victoria and Albert Museum, IS.2-1896 72/117.

Figure 69. Portrait of Tansen, c. 1585–90. Courtesy of the National Museum, New Delhi.

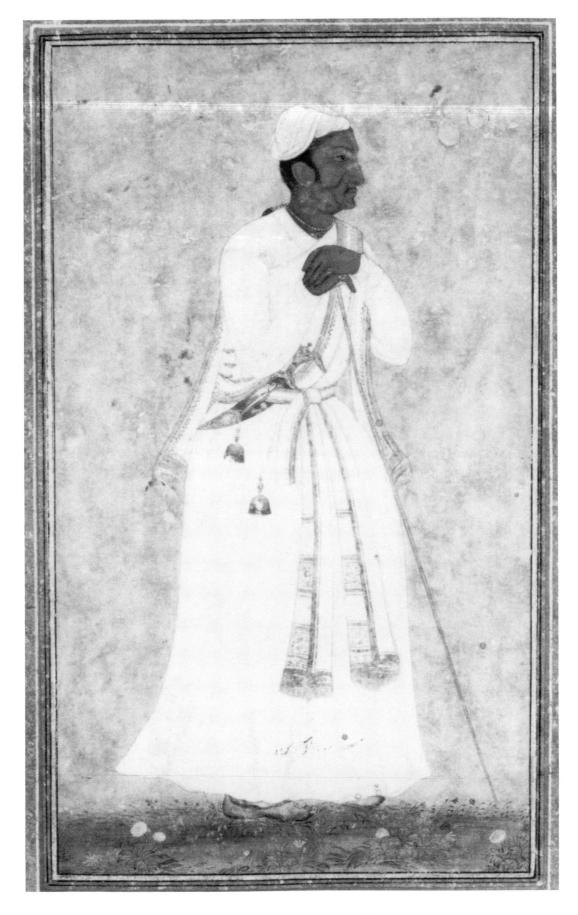

Figure 70. Portrait of Tansen, c. 1580. Indian, Mughal dynasty, Akbar period, opaque watercolor on paper, 13.7 cm × 7.0 cm. Courtesy of the Chrysler Museum, Norfolk, Va., museum purchase, Grandy Art Trust Fund, 58.27.20.

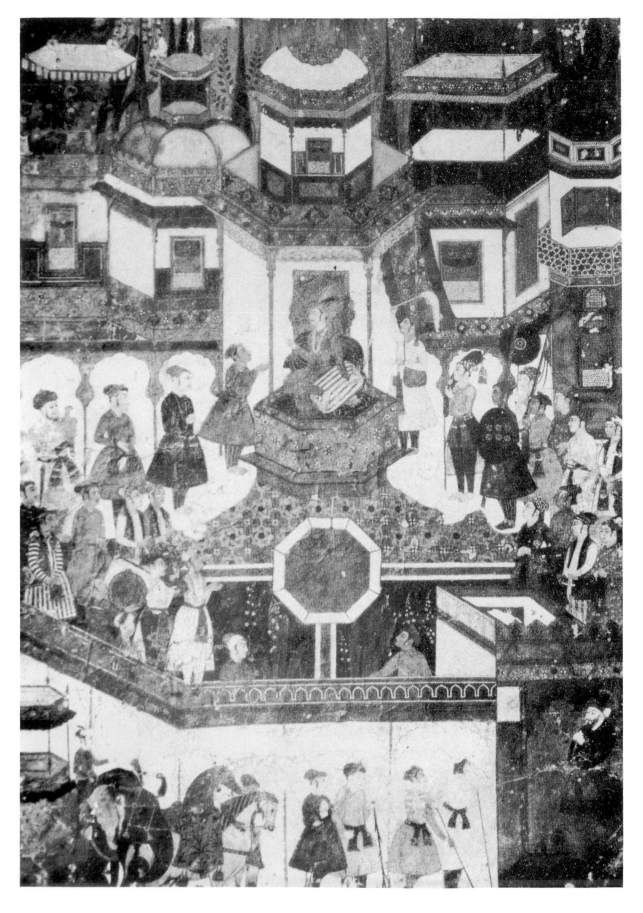

Figure 71. The arrival of Tansen, the musician, at the court of Akbar, 1562. 32.8 cm × 22.8 cm. Courtesy of the Indian Museum, Calcutta, no. 342.

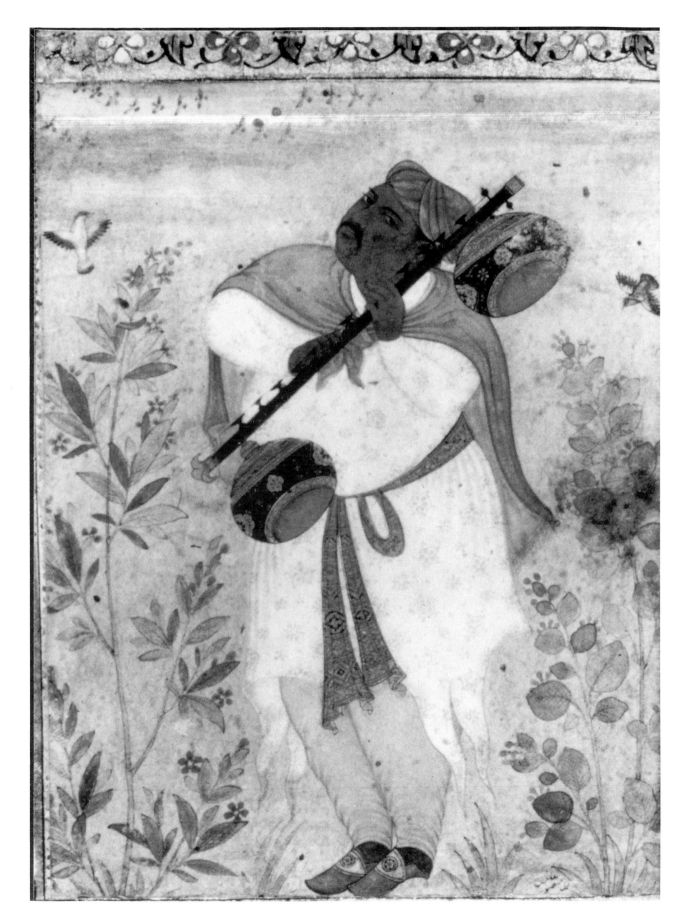

Figure 72. A *vīṇā* player, c. 1604. Reproduced by permission of the British Library.

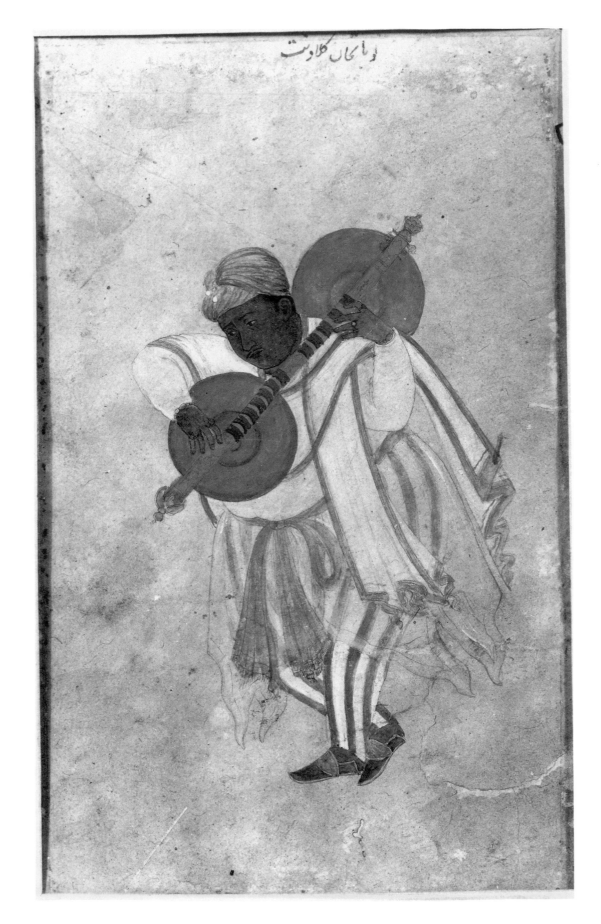

Figure 73. Portrait of Naubat Khan with *vīṇā* (Numa Khan Kalavant [a musician of the court of Jahangir]), early seventeenth century. Ross-Coomaraswamy Collection. Courtesy of the Museum of Fine Arts, Boston, 17.3102.

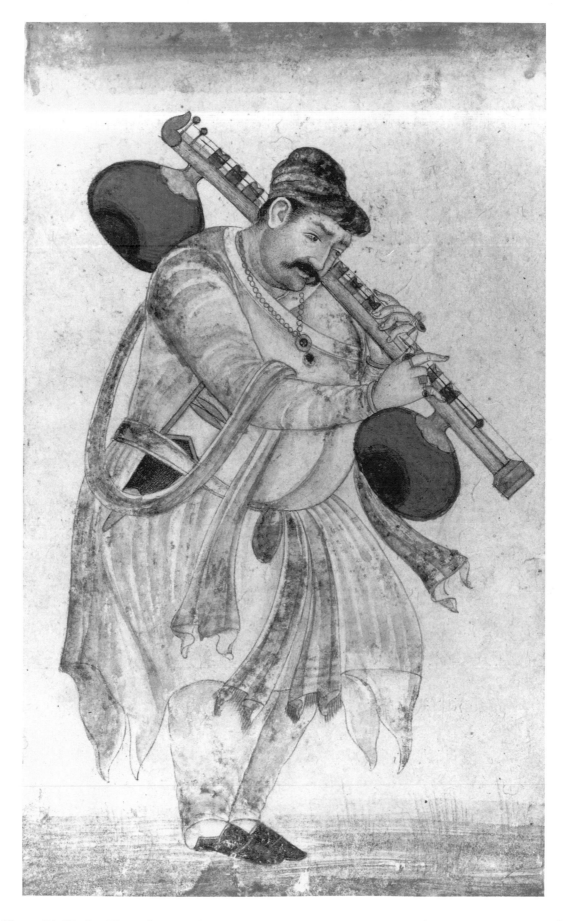

Figure 74. Naubat Khan, the *vīṇā* player. Eighteenth century, opaque watercolor on paper. Courtesy of the San Diego Museum of Art, Edwin Binney 3rd Collection, 1990:0379.

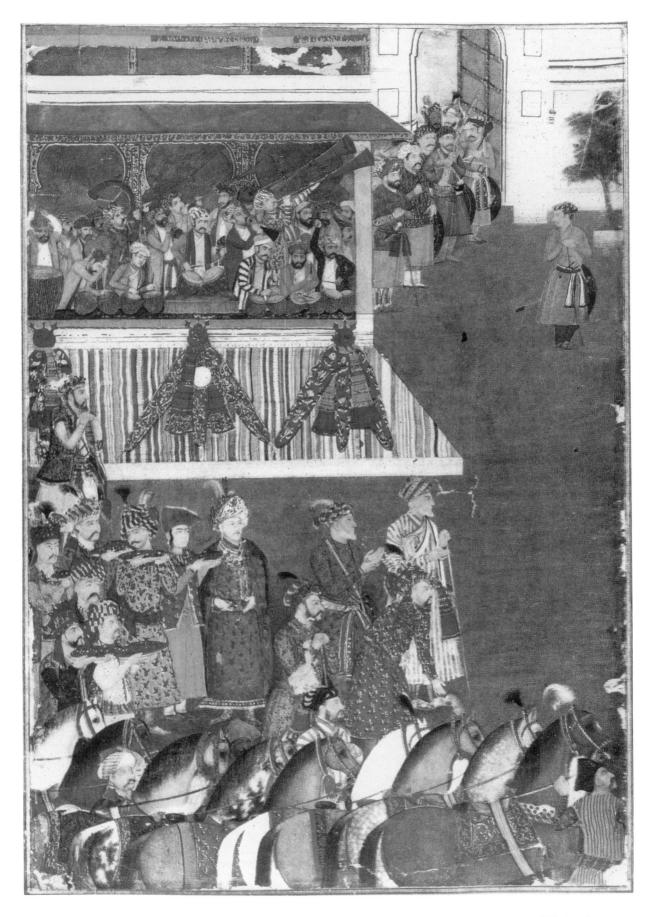

Figure 75. A *darbār* scene: Escorting the Persian noble ʿAli Mardan Khan to the presence of Shah Jahan, November 1638 (detail appears on p. 122). From a collection of the late Sri Sitaram Sah of Benares, Varanasi. Reprinted by permission of Pushpalata Pratap.

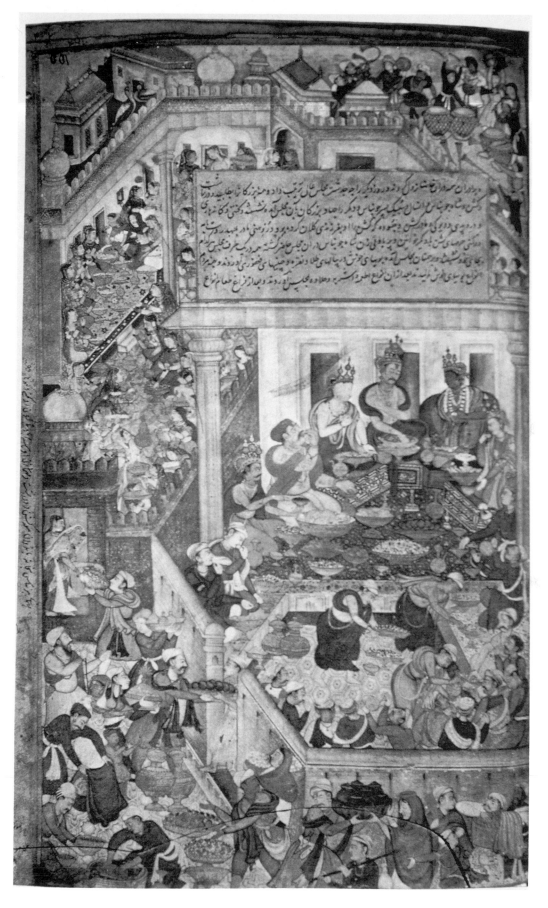

Figure 76. A feast at the house of the Pandavas at Hastinapura (detail appears on p. 123). *RN*, c. 1584–85, by Daswanth, painted by Bhora, accession no. 1785.

Figure 77. Infant son of King Isfahan responds to music. *TuN*, fol. 105r, India, Mughal school, reign of Akbar, c. 1560, color and gold on paper, 20.3 cm × 14.0 cm. © The Cleveland Museum of Art, 1997, Gift of Mrs. A. Dean Perry, 1962.279.

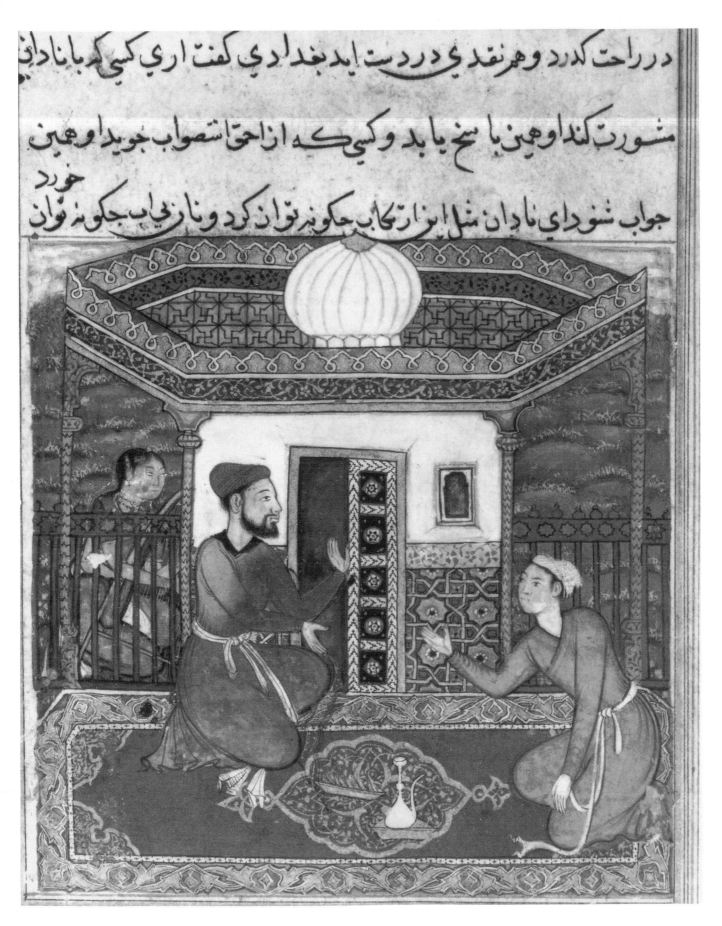

Figure 78. Young man of Baghdad asks advice from a friend (detail appears on p. 127). *TuN*, fol. 305r, India, Mughal school, reign of Akbar, c. 1560, color and gold on paper, 20.3 cm × 14.0 cm. © The Cleveland Museum of Art, 1997, Gift of Mrs. A. Dean Perry, 1962.279.

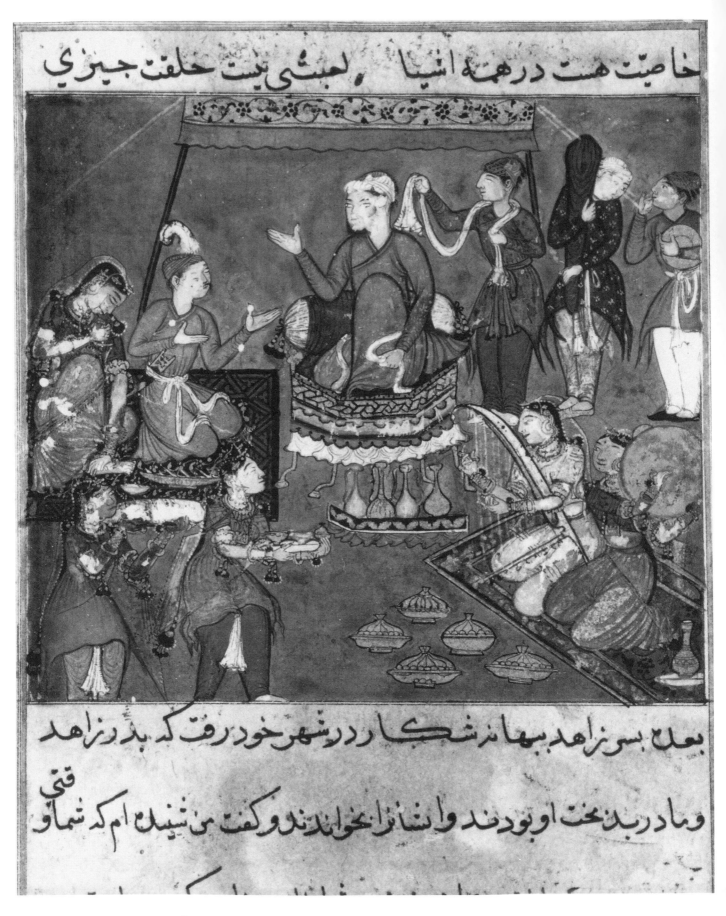

Figure 79. The king gives his daughter in marriage to the pious man's son. *TuN*, fol. 339r, India, Mughal school, reign of Akbar, c. 1560, color and gold on paper, 20.3 cm × 14.0 cm. © The Cleveland Museum of Art, 1997, Gift of Mrs. A. Dean Perry, 1962.279.

Figure 80. The sultan of Baghdad and a Chinese girl. *Anvār-i-Suhailī*, fol. 320, 1610, attributed to Bishandas. Reproduced by permission of the British Library, ADD18579.

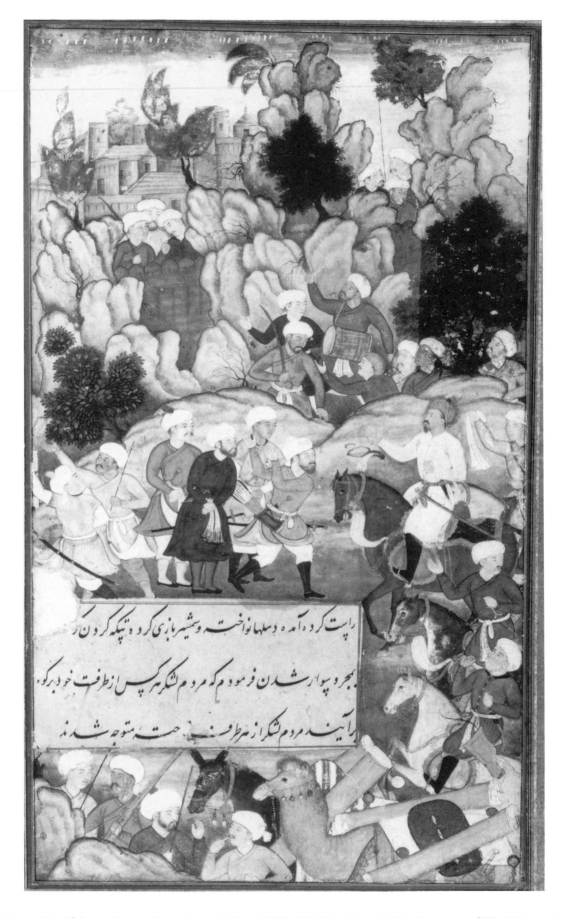

Figure 81. Afghan prisoners brought to Babur, 1507. *BN*, fol. 13v, c. 1593. Courtesy of The Walters Art Gallery, Baltimore, W. 596.

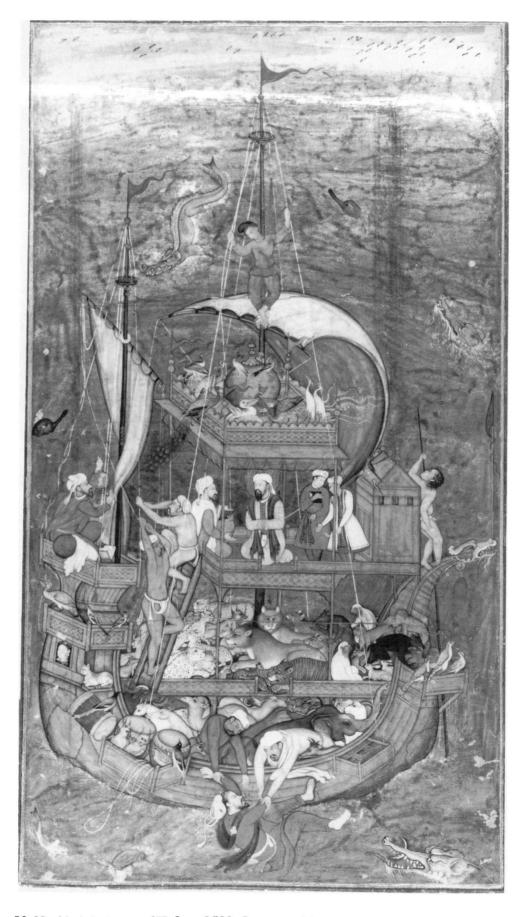

Figure 82. Noah's Ark. *Dīvān* of Hafiz, c. 1590. Courtesy of the Freer Gallery of Art, Smithsonian Institution, Washington, D.C., 48.8.

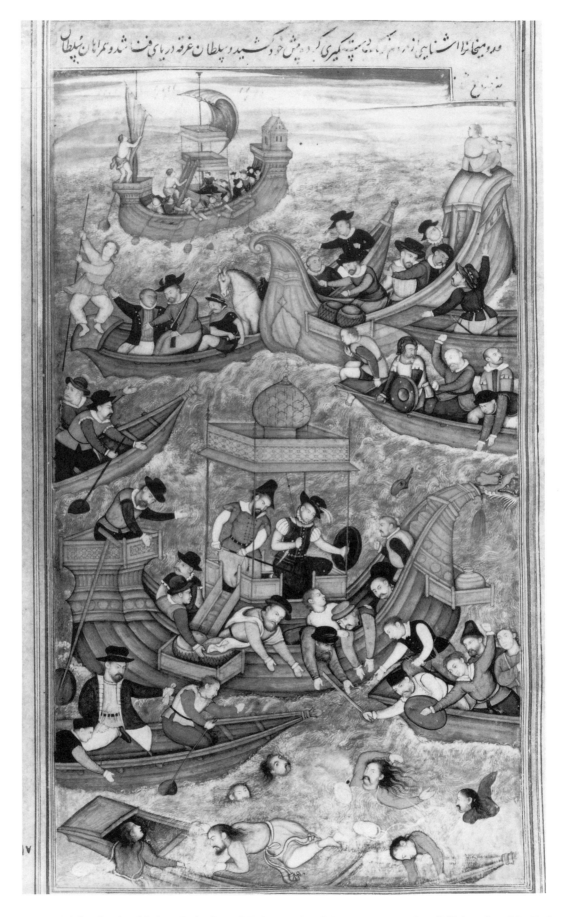

Figure 83. The death of Sultan Bahadur of Gujarat. *AN*, fol. 66r, 1596–97 or 1604, painted by Lal. Reproduced by permission of the British Library, OR12988.

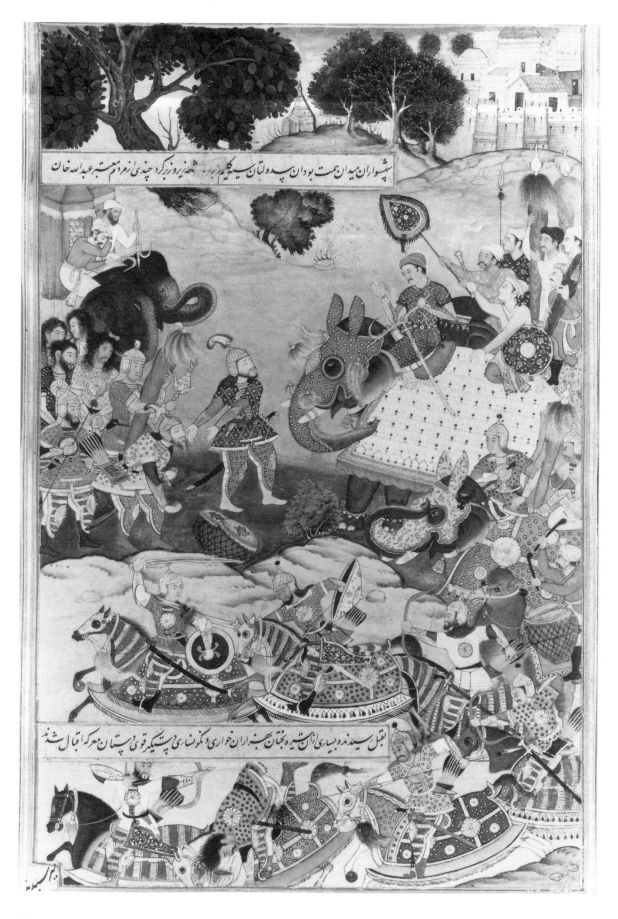

Figure 84. Akbar receives a drum and standard from Abdullah Uzbeg. *AN*, fol. 41, 1590 or earlier, painted by Anant. Courtesy of the Board of Trustees of the Victoria and Albert Museum, IS.2-1896 41/117.

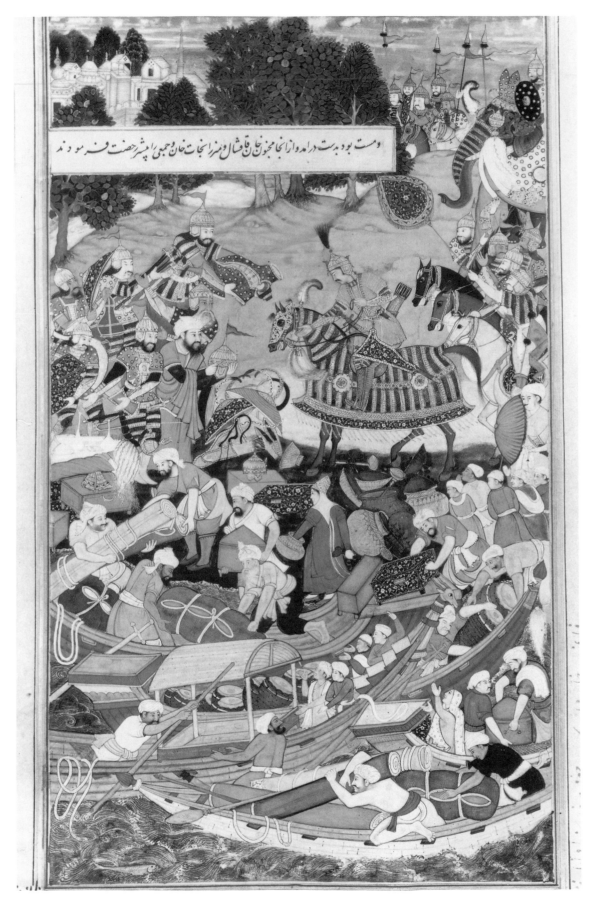

Figure 85. Akbar receives booty from the defeat of Khan Zaman. *AN*, fol. 97, 1590 or earlier, painted by Makhlas. Courtesy of the Board of Trustees of the Victoria and Albert Museum, IS.2-1896 97/117.

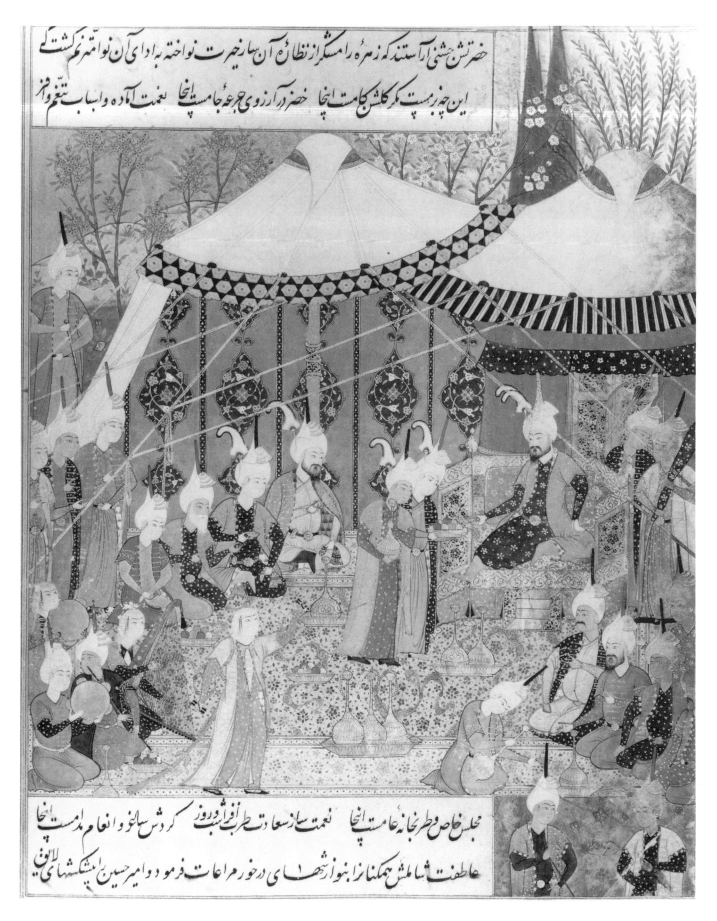

Figure 86. Timur enthroned, 1552. Reproduced by permission of the British Library, OR1359, fol. 35b.

Figure 87. The delivery of presents for Prince Dara Shikoh's wedding (details appear on pp. 131, 179, 180, 192). *PSN*, fol. 121A, c. 1635, attributed to Bishandas. The Royal Collection © 1996 Her Majesty Queen Elizabeth II, Holmes Binding 149, p. 241.

Figure 88. Young man listens to recitation, 1588. *Dīvān* of Hafiz, fol. 321, by the Persian artist Farrukh Beg. Housed at the Rampur Raza Library.

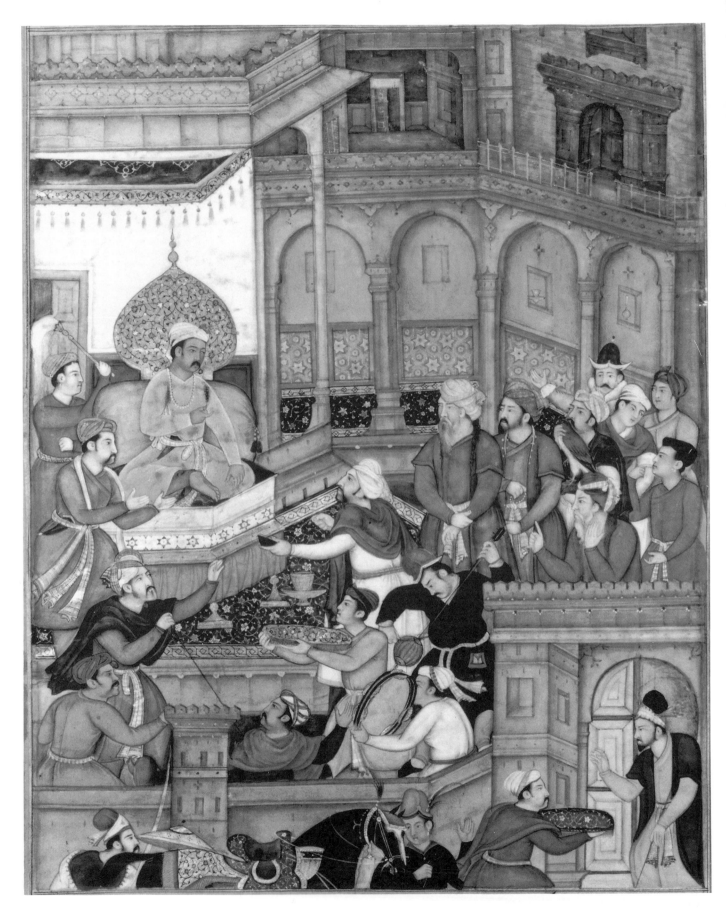

Figure 89. Kamran Mirza submits to Humayun. *AN*, fol. 73v, 1596–97 or 1604. Reproduced by permission of the British Library, OR12988.

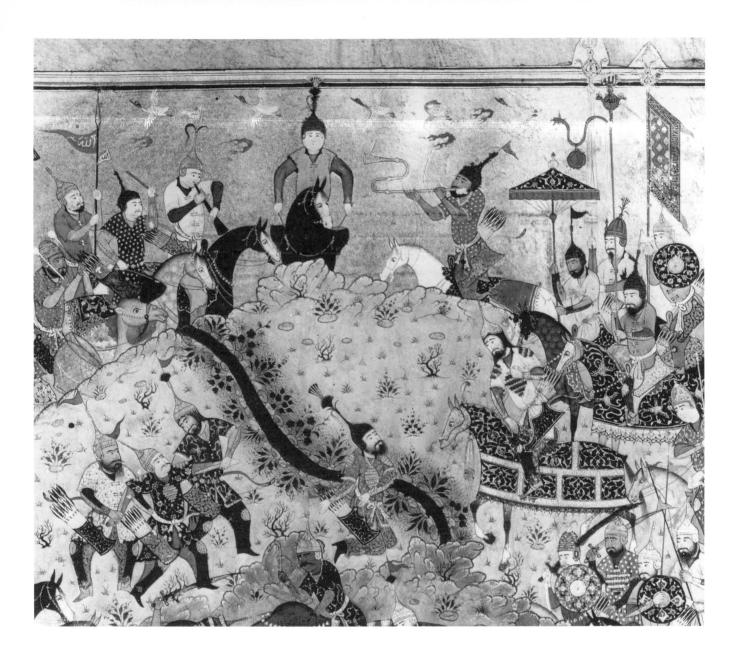

Figure 90. Bukhara prince less favored by father proves superiority in battle (detail). *Gulistān* of Saʾdi, fol. 14b, 1567–68, by Sham Muzahhib. Reproduced by permission of the British Library, OR5302.

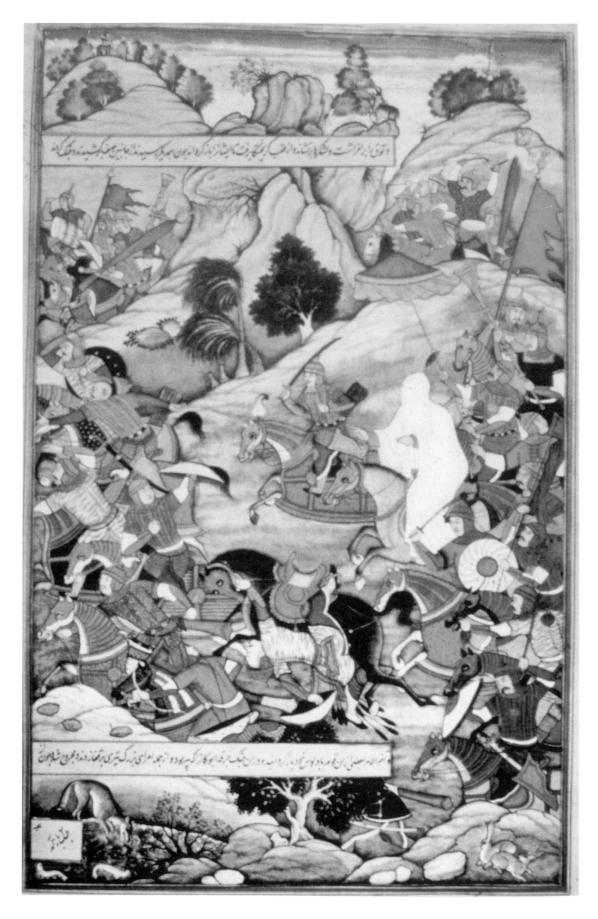

Figure 91. Oslun, mother of Chinggis Khan and the future Khan, pursues tribes of Mongols, or the boy Chinggis and his mother. *Chinggis Nāma*, 1596, drawn by Basawan, color by Nand Gwalior. Courtesy of the Golestan Palace Museum, Tehran.

Figure 92. A game of polo (detail appears on p. 139). *Dārab Nāma*, fol. 11v, 1564–65, painted by Mesh-
ked of Mashad. Reproduced by permission of the British Library, OR4615.

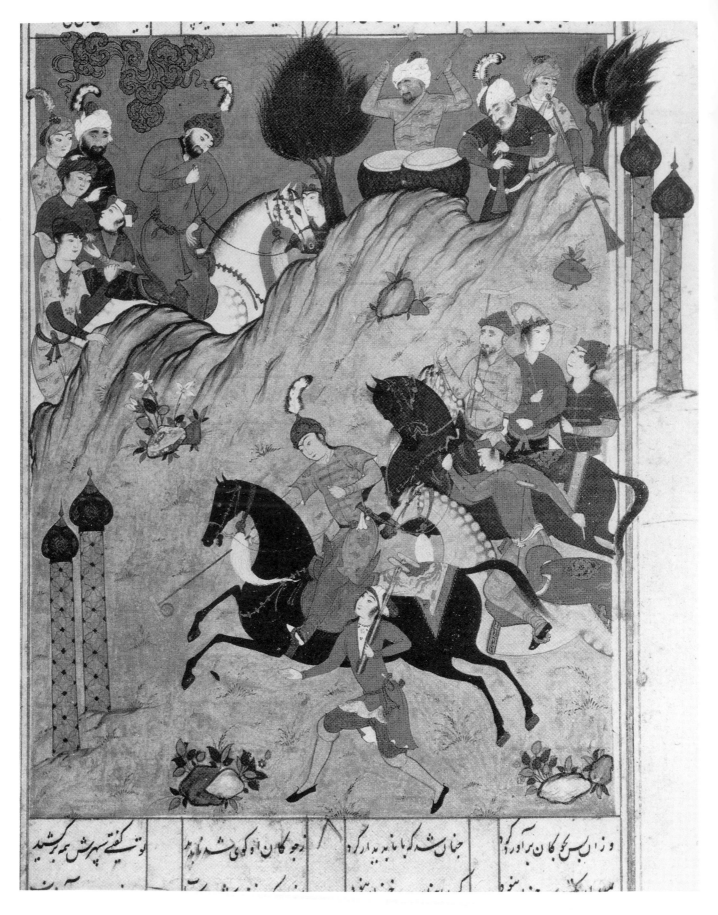

Figure 93. Siyawush playing polo. *Shah Nāma*, c. 1570, perhaps by ʿAli Asghar, Qazvin style. Reproduced by permission of the British Library.

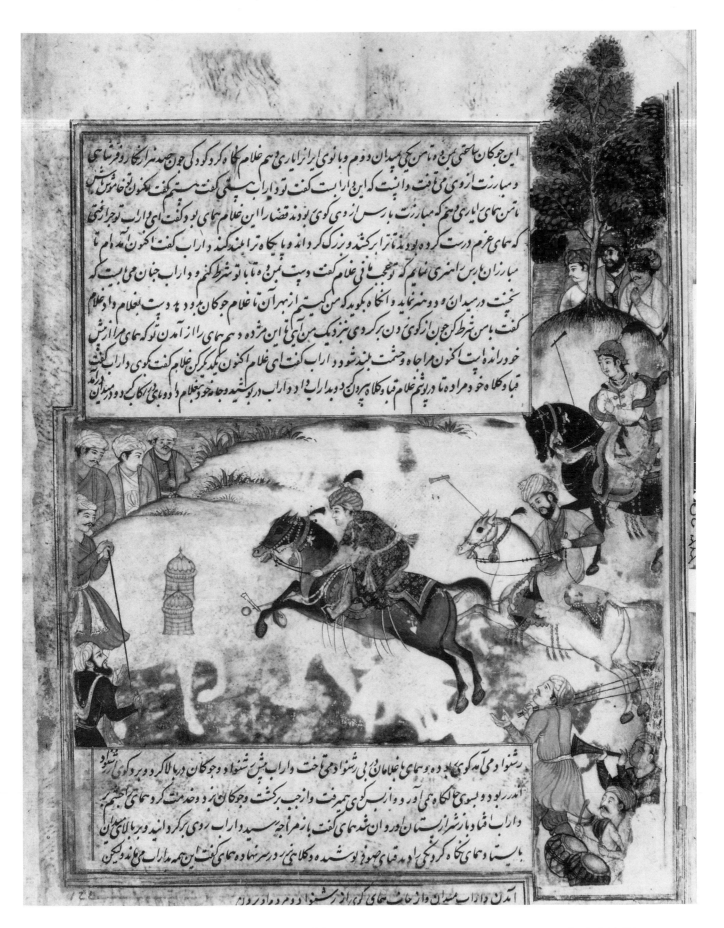

Figure 94. A game of polo. *Dārab Nāma*, fol. 12v, c. 1580. Reproduced by permission of the British Library, OR4615.

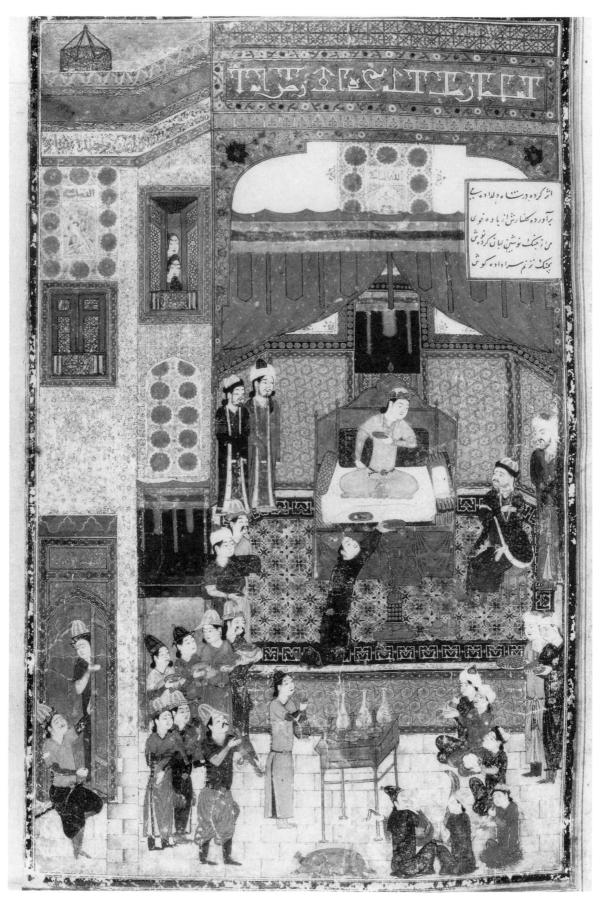

Figure 95. Humay at the Chinese court. *Khamsa* of Khvaju Kirmani, fol. 12, 1396, Jalayirid style, Baghdad, painted by Junayd, 28 cm × 17 cm. Reproduced by permission of the British Library, ADD18113.

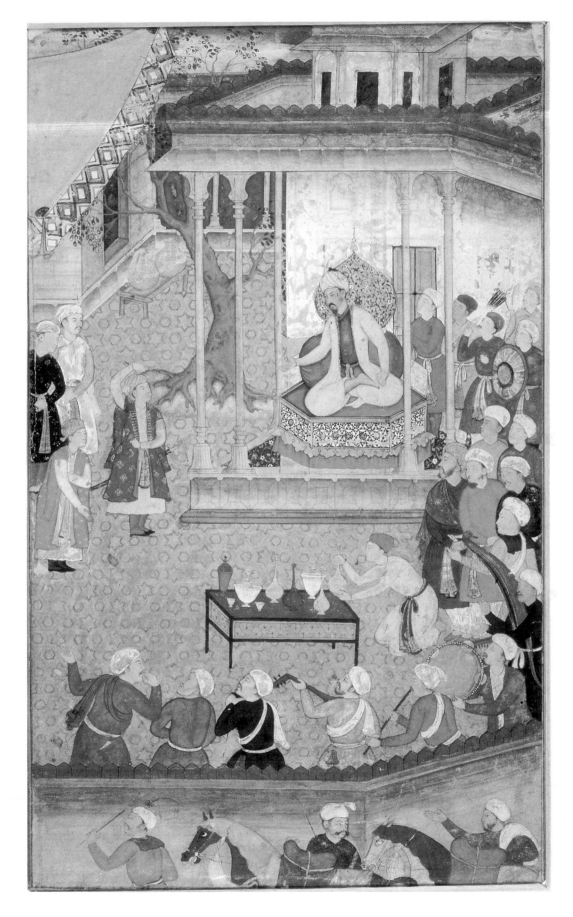

Figure 96. Babur's celebrations for ʿId at Agra. *BN*, fol. 64, c. 1593, tempera on paper, 25.8 cm × 16.0 cm. Courtesy of the State Museum of Oriental Art, Moscow, No. 1540 II.

Figure 97 (above and opposite). Timur granting an audience in Balkh on the occasion of his accession to power in April 1370. *Zafar Nāma* of Sharafuddin Ali Yazdi, Shiraz style, June–July 1436. Courtesy of the Arthur M. Sackler Gallery, Smithsonian Institution, Washington, D.C., S86.133.1/2.

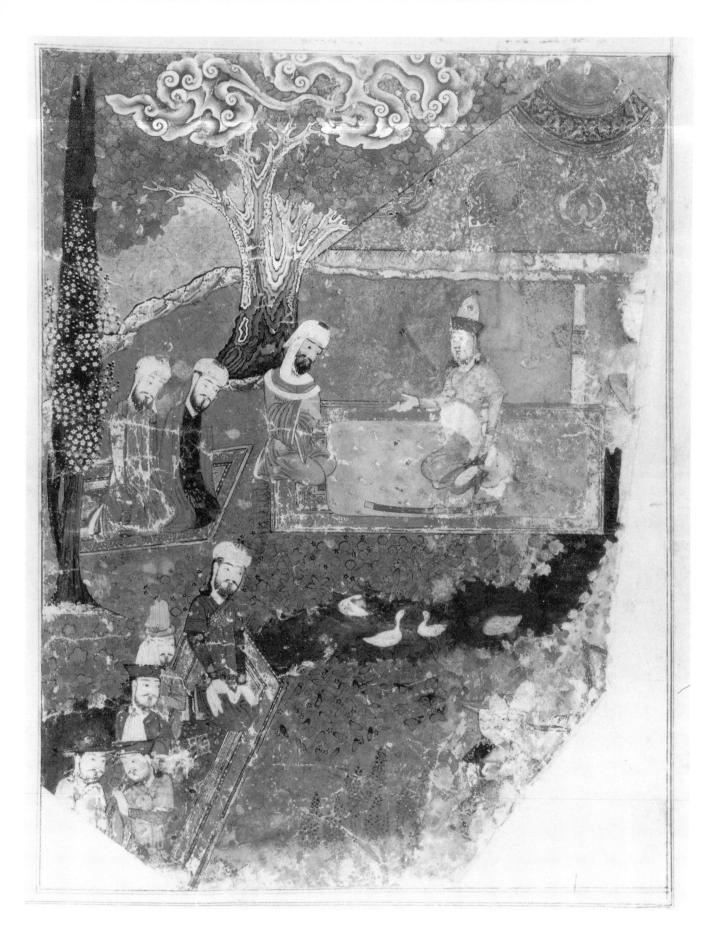

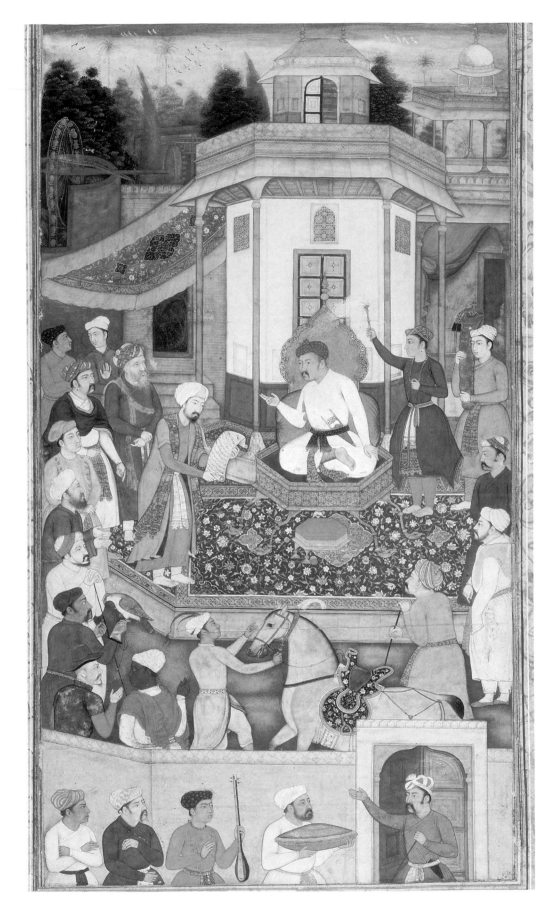

Figure 98. Akbar hears a petition. *AN*, c. 1604, attributed to Manohar, gold and color on paper, 26.1 cm × 14.2 cm. Courtesy of the Freer Gallery of Art, Smithsonian Institution, Washington, D.C., 60.28.

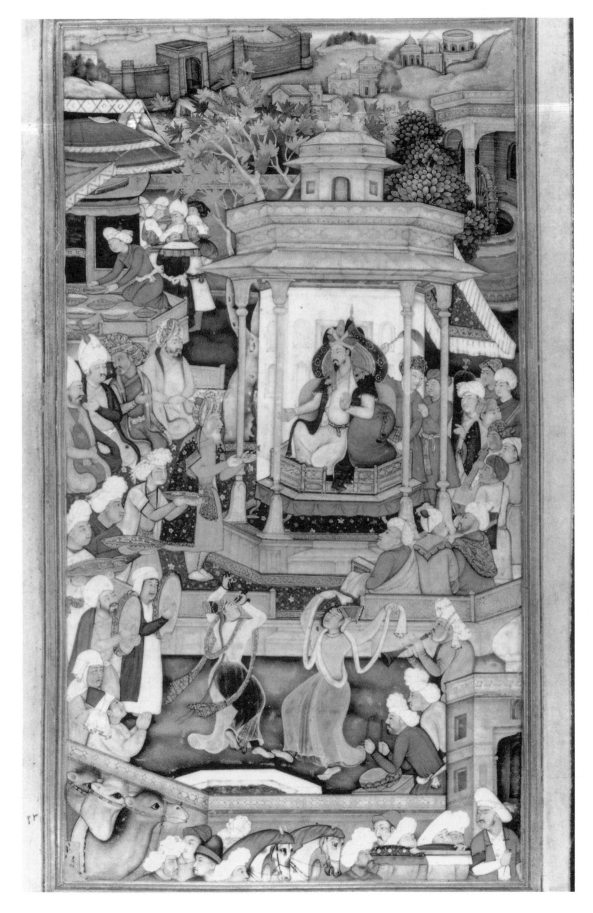

Figure 99. Humayun: A court scene (detail appears on p. 138). *AN*, fol. 96v, 1596–97 or 1604. Reproduced by permission of the British Library, OR12988.

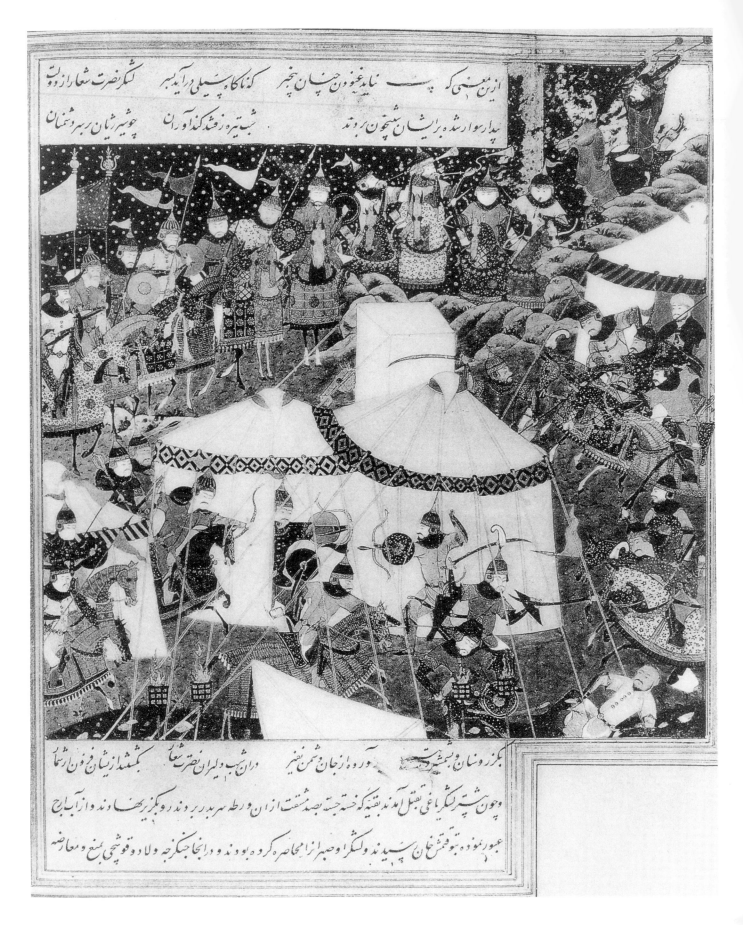

Figure 100. Surprise attack on an encampment of rebels by Timur's forces. *Zafar Nāma* of Sharafuddin Ali Yazdi, 1529. Courtesy of the Golestan Palace Museum, Tehran.

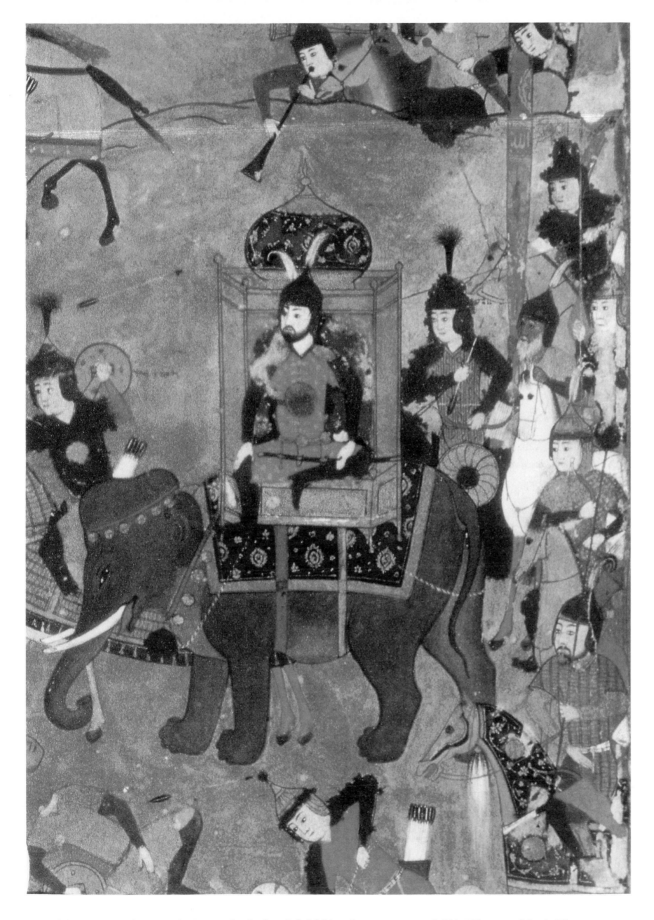

Figure 101. Shirin and Hosrov in the battlefield (detail appears on p. 142). *Khamsa* of Amir Khusrau Dihlavi, c. late fifteenth to early sixteenth century. Courtesy of the Salarjung Museum, Hyderabad.

Figure 102. Khusrau and Shirin listening to musicians. *Khamsa* of Nizami, fol. 65a, c. 1595. Reproduced by permission of the British Library, OR12208.

Figure 103. Zanib signals to her lover Zayd from the balcony of a house. *Khamsa* of Nizami, c. 1585–90, composed by Basawan. Keir Collection, Ham, Richmond, England.

Figure 104. Three men in conversation. *Dīvān* of Hafiz, c. 1588, by Narsingh. Housed at the Rampur Raza Library.

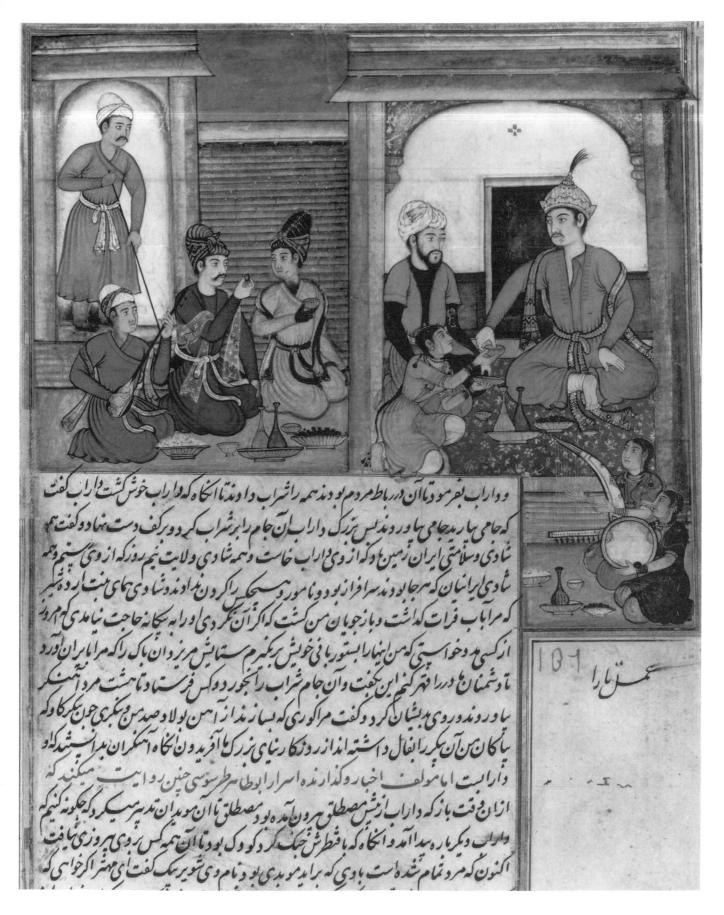

Figure 105. Men entertained by female musicians. *Dārab Nāma*, fol. 95v, c. 1580, painting by Tara. Reproduced by permission of the British Library, OR4615.

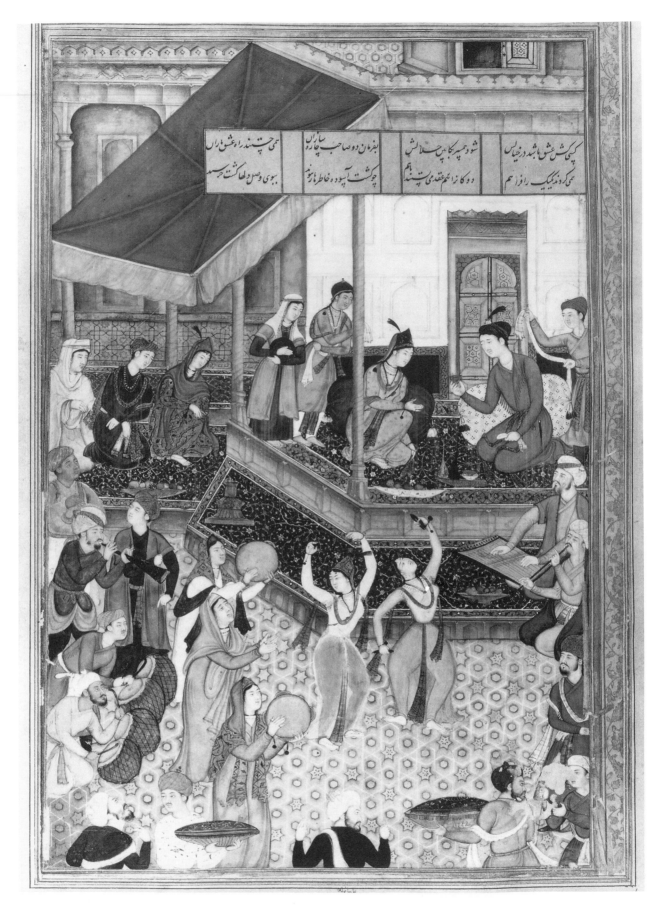

Figure 106. Deval Rani and Khizr Khan enjoying a dance together. *Khamsa* of Amir Khusrau Dihlavi, fol. 58, 1597–98. Courtesy of The Walters Art Gallery, Baltimore, W. 624.

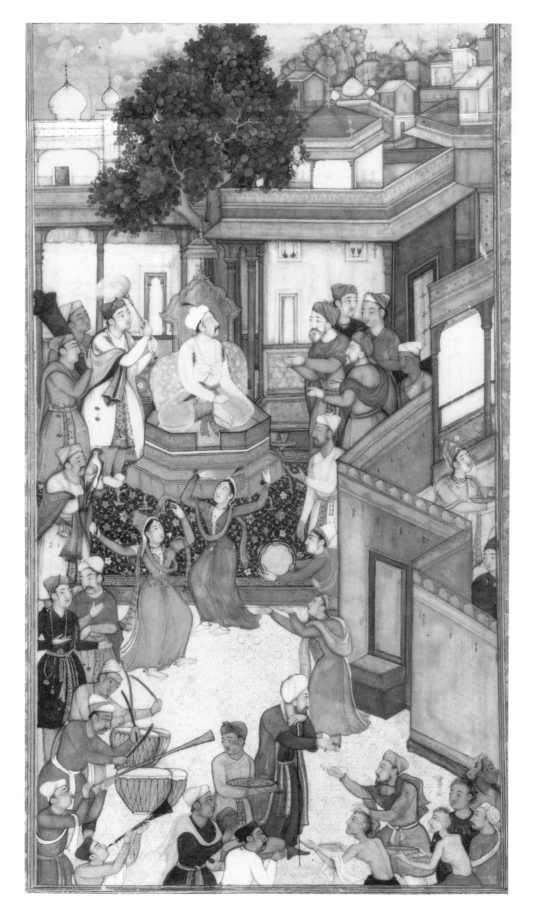

Figure 107. Circumcision ceremony for Akbar's sons. India, Mughal school, c. 1605, attributed to Dharmdas, color on paper, 22.9 cm × 12.1 cm. © The Cleveland Museum of Art, 1997, Andrew R. and Martha Holden Jennings Fund, 1971.76.

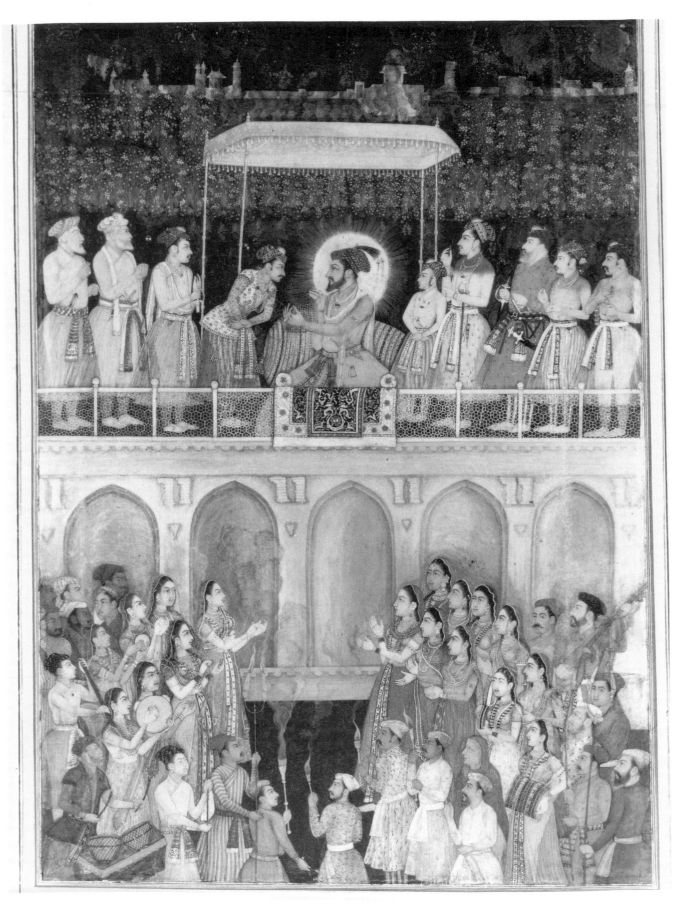

Figure 108. Shah Jahan honoring Aurangzeb at his wedding, 19 May 1637 (detail appears on p. 182). *PSN*, fol. 218B, c. 1640, attributed to Bhola. The Royal Collection © 1996 Her Majesty Queen Elizabeth II, Holmes Binding 149, p. 436.

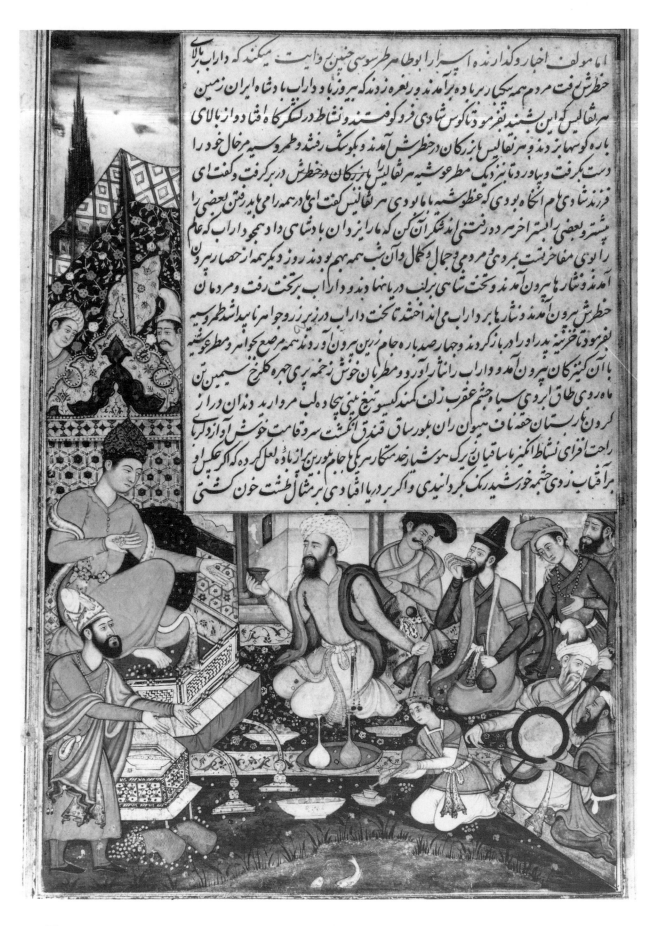

Figure 109. Darab celebrates victory. *Dārab Nāma*, fol. 81r, c. 1585, by Kesu Kahar. Reproduced by permission of the British Library, OR4615.

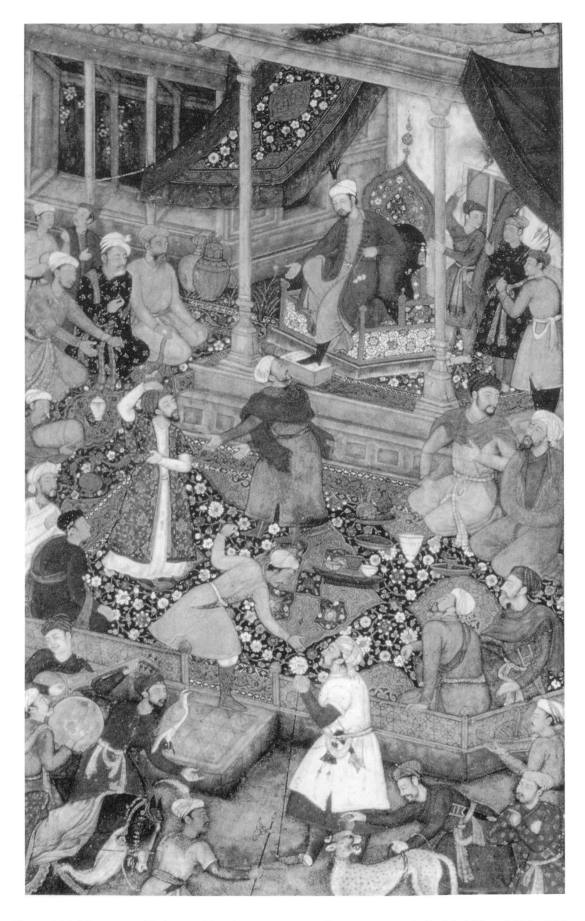

Figure 110. The court of Solomon (detail appears on p. 157). *Anvār-i-Suhailī*, fol. 208, c. 1596–97, by Basawan. Courtesy of Bharat Kala Bhavan, Banaras Hindu University, Varanasi, BKB9069/3.

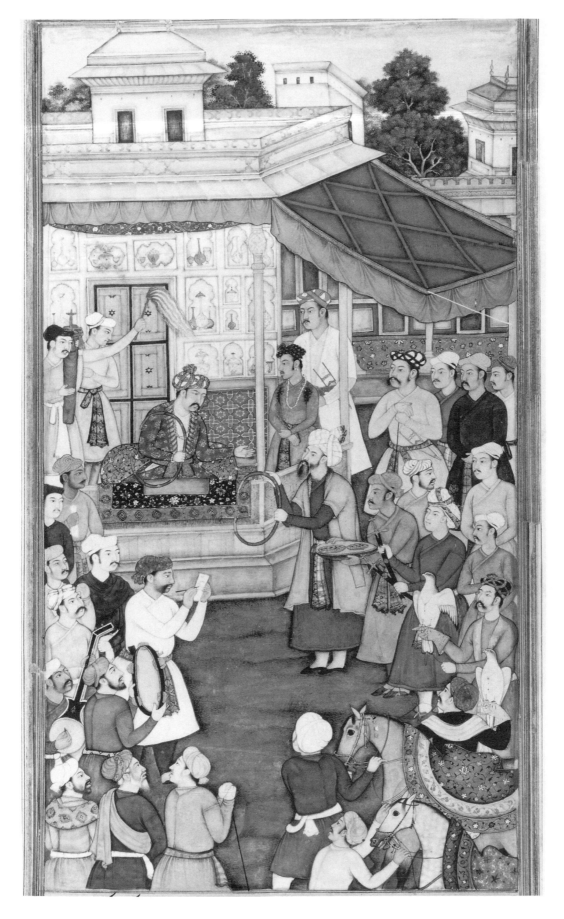

Figure 111. Akbar receiving ambassadors (to celebrate the submission of Bairam Khan). *AN*, fol. 54, 1596–97 or 1604, painted by Sur Das. Reproduced by kind permission of the Trustees of the Chester Beatty Library, Dublin.

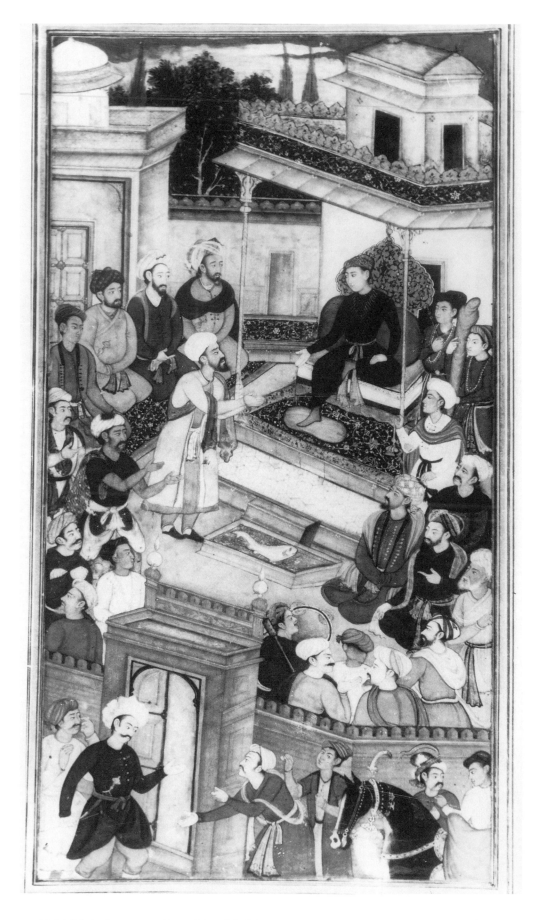

Figure 112. Fish in law court. *'Iyār-i Dānish*, fol. 208, 1597, by Jagannatha. Courtesy of Bharat Kala Bhavan, Banaras Hindu University, Varanasi.

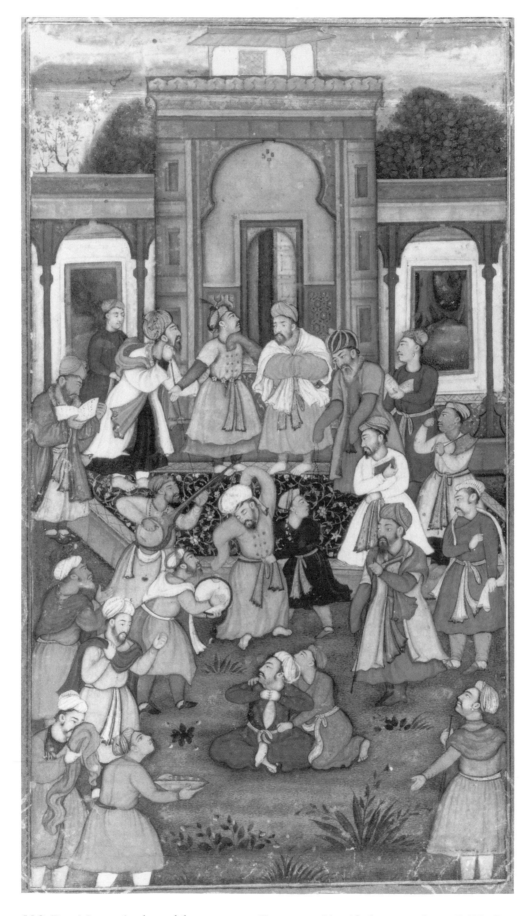

Figure 113. Dervishes and other celebrants trance. From an unidentified manuscript, c. 1600. Courtesy of the Board of Trustees of the Victoria and Albert Museum.

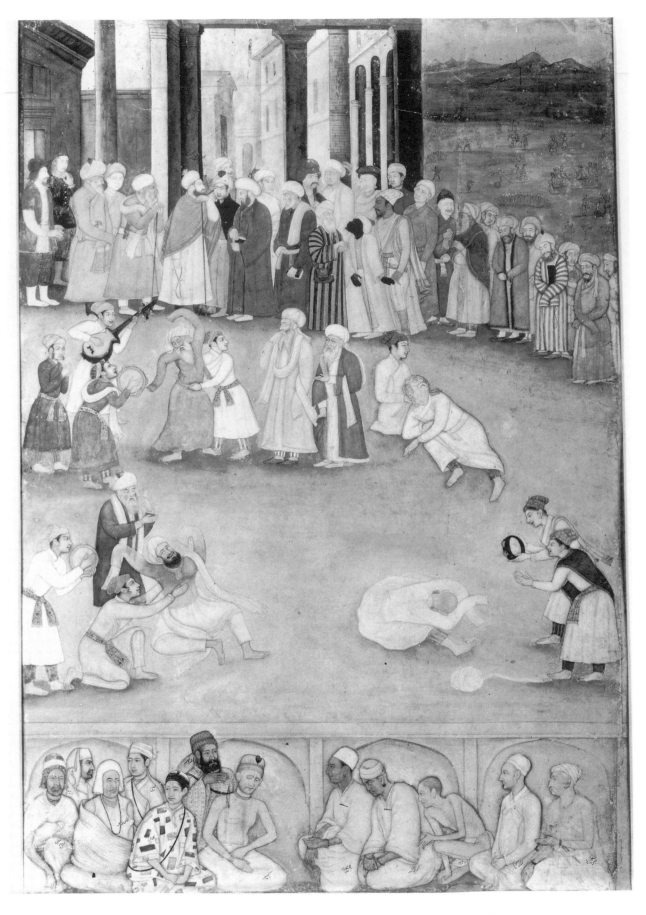

Figure 114. St. Khwaja Muinuddin Chisti and devotees at Ajmer, c. 1660–70 (details appear on p. 146). Courtesy of the Board of Trustees of the Victoria and Albert Museum, IS.94.1965.

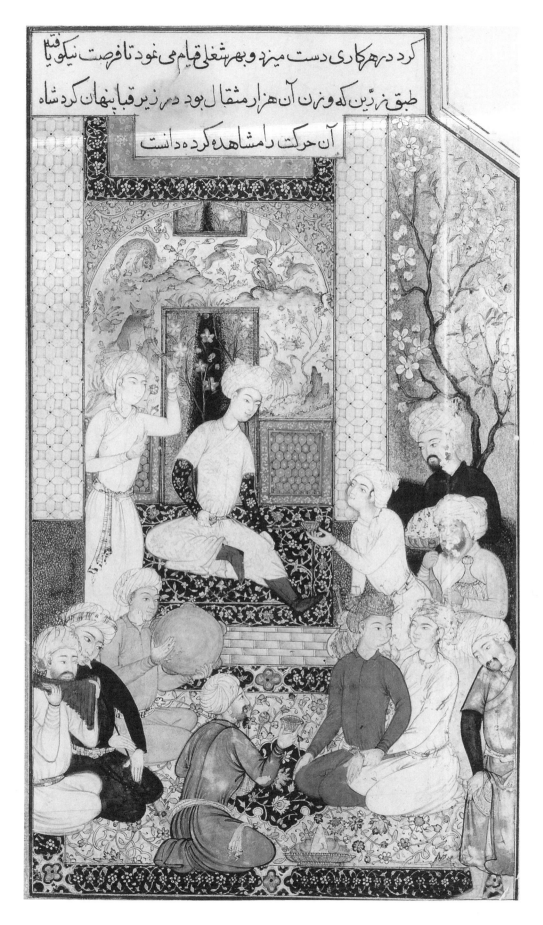

Figure 115. Gentlemen relax in a garden. *Anvār-i-Suhailī*, fol. 331v, c. 1596, painted by the Persian artist Aqa Riza. Reproduced by permission of the British Library, ADD18579.

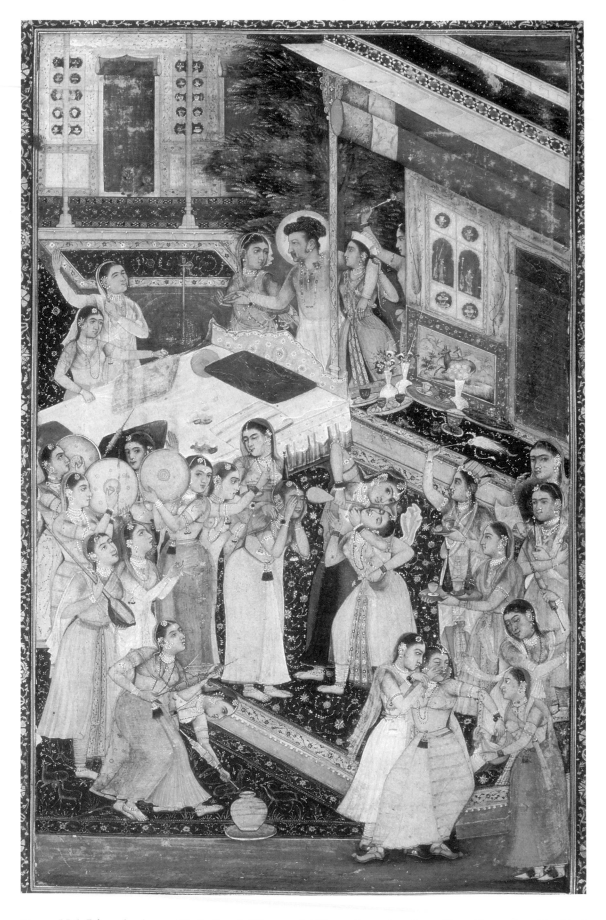

Figure 116. Jahangir plays at Holi. *Royal Album*, c. 1625, attributed to Govardhan. Reproduced by kind permission of the Trustees of the Chester Beatty Library, Dublin, MS 7, No. 3.

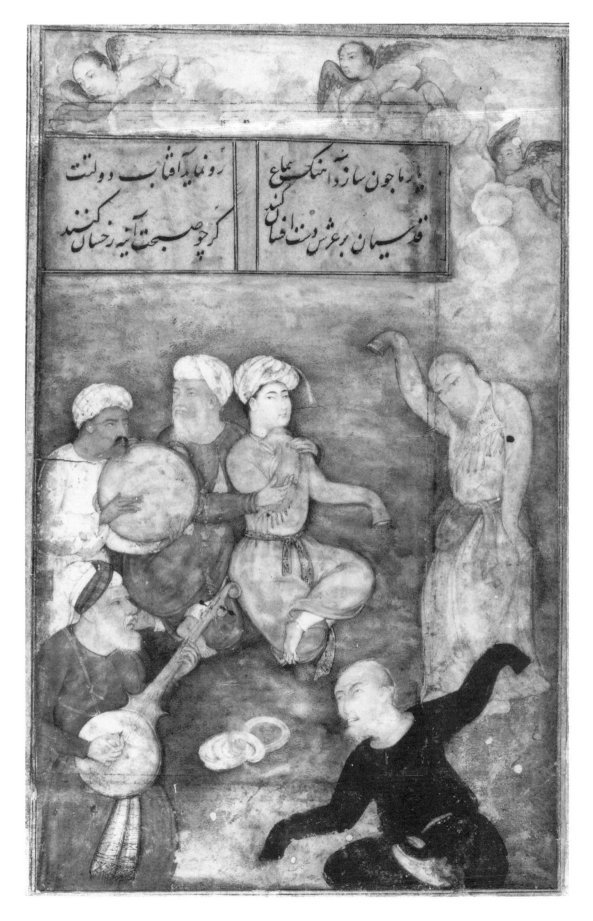

Figure 117. Dervishes dance. *Dīvān* of Hafiz, fol. 66v, c. 1610. Reproduced by permission of the British Library, OR7573.

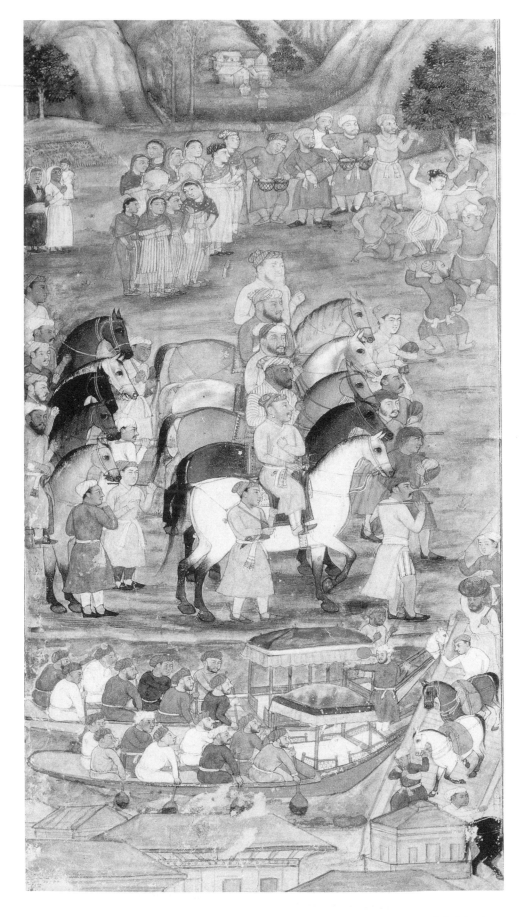

Figure 118. A review of troops (detail appears on p. 194). *Mathnavī* of Zafar Khan, fol. 12r, 1663. Courtesy of the Royal Asiatic Society, London.

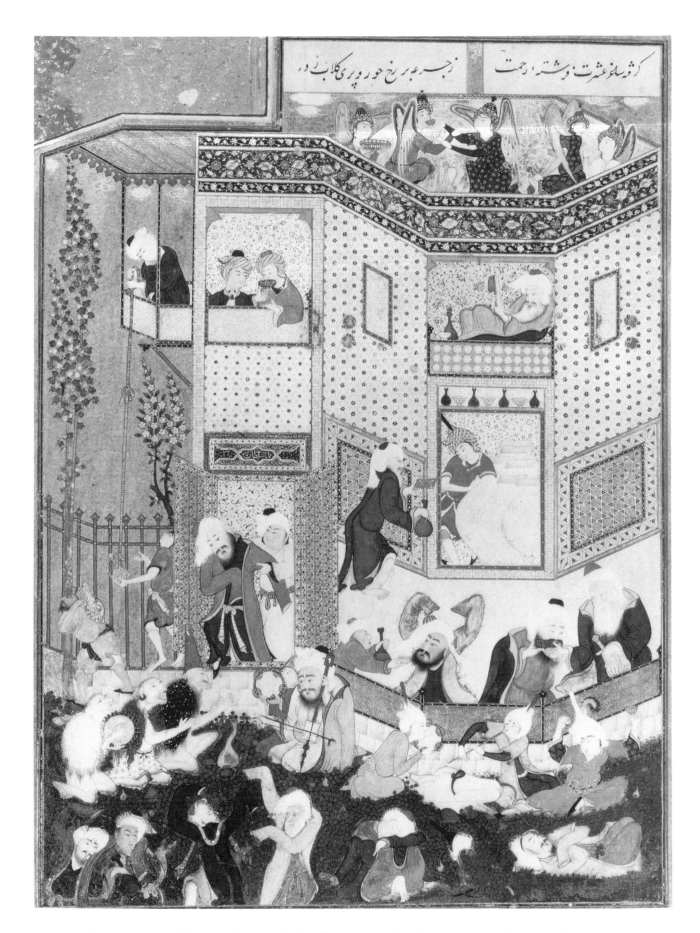

Figure 119. Worldly and otherworldly drunkenness, c. 1527. Opaque watercolor and gold on paper, 21.5 cm × 15.0 cm. Courtesy of the Arthur M. Sackler Museum, Harvard University Art Museums, Gift of Mr. and Mrs. Stuart Cary Welch, Jr., in honor of the students of Harvard University and Radcliffe College (promised gift), 1988.460. Partially owned by The Metropolitan Museum of Art and Harvard University Art Museums.

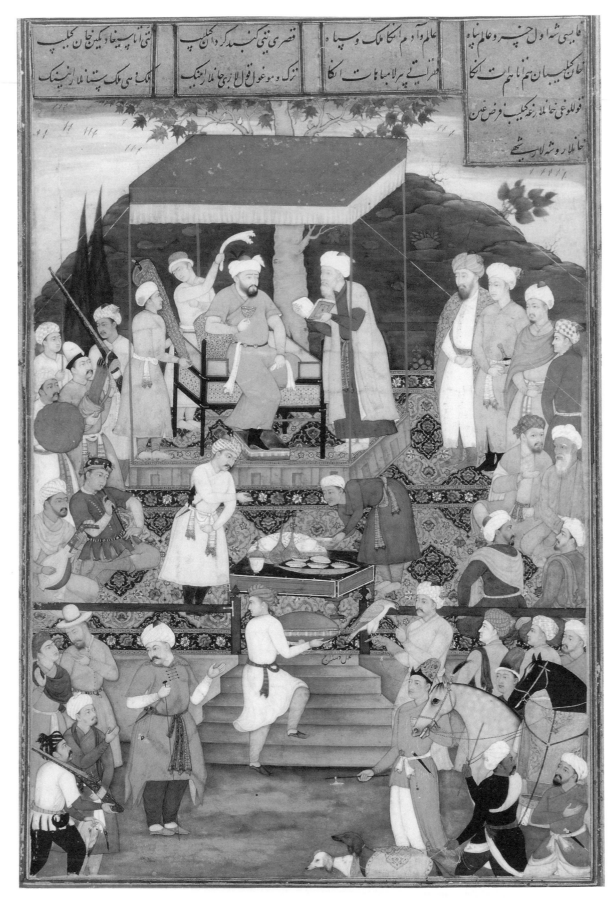

Figure 120. Sultan Husain Mirza. *Khamsa* of Navai (Nowai), fol. 12v, c. 1605. The Royal Collection © 1996 Her Majesty Queen Elizabeth II.

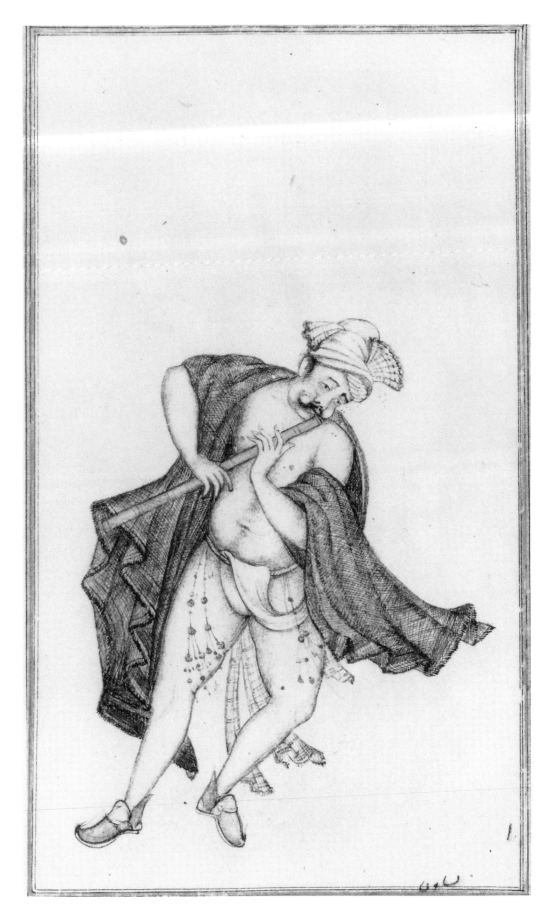

Figure 121. A flute player (*Joueur de flûte*). Signed by Basawan, c. 1590. Courtesy of Musée Guimet, Paris, 017314-142.

Figure 122. Plato (playing organ) charming the wild beasts. *Khamsa* of Nizami, fol. 298, c. 1595, painted by Madhu Khanazad. Reproduced by permission of the British Library, OR12208.

Figure 123. Organ in marginalia. *Album of Jahangir,* c. 1614–15. Courtesy of Staatliche Museen zu Berlin-Preußischer Kulturbesitz, Museum für Islamische Kunst, Orientabteilung B1 1a.

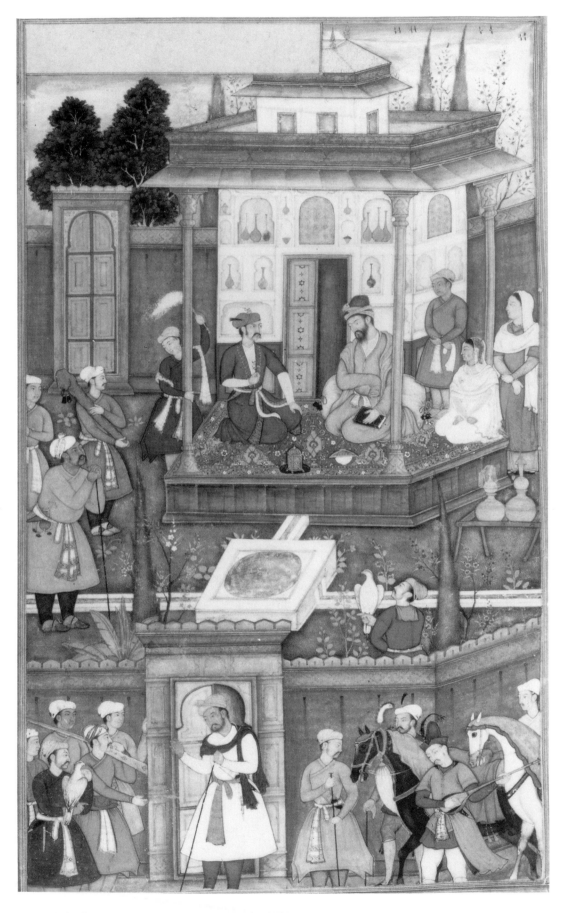

Figure 124. King visiting a dervish who abandoned his former way of life when introduced to worldly pleasures. *Gulistān* of Saʾdi, fol. 50, c. 1610. Reproduced by permission of the British Library, OR5302.

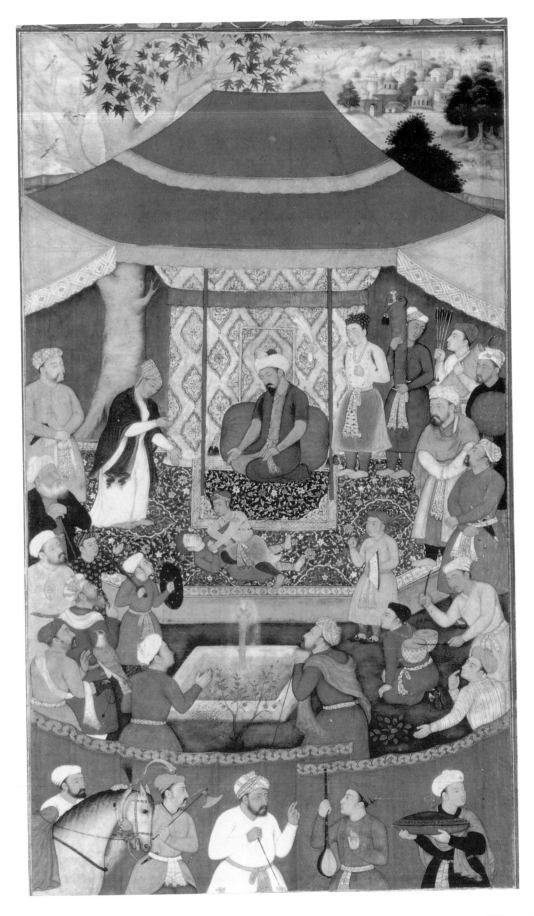

Figure 125. The child Akbar wrestling with his cousin Ibrahim Mirza for a painted drum. *AN*, c. 1605. Courtesy of the Freer Gallery of Art, Smithsonian Institution, Washington, D.C., LTS 1995.2.103.

Figure 128. Sultan Ghazan Khan entrusts his minister, Rashiduddin, with writing the history of the Mongols (detail appears on p. 157). *Chinggis Nāma*, 1596, drawing by Basawan, portrait by Manohar, color by Bhim Gujarati. Courtesy of the Golestan Palace Museum, Tehran.

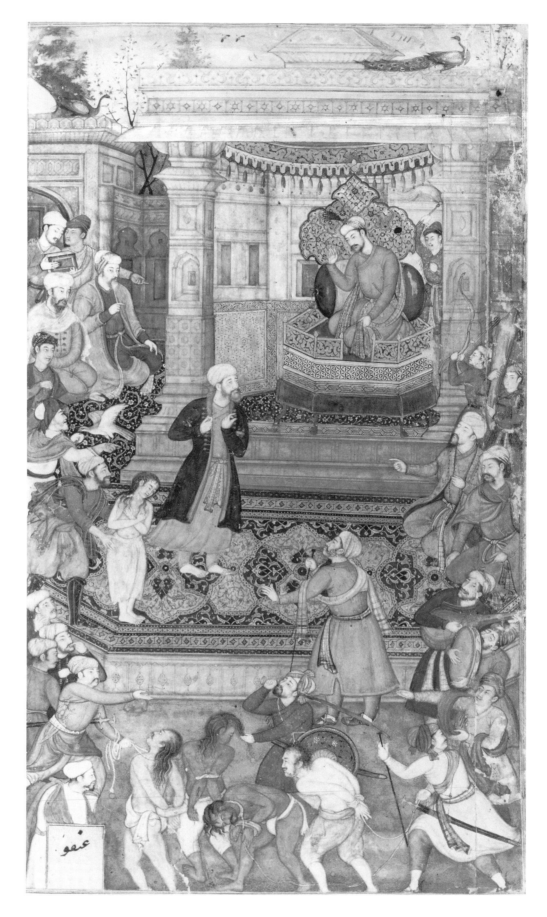

Figure 129. The indulgent vizier pleads for the life of the robber's son. Folio from the *Gulistān* of Saʾdi, India, Mughal, c. 1600, drawing by Basawan, opaque watercolors on paper, 28.6 cm × 15.9 cm. Courtesy of the Los Angeles County Museum of Art, Nasli and Alice Heeramaneck Collection, Museum Associates Purchase, M.79.9.12.

Figure 132. *Darbār* of Shah Jahan (detail appears on p. 203). From a looseleaf Mughal manuscript, c. 1660. Courtesy of Bharat Kala Bhavan, Banaras Hindu University, Varanasi.

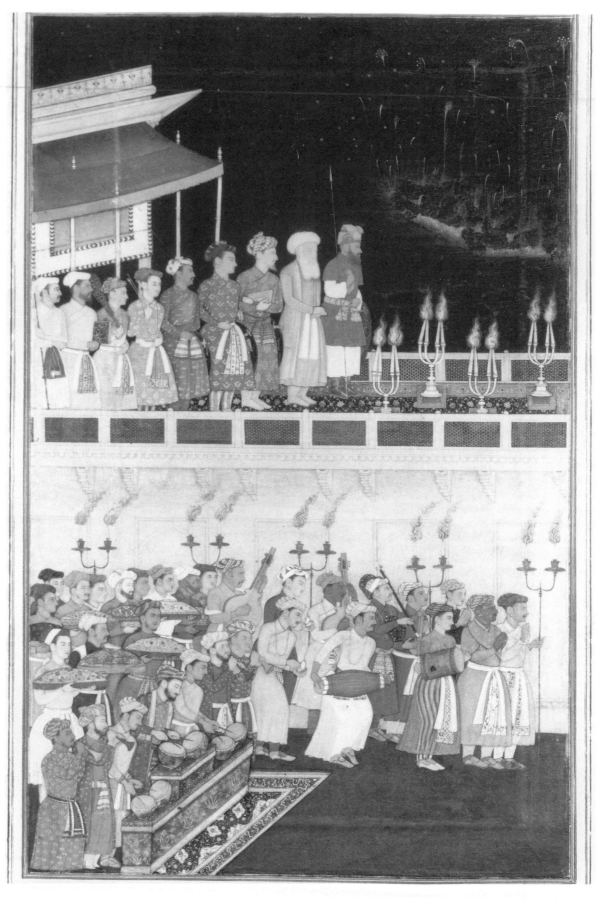

Figure 133. Shah Jahan honoring Prince Dara Shikoh at his wedding (details appear on pp. 180, 190). *PSN*, fol. 125A, c. 1635, painted by Bulaqi, son of Hoshang. The Royal Collection © 1996 Her Majesty Queen Elizabeth II, Holmes Binding 149, p. 249.

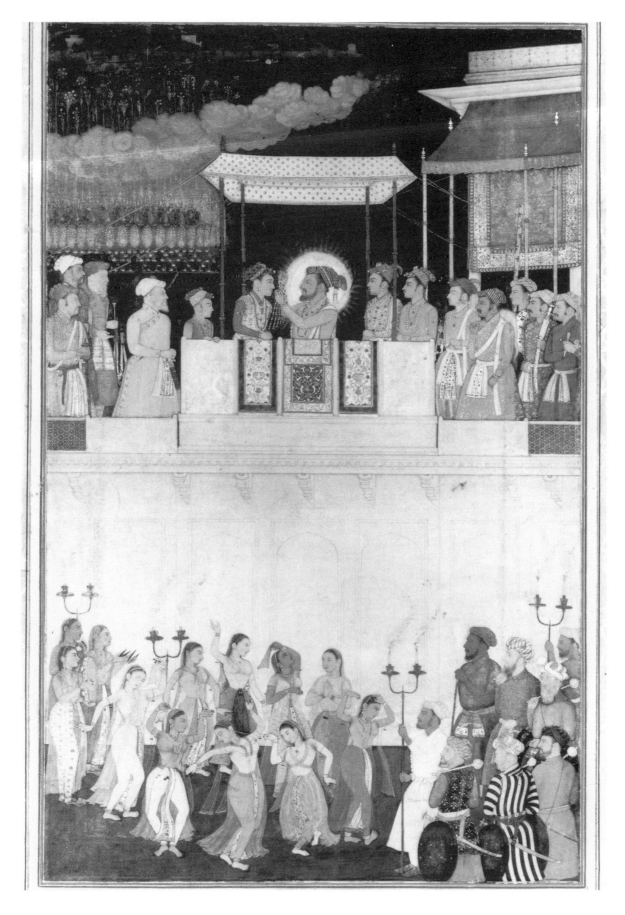

Figure 134. Shah Jahan honoring Prince Dara Shikoh at his wedding. *PSN,* fol. 124B, c. 1635, painted by Bulaqi, son of Hoshang. The Royal Collection © 1996 Her Majesty Queen Elizabeth II, Holmes Binding 149, p. 248.

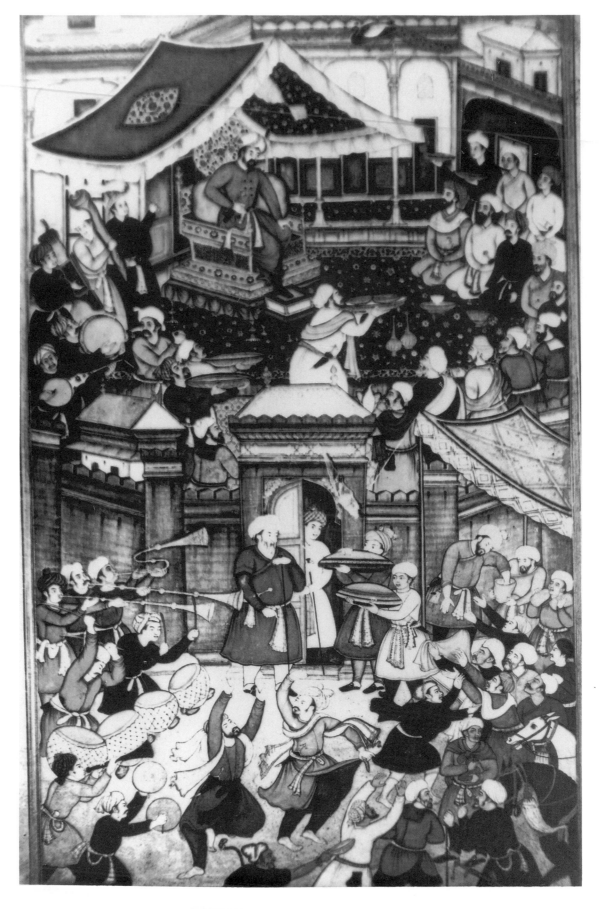

Figure 135. Babur celebrates the birth of Humayun. *Tīmūr Nāma*, fol. 294a, c. 1574–94, by Surjiv. Courtesy of the Khuda Bakhsh Oriental Public Library, Patna.

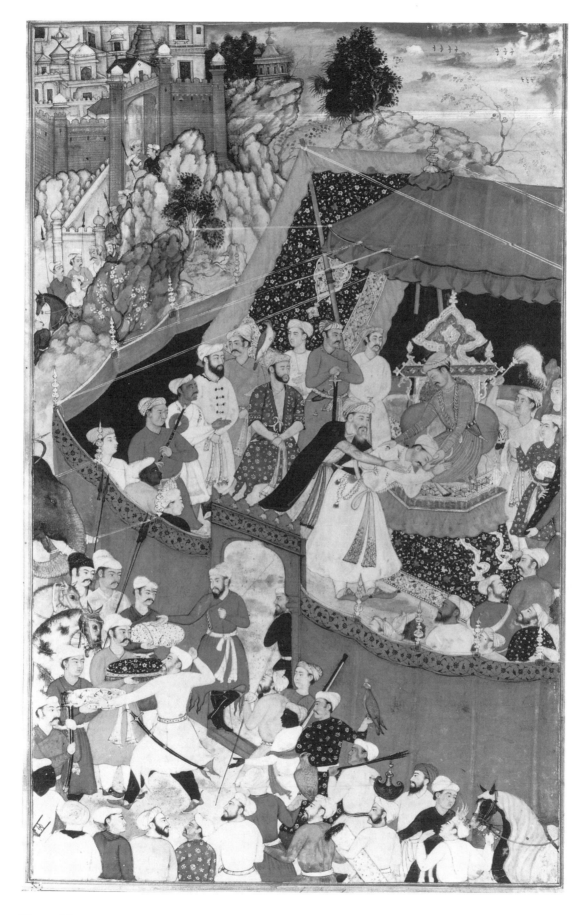

Figure 136. Raja Surjan Hada submits the keys of Ranthambhor Fort. *AN*, 1590 or earlier, composed by Mukind, painted by Shankar. Courtesy of the Board of Trustees of the Victoria and Albert Museum, IS.2-1896 160/117.

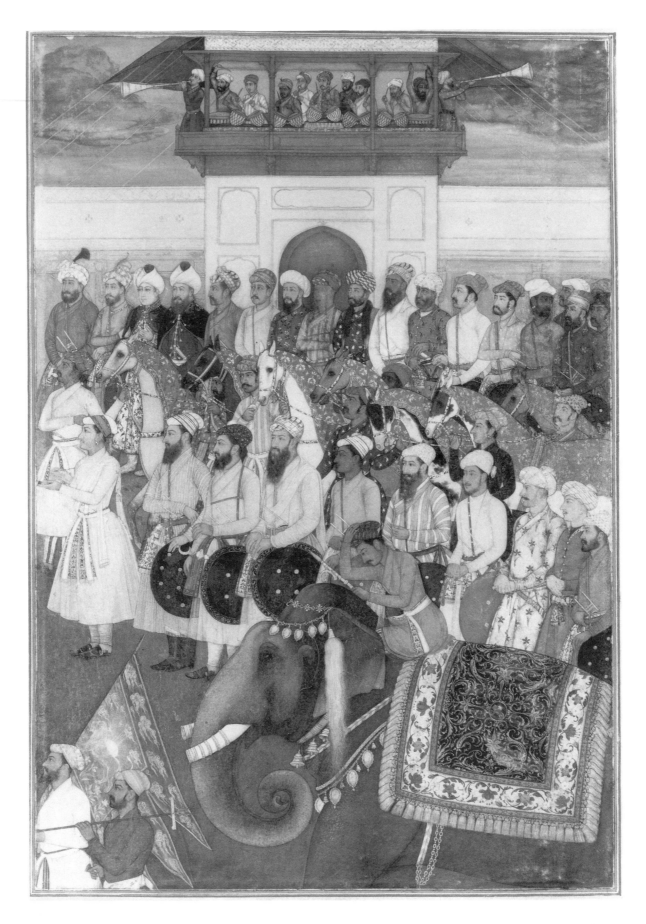

Figure 139. Jahangir receives Prince Khurram on his return from the Deccan. *PSN*, fol. 48B, c. 1640, painted by Ramdas. The Royal Collection © 1996 Her Majesty Queen Elizabeth II, Holmes Binding 149, p. 96.

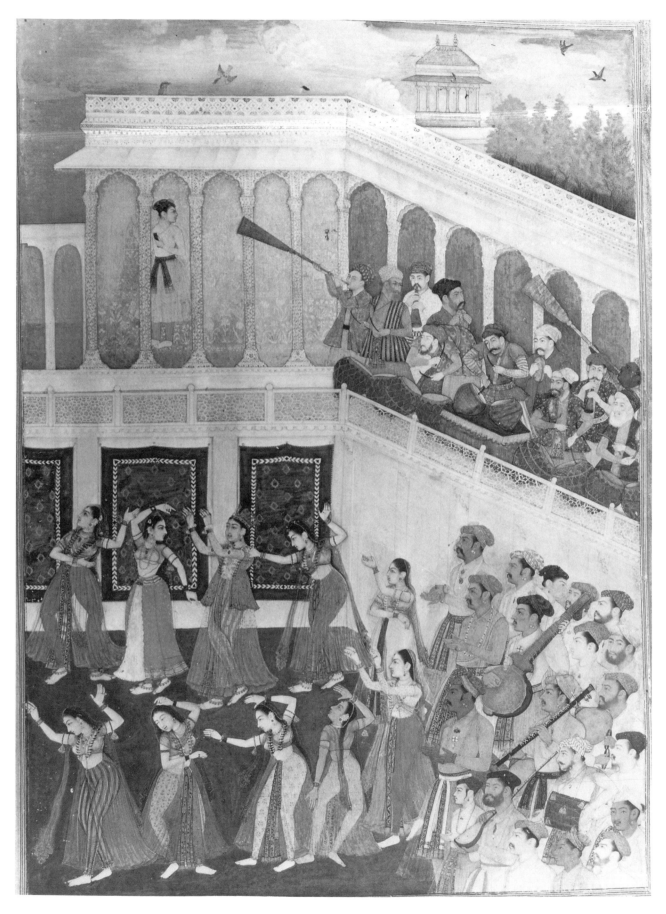

Figure 140. The weighing of Shah Jahan on his forty-second lunar birthday (details appear on pp. 170, 188, 193, 194, 195). *PSN*, fol. 70B, c. 1635, painted by Bhola. The Royal Collection © 1996 Her Majesty Queen Elizabeth II, Holmes Binding 149, p. 140.

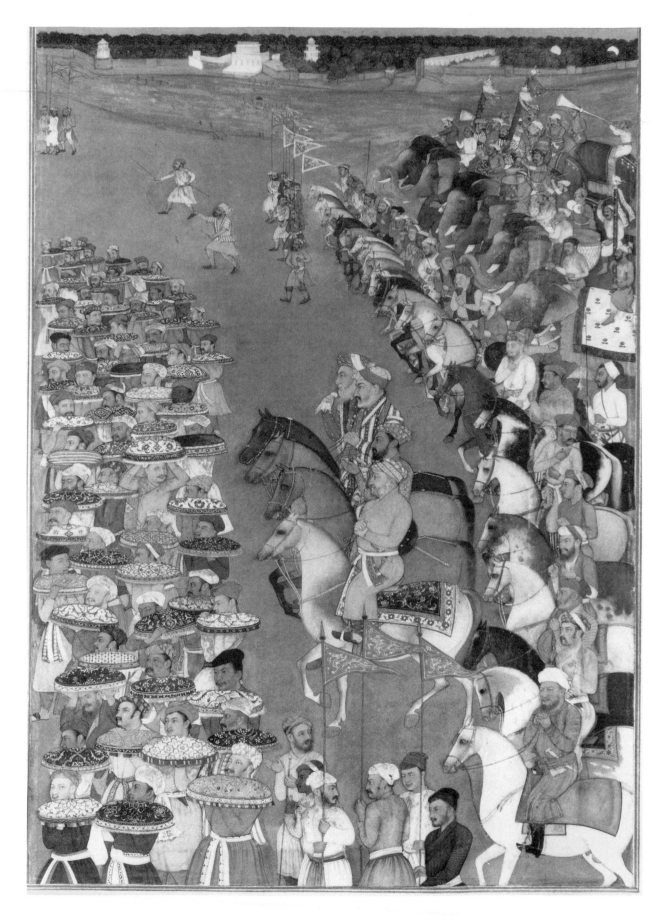

Figure 141. The delivery of presents for Prince Dara Shikoh's wedding. *PSN*, fol. 120B, c. 1635, attributed to Bishandas. The Royal Collection © 1996 Her Majesty Queen Elizabeth II, Holmes Binding 149, p. 240.

Figure 142. Leaf of calligraphy. *Album of Jahangir*, c. 1602, marginalia attributed to Ghulam Mir Ali. Courtesy of the Museum of Fine Arts, Springfield, Mass., Gift of Mrs. Roselle L. Shields.

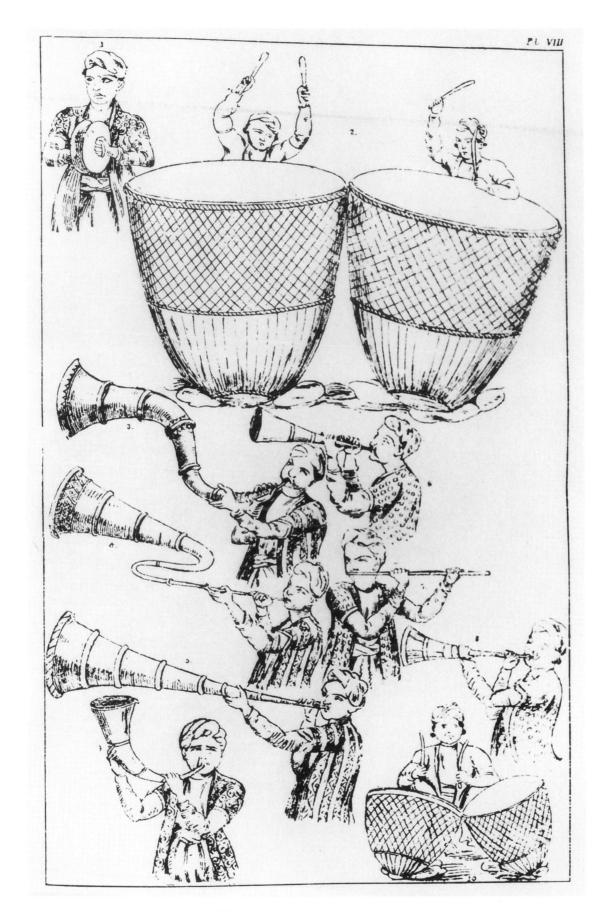

Figure 143. The *naqqāra khāna*: A plate of *naubat* instrument sketches. From *A'īn-i Akbarī*, by Abu'l Fazl 'Allami, translated by H. Blochmann (New Delhi: Oriental Books Reprint Corp., 1977), 1:52. Reprinted by permission.

Figure 144. Horn. *Tilasm*, c. 1565–70. Housed at the Rampur Raza Library.

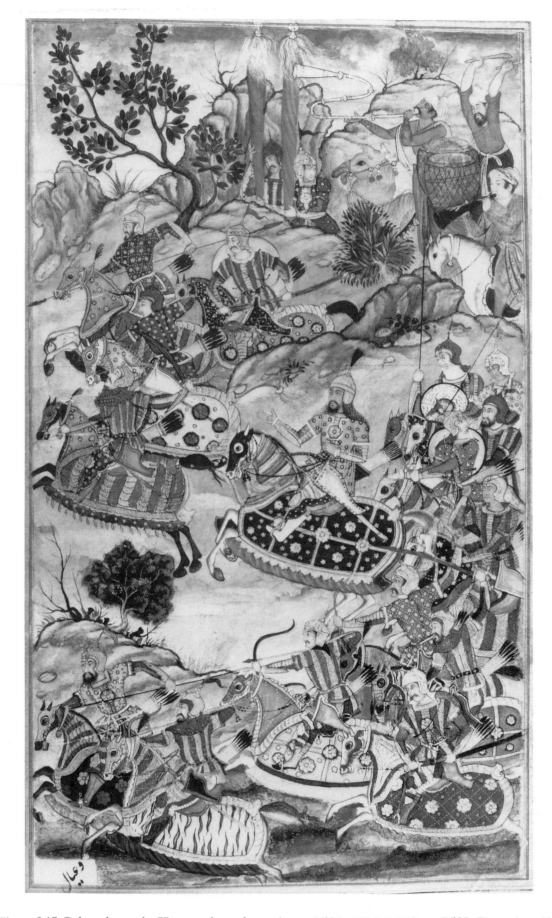

Figure 145. Babur chases the Hazaras through a ravine, c. 1507. *BN*, fol. 270v, c. 1591. Reproduced by permission of the British Library, OR3714.

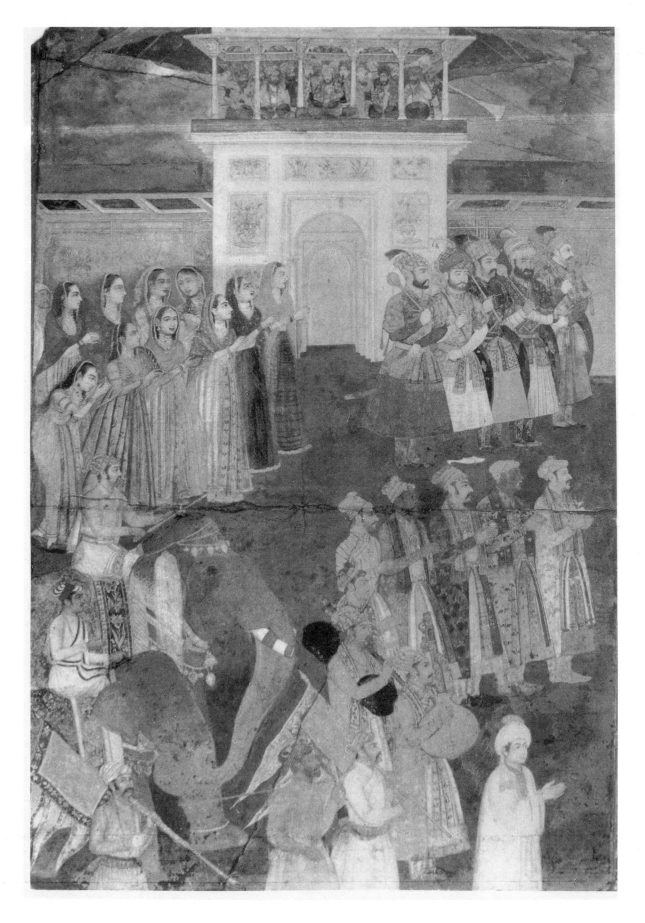

Figure 146. Celebration of the marriage of Prince Khurram, 1610.

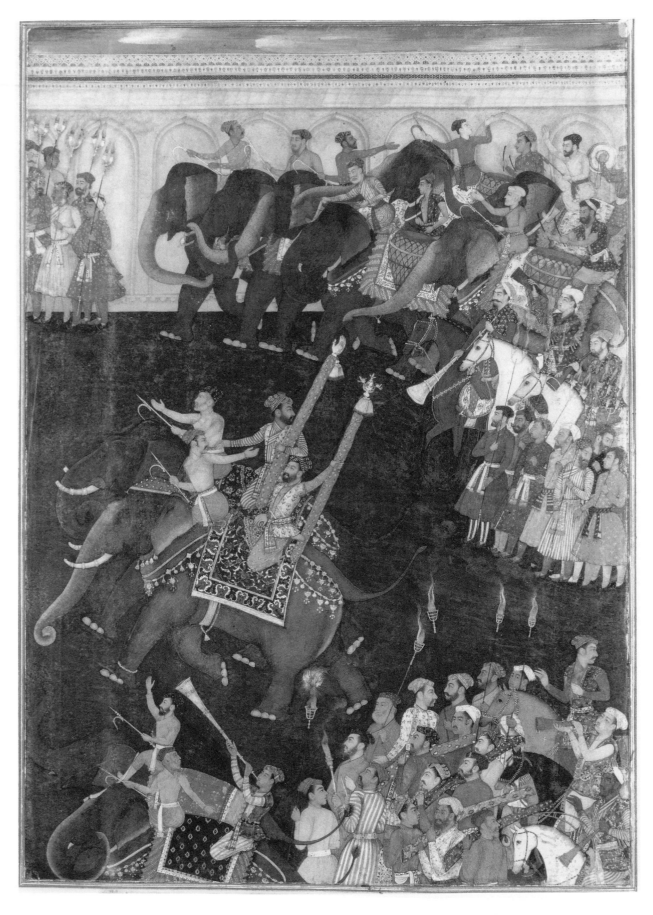

Figure 147. The wedding procession of Prince Shah Shujaʿ. *PSN*, fol. 127A, c. 1635, attributed to Bhola.
The Royal Collection © 1996 Her Majesty Queen Elizabeth II, Holmes Binding 149, p. 252.

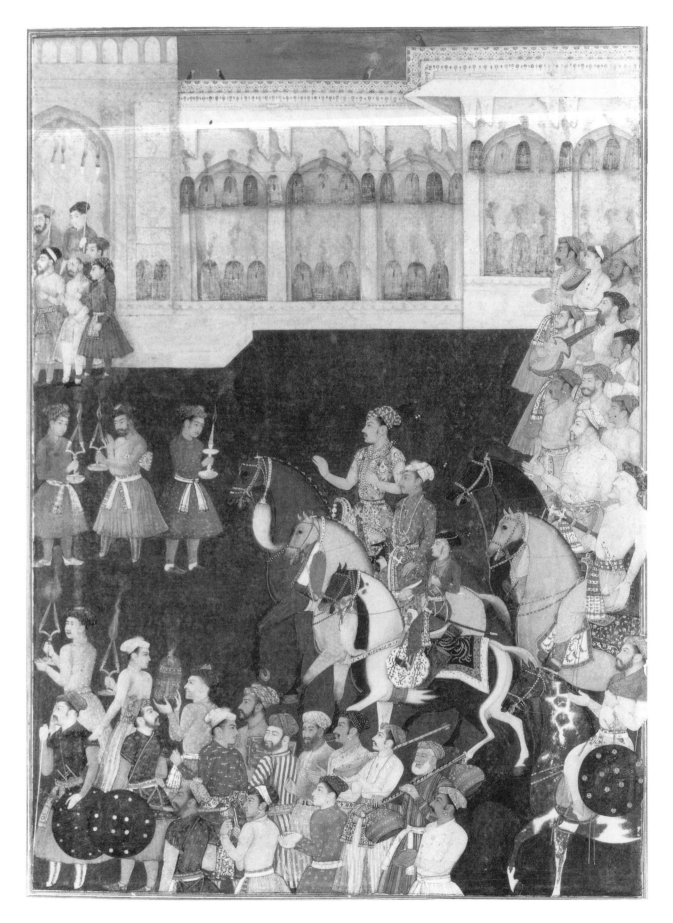

Figure 148. The wedding procession of Prince Shah Shuja‘ (detail appears on p. 203). *PSN*, fol. 126B, c. 1635, attributed to Bhola. The Royal Collection © 1996 Her Majesty Queen Elizabeth II, Holmes Binding 149, p. 253.

Figure 151. Humayun receiving courtiers, c. 1570–80. Reproduced by permission of the British Library, J.27.9.

Figure 152. Prince and friends listening to music (Izzat Khan and son, governor of Sind). *Royal Album* or *Late Shāh Jahān Album*, 1633 or later. Reproduced by kind permission of the Trustees of the Chester Beatty Library, Dublin, MS 7, No. 20.

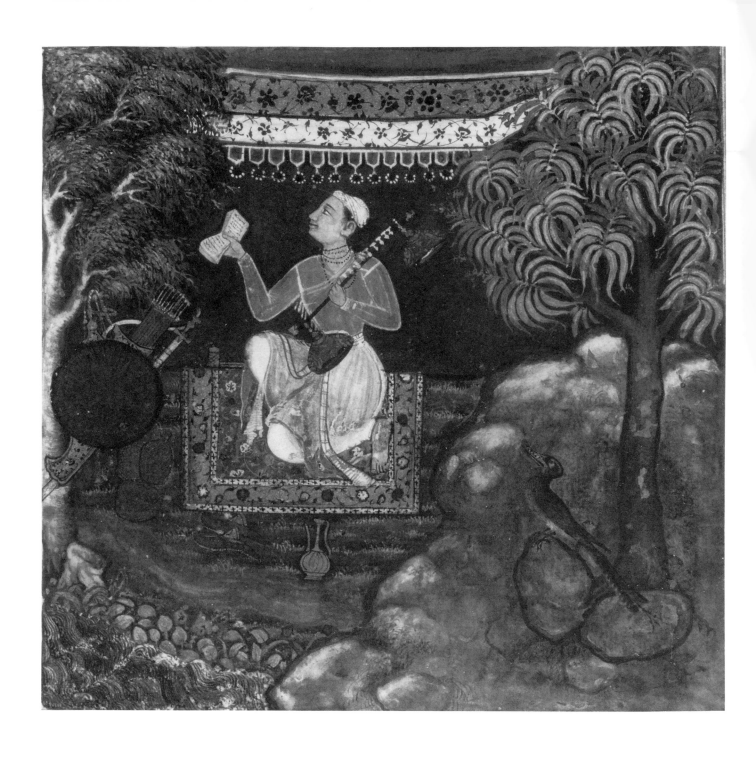

Figure 155. Origin of music from Indian bird with seven holes in its beak. *TuN*, fol. 110v, India, Mughal school, reign of Akbar, c. 1560, color and gold on paper, 20.3 cm × 14.0 cm. © The Cleveland Museum of Art, 1997, Gift of Mrs. A. Dean Perry, 1962.279.

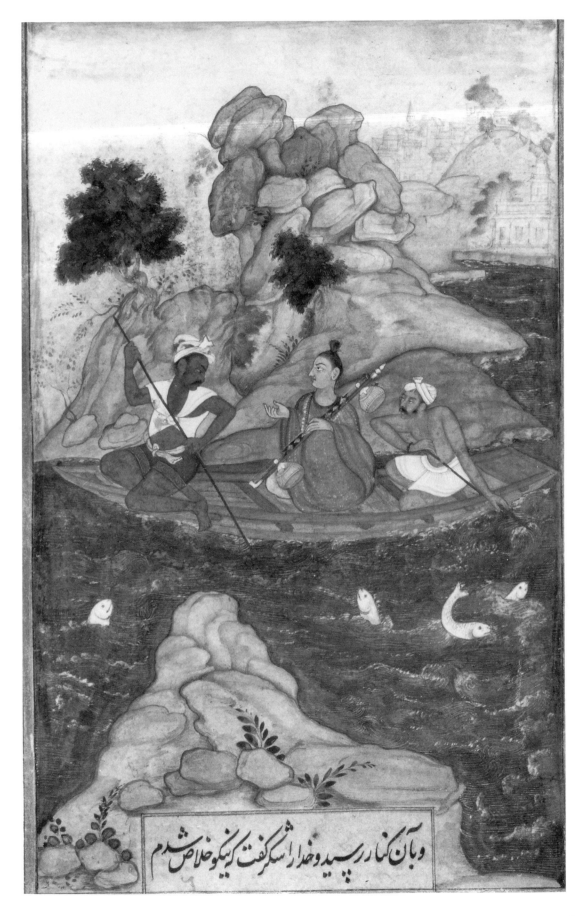

Figure 156. A *yogi* sings on a raft. *Yog Vashisht*, 1603. Reproduced by kind permission of the Trustees of the Chester Beatty Library, Dublin, MS 37.

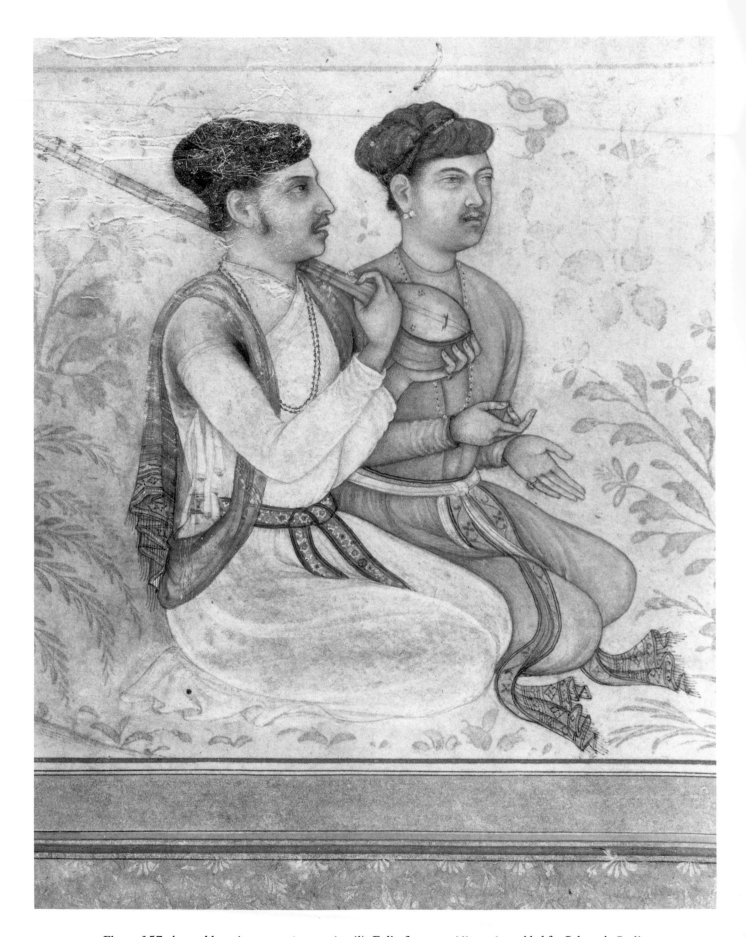

Figure 157. A royal hunting party (verso: detail). Folio from an *Album Assembled for Jahangir*, India, Mughal, c. 1591, opaque watercolors, gold and ink on paper, 41.0 cm × 23.8 cm. Courtesy of the Los Angeles County Museum of Art, Nasli and Alice Heeramaneck Collection, Museum Associates Purchase, M.78.9.11.

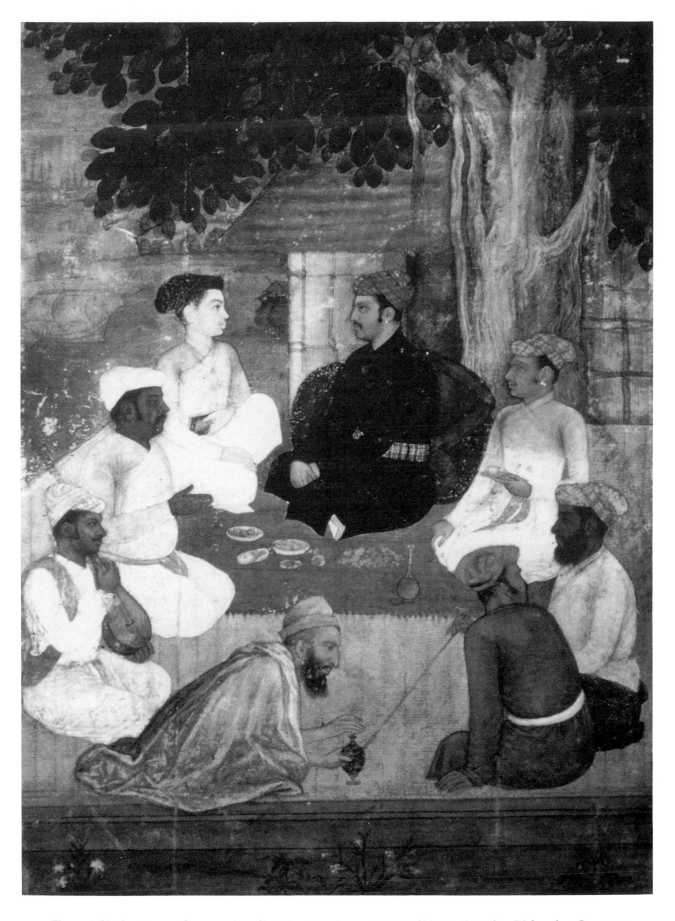

Figure 158. A prince and companions listening to a singer. *BN*, c. 1590, attributed to Bishandas. Courtesy of the Board of Trustees of the Victoria and Albert Museum, IS 89-1965.

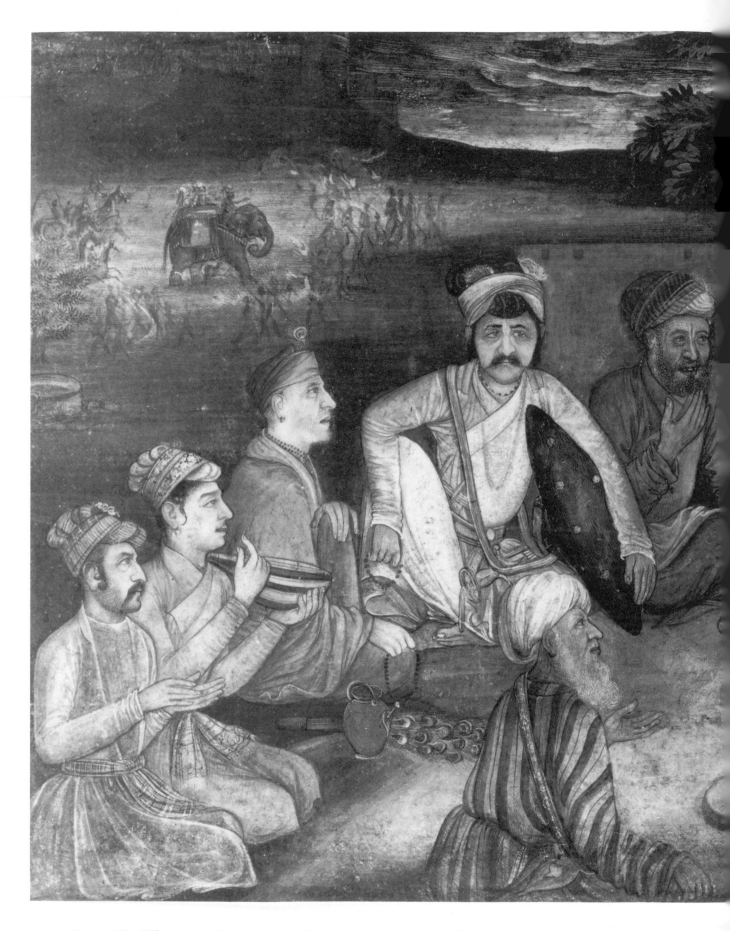

Figure 159. Officers and philosophers seated around a candle at night. Shah Jahan period, c. 1655, attributed to Payag, opaque watercolor and gold on paper, 10.8 cm × 17.2 cm. Courtesy of the San Diego Museum of Art, Edwin Binney 3rd Collection, 1990:0350.

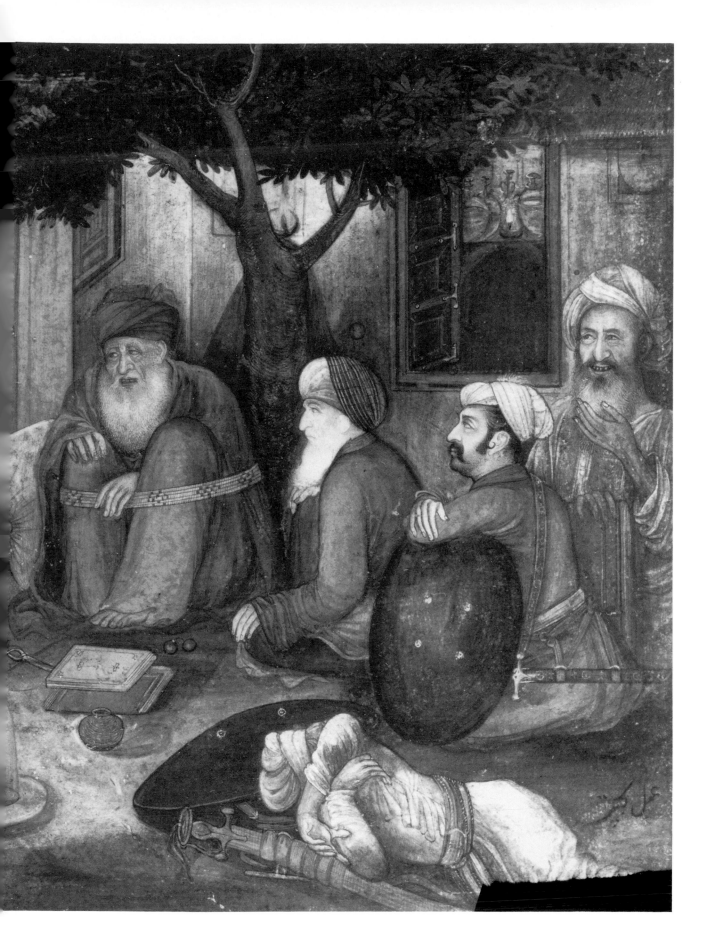

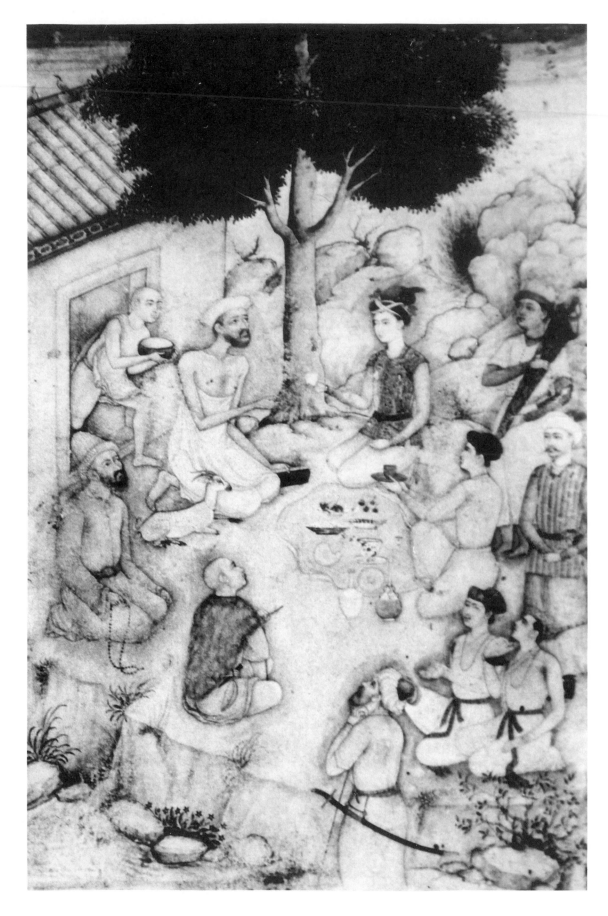

Figure 160. Prince visiting an ascetic, c. 1610. Private collection.

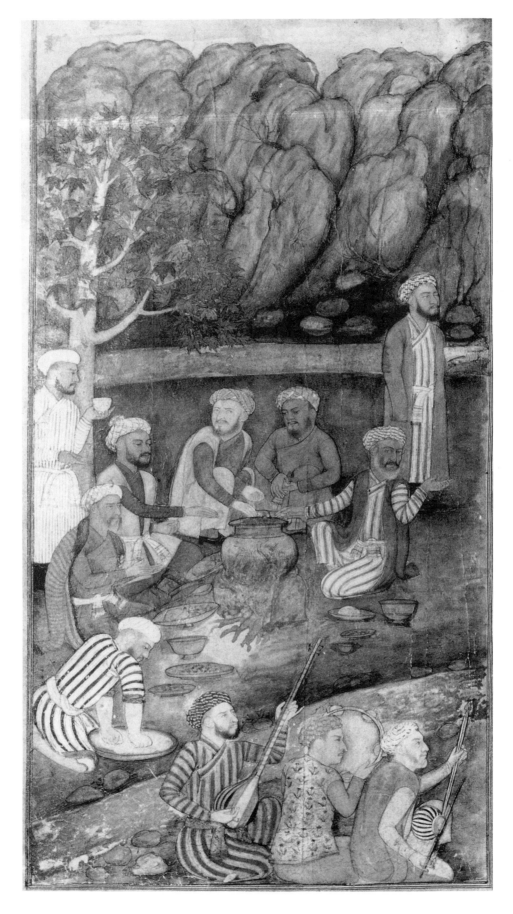

Figure 161. Zafar Khan's outdoor pleasure party. *Mathnavī* of Zafar Khan, fol. 27r, c. 1663. Courtesy of the Royal Asiatic Society, London.

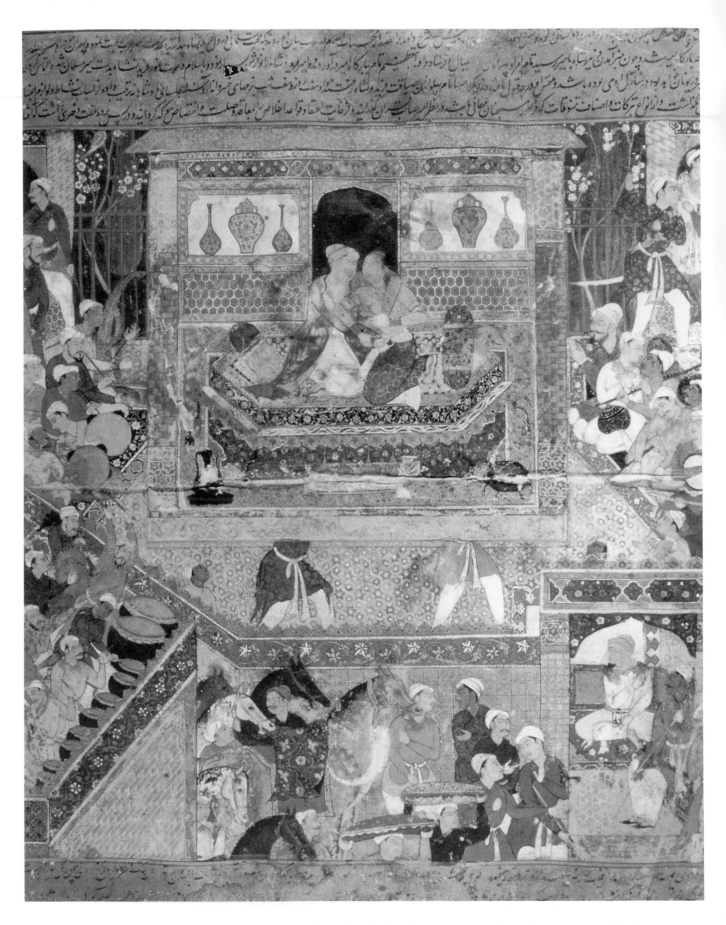

Figure 162. Hamza marries the daughter of Faridun Shah, who converts to Islam. *Ḥamza Nāma*, fol. 4v, c. 1562–77. Courtesy of the MAK-Österreichisches Museum für angewandte Kunst.

Figure 163. Virgin and child, n.d. Reproduced by kind permission of the Trustees of the Chester Beatty Library, Dublin.

Figure 164. Iskandar disguised as a legate with his portrait, before Queen Qaydafa, 1560. Shiraz style.
Reproduced by permission of the British Library, Persian Ethe 863 (I.O.133), fol. 349a.

Figure 165. Prince and ascetics. India, Mughal school, Shah Jahan period, c. 1630, attributed to Govardhan, painting, 37.5 cm × 25.4 cm. © The Cleveland Museum of Art, 1997, Andrew R. and Martha Holden Jennings Fund, 1971.79.

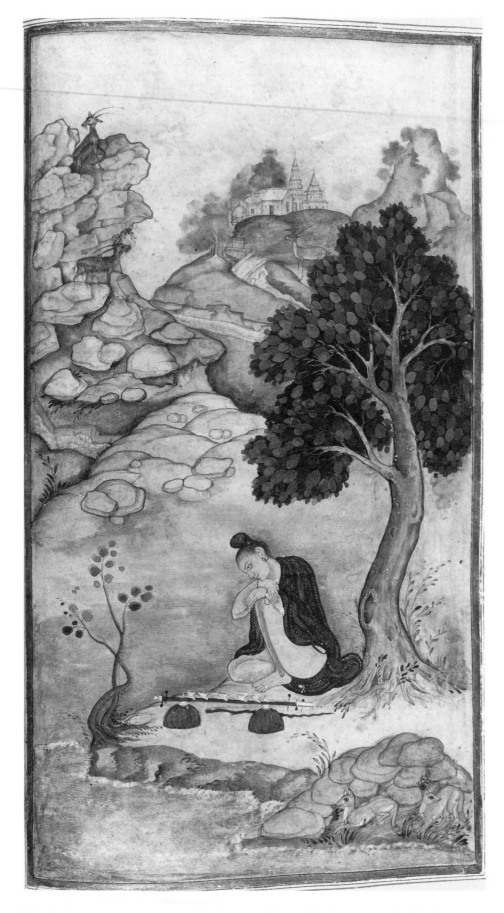

Figure 166. *Yogi* with *bīn* rests under a tree. *Yog Vashisht*, 1603. Reproduced by kind permission of the Trustees of the Chester Beatty Library, Dublin.

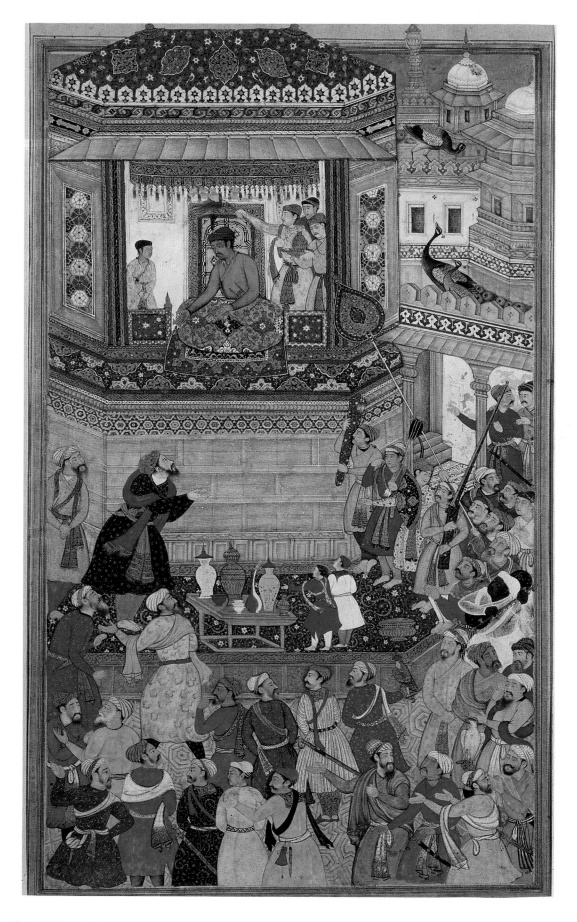

Plate 1. Husain Quli presents prisoners of war from Gujarat. *AN*, 1590 or earlier, composed and painted by Husain Naqqash, faces by Kesu Kalan. Courtesy of the Board of Trustees of the Victoria and Albert Museum, IS.2-1896 113/117.

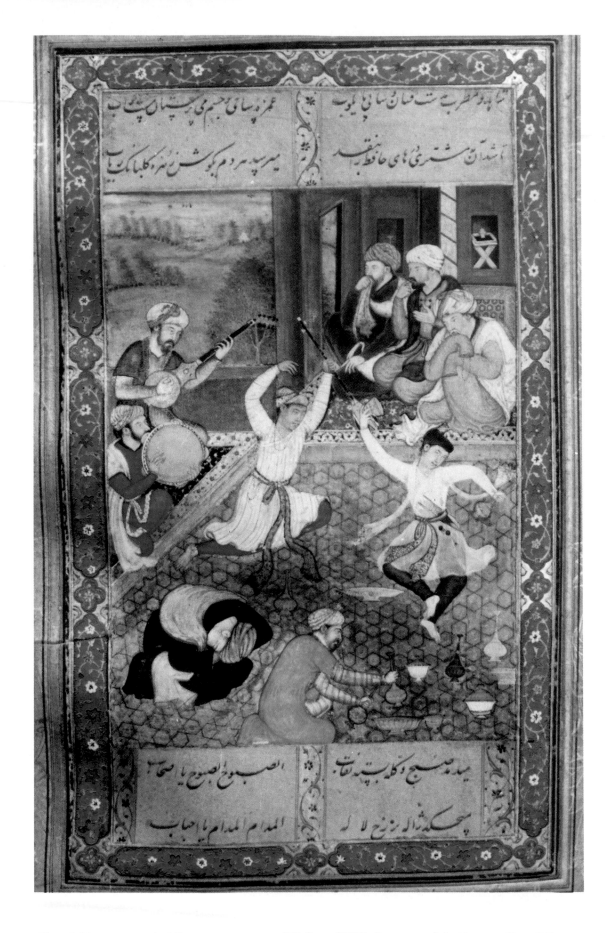

Plate 2. Dancers, one holding a lute. *Dīvān* of Hafiz, c. 1588. Courtesy of the Rampur Raza Library.

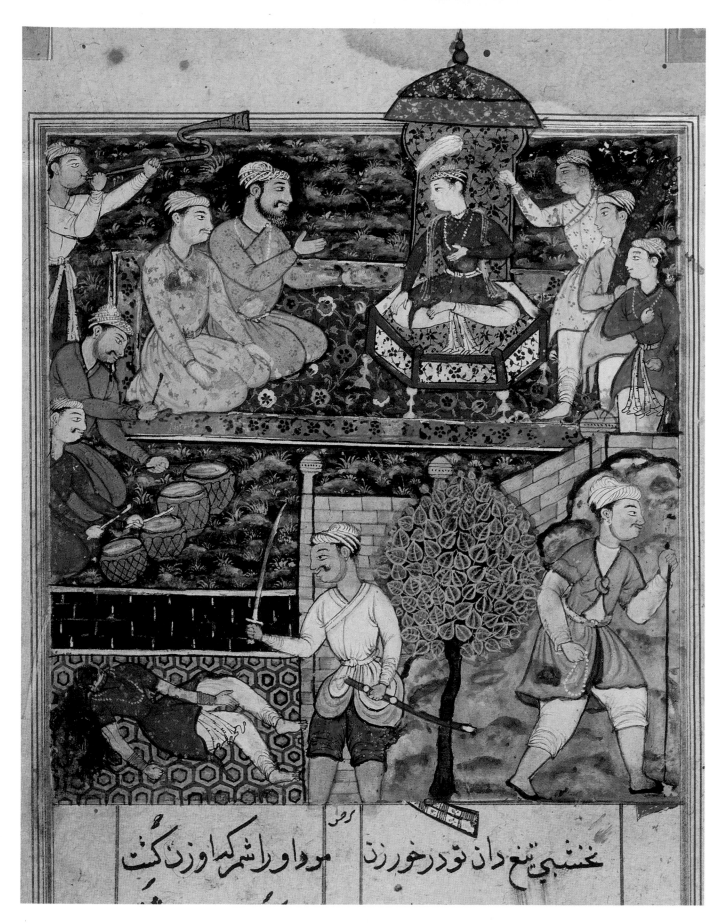

Plate 3. Prince is crowned and the wicked handmaiden iṣ executed. *TuN*, fol. 73r, India, Mughal school, reign of Akbar, c. 1560, color and gold on paper, 20.3 cm × 14.0 cm. © The Cleveland Museum of Art, 1997, Gift of Mrs. A. Dean Perry, 1962.279.

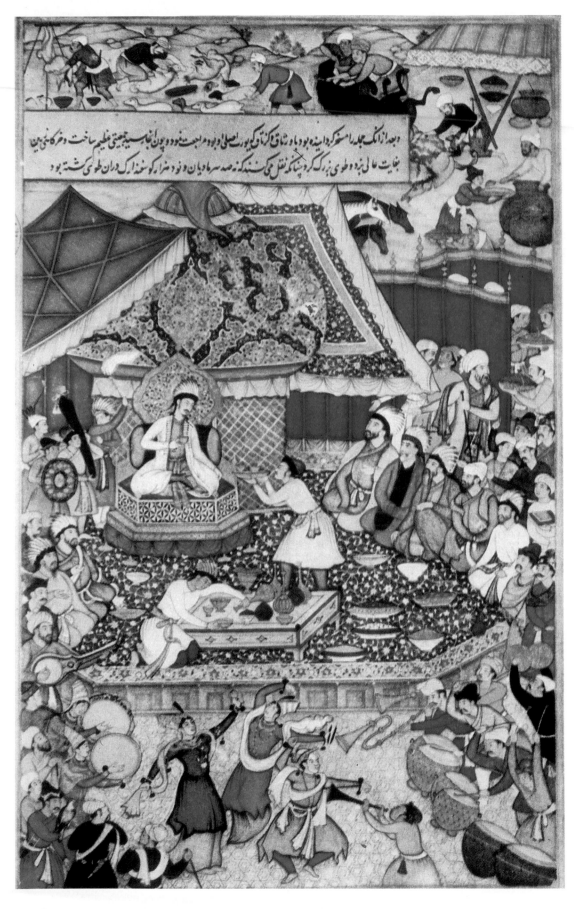

Plate 4. King Oghuz holds a feast in a gold tent to celebrate victory over Iran, Turan, and Rum. *Chinggis Nāma*, 1596, by Surdas Gujarati, portrait by Basawan. Courtesy of the Golestan Palace Museum, Tehran.

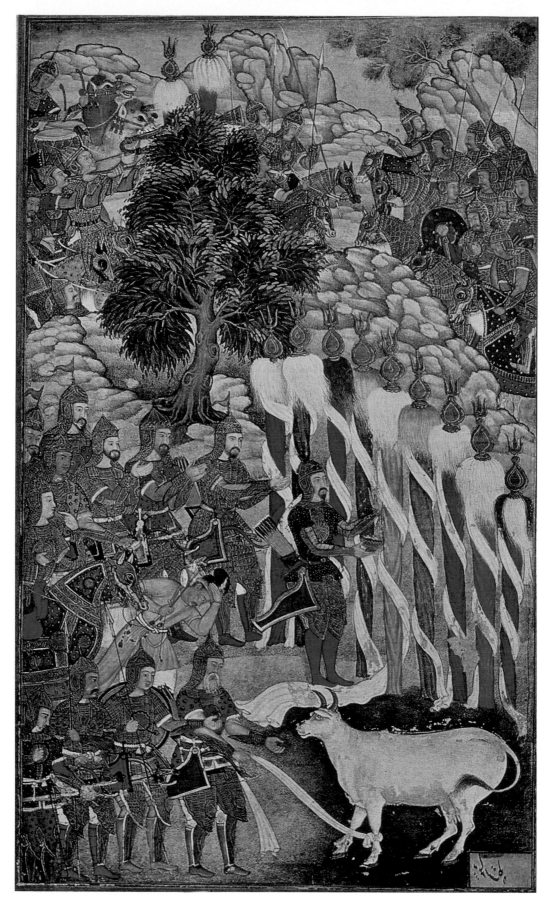

Plate 5. Acclamation of nine standards. *BN*, fol. 90v, c. 1597–98, painted by Jagnath.
Courtesy of the National Museum, New Delhi.

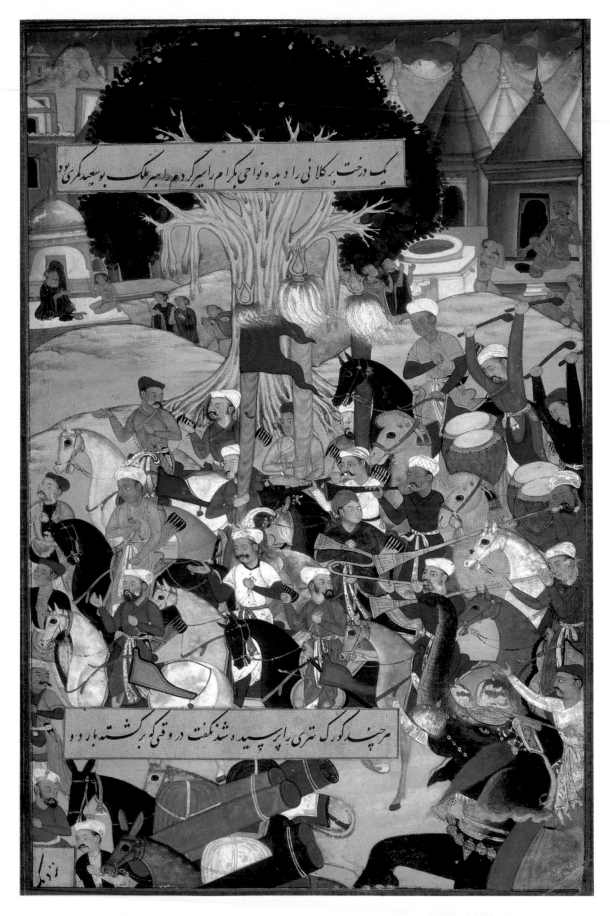

Plate 6. The attempt to find Gur-Khattri. *BN*, fol. 10v, c. 1595–1605.
Courtesy of The Walters Art Gallery, Baltimore, W. 596.

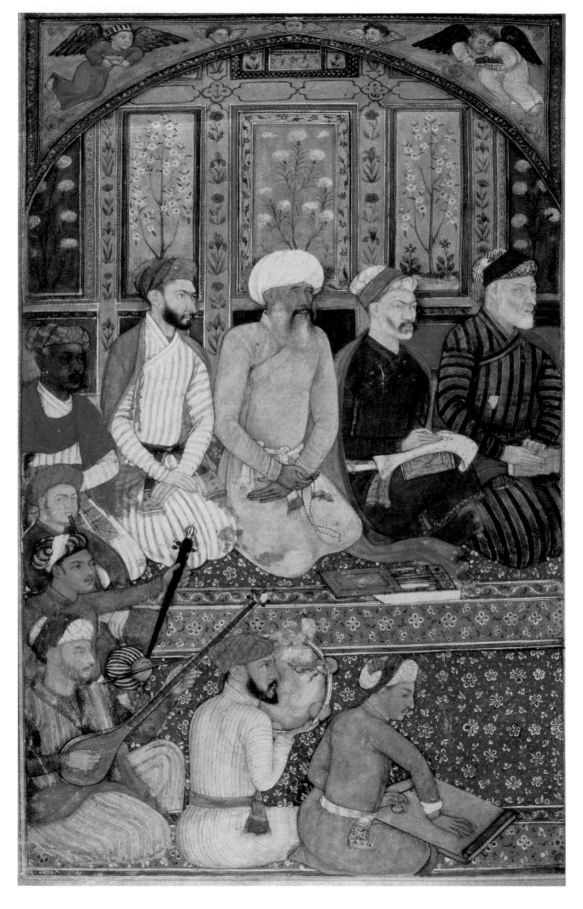

Plate 7. Zafar Khan in the company of poets, dervishes, a painter (detail appears on p. 49). *Mathnavī* of Zafar Khan, c. 1663. Courtesy of the Royal Asiatic Society, London.

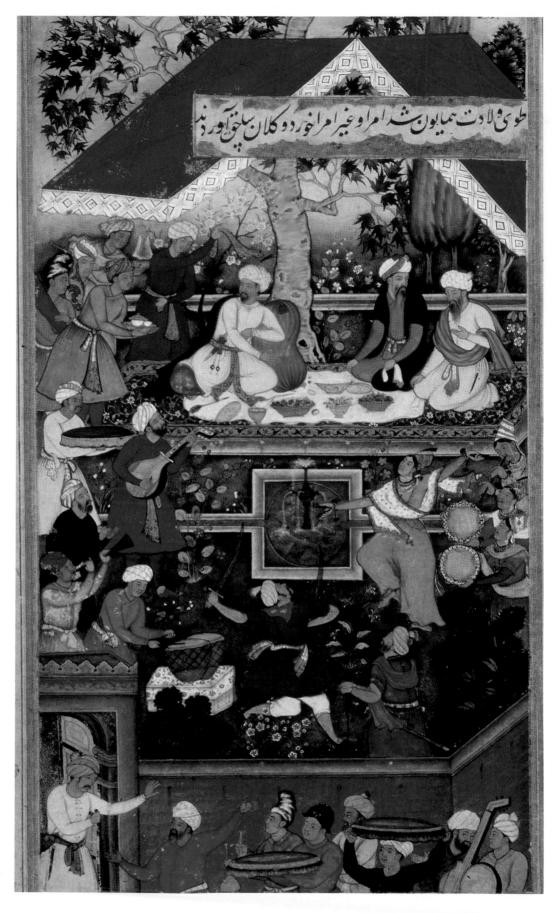

Plate 8. Celebration of Humayun's birth. *BN*, fol. 295r, c. 1591. Reproduced by permission of the British Library, OR3714.

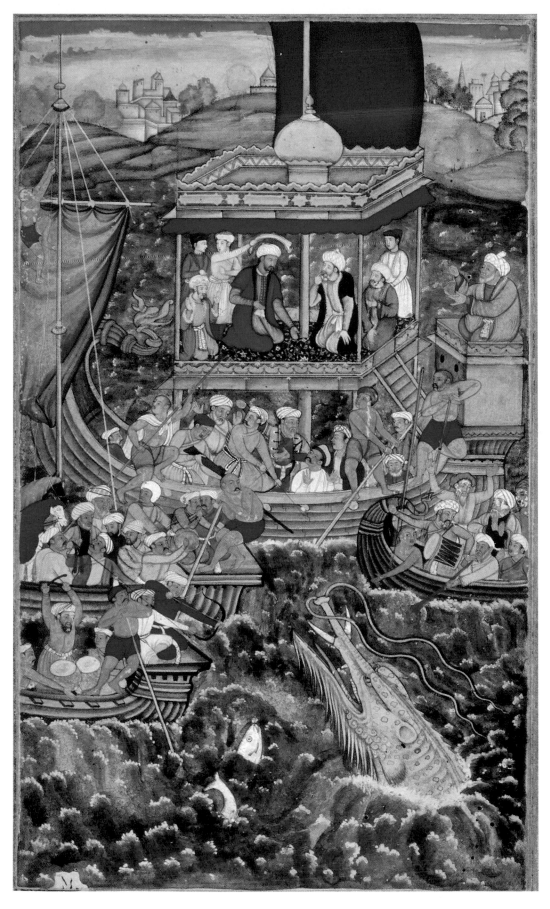

Plate 9. The crocodile frightens the fish, which jump into one of Babur's boats (detail appears on p. 56). *BN*, fol. 504v, c. 1591. Reproduced by permission of the British Library, OR3714.

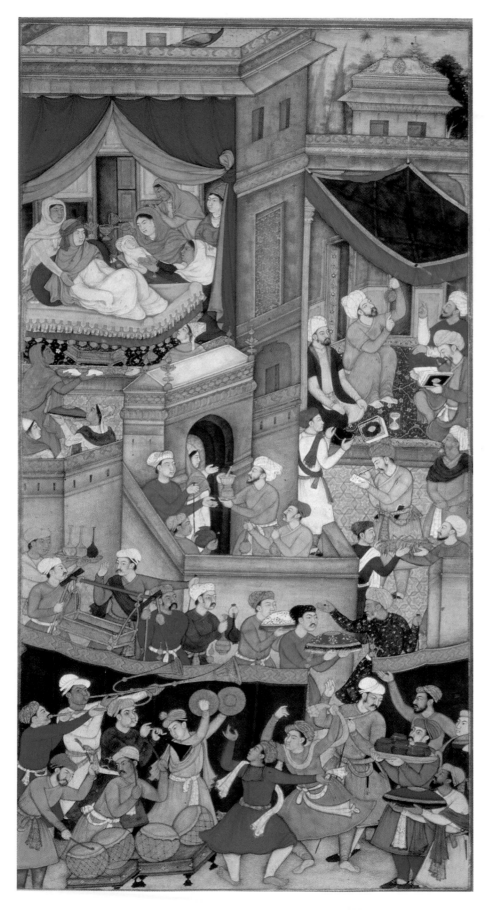

Plate 10. Celebrations on the birth of Timur. *AN*, fol. 34v, 1596–97 or 1604, by Sur Das Gujarati, 23.6 cm × 12.2 cm. Reproduced by permission of the British Library, OR12988.

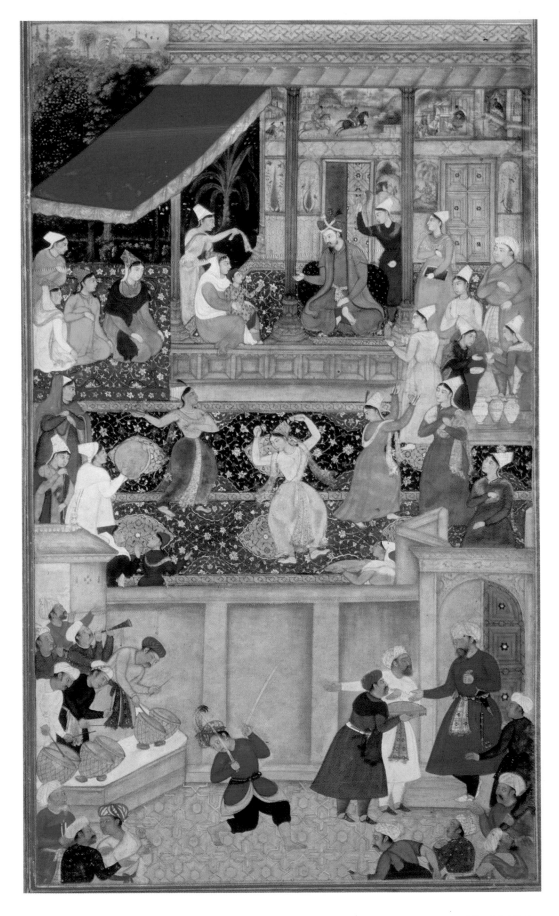

Plate 11. Emperor Humayun at the celebration of his son Akbar's circumcision. *AN*, fol. 114, 1596–97 or 1604. Reproduced by permission of the British Library, OR12988.

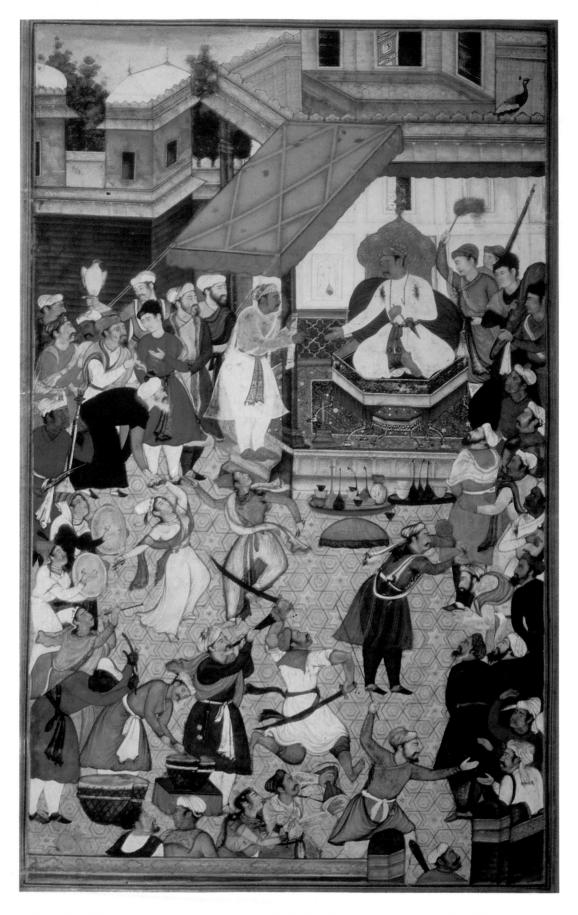

Plate 12. Akbar receives the news of Salim's birth (detail appears on p. 78). *AN*, 1590 or earlier, composed by Kesu Kalan and painted by Chitra. Courtesy of the Board of Trustees of the Victoria and Albert Museum, IS 2-1896 79/117.

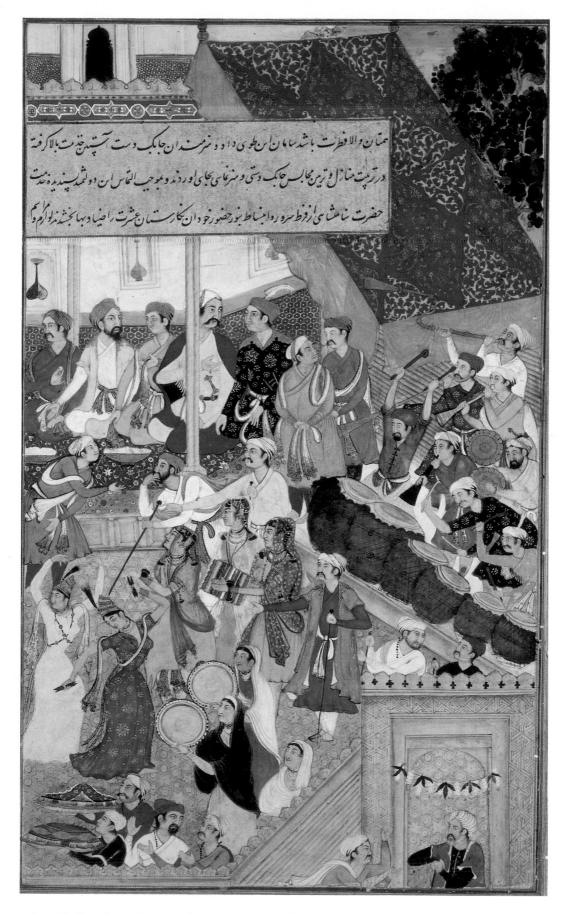

Plate 13. Royal musicians perform at a marriage (detail appears on p. 141). *AN*, 1590 or earlier. Courtesy of the Board of Trustees of the Victoria and Albert Museum, IS.2-1896 8/117.

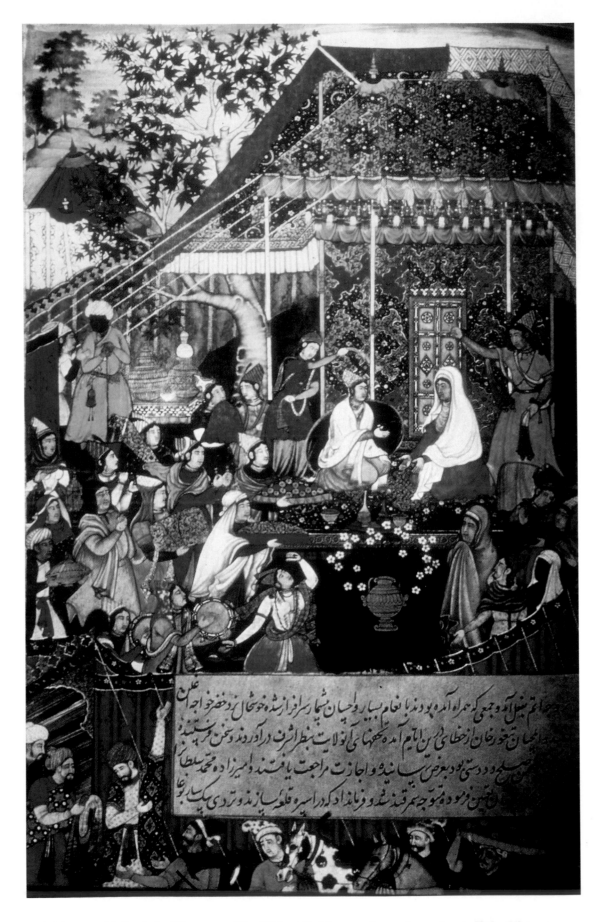

Plate 14. Malka Agha Khanam, wife of Prince Rukh, granting an interview to Tuku Khanam (detail appears on p. 87). *Tīmūr Nāma*, fol. 72a, c. 1580–85. Courtesy of the Khuda Bakhsh Oriental Public Library, Patna.

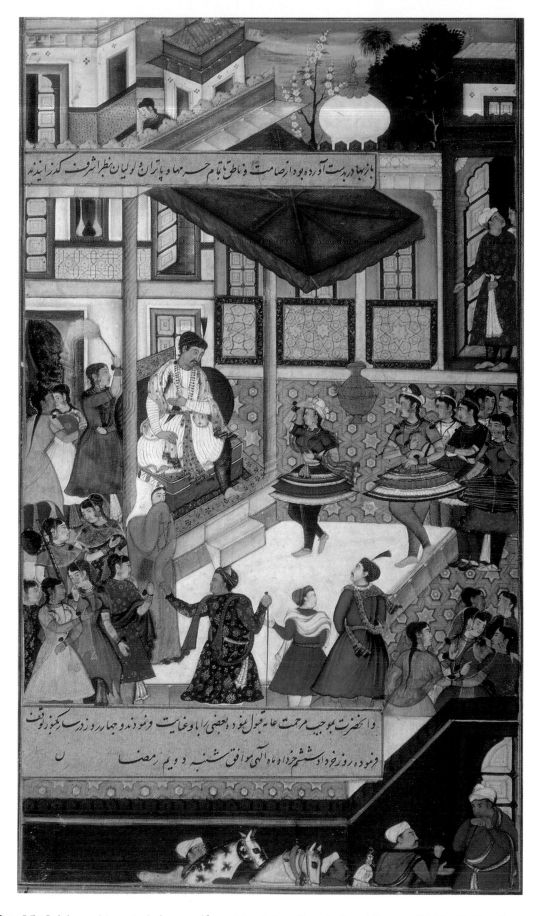

Plate 15. Celebrated (captive) dancers (from Mandu) perform before Akbar, c. 1530–60 (detail appears on p. 91). *AN*, 1590 or earlier, painted by Dharmdas, composed by Kesu Kalan. Courtesy of the Board of Trustees of the Victoria and Albert Museum, IS.2-1896 16/117.

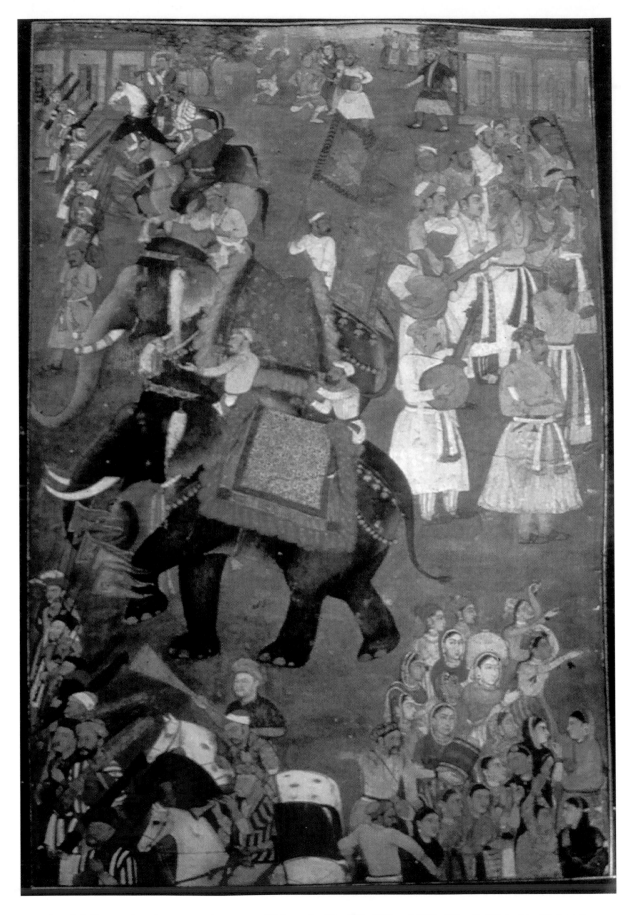

Plate 16. Processional scene at the court of Jahangir. Possibly *TiJ*, c. 1610–20, attributed to Bishandas. Housed at the Rampur Raza Library.

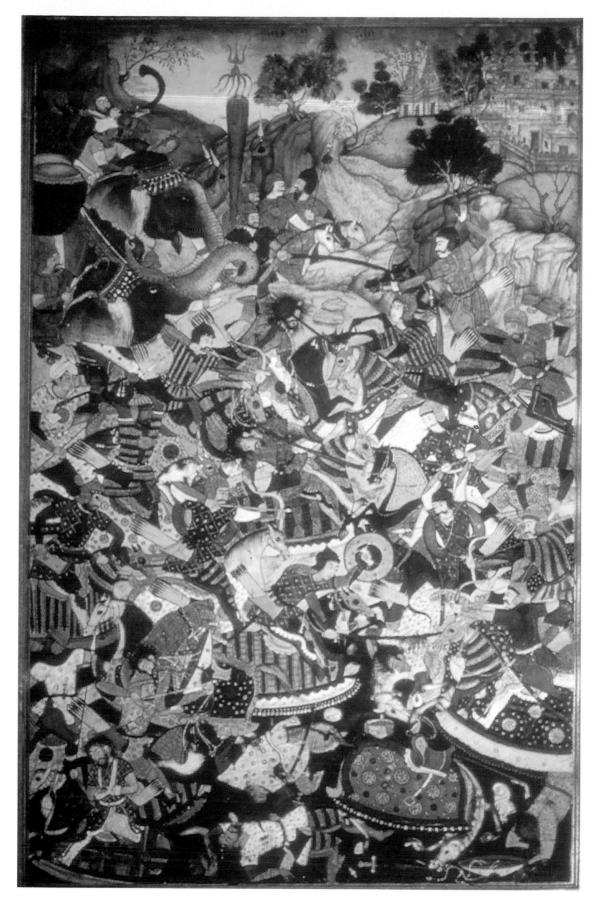

Plate 17. Victory of Qutbuddin Khan at Gujarat. *AN*, 1590 or earlier, composed by Lal, painted by Mani. Courtesy of the Board of Trustees of the Victoria and Albert Museum, IS.2-1896 109/117.

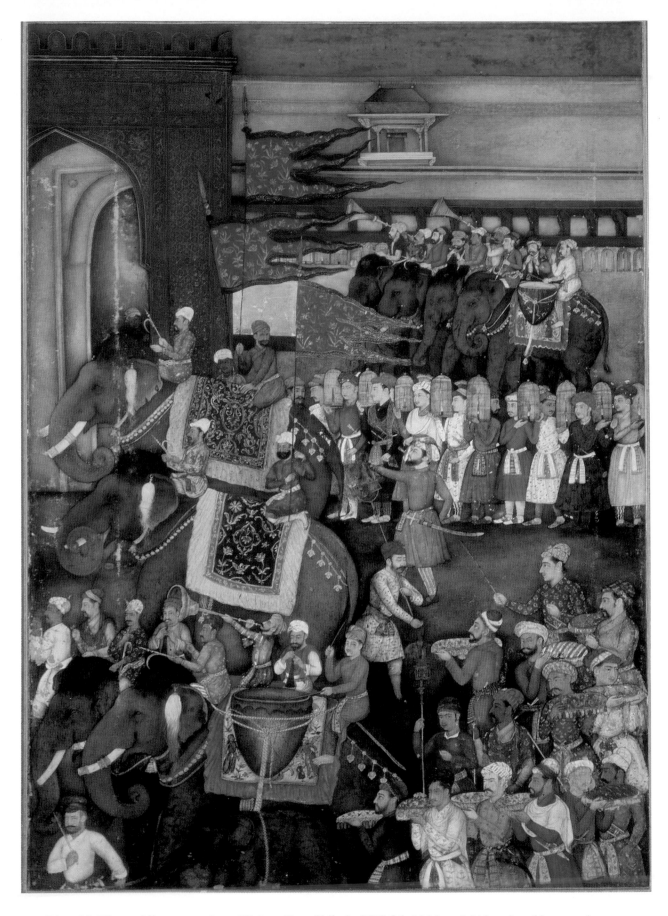

Plate 18. The wedding procession of Prince Dara Shikoh. *PSN*, fol. 123A, c. 1640, painted by an unknown artist. The Royal Collection © 1996 Her Majesty Queen Elizabeth II, Holmes Binding 149, p. 245.

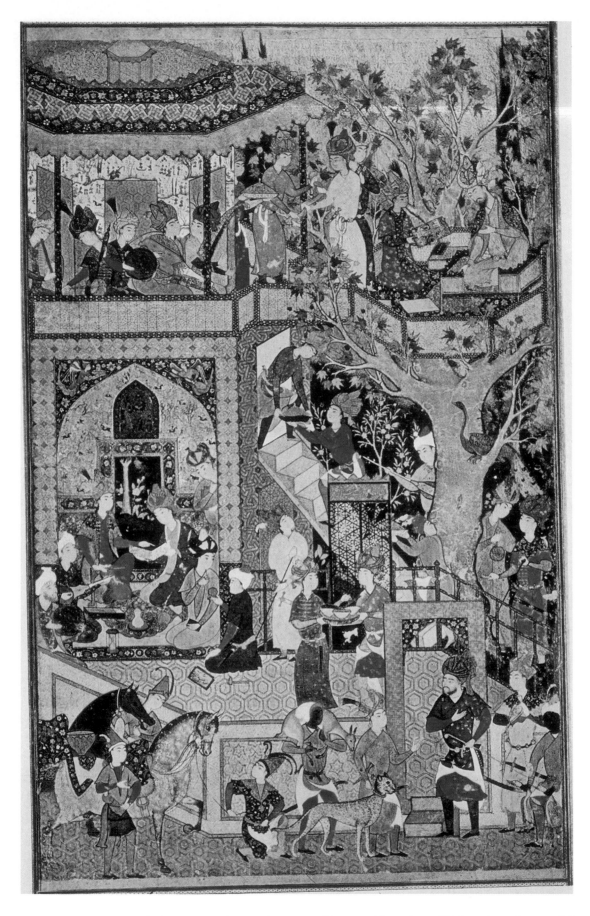

Plate 19. Humayun and Akbar in a garden pavilion, c. 1555. Signed by painter ʿAbd-as-Samad, one of the two Persian artists hired by Humayun. Courtesy of the Golestan Palace Museum, Tehran.

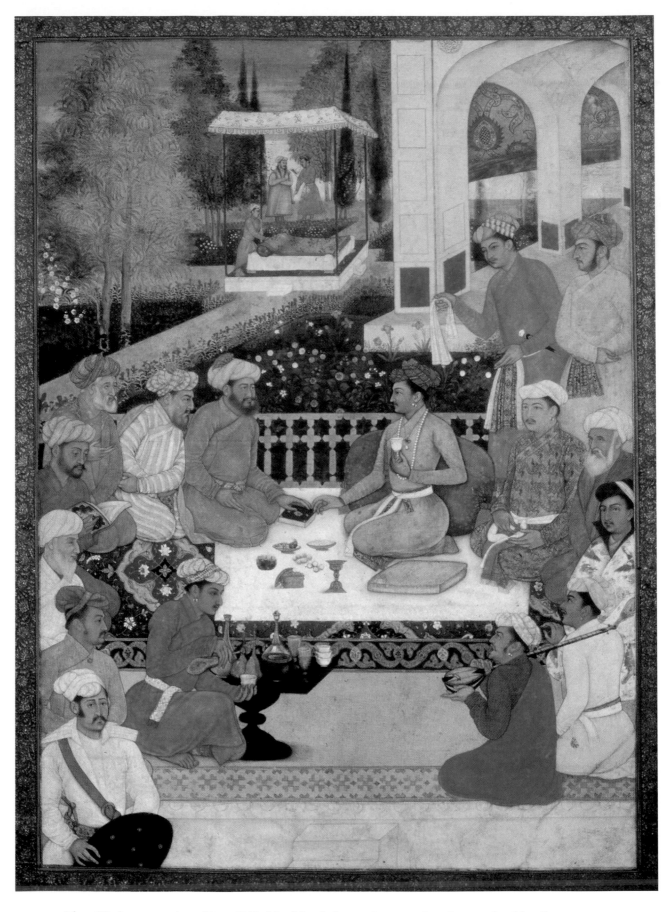

Plate 20. A young prince (Dara Shikoh) with scholars and companions in a garden (detail appears on p. 198). *Royal Album* or *Album of Jahangir,* fol. 7, c. 1625. Reproduced by kind permission of the Trustees of the Chester Beatty Library, Dublin, MS 7, no. 7.

That a corpulent, dark-skinned player of the *bīn* would have been so prominently pictured can be explained with musical as well as painterly reasons. Naubat Khan was an influential musician on two accounts: Oral information indicates that the *rudra vīṇā*, called the *bīn*, came into its period of prominence from the time of Tansen's contemporary and son-in-law Naubat Khan (Miner 1981:357). In the paintings, it is clearly Naubat Khan and not Tansen who is associated with the instrument that was adopted by Akbar for his formal court sessions. In addition, Naubat Khan was appointed in the 1590s to the prestigious position of *dārogha* (keeper) of the *naqqāra khāna*.

Naubat Khan was such an attractive subject that other portraits of him were painted around the turn of the seventeenth century. In "Portrait of Naubat Khan with *vīṇā* (Numa Khan Kalavant [a musician of the court of Jahangir]), the same musician stands (rather tentatively poised for such a heavy man) looking respectfully downward, holding a *vīṇā* whose gourd proportions have been enlarged to match that of the player (fig. 73).[16] Yet another *rudra vīṇā* player, whose different face suggests that the drawing is a representation rather than a portrait, is otherwise the ubiquitous Naubat Khan by proportions and instrument (fig. 74).

But who was Naubat Khan? For such a prominent musician, the confusion over his identity is remarkable. Say Meer and Bor, citing M. K. Imam: "Raja Samokhan Singh, a Rajput from Khandar, the son-in-law of Tansen, was the greatest *binkār* (*vīṇā* player) in Akbar's court. Better known as Naubat Khan Kalavant, he was the first in a 'century after century succession through the ages of instrumentalists who would represent until the 20th century the Seniya gharana'" (1982:132). Sharmistha Ghosh also cites Imam:

> Tradition has it that Samokhan Singh, a Beenkāra of great repute, married the daughter of Tansen and was given the title of Naubat Khan by Akbar. . . . But this is not universally accepted. According to Ustad Dabir Khan, a direct descendant of Naubat Khan, it was Misri Singh, the son of Samokhan Singh, who was Tansen's son-in-law. Akbar conferred on Misri Singh the title of Naubat Khan. (Ghosh 1988, 1:56 with note).

Agreeing with Ghosh that Misri Singh was Naubat Khan, Ravi Shankar explained Tansen's genealogy: "The other lineage stems from the family of Tan Sen's daughter Saraswati, who was married to a noted *been* player, Misri Singh (who was later renamed Nabat Khan, upon his conversion to Islam)" (Shankar 1968:50).

Adding an authoritative voice to the confusion is Jahangir, in whose court Naubat Khan also served. On an expedition in 1607 to Kabul, Jahangir made a pilgrimage to the tomb of his grandfather, Babur. In a paragraph of miscellany in his memoirs, he recorded his diverse administrative actions among which, in his enumeration of awards, he sandwiched in his promotion of a Naubat Khan as well as a sentence about how he was treating his rebellious son, Khusrau:

> I promoted Chīn Qilīj Khān, to the rank of 800 personal and 500 horse. On the 12th I sent for Khusrau and ordered them to take the chains off his legs that he might walk in the Shahrārā garden. My fatherly affection would not permit me to exclude him from walking in the aforesaid garden. I transferred the fort of Attock and that neighbourhood from Ahmad Beg

to Ẕafar Khān. To Taj Khān, who was nominated to beat back the Afghans of Bangash, I gave 50,000 rupees. On the 14th I gave 'Ali Khān Karorī, who was one of my revered father's old servants and was the *darogha* of the Naqārakhāna (drum-house), the title of Naubat Khān, and promoted him to the rank of 500 personal and 200 horse. . . . On Friday, the 18th, the *wazn-i-qamari* (the weighing according to the lunar year) for my 40th year took place. (*TiJ* 1:111)

Jahangir's entry, then, documents Naubat Khān's office as *darogha* under Akbar. And while it had appeared that the title Naubat Khān was not awarded upon the *bīnkār*'s adoption of Islam, if his name was already 'Ali Khan Karori, Jahangir also provides the missing link: Misri Singh may have taken the name 'Ali Khan Karori upon adoption of Islam and was honored with the title of Naubat Khan by Jahangir when the musician was an old man, "Naubat" refering to the ensemble in the *naqqāra khāna* over which he had administrative charge.[17]

For such a prominent musician as Misri Singh / Naubat Khan, there were the requisite accompanying legends. In one, the musical status of Tansen's future son-in-law is established. This story emphasizes the Hindu religion of Misri Singh and offers an entirely fanciful interpretation of the relationships among patrons and musicians.

It seems Akbar was on one of his usual shikārs (hunts) and feeling acutely thirsty came across a Śiva temple. There, as he was quenching his thirst, he heard the sweet sounds of the Vīṇa. He cautiously went inside and found a Sādhu deeply engrossed in playing the Vīṇa before the idol. On interrogation of the Sādhu, it was found that he, in a moment of jealous, insane ambition had caused the assassination of his father, Mahārāja Samōkhan Singh and therefore, in profound remorse and penitence, Miśri Singh had renounced the world and taken to music and meditation. Akbar could not resist the alluring music of Miśri Singh's Vīṇa. He ardently persuaded Miśri Singh to accompany him to Delhi. At Delhi, Miśri Singh was easily the best Vīṇa player. In those days, it was customary for the Dhruvapāda singers to be accompanied on the Vīṇa. So Miśri Singh began accompanying Tānsen. This combination continued wonderfully for some time. But then as often unfortunately happens between even the greatest artists, healthy competition led to unsavoury rivalry, then finally to bitter enmity. It is said that Tānsen determined to put down Miśri Singh, came prepared one day with a difficult Dhruvapāda which Miśri Singh despite his uncanny virtuosity was unable to follow. He failed to reproduce all the subtle nuances of the composition as well as the intricacies of the tāḷa which Tānsen did. An altercation ensued resulting in physical assault of Tānsen by Miśri Singh as he was unable to control the Rajput fire of indignation in him. Miśri Singh immediately fled from Delhi realising the catastrophic consequences of his action in the event of this coming to the knowledge of the Emperor. Miśri Singh went again into self-chosen inevitable oblivion. But a few years later one of Akbar's ministers Khān Khāna accidentally met him in a forest and induced him to return to Delhi [and] personally assured him of the Emperor's pardon.

When Miśri Singh came back to Delhi, Akbar was in a dilemma as to how he could successfully compromise an act tantamounting to a contempt of court and at the same time retain Miśri Singh in his state, as Tānsen was also after his blood. Akbar is said to have followed the advice given by Khān Khāna whose guest Miśri Singh was. Miśri Singh was disguised as a woman in purdāh and asked to give a recital in Khān Khāna's house. An

announcement was made by Akbar of the presence of an exceptionally fine lady Vīṇā player. Tānsen naturally could not desist from attending the programme. Miśri Singh was playing behind a screen, but Tānsen no sooner heard the Vīṇa recognised the player without hesitation and demanded the removal of the screen and lifting of the purdāh. The cat was out of the bag but before Tānsen could vent his rage on Miśri Singh, Akbar sent word to him and assured him that in case Tānsen could point out another Vīṇa player of the caliber of Miśri Singh he would surely order his execution for the insult done by him to Tānsen. Later Tānsen is said to have given his daughter Sarasvati in marriage to Miśri Singh. (Kuppuswamy and Hariharan 1984:78–79)

BAZ BAHADUR

Also counted among the musicians patronized by Akbar was the previously mentioned Baz Bahadur, erstwhile ruler of the kingdom of Malwa, who joined Akbar's household in 1570 (see chapter 3). According to Bada'uni, there may have been a musical connection between Tansen and Baz Bahadur, through the Sur ruler 'Adli, who may have been among Tansen's teachers and whom Tansen greatly admired:

> Bāz Bahādur, son of Sazāwal Khān, who was also one of the most gifted men of his age and had no equal in this life-wasting accomplishment acquired the art (of music) from 'Adlī.
>
> They owned no rival, but surpassed them all,
> May God *He is exalted and glorified,* pardon them.
> (*MtT* 1:557)

"They" who "owned no rival" were Tansen and Baz Bahadur.[18] While Bada'uni did not approve of their devotion to music, Akbar clearly did, because he awarded Baz Bahadur the rank of *mansabdar* with 1,000 horses.

Meaningful Instruments in Akbari Paintings

The addition of aural meaning by the inclusion of music-making in numerous scenes has been discussed above. Indian culture is asserted by the sound of Indian music in the scene of Akbar's celebrating the birth of his heir, Salim (pl. 12). A political kind of pleasure is implied by his being entertained by the Indian musicians and dancers captured from the court of Baz Bahadur (pl. 15).

THE SOUTH ASIAN HORN

Another pointed example of aural meaning added to scenes is the depiction of an unmistakably Indian instrument, the *sīṅg* (*śṛṅga, sīṅgā, sīg, sīgā*), or C-shaped horn. An ancient Indian instrument, the *śṛṅga*, the indigenous term for horns in Sanskrit and the derivative North Indian languages, is found even in the *Ṛg-veda* (later 2d millennium B.C.E.). The *śṛṅga* described in the thirteenth-century *Saṅgītaratnākara* was a well-formed buffalo horn with an "elephant mouth," i.e., notched at the wide end. To increase its volume a mouthpiece consisting of a conical section of ox horn, c. 15 cm long, with its tip removed, was inserted into the apex (Dick 1984b). By the sixteenth century, the instrument was made of brass in the form of a cow's horn and was referred

Detail of figure 75

to in the *A'īn-i Akbarī* as the *sīng* (*AiA* 1:53). By the seventeenth century, as seen in paintings of the Shah Jahani period, it was being made of multiple conical sections with juncture rings visible, and the ending section was anchored; in figure 75 (see detail) there seems to be a cord (perhaps with decorative tassel hanging down) attached to the very end and to the second juncture ring from the end.[19]

Those who have commented on the sound of the *sīng* use various adjectives, but with a similar sense. "It produces a somewhat hoarse tone and is not capable of many notes" (Krishnaswamy 1965:89). "It gives a very shrill note" (Sambamoorthy 1962:21).

> In playing the high notes in many of the calls, shrill wavering cadences are produced, which have a startling and peculiarly wild effect, as heard from the wall of some ancient fortress, or from village tower and gates as night falls, and more especially in the otherwise unbroken stillness of night, [and] wailing blasts for the dead are played upon it at the funerals of Hindus of the lower classes and castes or equally so at the cremation of Hindu princes. (Day 1891:153)

The C-shaped horn, the *sīng*, occurs in very few paintings in the Akbari period. In two of three paintings I have seen to date, the meaning of the instrument is clear: it is intended to represent explicitly localized Indian culture. In an illustration of an *Akbar Nāma* manuscript of a furious battle during Akbar's long struggle to subdue the rulers of Gujarat, the Indian forces face right, toward their foes, the Mughals (pl. 17). To identify the Indian forces (uniforms of opposing sides seldom differ in Mughal paintings), the artist has topped the standard of the Indian leader with a trident, the symbol of Lord Vishnu, and has bolstered the Indian soldiers by drawing a C-shaped horn, unmistakably configured in profile against the light sky. This military context for the *sīng* is ancient, for in the Vedic period through the first millennium C.E., the term *śṛṅga* was used to describe an instrument both of warfare and signaling (Dick 1984b).

A second obviously Indian illustration from the Akbari period shows the C-shaped horn in a

heralding ensemble. From the *Razm Nāma,* an illustrated manuscript of the Indian epic story, the *Mahābhārata,* a court scene painted c. 1580 by Daswanth, is crowded with tiny figures (fig. 76, see detail). On a parapet far above the central characters, a large ensemble blares and pounds away on drums, including not one, but two C-shaped horns and a long conical horn, undergirding Abu'l Fazl's statement: "They blow two together" (*AiA* 1:53).

The heralding function of the C-shaped horn continued in succeeding centuries. Captain Day reported at the end of the nineteenth century:

> No native authority traverses the country without one, frequently several, in his train, and as town or village are approached the great man's advent is heralded by flourishes of the instrument blown by the performer who struts at the head of the cavalcade. These blasts are answered by others from the town or village gate, whence the local authorities come out to meet the visitor and present their offerings of welcome. On these occasions the horn-blowers on both sides vie with each other in producing their grandest effects, and the discordance is generally indescribable (Day 1891:153)

Even in 1962, "When high officials or persons of dignity come to a village, the horn-blowers stand at the village gate and blow their horns with tremendous effort by way of welcoming them" (Sambamoorthy 1962:21).

A third Akbari scene including a *sing* is more difficult to explain, but its appearance in paintings of the period is so striking that I cannot believe that no interpretive information is intended.

Detail of figure 76

The "Attempt to assassinate Akbar at Delhi" (fig. 3 and detail on p. 5) failed, but it provided an excellent opportunity to assert Akbar's invincibility by visual means. As told by Abu'l Fazl:

> The cortege of His Majesty the Sh̲āhinsh̲āh after arriving in Delhi had proceeded . . . to visit the shrine of Sh̲aikh Niẓāmu-d-dīn auliyā. May his grave be holy! He was returning from there to his dwelling and when he reached the crossways one of the death-designed ingrates was standing near Māham Anaga's Madrasa. When His Majesty had gone on beyond him the latter discharged an arrow against that *qibla* of the world. It struck His Majesty's right shoulder and penetrated about the length of a span. A cry arose from heaven and earth and devoted followers fell upon that wretch. They wished to examine him and not to kill him at once, but His Majesty indicated that he should be speedily put to death lest a number of loyalists should fall under suspicion. In an instant they cut him to pieces. Though the hearts of the loyal and the minds of the superficial men of the world were perplexed as to the remedy, that spiritual and temporal king preserved his composure and comforted the faithful. He bade his followers extract the arrow. I have heard from the glorious tongue (Akbar) that at first he thought someone had unwittingly thrown a fragment of a stone from a roof. In spite of such a wound he remained as before on his horse and proceeded to his palace. As the Divine protection and the prayers of the saints were guarding him, the wound was not serious. (*AN* 2:313)

Activity fills the illustration of this event. Akbar's route through the city is suggested by the cloth merchant's stall in an alcove of the wall of a substantial dwelling; men stand above the shop watching the events, while opposite them, at the same high level, an ensemble of musicians heralds the emperor. Other men stand at the entrance to the dwelling, motioning in greeting. Akbar holds up the arrow and looks around as if to show the crowd of courtiers behind him on horseback that he is all right. The would-be assassin no longer has his head on his shoulders.

A more subdued report of the incident was given by Bada'uni:

> At this time, when one day the Emperor was walking and came near the Madrasah-e Bēgum, a slave named Fūlād, whom Mīrzā Sharaf-ud-dīn Ḥusain, when he fled and went to Makka, had set free, shot an arrow at him from the top of the balcony of the Madrasah, which happily did no more than graze his skin. . . . The Emperor ordered the wretched man to be brought to his deserts at once, although some of the Amīrs wished him to delay a little until the affairs should be investigated, with a veiw to discovering what persons were implicated in the conspiracy. His Majesty went on horseback to the fortress, and there the physicians applied themselves to his cure, so that in a short time he was healed of his wound, and mounting his royal litter went to Āgra. (*MtT* 2:60–61)

While none of the instruments in the *naubat* ensemble that heralds Akbar from the parapet of the *madrasa* is well drawn or painted in the illustration, the artist has clearly asserted "Indianness" by means of the rare occurrence of a C-shaped horn in the group. It is complemented by one other specifically Indian image in the painting: the woman, probably a servant who was sent to watch the musicians, peeks out from a window at the very top, very center of the picture. She is quite noticeable because, like the *sīṅg,* a woman so exposed in an otherwise entirely male context is striking. Finding the presence of that "still, enigmatic figure, silhoutted against a dark window" to be unusual, the art historian Geeti Sen (1984:83) conjectures that the motive suggested by Bada'uni for

the attempted assassination may have been real rather than another case of that author's tendency to slander and sarcasm. Bada'uni's account continues:

> And it was at that place [Dihlī] that His Majesty's intention of connecting himself by marriage with the nobles of Dihlī was first broached, and Qawwāls [a person sent to the father of a lady in the proposals of marriage] and eunuchs were sent into the harems for the purpose of selecting daughters of the nobles, and of investigating their condition. And a great terror fell upon the city.
>
> [One woman, a daughter-in-law of Shaikh Badah,] whose husband was still living, was wonderfully beautiful, and altogether a charming wife without a peer. One day it chanced that the eyes of the Emperor fell upon her, and so he sent to the Shaikh a proposal of union, and held out hopes to the husband. For it is a law of the Mughal Emperors [from the Code of Chinggis Khan] that, if the Emperor cast his eye with desire on any woman, the husband is bound to divorce her. . . . Then 'Abd-ul-Wāsi . . . bound three divorces in the corner of the skirt of his wife, and went to the city of Bīdar in the kingdom of the Dakkan, and so was lost sight of; and the virtuous lady entered the Imperial Ḥaram.
>
> Then Fātimah [a widowed daughter-in-law of Shaikh Badah], at the instigation of her own father-in-law urged that the Emperor should become connected in marriage with other nobles also of Āgra and Dihlī, that the relation of equality [between the different families] being manifested, any necessity for unreasonable preference might be avoided. (*MtT* 2:59–60)

A respected historian of religions in India definitely attributes the assassination attempt to this cause.

> The success of the matrimonial alliances with the Rajputs seems to have prompted Akbar to establish similar alliances with the prominent Muslim families of Delhi and Agra. In this he was badly advised by certain holy men of Agra and the mishandling of the situation by professional intermediaries precipitated a crisis. In 1564 an attempt on his life in Delhi alarmed the Emperor and he gave up the idea of establishing matrimonial alliances with the Muslim families. (Rizvi 1975b:184)

Perhaps the Indian woman and the unmistakably Indian *sīṅg* are there in the painting as a reminder of the essentially positive reason—successful integration of Indian culture—behind Akbar's intentions.

The West Asian Harp

A particular musical instrument can be used by the artist in a painting to indicate a non-Indian context, and in Mughal paintings that certainly is usually the case with the harp. Good examples of this technique are found in the Cleveland Museum copy of the early manuscript, the *Tūtī Nāma* (see chapter 1), where it occurs in illustrations of three stories located outside India. Since this is a good cultural indicator, I will discuss these stories at length.

One story, of the thirteenth night, is about a king in Isfahan who, in order to be sure that his infant heir was worthy of assuming the throne, put him to the test of responding to music. Assembling "all kinds of instrument," the king receives reassurance when his son listens attentively from

his cradle (*TuN* 97–101). Hints for the artist as to which instruments to depict are scattered through the story, as well as enumerated in a list:

> When the golden lute [*barbaṭ*]—the sun—was placed in its receptacle in the west, and the silvery tambourine [*dāʾira*]—the moon—was lifted out of its orbit in the east, Khojasta, like a desperate Venus, grieving over her love, went to ask Tuti's permission to leave and said, "Oh the nightingale of orators and the melodious ring-dove!"
>
> > So many veins are protruding from my body like a harp
> > [*chang*], a loud cry is uttered from each hair[20]
>
> For days my eyes have been glued to the road like a *nay*. Love will bend my posture to look like a *chang* before I will obtain my desire. How long will this suffering continue!
>
> Tuti replied, "Oh Khojasta, although passion torments the body, it is not befitting to complain of love. Like a *ṭunbūr* every person has a voice, and your voice is bewailing your love." (*TuN* 97)

Khojasta tells Tuti that she wants to learn the facts about her beloved's family and be fully informed about his background and experience. "The manifestations of man's knowledge are many and the revelations of his character are numerous," Tuti responds. "One of these is his reaction to the sound of music, the tone of the organ [*arghanūn*], the melody of the lute [*tār*]" (*ibid.*). Then Tuti tells Khojasta about the heir of the king of Isfahan,

> Eighty clear-thinking wise men convened and by unanimous opinion and with complete agreement decided that all kinds of musical instrument should be brought, that every variety of implements for playing joyful music should be assembled, and that other cradles should be placed next to the prince's cradle. If he should respond gleefully when he hears the music, then he is truly a noble birth, but if he should not be moved by it, he is without doubt of low origin.
>
> The musicians performed upon the dulcimer [*anqā*], the *qānūn*, the *chang*; they played the *ṭunbūr*, the crescent [*chaghānah*], the *kamancha* and the comb (and paper) [*shānah*]; they sounded the lute [*barbaṭ*], the *rabāb*, and the Chinese cymbals [*silḥ-i khitāʾi*]. (*TuN* 99)

An artist put into an illustration of this story (fig. 77) the *nāʾī*, cymbals, *dāʾira*, and *chang* (harp) from the narrative; for the rest he improvised—singers, *naqqāra*, and an Indian *rudra vīṇā*. Only the *chang* asserts the setting in "Isfahan," since all other instruments were common in Indian paintings.[21] What is significant about this folio is that it was designed by an artist of the Candayana style, i.e., by an Indian painter (Seyller 1992).

Khojasta seeks to leave to see her lover on the forty-eighth night of her husband's absence, but Tuti delays her with another story located outside India.

> Khojasta with great impatience and tearful eyes went to Tuti and said, ". . . I do not know whether I have been given the entire love potion or whether some of it has been given to my adored lover."
>
> Tuti replied, "I know that he is not being affected by that kind of fire, nor is he being consumed by such a smokeless flame. Yea, one cannot applaud with only one hand nor will

Detail of figure 78

one millstone make a gristmill. If your loyalty and sincerity had been equalled by his, then surely your wishes would have been fulfilled and your desires would have been attained just as the aspirations of the young man from Baghdad and his slave girl were fulfilled and their wishes attained because their loyalty and devotion to each other were of balanced intensity."

Khojasta inquired: "What was that story?"

Tuti replied: "It is said that there lived a young man in Baghdad who possessed much property and riches. He fell in love with a slave who was a songstress. He purchased her for a large sum of money and lavished all his wealth on her. He went bankrupt, became destitute, and was soon reduced to poverty." (*TuN* 295)

In the illustration of this story, a new painting by a Mughal artist, the young man of Baghdad asks a friend's advice on how to escape from his disastrous circumstances (fig. 78). Although the painting is very Persianate in such details as the carpet on which the men sit and the decorative tiles on the chamber wall, the fact of its setting outside India is declared by the slave girl who kneels in the background, playing a harp (see detail). The conventional use of the harp appears to have been shared by the Indian/Candayana and Mughal artists.

On the last night of temptation, when Khojasta seeks Tuti to ask his permission to leave to see her lover, she finds the parrot with his head bent low in meditation, silent in deep thought.

"Oh Khojasta," said Tuti, "I dreamed last night that your husband had returned from his journey, that the master had come back to his home. All my thoughts and worries are about this dream which I hope will not become a reality. If your husband should arrive today or tomorrow, you will be just as humiliated about your lover as the wife of the pious man was in front of her husband."

Khojasta inquired, "How did that happen?"

Tuti replied: "In stories written for entertainment and in strange tales I have read that
in lands west of the Israelites there lived a pious man who had a wife and a son." (*TuN* 323)

In figure 79, designed by a Mughal artist, "The king gives his daughter in marriage to the pious
man's son," in lands "west of the Israelites," a female harpist and tambourine player constitute the
entertaining ensemble in this version of a conventional courtly scene.

Finally, in "The sultan of Baghdad and a Chinese girl" (fig. 80), painted in 1610 by Bishandas,
an otherwise Indianized illustration in terms of pictorial content, the musical ensemble (but par-
ticularly the harp) is the most distinctly West Asian element.

The West Asian harp, though, did not take a sustained place in the instrumentarium of the
Mughal courts in India. Although harps in an archaic *chang* design can still be found today, the
harp in general was replaced in India by stick-zithers and long-necked lutes between the fourteenth
and sixteenth centuries when the modal system was changing toward what we hear today. Clearly,
by the end of the sixteenth century, depicting it was a useful visual indication of non-Indian culture.

A CYLINDRICAL DRUM

Another example of the technique used to indicate departure from the normal context is found in
a *Bābur Nāma* illustration with the unusual occurrence of a male playing a cylindrical drum, indi-
cating the presence of a non-Mughal person (fig. 81). Not that the cylindrical drum was unknown
to the Mughals; it just was not often pictured among their instruments, being more likely to appear
in depictions of explicitly South Asian culture (fig. 40). In this case, a drum played by an Afghan is
mentioned in the text. The unremarkable scene of September 1507 may have been selected for
illustration because it marked the second time that Babur set out in the direction of Hindustan
(although such expeditions were not serious intents on empire until after he resigned himself to
the impossibility of permanently holding Samarkand).

> The Afghāns belonging between Kābul and Lamghān (Ningnahār) are thieves and abettors
> of thieves even in quiet times. . . . On the morning we marched from Jagdālīk, the Afghāns
> . . . thought of blocking the pass, arrayed on the mountain to the north, and advancing with
> sound of tambour and flourish of sword, began to shew themselves off. (*BN* 341)

They were defeated, and the illustrations of the moment show "Afghan prisoners brought to Ba-
bur, 1507." We are to assume, I think, that this is an Afghani drum; it appears to be a single-headed,
stick-beaten cylindrical drum, slung to one side suspended by a cord around the neck of the player
who stands (hides?) behind the rocks but is certainly in view sufficiently for us to see that a cultural
distinction is being drawn through the instrument (see fig. 81).

The cylindrical drum is shown as a utility drum in a fantastic interpretation of Noah's Ark
produced c. 1590 by the illustrious Miskin, who specialized in painting animals (fig. 82). Along with
bowl-shaped drums (fig. 83), the cylindrical drum must have been used for coordination purposes
on boats.

A Symbol of Power: The Naqqāra

The meaning associated with another musical instrument, the *naqqāra,* is transmitted in Mughal paintings (figs. 84, 85). Important in Mughal rule was the awarding of symbols and standards of power by the emperor. The bestowing of a kettledrum (*naqqāra*) and a standard as emblems of honor and authority recurs often in the *Akbar Nāma* and was a custom already in place when Akbar came to the throne. While in Babur's time, according to the *Bābur Nāma,* those who are being honored are awarded "honorary dress" and the coveted *tīpūchāq* horses, Gulbadan Begum mentions that Humayun presented drum and standard to a man whose help he needed. On his flight from Hindustan, Humayun reached the Indus river, which he needed to cross. According to Gulbadan Begum,

> There was a Balūchī named Bakhshū who had forts and many men. His Majesty sent him a banner and kettledrums, and a horse, and a head-to-foot suit, and asked for boats and also for corn. (*HN* 147–48)

To Bada'uni, who recounts Akbar's withdrawal of the insignia on one occasion, they were "accessories of conceit," but their value to recipients is explicitly noted:

> After two or three days the Khān Khānān . . . sent to Pīr Muhammad Khān the following message . . . : "You will remember that you came to Qandahār in the position of an unfortunate student, and that when we found that you possessed ability and the quality of fidelity, and when also some worthy services had been performed by you, we raised you, a mere student and beggar, from the lowest step among the degraded, to the highest grade among the exalted in Sulṭānship and Khānship, and to the post of an Amīr of Amīrs; but, since the carrying of a high position is not in your capacity, nothing but suspicious rebelliousness and baseness remains in you. So we will take away from you for a time the insignia of your pride, that your base disposition and inflated brain may come to their senses. Now it is right that you should surrender the standard, and kettle-drum, and paraphernalia of pomp." So Pīr Muhammad Khān, in accordance with this command, surrendered on the spot to some of the Khān's people those accessories of conceit (which have carried a host of ignorant men off their balance, and do so still, and have driven, and still do drive them, from the path of manliness and generosity, and have made, and still make, them associates of the Ghūls of the desert), and become the same *Mullā* Pīr Muhammad that he was before. (*MtT* 2:20–21)

Akbar sometimes revoked the insignia for other reasons:

> Some servants were sent to Nasirul-mulk with the message: You were wearing the dress of a poor scholar when you came to Qandahar. As you appeared simple and honest, and did good service you were raised to high office by me, and from being a Mullā you became a leader of armies. As your capacity was small you easily became intoxicated and got out of hand after one cup. We fear least some great mischief may be committed by you which it will be difficult to remedy. It is better that for some time you should draw in your feet under the blanket of disappointment, and sit down in a corner. You will now make over your standard, drum and other insignia of distinction . . . for this is good both for yourself, and for the world. (*AN* 2:131)

In the episode illustrated in the *Akbar Nāma* in figure 84, a *naqqāra* is reclaimed from Abdullah Uzbeg; and while the recounting of it mentions booty, the meaning in the painting is loss of authority. 'Abdullah Khan Uzbeg had fought with Akbar in important victories, but in July 1564, turned to "uplifting the head of rebellion in Malwa." To squelch the ingrate, Akbar made an expedition to Malwa, using elephant-hunting as pretext.

> When the news of the expedition reached 'Abdullah Khān he—for a traitor is ever fearful—made certain that he would be destroyed, and that as he saw himself imprisoned and bound by the wrath of the Shāhinshāh, he took to flight. . . . H.M. left Mandū and pursued him. [Several battles followed.] The particulars of [the final victory] were that the landholders of that neighbourhood had from loyalty joined the army, and set their hearts upon doing service. The brave men of the victorious army raised the war-cry, and fell upon the camp of 'Abdullah Khān near a defile, from which Cāmpānīr is visible. That infamous one, who had no sense of honour, fell into confusion and left his women in the wilderness, and went off, taking his son with him. The great officers surrounded all his property, especially his women and his elephants, and halted at that stage. . . . The villan escaped from that place of danger, with frustration and loss, and only half-alive. As he had still some breaths remaining, he reached the boundaries of Gujrat. As no world-obeyed order had been issued for making that country the arena of fighting, the victorious troops stopped there. When the good news reached the royal ears, H.M. went forward and arrived at that place, and returned thanks to God! The loyal officers were exalted by an audience. An abundant booty, consisting of women, elephants, horses, as well as money and other goods, were shown to him. (*AN* 2: 346–50)

According to the size of the drums among the booty received on his defeat, the rank of Khan Zaman Makhlas was clearly much higher than that of 'Abdullah Uzbeg (fig. 85). Ali Quli Khan, better known as Khan Zaman, was an able officer but had displayed disloyalty to Akbar on several occasions (*AN* 2:125, 227–29, 375f.). Finally, on 6 May 1567, Akbar ordered a march against him and his equally rebellious brother, Bahadur Khan. Their armies met near the banks of the Ganges River in the region of Benares. Akbar's five hundred men were aided by five hundred elephants, inspiring a folio in the *Akbar Nāma* illustrating war elephants colliding in battle. In figure 85 one can see the booty retrieved from Khan Zaman and Bahadur Khan; in the prose there is mention of "women and dancing girls" who fell into the hands of the imperial servants, and indeed one woman stands in a boat, in the center of the painting (*AN* 2:435).[22]

The Suggestion of Historical Time

Artists' attempts to depict earlier times might also have led them to include particular pictorial content, such as illustrations of ensembles of dance accompanists that include both male and female players. A few Akbari paintings of historical or literary-legendary times include a mixed male–female ensemble. For example, figure 23 from the *Chinggis Nāma* shows a woman *dāʾira* player rushing to join the two already seated male musicians (playing *dāʾira* and bowed lute). In another, a mixed male–female ensemble (if you can call angels male and female) accompanies two dancing

angels in an illustration of Amir Khusrau's poem *Deval Rani Khizr Khan* (fig. 13). This Persianate ensemble consists of a female flutist and a male harpist; such mixed-sex ensembles are found in Persian paintings. In a celebratory interpretation of "Timur enthroned," an anonymous 1552 Shiraz-style painting shows entertainment offered by male *dā'ira* and *nā'ī* players with female *dā'ira* and harp players, accompanying a female dancer (fig. 86).

Similarly, in an illustration of the *Chinggis Nāma* (*Jāmī al-Tavārīkh*), by placing male and female dancers in an arrangement that suggests that they dance together, it is possible that the artist Basawan either had a strong impression that that would have been appropriate for the period depicted—fourteenth century or earlier—or at least he wanted to suggest a time and place different from his own. In plate 4, "King Oghuz holds a feast in a gold tent," each dancer stands beside his or her usual accompanists, but so closely contiguous as to suggest a relationship in the dance. Since the painting is unusual in showing male and female dancers in contiguous (albeit uncoordinated) dance position, it appears that Basawan was using his imagination. From all other Mughal paintings, the cumulative evidence suggests that in contemporary (Mughal) times, men and women in the court context cultivated separate dance traditions.

The Depiction of Levity

Another artistic convention, as it were, is that it seems in some paintings the artist used musical content to lend an air of levity, or perhaps sarcasm. There are several instances of levity in the paintings: The *dā'ira* player who rushes into the scene in figure 23 is one, as are two details in

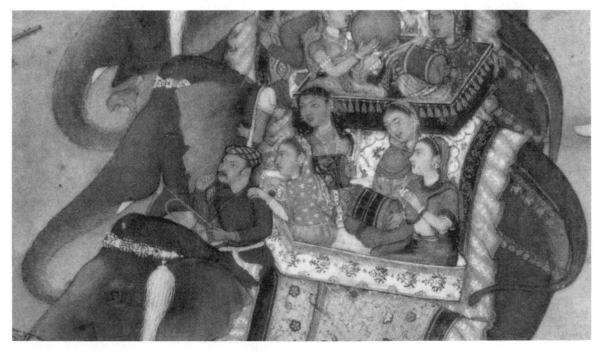

Detail of figure 87

paintings of the Shah Jahani period (both of the wedding of Dara Shikoh): the trumpet player whose loud, raucous instrument is aimed right at the *surnā* player, whose face is green (pl. 18); and the female musician riding in the wedding procession who is busy flirting with the elephant keeper (fig. 87, see detail). In the scene of the birth of Prince Murad, the players of the trumpets and the *surnā* as well as the cymbal player seem intent on bothering the women clustered on the balcony just above them by aiming their instruments upward at the terrace (fig. 55). Farrukh Beg, a Persian artist, seems to have little respect for musicians if his placing of a beautiful, delicate plucked lute in the hands of a horse-tender/bodyguard type of character who walks before Akbar in triumphant entry into the much-contested city of Surat in Gujarat is any indication (fig. 12), or the portly, debauched *rabāb* player in a typical Persianate composition that should have portrayed the ultimate in sophisticated, refined, manly entertainment (fig. 88).

Political sarcasm may have been intended in figure 89: the instrumentalist is bowing the back of the bowl of the *ghichak!* The artist just might have been showing disrespect for the person (probably Kamran, the rebellious half brother) who is submitting to Humayun. It is also possible that the artist is evincing disrespect for players of the bowed lute: that the musician is a person of low status is indicated by his hat and clothing, which match that of the servant who holds the horse outside the wall. In addition, his instrument has been painted with extreme carelessness. On the other hand, this character may not have been a professional musician at all, but rather a buffoon who used the instrument as a prop. The presence of a European in the crowd of courtiers is remarkable in the painting, too and, as far as we know, incorrect (M. C. Beach, pers. comm., July 1994).

Persian and Other Models for Music in Paintings

Persian models explain some musical content as well as the composition of scenes in Mughal paintings. The most blatant examples are in battle scenes which include signaling instruments. Such elements as the rocks, fort, or some other structure used as a backdrop to the fighting, or for division of the composition into spheres of action, or providing protection for the players of the signaling instruments and standard bearers, were expropriated directly into most Mughal battle scenes. The "musicians" are mounted: players of wind instruments on horseback, of small drums on horseback, of larger drums on camelback. In Persian painting, the musicians supporting one army might range across the top of the painting as in "Bukhara prince less favored by father proves superiority in battle" (fig. 90), an illustration by Sham Muzahhib for a *Gulistān* of Sa'di, 1567. Or they might be positioned along one side in the upper left or upper right corner, as they more frequently are in Mughal painting (pl. 17). In both Persian and Mughal battle scenes, opposing forces are each likely to have their own instrumentalists (fig. 91). In Mughal painting, the instruments could be treated with considerable pictorial flexibility, such as a battle scene in which the drum is overturned in the thick of battle (*Akbar Nāma* folio in the British Library).

With two, possibly three, exceptions, the same instruments appear in Persian and Mughal battle scenes. The aerophones are trumpets and horns—an S-shaped and straight *karnā*, with rings circling the juncture of parts along the lengths of the tubes—and the double-reed *surnā*.[23] These

are shown in a masterpiece of Safavid period art, "Karan slays Barman in battle," from a *Shāh Nāma* manuscript copied for Shah Tahmasp in Tabriz in 1537 (reproduced in Welch 1972:136–39).

One of the exceptions to the sameness of instruments in Persian and Mughal battle scenes is the very small drum that appears in the Persian painting in figure 90. In Mughal works, such small, rather rounded, conical drums as those occur in hunting scenes, suspended from the one visible horse's side. A model for this can be seen in plate 19, a painting by 'Abd as-Samad, one of the two Persian artists hired by Humayun. That is the type of drum used in both Persian and Mughal falconing to call the bird back or to reinforce its sense of direction relative to the hunter. In Mughal battle scenes, the signaling drums tend to be larger, necessitating suspension from a camel rather than a horse (fig. 5), while the truly large ones are carried on the backs of Indian elephants. A second exception to the Persian model is the Indian C-shaped horn (*siṅg*), discussed earlier (pl. 17). The third possible exception is a cymbal. While I have located it in several Mughal battle scenes, I have not yet seen one used for signaling in a Persian painting.

Corresponding also with Persian artistic composition, a game of polo urged on with the energetic, far-carrying sound of a *surnā* with kettledrums found its way into Mughal paintings. When any team scored a goal, the drums were beaten to acquaint the onlookers of the score (Ansari 1974: 171). For both the custom of musically accompanied polo matches and the scenes depicting them, the Persian precedent is well established in the epic poem the *Shāh Nāma* (Book of Kings), which the poet Firdawsi completed in over fifty thousand rhyming couplets in 1010 C.E. and which was calligraphed with illustrations from the fourteenth century onwards. In the *Shāh Nāma,* Firdawsi describes polo matches as a test in which a hero proves his ability and strength, in the story of Siyawush, who to demonstrate his prowess "mounted a fresh horse, threw up the ball and drove it out of sight to see the moon" (Titley 1979c: 4–5, pl. 201). In like manner, Akbar elevated the playing of polo to a status beyond the mere pursuit of amusement. As Abu'l Fazl noted:

> Men of more exalted views see in it a means of learning promptitude and decision. It tests the value of a man, and strengthens bonds of friendship. . . . Hence His Majesty is very fond of this game. Externally, the game adds to the splendour of the Court; but viewed from a higher point, it reveals concealed talents. (*AiA* 1:309)

Persian romantic poetry uses polo games for various ends as well, and these lively scenes were prime examples to copy for illustrations produced for both Mughal and Persian patrons. Illustrated c. 1580, the Akbari-period *Dārab Nāma* has three polo miniatures to illustrate the story of the queen, Humay, playing polo with her slaves against an opponent who dominated the game (fig. 92) until Humay's son Darab galloped onto the field and, taking the ball the length of the ground, scored a goal (Titley 1979c: 4).

In Persian paintings, the musicians are sometimes relegated to the landscape or a top corner in a convention similar to that in battle scenes (fig. 93), and that model is followed in figure 92.[24] In both Persian and Mughal traditions, main protagonists rather than the full complement of twelve to twenty players fill the center of the scene. The goalposts are usually shown (looking like Western grave stones), and servants on foot position themselves strategically, holding spare sticks

to replace those which get broken. Onlookers standing or mounted on horseback at the fringes as in figure 93 are shown in figure 94, a second of the three *Dārab Nāma* illustrations of polo. In "Siyawush playing polo," painted in Qazwin, c. 1570 (fig. 93), as in other Persian paintings, the horn as well as the *surnā* are used to urge the game on, but in Mughal paintings the *surnā* player is the only wind instrumentalist.[25]

Pictorial models for court scenes, whether celebratory occasions, accession events, or "ordinary" scenes of formal audience, also have been traced by art historians to various places in West Asia. As early as "Humay at the Chinese court" (fig. 95), painted in Baghdad in 1396, Norah Titley (1983) finds elements of composition that later were still being used by Mughal painters. The central character sits apart on a raised throne, with small steps shown by which he would ascend to it. Courtiers and servants stand to the sides in diagonal lines. Liquid refreshments are placed on a table in the center below, and one servant is designated to serve. Other courtiers or attendants bring food (or gifts). A falconer with a bird stands at the bottom left. Most significantly for our purpose, musicians grace the event. The size of the ensemble is large, matched in Mughal paintings only in scenes of particularly celebratory events such as the occasion of Babur seating himself in the private quarters of the defeated Lodi Sultan, Ibrahim (fig. 96). In fact, the very instruments in those two scenes must be compared: in "Humay at the Chinese court," plucked lute (with player's back to us), harp, vertical flute, frame drum, and singers; in the *Bābur Nāma* folio, the lutenist's back is also to us and the vertical flute player is next to him. The frame drum is a larger instrument, but the same type. The only difference in the instrumentarium is the two singers in the earlier painting.

In "Timur granting an audience in Balkh on the occasion of his accession to power in April 1370" (fig. 97), from a *Zafar Nāma* of Sharafuddin 'Ali Yazdi, painted in Shiraz in June–July 1436, the marking of accession by a relatively quiescent formal gathering rather than a grand festivity is shown to be an old custom. Although no musicians are included, some other pictorial elements of Mughal court scenes are found here. Again the king sits alone, with the highest-ranking courtiers placed closest to him; others more subordinate stand in a diagonal row at a greater distance. Most significantly, a riderless horse stands at the ready (*left*), and a regal cheetah (used for hunting) sits tamely in the background. (The setting of a garden with a stream running through and the Chinese-style clouds were not taken into Mughal painting because the Mughals had a different concept of a garden; the Timurids equated a garden with a palace [C. Asher, pers. comm., 1995].)

Looking from those Persian paintings to Mughal court audience scenes, the pictorial elements are familiar. In figure 11, Akbar sits on his raised throne complete with small steps, and courtiers and servants stand to either side of him. As Akbar receives the son of Bairam Khan, a cheetah is restrained (shown perilously close to the emperor!), a falcon starts to flex its wings, and a riderless horse is held at the ready. Musicians stand on the other side within the enclosing balustrade—a *bīnkār* flanked by two singers. Outside the balustrade the motifs are repeated, in one of the infinite variations on familiar themes: Another cheetah, more horses, an eager falcon with wings spread. In this scene, a bull has been added which undoubtedly conveys some meaning, although that has not been determined. Even in somewhat less formal audience scenes, the elements are maintained. As

"Akbar hears a petition" (fig. 98), a falconer and an attendant with a beautifully saddled horse stand with the courtiers. The musician in the painting seeks entrance with other hopefuls at the gate.

Artists' Choices

Although the decision to include musicians in Mughal paintings can frequently be explained by pictorial convention or specific function, it does seem that some artists more than others were likely to include them. Basawan, Lal, and Sur Das, for instance, appear to have been musically interested.[26] Among the paintings by Basawan included in this volume are figure 21 and plate 4, two illustrations from the manuscript about the history of the Mongol side of the Mughal family; and figure 59 from a *Bābur Nāma* manuscript. Some of Lal's works are the celebratory illustrations of the marriage of Maham Anaga's older son (fig. 62 and pl. 13), as well as the scene of rejoicing at the birth of Prince Salim (fig. 54). A jewel of a painting by Sur Das is "Prince Salim with a courtier and attendants in a tent" (fig. 66).

Finally, and perhaps most importantly, many Mughal miniature illustrations included music-making because it was true to the situation being depicted. One such major example is court scenes. Confirmation that music-making really did occur during formal Mughal *darbār* sessions can be found in the travel account of a Frenchman, Jean-Baptiste Tavernier. His description of a *darbār* of Akbar's grandson in 1676 is remarkably close to the scene in "Akbar at court receives the child Abdur-r-rahim at Agra, 1561" (fig. 11) that had been illustrated for the *Akbar Nāma* more than a century earlier.

> The public audience hall is a grand hall elevated some four feet above the ground, and open on three sides. In the middle of this hall, they place the throne when the Emperor comes to give audience and administer justice. It is a small bed of the size of our camp beds, with its four columns, the canopy, the back, a bolster, and counterpane: all of which are covered with diamonds.
>
> When the Emperor takes his seat, however, they spread on the bed a cover of gold brocade, or of some other rich stuff, and he ascends it by three small steps of two feet in length. On one side of the throne there is a parasol . . . and to each column of the throne one of the Emperor's weapons is attached, to one his shield, to another his sword, next his bow, his quiver, and arrows, and other things. . . .
>
> In the court below the throne there is a space twenty feet square, surrounded by balustrades. . . . Several nobles place themselves around the balustrades, and here also is placed the music, which is heard while the Emperor is in the Divan. The music is sweet and pleasant . . . and seems to disturb none. (Tavernier [1676] 1977:1:80−81).

Indeed, in so many instances, the instruments were actually there, the music was actually made, and the meaning was real.

CHAPTER FIVE

Synthesis with a Musical Text

Akbar's cultural agenda of synthesis was both a major concept and the occasion of constant activity in his reign. If any one painting can be said to have been created for Akbar to express that idea, it is figure 18, "A prince, attended by maidservants and musicians, watches a girl dancer," an illustration of a poem of the *Dīvān* of Anvari. Although the "heavenly joys" of the poem are not music and dance, either the artists in the imperial atelier or the patron himself found them to be a pertinent visual (and aural) translation of the meaning of the poem. The *Dīvān* of Anvari may be a book of Persian poetry, but it is unmistakably Akbar who luxuriates there in the illustration; as we have clearly seen, for Akbar music and dance were "heavenly joys." However, he would have even more reason to appear so contented, for before him dances a woman of Central Asian heritage, accompanied on two West Asian instruments and a South Asian instrument, played by Central and South Asian musicians.[1] While we cannot know whether the music they played to accompany the dancer was Persianized Indian music (or Indianized Persian music), we can certainly know by this illustration that Akbar created a context and associated himself with an agenda for the creation of a new culture by the juxtaposition of musicians from multiple cultures.

The Historical Precedent

The process of cultural synthesis of Hindu or Muslim adherents and South Asian, Central Asian, and West Asian cultures had long been underway in

Hindustan. In the Deccan (the important central region of the subcontinent), arts and learning had been patronized by Hindu kings and continued by Muslim rulers. Among them was 'Adil Shah (1489–1510), founder of the Muslim kingdom of Bijapur, who continued to underwrite the literary reputation of the former Hindu kingdom. He was eloquent in speech, a good judge of poetical composition, and an elegant writer of both prose and poetry. As reported by the famed traveler Firishta, he had a great taste for music, and his skill in it was superior to that of many a contemporary master musician whom he encouraged by handsome rewards to attend his court. He performed admirably on two or three kinds of instruments, and in his "delightful mood" sang extempore compositions. In most wealthy courts in the West Asian cultural sphere, learned men and artists from various areas of Persia and Central Asia lived together under royal patronage, 'Adil Shah was no exception and his son, Isma'il 'Adil Shah (1510–1534), followed his father's example, being also greatly adept in music, poetry, and painting. But the spirit with which this father and son participated in cultural pursuits was different from that of Babur or Akbar. Isma'il 'Adil Shah was educated under the supervision of his aunt Dilshad, who, at 'Adil Shah's insistence, isolated him from the company of the people of the Deccan, thus encouraging in Isma'il 'Adil Shah a greater love for Turkish and Persian music and language than for the culture of the Deccan. By the third generation, however, cultural synthesis within the family had increased. Ibrahim 'Adil Shah I (1534–1557) had the public accounts kept in the local vernacular (Dakkani) instead of Persian, and the inevitable intermarriage with princesses of Hindu faith occured when his son, Yusuf 'Adil Shah (1557–1580), married the daughter of a Mahratta chieftain (Firishta 3:8, 30, 31, cited in Law 1916:92–93).

In the next generation of this family's rule, the name of Ibrahim 'Adil Shah II (1580–1627), whose tenure in Bijapur straddled the end of Akbar's and the beginning of Jahangir's reign, is preserved in the history of Hindustani music as both a composer, of the vocal genre *dhrupad,* and instrumentalist. Sixteenth-century Deccani paintings provide an as yet untapped lode for the study of musical synthesis in Hindustan.

Another indication that cultural synthesis had been well under way in Hindustan is figure 16, a folio (108v) in the *Tūtī Nāma* manuscript which was illustrated in the Indian Candayana style in the 1560s. There a South Asian *rudra viṇā* is paired with a West Asian plucked lute. The instruments were not disturbed when the folio was overpainted by a Mughal artist in the process of updating and completing the manuscript for Akbar in the 1570s (Seyller 1992:314).

Evidence of Pre-Mughal Synthesis

THE DOUBLE-REED *SURNĀ / SHAHNĀ'Ī*

In paintings, depictions of instruments are the single most obvious element by which cultural synthesis can be traced—not only the presence (or absence) of a particular instrument or type of instrument, but morphological attributes of an instrument. One case in point is the double-reed *shahnā'ī* or *surnā,* which appears in a large number of Akbari-period paintings. It was the instrument in the imperial *naubat* ensemble most capable of playing melody; therefore the double-reed

players were utilized in more contexts than was the full ensemble. With the army on the march, the *surnā* player could function as part of the signal corps, but the player might also be part of the camp entertainment personnel when needed—joining a drummer to accompany a male sword dancer or encouraging the ever-present wrestlers. The instrument and its performer were prominent as well because Akbar had a particular fondness for renditions of "old Khwarizmite tunes" on the *surnā*. Not surprisingly, a *surnā* player, Ustad Shah Muhammad, is listed among the Imperial musicians in the *A'īn-i Akbarī* (*AiA* 681–82).

The *shahnā'ī*, or *surnā* as it was referred to in Mughal-period writing, is an aerophone of the reed category, meaning that air passes across a reed on its way to (or through) a resonating tube, thereby producing a very different sound than that which would be produced on a flute-type aerophone. Single-reed instruments (such as the clarinet), not known historically in South Asia, arrived only with the Europeans but now have entered the popular instrumentarium used, for example, in the ubiquitous Indian wedding bands. The *shahnā'ī/surnā* is a double-reed instrument; layers of reed vibrate against each other, creating a distinctive sound that carries very well across distances. The length of time that double-reed instruments of any variety have been used in India is a matter of debate. Deva and Jairazbhoy have suggested an indigenous Indian double-reed aerophone tradition, but it is more frequently assumed that the type was imported from West Asia.[2]

Categorized at a deeper organological level, the *surnā* is a shawm: a type of aerophone that consists of a double reed coupled to a resonance tube via a relatively small tube known as the staple (Flora 1986:39). Shawms came into existence relatively late in the long history of reed pipes, possibly not earlier than approximately the eighth century of the common era. Both the origin of shawms and the source of their diffusion are the subject of debate, however. Since the publication of Curt Sachs's work in 1923, shawms have been thought to have originated in West Asia and to have been disseminated throughout Asia, parts of Africa, Europe, and Central America as a result of the spread of Islam. In that vein, Alistair Dick (1984d) has suggested that shawms were imported

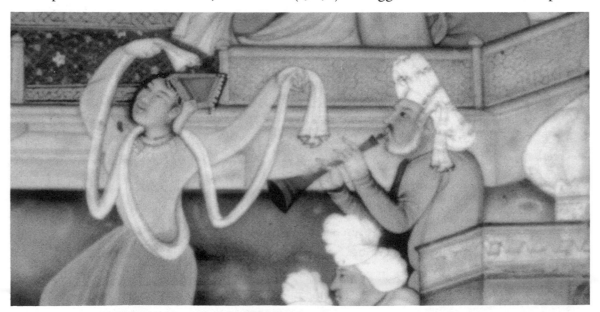

Detail of figure 99

into India from West Asia as early as the eighth or ninth century via Arab-culture residents in Sind (now in southern Pakistan). Flora asserts, however, that unequivocal evidence for a staple does not appear until the early twelfth century, "when this device is clearly described for the first time anywhere, to the best of my knowledge, in a Sanskrit treatise from central India, the *Mānasollāsa*" (Flora 1986:46). The first iconographic evidence he has found of such an instrument in India is a Jain manuscript folio in Western Indian painting style, which dates from c. 1475.[3]

The staple that holds the reed and that is crucial in defining the shawm as a subtype of double-reed aerophone can be seen clearly in some Mughal paintings. In figure 99 (see detail), a scene from an *Akbar Nāma* manuscript of Humayun on his throne, the *surnā* player stands close to two drummers and two female dancers; the profile view of his instrument silhouettes the staple. The prominent *surnā* player in plate 4, as well, holds the cylindrical tube up so that we can see how the proximal end of the tube ends and that there is a space between it and the player's face that allows for the staple.

Remarkably, another detail is drawn by some painters: As modern *shahnā'ī* players like to have spare reeds handy (they dangle down on a string in front of the instrument as it is held up for playing), there is an occasional suggestion of extra reeds. In figure 92, the *surnā* player for a polo match appears to be ready; what could be two extra reeds hang down from strands just below the instrument between his two hands (see detail).

In studying the aerophones in Mughal paintings, however, an immediate challenge in some cases is to distinguish a double reed from the trumpet and horn types of instrument. The length of

Detail of figure 92

the *surnā* is usually shorter than that of the trumpets/horns, although one can be deceived by that appearance if there is only one aerophone in the illustration. Another aid is color; the importance of the color of an instrument in a painting is instructive and in some instances definitively so. For example, if the instruments in an illustration are both gold-colored, that indicates metal and the likelihood that the instruments are trumpet and horn, while if an instrument is dark that indicates it is made from wood and likely a *surnā*. Neither is color foolproof, however; the *surnā* in figure 30, "Battle at Mirza's Bridge, 1497" is the same color as both the other aerophones just beside it. In this case there is another helpful factor, which is the way the player manipulates the instrument: The trumpet/horn type of instrument is generally played at an upward slant, while the *surnā* would be pointed more downward. But, again, there are numerous exceptions to that rule. In plate 4, for instance, a fairly long *surnā* is held in an upward position, perhaps functioning as the lead instrument in the ensemble accompanying the dancers in "King Oghuz holds a feast in a gold tent" from the *Chinggis Nāma*. In both plate 4 and figure 30, the *surnā* player obviously uses both hands to play, while the trumpet/horns are held in a supporting manner only. Puffed-out cheeks on a large percentage of the *surnā* players in the paintings suggest that the technique of circular breathing may have been in place then as it is now on the *shahnā'ī*. Distinguishing between a *surnā* and a trumpet/horn by this pictorial detail can be risky, however; occasionally in the paintings a trumpeter will also have puffed-out cheeks, suggesting that it was just an artistic means of showing forceful playing (pl. 10).

Context, too, should theoretically help in distinguishing a double-reed instrument from a trumpet or horn but again can be deceptive. Context suggests that that short, fat, conical horn supported by both hands of the player underneath (rather than being played with fingers above the tube) was occasionally mistakenly drawn where a *surnā* should have been. In an illustration of an *Akbar Nāma* manuscript, the wind player accompanies a sword dancer at the celebration of the news of the birth of an heir to Akbar (pl. 12). Sketched by Kesu Kalan and painted by Chitra, the instrument is the dark color used in most illustrations to indicate the wood of the *surnā*, and such male dancers are consistently accompanied on *surnā* and *naqqāra*—the *surnā* presumably playing melody, not the limited sounds that such a horn would provide.[4]

Once one has decided whether an aerophone is a shawm or a trumpet/horn, there is a further factor to consider in studying the shawms in the paintings. Abu'l Fazl specified that there were two types in the *naubat* ensemble: "The surna of the Persian and Indian kinds; they blow nine together" (*AiA* 1:53). Alistair Dick suggests that the two could be distinguished by shape: Persian instruments had a cylindrical tube with a large conical bell attached, while the "Indian" instruments were consistently conical, made from one piece of wood (1984d:89).[5] In disagreement, Reis Flora notes that a South Asian prototype has an attached bell, while shawms in West Asian regions, as represented by the *zurna* tradition and found from Kashmir through Iran, Turkey, and into the Balkans, have an integral wooden bell, the wooden pipe and bell turned from one piece of wood (1986:46).

The painters of fifty-nine illustrations that I have studied closely did indeed sketch two differ-

ent shapes of shawm-type instrument: instruments with a cylindrical tube that flares out into a bell (pl. 13, see detail), and conical instruments (fig. 47, see detail). The conical instruments are shown in relatively thinner (pl. 11) and wider (fig. 43) versions, as well as relatively longer (fig. 25), more standard (fig. 54), and shorter versions (pl. 16). The cylindrical-tube-with-bell instruments, too, show up in relatively longer (pl. 4) and shorter versions (fig. 99). The bells also come in thinner (fig. 55) and wider dimensions (pl. 10).

One reliable way to investigate which shape of shawm might have been considered by Abu'l Fazl to be the Indian and which the Persian (no matter what the history of the instruments was) is to consult Persian paintings. Indeed, the cylindrical-tube-with-bell does seem to be the type of shawm that is intended in some Persian paintings I have located. One such instrument is shown clearly in "Surprise attack on an encampment of rebels by Timur's forces," an illustration of the *Zafar Nāma* of Sharafuddin 'Ali Yazdi, in Tabriz style, dated 1529 (fig. 100).

In other Persian paintings the bell is more elongated, widening so gradually that the shape of the total length appears to be more half-cylindrical and half-conical (fig. 101).[6] It is noteworthy that this shape is very like that of the trumpets, and were it not for the dark color indicating wood, and the use of both hands to play, only the comparative lengths of the upper part of the tubes would distinguish the two. In "Siyawush playing polo" (fig. 93), produced in Qazwin, c. 1570, as in other paintings, the player's hands conceal the shape of the upper tube, so the actual shape is highly speculative.[7]

A far more thorough and systematic study of Persian paintings and of non-Mughal Indian paintings is needed before any affirmation or objection can be offered to the suggestion that the Persian instruments were primarily cylindrical with a bell, while the Indian type was conical. In any case, modern Indian double-reed instruments now used for classical music are a sleek conical shape.

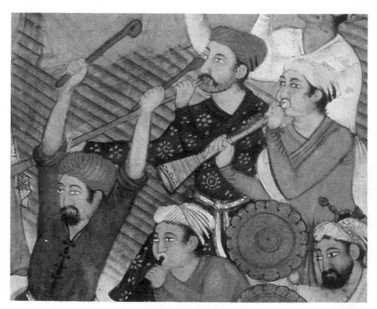

Detail of plate 13

Detail of figure 47

The bells are non-attached: the North Indian *shahnāʾī* bell is made of metal, while the South Indian *nagaswaram* bell is wood.

There is Persian precedent for another morphological characteristic of the *surnā* that occurs in Mughal paintings: a disc at the top end of the staple can be seen, against which the player rested his lips. Usually it is colored white for contrast with the dark wood of the instrument and the skin tone of the musician's face. A similar lip disc is shown on a *surnā* in the detail of a Herati illustration of Shirin and Hosrov on the battlefield, in a manuscript produced at the end of the fifteenth or beginning of the sixteenth century (fig. 101, see detail); it is painted a dark color there, and stands out in contrast to the white face of the player. Such a lip disc is used by *shahnāʾī* players of some folk traditions at the present time, but not by musicians of the classical tradition.

Between the Persian paintings I have observed and Mughal paintings, there is one difference in playing technique. While Persian *surnā* players are depicted with the elbow of the arm that is reaching for the distal end of the instrument held out uncomfortably away from their bodies (fig. 93; fig. 101, see detail), that playing position is rare in Mughal paintings. The implication of that technique could be that the fleshy part of the finger rather than the fingertips is being used by Persian players to cover the fingerholes, while in India *surnā* players began playing with their fingertips. Contradicting that, however, is the fact that modern Indian *shahnāʾī* performers play with the fleshy pad, yet hold both arms in a more relaxed position. In Mughal paintings, as in modern *shahnāʾī* practice, players are shown with either the left or right arm in the distal position.[8] There is no distinction in this respect between military signaling practice and playing in other contexts, so apparently musicians held whichever arm in the distal position they found comfortable. Or so the painters lead us to conclude.

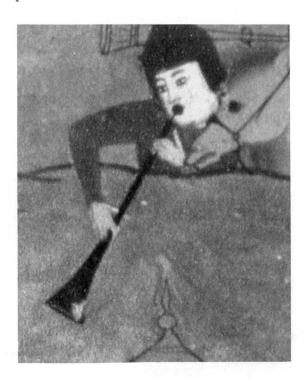

Detail of figure 101

THE FRAME DRUMS: *DĀʾIRA* AND *ḌAF*

A second instrument which permits us to trace cultural synthesis is one which seems to have been assimilated into the Indian instrumentarium before the Mughal period, the frame drum, called in contemporary sources the *dāʾira*: "*Dāʾira-dastān* (tambourinists) held up the mirror of fortune before their faces," wrote Abuʾl Fazl in a passage of eloquent poetic phrases invoking the natures of various musical instruments to impart the joy and meaning of the birth of Akbar.[9]

It is widely assumed that this type of frame drum (commonly referred to as the tambourine) is a West Asian instrument that was introduced into the Indian subcontinent. Generically it was and is known as *ḍuff/ḍaf*, though there are numerous local forms of that term throughout western Asia, central Asia, southern Europe and parts of Africa, South Asia, and Latin America.[10] Poche, for example, defines the *ḍuff/ḍaf* as "a single-headed frame drum, usually with a goatskin membrane and often with rattles or jingles. . . . It is basically a Semitic and an Arab instrument" (1984, 1:616). Indeed, in the paintings the female musicians who play the frame drum are almost invariably non-Indian, adorned in the high cap of the Turki women (fig. 27) or in a shawl-like cloth that covers their head in respectable Muslim fashion (fig. 102).[11] Furthermore, it is played by both men and women in ensemble with non-Indian instruments. The frame drum most frequently portrayed in Mughal miniature paintings has cymbals inserted into the frame.

Whether or not such instruments were also indigenous to India is questionable, for as Deva wrote,

> Most of the names by which they are called have close relations to cultures outside this land, though the instrument itself—in some form or name—is found among our tribes. . . . The North Indian word *ḍaff* (which gets transformed in the south into *ḍappu*, *ḍafli* and even *ṭep*) also has West Asian roots, as the Arabic has *ḍaff*, perhaps linked to the Hebrew *ṭof* (Sumerian—*aḍapa*, Akkadian—*aṭapu*). (1978:74)

According to Deva, the earliest visual representations in India are found in sculpture at Bharhut, second century B.C.E. (ibid.). A sketch of that instrument (Tarlekar 1972:78), however, shows it to be quite unlike the *ḍuff/ḍaf* variety of tambourines with regard to playing technique; it is suspended from and hung parallel to the body of the player and struck with a curved stick in one hand and a straight stick in the other. According to Tarlekar, not until the medieval period (which he considers to be the eleventh through fourteenth centuries), by which time West Asian instruments were being adopted in India, is there evidence in sculpture of a circular drum with cymbals in the frame. In one Orissan sculpture, a musician holds in the left hand a circular frame covered on one side with skin; circular metal pieces seem to be inserted into a few slits in the frame. Like *ḍaf*-type instruments, it is held in the left hand and played with the right hand (ibid.).

Amir Khusrau, writing in the late thirteenth/early fourteenth century, documents that an instrument by the name of *ḍuff* was in India in the Sultanate period but, unfortunately, provides no clarification of whether it was constructed with cymbals.

Duff is the only instrument of rhythm to keep constant company with the respectables like

"chang and rubab". . . . An official called Amir duffi, during the "Sultanat" period, headed other duff players on the pay-roll. (Sarmadee 1976:259)

By the sixteenth century, the *duff* type of instrument, or at least one which had been given the name of *duff,* had been thoroughly absorbed into the Indian instrumentarium: Abu'l Fazl lists the "*daf*" among the Indian instruments along with another tambourine that has an Indian name. "The Daf, or tambourine, is well-known. The Khanjari is a tambourine smaller than the Daf, but with cymbals, and its surface is about the size of a pitcher."[12] According to the information provided to Abu'l Fazl, the *duff/daf* was a relatively large frame drum constructed without any complementing idiophone. The criterion of size is a visually clear one that Mughal artists could easily have portrayed, but they did not do so sufficiently to provide us with documentation for that type of drum.[13] Indeed, any size of frame drum without cymbals is rare among Akbari-period paintings.

Abu'l Fazl provided additional information about the *duff/daf:* He wrote that among the *dafzān* (players of *daf*) were the women of the Indian *dhadhi* community who "chiefly play on the *Daf* and the *Duhul,* and sing the *Dhurpad* and the *Sohlā* on occasions of nuptial and birthday festivities in a very accomplished manner" (*AiA* 3:271–72). A painting which dovetails perfectly with those remarks is "Zanib signals to her lover Zayd from the balcony of a house" (fig. 103). Although the poetry that is being illustrated is the Persian *Khamsa* of Nizami, the artist Basawan has Indianized the pictorial content: The female musicians are Indian, as is the female dancer. Perhaps we are seeing *dhadhi* women here because the scene depicts the wedding celebration of Zanib. The bridegroom (with a double-handled Mughal-style knife tucked in his sash) sits with Zanib's father and two other men. The young and beautiful Zanib, who overlooks the negotiations of the men from the balcony above, signals to her lover Zayd, who stands outside the courtyard wall and returns her signal with uplifted hand. Most significantly here, the drums are the cylindrical Indian *dhol* and what appears to be a *daf*—a frame drum without cymbals. It is as if Basawan had read Abu'l Fazl's text in the *A'īn-i Akbarī* and put the information about the "*dafzān*" into visual form in painting; since Abu'l Fazl was writing his account at the time of this painting (c. 1585–90), such coordination was possible.

In Akbari-period paintings, numerous illustrations depict the frame drum with cymbals in the frame, whatever it was called. Scenes of private life abound: Akbar being entertained privately (fig. 18), a group of men relaxing together (figs. 31, 104, 105, pl. 2), or a couple relaxing together (fig. 106, notably a West Asian pictorial convention). More publicly, the *dā'ira* is included in the ensemble at festive events: marriage celebrations (figs. 27, 87, 108, pl. 16), the occasion of the birth (pl. 8) or the circumcision of a prince (pl. 11, fig. 107); victory or peace celebrations (pl. 4, figs. 25, 109). Scenes of ordinary "court" sessions abound (figs. 110, 111, 112), as do those of the submission of some important person at court (figs. 36, 48, 89). Accession *darbār*s, too, feature an ensemble including the *dā'ira* (figs. 29, 46).

To assert that frame drums with cymbals in the frame were used by non-Indian musicians in the Mughal period, while those without cymbals in the frame were used by Indian musicians, is to put too fine a point on it: paintings suggest that in a Muslim religious context, at least later in the

Mughal period, frame drums without cymbals were in use. Drawings of *Sufi* religious assemblies in the period of Shah Jahan and Aurangzeb include frame drums without cymbals.[14]

Lest it appear that an assertion can be made that *Sufi* music in Mughal India was the locale of the *daf* (as opposed to the *dā'ira*), there are paintings that suggest the use of either *daf* or *dā'ira*. In a folio (fig. 113) in the "Large" Clive Album at the Victoria and Albert Museum, painted c. 1600, for instance, a group of men cluster around a figure who has entered a state of trance, urged on by a player of plucked lute and *dā'ira*. Figure 114, however, painted c. 1660–70 in the period of Aurangzeb, depicts (at the top) the Chisti saint Khwaja Muinuddin and devotees at Ajmer. Three players of frame drums display the variety in such instruments (see details).

Because the *daf* (and, by extension, the *dā'ira*) was among the instruments most referred to in the sayings of Mohammad, it was widely used in Islamic cultures. But it did not escape entanglement in the lively medieval discussion among Muslims about the permissibility of listening to music. In the *Bawariq al-ilma* composed by Majd al-Din (d. 1126), for instance:

And in the *Musnad* of Aḥmad [it is reported that] the Abyssinians were playing the tambourine in the presence of Allāh's apostle (Allāh bless him, etc.) and dancing and saying, "Muḥammad is an upright servant." Then he (Allāh bless him, etc.) said, "What are they saying?" [The bystanders] said, They are saying, "Muḥammad is an upright servant." This tradition by its clearness indicates the permissibility of being present at dancing and the permissibility of listening to the sound of the tambourine and singing. So if anyone says that dancing is forbidden, and playing the tambourine and singing are forbidden, that is an acknowledgement from him that the Prophet (Allāh bless him, etc.) was present at what is forbidden and confirmed others in what is forbidden. And if that flutters in anyone's mind, he is an infidel by general consent.

But if he who disapproves says, "If this is allowable in the Prophet (Allāh bless him, etc.), why do you say it is allowable in us?" we say, The proof of its permissibility is that he (Allāh bless him, etc.) was a lawgiver, and it is not allowable for a lawgiver to conceal any matter concerning which there is a legal ordinance, according to His saying (Exalted is He!), "Verily, those who conceal the proofs and guidance we have sent down after we have made it clear to men in the book, those Allāh curses, and the cursers curse them"; and according to His saying (Exalted is He!), "And when Allāh made a covenant with those who were brought the Scripture [saying], You must certainly make it clear to men and not conceal it. . . ." So had the performance of dancing, and being present at audition, singing, and playing the tambourine been unlawful, it would have been necessary for him, by the ordinance of this verse, to draw other people's attention to it. And had that been lawful for him, but not for others, it would have been necessary for him to make it clear, as has come down in the tradition (*khābar*) that he (Allāh bless him, etc.) forbade them to combine [a series of fasts], then did it himself. When they questioned him, he said, "I am not like one of you; I spend the night with my Lord, He giving me food and drink." And since he was present at dancing, and listening to the tambourine and singing without prohibiting anyone from that, it indicates its absolute permissibility." (*Bawariq al-ilma* 1938:80–81)

[The] tambourine is a reference to the cycle of existing things . . . ; the skin which is fitted on to it is a reference to general existence . . . , the striking which takes place on the tambou-

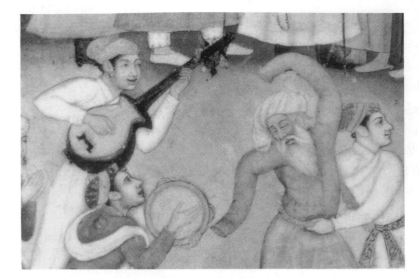

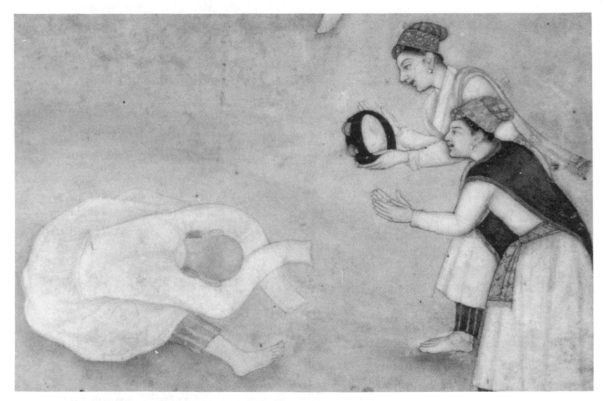

Details of figure 114

rine is a reference to the descent of the divine visitations . . . from the innermost arcana . . .
upon general existence to bring forth the things pertaining to the essence from the interior
to the exterior. (ibid. 98)

Whether or not there are cymbals in the frame of the tambourine was also part of the medieval
Islamic discussion about the permissibility of listening to the tambourine and singing.

Then if he who disapproves says, "We grant the permissibility of playing the tambourine which has no metal plates ($sun\bar{u}j$), for the tambourine of the Arabs was like that, but we do not admit the permissibility of playing the tambourine with the metal plates," we say, The permissibility of playing the tambourine which has no metal plates has been established by the traditions we have mentioned, and nothing has come down regarding the metal plates, either by way of prohibition or of disapproval, so it remains permissible. For if a permissible thing which has not been heard of is joined to a permissible thing which is heard of, the whole is permissible provided no context points to the combination of them being unlawful; like the marriage of two sisters, for marrying each one of them separately is permissible, but having them both as wives at the same time is unlawful. (ibid. 96)

That the number of cymbals is five is not arbitrary, either:

The five [small bells) are a reference to the prophetical ranks, the saintly ranks, the apostolic ranks, the <u>kh</u>alifate ranks, and the imāmate ranks, and their combined sound is a reference to the appearance of the divine revelations and unrestricted knowledge by means of these realities in the hearts of the saints and the people of perfection. (ibid. 98–99)

The Persianate-style painting by the Persian artist Aqa Riza for Jahangir's copy of the *Anvār-i Suhailī* reproduces the significant five sets of cymbals (fig. 115).

Since the frame drum with five sets of cymbals in the frame predominates by such a wide margin in Mughal-period paintings, there is reason to ask why an artist has drawn one with fewer than five sets. Indifferent rendering is probably the reason for the three-cymbal *dāʾira* in an illustration (fig. 109) from the *Dārab Nāma* painted c. 1585 for Akbar by Kesu Kuhar; both instruments in that painting are mere suggestions of a type.[15] There is also the possibility that a frame drum with fewer than five sets of cymbals is the Indian *khanjarī* (see below) rather than a *dāʾira*. The frame drums in figure 116 appear to have no discs, though that could be incautious artistry. It might or might not be significant that this painting depicts Jahangir amid a celebration of the Hindu festival of Holi.

Historically, it seems the case that frame drums with and without cymbals in the frame that had entered India sufficiently earlier than the sixteenth century had been absorbed into the instrumentarium. One of a smaller size had been given an Indian name (*khanjarī*) by the time Abu'l Fazl was writing. It is possible that the *dāʾira* and *khanjarī* were also distinguishable by the number of sets of cymbals in the frame, but even the Mughal court paintings do not permit us to be absolutely certain about it. The same instrument types were reimported in the Mughal period.[16]

A Venue for Musical Synthesis: Sufism

Evidence shows that *Sufi* culture (in which frame drums played such an important part) was an important venue through which musical synthesis could have taken place during the Mughal period. Bada'uni commented on a case in point:

Mullā ʿAbdu-'l-Qādir has much aptitude, and he has studied what the *Mullā*s of Hindūstān usually study in the ordinary branches of learning. He acquired accomplishments under my

honoured father, and I, your slave, have known him for nearly thirty-eight years. In addition to his acquirements in learning he has some skill in poetry, and good taste in prose composition, both Arabic and Persian. He has also acquired some knowledge of Indian astrology, and of accounts, in all their branches. He is acquainted with Indian and foreign music, and by no means ignorant of chess, both the two-handed and the four-handed game, and has some practice in playing the *bīn*. (*MtT* 3:419)

Akbar, himself the lavish patron of musicians, participated in the *Sufi* religious experience.

One of the occurrences was the flashing of the light of truth from his sacred soul. Though H.M. from his wide capacity and splendid genius knows that multiplicity is the veil of units, and keeps such ward and watch that every one of the enlightened men of the world and (also) of the swift-goers of the spiritual court regards that royal cavalier of insight as his own leader, yet as the thoughts of solitude have been kneaded into his constitution, the threads of the exquisite veil become occasionally broken. Accordingly, at this time, Bakhshū Qawwāl recited before him two heart-ravishing stanzas in a pleasing manner. That Syllabus of the roll of recognition (of God) displayed a countenance flashing with Divine lights. Those whose vision did not extend beyond the plain outward appearance received spiritual delight (from the singing). Much more then was the state of the internally farsighted! When H.M. returned from that wonderful condition, he gave thanksgivings to God, and filled the hope-skirt of the songster with rich coin. (*AN* 3:378)

It may have been *qawwāls* who were responsible for Akbar's initial connection with the important shrine at Ajmer (fig. 114). Early in January 1562, when he was hunting near Madhakur, eight miles west of Agra, the songs of "some Indian minstrels" about Khwaja Muinuddin Chisti, the founder of the Chisti sect in India, threw him into "indescribable transports of bliss" and filled him with a strong urge to visit the Khwaja's shrine at Ajmer (Rizvi 1975b:69). He not only visited the shrine shortly thereafter, but visited it often and patronized it generously (see Richards 1978a: 257).[17] Bada'uni reported on one visit by Akbar to the shrine at Ajmer:

And daily according to his custom held in that sacred shrine by night intercourse with holy, learned, and sincere men, and *seances* for dancing and çūfism took place. And the musicians and singers, each one of whom was a paragon without rival, striking their nails into the veins of the heart used to rend the soul with their mournful cries. And *dirhams* and *dīnars* were showered down like raindrops. (*MtT* 2:188)

Ecstatic movement in time to the music until the worshipper collapses in complete trance is a *Sufi* experience that has been dubbed "dance" in translations and other accounts. What was this dance? Abu'l Fazl tells us its meaning to a saint of India, Shaikh Badruddin.

His birthplace was Ghaznah. . . . In Delhi his desires were fulfilled and he received the office of viceregent. . . . In his old age when he was unable to move, the sound of a hymn would excite him to ecstacy and he would dance like a youth. When asked how it was that the Shaykh could dance notwithstanding his decrepitude, he replied: "Where is the Shaykh? It is Love that dances." (*AiA* 3:409)

In his memoirs, Jahangir recalled experiencing *Sufi* worship at the tomb of his father:

On Thursday, the 1st of the Divine month of Ābān [1619], I went on pilgrimage to the mausoleum of the late king (Akbar), and rubbed the head of supplication on the threshold. . . . All the Begams and other ladies, having sought the blessing of circulating round that shrine, which is the circling-place of angels, presented offerings. On the eve of Friday a lofty assembly was held of the holy men, the [ecclesiastics], *Huffāz* (those who recite the Qoran), and singing people, assembled in numbers, and practised ecstasies and religious dancing (*wajd* and *samāʿ*), to each of whom I gave a dress of honour, a *farjī*, and a shawl. (*TiJ* 2:101–2)

Dervishes were among the types of people who participated wholeheartedly in *Sufi* life, and from another passage in Jahangir's memoirs we can gain a sense of them:

On the night of Monday, the 8th, having sent for S̲h̲aikh Ḥusain Sirhindī and S̲h̲aikh Muṣṭafā, who were celebrated for the adoption of the ways of dervishdom and the state of poverty, a party was held, and by degrees the assembly engaged warmly in *samaʿ* and *wajd* (dervish dancing and ecstasy). Hilarity and frenzy were not wanting. After the meeting was over I gave money to each and gave him leave. (*TiJ* 1:172–73)

Among the followers of the Chisti sect of *Sufism*, particularly, trance dancing spread quickly and widely in North India, as devotees traveled far and wide, accompanied by the *qawwāl*s (singers). Recognizable in paintings through the Mughal period by the extra-long sleeves of the coat worn by a dancer and those sleeves covering and hanging down from one or both hands in the movement of the dance, participants are shown in painting sources as diverse as the Akbari-period *Khamsa* of Nizami (fig. 102), the Jahangiri-period *Dīvān* of Hafiz (fig. 117), the "Large" Clive Album (fig. 113) of the Shah Jahan period, and fol. 12r of the *Mathnavī* of Zafar Khan (fig. 118) from the time of Aurangzeb. The style is identified by Kapila Vatsyayan as distinct from other dance styles illustrated in Mughal folios (1982:89).

The music to which the dancing dervishes move in the paintings includes rhythmic enunciation on a *dāira/ḍaf.* The vertical flute occurs there as well, and the plucked lute (*rabab*) is a possibility.[18] While it is harder to identify singing with certainty, *qawwāl*s are definitely present in figure 114: in the middle line of men, the individual standing with the instrumentalists holds his hands in the characteristic gesture of a singer; and, on the lower right, with the player of the smaller frame drum is a singer standing beside a man who has fallen to the ground in a trance. In figure 113, the two men just below the instrumentalists are probably singers.[19]

Jahangir provides a clue into the form of the songs sung by the *qawwāl*s:

On the night of the 12th an uncommon and strange event took place. Some Delhi singers (*Qawwālān*) were singing songs in my presence, and Sayyidī S̲h̲āh was, by way of buffoonery, mimicking a religious dance. [A] verse of Amīr K̲h̲usrau was the refrain of the song. (*TiJ* 1:169)[20]

The modern form of *qawwālī* also features a refrain, and verses by the thirteenth–early fourteenth century Delhi poet, Amir Khusrau, continue to be sung.

Pilgrimages to tombs of important persons such as the Chisti founder Muinuddin at Ajmer and the Chisti saint, Nizamuddin Auliya (d. 1324) at Delhi constituted a major cultural-religious

activity throughout the Mughal period. A sense of the atmosphere is lent in a source of the eighteenth century, describing the time of the Mughal emperor Muhammad Shah (1720–48).

> The blessed abode of his Holiness [Hazrat Nizam-ud-Din-Aulia, d. 1324] is situated at a distance of half croh from [Purana Qila in] Old Dehli. . . . Every Wednesday the nobles and plebians dress themselves [and gather here] for pilgrimage and the *qawwal*s perform the ceremony of salutation with full traditions and regard. On the last Wednesday of the month of *Safar* an extraordinarily large gathering, having dressed their hair and adorned themselves, come here. After paying homage, they go wandering in the gardens in the surroundings of the blessed mausoleum. Artisans arrange their wares and all kinds of delicious eatables and other requisites are made available for the visitors. The excess of the melodies of the minstrals creates a cacophony of music. In every nook and corner are ventriloquists and dancers who perform to the best of their ability. (*Muraqqaʿ-e Dehli* 9)

Shrines were important venues for cultural sharing for several centuries. Vatsyayan asserts that the trance dance and singing of the *Sufi* musicians contributed to the shaping of a distinct North Indian dance style which is identified today as Kathak (1982:89–90). Widespread, public viewing of the style would have contributed greatly to these various cultural developments.

A CASE IN POINT: THE VERTICAL FLUTE ($N\bar{A}$' \bar{I})

In addition to the *surnā* and *dāʾira*, a third instrument type, the vertical flute, provides historical evidence of cultural synthesis; and its use in *Sufi* culture can be traced in Persian as well as Mughal painting. The scene of debauchery—but nevertheless populated with *Sufi*s with their long-sleeved coats—painted for Shah Tahmasp of Persia provides a humorous and perhaps disrespectful glimpse into this association (fig. 119). Other paintings, both Persian and Mughal, are far more respectful of the tradition. The use of the flute in the *samāʿ* of *Sufi*s was eloquently explained and defended in a tract on audition (listening to music) by Majd al-Din, a scholar who died at Qazvin in Persia in 1126 C.E. Whereas Muhammad had forbidden some instruments, he had mentioned nothing about the Persian flute (*qaṣab*), so it remained in use.

> The flute (*qaṣab*) is a reference to the human essence, and the nine holes are a reference to the openings in the outer frame (*ẓāhir*), which are nine, viz, the ears, the nostrils, the eyes, the mouth, and the private parts (*al-qubl waʾl-dubr*). Nine other holes are inverted from the exterior to the interior, viz. the armpits, the inner part of the elbows, under the knees, the inner part of the wrists and the navel. And there are nine ranks inside [the body] viz. the heart, the mind, the spirit, the soul, the conscience, the human essence, the memory, the interior of the heart (*fuʾād*), and the pericardium (*shaghāf*). And the breath which penetrates the flute is a reference to the light of Allah (Exalted is He!) penetrating the reed of man's essence. And their being moved in audition is a reference to the bird of human reality in the station of the eternal address, "Am I not your Lord?" [Qurʾan vii, 71] and to the excitement of the spirit on account of the cage of the body being broken and its return to the true home, since he said, "Love of home pertains to faith," i.e., the home of the spirits in which the spirit was brought into existence, since He said, "And I breathed into him of my spirit" [Qurʾan xv, 29]. (*Bawariq al-ilma* 99)

Another painting which shows the vertical flute in the ensemble accompanying religious dance, and might also offer a rare insight into the religious life of women—whether in the Mughal sphere of the painter or in the Persian sphere of the poetry—is an illustration of the *Khamsa* of Nizami (fig. 102). The women wear the garb of dervishes, though they seem more to be dancing than moving in a trance-like state; and female musicians, including a *nā'ī* player, sit to one side as they would in a formal assembly.

Thus, the sacred association with the flute—whether through the Hindu deity Krishna (see chapter 3) or in Muslim *Sufi* culture—was another common element that would have made the instrument an attractive medium for cultural synthesis. Two factors, then, made the West Asian *nā'ī* likely to be a participant in the process of synthesis of cultures in North India: its traditional role for dance accompaniment in both cultural spheres, and its association with expressive religious devotion in both cultures.

The use of the vertical flute in ensembles which entertained at private social gatherings in secular contexts was a particularly Persianate cultural practice. Since depiction of those affairs occurs mostly in illustrations of Persian poetry, it is difficult to know whether that was the primary context for flute music in the Mughal court. I would speculate that it was, based on a change in the paintings: While Persian paintings might show a couple being entertained by a small ensemble including a *nā'ī*, Mughal works are far more likely to depict a group of men relaxing together, enjoying a musical ensemble that includes a *nā'ī*. An illustration from a *Dīvān* of Hafiz shows a comfortable, homey, relaxed atmosphere through the real musical involvement among a singer, a drummer, and a flutist (fig. 104) and by displaying the preparation of food below. The *Anvār-i Suhailī* (fig. 115) is a strikingly Persianate version of young men relaxing together, painted by the Persian artist Aqa Riza for Jahangir. There, beside the ubiquitous frame drum, is a Chinese instrument—panpipes—the inclusion of which lends an air of otherworldliness to the Mughal painting. The nature of the private setting in these paintings is all the clearer when compared to figure 120, where the flute–lute duo entertains in a Jahangiri copy of a Persian painting of Sultan Husain Mirza.

"Zafar Khan in the company of poets, dervishes, a painter" is an extremely important painting for several musical historical reasons, including the depiction of a remarkably Persianate ensemble in the period of Shah Jahan (pl. 7). Showing the extent to which Kashmiri culture still maintained Persianate music, the *nā'ī* is being played with *ghichak*, a long-necked lute, *dā'ira*, and *qānūn*. The folio, the left side of a double-paged illustration in a manuscript of a *Mathnavī* by Zafar Khan, was commissioned by Prince Dara Shikoh or by Zafar Khan himself. Zafar Khan, whose father had been one of the foremost political figures during Jahangir's reign, was well known for living a cultivated life, patronizing poets, and maintaining a small atelier. Painted in the prevailing Mughal style of c. 1640–50 when Zafar Khan was governor of Kashmir, the manuscript of his *Mathnavī* was assembled in Lahore in 1663, where he was in retirement. Relatively unrelated to the poetic text, the illustrations record the gracious life led by the Mughals in the valley of Kashmir. As was sometimes done by patrons, Zafar Khan collected copies of literary works in the authors' own hands and added

portraits such as the one in plate 7 (Leach 1986:130–31). Care was taken in the painting of the musical instruments.

The context in which players of *nā'ī* would have entertained is explained more by those paintings than by references to them in any other contemporary documents. Two *nā'ī* players are mentioned specifically in the Mughal chronicles, neither of whom is likely to have been the free-wheeling character in a portrait (fig. 121) that might have been painted by the great Basawan. Among the principal musicians in Akbar's employ was a *nā'ī* player from Mashhad in Persia (*AiA* 1:681); but, as far as I can determine, no single portrait of a recognizable flutist exists in Akbari paintings.

Significant evidence for the infusion of music from the Deccan is that a *nā'ī* player from that area was summoned by Jahangir into the coterie of musicians at his court: "Ūstād Muḥammad Nāyī (flute player), who was unequalled in his craft, was sent by my son Khurram at my summons" (*TiJ* 1:376). This reference is to the fact that in 1617, while he was still prince Khurram, the future Shah Jahan was dispatched by his father Jahangir on an expedition from Lahore to the Deccan, where the rulers 'Adil Khan, Nizam al-Mulk, and Qutb al-Mulk were trying to occupy territory in the region of Ahmadnagar. Based in Burhanpur, Khurram successfully subdued those Deccan rulers who "offered their submission, agreed to pay tribute, and signed agreements to the effect that they would by no means again venture to slip out of their bounds" (*SJN* 9–10).[21] From that assignment, Khurram sent Ustad Muhammad Nayi to the imperial court. The flutist would have remained unknown to us if he had not been honored in a royal manner by Jahangir.

> I had heard some of his musical pieces (*majlis-sāz*), and he played a tune which he had composed for an ode (*ghazal*) in my name. On the 12th I ordered him to be weighed against rupees; this came to 6,300 rupees. I also gave him an elephant with a howdah, and I ordered him to ride on it and, having packed his rupees about him, to proceed to his lodging [the melody composed in his name is called Sant Jahangiri]. (*TiJ* 1:376)[22]

A European Contribution to Indian Musical Synthesis: The Organ

> On every branch the birds were organists,
> The rose-bush tossed her head at every note
> The early-waking nightingale sang love-ditties
> And quickened the ardour of the wine-bibbers,
> The Shāhinshāh by adorning the world
> Added another spring to spring.

Thus, chronicling the beginning of the "fourth Divine Year from the Sacred Accession" (*AN* 2:125), did Abu'l Fazl suggest by poetic metaphor the presence in Hindustan of another non-Indian instrument that led to cultural synthesis in the form of the harmonium of the present day.

The organ had roots in West Asian as well as European culture; it appears in Indo-Muslim

literature of the fourteenth century. Return momentarily to the story told by the parrot in the *Tūtī Nāma* about the king of Isfahan and his infant son, and we find an *arghanūn*:

> "The manifestations of man's knowledge are many and the revelations of his character are numerous," Tuti said. "One of these is his reaction to the sound of music, the tone of the organ (arghanūn), the melody of the tār as well as other melodies. The art of music will find response only in a gentle nature and a well-modulated disposition." (*TuN* 97)

Explanation for the organ in "Plato (playing organ) charming the wild beasts" (fig. 122), painted by Madhu Khanazad in the late Akbari period, has occasioned commentary by art historians in discussions of European artistic influence in Mughal art. It also adds visual confirmation of the actual presence of organs in Akbar's sphere.[23] Akbar heard of "novelties" that Europeans had brought with them to India and in 1578 dispatched an agent to Goa expressly to undertake a close investigation of the arts and industries there and, if possible, to purchase examples. To be certain that the expedition really accomplished something, the agent was accompanied by a small staff of expert craftsmen who were to make copies of items that could not be purchased. Bada'uni informs us that the organ was purchased, not copied, and was accompanied to the Mughal court by Europeans who were to play it. The instrument was exhibited to the public in Fatehpur Sikri at the beginning of 1581.

> At this time an organ, which was one of the wonders of creation, and which Ḥājī Ḥabīb-ullāh [one of the craftsmen dispatched by Akbar] had brought from Europe, was exhibited to mankind. It was like a great box the size of a man. A European sits inside it and plays the strings thereof, and two others outside keep putting their fingers on five peacock-wings, and all sorts of sounds come forth. (*MtT* 2:299)

An organ which meets this description better than the one played by "Plato" (fig. 122) decorates the lower left corner of a gorgeous folio of calligraphy in an album for Jahangir, c. 1614–15 (fig. 123). The peacock's wings were probably bellows; if there were five bellows, requiring two manipulators, the instrument brought to Akbar must have been very large—perhaps "the size of a man" indicates the height. Bada'uni's "strings" must have been the keys/pipes. With the cases that closed to protect the pipes standing in open position, it would have seemed to an observer that the player sat "inside it." The organ which Plato is playing (in fig. 122) is similar, though lacking bellows; the pipes are more distinguishable as pipes. The art historian Norah Titley connects the organ in figure 122 with the instrument brought by Habibullah to Akbar: "As a compliment to his royal patron Madhu has painted an organ which had been brought to Akbar's court from Italy and which had panels decorated with Italian paintings" (1983:205).

The spirit of this painting remains puzzling to me, however. Some details lead one to wonder whether a compliment to anyone was intended. On one of the "Italian" panels of the organ, the painting of a man with a tipped derby hat, looking like a sad sack, inserts an element of humor (or sarcasm?) to the scene. Most striking, however, are the animals. They are badly drawn and look positively dead. Akbar's painters were masters at illustrating animals, and these creatures would surely not have qualified as well-drawn unless there was some real intent to the rendition. Taken at

face value visually, the implication could be that the sound of the organ has deadened the animals beyond just a swoon.[24]

The flurry of excitement over the organ began in 1581, but "Plato (playing organ)" was painted only in 1595, and the Jahangiri marginalia even later, in 1615 (fig. 123). Jahangir, with interest similar to his father's, was undoubtedly familiar with the sound of Portuguese organs. In 1610 Jahangir amazed the Jesuits with a request to instruct three of his nephews in the Christian faith and to baptize them, at which ceremony organ music was played. Figure 123 was painted at this period of Jahangir's interest in Christianity.

The high point of presentation of keyboard instruments to Asian rulers was from c. 1575 to c. 1625 (see Woodfield 1990). Familiarity with Western civilization offered the possibility of numerous other musical instruments that might have been adopted into Indian culture in the Mughal period but were not.[25] If virginals and other instruments presented to Jahangir by the East India company were depicted in paintings even as curiosities, those paintings have not survived.[26] While the organ remained in the Indian instrumentarium in the form of the harmonium, other keyboard instruments did not.

A Rich Potential for Musical Synthesis

A remarkable glimpse at West Asian instruments that could have been taken into Indian music is afforded by "Humayun and Akbar in a garden pavilion" (pl. 19), signed by ʿAbd as-Samad, one of the (two) Persian artists hired by Humayun who determined the early history of the Mughal style of painting. Thought to have been painted c. 1555, the scene includes an enormous amount of music-making. It is easy to understand from this painting alone why an aurally astute Akbar would find this artist's work vital to his own purposes. Tucked into the top right corner of the painting are the important characters of the scene: the child Akbar sits with his father, Humayun, in a favorite Persianate getaway, an elegant platform perched in a tree. To entertain them at a discreet distance but on the same level is a musical ensemble situated on the second floor of an adjoining pavilion. The ensemble includes two instruments which were not absorbed into Mughal musical life—the harp and the ovoid-shaped plucked lute (*oud*). The bowed lute (*ghichak*) was part of early Mughal life but seems to have gradually faded from use. As discussed earlier, the vertical flute (*nāʾī*) and the frame drum (*dāʾira/ḍaf*) had long since been absorbed into the Indian instrumentarium. Across the bottom, ʿAbd as-Samad includes hunters. Those with the imperial cheetah have returned with a deer and we know that the two in the left corner have been falconing because of the small drum suspended from the saddle of one of the horses.

Plucked Lutes

Peeking out from behind the trunk of the tree in which Humayun and Akbar are sitting in plate 19 is a player of a longed-necked plucked lute. Played at the left center of the painting is a *rabāb* type

of plucked lute. These two types of instrument played a very significant role in the process of cultural synthesis through the entire Mughal period.

THE LONG-NECKED PLUCKED LUTE

The long-necked plucked lute is only partially seen from behind the tree, but the whole can be imagined from similar instruments in Mughal paintings: morphologically, it has a shallow bowl, an ovoid face (probably wood) that tapers to meet a thin, straight neck, along the end of which the pegs are inserted laterally. This type of instrument appears in a few Mughal paintings. Were there not some clear consistencies in a few paintings, it would be hazardous indeed to draw any conclusions about it. In terms of the length of the neck, for instance, the ratio of neck to length of the instrument's resonating bowl varies from 1:1.6 to 1:4, without any correlation between earlier and later paintings (see fig. 105, painted c. 1580, and fig. 124, painted c. 1610). Some of these instruments have frets along the neck (though most do not), but they are all presumably being used to produce melody, since both of the player's hands are active.

Some of the paintings which include this (relatively) long-necked plucked lute are scenes which are placed outside of India. An example is figure 31, a party attended by Babur in Ghazni in the spring of 1505, well prior to his Indian conquests. Plate 2, a lyrical scene illustrating a poem from a *Dīvān* of the Persian poet Hafiz is reminiscent of passages in Babur's memoirs. And the wrestling contest between the child Akbar and his cousin occurred in Kabul (fig. 125). While figure 12 does occur in India—the triumphant entry of Akbar into the much-contested city of Surat—the style of the entire work is characteristically Persianate, painted as it was by the Persian artist Farrukh Beg, recently arrived in India.

The motif of this type of plucked lute being held rather than played recurs a remarkable number of times with a different spirit than that chronicled in the male social gathering of plate 2: the person who holds it stands outside the inner circle of the scene, hoping to be admitted. The player of this type of plucked lute seeks admission to the royal circle in the scene of Akbar wrestling with his cousin (fig. 125), and that motif also occurs in figure 124, a beautiful painting, c. 1610, of an episode in the *Gulistān* by the thirteenth-century Persian poet Sa'di. In "Akbar hears a petition" (fig. 98), the artist Manohar has so purposefully drawn a particular instrument in this context that we can even see its frets along the delicate neck. If one were to interpret this pictorial content literally, one could say that this melodic instrument was not particularly favored in Mughal court music. Contradicting that is the inclusion of no fewer than four *tāmbūr* players listed among Akbar's musicians: "25. Ustā Yūsuf, of Hirāt, plays on the *ṭambūra*. 30. Sulṭān Hāshim, of Mashhad, plays on the *ṭambūra*. 32. Ustā Muḥammad Amīn plays on the *ṭambūra*. 36. Usta Muhammad Husaya, plays the *ṭambūra*" (*AiA* 1:682).

The struggle of the musicians outside the gate to gain access to the inner circle becomes vividly real through an anecdote related by a Venetian traveler to India during Shah Jahan's reign. One such musician was a favorite of Shah Jahan; as described by Manucci (who occasionally tended to hyperbole), the musician was not only a graceful poet, but also a buffoon.

This musician was worried by the palace gate-keepers, who are exceedingly rude to anyone who requires entrance to court. They will not permit anyone's entrance or exit without some douceur, excepting the officials, to whom they can say nothing for fear of a beating. Every time that this musician came to court the gate-keepers made him wait a long time, until he either gave them or promised them something. Anxious to rid himself of such hindrances, he composed some verses, and arrived to recite them in the presence of the king. The gate-keepers did not fail to display their accustomed insolence, detaining him until he had promised to give them all that was bestowed on him this time by the king. He went in and recited it in such fine style and with such graceful behaviour that the king was much delighted, and ordered for him a reward of one thousand rupees. The singer transmuted his joy into tears, raising his hands to heaven, weeping and beating his breast to show his sorrow at such a present. He said to the king with many bows that he prayed him as a favour to order him in place of the thousand rupees to receive one thousand stripes. Shahjahan smiled, and asked why he made such a request.

He replied that he had promised to the gate-keepers all that he should acquire, or his majesty should make a gift of to him during the day. Thus, since they were rude, not allowing him to enter or go out without his taking out his purse and giving something, he was willing to transfer to them the thousand stripes, or even more if the king so wished. The king laughed heartily, and to satisfy him sent an order to serve out the thousand stripes to the twenty-five gate-keepers then on duty. The gate-keepers complained; but the poet made his excuses, saying he had only kept his promise. The gate-keepers got the thousand blows, while he carried off the thousand rupees, and, in addition, a horse of which the king made him a gift. . . . From that day forth the gate-keepers were very respectful to this musician, so that they might not get any more beatings. (Manucci 1907, 1:182–83)

THE *RABĀB* TYPE OF PLUCKED LUTE

In the left-center cluster of figures of plate 19, painted by ʿAbd as-Samad, sits a player of the most frequently portrayed type of plucked lute in Mughal paintings of the Akbari period; it is a *rabāb*. This type of plucked lute is distinguished by a bowl that adjoins the neck by an intervening "neck link." A sufficient number of paintings permit the generalization that the player uses a plectrum for the right hand techniques.

A number of variations occur in the morphology of the *rabāb*-type instruments in the paintings. The shape of the bowl as we see it from the artists' perspectives is round or ovoid, and the bowls are relatively smaller and larger. The materials covering the bowl of some of the instruments seem to be wood; of others, skin. Some bowls are deeper than others. The neck link shapes vary from curved, squared-off, cusp, to (later) ram's horn–shaped. The necks are straight (with parallel sides) or tapering, and they are relatively thicker or thinner. The designs of peg attachments differ as well.

Neck Links

 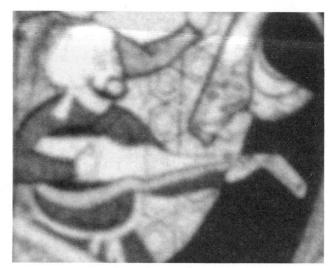

| Detail of figure 110 | Detail of figure 128 |

Rabāb-type plucked lutes were played for celebrations, for formal court sessions, or for more private entertainment. Figure 59 from the *Bābur Nāma* and an exceptional painting in the *Tilasm* manuscript, c. 1565–70 (fig. 126) suggest that noble women listened to but also played *rabāb*-type plucked lutes.

I consider the evidence to be strong for the following scenario with regard to *rabāb*-type instruments. There were essentially two designs in use in the Akbari period. They were distinguished not by the shape of the bowl, nor by the shape or proportions of the neck link, nor even by the tapered or parallel shape of the neck. Rather, they were distinguished by the means of attaching the pegs/strings to a bent scroll or to a bulbous attachment on the underside (or sometimes, in the perspective of the artists, to the side) of the neck. A third type, a Persianate curved scroll, occurs in paintings by the Persian artist Farrukh Beg (fig. 88).[27]

The instruments with bent scroll fall into two groups. Those which feature a neck link that proceeds to a wide, tapering neck are clearly distinguishable from those (most in the Mughal paintings) whose neck link meets a very slightly tapering neck or a straight neck (with parallel sides). It is striking to compare the instrument in figures 110 (see detail) and 127 with that in figure 128 (see detail), for instance.

Some of the tapering-neck instruments with bent scroll—all painted in the 1590s—are heavier than the rest, with depth continuing under the neck link and up the neck (see figs. 21, 37, 128, and 129). These instruments are held by the players at an angle almost parallel to the ground rather than relatively more vertically as the presumably lighter instruments are held. Two of these instruments (in figs. 21 and 128) meet most closely the description by Andrew Grieg of the "Afghani" *rabāb:* pear-shaped lute, having a rounded body partially covered with circular skin, tapered into a short neck, with receding peg box (1980:167). If indeed these were Afghani *rabāb*s, then these paintings are evidence for the existence in the court sphere for the type of plucked lute that eventually was developed into the modern *sarod.*

On the basis of evidence (of a negative nature) in paintings, the *rabāb* with the other type of

mechanism used to attach pegs—a rounded (I call it bulb-like) attachment to the back (or side) of the neck—does not appear to have been part of the instrumentarium fostered by Akbar. I have found it at only two moments of association with the atelier of Akbar himself: In the 1560s—in the *Tūtī Nāma* manuscript, and not again until an Akbari manuscript of 1598–99. Figure 16, a folio in the *Tūtī Nāma* manuscript, was painted in Candayana style and is therefore to be taken as a product of non-Mughal Indian culture. Then in a folio of a *Razm Nāma* manuscript, the *rabāb* with bulb-like peg attachment is played in an episode from the Indian epic, the *Mahābhārata* (fig. 130).

Because plucked lutes with the bulb-like mechanism for peg attachment are depicted in paintings completed in India during the Mughal period but not in the Mughal court, it could be that this instrument was in use in specifically Indian culture during the Akbari period and was not brought into court favor until the period of Jahangir. Figure 50 was painted in an Indian style, probably in Jaunpur or Malwa c. 1525–70, i.e., closer to the period of the *Tūtī Nāma*. Playing in ensemble with a drum, a wind instrument, and small hand cymbals, the *rabāb* player accompanies the dance, entertaining Khanjahan, who sits in the top register.

A delightful scene of c. 1590—not a painting identified by art historians as part of one of the major Akbari manuscripts but in Mughal style—shows a Mughal-like king being entertained in a court setting by a popular theatrical troupe whose act features dance (fig. 51). The accompanying ensemble comprises an Indian drum and dance cymbals, a wind instrument of nondescript nature, and a court-style *rabāb* modified humorously by the curled-up scroll. In 1610 in Popular Mughal painting style, Ustad Saivahana illustrated the *Vijanpatipatra* with the same type of ensemble, again accompanying a dancer (fig. 131).

In the non-court paintings, depictions of the plucked lute with the bulb type of peg attachment differ from each other in several respects, as comparison of the instruments in figures 16 and 131 will show. Again it is a situation of mix and match of characteristics, such as the proportions of the neck link. The curvaceous ram's horn–like shape of the neck link of the instrument in figures 52 and 131 has to be noted particularly, because of the rarity of that shape in Mughal court paintings. The development of the *rabāb*-type plucked lutes beyond the Akbari period is an interesting and important one discussed in chapter 6.

Explicitly Indian Music in Akbar's Darbār

Because Persian precedent for musical content does not prevail in a number of Mughal illustrations, I think we can be certain that we have important evidence in the paintings for music in India during that period. We also have clear evidence of the nature of the musical patronage by each Mughal patron of art. A significant example is music-making depicted in formal court sessions. As discussed in chapter 4, music-making was a conventional element in Persian court scenes, but the choice of musicians was different in the Akbari sphere. Rather than the Persianate ensemble of bowed lute with frame drum, or plucked lute with frame drum, a player of the Indian *rudra vīnā* with singer(s) embellishes the *darbār* of Akbar. In figure 11 about the child 'Abdurrahim, and in plate 1, "Husain Quli presents prisoners of war from Gujarat," the *bīnkār* is easy to pick out, and a singer standing

adjacent has hands uplifted in the typical pictorial stance. In figure 11, the singer close to the balustrade even has his mouth open, singing.

The artists of scenes in the *Akbar Nāma* suggest that Indian musicians were present in the court sphere from the very beginning of Akbar's reign. The earliest event in the Akbari period in which a *bīnkār* is shown occured immediately after his accession in 1556, the "Arrest of Shah Abu'l Ma'ali" (fig. 61); whether that is a singer with the *bīnkār* outside the fabric wall is unclear. If the artist is suggesting anything meaningful by that placement, the Indian musicians are not yet in the inner circle. The event depicted in figure 11 took place in 1561; the Indian musicians are shown to be comfortable literally within the inner circle. Tansen joined the court in 1562, thereby undoubtedly heightening—but probably not initiating—Indian musical presence. It must be remembered, however, that the illustrations were painted in the 1580s at the earliest. We cannot ascertain from them when Indian musicians actually did replace non-Indian musicians in formal court sessions, or if indeed non-Indian musicians really were excluded from *darbār* sessions.

In terms of musical sound, it might have been far less disruptive to have singer(s) and *bīnkār* contributing music to the court session than to have the requisite melody-cum-percussion ensemble of Persianate practice. No Indian drum is shown in the Akbari court ensemble; marking of the rhythm would have been done in the traditional Indian manner of a singer clapping out the metric cycle. Rhythm could also be effectively delineated by plucking on the *rudra vīṇā*. I would not guess that Akbar preferred the Indian ensemble for that reason, however; the amount of activity in his court scenes belies the idea that even formal sessions had to be quiet rituals.

What is significant about the illustrations is that Akbar chose to assert a clearly Indian presence in his regal scenes; he could have chosen no clearer visual means of doing that than depiction of the quintessentially Indian ensemble of singer and *bīnkār*. One possible explanation for his choice: They could have been a symbol of the Mughal conquest of India, but a threatening tone of that nature would not have been characteristic of his use of musical content in court scenes.

While the *rudra vīṇā* is visually the Indian element that is striking in the court scenes, it was probably there due to the role of that instrument as an accompaniment for the singers. But it may not have escaped Akbar's acute sensitivity that the *rudra vīṇā* was an instrument associated with numerous Indian deities—Sarasvati and Parvati, for instance, and that it was the instrument with which *bhakti* musicians were likely to accompany themselves. The *dhrupad* genre which the vocalists were likely to have been singing was one as closely associated with praise of a deity as praise of a king. Seated on his throne in these court scenes, with those particular musicians looking up at him, this "iconography" may very well have suited Akbar's idea of himself as a divinely inspired monarch.

It is also likely that the Indian musicians could visually and aurally symbolize Akbar's interest in and patronage of Indian culture. Seeing them portrayed among the imperial "ensigns" of his Timurid heritage—the falcon and cheetah and riderless horse with their attendants—the coterie of viewers of the paintings saw a refined assertion of the Mughal ruler's agenda of cultural synthesis.

Transformations: The Indianization of Mughal Musical Culture

As Indian society became transformed by the interplay and integration of ethnic and religious forces, so, too, did the empire and culture, including artistic components. The Mughal empire was constructed on four pillars: leadership, alliance, balance of power, and tolerance, the last of which began to crumble during Aurangzeb's tenure. To achieve success in leadership, the Mughals had to exert their dominance in the South Asian sphere while simultaneously keeping content all the prime players within it—Rajput, Turki, Persian, Hindu, Muslim, Sikh, and myriad others. The key alliance for the Mughals was with the Rajputs, whom Akbar had changed from challengers to agents of the empire. Within the larger world context, with its catalogue of multiple empires and civilizations, the dominant players in the South and West Asian spheres were the Indian and Persian empires, so the emperor had to play his part in maintaining a regional balance of power between the Mughals of India and the Safavids of Iran.

Beginning with Babur (1526 C.E.), through the nearly two centuries until Aurangzeb's death (1707 C.E.), the Indian subcontinent was blessed with Mughal rulers who possessed talent, energy, and personality: The period of the Great Mughals, of whom the greatest was Akbar (maps 15–18). The Mughal Empire has been called by many "a culture state. It encouraged cultural endeavour through lavish patronage. It produced a galaxy of poets, historians, scholars, painters, calligraphers, architects, musicians, and craftsmen. . . . [The rulers] brought about a renaissance in which,

helped by good government and patronage, genius found a scope for blossoming into master-pieces. . . . Culture was sustained by tradition as well as by prosperity" (Naqvi 1990:255–56).[1] While West Asian culture had been a part of life in sections of the subcontinent for centuries, in Akbar's reign Persian became the polite as well as literary and official language throughout the empire.[2] On the other hand, Akbar's ideal of cultural synthesis resulted in deep blending in a number of spheres. In artistic terms, he patronized both Persian and Indian artists and subsidized Persian-style painting by both Hindus and Muslims, creating the now-familiar style of Mughal miniature painting. In architecture, too, the synthesis of West Asian and South Asian traditions which had begun earlier became more refined under Akbar with the introduction of Timurid and Safavid elements. In addition, regional Indian styles had been proven to work with non-Indian structures in ways that were extremely satisfactory aesthetically and practically (see Asher 1992:41–67).

Strikingly, while Akbar's patronage of musicians from multiple cultures was undoubtedly fostering synthesis in that sphere as well, concrete evidence of it is very scarce. In paintings, the only sure evidence relates to instruments—presence or absence of one instrument or another, instrument construction, playing position or technique, and other hints; unfortunately, we cannot tell what singers are doing. If pictorial content is any indication (and I certainly hope that I have proven it to be so), the process of synthesis seems to have been much slower in music than in art or architecture. That should not be surprising, as it seems to be axiomatic that music changes more slowly than other spheres of culture. The reasons for the slow rate of change in Akbari culture were probably numerous. The Indian musicians named in the *A'in-i Akbari* list of imperial musicians, for instance, had been trained in the traditional Indian system in Gwalior, a system that cultivates ideas of musical discipleship and tradition. They, rather than the several other groups of Indian musicians mentioned by Abu'l Fazl with specializations other than "art music," would have been the artists involved in synthesis in the "art music" sphere. Tansen's presence in Akbar's court may have been especially valuable precisely because he, more than other musicians, would be likely to encourage musical change. In any case, the fruits of the juxtaposition of South and West Asian musicians in Akbar's court do not become obvious pictorially until the next generation.

In this chapter, I focus on the transformations in music after the time of Akbar and emphasize two major and intersecting points: Changes occurred not only in the instrumentarium and music-making contexts, but also in the amount of musical content in paintings, which is quite dramatically reduced from this point on in the Mughal illustrations. In the century following his death, Akbar's son Jahangir (r. 1605–1627), grandson Shah Jahan (r. 1628–1657/58), and great-grandson Aurang-zeb (r. 1658–1707) carried out the remaining period of imperial glory within the larger span of Mughal rule which officially ended with the abdication of the last emperor, Bahadur Shah II, in 1858.[3] The reigns of Jahangir (World Seizer) and Shah Jahan (Sovereign of the World) are usually refered to as the Golden Age of Mughal rule, in part because of the enormous expenditure on the arts and architecture during this half-century. Jahangir was an aficionado of the miniaturists and maintained a superb atelier. His son, Shah Jahan, underwrote forts, mosques, and mausoleums, the most famous of which is the monument erected to his wife, Mumtaz Mahal, in Agra, conceived in

1632 and completed about 1647; but he also maintained a personal presence in the "smaller" arts. Like his predecessors, he inspected his artists' works, and he himself was an excellent calligrapher. When Aurangzeb, who ruled as 'Alamgir I, came to power, circumstances dictated that he be more intent on military and political endeavors. He treated music and art more functionally, tolerating music on traditional court ceremonial occasions and using pictures as a means to document conditions (see below) (map 19).

Jahangir and Shah Jahan, the Patrons

Particularly through his memoirs, the *Tūzuk-i Jahāngīrī,* that account for his life almost up to the seventeenth year of his reign, we gain a personal sense of Jahangir and his times. His was a complex character, full of contradictions, a mixture of bad temper and genial temperament, one who had disregard for human misery yet was acutely sensitive to art and nature, a lover of sport as well as entertainment. He was callous and cruel, yet garrulous and erudite. He was devoted to his wife, Nur Jahan (the daughter of his prime minister, sister of his son Shah Jahan's prime minister, aunt to Mumtaz Mahal), whose strong role in his reign was singular among women in Mughal imperial households.

Like many of the great princes in the Mughal family line, Jahangir proved an excellent leader and, as a successful military commander, participated in military exploits on his father's behalf (although after he became emperor he rarely supervised or commanded in person). Also like many in his family line before and after him, he was caught in the dilemma of rebellion against and imitation of his father. He had begun to chafe at his father's longevity, and in July 1600 the then Prince Salim attempted unsuccessfully to seize the Agra fort and for nearly two years tried futilely to overthrow his father. Eventually Akbar and Salim were reconciled, and he was designated heir-apparent.[4]

The episode was repeated when Jahangir's heir, Prince Khurram, rebelled against his father, thus demonstrating the most serious weakness of the Timurid system: that able, ambitious, and mature princes were a continuing threat to the emperor and a focal point for discontented factions. Although the revolt was finally quelled by Jahangir and Nur Jahan, Jahangir died 28 October 1627; after considerable intrigue and bloodletting among would-be successors, Prince Khurram entered Agra on 24 January 1628 as emperor and ruled from there for the next twenty years.

Shah Jahan was the dominant ruler in South Asia, with vast territories, unrivaled military power, and enormous wealth. He was extremely able, aggressive, and possessed of a certain arrogance. In fact, the empire and the emperor were well matched. In 1648, the court and capital was moved to the new imperial city of Shahjahanabad, in Delhi. "The spirit and form found in the new capital differed noticeably from [Akbar's] Fatehpur Sikri. Like the man, Shah Jahan's new city was appropriate to a more formal, more forbidding and grand monarchy and empire" [and by the mid-17th century] "the Mughal empire was expansive, invincible, and wealthy. . . . Shahjahanabad was a fitting new capital for a great empire" (Richards 1993:119, 150).[5]

Both Jahangir and Shah Jahan continued the tradition of grand patronage of the arts. In the

artistic sphere, like his father, Jahangir was an avid patron of painting. Even as he rebelliously set up his own princely establishment in Allahabad in 1600 as one of his statements to his long-lived father, the then prince Salim began to assert his own aesthetic preferences. Instead of maintaining a large stable of painters, Jahangir as ruler preferred restricting the number of artists in his employ to those he considered masters and having them produce tiny gems of portraiture and delicate figures in the margins around pages of calligraphy. As a result, artists dismissed from the imperial atelier sought employment in provincial centers, thereby spreading the Mughal style of painting throughout Hindustan.

From the time of Jahangir, paintings offer far less visual documentation for music, relatively speaking. That is not to say that Jahangir did not enjoy music: "This king was fond of feasts, dancing, and music," remarked the Venetian traveler Niccolao Manucci (1907, 1:153). Repeating what he must have heard at the court of Shah Jahan or Aurangzeb (because Jahangir was long dead before he arrived on the scene), Manucci recounted in his *Storia do Mogor* a few gossipy anecdotes that link Jahangir with musicians, one of which involved Nur Jahan, "Light of the World," the queen whom Jahangir dearly loved. What can be believed in this story is that Jahangir was a bibulous individual and that Nur Jahan, that high-spirited lady of good education, intelligence, and strong will had to contend with him. In this recounting, musicians had to come to her rescue.

> Nur Jahan succeeded in making the king drink less than he had done formerly, and after many entreaties he agreed that he would not drink more than nine cupfuls. Every time he drank it must be offered by her hand. If on any account he should ask for more, he was to be satisfied to allow her to put him off by excuses. Many days had not passed when the king, being engaged in listening to the singing of his musicians, began to drink joyously. In a short time he had come to the end of his nine cupfuls. As the music went on he asked for more, but the queen would not give it, saying that he had already had his nine cupfuls and she did not mean to give him any more. Jahangir went on asking for just one cup more. When he saw that the queen would not give ear to his words, he fell into a passion, laid hold of the queen and scratched her, she doing the same on her side, grappling with the king, biting and scratching him, and no one dared to separate them.
>
> The musicians, hearing the noise going on in the room, began to call out and weep, tearing their garments, and beating with their hands and feet, as if someone were doing them an injury. Thereupon out came the king and queen, who had been struggling together, to find out the reason of all these cries. Seeing that it was a feigned plot of the musicians, they fell a-laughing, and the fight ended. The king was highly delighted with the trick played by the musicians, to whom he gave a handsome reward. (ibid. 157–58)

Musicians were a regular part of life in the imperial household in the time of Shah Jahan as well. We get insight into that in 'Inayat Khan's condensed version of the chronicle of Shah Jahan's reign, the *Shāh Jahān Nāma*.[6] Musicians were rewarded on the occasion of the birth of a prince, for instance.

> On [9 May 1628], an auspicious star appeared in the sky of the Caliphate; that is, a son was born to Her Majesty the Queen [Mumtaz Mahal], who was named as Sultan Daulat Afza. His Majesty, the Shadow of God, extended the hand of favor and awarded distinguished

robes of honor to the high ranking nobles, and distributed large sums of money to the turbaned religious scholars, deserving persons, and musicians and dancers. (*SJN* 23)

That Shah Jahan himself sang may be indicated in the doleful account of the monarch's reaction to the death of Mumtaz Mahal (giving birth to their fourteenth child) on 17 June 1631.

> For a whole week after this distressing occurrence, His Majesty from excess of grief did not appear in public nor transact any affairs of state. . . . After this calamity, he refrained from the practice of listening to music, singing, and wearing fine linen. From constant weeping he was forced to use spectacles; and his august beard and mustache, which had only a few white hairs in them before, became in a few days from intense sorrow more than one-third white. (*SJN* 70)

The marriage of the heir, Prince Dara Shikoh, in February 1633 caused restoration of music-making for court festivities. "As music and singing at His Majesty's order, had up to this date been entirely discarded in consequence of the Queen's melancholy death, the royal permission was now granted for their revival" (*SJN* 91). An additional comment in 'Inayat Khan's chronicle suggests Shah Jahan's personal interest in music:

> On [9 March 1655], the author Zu'l-Qar'ain Farangi, who was endowed with the utmost skill in composing Hindi songs, had a debt of 12,000 rupees remitted in recompense for a composition of his that he had presented aloud in the auspicious hearing, and which had been approved of by His Majesty's critical taste. (*SJN* 506)

In fact, enjoyment of music was part of the daily routine which Shah Jahan followed strictly whether he was in camp or at the capital (Saksena 1962:238–43). Following the long practice of the Mughal rulers, he awoke about two watches before sunrise, and after performing his daily ablutions went to his private mosque where, sitting on a carpet, he waited for the hour of prayer. After saying the morning prayer, he counted his beads until sunrise. From the mosque he went through the morning to a series of audiences that progressed from most public to most private. First to the *jharokā darshan*, where he showed himself to his subjects for about an hour and would hear pleas (the custom initiated by Akbar [see pl. 1] and followed until it was abolished by Aurangzeb). From there he went to the Hall of Public Audience, where he was awaited by officers, courtiers, and soldiers to conduct regular business; followed by a period in the Hall of Private Audience in order to transact business with high-ranking ministers that for political or administrative reasons were not conducted publicly. There Shah Jahan inspected works of art and plans for new buildings. The most secretive meeting, about two watches in length, was next, in the Shah Burj or "Royal Tower"; with the exception of the princes and three or four other officers, none was allowed entry. Finally he lunched and rested in the *ḥarem*, but he also conducted women's business there. In the afternoon he went to congregational prayers, after which he spent the evening doing more work in the Hall of Private Audience and then listened to music or witnessed deer fights. At 8 P.M., after holding another council for half an hour in the Shah Burj, the Emperor retired to the *ḥarem* where he ate supper and then listened to songs sung by women musicians. Bedtime was c. 10 P.M., but he would listen to good readers of books on various subjects such as travel, the lives of saints, or history; his favorite was the autobiography of Babur. Thus, music was just enfolded into the rhythm of his life.

Court life under Shah Jahan reached a very high level of sophistication. This was embodied in the *khānazād*s, who were

> fully assimilated to the polish and sophistication of Indo-Persian courtly culture in its elaborate Mughal version. The ideal *khanazad* was dignified, courteous, and well-mannered. He understood the intricate rules for comportment in all social encounters . . . He valued and often quoted Persian and perhaps Hindustani or Turki poetry, and appreciated Hindustani music, painting, and the other arts nurtured at court. (Richards 1993:148–49)

Fortunately for music historians, the priceless manuscript chronicling his reign, the *Pādshāh Nāma* includes rich scenes of music-making that provide a plethora of information. Those scenes can be considered the pinnacle—and, unfortunately, final blaze of glory—of visual evidence for the history of Indian music in the Mughal period.

Shah Jahan's reign came to a premature end when his son, Aurangzeb, rebelled against him successfully and Shah Jahan surrendered on 8 June 1658. Aurangzeb confined Shah Jahan to quarters in the Agra Fort overlooking the river across from the Taj Mahal until he died in 1666. Aurangzeb paused briefly in Delhi to have himself crowned Emperor (for the first time) on 21 July 1658 in the Shalimar Gardens; he systematically proceeded to eliminate all potentially threatening brothers and cousins.

Transformations in Scene Types

In terms of musical and other pictorial content, some conventional scene types changed from the period of Jahangir forward. Court scenes, for instance, continued to show the emperor in an elevated position with courtiers lined up diagonally to the side (fig. 132); usually missing, however, is the implied hustle and bustle of the Akbari court, with falconers, horses, cheetahs, and particularly musicians (as in fig. 11) creating a sense of aural and visual liveliness. Lost also is the sense of play: the scene is far more formal, even ritualized, with the placement and attitude of the courtiers toward the Mughal appearing more like devotees coming to pay tribute in a sacred space. This is the case even in portrayals of the most festive occasions such as the marriage of the heir (figs. 133 and 134).

In reality, however, we get two different impressions of the soundscape of Shah Jahan's court sessions. From the historian Saksena: "A loud cry of 'long live the King' greeted the Emperor every time he appeared whether in the *jharokā* (window) or at court. This was followed by silence, and ordinary business was carried on in whispers" (1962:245). A contradictory report was given by the French traveler, Tavernier (1977, 1:80–81, cited at the end of chapter 4). My supposition is that the court procedure admitted of some variation; certainly the paintings suggest that.

The scene of the birth of a prince, too, became quite staid in portrayal, as in the *Tūzuk-i Jahāngīrī* (fig. 56) as compared to figure 135 from a *Bābur Nāma*. Manucci would have us believe, however, that the celebrations of royal births continued in traditional manner in the time of Aurangzeb, even though they were not "celebrated" through paintings:

When a princess is born in the mahal the women rejoice, and go to great expense as a mark of their joy. If a prince is born, then all the court takes part in the rejoicings, which last several days, as the king may ordain. Instruments are played and music resounds; the nobles appear to offer their congratulations to the king, bringing presents, either in jewels, money, elephants, or horses. The same day he imposes on the infant [a name] and fixes his allowance, always more than that given to the highest general in the army. (Manucci 1907, 2:320)

Enthronement scenes change, as well. The sedate Timurid model (fig. 97) is followed for Babur (fig. 29) and Akbar (Leach 1995, 1:235). Humayun's accession scene is more active (fig. 46), perhaps due to the reason discussed on p. 61. The European idea about coronation festivities may be reflected in the illustrations of Jahangir's coronation—heralding by the *naubat* and enthusiastic spectators on one folio, with the more sedate gathering of courtiers on a second folio (Beach 1992:98–99).

The most prominent scene types that included music-making in the periods of Jahangir and Shah Jahan are of two types: depictions of grand processions, and times of special festivity for the Mughal family itself. Although Jahangir was still ordering campaigns of conquest for large areas of the subcontinent, it is certain security rather than victorious struggle that is celebrated in the paintings. The overwhelming impression one receives is one of opulence, refinement, and pomp.

IMPERIAL PROCESSIONS

Processions had, of course, been important visual and audible reminders of the presence and power of the Mughal from the beginning of the dynasty (see chapter 1). The *Akbar Nāma* leaves little doubt about the nature of imperial processions in non-military circumstances. On 1 December 1581, for example, when Akbar returned to Fatehpur, Abu'l Fazl described the procession:

On this day of joy the great officers, the loyal servants, and others were drawn up in two sides of the way for a distance of four kos from the city. . . . The Khedive of the world proceeded on his way on a heaven-like elephant, attended by the "Avaunt" of the Divine Halo. . . . The noise of the drums and the melodies of the magician-like musicians gave forth news of joy. Crowds of men were gathered in astonishment on the roofs and at the doors. (*AN* 3:549)

Jahangir, too, was aware of the effect that a procession could have.

On Monday, the 3rd Muḥarram of the 5th year [of my reign], I halted at the Mandākar Garden, which is in the neighborhood of the city. On the morning on which was the auspicious hour of entry into the city, . . . I mounted and rode on a horse to the beginning of the inhabited part, and when I came to the immediate neighbourhood mounted on an elephant, so that the people from far and near might see, and scattering money on both sides of the road, at the hour that the astrologers had chosen, after midday had passed, entered with congratulation and happiness the royal palace. (*TiJ* 1:166–67)

The grandest pictorial renderings of imperial processions are offered by the *Pādshāh Nāma* of Shah Jahan. Even the usual scene of a court audience was turned into a procession of sorts. There was certainly cause for recording the audience on 29 November 1638 at which the Iranian noble ʿAli Mardan Khan was welcomed to the presence of Shah Jahan (fig. 75), being honored for having

handed the gateway city of Qandahar back to the Mughal ruler. According him an honor rarely shown to a noble, the emperor ordered two of his highest ministers (identifiable in the illustration) to receive 'Ali Mardan Khan at the entrance to the courtyard and escort him personally to the audience hall. As it happened, Shah Jahan's own ambassador to Iran, Safdar Khan, also appeared in court that day with numerous offerings, including five hundred Iraqi horses—which perhaps explains the profusion of horses in the painting (Begley 1986:141–42).

Whereas in Akbari practice and paintings scenes showing the submission of important persons to the emperor were placed in relatively conventional court settings, in the *Pādshāh Nāma* one submission scene is also the occasion of a grand procession. The contrast in effect is provided by two illustrations (figs. 136 and 137) of the submissions of important personages, one Akbari-period and one from the time of Shah Jahan. Both submissions occurred when the court was on the move in the traditional manner reported even by Gulbadan Begam about her brother Humayun, whose court days were Sundays and Tuesdays: no matter where they were, in the encampment they would erect the offices first, then "the pavilions and tents and the audience tent" (*HN* 129–30).

The audience tent with canopies for a roof and a strong fabric for walls is the setting for "Raja Surjan Hada submits the keys of Ranthambhor Fort" to Akbar (fig. 136). When it became clear that he could not resist Akbar's siege, the Raja requested the audience, and it was arranged with Akbar. On 22 March 1569,

> he came out of the fort and prostrated himself at the threshold. He tendered suitable gifts, and the keys of the fort, which were made of gold and silver. He was treated with great favour and attained to security and tranquillity. (*AN* 2:495)

Such a Rajput leader would be treated gently by Akbar, as a potential ally and in keeping with one of the pillars of empire: an alliance with a new imperial agent. In the painting (fig. 136), Akbar has accorded the Raja the courtesy of a full-fledged formal *darbār* setting in the tent, including musicians (note the *bīnkār*—an Indian musician) who would grace a similar setting in a fort. The Raja's gifts are ready, with servants poised at the entrance to the "court" area to bring them to Akbar. Just outside the "fence" are the falconer and the riderless horse which were familiar conventional elements of Mughal court scenes. The riderless horse (probably the prized *tīpūchāq*) is likely to be presented as a gift by the ruler; the long-necked *tīpūchāq* horses were beautiful, fast, and trained in special paces.

As is evident from figure 137, one side of a double-page illustration of the submission of Rana Amar Singh to prince Khurram (later, Shah Jahan), the royal encampment had become considerably grander in the time of Jahangir. In 1613, Jahangir dispatched Khurram to subdue the rebelling Rana Amar Singh, "who was the leader of the Rajas of Hind" (*SJN* 6). Pride in achieving control over Mewar, the surviving Rajput stronghold in Rajasthan (1614), and victoriously bringing the Rana "under the yoke of obedience" must have been the impetus for this 1650–60s painting for the *Pādshāh Nāma*. Even the motion of a procession is captured in it, as the prized riderless horses are led toward the tent of audience (which we do not see in this folio); beside the scarlet cloth walls of the imperial enclosure are placed stacks of "robes of honor," ready for distribution to those who have earned reward.

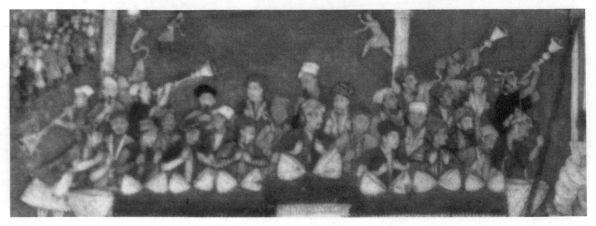

Detail of figure 137

The quietness of a *rudra vīṇā* in the court setting has yielded in this grander scene to the bombastic sound of a very large ensemble in the tented *naqqāra khāna* (see detail). The *naqqāra khāna* remained a potent symbol through the generations, providing the audible and visible reminder of the power of the imperial establishment wherever it went. In his memoirs, Jahangir expressed the significance to him of the ensemble as he recounted an anniversary of his accession to the throne.

> On the morning of Thursday, March 10, 1619, the world-enlightening year of the reign of this suppliant commenced in all prosperity and happiness. On Thursday, the 1st of the New Year, my prosperous son, S͟hāh-Jahān, who is the star of the forehead of accomplished desires, and the brilliancy of the brow of prosperity, prepared a grand entertainment, and presented me as offerings with a selection of the precious things of the age, and rarities and curiosities of every country. One of these is a ruby . . . further, six pearls. . . . Also one diamond, the price of which was Rs. 18,000. . . . Also a jewelled sash, a sword-hilt made in his own goldsmith's shop; most of the jewels he had himself set and cut. He had brought great dexterity to bear on the design. Its value was fixed as Rs. 50,000. The designs were his own; no one else had up to this day thought of them. Undoubtedly it was a fine piece of workmanship. There was also a pair of drums made of gold for playing the *mursal* (overture?) with a whole orchestra—viz., *kuwarga, naqqāra, karanā, surnā,* etc.—whatever was required for the *naqqāra-khāna* (music hall) of great princes, and all made of silver. At the auspicious hour at which I had seated myself on the throne of success these were all sounded. The whole of them came to a value of Rs. 65,000. (*TiJ* 2:78–79)

In the court of Shah Jahan, the *naubat* continued to function in a meaningful manner with the sovereign both on the move and in permanent residence. On 4 April 1644, a terrible accident occurred in the imperial household. The Emperor's oldest daughter, Jahanara, who took over the running of affairs after the death of Mumtaz Mahal, was burned very badly when her clothing brushed against a lamp left burning on the floor in the middle of a hall. After eight months in critical condition, she recovered sufficiently that in honor of the event, Shah Jahan ordered her to be weighed against gold—an observance hitherto limited solely to the person of the Emperor. "As

the Princess's sufferings were now much alleviated, it was ordered that the imperial kettle drums should be sounded in token of gladness" (*SJN* 314). (On her full recovery, lavish gifts were distributed; "the minstrels and musicians received munificent sums," ibid. 319.)

The state entry on 18 April 1648 into the fort of the new metropolis of Shahjahanabad, Shah Jahan's new capital in Delhi, was a grand occasion.

> After inspecting the various buildings and edifices, the [Emperor] took his seat on the Jeweled Throne in the Hall of Public Audience, where he held a public levee whilst the loud beating of the royal drums made the glad sounds of rejoicing peal through the universe. (*SJN* 408)

The next generation also cultivated the effectiveness of the *naubat*. In the procession of the army of Shah Jahan's son, Manucci commented, "Last of all was Dara on his magnificent elephant, followed by numerous elephants carrying drums, trumpets, and all manner of music, forming his retinue" (Manucci 1907, 1:263). In figure 138 the great trumpets of a *naubat* ensemble precede rather than follow the prince on his elephant.

The custom of a *naubat*-accompanied procession arranged to honor an important visitor is recorded by Manucci in the second year of Aurangzeb's reign.

> Aurangzeb gave orders for soldiers to be posted on both sides of the street, a league in length, through which the ambassador would pass. The principal streets were decorated with rich stuffs, both in the shops and at the windows, and the ambassador was brought through them, escorted by a number of officers, with music, drums, pipes, and trumpets (1907, 2:45)

Aurangzeb clearly recognized the *naubat* as a given ensign of royalty. In a writing style reminiscent of that of Abu'l Fazl, Khafi Khan, Aurangzeb's chronicler for the first ten years of his reign, invokes the impression of the *naubat* on the occasion of that sovereign's first coronation.

> On Friday (22 July 1658) after saying the Friday prayers, and at a fortunate hour and an auspicious moment, when the sun was in the tenth sign of zodiac he started the celebration of his coronation . . . and took his seat on the throne of the extensive and heaven-like empire of Hindustan. The sounds of music, the beating of drums, and the blowing of trumpets spread under the green-coloured dome of the sky (i.e., the world) and words of congratulations from the tongues of the genii, the angels and the men reached the ears of the people of the world. (*History of Alamgir* 45)

Then, in the manner of the Mughal predecessors, large amounts of red (gold) and white (silver) coins were given in *ināms* and gifts to the musicians, the needy and pious men, and the poets (ibid.).

Evidence in narratives by court officials, travelers, and historians makes it clear that the *naubat* continued to function as a major indicator of the power and pomp of royalty during the reigns of the later emperors. The *naubat* drums beat in victory; the *naubat* was used in procession, for announcing the arrival of the emperor, and at other court functions through the end of the empire (see Irvine 1922, vol. 1, chapters 1–4; vol. 2, chapter 10, passim, for example).

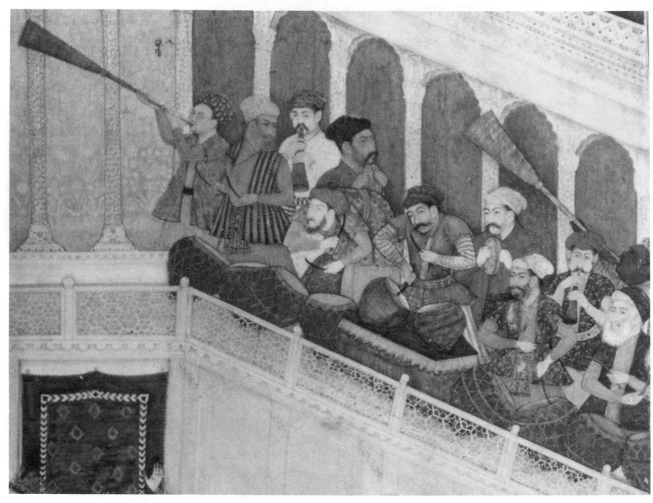

Detail of figure 140

TRANSFORMATIONS IN THE *NAUBAT* ENSEMBLE

Some changes in the *naubat* ensemble can be traced through the paintings in the *Pādshāh Nāma*. For example, some of the *naubat* ensembles in celebratory scenes do not include the *sanj* (cymbals): the gateway group in figure 139, for example, or the group on elephantback in a wedding procession (pl. 18). It could be that the instrument just did not seem important enough to include in the painting. In any case, a lesser role for the cymbals is indicated by the size of the pair in one of the few *naubat* ensembles in Shah Jahani paintings that include cymbals (fig. 140, see detail) as compared to an Akbari-period *sanj* (pl. 13). The Shah Jahani instrument seems to be a variant on the *tāla* dance cymbals with a shallow bowl shape, and the musicians also seem to be being as discreet as is possible with a cymbal.

There is some change in the drums (*naqqāra*), too. The magnificent ensembles in Akbari paintings (see pl. 13, for example) feature multiple sizes, shown in a gradual range from relatively smaller to relatively larger in a diagonal line. In the grand *naubat* ensembles that are featured in the manuscript of the *Pādshāh Nāma,* there are also multiple sizes of single-headed drums, but the

small drums are relatively smaller than those in the Akbari paintings (figs. 140, 75). And the gradual range of sizes is less likely to be seen in the Shah Jahani ensemble; in figure 75, for instance, a tall, single drum really contrasts with the smaller pairs in the ensemble. A similar jump in size from relatively larger drums to smaller ones can be seen in another Shah Jahani painting (reproduced in Beach 1978:83), in which the larger drums comprise a pair.

The Akbari *naqqāra* are painted in either of two colors, indicating that they are made of different materials. The different colors correlated with musical function: black is the prevailing color in heralding scenes, suggesting a body of wood or perhaps metal (fig. 3, pl. 13). The drums that are used for accompanying male dancers are almost always a tan/cream color, probably indicating a different wood or perhaps metal (figs. 48; 135; pls. 11, 10).[7]

It is important to note, then, when multiple colors of drums appear in a single Akbari painting. When the *naubat* ensemble with its telling selection of other instruments—trumpets, horns, cymbals, double-reed—is being used to accompany dance, the dance drums are included. For instance, in a scene (pl. 4, male dancer; there is also a female ensemble) from a historical manuscript, the *Chinggis Nāma,* two pairs of the drums are tan-colored, while the third pair is black. This is such a consistent detail that it is possible to say that the Akbari imperial orchestra is not intended to be understood as part of the dance accompaniment if all the drums are black (in pl. 13, for instance).

In Shah Jahani *naubat* ensembles, there are also alternative colors to black: tan (fig. 141) or red (fig. 140), but the correlation of drum color and dance accompaniment does not hold in illustrations of that period. The drums being used to accompany dancers at the celebration for the marriage of Prince Dara Shikoh in figure 133, for example, are red; perhaps they are made of copper or have been painted to be a more festive color. The small drum in the center of the ensemble that heralds a procession from the *naqqāra khāna* in figure 139 is a lighter color; enormous drums used in a procession are colored tan (fig. 141) and red (pl. 18) as well as black.

However, more has changed in the Shah Jahani *naubat* ensemble than the placement of the drums and sizes and colors of the *naqqāra.* The percussion parts also appear to have changed, because the playing technique is different. In the Akbari drum pairs, most drums are aimed straight up, and paintings in which this is not the case are exceptional—dance accompaniment in figure 135 from the *Timūr Nāma* and plate 10, an *Akbar Nāma* folio. Significantly, in an early Jahangiri painting and in most Shah Jahani paintings, the two drums of a pair are tilted toward each other (Beach and Koch 1997:119; see fig. 75). Further, the position of the player's hands suggest that what is being played on the drums has changed; rather than coming straight down on the head, players are shown crossing hands, and striking a drum with the opposite stick. That may be the technique pictured in the vignette of a drummer with a male dancer, in the marginalia of a folio from an album of Jahangir (fig. 142). The use of a greater number of small-sized drums, too, suggests the possibility that dance-style drumming was influencing the music of the heralding ensemble.

The trumpets and horns of the *naubat* ensemble also change somewhat from the period of Akbar to that of his grandson, Shah Jahan. This is easy to trace, because aerophones of both those categories are shown in a sufficiently large number of Mughal paintings due to their important

function in both battle and heralding scenes. Morphologically, they are distinguishable from double-reed and flute-type aerophones in two ways: They have no fingerholes, and they have a cup-like mouthpiece.[8]

A trumpet has two primary characteristics that distinguish it from a horn: The tube is more cylindrical than conical, and it has a flared or funnel bell. The horn, on the other hand, is more conical than cylindrical and does not have a flared or funnel bell (the conical shape itself creating a wider opening at the distal end). Particularly in paintings, it is frequently difficult to know what the instrument maker intended when the artist is suggesting the presence of the instrument rather than documenting it as an object; thus, the cautious relativity in "more one shape than the other" is helpful.

In the section in the *A'īn-i Akbarī* on the *naqqāra khāna*, Abu'l Fazl enumerated aerophones other than the *surnā* type, thereby listing trumpets and horns:

> The *Karnā* is made of gold, silver, brass, and other metals, and they never blow fewer than four. The *Nafīr*, of the Persian, European and Indian kinds; they blow some of each kind. The *Sing* is of brass, and made in the form of a cow's horn; they blow two together. (*AiA* 1:53)

The *sing* has a distinctive shape about which Abu'l Fazl is explicit, and it is easy to distinguish in the paintings (fig. 3); it is clearly a horn, having a conical tube. However, the usually effusive chronicler offers insufficient information to be able to distinguish the other *karnā* and *nafīr* from each other, and nothing about their shape which would permit us to place them in an organological classification, thereby identifying them with more certainty in the paintings. We expect to find one kind of *karnā*, but three kinds of *nafīr* (Persian, European, and Indian), without clues as to how to identify them.

Concerning hierarchy among the three aerophones, we would expect the *karnā* to have precedence, since a player of that instrument is listed among the primary musicians of Akbar: "Shaikh Dāwan Dhari, performs on the *karanā*" (*AiA* 1:682). Abu'l Fazl's description of its musical role in the *naubat* ensemble is unfortunately too sparse to be of much help:

> One *gharī* before sunrise, the musicians commence to blow the *surnā*, and wake up those that are asleep; and one *gharī* after sunrise, they play a short prelude, when they beat the *kuwarga* a little, whereupon they blow the *karnā*, the *nafīr*, and the other instruments, without, however, making use of the *naqqāra*; after a little pause the *surnās* are blown again, the time of the music being indicated by the *nafīrs*. (*AiA* 1:53)

With his translation of the *A'īn-i Akbarī*, Blochmann included both helpful and confusing sketches of the instruments (fig. 143) in an effort to match the terms and pictorial depictions of them. One instrument, with a conical tube made of multiple sections whose joints are indicated by a knob-like shape, ends in a flared conical bell. Confirming this to be the *karnā*, Shahab Sarmadee adds:

> *Karnā* (Turkish *Qarnā*) is sometimes called by its original name: *Khar-nāy*, meaning *nāy* of the bigger variety. Our researches, however, lead to its more probable origin, *Kār-nāy*, *Kār* in Old Persian and Pahlavī standing for warfare and battle. (Pers. comm., March 1982)

Not a conical, but a cylindrical tube–trumpet appears in more than half the battle scenes (for example) in Mughal paintings, however (fig. 5). That the *karnā* served a function in warfare for the conquering Mughals in India is clear in the contemporary accounts, especially the *Akbar Nāma*.

> The rebels had been confident in their numbers and had pressed on the siege. . . . When the sublime cavalcade came near the Sabarmati the order was given that the troops should be drawn up in order and should cross the river. The officers were expecting the army of Gujrat and hesitated to advance. . . . The noise of trumpets [*karnā*] and drums [*naqqāra*] resounded. (*AN* 3:74)

> He made ready for battle and mounted a world-traversing steed and uttered lofty and inspiriting words. He gave orders for the beating of drums (*naqqāra*) and the blowing of trumpets (*karnā*). The drummer was so alarmed that he could neither hear the sacred order, nor address himself to his work till he was brought to his senses by the menace of a spear, and began to beat his drum. (*AN* 3:85–86)

> I arranged with the commanders of the batteries that within this week they would turn their face towards the True Disposer (God) and would run to the taking of the fort [Mali]. When the sound of the drum (*naqqāra*) and trumpet (*karnā*) reached their ears, every one was to come with the ladders, and beat the drum loudly. Though they agreed, *nolentes volentes,* yet many thought it was madness. (*AN* 3:1164)

The last passage, as translated by Shahab Sarmadee, however, relates a strategic part that the instruments were to play: When *naqqāra* and *karnā* sounded, everyone was to appear on the scaling ladder, and then the *kus* (the biggest drum at the site of the siege) was to sound at its loudest to cover the sounds of the scaling soldiers (pers. comm., March 1982).

Because of the match between written and visual sources of the period, and bolstered by Sarmadee's information, I suggest that the trumpet—cylindrical tube with a flared bell attached at the end—must be the *karnā*. Andrew Grieg identifies this instrument as the *nafīr*: "The *Nafīr* had a narrow, cylindrical bore, constructed in sections of tubing joined with bulging metal rings" (1987: 487), but for me the *nafīr* is still a mystery instrument not elucidated in the paintings. Perhaps it is the conical instrument spotlighted in figure 144.

Although Abu'l Fazl did not lead us to expect more than one type of *karnā,* a second shape of trumpet is drawn in a number of Mughal paintings (pls. 3, 13, and 6): the cylindrical tube is curved in a swan's neck type of curve (Grieg 1980:159).[9] The swan's neck shape rather than the straight tube is the *karnā* of choice in figure 145, for instance, a scene of Babur's army chasing Afghani Hazaras through a mountain ravine. Grieg's explanation for the curved shape of trumpets in the paintings has to do with relative length:

> They had no valves, the notes they were capable of playing were related to rational fractions of the length of the trumpet. Therefore, they were sometimes rather long, attained lengths of 120 cms to more than two meters. The longest ones, whose length made them unwieldy, were sometimes redoubled upon themselves in a radical swan's neck, or "S" curve. (1987:487–88)

The length of the tube determined the pitches produced on the instrument.

The multi-sectional cylindrical tube trumpet with conical bell attached is the military instrument also shown in Persian paintings. Both shapes are there: In "Karan slays Barman in battle," painted in Tabriz in 1537 for a copy of the *Shāh Nāma* of Firdausi, the instruments are very long and very delicate (see Welch 1972:136–39). In figure 100 as well, they are very delicate and are used there with the Persian *surnā*. I have found the straight *karnā* in a greater number of Persian paintings, but the curved-neck type is also used as an independent signaling instrument in some illustrations.

In Mughal paintings, each form of *karnā*—straight and swan's neck–shaped—appears as the only aerophone in a battle scene; each also appears paired with the *surnā* in battle scenes (though it is more likely to be the swan's neck shape, as in fig. 145). Both lengths of *karnā* are shown together (fig. 3) as well, so it was not a matter of one or the other being used at a time. When used together, they probably provided a greater variety of signals that could be counted on by the army, since the length of tube determined the pitch. And both appear together in scenes of the heralding *naubat* ensemble during the Akbari period (pl. 10).

By Shah Jahan's time, three major changes have occurred with respect to the trumpets and horns. The *karnā* with swan's neck–curved tube disappears from (most of) the paintings of the *naubat* ensemble.

A second major change is the relatively frequent inclusion (compared to its rare occurrence in Akbari paintings) of the C-shaped horn in the *naubat* ensemble; perhaps it replaced the musical function of the swan's neck *karnā* as the court instrumentarium became increasingly Indianized in the seventeenth century. "A *darbār* scene: Escorting the Persian noble ʿAli Mardan Khan to the presence of Shah Jahan, November 1638" is a typically grand Shah Jahani rendition of a court celebration (fig. 75) that includes the Indian C-shaped horn. The *naubat* is in full view; just in front of it are stacked the robes of honor which were given as awards in the court occasion, and in front of them are courtiers and visitors waiting with gifts to present to the sovereign.[10]

A third major change which occurs in paintings of the Jahangiri and Shah Jahani periods successively is that the *karnā* become larger and heavier than they were in the Akbari period. The fantastic instrument depicted in plate 18 still has the cylindrical tube of a trumpet, but the bell is now huge. In other paintings, the proportions of the parts of these aerophones also can be seen to have changed to the extent that the distinction between cylindrical and conical tube practically disappears. In a Jahangiri illustration, a trumpeter on horseback in a marriage procession holds up for all to see a *karnā* with a conical bell which is so long that to distinguish this as a horn or trumpet is really an exercise in organological futility (pl. 16). The same is true of the instruments held aloft in the weighing celebration illustrated in the *Pādshāh Nāma* (fig. 140).

THE HERALDING ROLE IN A PROCESSION

Although they were definitely still used for signaling in battles, the instruments of the *naqqāra khāna* in post-Akbari illustrations are shown as heralding instruments in scenes of festivities and processions. When the Mughal ruler departed from his sovereign city to travel some distance and to stay away for some time, "the procession" meant transporting the entire imperial establishment,

and an imperial city would literally be reconstructed wherever he went (see chapter 1). That is the function they fulfilled in the most impressive description of an ordinary imperial procession that I have found. While too long to reproduce here verbatim, an abridged version of Niccolao Manucci's description of such an endeavor during Aurangzeb's rule illustrates the way in which the musicians of the *naqqāra khāna* functioned. At the urging of his sister Roshanara Begam, Aurangzeb made a journey to Kashmir.

Thus Aurangzeb started from the city of Dihli on the 6th December of [1662] at three o'clock in the afternoon, the joint decision of the astrologers being that this was the best date that could be found for the king to start on a long journey, which must last at least a year, or even more, in going, coming, and staying. . . .

The king, on leaving the city, rested for the night in an extensive garden called Shalimar, planted by Shahjahan as a pleasure resort; it lies three leagues distant from the royal palace, adjoining the road to Lahor. Here Aurangzeb halted six days to give time for everyone to make his preparations, and when everybody had joined the army he meant to begin his march. It is the custom in the Mogul country when an army is in the field to order a trumpet to be blown at nine o'clock at night as a signal that there will be no march on the following morning.

On the sixth evening there was no trumpet, and the advance tents were sent on. . . . In the Mogul kingdom the king and many of the nobles march with two sets of tents, so that while the one set is in use the other may be sent on for the next day. . . .

On the seventh day at three o'clock in the morning the march began. First went the heavy artillery, which always marches in front. . . . With it went a handsome boat upon a large car to ferry the royal person across any river when necessary. Then followed the baggage. . . . With the rest, went two hundred camels, loaded with silver rupees. . . .

The royal office of record also was there, for the original records always accompany the court, and this required eighty camels, thirty elephants, and twenty carts, loaded with the registers and papers of account of the empire. In addition to these there were fifty camels carrying water. . . . The princes of the blood-royal marched in the same fashion, each according to his rank.

It was the custom of the court, when the king is to march the next day, that at ten o'clock of the night the royal kitchen should start. It consists of fifty camels, loaded with supplies, and fifty well-fed cows to give milk. Also there are sent dainties in charge of cooks, from each one of whom the preparation of only one dish is required. . . . Further, there are fifty camels carrying one hundred cases packed with robes of honour: also thirty elephants loaded with special arms and jewels to be distributed among the generals, captains, etc. . . . ; also things to give to ladies, jewels to wear on the breast and other varieties. . . . Aurangzeb started at six o'clock of the day, seated on the throne presented to him by the Dutch. . . .

The following is the order of the king's march. At the time when he mounted the throne and issued from his tents all the warlike instruments of music were sounded. At the head came the son of the deceased Shekh Mir with eight thousand cavaliers . . . [followed by thousands of other soldiers]. In the rear of these two wings were the mounted huntsmen, each with his bird of prey (hawk) on his wrist. Immediately in front of the king went nine elephants with showy flags; behind these nine were other four, bearing green standards with a sun depicted on them. Behind these elephants were nine horses of state, all adorned and

ready saddled; after these horses came two horsemen, one carrying a standard with Arabic letters on it, the other with a kettle-drum, which he struck lightly from time to time as a warning that the king was approaching.

There was no want of men on foot, who advanced in ordered files on the one and the other side of the king. . . . Among the men on foot were some with perfumes, while others were continually watering the road. By their side was an official provided with a description of the provinces, lands, and villages through which the king must pass, in order to explain at once if the king asked what land and whose province it was through which he was then passing. These men can give him an account of everything down to the petty villages and the revenue obtained from the land. . . .

So great is the dignity with which the Mogul kings travel, and the delicacy with which they are treated, that ahead of the column goes a camel carrying some white cloth, which is used to cover over any dead animal or human being found on the road. . . .

After the king came ten horsemen, four with the royal matchlocks enclosed in cloth-of-gold bags: one bore his spear, one his sword, one his shield, one his dagger, one his bow, one the royal arrows and quiver; all of these in cloth-of-gold bags. After the weapons came the captain of the guard with his troops, then the three royal palanquins, and other palanquins for the princes: then, after the palanquins, twenty-four horsemen, eight with pipes [probably *surnā*], eight with trumpets, and eight with kettle-drums. Behind these mounted musicians were a number of elephants. . . . All these elephants were decorated with valuable housings and ornaments. They were followed by twelve more bearing large kettle-drums and other instruments made of refined metals not employed in Europe. They are of the nature of large dishes which, being beaten one against the other, make a great noise. These musical instruments are employed by Armenians, Syrians, and Maronites in Syria at church solemnities and at weddings; they are also used at such events by the Turks. . . .

At some distance from the foregoing came Roshan Ara Begam upon a very large elephant in a litter called *pitambar,* which is a dome-roofed throne, very brilliant, made all of enamelled gold, and highly adorned. Behind her followed one hundred and fifty women, her servants, riding handsome horses, and covered from head to foot with their mantles of various colours, each with a cane in her hand. . . .

Behind Roshan Ara Begam came her retinue, which consisted of several sour-faced eunuchs on horseback. . . . After Roshan Ara Begam's retinue came three queens, wives of Aurangzeb, and other ladies of the harem, each with her own special retinue. It would be very lengthy to recount all the details of this march, the Moguls being extremely choice in such matters, overlooking no detail that could minister to their glory.

It remains to state that ahead of all this innumerable throne there always moved one day ahead, at the least, the Grand Master of the Royal Household, with other engineers, to choose an appropriate site where the royal tents should be unloaded. In the first instance they fix the site of the royal enclosure. . . . Behind the royal quarters is another gateway, where the women live, a place much respected. After this is arranged they fix the position of the tents of the princes, the generals, and the nobles. . . . The central space is encircled by scarlet cloths . . . and these serve as walls. In front of the gateway is a large raised tent for the drummers and players of music. [When the king arrives] the musicians commence anew to play their instruments until the king has passed through the gateways of the tents. (Manucci 1907, 2:61–68)

Imperial Marriage Celebrations

From the Jahangiri period, illustrations of processions also merged with scenes of imperial marriage celebrations. In these post-Akbari paintings, the wealth of the empire and the size of the royal establishment is suggested not only by the players of the *naqqāra khāna* but also by a panoply of other instrumentalists and singers. A scene possibly from the *Tūzuk-i Jahāngīrī* (pl. 16), thought by some art historians to be a marriage procession, includes both the *surnā* (bottom and top left) and the heralding trumpets of a *naubat* ensemble. In addition, female musicians and a dancer joined by two male drummers form a cluster at the bottom right. With their higher rank shown perhaps by their greater size in the painting (which contradicts the proper manner for achieving the perspective of distance from the viewer), what are probably male *darbār* musicians cluster at the top right. Folk musicians and dancers are shown at the very top in the center. In a pictorially more formal arrangement, the celebration of Prince Khurram's marriage likewise includes musical variety (fig. 146): the *naubat* from the gateway, a chorus of women singers lined up next to the gateway, and players of *rudra vīṇā* and *rabāb* walking just in front of the prince on his elephant.

That marriage festivities should have been depicted at all is also a striking change through time. Marriages in the Akbari period were generally not the subject of illustrations. The wedding of Maham Anaga's son, for instance, was a very specific subject in which the marriage itself was almost beside the point (fig. 62 and pl. 13). By contrast, generous illustration space is given to marriage celebrations in the *Pādshāh Nāma* of Shah Jahan.

The most lavish description in both prose and painting of an imperial Mughal wedding was that of prince Dara Shikoh, the heir apparent of Shah Jahan. Herein the family's wealth and the continuing role of music-making on celebratory occasions is conspicuously documented. Gifts sent from the grooms family to the bride initiated the round of ceremonial events. Since Mumtaz Mahal, Shah Jahan's primary wife and the mother of Dara Shikoh, had died, oversight of the arrangements for the festivities—including gifts—was the responsibility of Her Highness, Princess Jahanara Begam, full sister of the groom.

> The whole amount of property and cash was valued at 16 lakhs of rupees, including both what the late Queen [Mumtaz Mahal] during her lifetime had set aside for the Prince on his forming an alliance, and what her Highness Jahanara Begam had added besides. [In early February 1633], out of the above-named sum, 100 robes of honor were privately presented to the illustrious Princes and Princesses, and the wives and daughters of the nobles; each of whom received not less than seven and not more than nine pieces of rich fabric, most of which were accompanied by some article of jewelry.
>
> Among the public presentations, Yamin al-Daula [the highest-ranking noble of the court] received nine suits of handsome clothes with gold-embroidered vests, and a jeweled dagger and sword of great value. Likewise a few of the chief officers of the state received robes of honor with gold-embroidered vests, with others jeweled daggers. The remaining nobles and all the attendant courtiers received dresses of honor, according to their respective ranks; whilst the minstrels and musicians were also rewarded with robes and gratuities. (*SJN* 90–91)

The round of ceremonies continued unabated.

> On [11 February 1633], the ceremony of *hina bandi* was performed in the royal chambers of the Private Audience Hall (*Ghusal-Khana*); and from the vast number of candles, lamps, torches, and lanterns, the surface of the earth rivaled the starry expanse of heaven.
>
> As music and singing, at His Majesty's order, had up to this date been entirely discarded in consequence of the late Queen's melancholy death, the royal permission was now granted for their revival. According to custom, girdles of gold thread were distributed among those present, and trays filled with conserves of roses, *pan* and *argaja* essence, and condiments and fruits of different kinds were brought into the assembly by the imperial domestics. At the close of the day numerous fireworks set up by the future bride's relatives were ignited along the banks of the Jumna, which afforded the greater delight to the spectators.
>
> Next day, in conformity to the ever-obeyed mandate, the Princes Muhammad Shah Shuja', Muhammad Aurangzeb, and Murad Bakhsh, attended by Yamin al-Daula Asaf Khan and all the grandees of high rank, proceeded to His Royal Highness's mansion. And in the early part of the night, having formed a gorgeous procession [pl. 18], in which some of the nobles were on horseback and others on foot according to their ranks, they proceeded to conduct the heir-apparent with great pomp and magnificence into the public assembly in the Forty-Pillared Hall of Public and Private Audience and introduced him into the august presence [figs. 133, 134].
>
> His Majesty, the Shadow of God, then conferred on him a superb robe of honor, a jeweled dagger with incised floral ornament; a sword and belt studded with gems; a rosary of pearls, on which were also strung some rubies; two fine horses, one carrying a jeweled, the other an enameled saddle; and a splendid elephant caparisoned with silver housings, together with a female one—the whole being worth four lakhs of rupees. On Yamin al-Daula he bestowed a handsome robe of honor with vest worked in gold and a jeweled dagger with incised ornament; and on the other chief dignitaries, nobles and men of note, there were bestowed choice robes of honor as well as dresses, with gratuities being presented to the various entertainers. By His Majesty's command, the gardens beneath the royal chambers and the grounds below the audience balconies, as well as the boats upon the Jumna, were illuminated with lamps; and fireworks, which had been provided at his private expense, were displayed on the banks of the Jumna and, since two *pahars* after noon, music and singing were kept up with spirit until two *pahrs* and six *gharis* (about nine hours) of the night had passed, when the propitious moment for the nuptials finally arrived. Qazi Muhammad Aslam was summoned, and he read the marriage service in the sublime presence, and fixed the lady's jointure at five lakhs of rupees. At the conclusion of the ceremony, shouts of congratulation rose from earth to heaven, and the sounds of the kettle-drums of joy rent the skies. (*SJN* 91–92)

Probably because he was the heir apparent, no fewer than four folios in the illustrated manuscript of the *Pādshāh Nāma* in the Royal Library at Windsor Castle (England) lavishly depict the procession and the greeting of the groom by his father, Shah Jahan.

Instead of the Muslim custom of the bride coming in procession, as noted in the *Akbar Nāma*, in this era it is the groom who processes as in Hindu custom. Royal flags fly free, unfurled. Players from the *naqqāra khāna* (pl. 18) head the procession seated on several magnificent ele-

phants. The drums are the huge *damāmā* (or *kuwarga*); the *karnā* is very long with a huge bell; the *surnā* player's cheeks are as puffed as they could get. Three months earlier a grand procession had also formed to bring gifts to the groom. Courtiers on foot and horseback (fig. 141), preceded and followed by bearers of gifts, advance by the fading light in the sky. On elephantback and on pony-carts (fig. 87) are more musicians: small ensembles of women musicians on platforms on elephants' backs, small ensembles of men musicians in the horsecarts. The large number of musical ensembles creates the impression of imperial wealth and might. The groups of four women musicians vary—two players of cylindrical drum with two singers, two players of *dāʾira* and one player of cylindrical drum with just one woman singing (fig. 87, see detail). Looking closely, one observes that the women with drums are mostly depicted with mouths open, singing. Though it is hard to be certain of the clusters of male musicians, they, too, seem to be in varying groups of four; in all they include singers, players of bowed lutes, *rabāb, qānūn* (or *swarmaṇḍal*), *rudra vīṇā,* and *ḍhol* (fig. 87, see detail). All groups seem to be playing and singing simultaneously, which is not an impossibility, for such closely located simultaneous music-making by numerous groups in various Indian festivities is common today, and the gaiety of the procession would have been considerably heightened by a cacophony of musical sounds.

Subsequent paintings provide striking evidence for the process of Indianization of music at the Mughal court as Indian instruments predominate (fig. 133, see detail; fig. 134). Having reached the waiting emperor, a group of male and female musicians and female dancers offer spirited entertainment on the level below the audience balcony while Shah Jahan greets Dara Shikoh on the balcony above. Percussion instruments are prominently placed in the group; two men play the small hand cymbals associated with Indian dance, one man plays a *pakhāvaj,* another a cylindrical *ḍhol,* while another plays a tiny frame drum that has no cymbals in its frame (and therefore does not

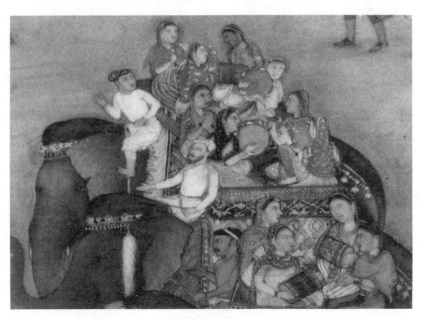

Detail of figure 87

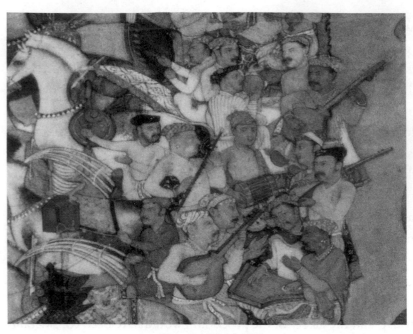

Detail of figure 87

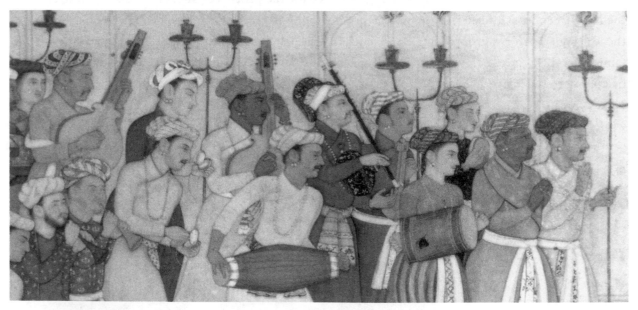

Detail of figure 133

qualify for being one of the frame drums mentioned by Abu'l Fazl). In front are two singers; probably supporting them melodically are the players of *rudra vīṇā*, a bowed lute that looks like a small *sārangī*, and two players of *rabāb*. Only the *rabāb*, *rudra vīṇā*, and cylindrical drum are in both this internal greeting scene and the public procession.

Preparations for the marriage of Shah Jahan's second son, Muhammad Shah Shujaʿ, followed immediately, also organized by Jahanara Begam. Again, musicians received gifts.

By her spirited exertions, everything was satisfactorily and punctually prepared. On 19 February 1633, one lakh and 60,000 rupees in cash and one lakh worth of goods were dispatched, by way of *sachak* wedding present and trousseau to the mansion of the honorable Mirza Rustam.

As the time of the wedding approached, on the night of Thursday, 4 March 1633, the *hina* was brought with suitable pomp from the noble Mirza's house, and the ceremony of applying it was performed in the Forty-Pillared Hall [Hall of Public Audience]. The profusion of lamps and fireworks that had been provided by the future bride's relatives, afforded a great pyrotechnic display. By the royal command, Yamin al-Daula and the other grandees and men of note forwarded to the Prince's mansion robes of honor and gratuities for the singers and musicians, as on the previous occasion.

At the close of the day, His Majesty took his seat at the balcony of the Forty-Pillared Hall; and the Princes Muhammad Aurangzeb and Murad Bakhsh, along with Yamin al-Daula and all the nobles, proceeded at the august command to His Royal Highness's residence and conducted him along the river bank into the royal presence [figs. 147, 148]. During his progress thither, many bright lamps and fireworks—the most beautiful that can be conceived—were exhibited on all sides. (*SJN* 93)

The relative rank of the second son is clear in the space for illustrations—only two—in the *Pādshāh Nāma*, and also in their content. In procession, the heralding instruments are fewer and relegated to the edges of fol. 127A (fig. 147); the musicians in fol. 126B (fig. 148) are on foot, though the two ensembles shown are different from each other, thus displaying the variety of musicians patronized in the household. Just ahead of the young princes are four musicians—two singers with accompanists; behind them, and beside the courtiers on horseback, are at least two singers and two more instrumentalists.

No women musicians are evident in these scenes of the marriage procession for Shah Shuja‘, although he is reported in a somewhat malicious fashion by the gossipy Manucci to have enjoyed their company:

Shah Shuja‘ followed the habits of his father, being a lover of songs, dances, and women, among whom he spent days without giving audience, drinking wine to excess, and spending a great deal of money on dancing women, to whom he gave valuable jewels and handsome clothes, conferring on them increased pay, as the fancy took him, without any regard to merit. (Manucci 1907, 1:219)

The same succession of events is enumerated in the *Pādshāh Nāma* on the occasion of the marriage of the third of Shah Jahan's sons, Muhammad Aurangzeb Bahadur, who eventually became the emperor ‘Alamgir I. While not mentioned in the prose account, there are musicians in the illustration of fol. 218v, "Shah Jahan honoring Aurangzeb at his wedding, 19 May 1637" (fig. 108). Strikingly, female singers predominate in the clusters of musicians who entertain below the now-familiar balcony. To one side the group is joined by a male *naqqāra* player and *bīnkār* as well, complementing the one woman who plays *dā'ira*. On the other side, a woman plays a gaily decorated cylindrical drum, joined by a male *rabāb* player. Why the predominance of female musicians? It is tempting to suggest that it is due to the lower rank of the third son. Relatively less was

Detail of figure 108

spent on the celebrations as we move down the line of sons; whereas about 32 *lakh*s of *rupee*s were spent on the marriage of the heir apparent, Dara Shikoh, only 10 *lakh*s of *rupee*s were allotted to that of Aurangzeb. Perhaps it was the choice of the woman who managed the celebration, or perhaps it is just one of the musical possibilities for such a celebration that is depicted here simply for pictorial variety in the manuscript.

It is also very striking in figure 108 (see detail) and in figure 146 that the women singers are so numerous as to constitute a chorus. Might there even be two different choruses? It is possible. In Niccolao Manucci's account of marriage customs, he mentions choruses of women singers, albeit placed at the bride's home rather than in the groom's father's place. I include his observations here because they ring true relative even to modern Indian customs.

The bridegroom enters, followed by his relations, servants, and slaves, and the rest of the men must remain without. . . . In the midst the bride is sitting on a highly decorated throne, clad in costly raiment and adorned with precious jewels. Round her stand many matrons with many instruments of music.

On the bridegroom's arrival opposite to her, never having seen her before this moment, he salutes her and makes the customary bows; and the singers, raising their voices, proclaim a welcome to the bridegroom, with wishes for the happiness of the marriage. At this point an aged Mulla (man of religious learning) appears; he is the priest. He holds his head low and keeps his eyes down, in a very modest attitude. He makes them husband and wife on condition that if there is any divorce the bridegroom will have to pay the bride so many millions.

> Once more the singers begin their song, saying these words: "May the marriage be blessed a hundredfold." They divide into two choirs, one singing the bridegroom's and the other the bride's praises. (Manucci 1907, 3:144)

In figure 108 there is the suggestion through different instruments of a chorus on the left and another on the right. A cylindrical drum is being played on the right, whereas *dā'ira* is played with the group on the left. This being an entirely groom's-side scene puts the bride-and-groom's choruses configuration into doubt, but juxtaposition of multiple ensembles is unusual neither in real life nor in paintings.

Women's choruses were not a new phenomenon in India. In the thirteenth-century Sanskrit treatise the *Saṅgītaratnākara,* for instance, the author is quite explicit about the performing forces (as pointed out by Prem Lata Sharma, pers. comm., August 1994).

> In the best ensemble of songstresses there are two main songstresses, ten subsidiary ones, two flutists and two players on the mardala. The medium ensemble consists of one main songstress, four subsidiary ones and one flutist. (*Saṅgītaratnākara* 3:204–9)

In his *A'īn-i Akbarī,* Abu'l Fazl confirmed the Indian tradition in the sixteenth century of groups of women singers in ensembles to accompany women dancers.

> The *Akhārā* is an entertainment held at night by the nobles of this country, some of whose (female) domestic servants are taught to sing and play. Four pretty women lead off a dance, and some graceful movements are executed. Four others are employed to sing, while four more accompany them with cymbals: two others play the *pakhāwaj,* two the *upang,* while the Dekhan *rabāb,* the *vinā* and the *yantra,* are each taken by one player. (*AiA* 3:273)

While the most important marriage of each of Shah Jahan's sons is celebrated in painting, it is not to be assumed that they married only once. A case in point is his first-born son, who is shown in a beautiful painting, "A young prince [Dara Shikoh] with scholars and companions in a garden" (pl. 20).

> [He was] a man of dignified manners, of a comely countenance, joyous and polite in conversation, ready and gracious of speech, of most extraordinary liberality, kindly and compassionate, but over-confident in his opinion of himself, considering himself competent in all things and having no need of advisers. . . . He was very fond of music and dancing, and once fell in love with a public dancing-girl named Ranadel (Ra'na-dil). His love was so violent that when his father refused his consent to a marriage with her, the prince began to pine to death. Seeing this state of things, Shahjahan was obliged to accord permission for the marriage, and she was granted the same dignities as the other princesses. This Ra'na-dil displayed afterwards her love and fidelity to Dara. (Manucci 1907, 1:213)

Imperial Birthdays and New Year's Celebrations

Other festivals at which women musicians entertained were birthdays, when the emperor and his sons were weighed and distributed commensurate gifts and especially on the New Year (*nawruz*). Such activities are recalled from the earlier Jahangiri times.

As this was the first New Year's Day (1606) after my auspicious accession I ordered them to decorate the porticoes of the private and public halls of the palace, as in the time of my revered father, with delicate stuffs, and to adorn them handsomely. From the first day of the Naurūz to the 19th degree of the Ram (Aries), which is the day of culmination, the people gave themselves over to enjoyment and happiness. Players and singers of all bands and castes were gathered together. Dancing lulis and charmers of India whose caresses would captivate the hearts of angels kept up the excitement of the assemblies. I gave orders that whoever might wish for intoxicating drinks and exhilarating drugs should not be debarred from using them.

In my father's time it had become established that one of the great nobles should prepare an entertainment on each of the 17 or 18 days of the festival, and should present His Majesty the king with choice gifts of all kinds of jewels and jewelled things, precious stuffs, and elephants and horses, and should invite him to take the trouble to come to his assembly. By way of exalting his servants, he would deign to be present, and having looked at the presents would take what he approved of and bestow the remainder on the giver of the entertainment. . . .

On the last day of the feast of the New Year, many servants of the State were honoured with favours and increase of rank. (*TiJ* 1:48–50; see also chapter 5, note 22)

The *Pādshāh Nāma* provides us a view of a birthday celebration (fig. 140), the ritual weighing of Shah Jahan on his forty-second lunar birthday (23 October 1632). (The weighing is shown on one folio of a double-page illustration; only the second folio is reproduced here.) Women dancers grace the occasion, moving in uncoordinated steps in a circular formation. Beside them stands a collection of male musicians who are their accompanists, while above them, but unrelated (I think), a *naubat* ensemble blares forth. The one dancer who is not wearing the typical Indian woman's clothing may be a Turki dancer whose costume is gradually being adjusted to Indian style; a rather similar cap is worn by two women dancers in the Jahangiri illustration (pl. 16), one of whom carries the castanets that were usually used by the Turki women dancers in Akbari paintings.

The chief ladies of the court were also obliged to attend birthdays and the New Year celebrations at the palace to pay their compliments to the queens and princesses and to offer costly gifts.

The dancing-women and singing-women receive on these occasions handsome presents from the princesses and other great ladies. They either sing to compliment them on their birthday, or invoke on them all kinds of prosperity when congratulating them at the New Year.

The ladies respond then to all the praises, which the singing-women never fail to shower on them, by full trays of gold and silver coin which they throw to them. (Manucci 1907, 2:322–23)

While there are certainly women musicians and dancers in Akbari-period paintings, the presence of such large groups of them in the paintings of the *Pādshāh Nāma* is truly striking. That Shah Jahan was entertained regularly by women musicians is a fact, but here we see fairly large groups of dancers, accompanied by male musicians. Perhaps they are of a group named by Niccolao Manucci.

Among them is one caste called Cancheny (*Kanchani*), who were under obligation to attend twice a week at court, for which they received pay, and to perform at a special place which the king had assigned to them. This class is more esteemed than others, by reason of their great beauty. When they go to court, to the number of more than five hundred, they all ride in highly embellished vehicles, and are clothed in rich raiment. All of them appear and dance in the royal presence. . . . Ordinarily the dancing women dance in the principle open places in the city, beginning at six o'clock in the evening and go on till nine, lighted by many torches, and from this dancing they earn a good deal of money. (1907, 1:189)

We should remember in reading Manucci that it was a Mughal princess who arranged for the entertainment at important imperial festivities such as the marriages of princes and celebrations for the New Year. They, too, had musicians and dancers in their employ, so the artists we see entertaining in these paintings could have been performers who were fairly cloistered except at such festive celebrations, or relatively more public women.

In any event, the grand numbers of performing forces in these celebratory paintings impart the feeling of security of the ruler, and extreme wealth and status. Shah Jahan was an impressive administrator who solidified the empire, providing a certain stability and splendor which exuded the aura that imperial greatness had reached its zenith.

Aurangzeb, or ʿAlamgir I

Aurangzeb (Ornament of the Throne), known after 1658 as Emperor ʿAlamgir I (Seizer of the Universe), was a very different person from the father he ousted; and he himself displayed two different persona during his long rule. At the start of his reign, we have the sense that court life continued somewhat as usual:

The weighing ceremony of the forty-first solar year of the Emperor's life was celebrated [1658]. The servants from far and near, got . . . jewels and other gifts, and thousands of musicians and needy persons collected sums of money (which could last) for years. (*History of Alamgir* 51)

On the occasion of his official coronation in the second year of his reign:

The doors and walls of the apartments near the Imperial residence, the *Diwan-i-ʿAm* and the *Ghusl-khanah* (Council Chamber) were all decorated with carpets, brocade and cloth woven in gold and silk thread. . . . The coquetish singers with thousands of blandishments were present at the gatherings, and by their varied tones and rhythms they lent colour and excitement to the music and dancing parties. . . .

The celebrations continued for two months and a half. Every night there was a display of skill in fire-works and illuminations. . . . On the banks of the river below the Fort the decorated and illuminated boats entertained the sight-seers with the beating of drums. (ibid. 80, 82–83)

The (advent of) third year of the reign . . . was celebrated in such a way (that the Palace) became a true model of the garden of paradise; on each side of that the world-illuminating

house of pleasures and also within its precincts, venus-faced singers, dancers like houris and heart enchanting musicians, created a tumultuous life of enjoyments on the occasion.

> *Verse*
> The voice of the musicians and the notes of instruments,
> were in perfect harmony in this gathering of joy.
> On every side the coquetish and the enchanting dancers were
> busy in dancing and stretched their hands to snatch the heart.
> From the handsome mouth of every singer came the sound of
> "tahe tahe" like the sound of "Qul Qul" that [came] from the
> narrow necked decanters.

. . . Khushhal Khan Kalawant, the chief musician, was weighed in silver coins which came to seven thousand rupees. This amount was given to him in reward. (ibid. 112–23)

Though Manucci did not place his description of life in the *ḥarem* into any specific time frame, he does supply substantial detail about women musicians in that segment of Aurangzeb's imperial household. That sovereign conferred special names on the female superintendents of the women musicians and dancers; Manucci lists thirty-three superintendents with a translation of the titles: Surosh Bae was "The lady with the good voice," for instance; Chanchal Bae was "The Bold"; Dhyan Bae was "The Well-informed"; Kesar Bae was "Saffron" (1907, 2:313).

> All of the above names are Hindu, and ordinarily these overseers of the music are Hindus by race, who have been carried off in infancy from various villages or the houses of different rebel Hindu princes. In spite of their Hindu names, they are, however, Mahomedans. Each has under her orders about ten apprentices; and along with these apprentices they attend the queens, the princesses, and the concubines. Each one has her special rank according to her standing. The queens and the other ladies pass their time in their rooms, each with her own set of musicians. None of these musicians are allowed to sing elsewhere than in the rooms of the person to whom they are attached, except at some great festival. Then they are all assembled and ordered to sing together some piece or other in praise of, or to the honour of, the festival. All these women are pretty, have a good style and much grace in their gait, are very free in their talk and exceedingly lacivious, their only occupation, outside the duties of their office, being lewdness. (Ibid. 313–14)

It is easy to imagine that it was these "household" women musicians who rode in the palanquins on the backs of elephants in the wedding procession for Aurangzeb's older brother, Dara Shikoh (fig. 87, see detail on p. 179). One has turned around completely to face the elephant driver rather than her fellow musicians.

In terms of instrumentation, these ladies reveal that they are comfortable mixing the West Asian frame drum and the South Asian cylindrical drum to accompany their singing. There is nothing to suggest that they were from different cultures, as women *dāʾira* and *ḍhol* players would have been in the Akbari period. It is clear that in these illustrations we are witnessing a gradual merging of musical traditions.

In the eleventh year of his reign, however, Aurangzeb's conduct of affairs began to change radically, in keeping with the dictates of orthodox *Sunni* Islam and also probably reflecting a

growing ossification of empire. The Mughal rulers through Jahangir had exhibited flexible *modi operandi* and *vivendi,* and Jahangir's government and state activity evinced a certain fluidity expressed, perhaps, in the vivacious art produced during his reign. Shah Jahan's empire became more static, more rooted in place, perhaps best symbolized in the enormous architectural monuments of his reign, including his own Shalimar Gardens in Lahore, the magnificent Taj Mahal in Agra, and in Delhi the Red Fort, the Great Mosque, and his new capital—a whole city, Shahjahanabad, today's Old Delhi. This consolidation and growing stasis perhaps set the context for Aurangzeb's gradual change.[11] This is revealed in the history of the period, too, for instead of the florid passages cited above, written in the style of Abu'l Fazl, we have a straightforward account, from the second decade of Aurangzeb's tenure on, of battles and awards, of struggles but of drums of victory. The emperor 'Alamgir I effectively spent the bulk of his reign attempting to wrest control of the elusive Deccan area of middle India, throwing the great riches of his kingdom into fruitless military might (maps 20, 21).

As part of his conservative legacy, Aurangzeb's reputation in music history was sealed forever as a result of the following event, which occured at some point between his eleventh and twenty-first years of rule:

> The *kalanwats* and the *qawwals,* famous for their performances, who were employed as state musicians were asked to take a vow of leaving their professions, and their ranks were raised: an order was promulgated prohibiting music and dancing. They say that one day a large party of *kalanwats* and *qawwals* assembled and made great noise; they took a funeral procession, weeping and wailing and passed by the foot of the *jharukah-i-darshan.* On receiving the report the Emperor inquired about the funeral. The *kalanwats* said: "We are carrying the dead body of the music so that we may bury it." The Emperor replied: "Bury it deep in the ground so that no sound or voice may come out of it again." (*History of Alamgir* 215)

The prohibition against music applied to all and included religious hymns sung on the anniversary of the birth of the Prophet (Hallissey 1977:85).[12]

It was confirmed by a contemporary that 'Alamgir I early on tolerated music on occasions when traditionally it had become part of the court ceremonial, as with specific celebrations; and on such occasions the musicians were rewarded in the usual way. Later, the musicians attached to his court were given other duties to perform at enhanced salaries when music was discontinued at imperial functions (*Alamgirnāma* 1072, 448). Manucci asserts, however, that music and dance continued in his palaces for the diversion of the queens and his daughters (2:312).

Transformations in Instrumentarium

With Plate 16, possibly a wedding procession in the *Tūzuk-i Jahāngīrī,* and with the accompanists for the women dancers in figure 140, I will now focus more intensively on a critical point of this chapter: whereas West Asian instruments predominate in paintings of the Akbari period, a gradual transformation and in some cases Indianization of the instrumentarium at the Mughal court is evident through the paintings of the Jahangiri and especially the Shah Jahani period. Already evident is the change from one or two Indian female dancers providing entertainment (pl. 15, fig. 54)

or one, two, or three Turki women dancers (pl. 8, pl. 13, pl. 11) to larger groups of women dancers, and also choruses of singers. While those were probably a matter of pictorial choice in increasingly wealthy court spheres, the paintings probably also record the reality of transformation as it is underway.

PLUCKED LUTES (*RABĀB*)

Significant in paintings throughout the Mughal period are plucked lutes (see chapter 5). Those in the Jahangiri wedding procession and in the Shah Jahani birthday celebration are the *rabāb* type. In chapter 5 I mentioned a distinctive *rabāb* type of plucked lute that appeared in Indian paintings produced during the Akbari period but mostly outside the imperial ateliers and that appears to have been an instrument of specifically Indian culture (fig. 130). The most distinctive characteristic of those lutes is the mechanism for attaching the pegs—not the bent scroll that predominates in Akbari paintings, but a rounded (I call it bulb-like) attachment to the back of the neck. Suddenly, in paintings commissioned by Jahangir, instruments with that type of peg attachment appear in the hands of male musicians in a Mughal context, the wedding procession (pl. 16). It continues in imperial currency from that time on, played by Shah Jahan's lutenists in figures 140 (see detail) and 87.

This *rabāb*-type plucked lute simply does not appear to have been part of the instrumentarium fostered by Akbar. In an act of imperial patronage, Jahangir brought it into court music. One supposes, for instance, that when he rebelliously established his own court in Allahabad before his father's death, he asserted his independence in this musical way, fostering the musicians who specialized in this *rabāb* type of plucked lute. He might have known musicians who played this type of *rabāb* from his upbringing by his Rajput mother. There are certainly regional variants of instru-

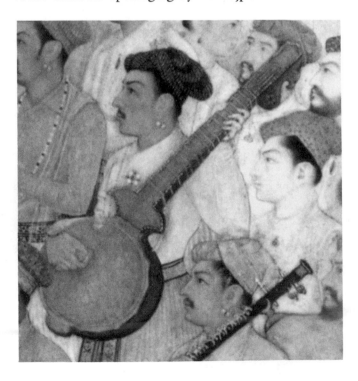

Detail of figure 140

mental style and vocal style in India today, and pictorial evidence indicates that they flourished in the sixteenth and seventeenth centuries as well.

When it reemerges in the paintings, this plucked lute is a more substantial instrument with a larger resonating chamber than the one depicted in the 1560s. It has two other distinguishing characteristics as well: an appreciably longer neck (length of neck plus scroll relative to length of face plus neck link) and also a considerably wider neck (see, for example, fig. 130, c. 1598–99; fig. 149, c. 1625; and fig. 140, painted c. 1635). While instruments with relatively longer necks do appear in Akbari-period paintings (pls. 2, fig. 22), instruments with relatively shorter necks definitely predominate in them. Finally, the shape of neck link that more closely resembles the curved-under ram's horn shape (albeit truncated) of some Central Asian lutes can be seen in figures 87 and 140. This shape of neck link is shown on the plucked lutes only after the Akbari period. Andrew Grieg dubs the plucked lutes with these characteristics the "Indian" *rabāb* (Grieg 1980:167). Comparison of all these instruments with that bulb-like peg attachment in these paintings reveals that the instrument was not standardized, just as instruments are not to the present day.[13]

An utterly different type of plucked lute is drawn in figure 150. Every element of this picture suggests rusticity. While this painting is titled "The *tāmbūra* player" in art/historical sources, the lute is not to be mistaken for the *tāmbūr* that is mentioned in so many contemporary sources from the court-related culture. There are insufficient occurrences of it in Mughal paintings to do more than include mention of it.

BOWED LUTES

In the Jahangir marriage procession (pl. 16), two male musicians play bowed lutes as well; the one just below the *bīnkār* on the right side is easiest to see. The instrument is not the long Persian *ghichak/kamānche* (spike fiddle) that is discussed in chapter 4. Indeed, another type of spike fiddle is depicted in Mughal paintings even in the Akbari period, and it differs from the *ghichak* in several ways. The proportions are different in that the lower spike is short; the neck is thin, is relatively longer or shorter, and has parallel sides. The pegbox is not incorporated within the line of the neck but is a small, more or less rectangular box, with or without a decorative finial above it. This can be seen in figures 48, 89, and plates 12 and 16. The sound box may be striped or solid, without decoration or construction from strips of wood. Strikingly similar to the shape of the pegbox and knobbed finial in figure 48 is the instrument in figure 151, though the latter instrument has a shorter neck, relatively speaking.[14] The instrument in figure 35 (see detail) is a composite of two types: a long, *ghichak*-like ornate spike out of the bottom, but a very long neck with parallel sides and box-like pegbox. An instrument called *sārangī* was mentioned by Abu'l Fazl in the *A'īn-i Akbarī*: "The *Sārangī* is smaller than the *Rabāb* and is played like the *Ghichak*" (*AiA* 3:269). Are the Akbari-period spike fiddles with rectangular necks that Indian instrument? Or is the bowed lute in plate 16 that Indian instrument? Certainly, the term *sārangī* now indicates an instrument with an extremely wide neck, relatively speaking; but more important organologically, it is not a spike fiddle because the neck stops where it meets the resonating chamber. Discussed fully by Joep Bor is figure 152, a folio from a late Shah Jahan Album which he considers to be the first depiction of a *sārangī*.

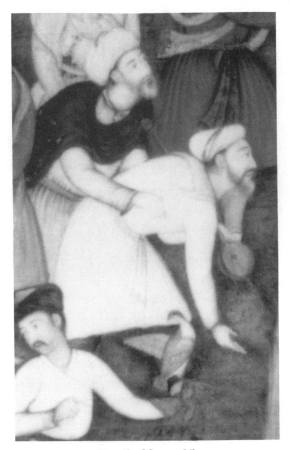

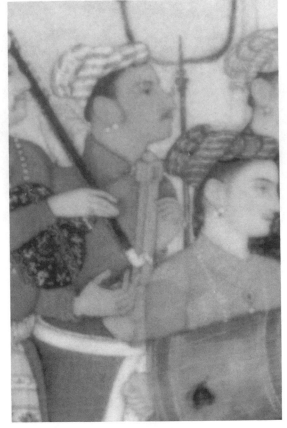

Detail of figure 35

Detail of figure 133

The first [painting] to feature a sarangi player dates back to the beginning of the 17th century. It depicts a left-handed fakir, playing his instrument under a tree, accompanied by a musician playing a *dhol* (or *duhul*). Four men, one of them a prince (perhaps Dara Shukoh), are listening to the music. The painting shows a number of relevant details. The sarangi has a box-shaped resonator with a broad stringholder at the bottom, a long wide neck, a pegbox with an arch-shaped opening, and, on top of it, a characteristic decoration. It has four playing strings, six or seven resonance strings, a nut, and a bridge.

Its resemblance to the present-day Gujaratan sarangi is indeed remarkable. The main difference is that the belly of the latter instrument is slightly waisted. Listening to its last interpreter, Hayat Mohmad Langa, we can easily imagine ourselves hearing the sarangi player in the painting over three and a half centuries ago. Time seems to have stopped. Was he perhaps Allah Dad Dhadhi? He must certainly have been a famous musician, because he features in at least three paintings, each in a slightly different setting. Whoever the sarangi player was and wherever his instrument originated—in Rajasthan, Gujarat, the Punjab or Uttar Pradesh—it is obvious that his sarangi was a sophisticated bowed instrument which, for centuries to come, would survive virtually unchanged. (Bor 1987b:55−56)

The prince listening to the *fakīr* with his friends may indeed have been Dara Shikoh, because he seems to have been a patron of bowed-lute players. The *sārangī* appears among the bevy of musicians gathered for the celebration of his marriage in that same year (1633), with the suggestion

that the player might have been in the prince's retinue (fig. 133, see detail). (No bowed lute player is among the musicians in the celebration scenes of either of his brothers' weddings.) It is a different player, however; he is right-handed and seems to be a court musician. Furthermore, his instrument is a different shape. Although the cavity in the pegbox is arch-shaped, the pegbox itself is not in a continuous line with the neck; it protrudes in box-like fashion. Unfortunately, his bowing hand blocks the whole shape of the lower body, but beneath the hand it is clearly rounded.

Among the several opinions cited by Joep Bor about the manner in which the Indian bowed lute, the *sāraṅgī*, came into existence are two that will sound familiar from the *Tūtī Nāma* story about the invention of musical instruments (fig. 16; see pp. 25–26 where the instrument created is a *vīṇā* rather than a *sāraṅgī*), thereby linking the term *sāraṅgī* to stories from Muslim Indian culture of at least the fourteenth century. While Hindu *sāraṅgī* players usually mention Ravana as the inventor, Muslim artists often give credit to a learned *hakīm* of the ancient past. As cited by Bor from Begum Fyzee-Rahamin (1914), in the story

> a hakim was once travelling on foot and, worn out with heart and fatigue, stopped to rest beneath a huge tree. Suddenly some sweet strains of music reached his ears; astonished, he listened attentively, and searched in vain from whence the sound came, until, at last, looking up, he discovered the object of his search. The dried skin of a dead monkey was stretched between two branches entangled with its dried guts, and the wind blowing through it caused melodious sounds. He carefully removed the skin and guts, replaced them on a construction of wood and after some years of labour, with due modifications and additions, completed the present-day sarangi.
>
> The same story was told to me [Joep Bor] by a musician, but here the leading figure was a Greek, Bu Ali Ibn Sina, supposedly a disciple of Pythagoras! "He was a renowned physician who treated his patients with herbs and music. Later on the sarangi was brought to India and improved upon." (Bor 1987b:48)[15]

Bowed lutes are played in that grandest of all imperial Mughal processions for the marriage of prince Dara Shikoh: mounted on horseback are platforms bearing ensembles of male musicians. Among the male musicians are two players of bowed lute (fig. 87, see detail), not of a "rectangular" *sāraṅgī*, but a smaller instrument that may be the one played by the court musician in figure 133 because the pegbox is the same design. The neck is slighter, however. The instrument played on the lower of the two palanquins has a diamond-shaped protrusion at the bottom that is probably a string attachment mechanism. If the instrument on the upper palanquin has that appendage, it is not visible; it would also serve as a means of support when tucked into the musician's sash.

Who were these male musicians? Possibly they and many of the other court musicians pictured in these Mughal court paintings were *dhādhi*s, a community of musicians spoken about in commentaries from the *A'īn-i Akbarī*, in the writings of Sikh religious leaders, in the *Kitāb-i Nauras* of the Deccani ruler Ibrahim Adil Shah, and in a work authored by Faqirulla contemporary with the reign of Shah Jahan. According to Faqirulla, the majority of the *dhādhi* were singers and composers, or players of *rabāb, pakhāvaj, ḍaf/dā'ira*, and—pertinent here—*sāraṅgī* (Sarmadee 1984–85:23).

A third shape of Indian bowed lute is depicted in an early seventeenth-century painting of a

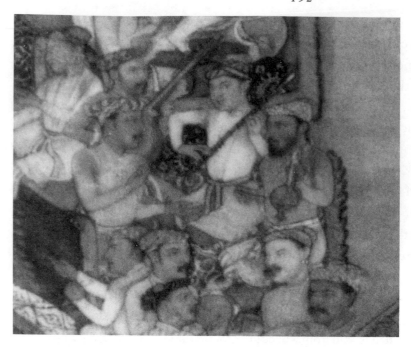

Detail of figure 87

dervish with a rustic musician whose dancing motion has upturned his sleeve, thus depriving us of a view of the pegbox (fig. 153). "The three-stringed sarangi resembles a *chikara* but is lacking in fine detail," says Bor (1987b:57).

After thorough discussion of documentation for the history of the *sāraṅgī* and its depiction in paintings, Bor concludes:

> Mughal paintings from the 17th century show different types of sarangis, but all that these paintings have in common is the setting. The fiddler always sings and plays in the vicinity of holy men, Muslim or Hindu. His sarangi is small, light and portable, and this, combined with its expressive sound quality, makes it an ideal instrument to accompany devotional songs. (ibid.)

To see how Indianized the characterization of dervishes had become, one need only contrast figure 153 with figure 119, a Persian painting.[16] In general, the paintings reflect the diminishing interest in the West Asian spike lutes through the Mughal period.

DRUMS

Similar changes apply through time as regards the drums. Indian music dominates in the cluster of musicians on the bottom right of the illustration of the Jahangiri wedding procession (pl. 16). A man who is probably a *pakhāvaj* player stands at the very bottom, back turned to us, with his arms out to reach the heads of a large double-headed drum. This is notable because the few Akbari-period paintings I have located that show the *pakhāvaj* place it in the hands of female dance accompanists (pl. 15 and fig. 17). Male players of *pakhāvaj* do occur in provincial paintings of the period (fig. 51). Thus, the male *pakhāvaj* player in this group suggests that Jahangir was again making a change. Male *pakhāvaj* players abound in the illustrations for the manuscript of the Hindu *Yog Vashisht* which he commissioned. In plate 16 the *pakhāvaj* player stands beside a player of an Indian

drum in a depiction familiar from Akbari paintings—the waisted *huruk* that is being held down at arm's length, with the left hand squeezing the lashing rope and the right hand drumming. Joining the bevy of Indian women singers in that group is one woman who plays the cylindrical *dhol*, also familiar from Akbari paintings. To have three types of Indian drums in one court scene is a significant change. The West Asian *dā'ira* is being played at the top of the cluster, presumably by one of the two turbaned women who stand directly behind the two women dancers; they are the only overtly non-Indian element in the entertainment.

While in occasional depictions in the Akbari period the *dhol* was played by males as an instrument of the *naubat* ensemble,[17] in the Shah Jahani period it was played by males in court entertainment contexts as well. A beautiful cylindrical drum is used by an accompanist for the female dancers at the weighing celebration (fig. 140, see detail); because it is not covered with decorative fabric, the Y-pattern of the lashing is clearly visible. What appear to be tassels hanging from the lashing lend elegance to the instrument. A more ordinary instrument is used by the musician in the gift procession for Dara Shikoh (fig. 87, see detail on p. 180); its lashing is a V-pattern. If the drum in figure 154 is indeed a cylindrical drum as the one visible end suggests, it was also used in quiet contexts: dignity and calm reigns in "A prince meeting a holy man," illustrated c. 1640 in the period of Shah Jahan. These drums are being played with the hands, suggesting that the court tradition was different from a folk tradition depicted in the period of Aurangzeb (fig. 118, see detail). As men pass in "A review of troops," from the *Mathnavī* of Zafar Khan, a *dhol* player using a stick to beat his drum plays in the distance with other instrumentalists to service dancers of what appear to be three different dance styles.

One further development, or at least difference, with regard to a percussion instrument can be noted. Tucked behind the player of *rudra vīṇā* in the birthday celebration illustration (fig. 140,

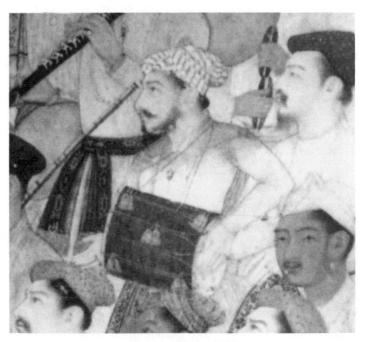

Detail of figure 140

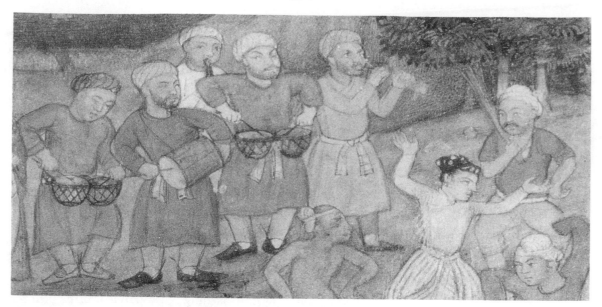

Detail of figure 118

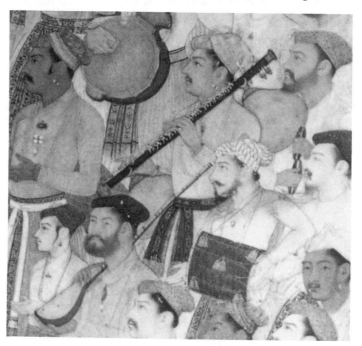

Detail of figure 140

see detail) has been included a truly unusual detail: a *man* plays the castanets that we have seen earlier in the hands of Turki women dancers in so many Akbari paintings.

MALE SINGERS

There are additional new musical developments, or at least differences, to note in both the Jahangiri wedding procession and in the assemblage of musicians who accompany the female dancers at Shah Jahan's birthday celebration. One is the number of male singers: whereas in earlier paintings there are no more than two male singers clearly distinguishable in any ensemble, in both these paintings

(pl. 16, fig. 140), there are at least four who have their hands upturned in the conventional position to indicate a singer. Not only, then, are female, but male choruses suggested as well.

Keeper of a Continuous Drone ($\mathit{T\bar{A}MB\bar{U}R}$)

Finally, and most significantly for what I propose, is the evidence of musical synthesis at the Mughal courts. In figure 140 (see detail), a man stands playing a plucked lute-type instrument called *tāmbūr* that he appears to be using for a drone (a constantly sounding reference pitch). About the drone in Indian music, the historian of music theory L. E. Rowell wrote:

> It is quite certain that the continuous drone had not yet become a standard feature of Indian music, and it would not become one until as late as the fifteenth or sixteenth century. It stretches belief that such an important practice, with so many symbolic connotations and so many practical consequences for musical style, would have been ignored by all the principal authors. It is also clear that the modal system prevailing as late as the thirteenth century had not yet settled upon [pitch] *sa* as a universal fundamental tone, and hence the choice of a particular ground tone for a drone would not have the same musical meaning it now holds. (1992:293)

It is entirely possible that a drone was being produced on a number of the instruments depicted in Akbari-period paintings that extend from the 1560s to 1605. A string or multiple strings on any plucked lute, for instance, or on the *rudra vīṇā* could have been tuned specifically for use as a pitch referent, or a string used both for melody and as a pitch referent. A flutist could have produced a reference pitch or even a continuous drone, as could a player of *surnā* or trumpet. One of the heads of a *pakhāvaj* might have sounded a clear pitch referent. We cannot discern that from the paintings. With visual evidence, it is only fruitful to look for an instrument that seems devoted to a musical role other than melody.

Detail of figure 140

Searching the Akbari-period paintings for any evidence of producing a drone, I examined a *Tūtī Nāma* folio (fig. 155) which illustrates the creation of musical science, showing a nobleman holding a book with one hand and a *rudra vīṇā* with the other. The presence of frets, of course, strongly implied that this is a melody-producing instrument, whether or not the player is using it as such at the moment of depiction. That a stringed instrument is being used primarily for a pitch referent rather than for melody would be most blatantly suggested by the use of a single hand on the instrument. I think we can assume that if an artist depicts a player with both hands busy, the implication is that melody is being made. On close examination of that painting, however, it appears that the nobleman is not playing at all. For that and for painterly reasons, I do not think that we should take this particular work as evidence of the use of the *rudra vīṇā* for a drone. Among the illustrations in Akbari-period paintings, I have found only the woman who holds a board zither in vertical playing position in a folio from the *Dārab Nāma* (fig. 58) to be a possible player of an instrument that is devoted entirely to the musical role of producing a pitch referent rather than melody.

Suddenly, in the *Yog Vashisht,* probably from the atelier of (the future) Jahangir, we see numerous depictions of a drone instrument. Even before his father died, then-prince Salim had established an artist's workshop. A Sanskrit text on Hindu spiritual mysteries that Akbar had translated into Persian, the illustrated manuscript of *Yog Vashisht* may have been commissioned by Salim and completed in 1602 or 1603. In a number of paintings, a *yogi*—colored blue like Lord Krishna—is unmistakable partly because he carries the instrument associated with Hindu holy men, the *rudra vīṇā*. (Even if he does not carry it, a *rudra vīṇā* rests on the ground, or on a raft beside him.) While the ten illustrations that include a *rudra vīṇā* differ sufficiently from each other that they seem to have been produced by several painters, they are consistent in that none shows the instrument being played with both hands. In three illustrations there is considerable indication that a reference pitch is being plucked by the one hand on the instrument, as self-accompaniment for singing. In figure 156, for example, the *yogi* is seated on a raft, singing as two oarsmen pilot the craft. He plucks with his left hand, as the instrument rests over his left shoulder, and he gestures with his right hand as he sings. The contextual suggestion in the *Yog Vashisht* paintings is that self-accompaniment on a drone pitch was commonplace in the singing of devotional songs by *yogi*s, even though it was not obviously a practice in the accompaniment of singing in the Akbari court context.

Then, after Jahangir became emperor, works produced in the imperial atelier depict delicate lutes with long, narrow necks held by male musicians in such a position that they could only be played to produce a drone. The bowl of the instrument is close to the face of the player, while the neck extends out beyond the player's back, balanced over a shoulder (fig. 157, dated c. 1591; fig. 158, dated c. 1590). In the Jahangiri painting of the Hindu festival of Holi, the lute is played by a woman (fig. 116). By Shah Jahan's time, the drone lutes come as no surprise (figs. 140, 154, and 159). In later paintings, the necks of the instruments are somewhat shorter.

To play these delicate instruments for the purpose of producing a drone, the men kneel on both knees, as most players of the *rabāb*-type instruments did and as the singers do in contexts that permitted any pose but standing. It was necessary for everyone to stand in Jahangir's presence in

figure 63; the *ṭāmbūr* player stands to the left about midway in the picture. He closely resembles the musician in plate 20. Somewhat closer to present-day position is the vertical manner of holding the drone-producing instrument that is shown in figure 158. There might be reasons for these exceptions. In figure 158 the bowl of the instrument is much heavier, although the neck is long and narrow; this could be a characteristic of a particular musician or—more likely—of the very large singer next to him who required a heavier instrument for his vocal quality or range. Such a heavy instrument could not easily be supported over the shoulder as the other instruments are.

With the instrument resting on or toward the left shoulder, the players of these drone-producing lutes are plucking with their right hand, using the left hand to gesture or to support the instrument (figs. 157, 158). They pluck the strings at the point where the bowl tapers to meet the neck of the instrument. Other musicians position the lute over the right shoulder (pl. 20, figs. 140 and 160).

In several of the paintings, it is clear that the lute player is accompanying a singer (figs. 158, 159). In figure 157, a pair of male musicians contribute to a mini-scene in the top margin in quintessential Jahangiri style. This lute player, too, performs with a man who is clearly singing.

The drone lute was used for self-accompaniment as well as with the singing of another musician. In figure 159, both musicians are clearly singing; the lute player's mouth is open and he, like the lute player in plate 20, is managing a gesture. Most decisive, however, is figure 154 (c. 1640), "A prince meeting a holy man," in which a singer holds his drone-producing lute while his fellow musician plays a drum.

A quiet mood prevails in most of the paintings in which the drone-producing lute occurs, even the minimally contextualized vignette in figure 157. Quite strikingly, the pair of male musicians—one of whom plays a drone-producing lute—makes its appearance with a thematic ilk of painting in the Jahangiri–Shah Jahani periods. Whether secular or sacred in setting, a group of congenial men spend quiet time together.[18] Figure 158, attributed to the painter Bishandas c. 1613, places the scene outdoors on a cool evening, as a prince and companions listen to music, smoke, and converse. A garden scene of more formal elegance (pl. 20) from an Album of Jahangir, c, 1625, shows Prince Dara Shikoh with scholars and companions. From the Shah Jahani period, a painting of c. 1655 (fig. 159) attributed to the artist Payag depicts officers and wise men enjoying one another's company.

The *ṭāmbūr,* as a drone instrument, was clearly ensconced in the instrumentarium for both informal and formal male entertainment by the mid-seventeenth century. The *ṭāmbūr* (plucked-lute) player among the accompanists for the female dancers at the birthday weighing (fig. 140, painted c. 1635) presents a striking contrast to the predominant scene-type of a quiet, informal gathering. In formal *darbār* session as well, a scene painted c. 1660 (fig. 132), after Shah Jahan had built his many-pillared audience hall, shows the drone player with singer and drummer standing among the courtiers to the side.

What is particularly fascinating is that the drone came to be produced in the Mughal period on an instrument that was imported from West Asia as a melody-producing instrument and that continued in use for melody-making beyond its adoption for the drone.[19] In the quiet, dignified

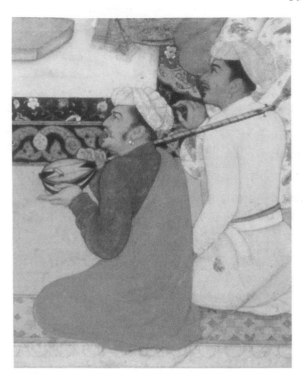

Detail of plate 20

scene of "Zafar Khan's outdoor pleasure party" (fig. 161), an Aurangzebi-period illustration of the *Mathnavī* of Zafar Khan painted in 1663, a musician plays a very long necked plucked lute which is similar to instruments on which drone is being produced. Its resonance bowl is made of wood, of the decorative strips that can be clearly seen in figure 159. Most decisively, in figure 161 that lute is being played with both hands and, undoubtedly for a melodic line, has very obvious frets along the length of the neck. Those lutes being used for a drone in plate 20 (see detail) and figures 160 and 140 as well still have frets up the neck. That plucked lute appears to have been a flexible instrument, used for either melody or for a pitch referent.

What we are witnessing in the paintings of the various reigns appears to be a real transformation in process, toward Hindustani music as we know it today. It is possible to conjecture that Jahangir, whose mother was an Indian princess, grew up hearing various types of Indian music as a part of daily life and therefore naturally welcomed more Indianized music-making in his culture sphere (fig. 116). There is certainly evidence that the Indianization of court music accelerated from the period of his reign.

Stability within Transformation

BOARD ZITHERS

In change, of course, there is also continuity. One case in point is the *qānūn* or *svarmaṇḍal,* which is clearly an instrument of West Asian origin that remained in currency through the period of Shah Jahan (fig. 87, see detail on p. 180) and beyond. The *qānūn* and/or the *svarmaṇḍal* (*svaramaṇḍala* or *surmaṇḍal* or *sarmaṇḍal*) are board zithers, in effect a box over which a number of strings run,

above the full length of the sounding board in a plane parallel to it. Abu'l Fazl's material on the Akbari period mentions both instruments, and they were apparently very similar: "The *sarmandal* is like the *Kānun*" (*AiA* 3:269). In Abu'l Fazl's descriptions of numerous Indian instruments in that section of the *A'īn-i Akbarī*, he distinguished them from each other by such basic morphological details as the design and length of a neck, presence and number of frets, material and number of strings, and number and nature of resonators. Unfortunately, his description of the *svarmandal* and *qānūn* was limited to the strings: "It has twenty-one strings, some of steel, some of brass, and some of gut" (ibid.). That statement can be interpreted to say that they were alike with respect to the strings, since in other comparisons of instruments in this section the distinctions were framed as such: "The *Sar-vinā* is also like the *Vinā*, but without frets" (ibid.). It is also possible that Abu'l Fazl meant to suggest a difference, that the number of strings on the *svarmandal* was smaller or larger than those on the *qānūn*, and that the material of the strings was different. The paintings offer no clarification.

The paucity of information given by the usually indefatigable Abu'l Fazl indicates perhaps that he could assume that his readers would know about the *qānūn*, because it was in common use, but that cannot be affirmed or denied by the paintings. If the depictions of the harp were few during the Mughal period, the depictions of the *qānūn/svarmandal* surprisingly are even fewer. It is not a type of instrument that could be played easily in a standing position; that factor might have eliminated it from depiction in many miniatures, because the court etiquette dictated a standing position for servants and other attendants. Players could have suspended it by a cord around their shoulders, however, so I consider its absence from scenes of formal court sessions to indicate that the instrument was used in private circumstances where the musicians could play with the instrument flat to the floor or resting on the crossed legs of the seated player.

A *qānūn* player was first singled out by name in the *Akbar Nāma* in Abu'l Fazl's account of Humayun's reception in 1544 by Shah Tahmasp's son, the governor of Khurasan (Herat) in Central Asia:

> It is proper that Ḥāfiẓ Sābir Qāq, Maulānā Qāsim Qānūnī, the qānūn player,[20] Ustād S̲h̲āh Muḥammad, the sūrna player, Ḥāfiẓ Dōst Muḥammad K̲h̲āfī, and Ustād Yūsuf Maudūd, and other famous singers and musicians who may be in the city, be always present, and whenever his Majesty desire it, please him by singing and playing so that any moment the king desired they would instantly play [tunes] to bring joy to His Majesty. (*AN* 1:427)

In the *Bābur Nāma* as well, a player of "dulcimer" was singled out among the musicians in the household of Babur's Timurid cousin in Herat, Sultan Ahmad Mirza: By name "Khwāja 'Abdu'l-lāh Marwārīd" (*BN* 291). The presence of *qānūn* players in the Timurid cultural sphere is thus documented in prose, however sparsely. Surprisingly for the few Akbari-period paintings that depict the board zither, players of both the *qānūn* and *svarmandal* are listed by Abu'l Fazl among the thirty most prominent musicians at the court of Akbar (*AiA* 1:681, 682). A musician from Gwalior, one Bir Mandal Khan, was the player of *svarmandal*; the player of the *qānūn* was one Mir 'Abdullah, brother to Mir 'Abdul-Hay. It is probably meaningful as evidence for cultural synthesis that both those players were Muslim.

Distinguishing the *qānūn* from the *svarmaṇḍal* in the paintings remains impossible. Shape is one way to consider the quandary. Only one generalization can be made for all the drawings: The longest side of the instrument is next to the player's body. A consistent feature in seven of the nine paintings that I have seen is a right angle created by two sides—the side held next to the player's body and the right side (figs. 162, 87, pl. 7, and fig. 37). Two have no right angle formed by two sides.[21] The sketch of such an instrument (fig. 163) by the artist Kesu also provides a good example of the interest shown by Mughal patrons and artists in Western art. Like most of the content of the painting, the board zither may have been incorrectly drawn from a European model. The character playing it, however, is straight out of Mughal central casting! Where the artist has included a line drawn in from and parallel to the right side, it is probably intended to indicate a long, fixed bridge.

The shapes of the board zithers differ beyond the right-angled sides, however. Two distinctively different shapes are drawn. A curve graces the instruments in figures 162 and 87.[22] In two other paintings, figure 37 and plate 7, the shape is trapezoidal, with the left side at an acute angle inward.

Could this element of shape be a distinction between the *qānūn* and the *svarmaṇḍal*? Perhaps. The gracefully curved instrument is shown in an illustration of the *Ḥamza Nāma* (fig. 162) of c. 1562–77, one of the two earliest manuscripts illustrated in Mughal style. There are arguments for and against the intention of the artist to be showing the South Asian *svarmaṇḍal*. Arguing for the intent is the player's proximity to a musician who is definitely Indian because he plays the *rudra vīṇā,* so it is possible that the artist intended to be showing the South Asian *svarmaṇḍal*. On the other side of the zither player are two *rabāb* players, however; that could be an argument either for or against, for the *rabāb* was a West Asian instrument. The *rabāb* had been ensconced on the subcontinent for a long time, and the shape of the peg attachment of the *rabāb* held by the player toward the bottom of the painting is the older type that was depicted as well in the Indian *Tūtī Nāma* manuscript of the 1560s–1570s. That suggests an Indian ensemble here, including a *svarmaṇḍal*. Significantly, the other miniature in which the board zither has the gracefully curving shape is from the Shah Jahani period (fig. 87), when the instrumentarium was becoming greatly Indianized. Among the instruments in the same painting, in fact, is that *rabāb* with the bulb-like peg attachment mechanism.

The trapezoidal shape, on the other hand, occurs in illustrations with more Persianate associations and may be the *qānūn*. The beautiful painting of the *Mathnavī* of Zafar Khan (pl. 7) depicts an ensemble marked as West Asian by the *kamānche* and the distinctive plucked lute. A miniature from the Walters *Khamsa* of Amir Khusrau Dihlavi (fig. 106) is a Mughal reinterpretation of a Persian literary work—the scene of Deval Rani and Khizr Khan sitting together to enjoy a dance performance.

Unfortunately, it is not possible to distinguish the *svarmaṇḍal* from the trapezoidal *qānūn* on the basis of West Asian pictorial sources. In the first place, few Persian paintings depict a board zither, and the relatively few that do show instruments with different shapes. A Shirazi painting of 1560, "Iskandar disguised as a legate with his portrait, before Queen Qaydafa" (fig. 164)—the interpretation of a scene from another story in the *Khamsa* of Nizami—shows a board zither which

has the right angle on the left side rather than the right, and a curvature on the right rather than the left; curvature it has, however. A board zither in a painting from Qazvin in 1579–80 has yet another shape—two right angles, and a single side that curves away from the player instead of toward the player; that painting depicts Timur feasting on the occasion of the marriage of his grandsons (Lowry and Beach 1988, pl. 39).

Playing technique is another factor to be considered for distinguishing the *qānūn* from the *svarmaṇḍal,* but there is insufficient evidence to draw any conclusions. In most of the paintings, both hands are being used to pluck the strings. In two of the paintings, a plectrum is clearly visible.[23] In plate 7 and figure 37, the plectrum seems to be just that, the color of horn and shaped for plucking. It is highly likely that melody is being produced with the use of both hands, with or without a plectrum. As well, it may or may not be significant that both of these paintings are highly Persianate in style.

To further complicate matters, a different playing position and technique occurs in a folio of a *Dārab Nāma* manuscript of c. 1585 (fig. 58): a woman holds a board zither vertically, supporting it underneath with her left arm, plucking only with her right hand. The shape of the instrument is rendered unclear by her body, but the suggestion of her position is that she might be producing pitch referents rather than a more elaborate melody, perhaps even in the wash-of-sound, multi-pitched droning manner of the modern use of the *svarmaṇḍal* by Hindustani musicians. Could this be a Mughal-period *svarmaṇḍal*? By dress we recognize the woman to be an Indian musician, and she stands next to what is clearly an Indian musician playing a *rudra vīṇā,* among other Indian women.

Does this configuration occur in West Asian sources? Yes. Reproduced in an article by the ethnomusicologist George Sawa is a trapezoidal *santir* from a fourteenth-century Egyptian manuscript: a male musician seated on a carpet holds the instrument in upright position with his left hand and plucks the strings with his right hand. Drawing on written information about *santir* from that time, however, Sawa argues against use of that painting as evidence for that playing position and suggests that the artist did not have at his disposal the necessary technique to portray with any accuracy of perspective a three-dimensional image on a two-dimensional surface (1989:15–16). Other similar visual reproductions of trapezoidal instruments, such as a sixteenth-century Byzantine fresco in Vertkov (1984) and a fresco labeled as eleventh century that I observed (1989) in the old cathedral at Mtskheta, Georgia (in the Caucasus), may also be misleading.

It is entirely possible that—as the paintings suggest—the board zither was used by Indian musicians, for Indian music, for both drone and melodic purposes in the sixteenth century. Unlike their fourteenth-century Egyptian counterparts, Mughal artists did draw board zithers in horizontal playing position; therefore the *Dārab Nāma* drawing of vertical playing should be taken more seriously. Perhaps the young woman really was playing pitch referents or a wash of sound. Perhaps this is a *svarmaṇḍal;* the term does suggest that it was used for giving the *svar*—"pitch."[24] If so, it would be a second West Asian type of instrument used in India for both melody and drone.

There are two additional explanations to include in this speculative discussion. It is difficult to imagine that Abu'l Fazl would list a musician who played only a drone instrument among the

primary musicians in Akbar's employ. That our esteemed chronicler would have listed players for the *qānūn* and *svarmaṇḍal*—although the two were not distinguishable either as physical objects or always by musical function—could be explained purely in terms of diplomacy, or as an indication of the separateness of West Asian and South Asian ensemble musicians. Whatever the case, the board zither type of instrument remained in use during the Mughal period from Akbar through Aurangzeb's time—and, indeed, to the present day.

Stick Zither (*Rudra Vīṇā*)

Another element of continuity in the instrumentarium in the Mughal courts that is present in Akbari paintings from the earliest manuscripts is the Indian *rudra vīṇā,* although the illustrations also reveal change in the instrument through time. Taking the paintings of the 1590s—the period of the musical leadership of Naubat Khan in Akbar's court—as a watershed, some physical differences can be seen in the *vīṇās* before and after that date. In early Mughal paintings, for instance, the lower end of the stem is usually a tailpiece that curves up to hold the string (figs. 155, 16). A different design may have been introduced by Naubat Khan, since it appears on the instruments in two of his portraits (figs. 72, 73). Sixty years later, it is there on a *rudra vīṇā* in a Shah Jahani *darbār* scene (fig. 132, see detail). Made of some gold-colored metal such as brass, its finger-like prongs reach back toward the stem; in figure 72, at least one string seems to be attached to a prong.

An increasingly larger size of gourds through the period of these paintings suggests a desire for more prominent sound from the *rudra vīṇā.* That is made clear by comparing the gourds in the *Tūtī Nāma* paintings of the 1560s–1570s (figs. 16, 155) with those on the instrument of the female musician in the illustration of the *Dīvān* of Anvari in 1588 (fig. 18). Whereas early instruments have a shape approximately half or five-eighths of the gourd and are smaller than, for comparison's sake, the head of the player, they become three-quarters to almost full gourds and much larger than the head of the player. That is also the case in figure 108 of the marriage of Aurangzeb, and "Prince and ascetics" (fig. 165). So distinctively large (and bell-shaped) are the gourds on the *rudra vīṇā* of the processing musician with the flowing white beard in figure 148 (and so striking is the player, see detail) that one wonders if this is portraiture of a valued musician in the household of the groom, Prince Shah Shuja'.

Standard coloration in early paintings was black gourd with red inside as in figure 16 from the *Tūtī Nāma.* Decoration increased, however, to dark blue, black, or green with gold-colored filigree. A plainer gourd becomes quite noticeable by contrast, such as those in the *Yog Vashisht* illustrations (fig. 156), and, strikingly, the huge resonators in figure 148.

There is the question of the relationship of the *rudra vīṇās* in Mughal paintings to those described in sixteenth-century writing. From information about the South Indian *vīṇā* described in the *Svaramelakalanidhi* by Ramamatya (1550), we might expect to see an instrument with seven strings and eighteen frets that were fixed in wax (Meer and Bor 1982:132). But that is not what we do see. Strings are difficult to depict on an instrument that is usually shown in profile. However, with pegs or a vertical stringholder at the upper end taken as visible indication of the number of strings, the instruments shown in the Akbari-period paintings have only one, or perhaps two,

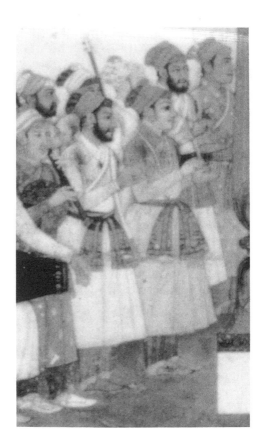

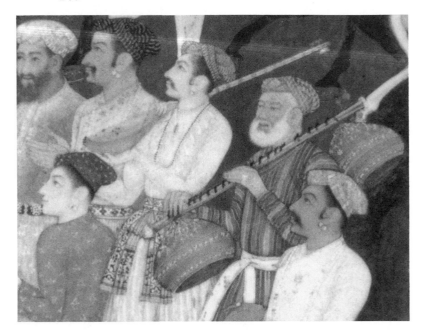

Detail of figure 148

Detail of figure 132

strings, with three strings indicated in Shah Jahani paintings; see, for example, the portrait of Naubat Khan (fig. 72), one of the *rudra vīṇā*s in the Jahangiri *Yog Vashisht* manuscript (fig. 166), and a Shah Jahani period instrument (fig. 140). Since it would have been entirely possible for more pegs to have been drawn on a number of the instruments in these paintings, I doubt that the *rudra vīṇā* in use in Mughal court ensembles was the same instrument as that described by Ramamatya for music in Andhra Pradesh.

Because the players' hands always cover frets, it is not possible to be precise about the total number on those instruments. Roughly speaking, there are eight or more frets on *rudra vīṇā*s in early Mughal paintings, but the number definitely increases even through the Akbari period. Perhaps significantly, the portraits of Naubat Khan show at least eleven frets. Two of the *rudra vīṇā*s in *Yog Vashisht* illustrations that are similar enough to have been painted by the same artist sport fourteen or fifteen frets, and there are at least that number of Shah Jahani–period instruments. In this respect, the later Mughal instruments are similar to those described by Ramamatya. There is insufficient consistency in spacing of the frets to draw any conclusion about tunings.

The frets in early Akbari instruments are very thick and high; they remain high in some later paintings but become more delicate. The shape of the frets remains consistent—wide at the stem, slimmer in the middle of the height, and wide again under the string. In only a few paintings is it possible to see such detail as the width of the fret at the top relative to string placement; in plate 1, however, Naubat Khan seems to have plenty of space for deflecting the string across his frets. It is possible to see that because the instrument is being held at a downward angle; indeed, Naubat

Khan may have initiated the diagonal holding position with the instrument supported under his right arm in order to facilitate greater use of such techniques as string deflection.

The Mughal paintings, then, provide evidence that the *rudra vīṇā* was becoming a more substantial instrument in morphological terms, more complex in terms of number of strings and frets, and more ornately adorned.[25] One can see its prestige increase. There is also some visual evidence that the distinguished musician Naubat Khan was responsible for—or at least associated with—some changes in the instrument and in playing technique and therefore in the music.

The ethnomusicologist Allyn Miner considers the musical role of the *rudra vīṇā* in the Mughal period to have been both an accompanying and a solo one (1981:358). In Akbari paintings, the *bīnkār* is rarely alone to suggest a solo role in the literal sense of the word. A *bīnkār* does stand without other musicians in "Submission of Ali Quli Khan Zaman" (Victoria and Albert *Akbar Nāma,* fol. 20), but the space on the balcony with Akbar is so constricted for the painter relative to its proportion with the total picture that this is scant evidence for a solo *rudra vīṇā* role. In informal contexts in Akbari-period illustrations, the *bīnkār* appears with other instrumentalists as well as vocalists; for example, one is depicted in ensemble with the vertical flute (*nā'ī*) in "The birth of Prince Salim" (fig. 54) and with flute and frame drum in "A prince, attended by maidservants and musicians, watches a girl dancer" (fig. 18). There is no way of knowing if one instrument or another provides a leading melodic role, in that sense of "solo." Thus I have found no incontestable visual evidence that the *rudra vīṇā* was or was not a solo instrument.

Link to the Present

The methodology I have used in tandem with visual sources, archival materials, travel accounts, and other primary documentation to undertake this ethnomusicological study of the Mughal era, to explain and analyze this long chapter in the history of Indian classical music, offers an indispensable tool and rich visual resource seldom employed in such an endeavor. It has undergirded my theoretical proposition about a cultural agenda of synthesis and aided exploration of change and continuity in musical instruments, music-making, music contexts, musicians, and patrons to support that theory of synthesis, of several musical cultures becoming one South Asian tradition: A North Indian classical music culture.

Perhaps most significantly for the purpose of tracking the history of Indian classical music, and to make a final point, one illustration of the reign of Shah Jahan can provide a clear link from the past to the tradition as we know it today. In figure 132, painted after his reign, c. 1660, Shah Jahan is shown holding a formal court session in his new audience hall, the design of which caused radical modification of the Persian model for scenes of *darbār*. The riderless horse outside the balustrade is still there—but joined by the mighty Indian elephant. The barrier to "the outside" is still there—but the courtiers beside the balustrade feel much farther away from the action due to the wide portico the emperor had built in front of the throne to protect his grandees from the hot sun. The sovereign himself is still there—but much less accessible, half hidden as he is by the design

of his throne. Finally, musicians are still there—but more of them. Significantly, the ensemble is familiar to us from performance of the vocal genre *dhrupad* (see detail, p. 202): two vocalists, a *ṭāmbūr* player keeping the drone, a *pakhāvaj* player. There is also a *bīnkār*, whose successors would have accompanied *dhrupad* until the eighteenth century or later and whose repertoire today is still based on that form. Suddenly, the Mughal period does not seem so long ago.

APPENDIX
LIST OF ILLUSTRATED MANUSCRIPTS AND ALBUMS

ABBREVIATIONS FOR MUSEUMS AND LIBRARIES

AIC	Art Institute of Chicago
AMSG	Arthur M. Sackler Gallery, Smithsonian Institution, Washington, D.C.
ASG	(see FAM; all materials cited in this book as previously held in the Fogg Art Museum at Harvard are now in the Arthur M. Sackler Gallery at Harvard and are cited as FAM).
BKB	Bharat Kala Bhavan, Banaras Hindu University, Varanasi, India
BL	British Library, London
BM	British Museum, London
BNP	Bibliothèque Nationale, Paris
BO	Bodleian Library, Oxford
BSK	Staatliches Kunstgewerbe, Berlin (now SBB, q.v.)
CAG	Calcutta Art Gallery, India
CBL	Chester Beatty Library and Gallery of Oriental Art, Dublin
CAM	Cincinnati Art Museum
CM	Cleveland Museum of Art
CMN	Chrysler Museum, Norfolk, Virginia
FG	Freer Gallery of Art, Smithsonian Institution, Washington, D.C.
FAM	Fogg Art Museum, Harvard University, Cambridge, Mass. (see ASG)
FLP	Free Library, Philadelphia
IMC	Indian Museum, Calcutta
ILT	Imperial Library of the Golestan Palace, Tehran
IOL	India Office, London
Keir	Keir Collection (private collection)
KBL	Khuda Bakhsh Oriental Public Library, Patna
KM	Kunsthistoriches Museum (Museum of Applied Arts), Vienna
LACMA	Los Angeles County Museum of Art
LGP	Library of Golestan Palace, Tehran

LM	Lucknow Museum, India
MAD	Musée des Arts Décoratifs, Paris
MFA	Museum of Fine Arts, Boston
MG	Musée Guimet, Paris
MMA	Metropolitan Museum of Art, New York
MSM	State Museum of Oriental Cultures, Moscow
MSMSJ	Maharaja Sawai Man Singh II City Palace Museum, Jaipur
NDM	National Museum of India, New Delhi
PC	private collection
PMA	Portland Museum of Art, Portland, Oregon
RL	Raza Library, Rampur
RSL	Rampur State Library, Rampur
SBB	Staatsbibliothek, Berlin
SDMA	San Diego Museum of Art
SMA	Museum of Art, Springfield, Massachusetts
SMH	Salarjung Museum, Hyderabad, India
SMJ	Sardar Museum, Jodhpur
SOAS	School of Oriental and African Studies, University of London
TAM	National Art Museum, Tehran
VAM	Victoria and Albert Museum, London
WC	Windsor Castle
WG	Walters Art Gallery, Baltimore

ILLUSTRATED MANUSCRIPTS

1396	*Khamsa* (Quintet [Five Poems]) of Kvaju Kirmani (BL), by Jalayirid; Baghdad
1404	*Zafar Nāma* (Book of Victories/Conquest), commissioned by Timur
1404	*Shāh Nāma* (Book of Kings) of Muhammad Juki (LRAS); Herat
1436	*Zafar Nāma* of Sharafuddin Ali Yazdi (AMSG). Completed June-July 1436, Shiraz. Several illustrated copies made in the early sixteenth century at Shiraz; two in the BL as OR1359 and ADD7635
c. 1450	*Khamsa* of Amir Khusrau Dihlavi, possibly earlier (PC)/(SMH)
1534	(Delhi) Sultanate Manuscript (CAG)
1536–37	*Shāh Nāma* from Tabriz
1552	*Tīmūr Nāma/Zafar Nāma* (BL)
c. 1560 *	*Tūtī Nāma* (Tales of a Parrot) (CM and dispersed). Compiled by Ziya'al-Din Nakshabi; illustrated by Banwari, Basawan, Daswanth, Ghulam Ali, Gujarati, Iqbal, Lalu, Sravana, Suraju, and Tara. A famous compendium of 52 tales and 218 illustrations. Pramod Chandra and Daniel Ehnbom believe that the *Tūtī Nāma* is the earliest Akbari manuscript (pers. comm., July 1996).
c. 1562–77	*Ḥamza Nāma* (Tales of Hamza) (KM, VAM, and dispersed). A mélange of fact, folktales, and fantasy. The hero is called Hamza and he seeks to spread Islam throughout the world. Originally with 1400 illustrations—in 16 vols. (Bada'uni) or 12 vols. (Abu'l Fazl)—only about 150 of which are presently known. 60 folios in the KM; 27 in the VAM. Supervised first by two master Iranian artists, Mir Sayyid 'Ali and the younger 'Abd as-Samad, although no paintings are attributed to either. Beach (1981:59) suggests it is likely that both Daswanth—a student of as-Samad and considered the greatest of Akbar's painters—and Basawan worked on it.
1564–65	*Dīvān* (Pocket book) of 'Ali Sher Nava'i (BNP). Painted in Mashad. See c. 1605, *Khamsa,* below.
c. 1565–70	*Tilasm and Zodiac* (RL/RSL). 16 folios on astrology and the zodiac, illustrated on both sides.
1567	*Gulistān* (Rose Garden) of Sa'di (BM). A work by the thirteenth-century Persian poet Sa'di. Copied by Sham Muzahhib.
1567–68	*Deval Rani Khizr Khan/Deval Devi Khidr Khan* (Story of Deval Rani and Khizr Khan) of

* 1570 according to Seyller.

Amir Khusrau Dihlavi (NDM). Copied by Sultan Bayazid ibn Nizam. 157 folios and two unsigned paintings. Beach (pers. comm., July 1994) gives 1568 as the likely date.

1570* *Anvār-i-Suhailī* (The Lights of Canopus) (SOAS) (see 1596 below). 349 folios and 24 unsigned illustrations. Copied by Muhibb-Ali b. Hasan. A popular version of the *Kalilah and Dimnah*. The *Kalilah and Dimnah* was originally compiled in Pahlavi (middle Persian) in the 6th century C.E. and is the translation of the great Indian collection of fables on statecraft, *The Panchatantra*.

c. 1580–85† *Dārab Nāma* (Tales of Darab, son of Queen Humay) (BL, BM). By Abu Zahir Tarasusi. Illustrated c. 1585 with 157 miniatures by 42 artists—see Beach 1981:215 for a complete list—including outstanding ones by Basawan, Mishkin, Kesu, and Khem Karan. It apparently documents Akbar's state of mind when he moved from Fatehpur Sikri to Lahore.

1581 *Gulistān* of Sa'di (LRAS). Copied by Muhammad Husain, Zarrin Qalam.

c. 1582 *Rāmayāna* (Story of Rama) (FG). One of the two great Indian (Sanskrit) epics. The story of the respected ruler Ram Chand and his trials and triumph.

c. 1582–86 *Razm Nāma* (*Razmnāma*) (Book of Wars) (reportedly in the MSMSJ, some items in the SMJ). Translation into Persian of the other great Sanskrit epic, the *Mahābhārata* (Great War), known here by its Persian name. Begun in 1582, the text was completed in 1584, the latest paintings dated 1586. 176 illustrations, the majority executed by Basawan, Daswanth, and Lal. The major assistant painter was Miskin. See Beach 1981:216–18 for a complete list of artists, collaborators, and contributions.

c. 1580–85 *Tīmūr Nāma* (Story of Timur) (KBL). 338 folios and 132 illustrations. Major designers, Basawan and Lal. See Beach 1981:218–20 for complete list of artists, collaborators, and contributions.

c. 1584–89 *Rāmayāna* (reputedly in the MSMSJ). Unpublished and inaccessible.

c. 1585–90 *Khamsa* of Nizami (PC: Keir). 397 folios, of which 356 copied at Yazd, Iran, and 41 in India. See Beach 1981:220–21 for complete list of artists, collaborators, and contributions.

c. 1585 *Harivamsá* (Genealogy of Hari / Vishnu) (reputedly in the MSMSJ). A section, essentially the last 17 illustrations, of the *Razm Nāma*, giving further details of the life of Krishna, interest in whose cult became intense after the main translation of the *Mahābhārata*, in which he is a major figure. Translated into Persian by Mawlana Sheri. 28 known pages. The text and six originals are in the LM.

c. 1588 *Divān* of Hafiz (RL). 203 folios with 11 illustrations attributed to Farrukh Chela, Kanha, Manohar, Nar Singh, and Sanwlah.

1588 *Bābur Nāma* (Story of Babur) (BL) (Beach 1992:60 says at least seven illustrated copies of the *Bābur Nāma* have survived that can be dated to between 1589 and the end of Akbar's reign).

1588 *Divān* of Anvari (FAM). Fifteen miniatures commissioned by Akbar. Copied at Lahore by an unnamed calligrapher.

c. 1589 *Bābur Nāma* (VAM and dispersed). There were 191 illustrations. As of 1981, Smart had located 108, 21 being the famous VAM group. She believes this to be the first presentation copy (see Beach 1981:77 and 1588 *Bābur Nāma* above).

c. 1590‡ *Akbar Nāma* (Story of Akbar) (VAM and dispersed). There are two major illustrated *Akbar Nāma* mss., neither complete. The VAM has 116 illustrations of events dating between 1560 and 1578. Beach (1981) says that the illustrations logically should be dated in the later 1590s but stylistically may be earlier, intended for a different text. The BL/BCL paintings were copied at the time the text was copied.

c. 1590–94 *Tarīkh-i-Alfī* (History of a Thousand) (FG). A new history of the Islamic world commissioned by Akbar to be completed by the Islamic millennium. Two volumes are by Mulla Ahmad of Thathah, the third by Asaf Khan. Bada'uni revised some of this version.

c. 1590–95 *'Iyār* (*Ayār*)-*i Dānish*. Abu'l Fazl's translation of the *Anvār-i Suhailī*. CBL has the major por-

* Beach (pers. comm., July 1994) gives the likely date as 1571.
† c. 1595 according to Welch.
‡ Or earlier.

tion of the manuscript; other parts are possibly in the Sir Cowasjee Jahangir Collection. 96 illustrations in the CBL group are by more than two dozen artists (see Beach 1981:222).

c. 1591	*Bābur Nāma* (BL). Originally 183 paintings; 143 are still in the bound volume. See Beach 1981: 222–23 for an itemization of all the artists and folio illustrations.
c. 1593	*Bābur Nāma* (WG/MSM). The original manuscript had 183 illustrations. Two major groups of folios have survived: 59 in MSM, 34 in WG.
c. 1595	*Harivamśa* (VAM). See c. 1585 above.
1595	*Bahāristān* (Spring Garden) of Jami (BO). Six illustrations and rich marginal decoration signed by 19 artists (see Beach 1981:223).
1595	*Khamsa* of Nizami (BL/WG). *See* 1597–98. The major part is in the BL with 37 illustrations. The WG has 39 folios with five paintings. Copied and inscribed by 'Abd al-Rahim, Ambarin Qalam. Painted by 23 artists (see Beach 1981:223). Dispersed copies in the SMH.
c. 1595	*Akhlāt-i Nasiri* (Nasirean Ethics) of Nasiruddin Tusi. Appeared initially c. 1235 and became the best-known ethical digest to be compiled in medieval Persia, if not the entire medieval Islamic world.
c. 1595	*Divān* of Amir Khusrau Dihlavi (MMA)
c. 1595	*Divān* of Amir Shahi. Painters: one page signed by Kesu Das, others attributed to Basawan and Miskin.
1596	*Anvār-i-Suhaili* (BKB). 27 illustrations with ascriptions to 13 painters. Copied at Lahore by Abdul-Rahim Harawi.
1596	*Chinggis Nāma* (History of Chinggis Khan). Also called the *Kitāb-i-Chinggis Nāma* (Book of the History of Chinggis); related to the second half of the first section of that book. A portion of the *Jāmi al-Tavārikh*.
1596	*Jāmi al-Tavārikh* (History of the World, Collection of Histories) (ILT). Written by Rashiduddin and finished in 1310. An earlier version is known and datable to 1307. (This is an extension of Juwaini's *History of the Mongols*.) Commissioned by the Il-Khans ruler Ghazan Khan (1295–1304) for his successor Öljeitü (1304–1316). 304 folios with 98 illustrations. See Beach 1981: 223–27 for list of painters, designers, and collaborators by assignment, together with collaborators listed by folio numbers for the portion of the manuscript in Tehran.
1596–97 *	*Akbar Nāma* (CBL/BL copy, and dispersed). See 1604 below.
1597–98	*Khamsa* of Amir Khusrau Dihlavi (WG, MMA, and dispersed). Copied by Muhammad Husayn Zarrin-Qalam. 211 folios with 21 illustrations. The original lacquer covers are at the WG. Several of the illustrations are at the MMA. Illuminations are signed by four persons. Marginal inscriptions name 11 artists.
1597–98	*Khamsa* of Nizami (BL)
1597–98	*Bābur Nāma* (NDM). 183 illustrations; 173 remain in the volume.
c. 1598–99	*Razm Nāma* (Book of Wars) (FLP)
c. 1600	*Gulistān* of Sa'di (CAM, WG, LACMA; Text in the BL). A series of often ribald stories, entertaining but also with lessons about comportment. Six of 13 illustrations are attributable to Mughal artists and date to about 1600. Eight paintings are in the CAM and assigned to eight artists. Some are in the WG. Other possible dispersed folios are in LACMA (ascribed to Basawan) and a private collection (attributed to Miskin). Copied in 1567, probably in Bukhara.
1602	*Yog Vashisht* (About Hindu Ascetic Practices) (CBL). 41 illustrations, 323 folios; an illustrated version of a 12th- or 13th-century C.E. Sanskrit work. Created for Prince Salim at Allahabad.
1603	*Nafahāt al-uns* of Jāmi (BL). 17 illustrations with six artists' names.
1603–4	*Raj Kunwar* (CBL). 132 folios, 51 miniatures. An eastern Indian romance titled by the name of the hero. Created by Prince Salim at Allahabad.
c. 1604	*Akbar Nāma* (BL/CBL and dispersed). The largest section was bought by Beatty; therefore this is known as the Chester Beatty *Akbar Nāma*. Many dispersed pages are in public and private collections. The BL portion corresponds to vol. 1 of Abu'l Fazl's text and covers to Humayun's death; the CBL portion begins with Akbar's coronation and ends in March 1589. See

* Beach says 1597 based on Seyller, pers. comm., September 1994.

Beach 1981:227–28 for contemporary attributions and the number of assigned folios for the two major portions. See 1596–97 above.

c. 1604	*Kulliyāt* (Collected Works) of Sa'di (PC)
c. 1605	*Būstān* (Orchard) of Sa'di (PC). Copied at Agra by Abdal Rahim, Ambarin Qalam. One illustration is signed by Daulat; others are attributed to several other artists.
c. 1605	*Khamsa* of Mir 'Ali Shir Nava'i (WC). Paintings by Nanha and Manohar. Illustrated first in Herat in 1492. Copied by Dhanraj(?)
c. 1605–10	*Jahāngīr Nāma* (History of Jahangir) (MFA). Several plates attributable to Bishandas, Abu'l Hasan, and Manohar.
c. 1610	*Dīvān* of Hafiz series (BM)
1610	*Anvār-i-Suhailī* (BL)
1610–13	*Gulistān* of Sa'di (BM)
c. 1610–20	*Jahāngīr Nāma*
c. 1615	*Tūzuk-i-Jahāngīrī* (Memoirs of Jahangir) (BM)
1620	*Tūzuk-i-Jahāngīrī* (MFA)
	Tūzuk-i-Jahāngīrī (RSL)
c. 1633	*Shāh Shuja* series (about Sher Shah)
c. 1635–40	*Pādshāh Nāma* (History of Shah Jahan) (WC). Completed in 1656–57 by the scribe Muhammad Amin of Mashad, c. 1653. There are 44 illustrations signed by several famous artists painted earlier, c. 1635–40.
c. 1663	*Mathnavī* (Rhyming couplets) of Zafar Khan series (LRAS). *Mathnavī* are heroic, romantic, or didactic poems in rhyming couplets. Copied at Lahore by Zafar Khan.

ALBUMS (*Muraqqa's*)

The bulk of these are devoted to Jahangir and Shah Jahan—not surprisingly, for the majority of paintings made for both Jahangir and Shah Jahan were put into albums. Jahangir was interested less in history and more in personalities, objects, and events. There are three major groups of Jahangir album pages and a small number of dispersed folios. The largest group, the *Muraqqa'-e-Gulshan*, is from the former ILT and dates from c. 1599–1609. The second group, the Berlin Album, is in the SBB. The third group of 40 pages is dispersed. There are three major assemblages of Shah Jahan Albums: the Minto, Wantage, and Kevorkian (the latter two contain later paintings, c. 1800). A fourth, the so-called *Late Shāh Jahān Album*, dating from c. 1635–50, is dispersed in private collections.

c. 1434	Album of the *Zafar Nāma* (Book of Victories) of Sharafuddin 'Ali Yazdi; text completed 1425. See Titley 1983:50.
c. 1555	Album (LGP)
1570–80	Johnson Album 27 (IOL). Contains illustrations on Humayun.
1602	Album of Jahangir
1610	Album of Jahangir (LACMA)
1614–15	Album of Jahangir (BSK)
	Large Clive Album (VAM)
1625	Jahangir Album (FG). Paintings by Bichitr.
c. 1625	Jahangir Album (CBL). Paintings by Govardhan.
c. 1625–40	Royal Album (Minto) (also known as the *Pādshāh Nāma Album* or *Shāh Jahān Album*) (VAM and CBL). There are 40 double-sided pages; 21 in the VAM, 19 in the CBL.
c. 1640	*Pādshāh Nāma Album* (CM)
c. 1641–42	*Dārā Shikōh Album* (IOL). Paintings for/of Shah Jahan's favorite son and heir apparent.
	Stowe Album (BM)
	Skinner Album (BL)
c. 1800s	Kevorkian Album (FG and MMA). Ascribed to Mansur. Shah Jahan paintings of 46 double-sided folios and four illustrated rosettes.
c. 1800s	Wantage Album (VAM). Shah Jahan paintings.

NOTES

INTRODUCTION

1. Numerous other primary sources have enlarged the historical context for this study, and sources are available in other languages which focus on some major antecedents and contemporaries of the "Great Mughals." These include Timur's memoirs, *Malfuzat-i Timurī* (*Tūzuk-i Timurī*), and both the *Zafar Nāma* (The Book of Conquest/Book of Victories) of Sharafuddin Khuttalani Samarqandi, in Turki, and the *Zafar Nāma* of Nizamuddin Ali Shami, written in 1404 in Persian. This latter is probably the most important because it was commissioned by Timur to "objectively" document his rise to power.

A word here about the term "Mughal." One finds it spelled various ways and also with some controversy to its application. Dale (1996:636–37, n. 3) thinks that the Persian and Turki word for "Mughal" is more accurately rendered as Mughul or Mughûl. Further, he believes that the empire should more accurately be referred to as a "Timurid" empire but, he avers, "given the widespread use of Mughal for the South Asian Timurids, it would be preferable to adopt John Richards's recent compromise and refer to the dynasty as Timurid-Mughal. While I recognize the enormous Timurid contribution to the empire, I have chosen to refer to it as the Mughal empire.

Mohibbul Hasan's *Babur, Founder of the Mughal Empire in India* (1985) is useful, but we still lack a first-rate history that places Babur in both his Central Asian and northern South Asian worlds, something I hope my book can help move us toward in some small way.

2. While we learn of Humayun sympathetically from these sources, they are supplemented by historical studies which include Ishwari Prasad's *Life and Times of Humayun* (1951) and Iqtidar Alam Khan's biography of the Mughal ruler's troublesome brother, *Mirza Kamran* (1964). Also useful for understanding the embattled Humayun is I. H. Siddiqi's fine study, *History of Sher Shah Sur* (1971), about the Surs and Humayun's and the incipient Mughal empire's main antagonist. Of considerable importance about that dominating figure—a major player in the early decades of the consolidation of Mughal power, who, if successful, would have ensured that there was no great Mughal Empire—is the *Tarīkh-i Sher Shahī*. It is a biography by a distant

relative of Sher Shah's, Abbas Khan Sharwani, who interviewed officials who served during his period of power (1540–1545). The work was requested by Akbar and completed about 1579.

3. Other sources, although they may not include illustrations, offer enlightening checks and balances to "official" works. One such is the unofficial and unsympathetic yet insightful work by Abdul Qadir Bada'uni, *Muntakhabu-t-Tawārīkh* (also called the *Tarīkh-i Bada'uni*). Completed in 1596 by a member of Akbar's court who disliked the ruler's unorthodox religious ideas, it provides a palliative and useful corrective to Abu'l Fazl's adulatory and occasionally hagiographic *Akbar Nāma*. It also offers biographical sketches of contemporary Muslim scholars and theologians. Another unofficial history of Islamic rule in India to the thirty-ninth year of Akbar's reign is the dry *Ṭabakāt-i Akbarī* (known also as the *Tarīkh-i Nizāmī*). It was written in the late sixteenth century (c. 1593) by Akbar's military secretary, Khwajah Nizamuddin Ahmad, whose orthodox views caused him to omit any reference to Akbar's unorthodox religious activities. Muhammad Kasim Firishta's *Tarīkh-i Firishta* (or *Gulshan-i Ibrahimī*), completed in the early seventeenth century, is a useful if uncritical selection of materials from earlier chronicles with some information on Deccan affairs from his own personal experience.

Recent historical interpretations of Akbar's religious views are found in K. A. Nizami's *Akbar and Religion* (1989); S. A. A. Rizvi's *Religious and Intellectual History of the Muslims in Akbar's Reign* (1975b); his detailed study of religious change in Indian Islam, *Muslim Revivalist Movements in Northern India in the Sixteenth and Seventeenth Centuries* (1965); and his two-volume comprehensive treatment of the *Sufis* in Mughal India in *A History of Sufism* (1975–83).

4. Drawing somewhat on the concept of the segmentary state, Streusand sees the Mughal Empire thus created as "a hybrid, Islamic—in the broadest sense—at the centre; Indian in the provinces. . . . The Mughal government as an imperial centre, supported by a shifting structure of segments. It could manipulate the segments, but not fuse them. . . . The instability in the provinces did not threaten the Mughals. It was a part of the dynamic *modus vivendi* of the empire" (1989:181).

In a supplement to political analyses, the importance of economic development in Akbar's empire is graphically delineated in Irfan Habib's superb *Atlas of the Mughal Empire* (1982), which provides economic and political maps for each province, and his *Agrarian System of Mughal India* (1963), a major work on the underpinning resource of the empire. Also important is Shireen Moosvi's *The Economy of the Mughal Empire c. 1595* (1987).

5. Two fine contemporary accounts for the Shah Jahan period are *The Travels of Sebastian Manrique* (1926–27), by a Portuguese missionary who observed much of northern India in the early seventeenth century, and *The Travels of Peter Mundy* (1907–36), considered a quite accurate description of people, places, and conditions in northern India during 1628–1634 by an employee of the British East India Company. Banarsi Saksena's *History of Shah Jahan of Dihli* (1962) is still the standard but quite outdated. Like Jahangir and Humayun, this Mughal ruler needs more scholarly attention.

6. The *Ma'āṣir-i Alāmgīrī* is a concise official history of Aurangzeb's reign by a member of his court who witnessed many of the events discussed therein. Taken from the *Muntakhab-al-Lubab*, a history of Mughal rule from 1519 to 1733 written between 1717 and 1733, the *History of 'Alamgir* is a contemporary account of his reign by a Mughal official, Khafi Khan—one of the few extant histories of the period, since 'Alamgir soon prohibited the writing of official court chronicles. Concerning that prohibition's effect on the arts, Stuart Cary Welch suggests that "however much 'Alamgir enjoyed such entertainments early in his reign . . . , he became too preoccupied with matters of state for such indulgences . . . [and] virtually closed down the royal workshops a few years after he came to the throne" (1978:115).

Also of value regarding this complex and austere figure are the *Rukaat-i Alāmgīrī* (Letters of Aurangzeb), a collection of letters concerning mostly personal matters, with occasional reference to minor historical events, which Aurangzeb wrote to his sons and officers during his various Deccan campaigns from 1683 to 1707; and the *Anecdotes of Aurangzeb,* a translation with commentary by Jadunath Sarkar of contemporary accounts which offer revealing insights into the emperor's personality. Jadunath Sarkar's old *History of Aurangzib* (1912–30) is still the best narrative we have of that ruler.

There are several good volumes on the Mughal nobility, including two works by M. Athar Ali, *The Mughal Nobility under Aurangzeb* (1966) and *The Apparatus of Empire* (1985). Regional studies have also come to the fore. During the past two decades many insightful studies of the Rajputs have added to the historical picture, including Kunwar Refaqat Ali Khan's *The Kachhwahas under Akbar and Jahangir* (1976), Norman Ziegler's "Some Notes on Rajput Loyalties during the Mughal Period" (1978), and Robert Hallisey's *The Rajput Rebellion against Aurangzeb* (1977).

7. For additional primary sources and a fuller range of historical works that informed this study, see the bibliography.

8. As Peter Hardy has pointed out, "The study of the history of medieval Muslim India has been primarily the study of historians by historians. . . . [Writers went] exclusively to the works of their predecessors as historians" (1966:1), despite the abundance of other kinds of evidence. Further, not only did these "historians" use only one class of source material, "they also confined their aims to the writing of one form of history, the political, and in one mode, the narrative" (p. 3). The function of histories by Indian Muslims, particularly from the 1920s and 1930s, was "to justify to their non-Muslim contemporaries (and indeed themselves) the historical record of their community in South Asia" (p. 11). Writing more than three decades ago, Hardy did comment that newer intellectual currents were abroad and that younger scholars were trying to use other sources and to focus on different types of histories. And, he accurately points out, "The most difficult aspect of historical research is to know what questions to ask in a sound expectation that the evidence can yield an answer which will stand the test of criticism" (p. 130). Thus, the new focus on and use of visual sources in the present book represents a departure from older methodologies and resources.

9. See, for example, Citron, *Gender and the Musical Canon* (1993); Holub, *Reception Theory: A Critical Introduction* (1984); and Leppert and McClary, *Music and Society: The Politics of Composition, Performance and Reception* (1987). See also Koskoff, *Women and Music in Cross-cultural Perspective* (1987); di Leonardo, *Gender at the Crossroads of Knowledge: Feminist Anthropology in the Postmodern Era* (1991); Rebollo-Sborghi, "Decentering the Feminist Self" (1993); Sarkissian, "Gender and Music" (1992); Herndon and Ziegler, *Music, Gender, and Culture* (1990).

10. See, for example, Clifford, "On Ethnographic Authority" (1983); Clifford and Marcus, *Writing Culture* (1986); Marcus and Fisher *Anthropology as Cultural Critique* (1986) and *The Predicament of Culture* (1988); Geertz, *Works and Lives* (1988); Jameson, *Postmodernism; or, the Cultural Logic of Late Capitalism* (1991); Daniel and Peck, *Culture/Contexture: Explorations in Anthropology and Literary Studies* (1995); Bordieu, *Distinction* (1984); Marcus and Myers, *The Traffic in Culture* (1995); and Napier, *Foreign Bodies* (1992).

11. See, for example, Wade, "Performing the Drone in Hindustani Classical Music: What Mughal Paintings Show Us to Hear" (1996).

CHAPTER ONE

1. Various geographic designators appear throughout this book. I use the term South Asia to denote a territory distinguished from other geographic entities such as West Asia, Central Asia, or East Asia. Essentially, South Asia refers to the Indian subcontinent: Bangladesh, Bhutan, India, Nepal, Pakistan, Sikkim, and Sri Lanka. The territory on which this study focuses is historic, i.e., pre-partition (pre-1947) India; thus Lahore and Quetta, now in Pakistan, were major cities in historic India. The term Hindustan refers to the northern half of the subcontinent—essentially the Indo-Gangetic plain—and the system of Indian classical music prevalent there, in contrast to the Karnatak (Carnatic) or southern half of the subcontinent and the Indian classical music system of that region.

2. Text, *shīr-andām*, "tiger-shaped," which I think means thin in the flank (see Steingass, s.v.), I [Henry Beveridge] have taken the translation of the words *malāḥat* and *ṣabāḥat* from Elliott. See his note vi, 376, where the two words seem wrongly spelt [footnote in original].

3. The author further notes

the immense degree of systematization that was a characteristic feature of the empire. In the main . . . [it] was the work of its greatest emperor, Akbar. . . . The Mughal polity, so long as it functioned with any effectiveness, say, until the early years of the eighteenth century, continued basically with the organizational forms that Akbar instituted.

The most striking aspect of the systematization was the *manṣab* (termed "Rank" in our title), the result of an attempt to coalesce into a pair of numbers exact indications of rank, payment, military and other obligations of the holder of the *manṣab*.

Granting a *manṣab* was theoretically the sole prerogative of the Emperor. . . . Certain criteria appear to have been followed for *manṣab* grants, particularly for initial recruitment. First of all, a primary claim on a *manṣab* was thought to vest in the sons and close kinsmen of those already in service. Such persons were known as *khānazād*s, i.e. those born of persons already "slaves" of the Emperor. . . .

A second and very interesting criterion was the recipient's status and service in another empire or kingdom. The Mughals followed the policy of giving *manṣab*s to persons who either themselves held high office in the Ṣafavid and Uzbek empires or were sons or kinsmen of such officials. The family

of Nūr Jahān offers a well-known example of Ṣafavid bureaucrats migrating to India over a span of two or three generations. The bulk of Persian (Irānī, Irāqī, Khurāsānī) and Central Asian (Tūrānī) immigrants belonged to this category (map 1).

A third criterion was possession of a hereditary principality, recognized as *waṭan jāgīr*. This was especially the case with the Rajput ruling chiefs. . . .

. . . Some scope still remained for other entrants. The Mughals were no believers in equality; and considerations of race played a considerable part in their system of recruitment. . . . Other things being equal, those belonging to particular racial or cultural groups [such as the Irani] had a greater chance of advancement than others [Indian Muslims].

There remained room for talent and ability, in search of which the Emperor might go [to] the scholarly families of Indian Muslims from amongst whom came Abul Faẓl and Saʿdullah Khān, the famous ministers of Akbar and Shāh Jahān. Similarly, the Indian secretarial and accountant castes . . . produced high officers including Todar Mal and Raghunāth, the eminent finance ministers of Akbar and Aurangzeb. . . .

Recruitment to the Mughal nobility—or the act of granting a *manṣab*—took place without any test or examination, military or academic.

The *manṣab* system represented one facet of the extreme degree of systematization and centralization reached in the Mughal empire. It was similarly reflected in the uniformity enforced in the posts and functions attached thereto in all parts of the empire.

An important feature of the Mughal system of titles was that the same title was never assigned to two nobles at the same time. When this convention was broken by Bahādur Shāh [I] (1707–12) for the first time, it created considerable bureaucratic consternation. (Athar Ali 1985:xi, xvi–xxiv passim)

Finally, it should be noted that although *khānazād*s had a primary claim on a *mansab* it was not hereditary. When a *mansabdar* died, the central government retrieved the property. It was a mark of unusual favor for a Mughal ruler to permit a *mansabdar*'s son to inherit a major portion of his territory (Streusand 1989:139).

As regards military organization, the Muslims early adopted the system of organizing their armies on a decimal basis, and the system adopted by the Mongols was similar. Chinggis Khan reportedly organized his troops into tens, hundreds, and thousands, with a *tūmān* equalling ten thousand, although with the decline of the Timurids, the terms began to lose their original meanings. For example, under Babur the term *tūmān* was used to designate 500 or 1,000 (Naqvi 1990:95).

What articulated the relationship of the emperor and his *mansabdar*s was the *darbār*, the ritual exchange of gifts giving the relationship form (Streusand 1989:138–39).

4. Bada'uni dates the abolition in 1579 (987 A.H.) while Abu'l Fazl dates it from 1564 (971 A.H.) Streusand suggests that the 1579 date fits the politico-religious situation better (1989:114–15). The tax was reimposed by ʿAlamgir in the 22d year of his reign (2 April 1679, Hallissey 1977:59), abolished 34 years later during the short-lived rule of Farrukhsiyar, reimposed again, and finally abolished in the first year of Emperor Muhammad Shah (r. 1720–1748).

5. The category "patrimonial-bureaucratic empire" originated with Max Weber, although Weber designated the great Mughal cities as merely princely camps. Blake's analysis of Asian sovereign cities suggests that the patrimonial-bureaucratic empire was the type of state which characterized other Asian empires from about 1400 to 1750 as well—the Turkish Ottoman and Persian Safavid empires, the Japanese Tokugawa and Chinese Ming states (Blake 1991). Not all scholars of Mughal history agree with his interpretation, but I find Blake's sense of the imperial household to be useful. In such an empire, the patrimonial ruler tried to assimilate state to household: he attempted to administer, control, and finance the entire realm as if it were part of his own private domain. Indeed, Weber's patrimonial state <u>is</u> an extension of the household of the ruler, whose authority is an expansion of that of the father in a patriarchal family.

Others have affirmed that "the Mughuls did not draw a firm line between the household and public functions; the monarch was the state so far as the Mughuls were concerned" (Naqvi 1990:51–52). Richards notes that, beginning early in the empire, "by a series of symbolic acts, Akbar built upon his personal appeal to establish an image or metaphor of the Emperor's person as an embodiment of the Empire. To challenge or destroy the Emperor's person was to challenge or destroy the imperial system. . . . [His assertion of] paramount spiritual authority . . . unprecedented in previous Indo-Muslim experience . . . merged with the recognized familial charisma residing

in direct descent from the Timurid line which, for Muslims at least, connoted legitimate monarchy" (Richards 1978a:253).

6. It was also a mobile mansion. The Mughals traveled frequently and were exceedingly partial to camp life. "The Mughul camp was like a moving city. The imperial tents were in the centre. The harem . . . and other buildings of public importance had their counterparts in the camp. The larger tents were made of timber and in fact were portable buildings [some two stories high] which could be taken apart and reassembled; . . . These tents were all in duplicate; when the court moved from one site, the tents [as well as all else were] moved two stages ahead and erected there" (Naqvi 1990:57). "All of the Emperor's tents were dyed scarlet, the Timurid, and previously, the Sassanian royal colors" (Richards 1978a:259).

Indeed, "Akbar's characteristically innovative solution . . . [to] tension was to revert to the court camp capital of his Turco-Mongol ancestry [and] . . . the precedent or model for the Mughal imperial camp must be traced back to practices of Timur and even earlier to the army encampments of the Mongols" (ibid. 258). See also pp. 255–58 for a detailed explanation of Akbar's building of many "capitals," both cities and camps, and their political rationale—public expression of his intended autonomy and the reduction of existing associations of legitimate rulership and claim to the imperial throne by others in the future—as, for example, his decision to move the capital from Delhi due to its association with previous Indo-Muslim rulers. Other "capital" strongholds and their likely rationales: Ajmer, at the northern gateway to Rajasthan, and its association with the Chistiyyas; Agra, considered the center of Hindustan; Fatehpur Sikri, which also underscored his mystical affinities; Allahabad, which, from its position at the confluence of the Ganges and Jamna, guarded the Gangetic Plain; and Lahore, protector of the passes against Afghani and Central Asian intruders.

7. Political-religious affirmation of such a presence occured with the remittance of the *jizya*, the issuance of the *maḥżar* (so-called Infallibility Decree, 1579) and, following Timur and Chinggisid practice, the recitation of the *khutba;* the last two came almost simultaneously and should be interpreted together. Streusand suggests that with the *khutba,* possibly, judging from content rather than context, Akbar tried to strengthen his legitimacy in Islamic tradition, likely because he had tried and failed to make the Indo-Muslim elite, from which most of the *ulama* came, his active supporters tied to him by marriage (1989:116–17).

It is worth noting here, too, that traditional interpretations of Akbar's alleged hostility to Islam—that Akbar punished the orthodox *ulama* for refusing to serve as missionaries for his new faith, the *Dīn-i Illāhi*—have been refuted by Rizvi (1975b) and Richards (1978a). It appears that *Dīn-i Illāhi* (literally divine faith/faith of God) was not a new religion but a type of *Sufi* order centered on Akbar. It did not replace Islam as Akbar's sovereign cult; *sulḥ-i kull* (general peace) did. Basically, *Dīn-i Illāhi* can be interpreted as a spiritual tie between the ruler and those of his officers who accepted him as their spiritual guide (as *Sufi* novices followed their *pīr*). In Akbar's case he acted as a spiritual guide as a means to an end: primarily to instill loyalty. The oath makes *Dīn-i Illāhi* an alternative to but not an apostasy from Islam because there is a distinction between *dīn* (faith) and *dunyā* (the world), i.e., spiritual and temporal (see further Rizvi 1975b:374–417; Richards, 1978a:267–71; Streusand 1989:122, 148–51).

Another example of rituals which contributed to the Mughal doctrine of kingship was the weighing ceremony (see chapter 5, note 22; see also note 12 below).

8. From a remark made by Bada'uni, it is clear that the gateway served as quarters for visitors as well:

> After they had finished their repast he granted his request for assistance, and promised him aid with such money and troops, as might enable him to reduce Badakhshān, and had apartments prepared for the Mīrzā in the tower of the Hatyāpūl [the Elephant Gate at Fatehpur Sikri], where was the *Naqārah-khānah. (MtT* 2:219)

9. A very similar painting of the Safavid era, c. 1515, shows musicians atop a gateway, but fully exposed in the open air. As in the Mughal heralding groups, there are multiple sizes of "kettledrums" and a horn. This is reproduced in 'Ukashah 1983:225.

10. This is visible only with a magnifying glass, as the figures are quite tiny.

11. The position and function of the *naubat* ensemble extended considerably beyond the Mughal period in North India. Erdman reported for the Rajasthani city of Jaipur:

> Today the Naubat Khānā is located in an apartment over a gateway inside the [Jaipur] City Palace between Sarbata audience hall and the courtyard of the Chandra Mahal. Previously it was in a gateway between administrative and residential areas of the palace, from which the drill-like sound of *naqqārā*

and the wail of the *shehnāi* issued forth to mark the six *gharīs* (watches) of the day. Until April 1944, the Jaipur State government used for its official purposes solar time read from the Samrat Yantra in the Observatory, with a gun fired from Nahargarh Fort as the time signal. This practice was abolished in that year, and Jaipur started using Indian Standard time. Now the sound of the *naqqārā* and *shehnāi* is reduced to making the standard noon-time of all India. (Erdman 1985:39)

12. Court rituals played a central role in Mughal politics and society. As Streusand notes, "without the rituals which surrounded it, Mughal sovereignty did not exist. The nature of the rituals propounded the nature of the sovereignty" (1989:123–24, 125–29 passim; see also Roe 1926:84–87, as well *AiA* 1:155–70 passim and *AN* 3:1069).

13. An earlier return of Akbar to Fatehpur Sikri was illustrated in the Victoria and Albert manuscript of the *Akbar Nāma*: fol. 191 designed by Kesu Kalan and painted by Nar Singh. That occasion, marking Akbar's victorious return upon the end of his conquest of Gujarat, was also the occasion of the renaming of Sikri to Fatehpur, meaning "the city of victory." According to custom, the ruler's three sons came out to greet him, and that is the detail which is emphasized in the illustration. The instruments of the *naqqārā khāna* in Akbar's entourage which are shown in the painting are a pair of drums and a *surnā*. The folio is reproduced in Sen 1984:144.

14. This description by Bada'uni, the other chronicler of the reign of Akbar, appears in an account of the fall of negligent courtiers in the Muslim calendar year A.H. 974.

15. John Richards suggests the basis for this action:

> Many of the basic problems of Islamic royal authority had been resolved in the heartlands of classical Arab and Persian civilization. . . . [The solutions] had all been determined in a generally accepted normative structure for Sunni kings. . . .
>
> The dynamic, continued expansion of Islamdom and its division of the world into the "Land of Islam" and the "Land of War" . . . did engender a basic instability, a continuing extraordinarily rapid process of societal change within Islamic societies . . . Expansion . . . created the opportunity and incentives for unregulated travel, settlement and movement of individuals outward from the heartland. . . . Return migration as well as the . . . Haj encouraged integration over an enormous cultural region—in itself a form of cultural assimilation and social change. Islam, in India as elsewhere, also constantly absorbed new populations. . . . One consequence for the style of monarchy was a muting of the opposition between the ritual role of the monarch as the exemplar and regulator of an ordered society and that of the aggrandizing warrior-administrator. Instead, the Indo-Muslim ruler fulfilled his obligations by mobilizing social resources for expansion and conquest. . . . Daily rhythms of withdrawal and public appearance were an aspect of courtly ritual, but the custom and the political determination of the ruler set this aspect—not the Sharia. (1978b:viii–ix)

16. *Darshan*, a Hindu religious term, literally means seeing, and is a basic feature of the interaction between Hindu spiritual teachers and their disciples (Lannoy 1971:366). Individuals who received *darshan* acknowledged the ruler by performing *kurnīsh* (a Persian term), putting the palm of the right hand on one's forehead and bending one's head downward, signifying humility as a gift to the royal assembly and obedience to any task demanded.

17. John Seyller dates the *Tūtī Nāma* paintings to c. 1570.

18. Among those important books was his own biography/chronicle of his reign, for which he organized the writing of primary sources. For Akbar (who did not write his memoirs) the *Waqi'navis* (newswriter/reporter) used to make a record/accounting of his daily actions—for instance, what he ate or drank, what books were read to him, and so forth. The diary had to be approved by Akbar and several other officers before it could be registered as an authentic record for posterity. This office of *Waqi'navis* also existed in former reigns, but according to Abu'l Fazl it was not turned to any useful purpose (cited in Law 1916:151 from the *original* edition of *Gladwin* n.d. 177, 178).

19. Bayazid Bayat served in Mun'im Khan's household and became chief officer with the title Khan Khanan after Bairam Khan's death. He dictated his memoirs in his old age, in accord with an imperial order for recollections of Humayun (Streusand 1989:20).

20. The book in question was either the original *Singh-āsan Battīsi* (*Thirty-two Thrones*) or it was Bada'uni's own translation to it, to which he gave the name *Khirad-āfzā*. *Singh-āsan Battīsi* was a series of thirty-two tales about Raja Bikramajit of Malwa. Bada'uni was instructed by Akbar to make a translation of it in Persian prose and verse. (*MtT* 2:186)

21. Law's sources inform us about educated Hindu and Muslim women long before the Mughal period, such as the Muslim Sultan Razia, the sole female ruler in the Sultanate period of Hindustani history. Commentators remarked about her that "there was nothing wanting except that she was not a man" and "as her evil fate did not make her a man, all her talents were useless to her. She, Durgavati of the Gond country, Chand Bibi and many others, were all born too soon" (Law 1916:xxviii).

22. Law 1916:202–4. According to numerous sources, compendia of tales such as the *Tūtī Nāma* (see Simsar 1978) and *Vikram and the Vampire* (see Baital-Pachisi 1893) were favorites of women of the time.

23. This political and practical action deserves some attention here. Norman Ziegler (1978) has written on Rajput loyalties during the Mughal period. He notes that the Rajput alliance was one of the more prominent Mughal successes and became one of the primary supports of the Empire (its partial dismemberment under Aurangzeb is often cited as one of the contributing causes of the empire's decline). The incorporation of a separate cultural group with its own history, myths, customs, and loyalties and its active participation in the policies and goals of empire warrants explanation.

> During the Mughal period, there were two primary units of reference and identification for a Rajpūt, . . . his brotherhood . . . and his relations by marriage (sagā). . . . In the widest sense, the brotherhood was a patrilineal unit of descent represented by the clan. . . . Functionally corporate units were smaller brotherhoods, named, internal segments of the wider clan . . . consisting of from three to . . . six generations and including *all members related by close ties of male blood, their wives, sons and unmarried daughters.* (p. 223)

> Wives are included as members of the brotherhood, because it is felt that upon marriage, a woman becomes transformed into a person related by male blood to her husband and his brothers. (note 24, p. 243)

> His *sagā*, those to whom he gave his daughters and/or from whom he received wives in marriage, . . . was of particular importance, for at the same time that the act of marriage was seen to unite a woman with her husband's brotherhood, it was also seen to create an alliance. (p. 224)

> These brotherhoods . . . [were] greatly influenced by two additional institutions, . . . rulership and clientship [with] a set of obligations incumbent upon each party. (p. 225)

> While the institutions of rulership and clientship . . . existed . . . prior to the Mughal period, they developed greatly during the sixteenth and seventeenth centuries at the expense of kinship as a basis of organization . . . Their development was a direct function of Mughal policy of indirect rule. . . . The [emperor exerted a] right to appoint successors to positions of rulerships . . . and in turn supported them [the Rajpūts] with arms and resources in the form of *jāgīr*s. (p. 226)

> Many of these local institutions and the sentiments surrounding them [ties of blood, sets of relationships based on service and exchange between a ruler and his servants each with a territorial aspect, and affiliations through ties of alliance and marriage with *saga*] Rajpūts were able to transfer directly to their relations with the Mughals, with whom they formed not only patron–client ties, but also marriage alliances. This transference does much to explain Rajpūt loyalty to the Mughals. (pp. 230–31)

> Alongside the normative rules of conduct and of honor which pertained to the brotherhood and the clan was the injunction commanding the service of one's master. This [was the] rule of *dharma*. (p. 233)

> Embedding of dyadic, patron–client ties in a myth of salvation and the obtainment of power and rulership extended to internal ranking among Rajpūts themselves, based on the subjective evaluation of outward differences in degrees of sovereignty and power among Rajpūts. (p. 234)

> In understanding medieval Rajpūt cultural conceptions of rank, power and sovereignty . . . the Muslim was also included within this hierarchical scheme as a Rajpūt. (p. 235)

> The shift in the ideology of honor from concerns with the brotherhood and norms of conduct appropriate to it, to concerns with powerful, individual rulers, local and imperial, from whom honor increasingly derived . . . was facilitated . . . by the myth of the Rajpūt [which] became greatly developed during the Mughal period . . . and [was] a model for relationships as they were . . . [and] as they should

be. . . . From the Rajpūt point of view, this was a period when society moved toward an image of itself, toward an image of what it ought to be. (p. 236)

[Despite isolated pockets of resistance and individual actions against the Mughal rulers] Rajpūt support for and adherence to the Mughal throne became an enduring feature of this period . . . [based on a] "fit" between Rajpūt ideals and aspirations . . . and Mughal actions. . . . Mughal policy of support for local rulers, of alliance through marriage, and of granting lands in return for service and allegiance all found a base of support in local ideology and allowed Rajpūts in turn to find fulfillment of their own ideals through subordination and loyalty to the Mughal throne. (p. 240)

24. The early Sultanate period began as a Turko-Afghan dynasty which lasted from 1192/1206–1398 in three phases: the Slave Kings (1206–1290), whose greatest leaders Iltutmish and Balban established the empire and successfully resisted the Mongols; the Khaljis (1296–1320), who pushed the Rajputs back to their homelands and thrust Islam deep into the southern parts of the subcontinent; and the Tughluqs (1320–1398), whose rule was effectively ended by Timur's destructive raid on northern India and sack of Delhi. (The period 1192–1206 marked the Ghurid capture of Delhi by Muhammad of Ghur until his assassination by his slave lieutenant Qutbuddin Aybak in 1206 and the official start of the Sultanate period. [see chapter 2, note 6].)

25. The pictorial convention of a man and woman being entertained with musicians—including a harp—and perhaps a dancer is an infrequent pictorial theme in the Akbari period, and then only in illustrations of Persian literary works. It appears again in the reign of Akbar's grandson, Shah Jahan, with female musician(s) singing to the self-accompaniment of a drone *ṭāmbūr*.

26. Adapted from the telling of the story in Yusopov 1983:[6]. Abhorring suffering (other than punishment he ordered, that is), Akbar abolished involuntary *satī*, the Hindu rite in which widows burned themselves alive on their husbands' funeral pyres (Schimmel 1983:30).

27. Dale also suggests that the influence of camp life may have been partly responsible for the openness with which Babur discussed his feelings and the individual characteristics of others, including women. He notes that women are seldom treated at length in premodern Islamic literature, except as stereotypical objects of romantic love.

It seems likely that Babur's frankness derived in some measure from his experience in the Turco-Mongol *ordu,* the relatively fluid, unstructured camp society in which he usually lived. [He also notes that while in Turkistan and Afghanistan the urban society] was clearly stratified, religiously conservative, and strongly influenced by Persian literary norms, the Central Asian and Afghan countryside and Babur's immediate entourage were still dominated by Turkic, Mughal [Mongol], and Afghan tribes, . . . clans and nomads. . . . Social relations within this milieu were strikingly casual, unpretentious, and egalitarian. . . . The camaraderie of common endeavor was still fundamentally important, and even an obscure Turkic woman, the troublesome Hul-hul Aniga, could drink openly and raucously with a padshah, the title Babur had assumed after taking Kabul in 1504. (1990:51–52)

28. In the next generation the political involvement of a woman reached its apex in the person of Nur Jahan, the wife of Jahangir, who effectively ran the empire in the last years of her husband's life. From Jahangir's memoirs we know that she held formal *darbār* sessions in the female apartments and bestowed the symbols of authority just as the emperor himself would (*TiJ* 1:278). For a thorough study of Nur Jahan see Findly 1993.

It is interesting to note that women's political involvements, even when they turned out wrong, were handled with tolerance by the ruler toward the woman herself, as for example in the case of Maham Anaga (see chapter 3). When Nur Jahan intrigued against Shah Jahan during Jahangir's lifetime, and after his death promoted Shahryar for the throne, she was not executed but rather bought off with a handsome pension (and with good sense retired from politics). Similarly, when Shah Jahan's daughter Jahanara supported Dara Shikoh, 'Alamgir I treated her with consideration and respect.

29. Dale notes that Babur (in both the *Bābur Nāma* and in his poetry) "distinguished himself as an exceptional figure in premodern (or precolonial) Islamic literature, by vividly conveying a sense of himself as a unique personality. Indeed, he wrote so directly, so openly, and so extensively of himself . . ." (1990:37).

30. The *rudra vīṇā* is a zither-type of stringed instrument (chordophone), i.e., an instrument that consists solely of a string bearer, or a string bearer with a resonator which is not integral and can be detached without destroying the sound-producing mechanism (Hornbostel and Sachs 1961:20). The string bearer on the *vīṇā* is a stick or a tube; a natural gourd is attached to act as a resonator, amplifying the sound of the instrument.

The same explanation is found among Muslim artists for the invention of the Indian bowed lute, the *sārangī* (See chapter 6 and note 15).

31. It has been suggested that

> Akbar's non-participation in the public rituals of Islam reinforced the position of general peace as the sovereign cult because it removed him from the category of Muslim. Right practice in the public cult— orthopraxy—is a matter of consensus in Islam, while right belief—orthodoxy—is harder to establish. There has never been an official mechanism to establish orthodoxy or denounce heterodoxy in Islam. To a degree, Akbar's avoidance of Muslim ritual did constitute an abandonment of Islam. He became an uncommitted arbiter of the relations of Muslim and non-Muslim. (Streusand 1989:137)

See also Watt 1973:5–6 and W. C. Smith 1957:20, who first applied the term orthopraxy to Islam.

32. Kartomi (1990:66) incorrectly states that new instruments such as the horns, trumpets, and drums of the royal Muslim *naubat* (wind and drum) ensembles were introduced by the Mughals in the mid-sixteenth century.

33. In Figure 19 two females play during the "ceremony," while a third probably sings. In the text of the story, there is no mention of music, or even really of a ceremony: "It is said that in one of the cities of India there was a king whose country was loyal to him and whose people were submissive to his will. After his youth had gone and the prime of his life had passed, a son was born to him. When the astrologers read the boy's horoscope, they said that at the age of thirteen he would encounter a great calamity. A painful misfortune would overtake him from which he would escape and be saved" (*TuN* 1976/Simsar 1978:56).

34. Milo Beach notes that "this was so important an episode it was one of the few Akbari episodes included in the *Timurnama* ms. of ca. 1580–85 also" (pers. comm., July 1994).

35. Sambamoorthy 1962:20. The conch shell is familiar both as a signaling instrument and in the ritual ensembles of Lamaistic Buddhism of Tibet. For a brief discussion of the tales and other associations with it, see Crossley-Holland 1982:16–17. For the Hindus, the conch is also a container for holy water. Where a real conch is not available or a more durable material is desired, a silver imitation of the conch, for instance, is used as a container of holy water (Deva 1978:114).

The powerful sacred meaning of the conch continues to the present time—in present-day Rajasthan, for example, where its sound is regarded as auspicious (Kothari 1977). Not only played in temples before the shrine, it can also be heard in other circumstances, such as performances by folk epic singers. To begin and end an epic story, the conch is considered necessary; and during the performance, whenever an auspicious incident in the hero's or a god's life occurs, the conch is played.

It can be played in several ways. Sambamoorthy's comment that it is blown through a small hole made in the spiral (1962:20) seems consonant with Deva's description of the playing technique as blown through a hole at the side, although he says he has not come across a side-blown *sankh* in India (1978:114). The most commonly depicted method of playing in paintings and sculptures is end-blowing through the top of the conch; indeed, that is the case in "Battle between two rival groups of *sannyāsī*s." A conch with an attached mouthpiece is shown in sculpture at Bharhut (2d c. B.C.E.). However it is played, its tone can be heard at a long distance.

A conch drone (*ottu sangu*) used in twentieth-century temple ritual music is mentioned by the South Indian scholar Sambamoorthy (1957:25). It is apparently played with circular breathing for a continuous stream of air. There are two conches being played together in figure 20, and it is not impossible that one was being used for a drone; although in the circumstances one would imagine hearing a series of short, frantic, loud blasts issuing from both.

CHAPTER TWO

1. In this, Akbar was not unlike his great ancestor, Timur, who "was keenly aware of the importance of books for legitimating his rule. They were a key component for positioning himself as a rightful successor to previous kings in the Islamic world" (Lentz and Lowry 1989:52). Among several such commissioned works, the most important was the *Zafar Nāma* (1404) of Nizamuddin Ali Shami.

As well, Timur "consciously used ritual and culture to make himself appear larger than life, cloaking an aura of power. The success of this policy depended on three elements: the aggrandizement of Timur and his achievements; the incorporation of past literary and visual traditions into the dynasty's aesthetic vocabulary; and the effort to form and codify a system of images that could be applied en masse to artistic production" (ibid. 32).

2. Several of the early Mongol rulers married women who were Christian, and a few, like Hülegü's son Tegüder Ahmad, were baptized young or converted. Nestorian Christianity was widespread among the women of the Il-

Khanid family. While Hülegü was probably a Buddhist, he was interested in other religions, and learned men disputed in his presence—another model for Mughal tolerance and interest in learning (see Lambton 1988:254–55).

3. It is suggested that Timur and his descendants were "able to manipulate the complex social, political, and cultural traditions of their Turco-Mongol heritage to provide an aura of legitimacy for their rule. One of the methods for accomplishing this was stressing the connections between their dynasty and the dynasty of Chingiz Khan" (Lentz and Lowry 1989:27). A member of the Barlas tribe of the Chagatai *ulus* (coalition of tribes), named after Chinggis's second son, Timur further continued traditional Mongol (Chinggisid) practices such as issuing orders and reading the *khutba* (official address), governed in strict accordance with Chinggis's *yasa*, adopted the Mongol title *kürägän* (son-in-law) after marrying a daughter of the Chagatai khan and, in as many other ways as possible, stressed his relationship to the descendants of the Mongol rulers (ibid.).

For a good, concise explanation of the myths, legends, and histories surrounding the Mongol and Timurid origins and lines of legitimacy see Richards 1978a:260–66.

4. It is said that Öljeitü Khan once had the Persian original of the *Jāmī al-Tavārīkh*, which eventually came into the hands of Shahrukh, one of Timur's sons (Law 1916:68).

5. The third of Chinggis's four khanates, the Khanate of Persia or Il-Khans, was built up by Chinggis's grandson Hülegü, whose Mongol–Turkish armies overran Persia by 1231 and captured Baghdad in 1258, thus ending the Abbassid Caliphate. The Khanate dissolved in 1335. Il-Khans means vassal Khans.

6. In the centuries immediately prior to the establishment of the Mughal Empire, North India was ruled by five major Muslim Turko-Afghan dynasties headquartered at Delhi, in what is known as the Sultanate period: the Afghan or Slave (1206–90); the Turkic Khalji (1290–1320), Tughluq (1320–1414), and Sayyid (1414–50); and the Lodi (a clan of Afghans) (1450–1526). (See chapter 1, note 24, for further explanation) (maps 5–8).

7. Dale suggests that despite lack of evidence as to why Babur actually composed this work, "the surviving text is itself persuasive evidence that Babur was, first of all, chronicling the life of a Timurid prince. More particularly, he was recording the life of the last independent *mīrzā* (prince) of Timur's lineage. His writing is suffused with a profound, unselfconscious sense of political legitimacy deriving from his Timurid descent. . . . He interpreted his life as a continuing struggle to establish a new Timurid state" (1990:40).

8. Dale's account is as follows (1990:41 with note 69):

> He [Babur] presumably intended the *Baburnama* [his memoirs] to be read by members and supporters of various Timurid factions as well as by individuals within his own immediate family. . . .
>
> . . . The composition of the *Baburnama* may be attributed . . . to the general driving force of [his] personality—his Timurid identity. . . . His dynastic sensibilities must have been heightened, and his desire to record his own life, stimulated, by awareness of such Timurid historical works as the *Zafarnama* (the Book of Victory) of Sharaf al-Din "Sharaf" Yazdi, cultural tutor and close personal friend of Babur's maternal grandfather, the Mughal [Mongol] Yunus Khan. . . .[69]
>
> That Babur deliberately chose his language and style is suggested by the contrasting preferences shown by his young cousin Mirza Muhammad Dughlat, when he wrote his own personally informed history of his ancestors and relatives, the Mughals [Mongols] of Central Asia. . . . Muhammad Haydar . . . chose to write the *Tārīkh-i Rashīdī* in Persian, the prestigious literary language which he probably knew no better than Babur, who composed competent Persian poetry.
>
> [69] Yunus Khan, who spent a long period of exile in Iran, combined Mughal [Mongol] steppe and Iranian urban culture. . . . [He] excelled in "penmanship, painting and other accomplishments conformable with a healthy nature, and was well trained in singing and instrumental music. . . . He was graced with good qualities and perfect manners, was unequaled in bravery and heroism and excelled especially in archery" (Elias and Ross *History of the Moghuls of Central Asia*, 1895:55).

9. The earliest illustrations are in a copy (c. 1589 or earlier) which the art historian Ellen Smart considers to have been the first presentation copy; it is dispersed, having been sold to various parties in London in 1913 (Smart 1977:38); twenty-one folios, for example, are in the Victoria and Albert Museum in London. The copy (c. 1591) which is now mostly in the British Library (OR3714) was apparently in the royal library in Delhi at the beginning of the nineteenth century. It was acquired by the British Museum in 1889 from a Mr. Henry Gee Barnard (Smart 1977:68–69). Another copy (c. 1593) is split primarily between two locations—the Walters Art Gallery in Baltimore, Maryland, and the State Museum of Oriental Cultures in Moscow, Russia, with additional leaves in France and Great Britain. A. V. Morozov bought from "travelling Persian merchants" 57 folios that were then acquired by

P. Stchoukine. At about the same time H. G. Walters, an American collector, made a trip to Europe and Russia, when he may have brought back the twenty-eight folios which are now in the Walters Art Gallery (10.596); it is not known where he acquired additional folios (10.668) (Smart 1977:109). According to a Mr. L. F. Rushbrook Williams, who had the opportunity to study another copy of the manuscript in 1913, that copy (dated 1597–98), which is now in the National Museum in New Delhi, was acquired by an Englishman in Agra at the beginning of this century and given to Agra College. It was taken to the National Museum shortly after independence in 1947 (Smart 1977:131). There are additional copies (partial) at Alwar and Istanbul (Smart 1986).

10. Shaibani Khan, a descendant of Chinggis Khan through his son Jochi and grandson Shaibani, was the leader of a warlike tribe, the Uzbeks, which had risen to prominence in the area between the Ural Mountains and the Aral Sea. Various Timurid chiefs struggled for power in Turkestan and for control of Samarkand. Into this fray came Shaibani Khan and his Uzbeks, who were the most successful in their ability to capture the city (see story quoted on p. 22 above and *BN* 125–26).

11. In *AN* 1:429, n. 1, the translator Henry Beveridge comments that Babur's use of terms to mean melodies possibly meant that the women as well as men were to recite and sing to the passersby. Most likely, however, it is referring to dance. Beveridge's note 5, pp. 428–29, says that Vambéry's *History of Bokhara* (1873) "describes a dance known as the Herātī," and that the *munshī* (scribe) of Burnes, author of Burnes *Travels* (1834), Mohan Lal, "rather maliciously observes that all the women of Herat know how to sing and dance, but show these accomplishments neither to their husbands nor to their relations, but merely to their friends."

12. On the occasion of the death of some important figure such as Sultan Husain Bayqara, Babur interrupted his daily accounts with an epitaph in the form of detailed information about the sphere of the deceased person. Babur's rather list-like format may have been the model which Abu'l Fazl followed in the *A'īn-i Akbarī* when he listed the imperial musicians at the court of Akbar and provided other information about music. Unfortunately, Abu'l Fazl does not seem to have been so personally involved as was Babur with music.

About the Herat Timurids, Dale suggests that they "had lost their savagery and group feeling; they could socialize but their taste, training, and organization for battle had atrophied" (1990:52).

13. This is folio 257r of the British Library copy of the *Bābur Nāma*.

14. Babur had publicly renounced wine drinking but, as he wrote on 10 February 1529 to Khwaja Kalan, his governor of Kabul, "in truth the longing and craving for a wine-party has been infinite and endless for two years past, so much so that sometimes the craving for wine brought me to the verge of tears" (*BN* 648).

15. *BN* 407. Porcelain cups were treasured items in Mongol culture. That they could have been carried safely even on the move is shown by the elaborate cloth, wood, and leather transport containers in Kalter 1983/84:57.

16. "Babur on a raft in the Panjhir River," 1519, painted by Kamal Kashmiri, with portraits by Madhu. In a private collection in France, published in the Hotel Georges V Sale Catalogue, 30 October 1975, lot 469 (Smart 1977:52) and in Pal 1983:122. The instrument is probably a *tāmbūr*.

17. Mark Slobin, writing of the musical instruments in the cultures of northern Afghanistan in the 1960s, describes a *qobüz*, the rarest of the instruments of the North, which he documented in only one locale (1976:248–50). The lengths of the neck and of the head ("pegbox") of the instrument are equal, and the length of those two together is only a bit shorter than the body. The body is shaped like a big ladle, that is to say, it is heart-shaped at the top, tapering to an elongated V. The heart-shaped area is left open, while the V is covered with membrane to create a soundbox. Slobin also cites a description of an instrument, called the *qobyz*, of the Kazakhs of Central Asia (Vertkov 1963:133). Like the Afghanistani instrument, it has a comparatively short neck and a ladle-shaped body. The lower, extended section of the body is closed by a membrane of camel skin, with the upper end round and open. That matches Nixon's description of the *qobuz* of the Kazakhs, a bowed lute which is still used by the semi-nomadic Uzbeks of Uzbekistan (1984c). I have not found a single Mughal painting that depicts a bowed lute of such description.

18. The term *dhol*, however, emerged in the thirteenth century in the period of the Delhi Sultanate, and is not derived from a Sanskrit term (Dick and Dournon 1984b:560).

19. Ibrahim had 100,000 men and 1,000 elephants, Babur perhaps 25,000 troops and horses in addition to matchlocks and mortars, probably from the Ottoman Turks.

20. In Smart's study (1977), this painting is titled "Babur's celebrations for 'Id of Shawwal" (c. 11 July 1526).

21. The climate in Hindustan permitted Babur to expand his use of gardens and broaden their function. His inherited nomadic tendency was reinforced by a lifetime spent as a soldier, and he preferred to live in his *charbagh*s as Timur had rather than in the confined space of a palace. The extensive walled and terraced *charbagh*s Babur built

in Hindustan were open-air palaces. Each terrace had a specific use which corresponded to certain rooms within a palace and included baths and a mosque. In his gardens, Babur planned military campaigns, held public audiences, wrote his memoirs, composed poetry and music, entertained, and reveled with his friends. And Moynihan asserts that, because of the age-old mystical response aroused by the Paradise gardens of Muslim culture, they were not perceived as displays of power by the Mughals, but rather intended to be places of perfect peace (1979:97, 123). The etymology, as explained by Moynihan, is *bagh,* "garden," and *chahar,* "four"; hence *chaharbagh,* a common term for four-fold, enclosed garden (ibid. 49).

22. The illustration of the fleeing forces is reproduced in Randhawa 1983:136.

23. The painter of the scene in fig. 43 may have had in mind a real scene. In his new imperial city of Fatehpur Sikri, Akbar had set aside a huge *maydan,* an open space where he engaged in a number of public or semi-public activities. Polo was played there, and the acrobatics of Akbar's beloved trained pigeons displayed, but also elephant fights and gladiatorial battles were staged which apparently continued, accompanied by the rhythms of four pairs of drums, until death befell one of the combatants (Brand and Lowry 1985:45).

24. The death of Rana Sanga and other Rajput chiefs at Kanua had shattered the likely Rajput resurgence in the North. In 1528, Babur and his troops stormed the great fort at Chandiri, stronghold of a great Rajput chief feudatory to the Rana of Mewar, and slaughtered the garrison (see Richards 1993:8).

25. In a large sense, Babur's assertion of his Timurid identity as a leitmotif of his narrative served a major purpose. As Dale notes: "The presence of certain didactic passages suggest that Babur composed the work not merely to inform Timurids, and posterity, of his genealogy and accomplishments but also to serve his heirs as a political guide, a mirror for Timurid princes" (1990:42). As Peter Hardy observed: "The 'Mirror of Princes' literature of the Perso-Islamic tradition outside India (and written before the Ghurid conquest [at the end of the twelfth century]) stresses that no kingdom or king will flourish without a wise minister, and lays down guide-lines for the king in the choice of and consultation with his (chief) minister. . . . The sultan is depicted in the Indo-Persian materials as the bringer of prosperity to his subjects . . . not by reason of his being, but by reason of his behaviour, that the sultan becomes the means whereby subjects enjoy welfare" (1978:200).

26. As summed up by Richards (1993:9):

> Babur bequeathed to his successors a distinguished lineage stretching back to the great Central Asian conqueror Timur, and also through the Chaghatai Turks back to Chingiz Khan. . . . In addition Babur's legacy included Central Asian horsemanship and battle tactics, life lived comfortably under canvas in tents, and the Turki language. He left a persistent and abiding Sunni Islamic faith and a familial connection with the orthodox Naqshbandi Sufi order which had originated in Central Asia. His legacy included a sophisticated cultural style derived from Timur's patronage at Samarkhand and refined at the courts of his successors in Central Asia.

27. In another illustration of Humayun's accession, fol. 273b of the *Tārīkh-i Khandan-i Tīmūriya* manuscript in the Khuda Baksh Library, Patna, Bihar, India, the artist Ramdas has provided as the court music not the usual plucked lute, but a bowed lute (*ghichak*) being played along with the usual *dā'ira.*

28. The kingdom Babur left to Humayun included Central Asian territories, Kabul, the Punjab, Delhi, and part of Bihar to the east and south to Gwalior. But it was a new conquest-state with little consolidation of Mughal rule in the new Indian territories (Richards 1993:8–9).

29. Conforming to the Timurid appanage system, Humayun had distributed provinces to each brother to administer: Mirza Sulaiman got Badakhshan in the northwest, Kamran was given Kabul and Kandahar, 'Askari and Hindal each received large districts in India.

30. Born in 1486, Sher Khan Sur was an Afghani chief who had quietly gained control of the *mansab* of his father in southern Bihar (Bihar was under Sultan Muhammad). In 1526 he joined forces with Babur and became the deputy of Bihar for young Sultan Jalal Khan. In 1533 Sher Khan defeated Jalal and soon became the leader of the Afghan resistance against the Mughals and de facto (if not de jure) king. While Humayun dithered in moving against him, in 1537 Sher Khan overran Bengal and laid siege to Muhammad Shah, the ruler of Bengal, at his capital, Gaur. Humayun had chosen to take Chunar fort rather than move on Gaur. Sultan Muhammad fled to Chunar but eventually it, too, fell. Humayun retook Gaur briefly, but in 1539 Sher Khan routed him, and Humayun fled to Agra. Several months of negotiations between Humayun and Sher Khan ended with a surprise Afghan attack in June 1539. Humayun barely escaped alive, and Sher Khan assumed the title Sher Shah in a post-battle coronation ceremony.

As noted above, nearly a year later, in May 1540, the Mughals and Afghans met again near Kanauj, but the Mughal army ran and was butchered.

31. There is some disagreement about this and other dates. For example, Spear (1972) says 23 November. Beveridge says that Hamida left Umarkot on 20 November and joined Humayun in early December.

32. Hardy discusses the role of astrology in the Indo-Persian sphere.

> Accession of a new ruler to power is repeatedly depicted as restoring stability to previously unstable situations, but, and this separates Indo-Islamic from Indian tradition, this transformation occurs not by reason of any cosmic quality or personal charisma of the king as a descent of Cosmic Being, but as a concomitant of the new ruler giving fresh vigour and wider currency to the mandates of the Islamic law. . . .
>
> . . . One order of symbols, often associated with rulers, which is noticeable in the thirteenth century Indo-Persian materials, namely the astronomical and the astrological . . . provokes the question whether astrology had the makings of a "shared interest" for both Muslim and non-Muslim ruling elites. (1978:201)

33. According to mythology, Alanquva bore three sons in this virgin birth; she is pictured with them in the *Chinggis Nāma/Jamī al-Tavārīkh*, in a folio in the Los Angeles County Museum of Art that is reproduced by Brand and Lowry (1985:136). It is through the youngest of the triplets, Buzanjar Qaan, that Abu'l Fazl traces "this hidden light" from Chingiss Khan, to Timur, and ultimately to Akbar.

A brief clarification is in order here as regards the Christian notions of immaculate conception and virgin birth. The former is a doctrine of the Roman Catholic Church that Mary was conceived without original sin. The latter is the doctrine that Jesus was born to Mary without prejudice to her virginity and that she was his only human parent.

Miryam Makani ("Residing with Mary") was the name Akbar chose for his mother after her death, according to the custom of referring posthumously to revered persons by a different, meaningful name. The phrase *Firdas Makani* ("Residing in Paradise") is the posthumous title of Babur, *Jannat Ashyani* ("Resting in the Heavenly Garden") denotes Humayun, *'Arsh Ashyani* ("Resting on the Divine Throne") was the name given for Akbar, and the like. In the chronicles a reader can know the person is deceased by the use of this name.

34. This painting is extremely similar to the birth scene in the *Jāmī al-Tavārīkh*, 1596, "The birth of Ghazan Khan" (r. 1295–1304). The art historian Milo Beach reproduces it in his article "Mughal Tents" (1985) to illustrate the use of fabric by the Mughals to make walls even within buildings. The wall of which he speaks separates the lower set of astrologers from the bottom of the painting. In "Celebrations at the birth of Timur" (see pl. 10) the wall is a solid architectural surface.

35. It has been suggested, although it is controversial among scholars, that Humayun, under great duress, accepted *Shi'a* Islam, after which Shah Tahmasp agreed to subvent Humayun's attempt to regain power in Hindustan.

36. This scene is illustration no. 31 from the British Library copy of the *Akbar Nāma* but is located at the Freer Gallery of Art (Smithsonian Institution) 39.57. It is reproduced by Beach (1981:103). No musicians elaborate the depiction.

37. Three points should be made about Humayun's final year for its import to Akbar. The officers who came to Hindustan with Humayun and became Akbar's subordinates were from three different backgrounds: Chagatai, who comprised the largest number; bureaucrats of the Iranian tradition of centralized government; and Turkmen nomads from the Safavid Persian empire. They, and a steady flow of immigrants from the Safavid empire and the Uzbek principalities with linguistic and technical skills, helped build the Mughal empire (Streusand 1989:44–45).

It is also of import that Babur had made changes in the Timurid doctrine of kingship by taking the title of *pādshāh* in Kabul in 1507; earlier Timurids had used the title *mīrzā*. Humayun, during his brief second reign in Delhi, introduced a new model of administration and social structure, which suggests that he, too, intended major changes in the doctrine of kingship.

And, despite his peripatetic existence, Humayun displayed his Timurid heritage in several ways that encouraged its permanence in the Mughal empire. One was his appreciation of culture, shown in part by his reverence for books and his mobile library. When he arrived in Persia in 1544, he had been entranced by its elegant culture and its arts; when he left to attempt to regain his "empire" he took with him two miniaturists—said by some to be the originators of the Mughal painting style. Humayun also sponsored and enjoyed musical entertainment as a normal pattern of "court" living. Although he did not write his memoirs, we know about music-making during his time from

others' accounts and that Humayun also patronized musicians, for they are classified as part of one of the groups integral to his scheme of life. By this scheme, Humayun divided the people in his empire into three classes: (i) The holy men, the philosophers, *ulama, Sufi*s, literati, law officers, and scientists formed a class called *ahli-sa'ādat;* to associate with such men, to honor and regard them highly would bring eternal prosperity. (ii) The relations of the Sultan, including other members of the Timurid family, the nobles and ministers as well as the military, formed the group called *ahli-daulat* (fortune—i.e., the good fortune of the ruler and thence his government, the modern Persian word for state); no wealth could be attained without them. (iii) Those who possessed beauty and elegance, were young and lovely, as also the musicians and singers, artists and architects, formed another class, the *ahli-murād* (people of pleasure or desire).

Humayun also categorized the days of the week and appointed two days for each of these three classes of people. Mondays and Wednesdays were designated for class (iii), for Monday was considered to be the day of the Moon and Wednesday of Mercury, and it was also thought reasonable that on those days the king should keep company with "young men beautiful as the moon, and hear sweet songs and delightful music." On Fridays he called together all three classes and sat with them as long as his leisure allowed (Law 1916:129–30, citing *Humāyūn Nāma* 5:119, 120; Streusand 1989:36–37).

CHAPTER THREE

1. Ann Lambton (1988) provides substantial background information and historical contexts on the power, influence, and importance of women of the Mughal predecessors, the ruling houses of the Mongols, and the dynasties derived therefrom for the eleventh to fourteenth centuries, including the ruling house of Persia.

As example, for the Mughal women, the historian E. B. Findly (1993) argues in her study of Nur Jahan, the wife of Jahangir, that because she had no children her political involvement was considerably broader than it would have been simply as a mother. She governed the empire for the last five years of her husband's dissipated life.

2. In the imperial household, the *ḥarem* not only constituted the largest department but also accounted for the heaviest expenses. Cash stipends (no paper drafts, i.e., *barat*) were paid. High ranking ladies (*mahīn-bāno*) received generous stipends. Other females were placed in two grades with a wide range of pay. Also, all the servants were paid and maintained, and the imperial kitchen cost considerably to run for the *ḥarem* (Moosvi 1987:248–50). As Pelsaert noted, "Each wife (of the noble) has separate apartments for herself and her slaves, of whom may be 10 or 20, or 100 according to her fortune. Each has a regular monthly allowance for her *gastos*. . . . Their food comes from one kitchen, but each wife takes it in her own apartments" (1925:65). It is also suggested that some of the high-ranking ladies of the imperial *ḥarem* maintained their own kitchens (Moosvi 1987:250).

3. Painted c. 1586–87, the illustrations were made originally for a historical text that is no longer known and were reused (or inserted over a separate text, thus "recycled," M. C. Beach, pers. comm., July 1994) with the text completed by Abu'l Fazl c. 1597 (Seyller 1990). Seyller concludes that the 1596–97 Chester Beatty *Akbar Nāma* is the first manuscript illustrating the *Akbar Nāma* text proper (1990:385). Milo Beach says it is likely that the Beatty–BM copy is the one prepared for and presented to Akbar (pers. comm., July 1994).

4. At present in North India the smaller variety (about 7 cm in diameter) comprises the *mañjīrā* or *tāl* (in South India *tāla* or *kanjam*), while the varieties of larger-sized cymbals are called *jhāñj, jhallarī/jhallarā*, and other terms. In the South the corresponding word is *jālrā*, says Deva (1978:56). Sambamoorthy describes these as

> circular flat discs. The two discs are connected by a cord or cotton thread passing round their centres. The *Jālrā* are principally used in Harikathā Kālakshēpams and Bhajana Parties. Mendicants use it to keep time to their music. Even with such a simple instrument, there are performers who are able to play all the difficult combinations of jatis and successfully with even the expert mridangam performers in concerts. (1962:27)

In plate VII of the Sambamoorthy catalogue, the difference between the *jālrā* and another large-sized variety of the South, the *Brahmatālam,* can be seen: The *jālrā* boss is small so the rim predominates, while the *Brahmatālam* has a boss that takes up almost half the total diameter of the plate. The plates of the small *tālam* photographed there have a total diameter of 1¼ inches, of which ¾ inch is consumed by the boss; they are not held together with a cord.

The term *tāla* is extended to *kartāl,* "to do the rhythm," which term is sometimes extended to metal cymbals but applies generally to any two surfaces struck against each other, such as castanets.

5. Painted in Popular Mughal style, this scene probably depicts the performance of an all-male drama troupe.

6. Compare the costume on the dancer in this all-female troupe with the dancer's costumes in plate 15. In figure 52 the woman standing beside the dancer appears to be a dance "master."

7. In his catalogue of Indian musical instruments in the nineteenth century, Colonel French made this entry: "41. *Hoodok.* 42. *Dak.* These drums are used by ballad singers, mendicants and the like, and need no particular description" (Tagore 1965:260). It seems that the tradition of accompanying ballads with *huruk* continued outside the Mughal court sphere.

8. When swords are a prop, there is only one dancer. When sashes are manipulated, there will usually be two dancers in the scene.

9. The woman dancing in the space alloted to illustration in a folio of the *Tārīkh-i-Alfi* (fig. 57) by the artist Tarya is a curious figure. She wears the cap (albeit a bit modified) and dress of a Central Asian woman but wrist tassels and ankle bells of an Indian dancer (see also fig. 27).

10. For additional evidence of such cultural synthesis in the sphere of dance, see Vatsyayan 1974.

11. Dick identifies this shape of drum as the *dholak* type and distinguishes it from the cylindrical or barrel-shaped *dhol* by these proportions (1984a).

12. It is also important to note that in addition to power and influence, Muslim women had important rights in Islamic law. For example, females and males have equal rights over property. As Fyzee notes, a "daughter does *not . . . by reason of her sex, suffer from any disability* to deal with her share of the property. She is the absolute master of her inheritance. The same rule applies to a widow or a mother" (1964:385, emphasis added). Nor does a woman change her status when she marries. "She remains subject to her own pre-marital school of law. Neither the husband nor the wife acquired any interest in the property of the other by reason of marriage" (ibid. 111). A full explanation of women's rights in Islamic law is found in Fyzee 1964.

13. It has been suggested that ethnic and religious conflicts were the root cause of dissension. The orthodox *Sunni* Muslim Central Asian (Turani) nobles disliked deferring to the all-powerful regent, who was a *Shi'ia*. This was compounded when Bairam Khan appointed a *Shi'ia* theologian as *sadr* (religious minister), who controlled state patronage of gifts, grants, and jobs (Richards 1993:14).

14. If, as Alistair Dick specifies, cylindrical (and barrel-shaped) drums were *dhols* (1984a), whereas the *dholak* was barrel-shaped only, the drums played by Indian women in Mughal paintings are *dhols*. I have not found a woman playing a barrel-shaped drum in the period under study. This type of drum was widespread, found in West Asia as well, but the contextual information in the Mughal paintings makes it clear that this was the drum of choice of Indian women.

15. Baz Bahadur fled to the Deccan Muslim Sultanate of Khandesh, whose ruler, along with the sultan of Berar, allied with him to temporarily repel the Mughal forces, now under Pir Muhammad Khan. Baz Bahadur temporarily regained Malwa until 1562, when he was defeated and his kingdom brought firmly within Mughal control. For eight years he wandered for refuge to various courts, until in 1570 he came to Akbar's court as an *amīr*.

16. After the incident with Adham Khan, Akbar assumed full control of the empire. He had to win over or break the power of the rich and well-armed Muslim nobility and the influential Islamic religious elites, the *ulama* and *Sufi shaikh*s. He decided to create four specialized ministerial posts—finance, military, household, religious affairs—thereby removing a single locus as the point for discontent and rebellion. Such a change also eliminated the threat of a poweful chief executive (*vakil*). In addition, Akbar began designing a system of loyalty which integrated his inherited Timurid charisma and authority, the centralized authority inherited from the Delhi Sultans and the Surs, and the idea of Islamic legitimacy; it came to fruition in the *Dīn-i Illāhi* (see chapter 1, note 7).

CHAPTER FOUR

1. This translation by Shahab Sarmadee (pers. comm., May 1984) differs somewhat from that in the Jarrett translation of the *A'īn-i Akbarī* (3:273), but the sense is the same.

Compared to the personal and detailed accounts of musicians and music-making in the *Bābur Nāma*, Abu'l Fazl provides relatively little about music in the *Akbar Nāma*. This stands in striking contrast to the abundance of music in illustrations produced for Akbar. It is almost as if Akbar instructed the painters: Abu'l Fazl is not as interested in music as I am; whether or not music is mentioned in the text, if music-making would have been going on at the occasion (or type of occasion) you are depicting, then put it in. I have already endorsed the suggestion that Akbar's dyslexia caused him to be more visually oriented, and he would have understood how an illustration constituted a complementary text. But I also posit that he was acutely aurally oriented as well, and the painters' responses

to that appear in the form of pictorial content. Whether or not they received actual instructions about musical content, they would surely have known and catered to the interests of their patron.

2. This was written sometime c. 1572–73. An entry for 1578 in the *Akbar Nāma* mentions a musician by the name of Gadai, without sufficient contextualization to relate the two passages: "At this time of joy a musician named Gadai was brought before H.M. and it appeared that he had twenty-five children from one wife" (*AN* 3:378). Gadai's appearance led Akbar to tell a story about "a Bilūci who had 20 children from one wife" (ibid.). The whole episode just seems to be one of general entertainment.

3. Note that Bhath and Pannah are mentioned, among other place names, as the kingdom of Ram Chand. He was a Baghela Rajput, and his capital was at Kalinjar.

4. Reproduced in *Marg* 4/3, fig. 11 is a painting by Salivahana in which musicians wear similar long *jāma*.

5. "Tānsen was not only a great singer but was reputed to be an accomplished bīnkār" (Khandalavala and Chandra 1955–56:21). "He also knew the art of playing on plucked instruments" (Ram 1982:163). "Akbar's serious enthusiasm for music was represented among the Nauratna [the "nine jewels" of the court] by Miyan Tansen, a Hindu singer and instrumentalist who became a Muslim and was awarded the title *mirza*" (Schimmel 1983:36).

6. This remark has also been taken by Schimmel (1983:36) and others as firm evidence that Tansen learned music with 'Adli (*MtT* 1:557). For the word "art," Bada'uni uses *wadi* (*wādī*), a valley or desert, apparently to show his disapproval of the art.

7. Taking its lead from the *Bhāgavad Gita* (Song of the Lord), which recommended devotion (*bhakti*) as the most efficacious form of religion, the *bhakti* movement presupposes an omniscient, omnipresent, and omnipotent personal God who confers His grace on the devotee, however lowly. *Sufism* also emphasizes a direct personal relationship between the individual and his God. *Sufi* modes of thought and religion appealed to Hindus who were attracted enough to convert to Islam.

8. One source suggests that Makarand Pande of the legend might have been Nayak Pandaviya, a Banaras musician at the court of the great Raja Mansingh Tomar (1486–1519) (Khandalavala and Chandra 1955–56:11). Another variant is that Muhammad Ghaus called on the parents after Tanna Misra had been born, assured Tansen's father that he would bless his son with sufficient longevity, and prophesied that the boy had a splendid future (Khandalavala and Chandra 1955–56:11).

9. Deva's discussion is as follows:

> The usual tradition says that he was a disciple of Swami Haridas of Brindavan. The story of how the saint came across the boy Ramtanu goes thus: Once Swami Haridas and his students were on a pilgrimage and had to pass through a dense forest. As they went through the woods, they heard the fearful growls of a lion. Frightened for their lives the young boys ran as fast as their legs could carry them to the hermit for protection. He had his own doubts and sent them back to find out where the animal was hidden. As they quietly and with fear searched around, they came upon not a lion but a boy of ten perched on the branch of a tree and shouting at them like the animal. They caught hold of the naughty fellow, produced him before their master and told him of the incident. Haridas was impressed by the vocal "talents" of the child. . . . The swami, then, called for Makarand Pande and persuaded him to send the boy to Brindavan to study music. Thus Ramtanu became the disciple of Swami Haridas and learnt from him for many a long year. . . .
>
> Some are of the opinion that Ramtanu's early musical education was in a school of music established in Gwalior by Raja Man Singh and that he joined the *swami* later on. It is surmised that Mohammad Ghouse was one of the teachers at this school. It is also said that at a later stage Tansen went to Bengal and was for some time studying with Mohammad Shah Adil, the last king of the Suri dynasty. After a few years of intense training he returned to Rewa to become the court musician of Raja Ramachandra. As far as Tansen's own account goes, no song of his mentions any *guru* other than Makarand. (1973:88–89)

10. Deva 1973:87. For a careful additional survey of sources on Tansen, see Srivastava 1977:141–43.

Another common legend connects Haridas as well as Tansen with Akbar; it, too, has variant versions. One relates that Akbar was very eager to hear Haridas, a great singer who lived at Brindaban, who was a great devotee of Krishna. Haridas refused to travel to Fatehpur so, in the guise of a *sādhu*, Akbar journeyed to Brindaban to hear Haridas, who was accompanied by Tansen. While singing before his *guru*, Tansen intentionally committed mistakes, providing the opportunity for Haridas to correct them by practical demonstration. This version has it that Haridas's

music had such an effect that the Emperor temporarily lost consciousness. After regaining his senses Akbar purportedly asked Tansen why he could not sing as well as his teacher. The reply was: "Your Majesty, I sing in the court of a mighty ruler, while my teacher sings in the court of God" (Khandalavala and Chandra 1955–56:15; Randhawa 1971:1). This legend was treated as historical fact in the eighteenth century and was illustrated by Rajasthani painters; because a *tāmbūr* is held by Haridas, a painting reproduced by Chaitanya (1979, fig. 47) could not be mistaken for one of the Akbari period. As related by Deva (1973:88):

> Once Emperor Akbar wanted to hear him. It was impossible to bring the *swami* to the royal court; and the hermitage was out of bounds to kings and such like. Therefore, Tansen thought of a ruse. Akbar would go in rags as a *tamboora* bearer with Tansen to Nidhuban! The two went as planned and the Emperor listened with rapt wonder to the divine music. On return to the court, Akbar remarked to Tansen, "How is it that with all your viruosity, your music is so insipid compared to your *guru's?*" Tansen replied, "What else can it be: for I sing to the Emperor of this land but he sings to the Emperor of Creation."

11. This passage is important also because Jahangir was reminding his readers of his privileged position not only as the designated successor to his father, but also as the successor to a saint.

12. Ram lavishes more detail on this version:

> When the child was slightly older, he was taken by the parents to the same Fakir Muhammad Ghaus to be blessed. The Muslim Fakir saint, while blessing the boy, put a little bit of the pan (betel) from his mouth, (he was chewing) into the boy's mouth and blessed him to be immortal. From that day, he was converted into a Muslim (on account of tasting the pan eaten by a Muslim Fakir), and had been given many Muslim names like "Atah Ali Khan," etc. and was brought up as a Muslim child. However, this name Miyan Tansen was conferred on him by the emperor, at a later time. (Ram 1982:161)

Deva cites another variant about Tansen's conversion to Islam: that the young Tanna Misra converted in order to marry a Muslim girl.

> Rani Mriganayani, the widow of Raja Mansingh, was herself a good musician and Tanna was one of her favoured artistes. The young man used to visit the palace often, both to listen to the queen as well as to sing to her. In the service of the *rani* there was a beautiful maid, Huseini (a Hindu but converted to Islam). The lass and Tanna fell in love with each other and got married with the consent of the queen. The wedding was celebrated with Hazrat Mohammad Ghouse as the chief priest. It was for this ceremony that Tanna became a Muslim and from then on came to be called Ata Ali Khan. (Deva 1973:89)

13. It is believed that there is a miraculous virtue in the leaves of the overshadowing *nīm* tree, which, when eaten, improve the human voice (Bhanu 1955:23–24). As a result, that poor tree is kept in a sad, scraggly condition.

According to Forbes (1834, 3:32), Tansen died at Lahore, and his body was taken to Gwalior at the express orders of the Emperor (Bhanu 1955:23). For some reason, Deva, who is usually more careful, declares that Tansen "seems to have spent his last years in Gwalior and passed away sometime between 1585 and 1610" (1974:52). Strangely, Khandalavala and Chandra (1955–56:12) conjecture that Tansen lived into Jahangir's reign. They base this on an article by P. M. Joshi (1950:193), which reported that at a music party at the palace of Ibrahim Adil Shah II in Bijapur in 1603–4, Ibrahim inquired of Asad Beg whether Tansen stood or sat while singing before Akbar, and was told that in the *darbār* and during daytime Tansen had to stand while singing, but at night and on the occasion of the Nawruz and Jashan festivals he and other musicians were permitted to sit while performing.

14. To their credit, Kuppuswamy and Hariharan are taking to task a conservative Hindu writer, Shri B. S. Sitholey, who dismisses the musical contributions of Tansen in a manner that leaves little doubt of anti-Muslim feeling. Such rhetoric is not new, however. It is reported by Fox Strangways (1967:84) and by Gangoly:

> It is generally believed in conservative musical circles that Tān Sen was principally responsible for abjuring many old traditions and for introducing innovations and questionable novelties which lead to the deterioration of the old Hindu system. (1948:53)

15. Therefore, that Lal Kalawant could not have been the Lal Khan who was honored by Shah Jahan with the title of *Guṇa-samudra* ("ocean of talents"), as indicated in the preface to the *Sahasarasa*. However, he may have

been Tansen's student (Sharma 1972:12–13). The Lal Khan of the time of Shah Jahan might have been the student of Tansen's son, Bilas Khan, who was reported by Faqirulla (1956:135) to have married a daughter of Bilas Khan.

16. The origin of the name "Numa Khan" is a mystery.

17. In the system of ranks, he had the salary equivalent to that of a fairly high ranking official who had 500 persons (troops and services) and 200 horses to support (see the discussion of *mansab* in chapter 1).

18. Based on some uncited source, the historian Bhanu makes a comparison between the two:

> A great quality of Baz Bahadur was that whereas Tan Sen and Baiju Bawra were more at home in the vocal aspect than the instrumental aspect of music, Baz Bahadur was both a vocalist and an instrumentalist of first rank. (1955:24)

19. In the nineteenth century, Captain Charles Day noted that "the *sringa* or *sing* is frequently found with a metal rod connecting both ends" (1891:153). And Sambamoorthy, describing an instrument in the collection of the Madras museum, confirmed that it still consists of four or five brass tubes fitting into one another, with the end pieces connected by a rod or cord to give stability (1962:21). The equivalent South Indian name (also meaning "horn" both musically and otherwise) is *kombu*. Grieg adds that the *sing* is found today in Nepal and India, of copper, c. 4′ long, four pieces, tapers backwards. The bell is c. 4″ across, with a ¼″ bore at the mouthpiece (1980:162).

20. This poem Simsar translated as "The veins of my body are protruding like the curves of a lyre, Every hair on my head is complaining." I have substituted the translation of Partow Hooshmanrad (pers. comm., June 1991), who explains that Nakhshabi likens the many veins coming out of his body—possibly due to hardships, anger, or helplessness—to the shape of the *chang* (harp, not lyre). His suffering is expressed in the loud cry [*faghan*] that comes out of each hair—which suggests both a vein and a musical string; there is no mention of "head" in the poem, and therefore Nakhshabi must be referring to "veins" in his body rather than "hair" on his head.

21. Among the folios from a *Tūtī Nāma* manuscript in the Chester Beatty Library in Dublin is the same scene, but greatly varied. The instrumentarium in the Chester Beatty folio includes *nā'ī, daf,* singer, and harp, as well as a plucked lute (as the story does), *shahnā'ī,* and what may be the Indian *pakhāvaj* that has partially blocked the body of another player. What is curious about this painting is that the six children are all actively responding to the music; while that still proves the sensitivity of the heir, it is not possible to pick him out.

22. As regards such war activities, the historian Richard Davis has compared looting in medieval India with its understanding in the modern West. Whereas Westerners have come to regard looting as a species of robbery, a side effect of war that is predatory, disorganized, and motivated by economic gain, Indians and the Mughals in the medieval period did not consider such seizure as theft, nor did they necessarily conduct it in a disorderly and surreptitious fashion.

> Rather, medieval South Asian rulers and their retinues carried out plunder as a normal and public aspect of war, organized by and around the person of the king, and directed as much toward symbolic objects as toward economic resources. . . .
>
> The most common target for royal appropriation in medieval India was regalia, a repertoire of objects associated with the king's person and his capacity to rule—banners, yak-tail fans, umbrellas, crowns, thrones, scepters, musical instruments, and gateways. (Davis 1993:27, 31)

The drums in figures 84 and 85 demonstrate that.

23. Such rings on trumpets/horns were common in art from Egypt across to India from earlier centuries. Examples include: "The wonders of Creation ('Aja'ib al-Makhluqat) of al-Qazwini: The Archangel Israfi," probably Iraq, c. 1370–80, a painting in the Freer Gallery of Art, reproduced in Ettinghausen 1962; a water clock, described and sketched in a 1354 Egyptian treatise (the *Automata* of al-Jazari), showed the passing of each hour with (among other things) a musical ensemble striking up a noisy tune. The ensemble includes two straight trumpets with ringed junctures, and a pair of kettledrums played by one drummer; the manuscript is in the collection of the Isabella Stewart Gardner Museum in Boston (Horioka 1975:105).

24. A polo game illustrating a *Dīvān* of 'Ali Sher Nava'i, painted in Meshed (Mashad) in 1564–65, shows two drummers and horn and *surnā* players high in a freestanding, two-story pavilion beside the polo field. That painting is in the Bibliothèque Nationale in Paris (Suppl turc 762).

25. See also the polo game illustration of a *Dīvān* of Amir Khusrau Dihlavi, fol. 41r, in the collection of the

Walters Art Gallery (W. 650). It was painted in the atelier of Prince Salim (Jahangir) in Allahabad in 1602–3 when he was rebelling against his father by setting up his own court establishment. The folio is reproduced in Beach 1978:37. In Sultanate and Deccani paintings, this may be different.

26. Beyond the question of whether or not to include musicians, painterly considerations might have extended to which instruments would be depicted, and especially to what the instruments would look like. For art historians, a vital question lies in figuring out who was responsible for what in the Mughal system for the production of illustrations, i.e., which system was adopted from the Persians: If a painting was designed by one artist, and painted by another, who was responsible for what the instrument actually looked like? That is a question I will consider in another publication.

CHAPTER FIVE

1. The fact that women musicians are playing the end-blown flute in Mughal paintings may show a difference from Persian cultural presentation in paintings. The only Persian-sphere illustrations I have seen in which women play that instrument are within the Timurid sphere from the fifteenth century; a plate of an illustration from a *Shāh Nāma* manuscript of 1439, for example, shows a familiar type of scene—a "Meeting of lovers" who cuddle in an alcove in a palace, accompanied by women musicians playing *nā'ī, dā'ira,* and harp ('Ukashah 1983:131, pl. 80; see also chapter 3 above). I have not searched Persian painting sufficiently to generalize about this point with certainty.

2. Jairazbhoy (1980) responds to the writing of B. Chaitanya Deva (1975, 1978) on an indigenous origin for double-reed instruments in India. Flora (1986) summarizes the arguments and evidence for double-reed instruments in South Asia and other parts of the Indian Ocean littoral, citing the work of Curt Sachs, Nazir Jairazbhoy, and Alistair Dick as well as contributing his own hypotheses.

3. Flora 1986:208. The folio is part of the Watson collection of Indian miniatures in the Elvehjem Art Center at the University of Wisconsin. It is reproduced in Flora's article as plate 1.

4. A lighter-colored, i.e., metal, distal end of the horn appears to be decoration rather than an attached bell. Strikingly, the same implied decoration appears in another illustration where a horn was mistakenly drawn in the place of a *surnā,* the instrument just below the cymbals in the *naubat* ensemble which heralds Akbar from a parapet during an assassination attempt (fig. 3). The artists who produced this painting are different (designer Jagan, painter Bhagwan Kalan), but the instrument is very similar in all ways except the color.

5. According to Dick, this "Indian" conical shawm was also imported from West Asia, but earlier—in the eighth or ninth century via Arab culture resident in Sind, now in southern Pakistan (1984d:80). Flora hypothesizes that the shape is not imported, but an Indian Ocean contribution, the origins of which lie in a spiraled-leaf prototype (1986:46). Flora further contrasts the West Asian *zurna* type from the South Asian/Indian Ocean littoral type by the material of the reed: cane in the former, but multiple layers of leaf material in the latter. Modern Indian double-reed instruments are thus a composite of the two historical types distinguished by Flora: the *shahnā'ī* and *nagaswaram* are "consistently conical" but have a cane reed.

6. See also "Rustam attacking the fortress of Kafur," in Shiraz style, 1560 (Robinson 1976:96).

7. The same difficulty in identifying the shape occurs in Mughal paintings as well. In a very early Mughal scene on cloth, "A prince riding an elephant in procession," c. 1570, the *surnā* player holds his instrument high so that we see a gradually widening conical "bell" but not the proximal end where his hands are positioned to play (Topsfield and Beach 1991:22–23); see figure 7.

8. Andrew Grieg found the right hand always to be shown on top in Mughal miniatures, but comments that Bismillah Khan holds his instrument with the left hand uppermost, while the other *shahnā'ī* players in his ensemble play with their right hands on top (1987:486). Reis Flora, who has studied *shahnā'ī* with several teachers, finds either hand used uppermost (pers. comm., January 1995).

9. *AN* 1:63. The players of *dā'ira* were more usually called *dā'iracī.* In this passage they were *dā'ira-dastān,* a compound which the translator Beveridge explains is not in the dictionaries but apparently means "tambourine-players." In the Walker manuscript of the *Akbar Nāma* in the Bodleian Library, this passage reads *dā'ira-sāzān,* which can also mean players of *dā'ira.* In modern-day Iran, the frame drum that is similar to the one played by the musicians in Mughal paintings is called *do'ira/dā'ira* (Zahra Taheri, pers. comm., July 1992; Farhad Ataei, pers. comm., August 1993).

10. For an excellent study of the frame drum in Italy, and specifically the drum as represented in iconography, see Guizzi 1988.

11. Women wearing both of those headdresses, as well as one woman who wears the cap with the cloth over it, can be seen in the same painting, "Presentation scene," reproduced in Beach 1987, fig. 52.

12. *AiA* 3:270. Another translation of this passage in the *A'īn-i Akbarī* differs somewhat but the gist is the same: "The *Duff*, is another kind of drum well known. The *Khenjir*, is a little Duff hung round with small bells" (Gladwin, "Sungeet," in Tagore 1965:206).

13. An extraordinarily small frame drum that has no visible cymbals in the frame is held at shoulder level by a male musician who stands in a cluster of other musicians in figure 133, of the Shah Jahani period. Most of the instruments there are Indian instruments, including the *rabāb*, which had been thoroughly integrated by that time. The frame drum player stands behind the singers, who are in the forefront, and beside a player of the bowed lute (*sāraṅgī*). That drum certainly does not meet Abu'l Fazl's criterion of size, but the scene was painted two generations later. If this is a *ḍaf*, then the *ḍaf* was made in multiple sizes.

14. Reproduced in the Falk and Archer catalogue of the Mughal collection in the India Office Library in London are three such paintings: plates 94, 98, and 111 in that catalogue are dated to c. 1650–60, 1660, and 1670, respectively.

15. A *rāgamāla* painting of Rag Pancham/Sarang in Provincial Mughal style, produced in the seventeenth century, likewise shows a frame drum with three sets of cymbals being played with *rudra vīṇā*s (Ebeling 1973:170). By the spacing, it seems that it would have four sets at most. It is probably a *khaṅjarī*.

16. The degree of absorption of (and resulting confusion from) terminology into the nineteenth century is ascertained from this entry by Colonel P. T. French in his "Catalogue of Indian Musical Instruments," in which a drum is described that seems to be the same as the ancient type found in sculpture:

> Duffde, dūffde [*sic*], hulkya, dayra, duff. These five instruments belong to one class, the common tambourine drum of India, which is played, partly by sticks, partly by the hand. The performer holds two long thin pieces of wood or twig in his left hand, which he rests upon the frame of the instrument, which is strung over his shoulder, while with the right he beats it with a short thick drumstick. The measure and tone can be changed and varied by the manner in which the notes are played by the sticks in the left hand, and in this respect the drummers are very expert. These instruments form the ordinary accompaniment to the [*siṅg*, the C-shaped] horn. . . . Every village, or watch on town bastions, fort walls, and the like, has one; and in native armies the duff is beaten furiously on occasions of attack. In all sorts of processions, festivals, and the like, they are employed; but they do not aspire to the refinement of other drums of a more scientific character. (Tagore 1965:259)

17. He continued his support of the Chishtiyyas. In 1570, Akbar fulfilled his vow made prior to the birth of his son Salim and walked the 228 miles from Agra to Ajmer to give thanks. It seems the case that Akbar had a genuine religious concern (evident in his frequent pilgrimages), but his control over two major Chishtiyya shrines and growing influence over members of the order were also likely supports in his ongoing ideological struggle with the orthodox *ulama* (see Richards 1978a:256–58).

18. The historian of religion Aditya Behl notes the use of a stringed instrument in *Sufi* worship as a distinctive development, given the concern about such instruments in Islamic thought through time (pers. comm., February 1996).

19. These musical details are consistent with other paintings of dancing dervishes (see also, for example, Falk and Archer 1981:406, 412). For a detailed discussion of figure 114, see Gadon 1986.

20. In a footnote, the translator Rogers adds that "*Sayyadī*" seems to be "dervish, hypocrite, perhaps buffoon." For a detailed study of the form of *qawwālī* and its function in a modern *Sufi* assembly, see R. B. Qureshi 1986. Qureshi's study of the gradual onset of trance is informed by analysis of videotaped gatherings.

21. The city of Burhanpur comes to our attention later in an unhappy chapter in Shah Jahan's life. When he became emperor, he had again to deal with rebellion in the Deccan: in 1629, "the imperial standards" left Akbarabad for Burhanpur, not to return to his own capital until 1632. But in June of 1631, his beloved Mumtaz Mahal died there in the Deccan. She was buried temporarily in a pavilion in the garden of Zainabad at Burhanpur, which is situated on the other side of the river Tapti (*SJN* 70). She was ultimately entombed in her matchless mausoleum, the Taj Mahal, in Agra.

22. Instruments have been a prime source for documenting cultural synthesis. Performers on those instruments were well rewarded for their virtuosity in various ways, among which was the "worth your weight in gold" award. One such weighing ceremony for the *nā'ī* player is noted here. As cited earlier, the weighing ceremony was an important court ritual. The ceremony of the weighing derived from a Hindu custom known as *tuladana;* and while

it is usually said to have been introduced into the Mughal calendar by Akbar, Humayun certainly was weighed against gold as early as 1533 (*AiA* 1:277; Banerjee 1938, 1:59).

> The Mughals had three major festivals a year: the solar and lunar birthdays of the monarch and Nawrūz, the Iranian new year on the vernal. The Mughals used the solar Illahī calendar for administrative and court purposes. On his birthdays, the monarch had himself weighed against various commodities. . . . The commodities weighed are distributed as charity. . . . Called *wazn* in Persian, from the Arabic root pertaining to weight. (Streusand 1989:128)

From at least the Akbari period of 1582 or 1583, there were two weighings each year, one for the solar birthday in public and one for the lunar birthday, usually in the privacy of the *harem;* the monarch's solar and lunar birthdays coincided only on the day of his birth, i.e., the date of birth was declared as both a lunar and solar birth; subsequently, birthdays on the two calendars were gradually separated by c. 11 days each per year. The imperial princes were also weighed on their birthdays.

> [Akbar] also resolved that every year he should be weighed twice. According as from his birth he had been weighed on 5 Rajab in conformity with the lunar calendar, so also he should be weighed on the day of Ormuzd of the month Āban of the solar year. The courtyard of bounty was thrown open, and twelve articles were prescribed for the solar weighing viz. (1) gold, (2) silk, (3) quicksilver [mercury], (4) perfumes, (5) copper, (6) pewter, (7) [intoxicating] drugs, (8) butter, (9) rice and milk, (10) iron, (11) various grains, (12) salt . . . [in order of cost]. For the lunar weighing eight things were appointed: silver, cloth, lead, tin, fruits, sweetmeats, vegetables, sesame-oil. . . . The weighings of sons and grandsons which took place according to the lunar year were at this time made according to solar year. (*AN* 3:580)

The items listed are of note in that they were practical articles which would be distributed to the poor. Akbar considered the weighings to be so important that they took place wherever he was, in residence or even when on the march with his army.

> He proceeded towards Jaunpūr. On the day when he reached the town of Nizāma the ceremony of weighing H.M. took place, and there was a great feast. Mankind received delight from the Shāhinshāh's bounty and offered up prayers for his long life and reign. Thereafter he marched on and arrived at Jaunpūr. (*AN* 2:397)

Jahangir, for whom public ceremonies became increasingly important through time, early in his reign described one of his weighings with apparent relish. The items against which he was weighed gradually became more imperial than practical but they were still awarded to holy men and the poor.

> On Wednesday . . . , after three watches and four gharis, the feast for my solar weighing, which is the commencement of the 38th year of my age, took place. According to custom they got ready the weighing apparatus and the scales in the house of Maryam-zamāni (his mother). At the moment appointed blessings were invoked and I sate in the scales. Each suspending rope was held by an elderly person who offered up prayers. The first time the weight in gold came to three Hindustani maunds and ten seers. After this I was weighed against several metals, perfumes, and essences, up to twelve weighings, the details of which will be given hereafter. Twice a year I weigh myself against gold and silver and other metals, and against all sorts of silks and cloths, and various grains, etc., once at the beginning of the solar year and once at that of the lunar. The weight of the money of the two weighings I hand over to the different treasurers for faqirs and those in want. (*TiJ* 1:77–78)

By Shah Jahan's reign, the distribution of goods from the weighing ceremony had been extended from the poor to numerous individuals at court, including musicians.

> On the 1st of Rajab this year 1040 (3 February 1631), a festival was held in commemoration of His Majesty [Shah Jahan] having completed the 39th solar year of his age, and his august person was weighed in gold and other valuables used on these occasions. This amount of gold and silver, as well as a supplementary offering of 30,000 rupees, was then distributed among the learned and the pious, and the poets, astrologers, and musicians that were in attendance at court. (*SJN* 55)

Aurangzeb discontinued the custom, but for a few exceptional occasions (Sarkar 1912–30, vol. 3 [1920]:97).

23. The European presence in India was greatly enlarged both in the Mughal cities by "a variety of wandering Poles and 'Muscovites,' Greeks and Levantines in the bazaars of Agra and Delhi" (Brown 1981:164), and in South India, where Jesuit missionaries were making inroads whose strong effects still remain. European culture first gained Akbar's attention in a concentrated and sustained manner, however, in 1572, when he pursued the conquest of Gujarat, in the vicinity of prolonged Portuguese activity. Since 1497, when Vasco da Gama landed in Calicut, on India's west coast, and throughout the sixteenth century, the Portuguese had established seaports for trading and factories at Calicut, Cochin, and Goa. Among the priests were craftsmen and artists, one of whom, Brother Aranha of Lisbon, designed and built many of the original Christian churches in the locality, decorating them with religious pictures that he himself painted. Akbar sent agents to procure instruments for the court:

> One of the occurrences was the [return] of Ḥājī Ḥabībūllāh. It has already been mentioned that he had been sent to the port of Goa with a large sum of money and skilful craftsmen in order that he might bring to this country the excellent arts and rarities of that place. On the 9th he came to do homage, attended by a large number of persons dressed up as Christians and playing European drums and clarions. He produced before H.M. the choice articles of that territory. Craftsmen who had gone to acquire skill displayed the arts which they had learnt and received praises in the critical place of testing. The musicians of that territory breathed fascination with the instruments of their country, especially the organ. Ear and eye were delighted, and so was the mind. (*AN* 3:322–23)

As regards Plato, the question can be asked: Why does Plato appear in a Mughal painting? The answer to that is complex, having to do with the history of Islamic culture and with Persian literary tradition. In a poetic reinterpretation of classical culture by Nizami, whose *Khamsa* this painting (fig. 122) illustrates, Plato, one of the seven sages who were advisers to Alexander the Great, was angered because he was not included in a learned discussion, so went away by himself to demonstrate his unique power over animals.

Iconographic depiction of animals from classical-period culture was well known in the Mughal court due to their use in Christian iconography. The first title page of the famous Antwerp Polyglot Bible which was presented to Akbar by a Jesuit mission in 1580 shows an ox, lion, wolf, and sheep lying down together under the rule of the Messiah. So appropriate as a pictorial expression of its own imagery of ideal rulership was that idea of bringing together the wild and tame beasts under the power of a divinely inspired king that Akbar's son and grandson adapted it to depictions of themselves (see Koch 1988 for an elaboration of the above discussion). In Shah Jahan's time the musical interpretation of that classical motif came to India again as Orpheus playing a *lyra di braccio* (a violin-like bowed lute). But in Nizami's poem, illustrated in the time of Akbar, it was Plato playing the organ to tame the beasts.

As for the interest in items pertaining to Western civilization, there might also be an explanation of a deeper nature in the intellectual foment of Akbar's court sphere. Competing equally in the philosophical discussions held by that sovereign were the Falasifas, Muslim thinkers who based their ideas upon the Aristotelian, Platonic, or neo-Platonic philosophies. Refuting their ideas was the official theology of *Sunni* Islam, which was the strongest sect in the Mughal court. Invited also by Akbar to the heated discussions were Christians, Jains, *Shiʿa* Muslims, *Sufi*s, and Hindus (see Rizvi 1975b).

For a fuller elaboration of the organ and Mughal life, see my "When West Met East" (1997).

24. Titley criticizes the Mughal artist, Madhu, for using dead creatures as his models for the hypnotized animals—which, she says, "is understandable, for they include lions, tigers, wolves and so on, but it does make a rather grim painting" (1983:205). The implication according to the story illustrated is that the animals are in a swoon from the power of Plato. These animals do, however, look dead, and I discuss that in my article (1997).

25. The European brass band became a part of Indian culture that has flourished beyond the colonial period (See Booth 1990). The similarity of that ensemble and the *naubat* ensemble is probably no accident.

26. Beach postulates that these instruments were not of real interest to the Indians and notes that there are few textual references to Europeans, too—"these contrasts are intensely interesting to 'us,' less interesting to the Mughals" (pers. comm., July 1994).

27. See also "The court of the Emperor Babur," c. 1580–86, published in Brown 1981, pl. XIV. Farrukh Beg worked at Kabul under Akbar's brother, Mirza Muhammad Hakim, upon whose death he was taken into Akbar's service, c. 1585. Brown suggests that the illustration is likely to have been produced for one of the copies of the *Bābur Nāma* (Brown 1981:65).

CHAPTER SIX

1. The Mughals were able to create an image of the position and functions of the emperor in the popular mind "which stands out clearly not only in historical and other literature of the period, but also in folklore which exists even today in the form of popular stories, narrated in the villages of the areas that constituted the [empire]. . . . [The emperors, in turn] possessed a high sense of responsibility" (Naqvi 1990:249–51).

2. The earliest form of Hindi-Urdu for which we have evidence is the trade jargon that became current in Delhi in the twelfth century. "Urdu" derives from the expression *zaban-i-urdu,* "the language of the camp," and is written in the Persian script. By Akbar's time, Urdu had attained the status of a separate language, important throughout Hindustan. Recall, also, that *ordu* is a Mongol camp or establishment of the Īl-Khān, or of a Mongol prince or princess (Īl Khānate).

3. By 1707, the Mughal empire had reached its farthest physical limits, and the imperial principle had been established over almost the entire subcontinent. But a variety of challenges to imperial power continued, so that by the mid-eighteenth century the imperial structure was disintegrating (see Alam 1986). Within the thirteen-year period from 'Alamgir I's death (1707) to the beginning of Muhammad Shah's reign (1720), five men tried with varying success to exert control. The Empire failed in the center during the period 1711–19, rapidly devolving into its constituent regional units.

Despite the tumultuous succession struggles and short-lived reigns of emperors between the death of 'Alamgir I and the accession of Muhammad Shah, and the subsequent slow decline of the dynasty for numerous reasons, the Empire lasted another century and a half. Gradually, though, such factors as the decline in the character of the nobility and the later emperors, decreasing efficiency of the army, alienation of *Shi'a* followers and various Hindu groups such as the Rajputs and Marathas, growth of factions at court, and other internal as well as external tensions led to the final collapse (see Irvine 1922, vol. 2, chap. 11). John Richards explains the survival of empire despite the fact that after 1720 the Mughal Empire was not a tight political entity, acknowledging that Muhammad Shah (1720–1748) and his successors

> no longer freely command the flow of money, goods, information and personnel to and from the capital nor direct the inter- and intra-provincial movement of these entities. Nevertheless, in spite of its sudden political collapse, the legacy of the imperial system remained. . . . the Mughal agrarian order decayed, but still recognizable, offered a rationale and techniques for recognition and assimilation of aristocracies rooted in local control. The imperial land tax structure still set limits, levels and acceptable modes of assessment and collection. . . . the Mughal currency system flourished. . . . Mughal courtly rituals, etiquette, terminology, honorific symbols, etc. retained their appeal in virtually every region. Imperial aesthetic standards in painting, calligraphy, literature, architecture, still provided a cultural reference point. . . .
>
> Most dramatic of these survivals was the continuing near-monopoly of the later Mughal emperors over the dispensation of legitimate authority in the form of Mughal offices, ranks and honors. (1978a:252)

The emperors continued to patronize the arts, as best they could afford, and some continued personally to display the artistic talents of their Timurid ancestors. Indeed,

> Even in the days of decadence, Shah 'Alam II, Akbar Shah II, and Bahadur Shah II were well educated and good poets.
>
>> Shah Alam's ode on his captivity and misery under Abd-u'l Qadir Rohilla is well known; *Delhi Akhbar* and other contemporary newspapers of Delhi published poems by Akbar Shah II; Bahadur Shah II [the last Mughal emperor] has left a *divan* [collection of poems] which is one of the classics of Urdu poetry. He used the *nom de plume* of Zafar. (Naqvi 1990:64 with note 75.)

4. Jahangir was spared a fratricidal struggle because his two brothers drank themselves to death; but he found himself in Akbar's position when his own son, Prince Khurram (later Shah Jahan), revolted against him in 1622.

In the matter of the "Divine Faith"—or *Dīn-i Illāhi* or imperial discipleship—Jahangir imitated his father's practice of selecting and initiating disciples from among his favorite nobles (see chapter 1, note 7, as well as Rizvi 1975b:391–92; Roe 1926:313–14, 244–45). The master–disciple tie seems to have been more significant in

Jahangir's than Akbar's reign. (See the *Bahāristān-i Ghaybī*, a wonderful autobiographical memoir of 'Alauddin Asfahani, a Persian noble known as Mirza Nathan. It is a complete account of his career in the Mughal service during the second and third decades of the seventeenth century and was completed in 1632 C.E.) The empire began to solidify under Jahangir, and the imperial discipleship was important in this; it was an enhancement of honor by submission to the Emperor's personal and dynastic authority and cut across racial, ethnic, and class lines. Later, under both Shah Jahan and Aurangzeb, the entire relationship (with its *bandal* [slave] and *khānazād* [son of the house/born to the house] elements) came to mean pride in hereditary imperial service without necessarily a discipleship aspect.

5. It is not an understatement to say that the Mughal empire was at its apex under Shah Jahan. Military strength was enormous, and the extent of the territories was vast; the restoration of many of them under Shah Jahan contributed to a steep rise in imperial revenues. While Akbar had amassed a huge treasury, Jahangir had reduced the reserve almost to depletion during his reign, so it was left to Shah Jahan to rebuild the reserves; the central treasury was at its fullest under his rule. Shah Jahan's administrative and financial skills were considerable, and he knew not only how to raise revenue but how and on what to spend it. Among these expenditures was a considerable sum for the construction of grand buildings which, in large measure, served as a celebratory statement of the extent, wealth, and stability of the Mughal empire. (See the *SJN*, Moosvi 1987, and Athar Ali 1985 for details on the administrative, military, and financial status of empire, and Habib 1982 for appropriate political and economic maps of the empire.)

6. The Mughal emperors assumed the title of *pashāh: pād* signifies stability and possession and *shāh* means origin and lord, so a *pādshāh* is a lord or king who is so powerful he cannot be ousted by anyone. It is also used for a superior king, an emperor. In this regard, Shah Jahan seems to have tried hard to emphasize the Central Asian affiliation of the Mughal dynasty, resurrecting the title *Sahib-i-Qiran-i-Sani*, after Timur. He had the ambition of recovering the ancestral Timurid possessions, from which one might infer that the Turanis received extra favors from him over the Iranis (Athar Ali 1985:xxi)

7. Two exceptions to tan-colored drums for male dance accompaniment must be noted. In plate 12, two sizes of either black *naqqāra* (or lighter-colored *naqqāra* with heavy black lashing) are beaten to accompany a sword dancer; the relatively smaller sizes of the drums are appropriate to dance accompaniment, however. In figure 45, on the other hand, small tan-colored drums replace the usual black drums of the *naubat* although there is no dancer. This painting also includes a strangely-shaped horn. These two departures from usual musical content add weight to the possibility mentioned on p. 60 that this painting was not originally intended for the depiction of Babur appointing Humayun as his successor. Perhaps it was even repainted to replace a dancer with other figures.

8. I am drawing here on the classification used by Brown and Lascelle (1972:79, 81) because their work in European instruments before 1800 led them to look closely at these types. It was appropriate for the instruments they studied to further distinguish the horn from the trumpet by length: the horn is shorter. For horns in the Mughal paintings, that is not a useful distinction; the artists draw too many long horns to doubt that they existed.

9. The sketches which Blochmann published with his translation of the *A'īn-i Akbarī* (fig. 143) show two shapes other than the long, straight shape. One is this swan's neck type. The other has a wider S shape, is more gracefully curved, and furthermore has a conical tube; that shape I have not found depicted in Mughal paintings. Sambamoorthy (1962:21) describes and illustrates an instrument which resembles that latter shape in the Blochmann sketch: S-shaped horns with variable numbers of sections. In the Government Museum collection, two have four pieces, one has six. Two big S-shaped horns of silver, formerly in the establishment of the Tanjore Rajas, can even now be seen in the Tanjore Palace.

10. A detail of this ensemble is also reproduced in Fox Strangways (1967, pl. 6). The *sing* player stands at the rear on the left side, behind players of cymbals and a large *karnā*.

11. The start of trouble probably began earlier, with Shah Jahan, who inherited a depleted treasury and greatly reduced *khālisa* territory (territory held for the emperor's income)(see maps 15–17). An explanation of the ranks and entitlements is in order. The *mansab* formally determined the rank and pay of a noble or official, but the *mansabdar*'s real position was indicated by the kind of *jāgīr* (territory) assigned to meet pay claims (*talab*) based on the *mansab*. Within the *jāgīr* were two rankings: *zāt mansab*s (the higher rank) and *sawār mansab*s. The emperor could enlarge his own territory (*khālisa*), hence income, by several means, one of which would be to reduce or restrict the area assigned in *jāgīr*s. Shah Jahan chose to enlarge his *khālisa* by reducing and/or restricting areas assigned in *jāgīr*s. Restricting *zāt jāgīr*s would limit only *mansab* personal pay; restricting the *sawār jāgīr*s would affect the strength of the standing army, since *sawār jāgīr*s were largely for the military. Thus Shah Jahan decided to reduce the *zāt jāgīr*s rather than the *sawār jāgīr*s (Athar Ali 1985:xvi). And, as discussed in note 5 above, although

Shah Jahan's reign was the apex of the Mughal empire in part because he had raised the revenues, the means by which he chose to do so eventually had its effect. (See below.)

Aurangzeb's rise to power resulted from the final resolution of an ongoing political and intellectual struggle which became polarized around the two most able and forceful sons of Shah Jahan: the liberal faction, committed to Akbar's eclectic agenda, focused on the influential and articulate favorite and heir-apparent, Dara Shikoh; and the conservatives, who found their champion in Aurangzeb. Dara Shikoh, whose greatest ally in the imperial household was his eldest sister Jahanara, seemed in many ways a contemporary version of Akbar, and his curiosity and tolerance soon earned for him the disdain of most Indian Muslims, who considered him an apostate. This perception was compounded by his pride and arrogance, his insensitivity to the nobles, and his mediocrity as a military leader. Aurangzeb, contrarily, was extremely pious, regularly observed Islam's public rituals, and actively courted the *ulama* and other orthodox officials. He was however, unlike his brother, an extremely able military commander and knew how to play the political game. The emperor's least favorite son, and at acrimonious odds with his father, Aurangzeb's greatest ally in the household was his elder sister, Roshanara Begam. For fuller details see Jadunath Sarkar 1912–30, *History of Alamgir*, S. Chandra 1981, Manucci 1907, and Jagdish Sarkar 1979.

Once finally successful, Aurangzeb ruled ably and vigorously. The situation developing from Shah Jahan's time (see above) made his primary task when he first assumed office to find positions and suitable lands for assignment as *jāgīr*s for his Muslim and Hindu officers, for a nobility that was quickly becoming saturated with talented but restive soldier–administrators. Needing this, and also capitalizing on his ability as a military commander during the struggles for succession, he undertook a policy of territorial expansion so he could make additional *jāgīr* appointments, for without these territorial revenue grants, the entire *mansabdari* system would collapse. These attempts resulted in costly failures. His ultimate solution was to reduce the power and independence of the leading Rajput chiefs by limiting the number of *jāgīr*s they could hold outside their own lands and to subsequently allot to other groups of the Mughal nobility the revenue grants and promotions that previously would have gone to the Rajputs. Increasingly restive, the Rajputs eventually revolted against the Mughal ruler. (See Hallissey 1977:33–38). Although previously modern historians have generally considered the Rajput rebellion as a Hindu–Muslim confrontation, Hallissey suggests that "the contest between the Rajputs and the Mughals was not a communal confrontation but a struggle between a parochial, traditional political system and an expansionist empire" (ibid. 89). That it developed into a conflict that threatened the existence of the Mughal empire seems to support the suggestions of other scholars that the Rajput turmoil was the beginning of the end for the Empire.

12. After the Benares *farmān* (decree) of February 1659, in which Aurangzeb prohibited the building of new Hindu temples and the repairing of old ones, a "series of rigid regulations aimed at establishing puritanical restrictions at the imperial court followed . . . : the emperor banned music and dancing, prohibited gambling and alcohol, eliminated public parties and festivals, and imposed imperial standards of dress and appearance" (Hallissey 1977:85). But Hallissey interprets these as less anti-Hindu and more part of the complexity of the emperor's religious policies. For example, the *farmān* also "prohibited Mughal officials in Benares from interfering with or disturbing the Brahmans or any other Hindus who visited the temples" (ibid.).

Some of Aurangzeb's edicts had no religious relevance at all. "One such measure was the discontinuance of the *darshan*, a Mughal [and earlier Timurid] custom introduced by Akbar of appearing on a palace balcony to acknowledge crowds assembled outside the imperial grounds." Sarkar asserts that he did so because it was "too Hindu" (Sarkar 1912–30, vol. 3 [1920]:101). Hallissey believes that the reason was practical: it was inconvenient and dangerous; failure to appear, as in the case of Shah Jahan in September 1657, caused rumors of his death which precipitated the war of succession among his sons (1977:85–86).

It is also generally believed that 'Alamgir I withdrew imperial patronage from painters leading to the decline of the schools of painters. He did employ at least one painter, however, for when one of his sons was imprisoned for a long time, a portrait of the prince was sent along with the physician's report to attest to the health/condition of the son. And there are paintings of 'Alamgir I not only in youth but older and in various guises, such as hunting and directing forces in military campaigns (Naqvi 1990:220). According to Verma (1994:24), 'Alamgir I employed a total of twelve painters during his reign: eight Hindu, four Muslim.

13. In the Calcutta Indian Museum there is an instrument labeled "*Rudravina* or *Rebab*" which is a composite of characteristics: the "Indian" *rabāb* with the ram's horn neck link and bulbous peg attachment, but the wide, tapering neck of the prototypical "Afghani" *rabāb*.

14. Humayun is the prominent figure in both these paintings, and the similarity between the two instruments leads me to conjecture that they were sketched by the same artist.

15. That the instrument came to India from abroad was also the opinion of the great organologist Curt Sachs, and others, such as Jean Jenkins, have adopted his view. Bor's reference is to Shahinda (Begum Fyzee-Rahamin)'s *Indian Music* (1914:55–56). The musician whose story he cites was Hafizullah Khan.

16. Given the choice posed by art historians about this painting between "Mughal" or "Mughal copy of a Persian painting" in the seventeenth century, I would select the latter. Compare it also with a seventeenth-century painting of another holy man—a portrait of Ali Shah Qalandar—and his instrument—the *kamānche/ghichak*, reproduced in Chaitanya 1979, fig. 39.

17. See the cylindrical drum in the boat scene from the *Bābur Nāma* (pl. 9). A fanciful illustration for a *Ḥamza Nāma* story, reproduced in Mekkes 1976:15, pl. 12, has a *naubat* ensemble frantically playing from a gateway as a giant falls headfirst down onto the building. War elephants and armed men rush toward him. What is probably a cylindrical drum (one end only is visible) of considerable size complements the *naqqāra*s in the ensemble.

18. The consistency of the pictorial convention on the theme of a prince visiting a holy man that includes this characteristic musical duo becomes even more obvious when an artist violates (or ignores) the convention. In his sketch on that theme, published in *Atharse Iran* (1939) 2:2, fig. 93, the artist Manohar replaces the drone player with a man standing behind the seated singer, playing a very similar instrument but in the position for playing melody on a *rabāb*-type instrument: neck against the left shoulder at about a $75°$ angle. For a long-necked plucked lute, the playing position is wrong; for the playing position, the instrument is wrong; for the pictorial convention, the instrument is entirely wrong.

19. For a fuller analysis of this see Wade 1996.

20. The Persian text reads *qānūn* (Farhad Ataei, pers. comm., July 1990). In the translation by Beveridge, the word *qānūn* is translated misleadingly as "harp." (Beveridge also translates *surnā* as "hautbois.") Of particular note is the name of the *qānūn* player, Maulana Qasim. It was a Qasim who played the *chang* on the occasion of the reconciliation of Humayun with his brother Kamran in Kabul. It is intriguing to consider the possibility that the player of *chang* was also the player of *qānūn* and that Maulana Qasim of Khurasan joined the entourage of Humayun, which must have been growing as his success increased. (*Maulānā* indicated a person knowledgeable in philosophy and theology.) It is possible that use of the *chang* gradually decreased in South Asia as the *qānūn* became the preferred instrument of the two.

A less than exhaustive search for paintings in which the harp is pictured suggests that it appears more in miniatures from Persian—Herat, Shiraz, Tabriz, Qazvin, and Yezd—than Central Asian centers.

21. See Leach 1995, 1:138, 141. In figure 106, the instrument played by the musician seated nearest to the couple either features two right angles, or is a trapezium, with no right angles (and no sides parallel); the placement of the long bridge in this drawing leads me to suspect carelessness and therefore imprecision with regard to this instrument. In Wade 1992, I identified this as a trapezium, but upon closer study of more paintings since that time, I have decided that indecision is wiser. A painting similar to figure 163 is Falk and Archer 1981, no. 39.

An eighth painting which includes a board zither is a scene from the Dyson-Perrins *Khamsa* of Nizami, in the British Library Manuscript Or. 12208. Fol. 65, a couple being entertained with music by an ensemble that sits considerably lower and to the side in a garden, is not a painting that I would identify as Mughal, from the musical perspective. The instruments are recognizable, but if I had to hazard a guess, and as unlikely as it might seem, I would suggest a considerably more recent Southeast Asian artist, perhaps Thai. The musical evidence, particularly the shape of the *kamānche* and other details, leads me to this suggestion.

22. This is the shape in two paintings in a manuscript of Nizami's *Khamsa* that was produced in Bukhara in mid-Mughal period, c. 1648. Bahram Gur is pictured with his Indian princess in the Black Palace, and with his Turkmen princess in the Golden Palace. In each painting they are serenaded by a trio of *qānūn,* long-necked plucked lutes, and frame drum. The manuscript is influenced by Indian artists, due to the flourishing of economic and cultural ties between Central and South Asia in the sixteenth and particularly in the seventeenth century (Yusupov 1985, notes to figs. 173 and 174). It is therefore not indicative of the presence of such a *qānūn* in Central Asia during the Mughal period.

23. A third if the Dyson-Perrins *Khamsa* illustration noted in fn. 21 is taken seriously.

24. I cannot resist wild conjecture about the disappearance of the West Asian harp in India. It is entirely without documentary basis, but if the *svarmaṇḍal* were used in India as the *Dārab Nāma* painting suggests, its musical function would have been the same as that of a harp—straightforward melody or occasional reference pitches or a continuous wash of pitches. Could it be that the *svarmaṇḍal,* with its resonating box that could increase the volume and permit pitches to sound for a longer duration, was attractive to harpists in India, to the extent that the arched

harp of the subcontinent was replaced by the *svarmaṇḍal?* The first step in confirming such a suggestion would be to discover just when the board zither made its first appearance on the subcontinent.

Some Indian authors have assumed unquestioningly that the *svarmaṇḍal* is an ancient, indigenous Indian instrument. Sambamoorthy, for instance, asserted: "It is referred to as the Sata tantri Vīna and the Kātyāyana Vīna (after the sage Kātāyana) in ancient literature" (1962:15). Another scholar concluded, "We may infer [from its name] that the Surmaṇḍal was an instrument indigenous to India, but there are no drawings or paintings of the Surmaṇḍal to my knowledge" (Grieg 1987:474). Dealing with the question of an indigenous origin for the *svarmaṇḍal,* the Indian musicologist B. C. Deva ultimately skirts the issue. See Wade 1992 for a summary of his arguments.

The organologist Alistair Dick considers it most likely that "*svaramaṇḍala*" was the term coined to name the *qānūn* which was introduced into India with the Muslim armies of the thirteenth-century Delhi Sultanate, but which was adopted and adapted by Indian musicians (Dick 1984c). Unfortunately, he does not cite thirteenth-century sources in this short article in *The New Grove Dictionary of Musical Instruments.*

25. In two of the historical manuscripts illustrated for Akbar—the *Chinggis Nāma* of 1596 and the *Timur Nāma* of 1584—it is noteworthy that the Indian *rudra vīṇā* is depicted (figs. 21, 26, 27), and I have attempted an explanation herein. It is significant that the instruments shown in those paintings have characteristics of the early Akbari-period *rudra vīṇā*s—the upward curving tailpiece at the bottom end of the stem, and gourds no more than five-eighths full. While in 1584 the *rudra vīṇā*s used by court musicians may still have resembled that, surely by 1597 most *rudra vīṇā*s were of the more substantial design. It is possible that Basawan, who designed the *Chinggis Nāma* folio (fig. 21), quite purposefully depicted the earlier model, thereby at least suggesting an earlier time.

GLOSSARY OF MUSICAL INSTRUMENTS AND TERMS

aīshlār	musical works
alat-i musiqi	a musical instrument
anqā	dulcimer
arghanūn	(*al-urghanūn*) organ
atāī	a singer who knows only practical music, theory
awaj	(*awej*) a double-headed, waisted-shaped drum; also called *huruk*
barbat	a long-necked, lute-type stringed instrument
bīn	(*been*) Hindustani stick zither–type stringed instrument, present-day name for the *rudra vīnā*
bīnkār	player of the rudra *vīnā*, *bīn*
bol(s)	mnemonic(s)
brahmatāḷam	South Indian large cymbal
chaghānah	a crescent
chang	a harp
chikāri	drone/rhythm string on instruments
ch'in	Chinese board zither–type stringed instrument
dā'ira	(*doira, dāyra*) single-headed frame drum (tambourine) with jingling disks (also *daf*)
da'iraci	2 groups of musicians; players of the *dā'ira*. Also called *dā'ira dastan* and *dā'ira sazan*
daf	(*duff, duffde, daff, daf*) same as *dā'ira*
dak	one name of a nineteenth-century drum used by ballad singers and mendicants
damāmā	(cf. *kuwarga*) large, bowl-shaped drum
dastan	any instrument player
dhādhi	a community of musicians, singers, composers, and instrumentalists
dhol	(Persian *duhūl*) double-headed cylindrical or barrel-shaped drum
dholak	double-headed barrel-shaped drum, now most commonly used in folk music

dhrupad	(*dhurpad, dhrupada, dhruvapada*) classical Hindustani vocal genre
duhūl	Persian equivalent of the *ḍhol*
gharānā	musically affiliated group with a distinctive style of singing or playing
ghichak	(*kamānche*) West Asian bowed, spiked lute–type stringed instrument (cf. *kamānche*)
harmonium	small, portable organ
hautbois	double-reed type of wind instrument; French term for oboe
hoodok	(*huruk*) one nineteenth-century name for a drum used by ballad singers and mendicants
huṛuk	(*hulkya*) waisted-shaped drum with two heads laced together (cf. *awaj*)
hurukīyā	(*hurikayah*) players of the *huruk*
jālrā	large South Indian cymbal
jhallarī/jhallarā	large North Indian cymbals (cf. *jhānj*)
jhānj	large North Indian cymbals (cf. *jhallari/jhallara*)
kalāwant	(*kalavant, kalan-wat, kalanwats*) a master musician
kamānche	(*kamāncha*) West Asian bowed, spiked lute–type instrument (cf. *ghichak*)
kanjam	(or *tāla*) small South Indian cymbal
karnā	(*karanā, khar-nay, kar-nay;* old Persian, *kar;* Turkish *qarna*) horn-type instrument
karkha	war songs and heroic chants (cf. *sādara*)
kartāl	"to do the rhythm"; term for a present-day Hindustani rhythm instrument
kath tāla	castanet-type instrument
khanjarī	(*khenjir*) a frame drum tambourine with fewer than five sets of cymbals; smaller than the *dāʾira*
khiil	Mongolian bowed lute–type stringed instrument, related to the *qübüz* (cf. *khur*)
khur	a Mongolian four-stringed, spiked fiddle (cf. *khiil*)
khyāl	a major Hindustani classical vocal genre
kombu	South Indian name meaning "horn," both musically and otherwise; South Indian (Karnatak) name for *siṅg*
kuraka	great drum
kus	huge drum
kuwarga	(cf. *damāmā*) deep-sounding bowl-shaped drum
lyra di braccio	European bowed lute
mālā	garland (*usually used in reference to rāgamālā* (q.v.)
maṅjīrā	(or *tāl*) music, musical instruments
mela	festival
mṛdaṅga	(sometimes referred to as *pakhāvaj*) double-headed, barrel-shaped drum, now the predominant percussion instrument in Karnatak music
mursal	a kind of overture
musiqi	the science of music
nafīr	trumpet or horn-type instrument
nagaswaram	the South Indian counterpart to the *shahnāʾī;* a conical double-reed instrument with non-attached wooden bell
naghamāt	melodies
naghamāt al mūsiqāt	musical melodies
nāʾī	(*nāyī, nai, nārh, nay*) West Asian long, vertical, flute-type wind instrument
naksh	musical airs
naqqāra	(*naqāra, naqqārah, nakāra*) a single or pair of kettledrums; bowl-shaped drum
naqqāra khāna	(*nakkāra khāna, naqārah khānah, naqārakhāna, naqqārakhāna*) the imperial ensemble; the gateway room or tent where the ensemble is housed
nauba	a company of musicians (West Asia, tenth century); later, music performed at particular times of day
naubat	"the orchestra of world dominion"; the imperial ensemble of wind and percussion instruments
ottu sangu	conch shell used for a drone
oud	West Asian ovoid, short-necked plucked lute

pakhāvaj	(*pakhāwaj*) double-headed barrel drum
panchajanya	a conch used by Krishna in the *Mahābhārata*
paṭaha	an ancient- and medieval-period Indian drum, elongated barrel-shaped (possible predecessor of the *pakhāvaj*)
peshrau	preludes
prabandha	historical Hindustani performance genre of multiple sections, predecessor of the *dhrupad*
qānūn	(*kānūn*) West Asian board zither–type stringed instrument (cf. *svarmaṇḍal*)
qaṣab	West Asian flute
qawwāli	Hindustani Muslim devotional vocal genre
qawwāls	singers of *qawwali*
qübüz	(*qoboz, qobüz* [Afghanistani version], *qübuz, qobyz* [Central Asian Khazakhs' version], *qobuz* [Uzbek version]) comparatively short-necked and ladle-shape–bodied stringed instrument; a bowed lute (cf. *khiil, khur*)
qūshūq	improvisations of combined dance and song
rabāb	(*rebab*) a West Asian round-bellied plucked lute– or zither–type stringed instrument; one form considered the predecessor of the Hindustani *sarod*
rāga	(*raug, rāg*) a melodic mode
rāgamālā	(*rāga māla*) a garland of *rāga*s, a series of *rāga*s performed in succession; a genre of Indian paintings
rasika	a knowledgeable listener; a person of aesthetic taste who responds to expressions of *rasa*
rudra vīṇā	Indian stick zither–type stringed instrument
sādara	war songs and heroic chants (cf. *karkha*)
saṅgīta	(*saṅgīt, saṅgeet*) music; also a generic term encompassing the three arts of singing, playing an instrument, and dancing
sanj	a cymbal
sankh	conch shell "trumpet," end-blown through the top or side-blown for signaling; considered a sacred instrument in battle by the Hindus, Buddhists, and Sikhs
sankha-nāda	the sound of the conch (used in the *Rāmayāna* to rouse the martial fervor of soldiers in battle)
santir	West Asian trapezoidal board zither–type stringed instrument (cf. *qānūn, svarmaṇḍal*)
sāraṅgī	lute-type instrument with sympathetic strings
sarod	modern Hindustani version of one form of the *rabāb*-type, plucked lute–type stringed instrument
sar-vīṇā	like the *vīṇā* but without frets
shahnā'ī	(*shahnā'ī, sahnāī, sanāī, shehnāī*) North Indian conical double-reed instrument with non-attached metal bell
shānah	comb and paper
silh-i khitā'i	Chinese cymbals
sīṅg	(*sṛṅga, sīṅgā, sīg, sīgā, s'riṅga, s'īng*) Indian C-shaped, horn-type wind instrument
sohlā	song form for nuptials and birthdays
svarmaṇḍal	(*surmaṇḍal, svaramaṇḍal, svaramaṇḍala, sarmaṇḍal*) board zither–type stringed instrument, possibly the same as *qānūn*
surnā	shawm-type, double-reed, wind-type instrument; predecessor of the *shahnā'ī*
ṣūt	musical theme
svar	pitch
tablā	pair of drums; primary percussion instrument in contemporary Hindustani classical music
ṭabl	generic term for drums
ṭabl-khāna	a military band of trumpets/horns and drums
tāla/tālī	hand cymbals used to mark the metric tāla; *tāla* is the metric system of Indian music; *tālī* is a count marking the beginning of a *tāla* subdivision
tālam	small cymbals used in dance accompaniment
ṭāmbūr	(*tāmbūra, tāmboora, tūnbūr, tāmbour*) long-necked, plucked lute–type stringed instrument

tār	lute
upang	ancient Indian instrument
vīṇā	generic term for stringed instrument in ancient India; a South Indian stringed instrument
yantra	an Indian stringed instrument
zurnā	a type of shawm (a *surnā*) of West Asian areas with a bell and pipe turned from one piece of wood

BIBLIOGRAPHY

MUGHAL-PERIOD AND OTHER EARLY SOURCES

Ahkam-i 'Alamgiri (Anecdotes of Aurangzeb). Compiled by Bahadur Hamid al-Din Khan. Cited from translation by Jadunath Sarkar, 3d ed. Calcutta: M. C. Sarkar, 1949 (1st ed. 1935).

AiA A'in-i Akbari. By Abu'l Fazl 'Allāmī ibn Mubārak. 3 vols. Cited from translation by H. Blochmann (vol. 1) and Colonel H. S. Jarrett (vols. 2–3). Calcutta: Royal Asiatic Society of Bengal, 1867–77; 2d ed.: vol. 1, 1927; vol. 2, 1949; vol.3, 1948. 3d ed. with corrections and further annotations to vols. 2 and 3 by Sir Jadunath Sarkar. New Delhi: Oriental Books Reprint Corp., 1977.

AiN Akhlāt-i Nasiri (The Nasirean Ethics). By Nasir ad-Din Tusi, c. 1235. Cited from translation by G. M. Wickens (UNESCO Collection of Representative Works, Persian series). London: Allen and Unwin, 1964.

Alamgirnāma. By Muhammad Kasim. Edited by Khadim Husain and Abdul Hai. Calcutta: Bibliotheca Indica, 1865–73. [Official court history of the first 10 years of Aurangzeb's reign.]

AN The Akbar Nāma. By Abu'l Fazl. Cited from translation by Henry Beveridge. 3 vols. Calcutta: Bibliotheca Indica, 1873–87. Repr., Delhi: Ess Ess Publications, 1977.

Bahāristān-i Ghaybi. By Mirza Nathan, completed in 1632 C.E. 2 vols. Cited from translation by M. I. Borah. Gauhati: Government of Assam, 1936.

Bawariq al-ilma Cited from *Tracts on Listening to Music, Being Dhamm al-malahi by Ibn abi l-Dunya and Bawariq al-ilma by Majd al-Din al-Tusi al-Ghazali,* edition with introduction, translation, and notes by James Robson. London: Royal Asiatic Society (Oriental Translation Fund n.s. 34), 1938.

BN Bābur Nāma (Memoirs of Babur). Cited from translation by Annette Susannah Beveridge. London: Luzac, 1922. Repr., New Delhi: Oriental Books Reprint Corp., 1979. Also translated by W. M. Thackston, Jr., as *Bâburnâma,* 3 vols. (Cambridge: Harvard University Press, 1993); *The Baburnama* (New York: Oxford University Press, 1996).

Gulshan-i-Ibrahimi. See *TiF.*

History of Alamgir, by Muhammad Hashim Khafi Khan (also Kwawafi Khan). Cited

from translation by S. Moinul Haq. Calcutta: Bibliotheca Indica, 1860–74. Repr., Karachi: Pakistan Historical Society, 1975. [Khafi Khan was a court official during 'Alamgir's rule and witnessed many of the events of the late seventeenth century.]

HN *Humāyūn Nāma* (The History of Humayun). By Gul-Badan Begam. Cited from translation by Annette S. Beveridge. London: Royal Asiatic Society, 1902. Repr., New Delhi: Oriental Books Reprint Corp., 1983.

Iqbal-nāmah-yi Jahāngīrī. By Mu'tamad Khan. Seventeenth and eighteenth centuries. Edited by Maulavi 'Abdal-Hayy and Maulavi Ahmad 'Ali Sahun. Vol. 1 [reigns of Babur and Humayun], vol. 2 [reigns of Akbar], Lucknow: Nawal Kishore, 1865; vol. 3 [reign of Jahangir], Calcutta: Bibliotheca Indica, 1870. [Originally written in Jahangir's time to supersede the *Akbar Nāma* by using simpler language and removing unfavorable references to Jahangir; finished after Jahangir's death.]

Kitāb-i-Nauras, by Ibrahim Adilshah II (r. 1580–1627). Introduction, notes, textual editing, and translation from the manuscript by Nazir Ahmad. New Delhi: Bharatiya Kala Kendra, 1956.

MiA *Ma'āsir-i-Alāmgīrī*, by Saqi Khan. Cited from translation by Jadunath Sarkar. Calcutta, 1947. Repr., Lahore: Suhail Academy, 1981. [Written shortly after the emperor's death by Mustad Khan Saqi, an imperial *mansabdar* under Aurangzeb, at the request of 'Inayat Khan, 'Alamgir's favorite secretary. Relies heavily on the *Alamgir-nāma* for the first ten years of the reign.]

MtT *Muntakhabu-t-Tāwārīkh* (The Reign of Akbar, from 963 to 1004 A.H.), by 'Abdu-l-Qādir Ibn-i-Mulūk Shah, known as Al-Bada'uni). 3 vols. Cited from edition and translation by W. H. Lowe, revised and enlarged with an account containing *The Contemporaries' Estimate of Akbar* by Brahmadeva Prasad Ambashthya. Delhi: Renaissance Publishing House, 1986 (1st ed. 1973).

Muraqqaʿ-e-Dehli, by Dargah Quli Khan. Cited from *Muraqqaʿ-e-Dehli: The Mughal Capital in Muhammad Shah's Time,* English translation with an introduction and notes by Chander Shekhar and Shama Mitra Chenoy. Delhi: Deputy Publications, 1989.

MutL *Muntakhab al-Lubab,* by Muhammad Hashim Khafi Khan (also Kwawafi Khan). Edited by K. D. Ahmad and Haig. Calcutta: Bibliotheca Indica, 1860–74. Repr., Karachi, 1963. [Originally published in 1734, this is a general history of the Mughals from 1519 to 1733 that has a very detailed, objective account of Aurangzeb's entire reign.]

PSN *Pādshāh Nāma,* by Abdul Hamid Lahōrī and (vol. 3) Mohammed Waris. Edited by Kabir al-Din Ahmad and Abd al-Rahim (as *Badshahnama: The Official History of the First 30 Years of Shah Jahan's Reign*). Calcutta: Royal Asiatic Society of Bengal, 1867. Cited from translation by A. R. Fuller, 1851. Repr., 1990. [Condensed as the *SJN,* q.v.; *PSN* is cited herein for paintings, *SJN* for quotations.]

Rāga Darpaṇa. Translated (1665–66) into Persian by Faqīrullā, from the Hindi verse *Mānakutūhala* of Manasingh Tomar (1488), and translated back into Hindi by H. Dvivedi as *Mānasingh Aur Manakutūhala* by H. D. Dvivedi. Gwalior: Vidyā Mandir Prakāshan Murār, 1954/56. [It is significant that it was originally composed in a vernacular, not in Sanskrit.]

RiA *Rukaat-i Alamgiri* (Letters of Aurangzeb). Edited by J. H. Bilimoria. Bombay: Taraporevala, 1916.

Saṅgītaratnākara of Śarngadeva (c. 1240). Edited by S. Subrahmaṇya Śastri, 4 vols. Madras: Adyar Library. [A thirteenth-century comprehensive synthesis of all previous musical learning.] 1943–53.

SJN *The Shāh Jahān Nāma*. Condensed from the *Pādshāh Nāma* by 'Inayat Khan (British Library, ADD30,777). Cited from translated by A. R. Fuller, 1891. Edited and completed by W. E. Begley and Z. A. Desai. Delhi: Oxford University Press, 1990. ['Inayat Khan was Keeper of the Imperial Library for, and a close friend of, Shah Jahan; this is a survey of his reign from 1627 to 1654; *SJN* is cited herein for quotations, *PSN* for paintings.]

Tadkira-i Humāyūn wa Akbar (or *Tazkhira-Humāyūn o Akbar*), by Bayazid Bayat. Edited by M. Hidayat Hosain. Calcutta: Bibliotheca Indica, 1941.

TaN *Ṭabakāt-i Nasīrī. A General History of the Muhammadan Dynasties of Asia, including Hindustan; from* A.H. 194 (810 C.E.) to A.H. 658 (1260 C.E.). Cited from translation by Major H. G. Raverty. New Delhi: Munshiram Manoharlal, 1970.

Tarīkh-i Akbarī (or *Tarīkh-i Qandahārī of Hajji Muhammad 'Arif Qandahari*), (c. 1579). Edited by Muinud-Din Nadwi, Azhar Ali Dihlwi, and Imtiyaz Ali Arshi. Rampur: Raza Library, 1962.

Tarīkh-i Rashīdī (A History of the Moghuls of Central Asia), by Mirza Muhammad Haidar Dughlat. Translated by N. Elias and D. Ross. London, 1895.

Tezkereh-al Vakiāt (Private Memoirs of the Moghul Emperor Humayun), by Jauhar Aftabchi (begun 1587). Trans-

lated by Charles Stewart. London, 1832. Repr., New York: Kelley (Reprints of Economic Classics), 1969; New Delhi: Kumar Brothers, 1970.

TiA *Ṭabakāt-i Akbarī* (or *Tabaqāt-i Akbarī*), by Kwajah Nizam al-Din Ahmad (1593). 3 vols. Edited by B. De; vol. 3 partly edited and revised by M. Hidayat Hosain. Calcutta: Bibliotheca Indica, 1913–31.

TiF *Tarīkh-i Firishta*. By Muhammad Qasim Firishta. Original title *Gulshan-i-Ibrahimi*. Kanpur: Nawal Kishore, 1874 and 1884.

TiJ *Tūzuk-i Jahāngīrī* (The Memoirs of Jahangir). Cited from translation by Alexander Rogers and Henry Beveridge. 2 vols. Delhi: Munshiram Manoharlal, 1968.

TiSS *Tarīkh-i Sher Shahī of Abbas Khan Sharwani*. Vol. 4 of *A History of India as Told by Its Historians*, edited by Henry M. Elliott. Calcutta: Susil Gupta, 1952–59. Repr., Dacca: Dacca University, 1964.

TuN *Tūtī Nāma* (Tales of a parrot), by Ziya'al-Din Nakshabi. 2 vols. Graz, Austria: Akademische Druck und Verlaganstalt, 1976. Cited from edition and translation by Muhammed A. Simsar, *Tales of a Parrot: The Cleveland Museum of Art's Tutinama*. Cleveland: Cleveland Museum of Art, 1978.

MODERN REFERENCES

Agrawala, Vasudeva Sharana. 1961. *Indian Miniatures: An Album*. New Delhi: Indian Dept. of Archaeology.

———. 1964. *The Heritage of Indian Art*. Delhi: Ministry of Information and Broadcasting, Publications Division.

Ahmad, N. L. 1963. "Some Aspects of Life and Culture in Mughal India during the Shah Jahan Period." *Jammu and Kashmir University Review* 6:35–62.

Aijazuddin, F. S. 1977. *Pahari Paintings and Sikh Portraits in the Lahore Museum*. Foreword by W. G. Archer. London: Sotheby Parke Bernet.

Alam, Muzaffar. 1986. *The Crisis of Empire in Mughal North India: Awadh and the Punjab, 1707–1748*. Delhi: Oxford University Press.

Ali, Mubarak. 1980. "The Mughal Court Ceremonies." *Journal Pakistan Historical Society* 28:42–62.

Alvi, Sajida. 1989. *Advice on the Art of Governance*. Albany: State University of New York Press.

Anand, Mulk Raj. 1973. *Album of Indian Paintings*. New Delhi: National Book Trust.

Andhare, Shridhar, and Rawat Nahar Singh. 1977. *Deogarh Painting*. Lalit Kala Series, portfolio 16. New Delhi: Lalit Kala Akademi.

Ansari, Muhammad Azhar. 1974. *Social Life of the Mughal Emperors*. Allahabad: Shanti Prakashan.

Ansari, Zoe, ed. 1976. *Life, Times, and Works of Amīr Khusrau Dehlavi (Amīr Khusrau Commemoration Volume)*. New Delhi: National Amir Khusrau Society.

Archer, William G. 1957a. *Indian Painting*. New York: Oxford University Press.

———. 1957b. *The Loves of Krishna, in Indian Painting and Poetry*. Ethical and Religious Classics of East and West, no. 18. London: Allen and Unwin.

———. 1958. *Central Indian Painting*. Faber Gallery of Oriental Art. London: Faber and Faber.

———. 1961. *Indian Miniatures from the XVth to the XIXth Centuries*. Catalogue of the Italian Exhibition of Robert Skelton. Venezia: Neri Pozza (Fondazione "Giorgio I Cini").

———. 1963. *Indian Miniatures from the Collection of W. G. and Mildred Archer, London*. Series Publication (S.I.): Traveling Exhibition Services No. 4520. Washington, D.C.: Smithsonian Institution.

———. 1973. *Indian Paintings from the Punjab Hills: A Survey and History of Pahari Miniature Painting*. London: Sotheby Parke Bernet.

Archer, William G., and Stanislaw Czuma. 1975. *Indian Art from the George P. Bickford Collection*. Cleveland: The Cleveland Museum of Art.

Arnold, Sir Thomas Walker. 1930. *Bihzad and His Paintings in the Zafar-Namah*. London: Quaritch.

Arnold, Sir Thomas Walker, and J. V. S. Wilkinson. 1928. *Painting in Islam*. Oxford: Clarendon.

———. 1936. *The Library of A. Chester Beatty: A Catalogue of Indian Miniatures*. 3 vols. London: Emery Walker, Ltd.

The Arts of India and Nepal: The Nasli and Alice Heeramaneck Collection. 1966. Boston: Museum of Fine Arts; New York: October House.

Asher, Catherine B. 1992. *Architecture in Mughal India*. The New Cambridge History of India, pt. 1, vol. 4. Cambridge: Cambridge University Press.

Ashton, Sir Leigh, ed. 1950. *The Art of India and Pakistan: A Commemorative Catalogue of the Exhibition Held at the Royal Academy of Arts, London, 1947–48*. London: Faber and Faber.

Asiatic Art in the Museum of Fine Arts, Boston. 1982. Boston: Museum of Fine Arts.

Asia Society. 1960. *Rajput Painting.* Introduction and notes by Sherman E. Lee; catalogue by George Montgomery. New York: Asia House Gallery.

Athar Ali, M. 1966. *The Mughal Nobility under Aurangzeb.* Bombay: Asia Publishing House.

———. 1985. *The Apparatus of Empire: Awards of Ranks, Office, and Titles of the Mughal Nobility 1574–1658.* Delhi: Oxford University Press.

Auboyer, Jeannine. 1951. *Arts et styles de l'Inde.* Arts, styles et techniques. Paris: Larousse.

Aziz, Abdul. 1945. *The Mansabdari System of the Mughal Army.* Lahore. Repr., London: A. Probsthain, 1946; Delhi: Chand, 1971.

———. 1967. *The Imperial Library of the Mughals,* ed. A. Shakoor Ahsan. Lahore: Panjab University Press.

Aziz, Ahmad. 1964. *Studies in Islamic Culture in the Indian Environment.* Oxford: Clarendon.

———. 1969. *An Intellectual History of Islam in India.* Edinburgh: Edinburgh University Press.

Bach, Hilde. 1985. *Indian Love Painting.* Varanasi, India: Lustre Press.

Baily, John. 1984. "Ghichak." In *The New Grove Dictionary of Musical Instruments,* ed. Stanley Sadie, 2:43. London: Macmillan.

Baital-Pachisi. 1893. *Vikram and the Vampire; or, Tales of Hindu Devilry.* Adapted by Sir Richard Burton; edited by Isabel Burton. London: Tylston and Edwards.

Banerjee, S. K. 1938. *Humayun Badshah.* 2 vols. London: Oxford University Press.

Banerji, Sures Chandra. 1976. *Fundamentals of Ancient Indian Music and Dance.* Lalbhai Dalpatbhai Series, no. 57. Ahmedabad: Lalbhai Dalpatbhai Institute of Indology.

Barrett, Douglas E. 1952. *Persian Painting of the Fourteenth Century.* London: Faber and Faber.

———. 1958. *Painting of the Deccan, XVI–XVII Century.* London: Faber and Faber.

Barrett, Douglas, and Basil Gray. 1963. *Painting of India.* Treasures of Art. Venice: Skira.

Basham, Arthur Llewellyn, ed. 1975. *A Cultural History of India.* Oxford: Clarendon.

Bautze, J. 1987. *Indian Miniature Paintings, c. 1590–c. 1850: A Catalogue of an Amsterdam Exhibition 1 October–30 November 1987.* Amsterdam: Saundarya Lahari.

Beach, Milo Cleveland. 1978. *The Grand Mogul: Imperial Painting in India 1600–1660.* Williamstown, Mass.: Sterling and Francine Clark Art Institute.

———. 1981. *The Imperial Image: Paintings for the Mughal Court.* Washington, D.C.: Freer Gallery of Art, Smithsonian Institution.

———. 1985. "Mughal Tents." *Orientations* 16 (1): 32–43.

———. 1987. *Early Mughal Painting.* Polsky Lectures in Indian and Southeast Asian Art and Archaeology. Cambridge: Harvard University Press.

———. 1992a. *Mughal and Rajput Painting.* The New Cambridge History of India, pt. 1, vol. 3. Cambridge: Cambridge University Press.

———. 1992b. "Jahangir's Jahangir-Nama." In *The Powers of Art: Patronage in Indian Culture,* ed. Barbara Stoler Miller, 224–34. New Delhi: Oxford University Press.

Beach, Milo, and Ebba Koch. 1997. *King of the World. The Padshahnama. An Imperial Mughal Manuscript from the Royal Library, Windsor Castle.* London: Azimuth Editions; Washington, D.C.: Sackler Gallery, Smithsonian Institution.

Beaune, C. 1985. "Mural Paintings of Bundi and Kota." *Orientations* 16 (6): 30–44.

Begley, Wayne E. 1986. "Illustrated Histories of Shah Jahan: New Identifications of Some Dispersed Paintings and the Problem of the Windsor Castle *Padshahnama.*" In *Facets of Indian Art,* ed. Robert Skelton et al., 139–52. London: Victoria and Albert Museum.

Beguin, Grilles. 1984. *L'Art indien.* La Grammaire des styles. Paris: Flammarion.

Bernier, François. 1916. *Travels in the Mogul Empire, A.D. 1656–1668.* 2d ed. Translated by Archibald Constable and Irving Brock; edited by Vincent A. Smith. London: Oxford University Press.

Betz, Gerd. 1965. *Orientalische Miniaturen.* Braunschweig: Georg Westermann.

Bhanu, Dharma. 1955. "Promotion of Music by the Turkish Afghan Rulers of India." *Islamic Culture* 24:9–36.

Bhattacharya, Arun Kumar. 1978. *A Treatise on Ancient Hindu Music.* Calcutta: K. P. Bagchi.

Bhattacharya, Sunil Kumar. 1966. *The Story of Indian Art.* Delhi: Atma Ram.

Binney, Edwin. 1968. *Rajput Miniatures from the Collection of Edwin Binney III*. Introduction by William G. Archer. Portland, Ore.: Portland Art Museum.

———. 1973. *Indian Miniature Painting from the Collection of Edwin Binney III: An Exhibition at the Portland Art Museum, Dec. 2, 1973 – Jan. 20, 1974.*

Binyon, Laurence. 1925. *L'Art asiatique au British Museum: Sculpture et peinture*. Vol. 6 of *Ars asiatica*. Paris: G. Van Oest.

———. 1930. *A Persian Painting of the Sixteenth Century: Emperors and Princes of the House of Timur*. London: British Museum.

———. 1932. *Akbar*. London: P. Davies.

———. 1935. *The Spirit of Man in Asian Art*. Norton Lectures, 1933–34. Cambridge: Harvard University Press.

Binyon, Laurence, J. V. S. Wilkinson, and Basil Gray. 1971. *Persian Miniature Painting, Including a Critical and Descriptive Catalogue of the Miniatures Exhibited at Burlington House, Jan.–March 1931*. New York: Dover.

Binyon, Laurence, and T. W. Arnold. 1921. *Court Painters of the Grand Moghuls*. London: Oxford University Press.

Blacker, J. F. 1975. *The ABC of Indian Art*. ABC Series for Collectors. Delhi: Indian Reprint Publishing Co.

Blake, Stephen P. 1991. *Shahjahanabad: The Sovereign City in Mughal India, 1639 –1739*. Cambridge: Cambridge University Press.

Blochet, Edgar. 1926. *Peintures et manuscrits arabes, persans, et turcs de la Bibliothèque Nationale*. Paris: Berthand Frères.

———. 1929. *Musulman Painting, 12th–17th Century*. Translated by Cicely M. Binyon. London: Methuen.

Blum, Stephen, Philip Bohlman, and Daniel Neuman, eds. 1991. *Ethnomusicology and Modern Music History*. Urbana: University of Illinois Press.

Blunt, Wilfred. 1976. *The Splendors of Islam*. New York: Viking.

Booth, Gregory. 1990. "Brass Bands: Tradition, Change, and the Mass Media in Indian Wedding Music." *Ethnomusicology* 34:245–63.

Bor, Joep. 1987a. "De klank van Indiase muziek." *Azie* I (3): 70–77.

———. 1987b. "The Voice of the Sarangi: An Illustrated History of Bowing in India." *Quarterly Journal, National Centre for the Performing Arts* 15(3–4), 16(1).

Bordieu, Pierre. 1984. *Distinction: A Social Critique of the Judgment of Taste*. Trans. Richard Nice. Cambridge: Harvard University Press.

Bose, Narendra Kumar. 1960. *Melodic Types of Hindusthan: A Scientific Interpretation of the Raga System of Northern India*. Bombay: Jaico.

Brand, Michael, and Glenn D. Lowry. 1985. *Akbar's India: Art from the Moghul City of Victory*. New York: Asia Society Galleries.

———, eds. 1987. *Fatehpur-Sikri: A Sourcebook*. Bombay: Marg.

Brinker, Helmut, and Eberhard Fischer. 1980. *Treasures from the Reitburg Museum: Catalogue from the 1980 Exhibition*. New York: Asia Society in association with J. Weatherhill.

British Museum. 1921. *Twelve Mughal Paintings*. London: British Museum.

Brown, Howard Mayer, and Joan Lascelle. 1972. *Musical Iconography: A Manual for Cataloguing Musical Subjects in Western Art before 1800*. Cambridge: Harvard University Press.

Brown, Percy. 1924. *Indian Painting under the Mughals A.D. 1550 to A.D. 1750*. London: Oxford University Press. Repr. New York: Hacker Art Books, 1975.

———. 1981. *Indian Painting under the Mughals A.D. 1550 to A.D. 1750*. New Delhi: Cosmo Publications.

———. 1982. *Indian Painting*. New Delhi: Harnam Publications.

Burnes, Sir Alexander. 1834. *Travels into Bokhara: Being the Account of a Journey into India*. N.p.

Bussagli, Mario. 1969. *Indian Miniatures*. London: Paul Hamlyn.

Bussagli, Mario, and Calembus Swaramamurti. 1971. *5000 Years of the Art of India*. New York: Abrams.

Canby, Sheila, ed. 1994. *Humayun's Garden Party. Princes of the House of Timur and Early Mughal Painting*. Bombay: Marg.

Caturvedi, Gopala Madhukara. 1982. *Bharatiya citrakala aitikasika sandarbha*. Aligarh: Jagrta Prakasana.

Chagatai, Muhammad 'Abdullah. 1981. *Kamaluddin Bihzad musavvir*. Lahore: Kitabh khanah-yi Mauras.

Chaitanya, Krishna. 1979. *A History of Indian Painting: Manuscript, Moghul, and Deccani Traditions*. 4 vols. (1976–84). New Delhi: Abhinav.

———. 1982. *Rajasthani Traditions*. New Delhi: Abhinav.

Chandra, Moti. 1949. *The Technique of Mughal Painting.* Lucknow: Uttar Pradesh Historical Society.

———. 1967. *Leaves from Indian Painting.* Lalit Kala Series, portfolio 4. New Delhi: Lalit Kala Akademi.

Chandra, Pramod, et al. 1983. *On the Study of Indian Art.* Polsky Lectures in Indian and Southeast Asian Art and Archaeology. Cambridge: Harvard University Press.

Chandra, Pramod, and Daniel J. Ehnbom. 1976. *The Cleveland Tuti-nama Manuscript and the Origins of Mughal Painting.* Cleveland: Cleveland Museum of Art.

Chandra, Satish. 1979. *Parties and Politics at the Mughal Court, 1707–40.* 3d ed. Aligarh: University Press.

———. 1981. *Medieval India, Society, the Jagirdari Crisis and the Village.* Delhi.

Chaturvedi, B. K. n.d. *Dresses and Costumes of India.* New Delhi: Diamond Pocket Books.

Chopra, Pran Nath. 1963. *Some Aspects of Society and Culture during the Mughal Age, 1526–1707.* 2d ed. Agra: Shiva Lal-Agarwala.

Citron, Marcia J. 1993. *Gender and the Musical Canon.* Cambridge: Cambridge University Press.

Clarke, C. Stanley. 1977. *Indian Drawings: Thirty Mogul Paintings of the School of Jahangir.* Lahore: Qausain (Victoria and Albert Museum).

———. 1983. *Mughal Paintings: The School of Jahangir.* New Delhi: Cosmo.

Clifford, James. 1983. "On Ethnographic Authority." *Representations* 1 (Spring): 118–46.

Clifford, James, and George Marcus, eds. 1986. *Writing Culture: The Poetics and Politics of Ethnography.* School of American Research Advanced Seminar. Berkeley and Los Angeles: University of California Press.

———. 1988. *The Predicament of Culture: Twentieth-Century Ethnography, Literature, and Art.* Cambridge: Harvard University Press.

Colnaghi, P. and D., and Co. 1976. *Persian and Mughal Art.* London: P. and D. Colnaghi and Company.

———. 1978. *Indian Painting: Mughal and Rajput and a Sultanate Manuscript.* London: P. and D. Colnaghi and Company.

Cook, Susan, and Judy S. Tsou, eds. 1994. *Cecelia Reclaimed: Feminist Perspective on Gender and Music.* Urbana: University of Illinois Press.

Coomaraswamy, Ananda Kentish. 1912a. "Rajput Painting." *The Burlington Magazine for Connoisseurs* 20:315–24.

———. 1912b. *Indian Drawings,* 2d ser. (1910–1912). London: Old Bourne Press.

———. 1912c. "Mughal Portraiture." *Orientalische Archiv* 3:12–15.

———. 1914. *Visvakarma: Examples of Indian Architecture, Sculpture, Painting, Handicraft.* London: Luzon.

———. 1916. *Rajput Painting.* 2 vols. Oxford: Oxford University Press.

———. 1923. *Portfolio of Indian Art.* Boston: Museum of Fine Arts.

———. 1925. *Bibliographies of Indian Art.* Boston: Museum of Fine Arts.

———. 1927. "The Relation of Mughal and Rajput Paintings." *Rupam* 31:88–91.

———. 1928. "Mughal Painting (Akbar and Jahangir)." *Bulletin of the Museum of Fine Arts, Boston* 16:2–8.

———. 1930. *Catalogue of the Indian Collections in the Museum of Fine Arts, Boston.* Pt. 6, *Mughal Painting.* Boston: Museum of Fine Arts.

———. 1964. *The Arts and Crafts of India and Ceylon.* Repr., New York: Farrar, Straus. Original ed., London: T. N. Foulis, 1913.

———. 1965. *History of Indian and Indonesian Art.* Repr., New York: Dover. Original ed., New York: E. Weghe, 1927.

———. 1969. *Introduction to Indian Art.* Delhi: Munshiram Manoharlal.

———. 1971. *A University Course in Indian Art,* ed. S. Durai Raja Singam. Petaling Jaya, Malaysia: S. Durai Raja Singam.

———. 1976. *A Catalog of the Special Exhibition of the Paintings and Books in Honor of the Birth Centenary of Ananda K. Coomaraswamy.* New Delhi: National Museum of India.

———. 1984. *Coomaraswamy Centenary Seminar.* New Delhi: Lalit Kala Akademi.

Correia-Afonso, John, ed. 1980. *Letters from the Mughal Court: The First Jesuit Mission to Akbar (1580–1583).* Bombay: Gujarat Sahitya Prakash.

Craven, Roy C. 1976. *A Concise History of Indian Art.* New York: Praeger; London: Thames and Hudson.

Crossley-Holland, Peter. 1982. *Musical Instruments in Tibetan Legend and Folklore.* Monograph Series in Ethnomusicology, no. 3. Los Angeles: University of California Department of Music.

Crowe, Sylvia, et al. 1972. *The Gardens of Mughal India.* London: Thames and Hudson.

Currie, P. M. 1989. *The Shrine and Cult of Muʿīn al-Dīn Chistī of Ajmer.* South Asian Studies Series. Delhi: Oxford University Press.

Czuma, Stanislaw J. 1975. *Indian Art from the George P. Bickford Collection.* Cleveland: Cleveland Museum of Art.

Dale, Stephen Frederic. 1990. "Steppe Humanism: The Autobiographical Writings of Zahir Al-Din Muhammad Babur, 1483–1530." *International Journal of Middle East Studies* 22 (1): 37–58.

———. 1996. "The Poetry and Autobiography of the Bâbur-nâma." *Journal of Asian Studies* 55: 635–64.

Daniel, E. Valentine, and Jeffrey M. Peck, eds. 1995. *Culture/Contexture: Exploration in Anthropology and Literary Studies.* Berkeley and Los Angeles: University of California Press.

Das, Ashok Kumar. 1967. "Moghul Royal Hunt in Miniature Paintings." *Indian Museum Bulletin* 2 (1): 1–5.

———. 1976. *Treasures of Indian Art from the Maharajah Sawai Man Singh II Museum, Jaipur.* Jaipur: Man Singh II Museum.

———. 1978. *Mughal Painting during Jahangir's Time.* Calcutta: Asiatic Society.

———. 1982. *Dawn of Mughal Painting.* Bombay: Vakils, Feffer and Simons.

———. 1986. *Splendour of Mughal Painting.* Bombay: Vakils, Feffer and Simons.

Das, Harihar H. 1959. *The Norris Embassy to Aurangzeb, 1699–1702.* Calcutta: K. L. Mukhopadhyay.

Datta, Bhupendranatha. 1956. *Indian Art in Relation to Culture.* Calcutta: Nababharat.

Davidson, J. Leroy. 1968. *Art of the Indian Subcontinent from Los Angeles Collections.* Los Angeles: Ward Ritchie Press.

Davies, Cuthbert Collin. 1957. *An Historical Atlas of the Indian Peninsula.* London: Oxford University Press.

Davis, Richard H. 1993. "Indian Art Objects as Loot." *Journal of Asian Studies* 52 (1): 22–48.

Day, Charles Russell, Capt. 1891. *The Music and Musical Instruments of Southern India and The Deccan.* Repr. 1974. Delhi: B. R. Publishing Corp.

Desai, Vishakha N. 1985. *Life at Court: Art for India's Rulers, 16th–19th c.* Boston: Museum of Fine Arts.

Deva, Bigamudre Chaitanya. 1973. *An Introduction to Indian Music.* New Delhi: Ministry of Information and Broadcasting, Publications Division.

———. 1974. *Indian Music.* New Delhi: Indian Council for Cultural Relations.

———. 1975. "The Double-Reed Aerophone of India." *Yearbook of the International Folk Music Council* 7: 77–84.

———. 1977. *Musical Instruments.* India: The Land and the People. New Delhi: National Book Trust.

———. 1978. *Musical Instruments of India: Their History and Development.* Calcutta: Firma KLM.

———. 1980. "Classification of Indian Musical Instruments." In *Indian Music: A Perspective,* ed. G. Kuppuswamy and M. Mariharan, 127–40. Delhi: Sundeep Prakashan.

———. 1981. *The Music of India: A Scientific Study.* New Delhi: Munshiram Manoharlal.

Devale, Sue Carol. 1989. "Power and Meaning in Musical Instruments." In *Music and the Experience of God,* ed. Mary Collins, David Power, and Mellonee Burnim, 94–110. Edinburgh: T. & T. Clark.

Dhavalikar, Madhukar Keshav. 1973. *Ajanta: A Cultural Study.* Poona: The University of Poona.

Dick, Alistair. 1984a. "Dholak." In *The New Grove Dictionary of Musical Instruments,* ed. Stanley Sadie, 1: 562. London: Macmillan.

———. 1984b. "Śṛṅga [sīṅg, sīṅgā, sīg, sīgā]." In *The New Grove Dictionary of Musical Instruments,* ed. Stanley Sadie, 3: 442. London: Macmillan.

———. 1984c. "Surmaṇḍal [svaramaṇḍala]." In *The New Grove Dictionary of Musical Instruments,* ed. Stanley Sadie, 3: 477. London: Macmillan.

———. 1984d. "The Early History of the Shawm in India." *Galpin Society Journal* 37: 80–98.

Dick, Alistair, and Genevieve Dournon. 1984a. "Chang." In *The New Grove Dictionary of Musical Instruments,* ed. Stanley Sadie, 1: 332. London: Macmillan.

———. 1984b. "Dhol." In *The New Grove Dictionary of Musical Instruments,* ed. Stanley Sadie, 1: 560–62. London: Macmillan.

Dickenson, Eric, and Karl Khandalawala. 1959. *Kishangarh Painting.* Lalit Kala Series of Indian Art. New Delhi: Lalit Kala Akademi.

Diez, Ernst. 1925. *Die Kunst Indiens.* Handbuch der Kunstwissenschaft, Ergänzungsband. Wildpark-Potsdam: Akademische Verlagsgesellschaft Athenaion.

Digby, Simon. 1967. "The Literary Evidence for Painting in the Delhi Sultanate." *Bulletin of the American Academy of Benares* 1: 47–58.

Dimand, Maurice Sven. 1933. *A Guide to an Exhibition of Islamic Miniature Painting and Book Illumination, October 9 through January 7, 1933–34.* New York: Metropolitan Museum of Art.

Dubash, Perviz Noshirwan Peerozshan. 1936. *Hindoo Art in Its Social Setting, Being a Dissertation on Art in the Ancient Indian Civilisation.* Madras: National Literature Publishing Co.

Dunn, Leslie C., and Nancy A. Jones, eds. 1994. *Embodied Voices: Representing Female Vocality in Western Culture.* Cambridge: Cambridge University Press.

During, Jean, Robert At'ayan, and Johanna Spector. 1984. "Kamanche." In *The New Grove Dictionary of Musical Instruments,* ed. Stanley M. Sadie, 2:353–54. London: Macmillan.

Dwivedi, Hariharnivas. 1977. "Man Singh's *Manakutuhala,* and the Dhrupad." *Quarterly Journal, National Centre for the Performing Arts* 6 (2): 12–21.

Eastman, Alvan Clark. 1959. *The Nala-Damayanti Drawings.* Boston: Museum of Fine Arts.

Ebeling, Klaus. 1973. *Ragamala Painting.* Basel and New Delhi: Ravi Kumar.

Ehnbom Daniel James. 1985. *Indian Miniatures: The Ehrenfeld Collection.* With essays by Robert Skelton, Pramod Chandra. New York: Hudson Hills Press.

Elliot, Henry Miers, and John Dowson. 1963–64. *The History of India as Told by Its Own Historians,* 1st Indian ed. Allahabad: Kitab Mahal.

Emsheimer, Ernst. 1986. "Earliest Reports about the Music of the Mongols." Trans. Robert Carroll. *Asian Music* 18 (1): 1–19.

Erdman, Joan Landy. 1985. *Patrons and Performers in Rajasthan: The Subtle Tradition.* Delhi: Chanakya.

Erdman, Joan Landy, ed. 1992. *Patronage in India: Methods, Motives, and Markets.* New Delhi: Manohar.

Erlman, Veit. 1983. "Notes on Musical Instruments among the Fulani of Diamare (North Cameroon)." *African Music* 6 (3): 16–41.

Ettinghausen, Richard. 1961. *Paintings of the Sultans and Emperors of India.* New Delhi: Lalit Kala Akademi.

———. 1962. *Arab Painting.* Treasures of Asia. Cleveland: World Publishing Co.

———. 1984. *Islamic Art and Archeology: Collected Writings.* Berlin: Mann.

Falk, Toby. 1976. *Persian and Mughal Art.* London: Colnaghi.

Falk, Toby, and Mildred Archer. 1981. *Indian Miniatures in the India Office Library.* London: Sotheby Parke Bernet; Delhi/Karachi: Oxford University.

Farmer, Henry George. 1929. *A History of Arabian Music to the Thirteenth Century.* Repr., London: Luzac.

———. 1939. *Studies in Oriental Musical Instruments.* Glasgow: Civic Press.

———. 1965. *The Sources of Arabian music.* 2d ed. Leiden: Brill.

———. 1966. *Islam: Musikgeschichte in Bildern.* Vol. 3, *Musik des Mittelaters und der Renaissance.* Leipzig: VEB Deutscher Verlag für Musik.

Farooqi, Anis. 1979. *Art of India and Persia.* Delhi: B. R. Publishing Corp.

Fehervari, Geza, and Yasin H. Safadi. 1981, *1400 Years of Islamic Arts: A Descriptive Catalogue.* London: Khalili Gallery.

Findly, Ellison Banks. 1981. *From the Courts of India.* Worcester, Mass.: Worcester Art Museum.

———. 1993. *Nur Jahan: Empress of Mughal India.* Oxford: Oxford University Press.

Flora, Reis Wenger. 1983. "Miniature Paintings: Important Sources for Music History." In *Performing Arts in India,* ed. Bonnie C. Wade. Lanham, Md.: University Press of America.

———. 1984. "Śahnāī [sanāī, shahnāī, shehnāī]," in *The New Grove Dictionary of Musical Instruments,* ed. Stanley Sadie, vol. 3:283–84. London: Macmillan.

———. 1986. "Spiralled-leaf Reedpipes and Shawms of the Indian Ocean Littoral: Two Related Regional Traditions." *Musicology Australia* 9:39–52.

———. 1995. "Styles of the śahnāī in Recent Decades: From *naubat* to gāyakī ang." *Yearbook for Traditional Music* 27:52–75.

Flynn, D. 1971. *Costumes of India.* New Delhi: Mohan Premlavi; Oxford and IBH Publishing Co.

Forbes, James. 1834. *Oriental Memoirs: A Narrative of 17 Years Residence in India.* 4 vols. London: R. Bentley. (1st ed. London: White, Cochrane, 1813.)

Fox Strangways, Arthur Henry. 1967. *The Music of Hindostan.* Repr., Oxford: Clarendon.

Fran, A. 1978. *Inde, cinq mille ans d'art.* Musée du Petit Palais de la ville de Paris, 17 novembre 1978–28 février 1979. Paris: Association Française d'Action Artistique.

Fyzee, Asaf A. A. 1964. *Outlines of Muhammadan Law,* 3d ed. London: Oxford University Press (1st ed., 1949).

Gadon, Elinor W. 1986. "Dara Shikuh's Mystical Vision of Hindu-Muslim Synthesis." In *Facets of Indian Art,* ed. Robert Skelton et al., 153–58. London: Victoria and Albert Museum.

Gangoly, Ordhendra Coomar. 1948. *Ragas and Raginis: A Pictorial and Iconographic Study of Indian Musical Modes Based on Original Sources.* Bombay: Nalanda.

———. 1957. *Indian Art and Heritage.* Compiled and edited by A. Goswami. Calcutta: Oxford Book and Stationery Co.

———. 1968. *Panorama of Indian Painting.* New Delhi: Ministry of Information and Broadcasting, Publications Division.

Gascoigne, Bamber. 1971. *The Great Moghuls.* London: Jonathan Cape.

Gaur, Albertine. 1980. *Women in India.* London: British Library.

Geertz, Clifford. 1973. *The Interpretation of Cultures.* New York: Basic Books.

———. 1988. *Works and Lives: The Anthropologist as Author.* Stanford. Stanford University Press.

George, Kenneth M. 1993. "Music-making, Ritual, and Gender in a Southeast Asian Hill Society." *Ethnomusicology* 37 (1): 1–28.

Ghosh, Manomohan, trans. 1961. *The Nātyaśāstra.* Vol. 1, Calcutta: Manisha Granthalya. Vol. 2, Calcutta: Asiatic Society.

Ghosh, Sharmistha. 1988. *String Instrument (Plucked Variety) of North India.* 2 vols. Delhi: Eastern Book Linkers.

Gibb, Hamilton Alexander Rosskeen. 1962. *Mohammedanism: An Historical Survey.* New York: Oxford University Press.

Gladwin, Francis. n.d. *The History of Jahangir.* Ed. Rao Bahadur K.V. Rangaswami Aiyangar. New ed. 1930, Madras: B. G. Paul.

Glück, von Heinrich, and Ernst Diez. 1925. *Die Kunst des Islam.* Propylaen Kungstgeschichte, no. 5. Berlin: Propyläen Verlag.

Godden, Rumer. 1980. *Gulbadan: Portrait of a Rose Princess.* London: Macmillan.

Goethals, Gregor T. 1990. "Ritual and Representation of Power in High and Popular Art." *Journal of Ritual Studies* 4 (2): 149–77.

Goetz, Hermann. 1930. *Bilderatlas zur Kulturgeschichte Indiens in der Grossmoghulzeit: Die materielle Kultur des Alltags, ihre Wurzeln, Schichten, Wandlungen und Beziehungen zu anderen Völkern auf Grund der indischen Miniature-Malerei und anderen Quellen dargestellt.* Berlin: Reimer.

———. 1947. "Indian Painting in the Muslim Period: A Revised Historical Outline." *Journal of the Indian Society of Oriental Art* 15: 19–41.

———. 1953. "The Nagaur School of Rajput Painting." *Artibus Asiae* 12: 89–98.

———. 1958. *The Indian and Persian Miniature Paintings in the Rijksprentenkabinet (Rijksmuseum) Amsterdam.* Amsterdam: Rijksmuseum.

———. 1964. *The Art of India: Five Thousand Years of Indian Art.* Repr., New York: Crown.

Goswami, Krsnadasa Kaviraja, trans. 1954. *Sri Chaitanya-Charitamrita.* Calcutta: Sri Sri Chaitanya-Charitamrita Karyalaya.

Gosvami, O. 1961. *The Story of Indian Music: Its Growth and Synthesis.* Bombay: Asia Publishing House.

Goswamy, B. N. 1972. "On Two Portraits of Pahari Artists." *Artibus Asiae* 34 (2–3): 225–31.

———. 1975. *Pahari Paintings of the Nala-Damayanti Theme in the Collection of Dr. Karan Singh.* New Delhi: National Museum.

———. 1986. *The Essence of Indian Art.* San Francisco: Asian Art Museum of San Francisco.

Gray, Basil. 1950. "Painting." In *The Art of India and Pakistan,* ed. Sir Leigh Ashton, 85–195. London: Faber and Faber.

———. 1953. "The Development of Painting in India in the 16th Century." *Marg* 6: 19–24.

———. 1956. *Iran: Persian Miniatures—Imperial Library.* UNESCO World Art Series, vol. 6. Greenwich, Conn.: New York Graphic Society.

———, ed. 1949. *Rajput Painting.* New York: Pitman.

———. 1981. *The Arts of India.* Ithaca, N.Y.: Cornell University Press.

Grieg, John Andrew. 1980. "Musical Instruments of Akbar's Court." *Journal of Asian Culture* 4 (Spring): 154–77.

———. 1987. "Tarikh-i Sangita: The Foundations of North Indian Music in the Sixteenth Century." Ph.D. diss., University of California, Los Angeles.

Grousset, René. 1970. *The Empire of the Steppes.* New Brunswick: Rutgers University Press.

Grube, Ernest J. 1968. *The Classical Style in Islamic Painting: The Early School of Herat and Its Impact on Islamic Painting of the Later 15th, the 16th, and 17th Centuries.* Venice: Edizioni Oriens.

———. 1972. *Islamic Paintings from the 11th to the 18th c. in the Collection of Hans P. Kraus.* New York: H. P. Kraus.

———, ed. 1991. *A Mirror for Princes from India: Illustrated Versions of the Kalilah wa Dimnah, Anvār-i Suhaylī, Iyār-i Dānish, and Humāyūn Nāmeh.* Bombay: Marg.

Guha, J. P. 1963. *Introducing Indian Art.* New Delhi: R. and K. Publishing House.

Guizzi, Febo. 1988. "The Continuity of the Pictorial Representation of a Folk Instrument's Playing Technique: The Iconography of the Tamburello in Italy." *World of Music* 30 (3): 28–58.

Habib, Irfan. 1963. *The Agrarian System of Mughal India (1556–1770).* Bombay: Asia Publishing House.

———. 1982. *An Atlas of the Mughal Empire: Political and Economic Maps with Detailed Notes.* Delhi: Oxford University Press.

Hajek, Lubor. 1960. *Indian Miniatures of the Moghul School.* London: Spring Books.

Halim, A. 1945. "Music and Musicians of the Court of Shah Jahan." *Islamic Culture* 19 (1): 354–60.

Hallissey, Robert C. 1977. *The Rajput Rebellion against Aurangzeb: A Study of the Mughal Empire in Seventeenth-Century India.* Columbia: University of Missouri Press.

Hambly, Gavin. 1977. *Cities of Mughul India: Delhi, Agra, and Fatehpur Sikri.* New Delhi: Vikas.

Hardy, Peter. 1966. *Historians of Medieval India: Studies in Indo-Muslim Historical Writing.* 2d ed. London: Luzac.

———. 1978. "The Growth of Authority over a Conquered Political Elite: The Early Delhi Sultanate as a Possible Case Study." In *Kingship and Authority,* ed. John F. Richards, 192–214. South Asian Studies, pub. 3. Madison: University of Wisconsin.

Harle, James C. 1986. *The Art and Architecture of the Indian Subcontinent.* London: Penguin.

Hasan, Ibn. 1967. *The Central Structure of the Mughal Empire and Its Practical Working up to the Year 1657.* London: Oxford University Press.

Hasan, Mohibbul. 1985. *Babur, Founder of the Mughal Empire in India.* New Delhi: Manohar.

Hasrat, Bikrama Jit. 1982. *Dara Shikuh: Life and Works.* 2d rev. ed. New Delhi: Munshiram Manoharlal.

Havell, Ernest Binfield. 1908. *Indian Sculpture and Painting.* London: J. Murray. Repr., Delhi: Cosmo, 1980.

———. 1920. *A Handbook of Indian Art.* New York: Dutton. Original ed., London: J. Murray, 1861.

———. 1964. *The Art Heritage of India.* Rev. ed. Bombay: D. B. Taraporevala Sons.

Heath, Lionel. 1925. *Examples of Indian Art at the British Empire Exhibition, 1924.* London: India Society.

Herndon, Marcia, and S. Ziegler, eds. 1990. *Music, Gender, and Culture.* Wilhelmshaven: Florian Noetzel.

Holroyde, Peggy. 1972. *The Music of India.* New York: Praeger.

Holub, Richard. 1984. *Reception Theory: A Critical Introduction.* London: Methuen.

Horioka, Yasuko, et al. 1975. *Oriental and Islamic Art in the Isabella Stewart Gardner Museum.* Boston: Isabella Stewart Gardner Museum.

Hornbostel, Erich M. von, and Curt Sachs. 1961. "A Classification of Musical Instruments." *Galpin Society Journal* 14:3–29.

Hosking, R. F., and G. M. Meredith-Owens, eds. 1966. *A Handbook of Asian Scripts.* London: British Museum.

Howorth, Henry H. 1970. *History of the Mongols from the 9th to the 19th Century.* 1876–88. 5 vols. Repr., Taipei: Ch'eng Wen.

Imam, Hakim Mohammad Karam. 1959. "Melody through the Centuries." Trans. Govind Vidyarthi. *Sangeet Natak Akademi Bulletin* 11–12 (April): 13–26, 33.

In the Image of Man: The Indian Perception of the Universe through 2000 Years of Painting and Sculpture: Hayward Gallery, London, 25 March–13 June 1982. Catalogue. 1982. Ed. George Mitchell et al. London: Weidenfeld and Nicolson.

Inal, Güner. 1979. "Realistic Motifs in Safavid Miniatures." In *Akten des VII. Internationalen Kongresses für Iranische Kunst und Archäelogie, München 7.–10. September 1976:* 43–48. Berlin: Reimer.

India Department of Tourism. 1965. *Miniature Paintings and Frescoes of India.* New Delhi: Ministry of Information and Broadcasting, Directorate of Advertising and Visual Publicity.

India, Government of. 1979. *Chitrakathi Tradition of Pinguli.* Bombay: Directorate of Government Printing and Stationery, Maharashtra State.

Indo-Iranian. The Quarterly Organ of the Iran Society. 1973. Amir Khusrau Number. Vol. 24, nos. 3–4 (September–December).

Irvine, William. 1903. *The Army of the Indian Moghuls.* London: Luzac. Repr., New Delhi: Eurasia Publishing House, 1962.

————. 1922. *Later Mughals.* 2 vols. (1:1701–1720, 2:1719–1739), ed. Jadunath Sarkar. Chaps. xi–xiii by the editor on Nadir Shah's invasion. Calcutta: M. C. Sarkar & Sons; London: Luzac.

Iyer, K. Bharatha. 1958. *Indian Art: A Short Introduction.* Bombay: Asia House.

Jafar Sharif. 1921. *Islam in India, or the Qanun-i Islam: The Customs of the Musalmans of India.* Trans. G. A. Herklots; new ed. by William Crooke. Oxford: Oxford University Press.

Jairazbhoy, Nazir Ali. 1971. *The Rags of North Indian Music: Their Structure and Evolution.* Middletown, Conn.: Wesleyan University Press.

————. 1980. "The South Asian Double-Reed Aerophone Reconsidered." *Ethnomusicology* 24 (1): 147–56.

Jameson, Fredric. 1991. *Postmodernism; or, the Cultural Logic of Late Capitalism.* Durham, N.C.: Duke University Press.

Jenkins, Jean, and Poul Rovsing Olsen. 1976. *Music and Musical Instruments in the World of Islam.* London: World of Islam Festival Publishing Co.

Jones, William, and N. Augustus Willard. 1962. *Music of India.* 2d rev. ed. Calcutta: Susil Gupta.

Joshi, Purshottam Mahadeo. 1950. "Asad Beg's Mission." *Potdar Commemoration Volume.* Poona: n.p.

Joshi, Rita. 1985. *The Afghan Nobility and the Mughals.* New Delhi: Vikas.

Kalter, Johannes. 1983/84. *The Arts and Crafts of Turkestan.* New York: Thames and Hudson.

Karomatov, Faizulla Muzaffarovich, V. A. Meskeris, and T. S. Vyzgo. 1987. *Mittelasien.* Leipzig: VEB Deutscher Verlag für Musik.

Kartomi, Margaret J. 1990. *On Concepts and Classifications of Musical Instruments.* Chicago: University of Chicago Press.

Kaul, Manohar. 1961. *Trends in Indian Painting: Ancient, Medieval, and Modern.* New Delhi: Dhoomimal Ramchand.

Keeling, Richard, et al. 1989. *Women in North American Indian Music: Six Essays.* Bloomington: Indiana University Press.

Keskar, Balkrishna Vishwanath. 1967. *Indian Music: Problems and Prospects.* Bombay: Popular Prakashan.

Khan, Iqtidar Alam. 1964. *Mirza Kamran.* New York: Asia Publishing House.

————. 1973. *The Political Biography of a Mughal Noble: Mun'im Khan Khan-i Khanan, 1497–1575.* New Delhi: Orient Longman.

Khan, Kunwar Refaqat Ali. 1976. *The Kachhwahas under Akbar and Jahangir.* New Delhi: Kitab.

Khan, Sufi Inayat. 1973. *Music.* New Delhi: The Sufi Publishing Co.

Khandalavala, Karl. 1960. *Miniature Painting.* Delhi: Lalit Kala Akademi.

————. 1962. "Some Problems of Mughal Painting." *Lalit Kala* 11 (April): 9–13.

————. 1981. *Mewar Painting.* Lalit Kala Series, portfolio 23. New Delhi: Lalit Kala Akademi.

————. 1974. *The Development of Style in Indian Painting.* Delhi: Macmillan.

————. 1977. *Deogarh Painting.* Lalit Kala Series, portfolio 16. New Delhi: Lalit Kala Akademi.

————. 1983. *An Age of Splendour: Islamic Art in India.* Ed. Saryu Doshi. Bombay: Marg.

Khandalavala, Karl, and Saryu Doshi. 1987. *A Collector's Dream: Indian Art in the Collections of Basant Kumar and Saraladevi Birla and the Birla Academy of Art and Culture.* Bombay: Marg.

Khandalavala, Karl, and Chandra Moti. 1955–56. "Editorial Notes: I. A Contemporary Portrait of Tansen." *Lalit Kala* 1–2 (April 1955–March 1956): 11–21.

————. 1962. *Miniatures and Sculptures from the Collection of the late Sir Cowasji Jehangir, Bart.* Bombay: Prince of Wales Museum of Western India.

————. 1969. *New Documents of Indian Painting: A Reappraisal.* Bombay: Prince of Wales Museum of Western India.

Kheiri, Sattar. 1921. *Indische Miniaturen den Islamic Zeit.* Orbis Pictus, no. 6. Berlin: Wastmuth.

Khusrau, Amir. 1988. *Duwal Rani Khazir Khan.* Trans. Khaliz Ahmad Nizami. Delhi: Idarah-i Adabiyat-i Delhi (IAD).

Koch, Ebba. 1988. *Shah Jahan and Orpheus: The Pietre Dure Decoration and the Programme of the Throne in the Hall of Public Audiences at the Red Fort of New Delhi.* Graz: Akademische Druck- und Verlagsanstalt.

Kolff, Dirk H. A. 1990. *Naukar, Rajput, and Sepoy: The Ethnohistory of the Military Labour Market in Hindustan, 1450–1850.* Cambridge: Cambridge University Press.

Koskoff, Ellen, ed. 1987. *Women and Music in Cross-Cultural Perspective.* Westport, Conn.: Greenwood.

Kothari, Komal S. 1968. *Indian Folk Musical Instruments.* New Delhi: Sangeet Natak Akademi.

———. 1977. *Folk Musical Instruments of Rajasthan: A Folio.* Borunda: Rajasthan Institute of Folklore.

Kothari, Sunil. 1989. *Kathak: Indian Classical Dance Art.* New Delhi: Abhinav.

Kramer, Lawrence. 1992. "The Musicology of the Future." *repercussions* 1 (Spring): 5–18.

———. 1995. *Classical Music and Postmodern Knowledge.* Berkeley and Los Angeles: University of California Press.

Kramrisch, Stella. 1937. *A Survey of Painting in the Deccan.* London: The India Society.

———. 1965. *The Art of India: Traditions of Indian Sculpture, Painting, and Architecture.* 3d ed. London: Phaidon.

———. 1986. *Painted Delight: Indian Paintings from Philadelphia Collections 01/26–04/20.* Philadelphia: Philadelphia Museum of Art.

Krannert Art Museum. 1964. *Art of India and Southeast Asia.* Champaign: Krannert Art Museum of the University of Illinois.

Krishna, Anand. 1973. "A Reassessment of the Tuti-nama Illustrations in the Cleveland Museum of Art (and Related Problems on Earliest Mughal Painting and Painters)." *Artibus Asiae* 35:241–68.

Krishnadasa, R. 1955. *Mughal Miniatures.* New Delhi: n.p.

Krishna Murthy, K. 1985. *Archaeology of Indian Musical Instruments.* Delhi: Sundeep Prakashan.

Krishnaswamy, S. 1965. *Musical Instruments of India.* New Delhi: Ministry of Information and Broadcasting, Publications Division.

Kühnel, Ernst. 1943. *Kunst und Kultur der arabischen Welt.* Heidelberg: K. Vowinckel.

———. 1937. *Indische Miniaturen aus dem Besitz der Staatlichen Museen zu Berlin.* Berlin: Ganymed. Repr., Berlin: Gebr. Mann, 1943.

———. 1955. *Mughal Mallerei.* Berlin: Mann.

———. 1962. *Die Kunst des Islam.* Stuttgart: Alfred Kröner.

———. 1966. *Islamic Art & Architecture.* Ithaca, N.Y.: Cornell University Press.

Kühnel, Ernst, and Hermann Goetz. 1924. *Indische Buchmalerein aus dem Jahangir-Album der Staatsbibliothek zu Berlin.* Berlin: Scarabaeus.

Kuppuswamy, Gowri. 1984. *Royal Patronage of Indian Music.* Delhi: Sundeep Prakashan.

Kuppuswamy, Gowri, and M. Hariharan, eds. 1980. *Indian Music: A Perspective.* Delhi: Sundeep Prakashan.

Lal, Mukandi. 1968. *Garhwal Painting.* New Delhi: Ministry of Information and Broadcasting, Publications Division.

Lal, Muni. 1980. *Akbar.* New Delhi: Vikas.

Lamb, Harold. 1961. *Babur, the Tiger.* Garden City, N.Y.: Doubleday.

Lambton, Ann K. S. 1988. *Continuity and Change in Medieval Persia: Aspects of Administrative, Economic, and Social History, 11th–14th Century.* London: Tauris.

Lane-Poole, Stanley 1896. *Aurangzib, and the Decay of the Mughal Empire.* Oxford: Clarendon. Repr., Delhi: S. Chand, 1957.

Lannoy, Richard. 1971. *The Speaking Tree.* London: Oxford University Press.

Lath, Mukund. 1978. *A Study of Dattilam: A Treatise on the Sacred Music of Ancient India.* New Delhi: Impex India.

Law, Narendra Nath. 1916. *Promotion of Learning in India During Muhammadan Rule (By Muhammadans).* London: Longmans, Green.

Leach, Linda York. 1986a. *Indian Miniature Paintings and Drawings.* Bloomington: Indiana University Press.

———. 1986b. "Painting in Kashmir from 1600 to 1650." In *Facets of Indian Art,* ed. Robert Skelton et al., 124–31. London: Victoria and Albert Museum.

———. 1995. *Mughal and Other Indian Paintings from the Chester Beatty Library.* 2 vols. London: Scorpion Cavendish.

Lee, Sherman E., and Pramod Chandra. 1963. "A Newly Discovered Tuti-Nama and the Continuity of the Indian Tradition of Manuscript Painting." *Burlington Magazine* 105 (December): 547–54.

Lentz, Thomas W., and Glenn D. Lowry. 1989. *Timur and the Princely Vision: Persian Art and Culture in the Fifteenth Century.* Los Angeles: Los Angeles County Museum of Art.

Leonardo, Micaela di, ed. 1991. *Gender at the Crossroads of Knowledge: Feminist Anthropology in the Postmodern Era.* Berkeley and Los Angeles: University of California Press.

Leppert, Richard, and Susan McClary. 1987. *Music and Society: The Politics of Composition, Performance, and Reception.* Cambridge: Cambridge University Press.

Lerner, Martin. 1984. *The Flame and the Lotus: Indian and Southeast Asian Art from the Kronos Collections.* New York: Harry N. Abrams.

Leveque, Jean-Jacques, and Nicole Memant. 1967. *La Peinture islamique et indienne.* Lausanne: Editions Recontre.

Levine, Debra Brown. 1974. "The Victoria and Albert Museum Akbar-Nama: A Study in History, Myth, and Image." Ph.D. diss., University of Michigan.

Levy, Mark. 1982. *Intonation in North Indian Music: A Select Comparison of Theories with Contemporary Practice.* New Delhi: Biblia Impex.

Lillys, William, Robert Reiff, and Emel Egin. 1965. *Oriental Miniatures: Persian, Indian, Turkish.* Rutland, Vt.: Tuttle.

Los Angeles County Museum of Art. 1950. *The Art of Greater India 3000 BC–1800 AD.* Los Angeles: Los Angeles County Museum of Art.

Losty, Jeremiah P. 1986. *Indian Book Painting.* London: British Library.

Lowry, Glenn D., and Milo Beach. 1988. *An Annotated and Illustrated Checklist of the Vever Collection.* Washington, D.C.: Arthur M. Sackler Gallery.

Mahillon, Victor-Charles. 1893–1922. *Catalogue descriptif et analytique de Musée Instrumental du Conservatoire Royal de Musique de Bruxelles.* 5 vols. Paris: Gand.

Manrique, Sebastian. 1926–27. *The Travels of Fray Sebastian Manrique, 1629–43,* ed. and trans. C. E. Luard and H. Hosten. Oxford: Hakluyt Society.

Mansukhani, Gobind Singh. 1982. "Musical Instruments." In *Indian Classical Music and Sikh Kirtan,* 49–65. New Delhi: Oxford and Indian Book House.

Manucci, Niccolao. 1907. *Storia do Mogor* (or *Mogul India 1653–1708*). 4 vols. Trans. William Irvine. London: J. Murray; Repr., Calcutta: Editions Indian, 1965–67. [Irvine includes materials from Manucci's letters etc. to carry the narrative to 1712.]

Manuel, Peter. 1989. *Thumri in Historical and Stylistic Perspectives.* Delhi: Motilal Banarsidass.

Marcel-Dubois, Claudie. 1941. *Les Instruments de musique de l'inde ancienne.* Paris: Presses Universitaires de France.

Marcus, George E., and Michael M. J. Fisher, eds. 1986. *Anthropology as Cultural Critique: An Experimental Moment in the Human Sciences.* Chicago: University of Chicago Press.

Marcus, George E., and Fred R. Myers. 1995. *The Traffic in Culture: Refiguring Art and Anthropology.* Berkeley and Los Angeles: University of California Press.

Marek, Jiri, and H. Knizkova. 1963. *The Jenghiz Khan Miniatures from the Court of Akbar the Great.* Trans. Olga Kuthanova. London: Spring Books.

Marg: A Magazine of the Arts. 1975. Homage to Amir Khusrau. Vol. 28, no. 3 (June).

Marshall, D. N. 1996. *Mughals in India: A Bibliographic Survey of Manuscripts.* Vol. 1. New Delhi: Munshiram Manoharlal.

Martin, Fredrik Robert. 1912. *The Miniature Painting and Painters of Persia, India, and Turkey from the 8th to the 18th century.* London: B. Quaritch.

McClary, Susan. 1991. *Feminine Endings: Music, Gender, and Sexuality.* Minneapolis: University of Minnesota Press.

McInerney, Terence. 1982. *Indian Painting, 1525–1825: An Exhibition.* London: Carrit.

McNeil, Adrian. 1992. "The Dynamics of Social and Musical Status in Hindustani Music: Sarodiyas, Seniyas, and the Margi-Desi Paradigm." Ph.D. diss., Monash University.

Meer, Wim van der, and Joep Bor. 1982. *De Roep van de Kokila: Historische en hedendaagse aspecten van de Indiase Muziek.* The Hague: Nijhoff.

Mekkes, V. 1976. *Painting from the Muslim Courts of India.* London: World of Islam Publishing Co.

Meredith-Owens, G. M., ed. 1965. *Persian Illustrated Manuscripts.* London: Oxford University Press.

———. 1968. *Handlist of Persian Manuscripts [acquired by the British Museum 1895–1966].* London: British Museum.

———. 1963. *Turkish Miniatures.* London: Oxford University Press.

———. 1971. *Mesa'ir us-su'ara, or Tezkere of 'Asik Celebi. Edited in Facsimile from the Manuscript OR6424 in the British Museum.* E. J. W. Gibb Memorial Series, n.s., no. 24. London: Luzac.

Metropolitan Museum of Art. 1982. *The Arts of Islam: Masterpieces from the Metropolitan.* Berlin Edition: "Kunstbuch Berlin." New York: Abrams.

Miller, Barbara Stoler, ed. 1992. *The Powers of Art: Patronage in Indian Culture.* New Delhi: Oxford University Press.

Miner, Allyn Jane. 1981. "Hindustani Instrumental Music in the Early Modern Period: A Study of the Sitar and Sarod in the Eighteenth and Nineteenth Centuries." Ph.D. thesis, Banaras Hindu University.

———. 1993 *Sitar and Sarod in the 18th and 19th Centuries.* Intercultural Music Studies, no. 5. Wilhelmshaven: Noetzel.

Misra, Rekha. 1967. *Women in Mughal India.* New Delhi: Munshiram Manoharlal.

Monserrate, Antonio. 1922. *The Commentary of Father Monserrate on His Journey to the Court of Akbar.* 1582. Translated and edited by J. S. Hoyland and annotated by S. N. Banerji. Repr., Cuttack: Oxford University Press.

Mookerjee, Ajit. 1952. *The Art of India.* Calcutta: Oxford Book and Stationery.

Moosvi, Shireen. 1987. *The Economy of the Mughal Empire c. 1595: A Statistical Study.* Delhi: Oxford University Press.

Moreland, William H. 1920. *India at the Death of Akbar.* London: Macmillan.

Moynihan, Elizabeth B. 1979. *Paradise as a Garden in Persia and Mughal India.* New York: Braziller.

Muhammad, K. K. 1986. "The Houses of the Nobility in Mughal India." *Islamic Culture* 60:81–104.

Mukerjee, Radhakamal. 1959. *The Culture and Art of India.* New York: Praeger.

Mukherjee, Hirendranath. 1969. "Portrait of Tansen." *Lalit Kala* 14:57.

Mundy, Peter. 1907–36. *The Travels of Peter Mundy.* 5 vols., ed. R. C. Temple. Cambridge: Hakluyt Society.

Myers, Helen, ed. 1992. *Ethnomusicology: An Introduction.* New York: Norton.

Nadvi, S. A. Zafar. 1945. "Libraries during the Muslim Rule in India." *Islamic Culture* 19 (4): 329–47.

———. 1946. "Libraries in Muslim India." *Islamic Culture* 20 (1): 3–20.

Napier, A. David. 1992. *Foreign Bodies, Performance, Art, and Symbolic Anthropology.* Berkeley and Los Angeles: University of California Press.

Naqvi, Hameeda Khatoon. 1990. *History of Mughal Government and Administration.* Delhi: Kanishka Publishing House.

National Museum of India. 1981. *Islamic Heritage of India.* New Delhi: National Museum of India.

Nawab, Sarabhai Manilal. 1956. *Masterpieces of the Kalpasutra Paintings.* Jain Art Publication Series, no. 7. Ahmedabad: Sarabhai Manilal Nawab.

Nawab, Vidya Sarabhai. 1964. *419 Illustrations of Indian Music and Dance in Western Indian Style.* Ahmedabad: Sarabhai Manilal Nawab.

Naylor, Tom L. 1979. *The Trumpet and Trombone in Graphic Arts, 1500–1800.* Nashville: The Brass Press.

te Nijenhuis, Emmie. 1976. *The Ragas of Somanatha.* Vol. 1. Orientalia Rheno-Traiectina, vol. 22. Leiden: Brill.

Nixon, Andrea. 1984a. "Khiil." In *The New Grove Dictionary of Musical Instruments,* ed. Stanley Sadie, 2:423. London: Macmillan.

———. 1984b. "Khuur." In *The New Grove Dictionary of Musical Instruments,* ed. Stanley Sadie, 2:425–26. London: Macmillan.

———. 1984c. "Qobuz." In *The New Grove Dictionary of Musical Instruments,* ed. Stanley Sadie, 3:174. London: Macmillan.

Nizami, Khaliq Ahmad. 1961. *Some Aspects of Religion and Politics in India during the Thirteenth Century.* Bombay: Asia Publishing House.

———. 1989. *Akbar and Religion.* Oriental Series, no. 33. Delhi: Idarah-i-Adabiyat-i-Delhi (IAD).

Ortner, Sherry B., and Harriet Whitehead, eds. 1981. *Sexual Meanings: The Cultural Construction of Gender and Sexuality.* Cambridge: Cambridge University Press.

Pal, Pratapaditya. 1967. *Ragamala Paintings in the Museum of Fine Arts Boston.* Boston: Museum of Fine Arts.

———. 1983. *Court Paintings of India: 16th–19th Centuries.* New York: Navin Kumar.

———, ed. 1972. *Aspects of Indian Art: Papers presented in a symposium at the Los Angeles County Museum of Art.* Leiden: Brill.

———. 1991. *Master Artists of the Imperial Mughal Court.* Bombay: Marg.

Pant, G. N. 1985. "An Illustrated Manuscript of the Babar Nama." *Orientations* 16 (3): 18–28.

Patnaik, Naveen. 1985. *A Second Paradise: Indian Courtly Life 1590–1947.* New York: The Metropolitan Museum of Art.

Pelsaert, Francisco. 1925. *Jahangir's India, The Remonstrantie of F. Pelsaert.* Trans. W. H. Moreland and P. Geyl. Cambridge: Heffer. [Covers 1620–27.]

Petrosyan, Yuri A., Oleg F. Akimushkin, Anas B. Khalidov, and Efim A. Rezvan. 1995. *Pages of Perfection Islamic Paintings and Calligraphy from the Russian Academy of Sciences, St. Petersburg.* Lugano: ARCH Foundation.

Pinder-Wilson, Ralph H. 1985. *Studies in Islamic Art.* London: Pindar Press.

Pinder-Wilson, Ralph H., Ellen Smart, and Douglas Barrett. 1976. *Paintings from the Muslim Courts of India: Exhibition catalogue.* London: British Museum.

Pingle, Bhava'Nra'V A. 1962 *History of Indian Music: With Particular Reference to Theory and Practice.* 3d ed. Calcutta: Susil Gupta.

Plumley, Gwendolen A. 1976. *El Tanbur: The Sudanese Lyre or The Nubian Kissar.* Cambridge: Town and Gown Press.

Poche, Christian. 1984. "Duff [daff]." In *The New Grove Dictionary of Musical Instruments,* ed. Stanley Sadie, 1: 616–17. London: Macmillan.

Poole, S. Stuart. 1892. *The Coins of the Mughal Emperors of Hindustan in tho British Museum.* London: British Museum.

Pope, Arthur Upham, ed., and Phyllis Ackerman, asst. ed. 1938–39. *A Survey of Persian Art from Prehistoric Times to the Present.* Vol. 5. London: Oxford University Press.

Prajnanananda, Swami. 1973. *The Historical Development of Indian Music: A Critical Study.* 2d new ed. Calcutta: Firma K. L. Mukhopadhyay.

———. 1979. *Music of the South-Asian Peoples: A Historical Study of Music of India, Kashmere, Ceylon, and Bangladesh and Pakistan.* Vol. 1. Calcutta: Ramakrishna Vedanta Math.

Prasad, Beni. 1922–23. "The Accession of Shah Jahan." *Journal of Indian History* 2:1–19.

———. 1930. *History of Jahangir.* 2d ed. London: Oxford University Press.

Prasad, Ishiwari. 1956. *The Life and Times of Humayun.* Bombay: Orient Longmans.

Qānūn-i Humāyūni (A statistical and administrative work). 1940. Ed. M. Hidayat Hosain. Calcutta: Bibliotheca Indica.

Qanungo, Kalika Ranja. 1935. *Dara Shikuh.* Calcutta: S. C. Sarkar.

Qureshi, Ishtiaq Husain. 1966. *The Administration of the Mughul Empire.* Patna: V.V. Publications.

Qureshi, Regula Burckhardt. 1986. *Sufi Music of India and Pakistan: Sound, Content, and Meaning in Qawwali.* Cambridge: Cambridge University Press.

Rahim, Abdur. 1934–35. "Mughal Relations with Persia and Central Asia." *Islamic Culture* 8–9.

Rajput Painting. 1962. With an introductory essay and catalogue notes by Sherman E. Lee. Catalogue by George Montgomery. New York: Asia House Gallery.

Ram, Vani Bai. 1982. *Glimpses of Indian Music.* Allahabad: Kitab Mahal.

Ramamatya. 1550. *Svaramelakalanidhi (A work on music).* Ed. by M. S. Ramaswami Aiyar. Repr., n.p.: Annamalai University, 1932.

Ranade, Ashok Damodar. 1989. *Maharashtra: Art Music.* New Delhi: Maharashtra Information Centre.

Ranade, Garesh Hari. 1971. *Hindusthani Music: Its Physics and Aesthetics.* 3d ed. Bombay: Popular Prakashan.

Randhawa, Mohinar Singh. 1966. *Kangra Paintings of the Bihari Sat Sai.* New Delhi: National Museum of India.

———. 1971. *Kangra Ragamala Paintings.* New Delhi: National Museum of India.

———. 1972. *Kangra Valley Painting.* New Delhi: Ministry of Information and Broadcasting, Publications Division.

———. 1983. *Paintings of the Babur Nama.* New Delhi: National Museum of India.

Randhawa, Mohindar Singh, and John Kenneth Galbraith. 1968. *Indian Painting: The Scene, Themes, and Legends.* Boston: Houghton Mifflin.

Randhawa, Mohindar Singh, and Doris Schreier Randhawa. 1980. *Kishangarh Painting.* Bombay: Vakils, Feffer, and Simons.

Ray, Nihar-Nanjan. 1975. *Mughal Court Painting: A Study in Social and Formal Analysis.* Calcutta: Indian Museum.

Raychaudhuri, Tapan, and Irfan Habib, eds. 1982. *The Cambridge Economic History of India.* Vol. 1. Cambridge: Cambridge University Press.

Rebollo-Sborghi, Francesca. 1993. "Decentering the Feminist Self." *repercussions* 1 (2): 26–51.

Reiff, Robert. 1959. *Indian Miniatures: The Rajput Painters.* Rutland, Vt.: Tuttle.

Richards, John F. 1978a. "The Formulation of Imperial Authority under Akbar and Jahangir." In *Kingship and Authority in South Asia,* ed. John F. Richards, 252–85.

———. 1993. *The Mughal Empire.* The New Cambridge History of India, pt. 1, vol. 5. Cambridge: Cambridge University Press.

———, ed. 1978b. *Kingship and Authority in South Asia.* South Asian Studies, pub. 3. Madison: University of Wisconsin.

Rizvi, Saiyid Athar Abbas. 1965. *Muslim Revivalist Movements in Northern India in the Sixteenth and Seventeenth Centuries.* Agra: Agra University Press.

———. 1975a. "The Muslim Ruling Dynasties." In *A Cultural History of India,* ed. A. Basham, 245–65. Oxford: Clarendon.

———. 1975b. *Religious and Intellectual History of the Muslims in Akbar's Reign.* New Delhi: Munshiram Manoharlal.

———. 1975–83. *A History of Sufism in India.* 2 vols. New Delhi: Munshiram Manoharlal.

Robinson, Basil William. 1965. *Drawings of the Masters: Persian Drawings from the 14th through the 19th Century.* Boston: Little, Brown.

———. 1976. *Persian Paintings in the India Office Library: A Descriptive Catalogue.* London: Sotheby Parke Bernet.

Robinson, Francis. 1982. *Atlas of the Islamic World since 1500.* New York: Facts on File.

Roe, Sir Thomas. 1926. *The Embassy of Sir Thomas Roe to India, 1615–19.* Rev. ed. Ed. William Foster. London: Oxford University Press.

Rogers, John Michael. 1983. *Islamic Art and Design, 1500–1700.* London: British Museum.

Rosaldo, Michelle Zimbalist, and Louise Lamphere, eds. 1974. *Woman, Culture, and Society.* Stanford: Stanford University Press.

Rosenthal, Ethel. 1928. *The Story of Indian Music and Its Instruments: A Study of the Present and a Record of the Past.* London: W. Reeves. Repr., New Delhi: Oriental Books Reprint Corp., 1970.

Rosenthal, Franz. 1975. *The Classical Heritage in Islam.* Trans. Emile and Jenny Marmorstein. London: Routledge and Kegan Paul.

Rowell, Lewis Eugene. 1992. *Music and Musical Thought in Early India.* Chicago: University of Chicago Press.

Rowland, Benjamin. 1967. *The Art and Architecture of India: Buddhist, Hindu, Jain.* 3d rev. ed. Harmondsworth: Penguin.

Roy Choudhury, Makhanlal. 1941. *The Dīn-i Ilāhi.* Calcutta: University of Calcutta.

Rührdanz, Karin. 1982. *Mittelalterliche Malerei im Orient.* Halle-Wittenburg: Martin Luther Universität.

Sachs, Curt. 1923. *Die Musikinstrumente Indiens und Indonesiens.* 2d ed. Handbücher der Staatlichen Museen zu Berlin. Berlin: de Gruyter.

Sahay, Binode Kumar. 1968. *Education and Learning under the Mughals, 1526–1707.* Bombay: New Literature Publishing Co.

Sakata, Hiromi Lorraine. 1983. *Music in the Mind: The Concepts of Music and Musician in Afghanistan.* Kent, Ohio: Kent State University Press.

Saksena, Banarsi Prasad. 1962. *History of Shahjahan of Dihli.* Repr., Allahabad: Central Book Depot.

Sambamoorthy, Pichu. 1957. *Sruti Vadyas (Drones).* Sangita Vadyalaya Series, vol. 1. New Delhi: All India Handicrafts Board.

———. 1962. *Catalogue of Musical Instruments Exhibited in the Government Museum, Madras.* 3d ed. Madras: Government of Madras, Controller of Stationery and Printing.

———. 1967. *The Flute.* 3d ed. Madras: Indian Music Publishing House.

Samnani, Saiyid Ghulam. 1968. *Amir Khusrau.* New Delhi: National Book Trust.

Sarkar, Jadunath N. 1972. *History of Aurangzeb: Mainly Based on Persian Sources.* 5 vols. Repr., Bombay: Orient Longmans. Originally ed., Calcutta: M. C. Sarkar, 1912–30.

Sarkar, Jagdish. 1969. *The Military Despatches of a Seventeenth Century Indian General.* Calcutta: Scientific Book Agency.

———. 1979. *The Life of Mir Jumla,* 2d ed., rev. and enl. New Delhi: Rajesh Publications.

Sarkissian, Margaret. 1992. "Gender and Music." In *Ethnomusicology: An Introduction,* ed. Helen Myers, 337–48. New York: Norton.

Sarmadee, Shahab. 1976. "About Music and Amir Khusrau's Own Writings on Music." In *Life, Times, and Works of Amir Khusrau.* Commemoration Volume, 241–69. New Delhi: Amir Khusrau Society.

———. 1984–85. "*Mankutuhal* and *Rag Darpan*—Reflections of a Great Seventeenth Century Scholar-Musician." *ISTAR Newsletter* 3–4:15–28.

———, ed. 1978. *Ghunyat-ul-Munya: The Earliest Known Persian Work on Indian Music.* Bombay: Asia Publishing House.

Sarre, Friedrich Paul Theodor, et al. 1912. *Die Ausstellung von Meisterwerken muhammedanischer Kunst in München.* Munich: Bruckmann.

Sawa, George Dimitri. 1989. "The Differing Worlds of the Music Illuminator and the Music Historian in Islamic Medieval Manuscripts." *Imago Musicae* 6:7–22.

Schimmel, Annemarie. 1983. Introduction to *Anvari's Divan: A Pocket Book for Akbar.* New York: Metropolitan Museum of Art.

Seeger, Anthony. 1991. "When Music Makes History." In *Ethnomusicology and Modern Music History,* ed. S. Blum, P. Bohlman, and D. Neuman, 23–34. Urbana: University of Illinois Press.

Sen, Geeti. 1979. "Music and Musical Instruments in the Paintings of the Akbar Nama." *Quarterly Journal, National Center for the Performing Arts* 8 (4): 1–7.

———. 1984. *Paintings from the Akbar Nama: A Visual Chronicle of Mughal India.* Calcutta: Lustre Press.

Sena, Paritosha. 1984. *Alekhyamanjari.* Calcutta: Pabalisarsa.

Seyller, John. 1985. "Model and Copy: The Illustration of the Razmnama Manuscripts." *Archives of Asian Art* 38: 37–66.

———. 1986. "The School of Oriental and African Studies *Anvār-i-Suhaylī:* The Illustration of a *DeLuxe* Mughal Manuscript." *Ars Orientalis* 16:119–51.

———. 1987. "Scribal Notes on Mughal Manuscript Illustrations." *Artibus Asiae* 48:6–24.

———. 1990. "Codicological Aspects of the Victoria and Albert Museum Akbarnāma and Their Historical Implications." *Art Journal* 49 (4): 379–87.

———. 1991. "Hashim." In *Master Artists of the Imperial Mughal Court,* ed. Pratapaditya Pal, 105–18. Bombay: Marg.

———. 1992. "Overpainting in the Cleveland *Tūtīnāma.*" *Artibus Asiae* 52:283–328.

———. 1993. "A Dated *Hamzanama* Illustration." *Artibus Asiae* 53:502–5.

Shahinda (Begum Fyzee-Rahamin). 1914. *Indian Music.* London: Luzac.

Shankar, Ravi. 1968. *My Music, My Life.* New York: Simon and Schuster.

Shankar, Ravi, and Penelope Estabrook. n.d. *Music Memory.* Kinnara Series on Music, no. 1. Bombay: Kinnara School of Music.

Sharma, Lokesh Chandra. 1979. *A Brief History of Indian Painting.* Meerut: Goel.

Sharma, Premlata, ed. 1972. *Sahasarasa.* New Delhi: Sangeet Natak Akademi.

Shiloah, Amnon. 1979a. *The Theory of Music in Arabic Writings (c. 900–1900): Descriptive Catalogue of Manuscripts in Libraries of Europe and the USA.* Repertoire International des Sources Musicales, no. B10. Munich: Henle.

———. 1979b. "The 'ud and the origin of music." In *Studia Orientalia: Memoriae D. H. Baneth Dedicata.* Jerusalem: Magnes.

Siddiqi, Iqtidar Husain. 1971. *History of Sher Shah Sur.* Aligarh: D. C. Swadash Sreni.

Sikh Sacred Music. 1967. New Delhi: Sikh Sacred Music Society.

Simsar, Muhammad Hasan. 1978. *Jughrafiya-yi tarīkhi-yi Sirāf.* Teheran: Chap'Khanah'i Ziba.

Siren, Osvald. 1936. *The Chinese Art of Painting.* Vol. 3. Peiping: H. Vetch.

Sivaramamurthi, Calambur. 1970. *Indian Painting.* New Delhi: National Book Trust.

———. 1977. *The Art of India.* New York: Abrams.

———. 1978. *The Painter in Ancient India.* New Delhi: Abhinav.

Skelton, Robert. 1957. "The Mughal Artist Farrokh Beg." *Ars Orientalis* 2:393–411.

———. 1982. *The Indian Heritage: Court Life and Arts under Mughal Rule.* London: Victoria and Albert Museum.

Skelton, Robert, Andrew Topsfield, Susan Stronge, and Rosemary Crill, eds. 1986. *Facets of Indian Art.* London: Victoria and Albert Museum.

Slobin, Mark. 1976. *Music in the Culture of Northern Afghanistan.* Tucson: University of Arizona Press.

Smart, Ellen Stevens. 1977. "Paintings from the *Baburnama:* A Study of Sixteenth Century Mughal Historical Manuscript Illustration." Ph.D. thesis, School of Oriental and African Studies, University of London.

———. 1978. "Six Folios from a Dispersed Manuscript of the *Baburnama*." In *Indian Painting*. London: Colnaghi and Co.

———. 1981. "Akbar, Illiterate Genius." In *Kaladarsana: American Studies in the Art of India*, ed. Joanna C. Williams, 99–107. New Delhi: Oxford and IBH Publishing Co.

———. 1986. "Yet Another Illustrated Akbari *Baburnama* Manuscript." In *Facets of Indian Art*, ed. Robert Skelton et al., 105–15. London: Victoria and Albert Museum.

Smart, Ellen, and Daniel S. Walker. 1985. *Pride of the princes: Indian Art of the Mughal Era in the Cincinnati Art Museum*. Cincinnati: Cincinnati Art Museum.

Smith, Vincent Arthur. 1911. *A History of Fine Art in India and Ceylon, from the Earliest Times to the Present Day*. Oxford: Clarendon.

———. 1919. *Akbar, the Great Mogul (1542–1605)*. 2d rev. ed. London: Oxford University Press. Repr., Delhi: S. Chand, 1958.

Smith, Wilfred Cantwell. 1957. *Islam in Modern History*. Princeton: Princeton University Press.

Solie, Ruth, ed. 1993. *Musicology and Difference: Gender and Sexuality in Music Scholarship*. Berkeley and Los Angeles: University of California Press.

Solomon, William Ewart Gladstone. 1932. *Essays in Mogul Painting*. London: Oxford University Press.

Spear, Percival. 1972. *India: A Modern History*. Ann Arbor: University of Michigan Press.

Spink and Son. 1980. *Islamic Art from India*. London: Spink and Son.

Srivastava, Indurama. 1977. *Dhrupada: A Study of Its Origin, Historical Development, Structure, and Present State*. Utrecht: Elinkwijk.

Stewart, Rebecca Marie. 1974. "The Tabla in Perspective." Ph.D. diss., University of California, Los Angeles.

Stooke, Herbert Johnston, and Karl Khandalavala. 1953. *The Laud Ragamala Miniatures: A Study in Indian Painting and Music*. Oxford: Cassirer.

Stchoukine, Ivan Vasilevich. 1929a. *Miniatures Indiennes de l'epoque des Grands Moghols au Musée de Louvre*. Paris: Ernest Leroux.

———. 1929b. *La Peinture indienne a l'époque des grands moghols*. Paris: Ernest Leroux.

Streusand, Douglas. 1989. *The Formation of the Mughal Empire*. Delhi: Oxford University Press.

Strzygowski, Josef, et al. 1933. *Asiatische Miniaturenmalerei im Anschluss an Wesen und Werden der Mogulmalerei*. Klagenfurt, Austria: Kollitsch.

Sulaimanova, Fozila. 1983. *Miniatures: Illuminations of Amir Hosrov Dehlevi's Works*. Tashkent: Fan.

———. 1985. *Miniatures: Illuminations of Nisami's "Hamsah."* Tashkent: Fan.

Swarup, Shanti. 1957. *The Arts and Crafts of India and Pakistan: A Pictorial Survey of Dancing, Music, Painting, Sculpture, Architecture*. Bombay: Taraporevala's Treasure House of Books.

Tagore, Raja Sir Sourindro Mohun Tagore, comp. 1965. *Hindu Music from Various Authors*. Chowkhamba Sanskrit Studies, vol. 49. Varanasi, India: Chowkhamba Sanskrit Series Office.

Tandan, Raj Kumar. 1982. *Indian Miniature Painting 16th through 19th Centuries*. Bangalore: Natesan.

———. 1983. *Pahari Ragamalas*. Bangalore: Natesan.

Tandon, Om Prakash. 1982. *Treasures of Indian Art in the Bharat Kala Bhavan: Ramayana*. Notes by Kamal Giri. Varanasi, India: Banares Hindu University.

Tanulmanyaval, Szakaly Ference. 1983. *Szigetvari Csobor Balazs torok Miniaturai [1570]*. Budapest: Bibliotheca Historica.

Tarlekar, Ganesh, and Nalini Tarlekar. 1972. *Musical Instruments in Indian Sculpture*. Pune: Vidyarthi Griha Prakashan.

Tata Industries. 1963. *Diary*. New Delhi: Tata Industries.

Tavernier, Jean-Baptiste. 1977. *Travels in India*. 2d ed. 2 vols. Trans. V. Ball. New Delhi: Oriental Books Reprint Corp.

Taylor, Richard. 1975. *Jesus in Indian Paintings*. Madras: Christian Literature Society.

Telang, M. R., ed. 1920. *Sangit-makaranda of Narada*. Gaekwad Sanskrit Series. Baroda: Central Library.

Thomas, Edward. 1967. *The Chronicles of the Pathan Kings of Delhi*. New Delhi: Munshiram Manoharlal.

Titley, Norah M. 1977. *Miniatures from Persian Manuscripts: A Catalog and Subject Index of Paintings from Persia, India, and Turkey in the British Library and British Museum*. London: British Museum.

———. 1979a. "Persian Miniature Painting: The Repetition of Compositions during the Fifteenth Century." In *Akten des VII. Internationalen Kongresses für iranische Kunst und Archäologie*, 471–91. Berlin: Reimer.

———. 1979b. *Plants and Gardens in Persian, Mughal, and Turkish Art.* London: British Library.

———. 1979c. *Sports and Pastimes: Scenes from Turkish Persian and Mughal Paintings.* London: British Library.

———. 1981. *Miniatures from Turkish Manuscripts.* London: British Library.

———. 1983. *Persian Miniature Painting and Its Influence on the Art of Turkey and India.* London: British Library.

Tiuliaev (Tyulyayev), Semen Ivanovich. 1955. *Pamiatniki iskusstva Indii v sobraniiakh muzeev SSSR.* Moscow: Gos. izd-vo izobrazitelnogo iskusstvo.

———. 1960. *Miniatures of Baburnama.* Moscow: State Fine Arts Publishing House.

———. 1968. *Iskusstvo Indii.* Moscow: Nauka.

———. 1977. *Svetoslav Roerich.* Moscow: Gos. izd-vo izobrazitelnogo iskusstvo.

Topsfield, Andrew. 1984. *An Introduction to Indian Court Painting.* Owings Mills, Md.: Stemmer House.

Topsfield, Andrew, and Milo Cleveland Beach. 1991. *Indian Paintings and Drawings from the Collection of Howard Hodgkin.* New York: Thames and Hudson.

Trikha, S. N. n.d. *A Glimpse of Hindustani Music and Musicians.* New Delhi: Narang Printing Press.

Tripathi, Rishi Raj. 1984. *Masterpieces in the Allahabad Museum.* Allahabad: Nagar Mahapalika.

Trubner, Henry, William Jay Rathbun, and Catherine A. Kaputa. 1973. *Asiatic Art in the Seattle Art Museum.* Photography by Paul Macapia. Seattle: Seattle Art Museum.

Turino, Thomas. 1991. "The History of a Peruvian Panpipe Style and the Politics of Interpretation." In *Ethnomusicology and Modern Music History,* ed. S. Blum, P. Bohlman, and D. Neuman, 121–38. Urbana: University of Illinois Press.

'Ukashah, Tharwat. 1983. *Al-Taswir. (Persian and Turkish Painting).* History of Art, no. 6. London: UNESCO.

Vambéry, Armin. 1873. *History of Bokhara from the Earliest Period down to the Present.* London: H. S. King.

Vaswani, A. S. 1963. *The Story of Dhruva Maharaj in Kangra Valley Paintings.* New Delhi: n.p.

Vatsyayan, Kapila. 1974. *Indian Classical Dance.* New Delhi: Ministry of Information and Broadcasting.

———. 1980. "A History of Indian Dance and Music." In *Indian Music: A Perspective,* ed. Gowry Kuppuswamy and M. Hariharan, 68–76. Delhi: Sundeep Prakashan.

———. 1982. *Dances in Indian Painting.* New Delhi: Abhinav.

Vaughan, Philippa. 1994. "Begams of the House of Timur and the Dynastic Image." In *Humayun's Garden Party,* ed. Sheila Canby, 117–34. Bombay: Marg.

Verma, Som Prakash. 1978. *Art and Material Culture in the Paintings of Akbar's Court.* New Delhi: Vikas.

———. 1994. *Mughal Painters and Their Work: A Biographical Survey and Comprehensive Catalogue.* Delhi: Oxford University Press.

Vertkov, Konstantin Aleksanarovich. 1963. *Atlas muzykal'nykh instrumentov narodov SSSR.* Moscow: Gos. muzykal'noe izd-vo.

Victoria and Albert Museum. 1962. *A Brief Guide to Indian Art.* London: Her Majesty's Stationery Office.

———. 1982. *The Indian Heritage: Court Life and Arts under Mughal Rule.* London: Herbert Press.

Wade, Bonnie C. 1983. *Performing Arts in India: Essays on Music, Dance, and Drama.* Lanham, Md.: University Press of America.

———. 1984. *Khyal: Creativity within North India's Classical Music Tradition.* Cambridge: Cambridge University Press.

———. 1990. "The Meeting of Musical Cultures in the 16th-Century Court of the Mughal Akbar." In *World of Music,* ed. Bonnie C. Wade, 32 (2): 3–24.

———. 1992. "Patronage in India's Musical Culture." In *Arts Patronage in India: Methods, Motives, and Markets,* ed. Joan L. Erdman, 181–94. New Delhi: Manohar.

———. 1995. "Music Making in Mughal Paintings." *Asian Art and Culture* 8 (3): 68–89.

———. 1996. "Performing the Drone in Hindustani Classical Music: What Mughal Paintings Show Us to Hear." In *World of Music,* ed. Bonnie C. Wade, 38 (2): 41–67.

———. 1997. "When West Met East: The Organ as an Instrument of Culture." In *Festschrift for Christoph-Hellmut Mahling zum 65. Geburstag,* ed. Axel Beer, Kristina Pfarr, and Wolfgang Ruf, 1479–1489. Tutzing: Han Schneider.

Waldschmidt, Ernst, and Rose Leonore. 1967. *Miniatures of Musical Inspiration.* Bombay: Popular Prakashan.

Waley, Arthur. 1981. *Oriental Art and Culture.* Delhi: Cosmo.

Watt, William Montgomery. 1973. *The Formative Period of Islamic Thought*. Edinburgh: Edinburgh University Press.

Welch, Stuart Cary. 1959. "Early Mughal Miniature Paintings from Two Private Collections Shown at the Fogg Art Museum," *Ars Orientalis* 3: 133–46.

———. 1963. *The Art of Mughal India: Painting and Precious Objects*. New York: Asia Society.

———. 1972. *A King's Book of Kings: The Shah-Nameh of Shah Tahmasp*. New York: Metropolitan Museum of Art.

———. 1973. *A Flower from Every Meadow: Indian Paintings from American Collections*. Contributions by Mark Zebrowski. New York: Asia Society.

———. 1976. *Indian Drawings and Painted Sketches*. New York: Asia Society.

———. 1978. *Imperial Mughal Painting*. New York: Brazillier.

———. 1985. *India: Art and Culture, 1300–1900*. New York: Holt, Rinehart, and Winston.

Welch, Stuart Cary, and Milo Beach. 1965. *Gods, Thrones, and Peacocks*. New York: Arno Press.

Welch, Stuart Cary, et al. 1987. *The Emperor's Album: Images of Mughal India*. New York: Harry N. Abrams.

Wellesz, Emmy. 1952. *Akbar's Religious Thought, Reflected in Mughal Painting*. London: Allen and Unwin.

Wilkinson, James Vere Stewart. 1931. *The Shah-namah of Firdausi: The Book of the Persian Kings*. London: Oxford University Press.

———. 1948. *Mughal Painting*. London: Faber and Faber.

Williams, Joanna C., ed. 1981. *Kaladarsana: American Studies in the Art of India*. New Delhi: Oxford and IBH Publishing Co.

Williams, Lawrence Frederic Rushbrook. 1962. *An Empire Builder of the 16th Century*. Repr., Delhi: S. Chand.

Winitz, Jan David, and The Breema Rug Study Society. 1984. *The Guide to Purchasing an Oriental Rug*. Oakland: Breema Rug Study Society.

Wolpert, Stanley. 1993. *A New History of India*. 4th ed. Oxford: Oxford University Press.

Woodfield, Ian. 1990. "The Keyboard Recital in Oriental Diplomacy, 1520–1620." *Journal of the Royal Musicological Association* 115 (1): 33–62.

Yusupov (Iusupov), E. Yu., ed. 1981a. *Artistically Illustrated Manuscripts of Works by Alisher Navoi*. Comp. Hamid Suleiman. Tashkent: Academy of Sciences of Uzbekistan, H. S. Suleimanov Institute of Manuscripts.

———. 1981b. *Miniatures to Works by Alisher Navoi*. Tashkent: Uzbek Academy of Sciences, H. S. Suleimanov Institute of Manuscripts.

———. 1982. *Miniature Illustrations of Alisher Navoi's Works of the XV–XIXth Centuries*. Comp. Hamid Suleiman and Fazila Suleimanova. Tashkent: Academy of Sciences of the Uzbek SSR.

———. 1983. *Miniatures Illuminations of Amir Hosrov Dehlevi's Works*. Tashkent: Academy of Sciences of the Uzbek SSR, H. S. Suleimanov Institute of Manuscripts.

———. 1985. *Miniatures Illuminations of Nisami's "Hamsah."* Comp. Fazila Suleimanova. Tashkent: Uzbek Academy of Sciences, Kh. S. Suleimanov Institute of Manuscripts.

Zebrowski, M. 1983. *Deccani Painting*. Berkeley and Los Angeles: University of California Press.

Ziegler, Norman P. 1978. "Some Notes on Rajput Loyalties during the Mughal Period." In *Kingship and Authority*, ed. John F. Richards, 215–51. South Asian Studies, pub. 3. Madison: University of Wisconsin.

Zulfiqar Ali Khan. 1925. *Sher Shah Suri*. Lahore: Civil & Military Gazette.

INDEX OF ILLUSTRATIONS

GENERAL INDEX

Abu'l Fazl (historian), li, 2, 3, 5, 31, 37,
 69, 71, 72, 80, 82, 84, 100, 124,
 141, 143, 144, 147, 169, 173, 180,
 187, 201, 216 n.3, 218 n.18, 223 n.12,
 225 n.33, 226 n.3, 232 n.13
Abu-Sa'id Mirza, Sultan, 21, 43
acrobats, 58, 224 n.23
Abdurrahim, 94, 135, 158
Adham Khan, 92, 93, 95, 96, 97, 98, 99,
 100, 227 n.16
aerophones (wind instruments), 35, 42,
 132, 139, 158, 183 (*upang*)
 conch type, 33, 34, 35, 106
 conch, 34, 35, 106
 ottu sangu, 221 n.35
 panchajanya, 34
 sankh, 33, 34, 221 n.35
 double-reed type, 5, 106, 171, 172,
 231 n.2
 hautbois, 9, 47, 238 n.20
 nagaswaram, 142, 231 n.5
 shahnā'i, 137–42, 218 n.11, 230 n.21,
 231 nn.5, 8
 surnā, 6, 8, 10, 39, 40, 48, 59, 64,
 77, 95, 132, 133, 134, 137–42, 150,
 168, 174, 176, 177, 179, 195, 218 n.13,
 230 n.24, 231 nn.4, 7, 238 n.20
 zurnā, 140, 231 n.5
 flute type, 89, 90, 150, 151, 172, 183, 195
 Chinese panpipes, 151
 nā'i, 20, 29, 39, 47, 49, 50, 55, 77,
 81, 87, 89, 126, 131, 134, 149, 150–
 52, 154, 230 n.21, 231 n.1, 232 n.22
 qaṣab, 150
 horn/trumpet type, 3, 5, 6, 7, 8, 10,
 31, 33, 34, 35, 39, 41, 56, 95, 106,

121–25, 131, 132, 139, 140, 169, 171–
 76, 195, 217 n.7, 221 n.32, 230 nn.19,
 23, 24, 231 n.4, 234 n.23, 236 nn.7,
 8, 9
 karnā, 6, 8, 48, 132, 168, 172–74,
 179, 236 n.10
 kombu, 230 n.19
 siṅg, 6, 121–25, 133, 172, 174, 230 n.19,
 232 n.16, 236 nn.9, 10
 nafīr, 6, 8, 172–74
 single-reed type (clarinet), 138
Afghan/Afghani, 3, 7, 53, 57, 58, 59,
 61, 71, 94, 128, 157, 173, 217 n.6,
 220 nn.24, 27, 222 n.6, 223 n.17,
 224 n.30, 237 n.13. *See also* Kabul
Afghanistan, 44, 47, 57, 71, 108, 220 n.27
Agra, 11, 13, 14, 21, 29, 54, 57, 58, 60, 61,
 62, 71, 75, 86, 93, 94, 114, 124, 125,
 135, 161, 162, 165, 187, 217 n.6,
 223 n.9, 224 n.30, 232 nn.17, 21,
 234 n.23
Ahmednegar, 110
A' in-i Akbari, li, 7, 8, 9, 11, 14, 17, 18, 28,
 56, 74, 78, 91, 108, 110, 112, 117,
 118, 122, 123, 133, 138, 140, 148,
 152, 155, 161, 172, 183, 189, 191, 199,
 218 n.12, 223 n.11, 227 n.1, 232 n.12,
 233 n.22, 239 n.25
Aīsān-daulat Begam, 21
Ajmer, 92, 145, 148, 149, 217 n.6, 232 n.17
Akbar, xxvi, xli, li, lv, lvi, 59, 62–71, 144,
 152, 153, 154, 155, 161, 162, 164,
 166–71, 174, 177, 199, 214 n.2,
 217 nn.6, 7, 218 nn.12–14, 218 n.18,
 220 n.26, 221 nn.31, 1, 225 n.33,
 227 nn.15, 16, 1, 228–29 n.10,

229 n.13, 231 n.4, 232 n.17, 233 n.22,
 234 nn.23, 27, 235 nn.3, 4, 236 n.5,
 237 n.11. *See also harem*
Akbari period
 in general, xl, xli, l, 1–38, 41, 50, 56,
 105–35, 149, 157, 158, 159, 186,
 202–4, 220 n.25, 221 n.34
 paintings, 156, 167, 171, 177, 184, 187,
 192–93, 195–96
Akbar Nāma
 music illustrations in, 81, 90, 92, 94,
 95, 122, 130, 139, 140, 171, 218 n.13,
 231 n.9
 quoted, 2, 3, 10, 11, 14, 32, 33, 48, 60,
 64, 65, 70, 95, 97, 107, 109, 115,
 129, 130, 148, 152, 166, 199, 228 n.2
 references to, li, 6, 13, 15, 29, 54, 61,
 63, 66, 75, 85, 98, 108, 115, 122,
 129, 159, 178, 214 n.3, 218 n.12,
 223 n.11, 227 n.1, 228 n.1
Akbar Nāma (CBL/BL and dispersed),
 132, 225 n.35, 226 n.3
Akbar Nāma (VAM), xxvi, xl, xli, 37,
 118, 204, 217 n.13, 226 n.3
Akhlāt-i Nasiri, 27–28, 39
'Alamgir I. *See* Aurangzeb
Alanquva, xx, xxiii, 66, 225 n.33
Ālāt-i mūsīqī, 25, 26
'Ali-dost Taghai, 9
'Ali Mardan Khan, 166, 174
Ali Mirza, Sultan, 22
'Ali Sher Navai, 45
Allahabad, 11, 163, 188, 217 n.6, 231 n.25
Allauddin Muhammad Khalji, 19, 89
Almira, 14
Amber, 19, 75, 76, 77

269

Vedic, 121, 122
Vijanpatipatra, 158
vīṇā. See chordophones
Vishnu, 32, 33, 38, 80, 113, 122

Wajid Ali Shah, 117
watches of the day, 7, 164, 166, 172. See
 also *pahr*
weighing, 120, 152, 168, 184, 185, 217n.7,
 232–33n.22
West Asia, West Asian
 in general, 7, 13, 18, 27, 28, 39, 85, 106,
 134, 136, 137, 160, 161, 215n.1,
 227n.14, 238–39n.24
 musical instruments, 89, 90, 125–28,
 138, 139, 140, 143, 152, 154–58,
 197, 198, 200–2, 227n.14, 238–
 39n.24
 See also Persia; Afghan

wind instruments. *See* aerophones
women, 9, 20, 54, 71, 72–101, 130, 215n.9,
 219n.22, 227n.12
 births, 54
 character in story, 19, 20, 22, 25–26,
 30–32, 72–101
 dancers. *See* dancers
 family members, 22
 household life, 13, 15, 19, 20, 72–101,
 124, 166, 175, 198, 226nn.1, 2
 Indian, 19, 20, 72–101
 literary/literacy, 16, 19, 219n.21
 marriage, 19, 25, 37, 72–101
 musicians, 20, 71, 77, 81, 82, 88–91, 95,
 100, 106, 127, 130, 131, 132, 143,
 151, 157, 164, 177, 179, 184–86,
 192–93, 196, 202, 220n.25,
 223n.11, 227n.14, 231n.1

patron, 19, 95
political activity, 19, 21–22, 68, 91–101,
 162, 220n.28, 226n.1, 227n.12
wrestling, 31, 59, 138, 155

yantra, 183
Yog Vashisht, 192, 196, 202–3
*yogi*s, 32, 48, 80, 196
Yunus Khan, xxiii, xxvi, 45, 222n.8

Zafar Nāma (1404), 213n.1, 221n.1
Zafar Nāma of Sharafuddin Ali Yazdi
 (1436), 134, 141, 213n.1, 222n.8
Zibunnissa, 16
Zoroastrian(s), 17